BRILLICONTENTS

	THE ROOTS OF ROCK AND ROLL
2	THE ROCK AND ROLL EXPLOSION
3	THE TRANSITION TO MAINSTREAM POP59
4	SOUL MUSIC8
5	THE FOLK INFLUENCE 103
C	THE BRITISH INVASION
7	1960S BLUES AND PSYCHEDELIA
8	CHANGING DIRECTIONS
9	THE HARDER EDGE OF ROCK IN THE SEVENTIES 223
0	BEYOND SOUL 249
	PUNK AND ITS AFTERMATH
2	THE EIGHTIES
3	THE NINETIES AND BEYOND

Study Questions, 27

CONTENTS

	Buddy Holly, 49	Sam Cooke, 87
	The End of an Era, 51	Motown, 89
	Chapter 2 Terms and Definitions, 52	The Assembly Line, 90
	Study Questions, 53	The Sound of Young America, 90
		Holland Dozier Holland, 91
	THE TRANSITION TO MAINSTREAM	Important Motown Artists, 93
)	POP	Smokey Robinson and the Miracles, 93
	Key Terms, 56	The Marvelettes, 93
	Key Figures, 56	Stevie Wonder, 94
	Key Albums, 56	Marvin Gaye, 95
	The Changing Landscape, 56	The Four Tops, 95
	The Death of Rock and Roll, 56	The Temptations, 96
	The Backlash, 57	The Supremes, 96
	Payola, 58	Martha and the Vandellas, 97
	The Pay For Play Scandal, 58	Stax Records, 97
	The Major Labels Stage a Comeback, 59	Back to Memphis, 97
	The Teen Idols—The Boy and Girl Next Door, 59	Stax is Born, 98
	Philadelphia, Dick Clark and <i>American Bandstand</i> , 60	Soulsville, U.S.A., 99
	Dance Crazes and Novelty Tunes, 61	Important Stax Artists, 100
	Brill Building Pop, 62	Booker T. & the MG's, 100
	Leiber and Stoller, 62	Otis Redding, 100
	Aldon Music, 64	Wilson Pickett, 101
	Burt Bacharach and Hal David, 65	Sam and Dave, 101
	Doc Pomus and Mort Shuman, 67	Muscle Shoals and Aretha Franklin, 102
	Pop Music Goes West, 67	Fame Studios, 102
	Los Angeles in the 1960s, 67	Aretha Franklin, 103
	Phil Spector, 67	Chapter 4 Terms and Definitions, 104
	The Wall of Sound, 69	Study Questions, 105
	The LA Pop Scene Explodes, 71	E. Control of the Con
	Surf, 72	THE FOLK INFLUENCE
	Surf Culture, 72	Key Terms, 108
	The Beach Boys, 73	Key Figures, 108
	Pet Sounds, 75	Key Albums, 108
	A Teenage Symphony to God, 76	The Folk Tradition, 108
	Study Questions, 79	The Left-Wing Folk Song Conspiracy, 108
,		Woody Guthrie and Pete Seeger, 109
1	SOUL MUSIC	Hootenannies and Witch Hunts, 109
	Key Terms, 82	The Fifties Folk Revival, 111
	Key Figures, 82	The Calypso Fad, 111
	Key Albums, 82	The Queen of Folk, 112
	The Origins of Soul, 82	The Greenwich Village Scene, 113
	The First Soul Record, 82	Broadside, 114
	Soul and the Civil Rights Movement, 83	Bob Dylan, 115
	What Is Soul?, 83	Boy from The North Country, 115
	The First Important Soul Artists, 84	Hammond's Folly, 116
	Ray Charles, 84	The Times They Are a Changin', 118
	James Brown, 85	Newport 1965, 119

vii

	The Basement Tapes, 120		Key Albums, 160
	Dylan's Later Career, 122		The Sixties Counterculture, 160
	The Dylan Legacy, 123		Seeds of Discontent, 160
	Chapter 5 Terms and Definitions, 123		Drugs, 162
	Study Questions, 125		San Francisco and Acid Rock, 163
			The Hippie Culture, 163
	THE BRITISH INVASION 127		The Summer of Love, 164
J	Key Terms, 128		Counter Culture Media, 165
	Key Figures, 128		Acid Rock, 165
	Key Albums, 128		Important San Francisco Acid Rock Performers, 166
	The British Pop Scene in the 1950s, 128		Jefferson Airplane, 166
	Postwar England, 128		The Grateful Dead, 168
	English Pop Culture, 129		Big Brother and the Holding Company/Janis Joplin, 170
	The Beatles, 130		Other Bay Area Acid Rock Bands, 173
	The Early Years, 134		The Sixties Los Angeles Psychedelic Scene, 174
	The Audition, 134		The Strip, 174
	Beatlemania!, 135		The Doors, 175
	Coming to America, 135		Frank Zappa/The Mothers of Invention, 178
	Meeting Dylan, 137		Woodstock and the Era of the Rock Music Festival, 180
	Coming of Age, 137		Woodstock Performers, 182
	Sgt. Pepper's, 138		British Blues and the Emergence of Hard Rock, 182
	All You Need Is Love, 139		Meanwhile, Across the Pond, 182
	Impending Doom, 139		Hard Rock—The Forerunner to Heavy Metal, 183
	The End, 140		Eric Clapton/Cream, 184
	The Aftermath, 141		Jimi Hendrix, 186
	The Rolling Stones, 142		The Experience, 187
	Image, 142		Coming To America, 188
	The Early Years, 143		Study Questions, 191
	Breaking Through, 143	0	
	Rock and Roll Bad Boys, 144	y	CHANGING DIRECTIONS 193
	Creative Triumph, Tragedy, 146		Key Terms, 194
	The Later Years, 147		Key Figures, 194
	The Who, 148		Key Albums, 194
	The Early Years, 148		The Seventies, 194
	From Mods to Maximum R&B, 148		The Changing Landscape, 194
	Monterey, 150		Fragmentation, 195
	Tommy, 150		Folk Rock, 196
	Final Triumph, Tragedy, 152		The Dylan Influence, 196
	Other British Invasion Bands, 152		The Byrds, 197
	The Mersey Beat Groups, 152		The Mamas and the Papas, 199
	The Blues Oriented Groups, 153		Buffalo Springfield, 199
	Chapter 6 Terms and Definitions, 155		Crosby, Stills, Nash & Young, 200
	Study Questions, 157		Simon & Garfunkel, 201
1			Other Folk Rock Artists, 202
	1960S BLUES AND PSYCHEDELIA 159		Singer/Songwriters, 203
	Key Terms, 160		The Dylan Influence (Again!), 203
	Key Figures, 160		Carole King, 204

viii	CONTENTS		
	Joni Mitchell, 205		Shock Rock: Arenas, Theatrics and Glam, 241
	Carly Simon, 206		Alice Cooper: Godfather of Gruesome Rock Theatre, 241
	James Taylor, 207		Glam Rock, 243
	Van Morrison, 207		David Bowie, 244
	Other Singer/Songwriters, 208		Other Important Glam Rockers, 245
	Country Rock, 208		Study Questions, 247
	Dylan Strikes Again, 208		
	Gram Parsons, 209	11	BEYOND SOUL 249
	The Band, 210	10	Key Terms, 250
	Creedence Clearwater Revival, 211		Key Figures, 250
	Other Country Rock Bands, 212		Key Albums, 250
	Southern Rock, 213		The Changing Soul Landscape, 250
	The Rural Cousin, 213		Soft Soul/Disco, 252
	Lynyrd Skynyrd, 213		The Sound of Philadelphia, 252
	The Allman Brothers Band, 214		Disco—The Underground Revolution, 253
	Other Southern Rock Bands, 215		Disco Conquers The Airwaves, 254
	Corporate Rock, 215		The Backlash, 255
	Mergers and Megahits, 215		Funk, 256
	The Eagles, 216		Black Pop Gets a Brand New Bag, 256
	Fleetwood Mac, 218		George Clinton, 257
	Study Questions, 221		Sly and the Family Stone, 258
			Other Important Funk Bands, 259
y	THE HARDER EDGE OF ROCK IN THE		Reggae, 260
•	SEVENTIES		What Is Reggae?, 260
	Key Terms, 224		Rastafari Culture, 261
	Key Figures, 224		Historical Background To Reggae, 261
	Key Albums, 224		Bob Marley and the Wailers, 262
	The Birth of Heavy Metal, 224		Other Reggae Artists, 263
	The Industrial Roots, 224		Rap, 264
	The Earliest Heavy Metal Bands, 226		Muhammad Ali and the Beginnings of Hip-Hop Culture, 264
	Black Sabbath, 226		The Jamaica-South Bronx Connection, 265
	Led Zeppelin, 227		The Beginnings of Rap, 266
	Other Important Heavy Metal Bands from the Seventies, 230		East Coast Rap, 268
	Deep Purple, 230		CNN for Black Culture, 269
	Judge Driest 221		West Coast and Gangsta Ran, 270

Judas Priest, 231 Queen, 232 Aerosmith, 232

KISS, 233	
Van Halen, 234	
Other Metal Bands From the 70s, 234	

Art Rock, 235

The Origins of Art Rock, 235

Important Art Rock Bands, 236

The Moody Blues, 236 King Crimson, 239

Yes, 240

Other Important Art Rock Bands, 241

Other Important Glam Rockers, 245
Study Questions, 247
BEYOND SOUL 249
Key Terms, 250
Key Figures, 250
Key Albums, 250
The Changing Soul Landscape, 250
Soft Soul/Disco, 252
The Sound of Philadelphia, 252
Disco—The Underground Revolution, 253
Disco Conquers The Airwaves, 254
The Backlash, 255
Funk, 256
Black Pop Gets a Brand New Bag, 256
George Clinton, 257
Sly and the Family Stone, 258
Other Important Funk Bands, 259
Reggae, 260
What Is Reggae?, 260
Rastafari Culture, 261
Historical Background To Reggae, 261
Bob Marley and the Wailers, 262
Other Reggae Artists, 263
Rap, 264
Muhammad Ali and the Beginnings of Hip-Hop Culture, 264
The Jamaica-South Bronx Connection, 265
The Beginnings of Rap, 266
East Coast Rap, 268
CNN for Black Culture, 269
West Coast and Gangsta Rap, 270
The East Coast-West Coast Rivalry, 272
Chapter 10 Terms and Definitions, 273
Study Questions, 275
PUNK AND ITS AFTERMATH27

Key Terms, 278

Key Figures, 278

Key Albums, 278 The Origins of Punk, 278

The Anti-Revolution, 278

Punk Culture, 279

The Earliest Punk Bands, 280 Protopunk, 280

ix

	The Velvet Underground, 281		Industrial, 318
	The New York Scene, 283		Other Eighties Goings On, 319
	CBGB, 283		Study Questions, 323
	The Ramones, 284		
	The London Scene, 285	12	TI-IE NINETIES AND BEYOND
	No Future, 285	I mad	Key Terms, 326
	The Sex Pistols, 286		Key Figures, 326
	The Clash, 289		Key Albums, 326
	Other Important Punk Bands, 290		The 1990s: The Triumph of Alternative Nation, 326
	The Punk Aftermath, 290		Nirvana, 326
	New Wave, 290		Grunge and the Seattle Scene, 328
	Hardcore, 293		Other Nineties Alternative Rock, 329
	Important Hardcore Bands, 294		Pop in the 1990s, 332
	Study Questions, 297		Soundscan, 332
10			The Boy Bands, 333
12	TI-IE EIGHTIES		The Girls Respond, 334
	Key Terms, 300		Rock in the New Millennium, 335
	Key Figures, 300		Rap/Soul/Hip-Hop, 335
	Key Albums, 300		Pop/Rock, 338
	Technology Rules, 300		Country, 342
	Changing Consumer Technologies, 300		Indie/Alternative, 343
	MIDI and Digital Tape Recording, 301		Contemporary Hard Rock/Metal, 345
	MTV, 302		The Music Industry in the Eighties and Nineties:
	Michael, Madonna, and Prince:		Living Large in LA, 346
	Post-Disco Dance Dominance, 303		The Majors Rule, 346
	The King of Pop, 303		Hubris, 347
	The Material Girl, 307		The Majors Meet Their Match, 348
	The Artist Formerly Known As , 308		Napster, 348
	The Boss, Bono, and the Rest: Back to Basics, 310		The iTunes Music Store and Beyond, 349
	The Boss, 310		The Future, 350
	U2, 311		The End of the World as We Know It?, 350
	Whitney Houston, 313		Study Questions, 353
	Eighties Alternative, 314		
	The Cultural Underground Railroad, 314		References, 355
	Important Alternative Bands, 315		Glossary, 359
	The Edgier Side of the Eighties, 317		Name Index, 367
	1980s Metal, 317		Subject Index, 385

A CONTRACTOR OF THE CONTRACTOR

CHAPTER 1

Music Cut 1: "I've Got You Under My Skin" (Cole Porter)—Frank Sinatra 5

Music Cut 2: "King Porter Stomp" (Jelly Roll Morton)—Benny Goodman Orchestra 6

Music Cut 3: "Cross Road Blues" (Robert Johnson)—Robert Johnson 14

Music Cut 4: "Koko" (Charlie Parker)—Charlie Parker's Reboppers 15

Music Cut 5: "Take My Hand, Precious Lord" (Thomas Dorsey)—Mahalia Jackson 16

Music Cut 6: "Choo Choo Ch' Boogie" (Vaughn Horton/DenverDarling/Milt Gabler)—Louis Jordan and His Tympany Five 18

Music Cut 7: "Why Do Fools Fall in Love" (Frankie Lymon/Morris Levy)—Frankie Lymon and the Teenagers 20

Music Cut 8: "Blue Yodel #1 (T for Texas)" (Jimmie Rodgers)—Jimmie Rodgers 22

Music Cut 9: "Blue Moon of Kentucky"
(Bill Monroe)—Bill Monroe and His Blue
Grass Boys 23

Music Cut 10: "Your Cheatin' Heart" (Hank Williams/Fred Rose)—Hank Williams 25

CHAPTER 2

Music Cut 11: "Rock Around the Clock" (Jimmy De Knight/Max C. Freedman)—Bill Haley and His Comets 32

Music Cut 12: "Rocket 88" (Jackie Brenston), Jackie Brenston and His Delta Cats 34

Music Cut 13: "That's All Right" (Arthur Crudup)—Elvis Presley, Scotty and Bill 36

Music Cut 14: "Hound Dog" (Jerry Leiber/

Mike Stoller)—Elvis Presley 38

Music Cut 15: "Tutti Frutti" (Richard Penniman, Dorothy LaBostrie, Joe Lubin)—Little Richard 42

Music Cut 16: "Bo Diddley" (Ellas McDaniel)—Bo Diddley 44

Music Cut 17: "Maybellene" (Berry/Russ Fratto/Alan Freed)—Chuck Berry **45**

Music Cut 18: "Blue Suede Shoes" (Carl Perkins)—Carl Perkins 48

Music Cut 19: "Great Balls of Fire" (Otis Blackwell/Jack Hammer)—Jerry Lee Lewis 49

Music Cut 20: "Beggy Sug" (Buddy Helly/Jarry)

Music Cut 20: "Peggy Sue" (Buddy Holly/Jerry Allison/Norman Petty)—Buddy Holly 50

CHAPTER 3

Music Cut 21: "The Twist" (Hank Ballard)—Chubby Checker 62

Music Cut 22: "On Broadway" (Jerry Leiber/ Mike Stoller/CynthiaWeill/Barry Mann)—the Drifters 63

Music Cut 23: "Will You Love Me Tomorrow" (Carole King/GerryGoffin)—the Shirelles 64

Music Cut 24: "Walk on By" (Burt Bacharach/ Hal David)—Dionne Warwick 66 Music Cut 25: "He's a Rebel" (Gene Pitney)—
The Crystals 69

Music Cut 26: "You've Lost That Lovin' Feeling" (Phil Spector/Barry Mann/Cynthia Weill)—the Righteous Brothers 70

Music Cut 27: "The Last Train to Clarksville" (Tommy Boyce/Bobby Hart)—The Monkees 71

Music Cut 28: "Miserlou" (Traditional/Nick Roubanis/Fred Wise/Milton Leeds/Bob Russell)—Dick Dale and the Del Tones 73

Music Cut 29: "Wouldn't It Be Nice" (Brian Wilson/Mike Love/TonyAsher)—the Beach Boys 75

Music Cut 30: "Good Vibrations" (Brian Wilson/ Mike Love)—the Beach Boys 76

CHAPTER 4

Music Cut 31: "I Got a Woman" (Ray Charles/ Renald Richard)—Ray Charles 85

Music Cut 32: "Cold Sweat" (James Brown/ Alfred Ellis)—James Brown 87

Music Cut 33: "A Change is Gonna Come" (Woody Guthrie)—Sam Cooke 88

Music Cut 34: "Where Did Our Love Go" (Brian Holland/Lamont Dozier/Eddie Holland)—the Supremes 92

Music Cut 35: "The Tracks of My Tears" (Smokey Robinson/Pete Moore/Marv Tarplin)—Smokey Robinson and the Miracles 93

Music Cut 36: "Fingertips Pt. 2" (Clarence Paul/ Henry Cosby)—Stevie Wonder 94

Music Cut 37: "Green Onions" (Booker T. Jones/ Steve Cropper/Lewie Steinberg/Al Jackson, Jr.)— Booker T. & the MG's 98

Music Cut 38: "In the Midnight Hour" (Wilson Pickett/Steve Cropper)—Wilson Pickett 101

Music Cut 39: "Soul Man" (Isaac Hayes/David Porter)—Sam and Dave 102

Music Cut 40: "Respect" (Otis Redding)— Aretha Franklin 104

CHAPTER 5

Music Cut 41: "Pretty Boy Floyd" (Woody Guthrie)—Woody Guthrie 109
Music Cut 42: "We Shall Overcome" (Traditional)—Pete Seeger 110

Music Cut 43: "Banana Boat Song (Day-O)" (Traditional)—Harry Belafonte 111

Music Cut 44: "Tom Dooley" (Traditional)—the Kingston Trio 112

Music Cut 45: "House of the Rising Sun" (traditional)—Joan Baez 113

Music Cut 46: "If I Had a Hammer" (Pete Seeger/ Lee Hays)—Peter, Paul and Mary 113

Music Cut 47: "Blowin' in the Wind" (Bob Dylan)—Bob Dylan 117

Music Cut 48: "Subterranean Homesick Blues" (Bob Dylan)—Bob Dylan 119

Music Cut 49: "Like a Rolling Stone" (Bob Dylan)—Bob Dylan 120

Music Cut 50: "Rainy Day Women #12 & 35" (Bob Dylan)—Bob Dylan 121

CHAPTER 6

Music Cut 51: "Hard Day's Night" (Lennon/McCartney)—The Beatles 136

Music Cut 52: "Tomorrow Never Knows" (John Lennon/Paul McCartney)—the Beatles 138

Music Cut 53: "Here Comes the Sun" (George Harrison)—the Beatles 141

Music Cut 54: "(I Can't Get No) Satisfaction" (Mick Jagger/Keith Richards)—the Rolling Stones 144

Music Cut 55: "Jumpin' Jack Flash" (Mick Jagger/ Keith Richards)—the Rolling Stones 145

Music Cut 56: "Sympathy for the Devil" (Mick Jagger/Keith Richards)—the Rolling Stones 146

Music Cut 57: "My Generation" (Pete Townshend)—the Who 150

Music Cut 58: "Won't Get Fooled Again" (Pete Townshend)—the Who 151

Music Cut 59: "On a Carousel" (Clarke/Hicks/Nash)—the Hollies 153

Music Cut 60: "House of the Rising Sun" (Traditional)—the Animals 155

CHAPTER 7

Music Cut 61: "White Rabbit" (Grace Slick)— Jefferson Airplane 167

Music Cut 62: "Truckin" (Jerry Garcia/Phil Lesh/Bob Weir/Robert Hunter)—The Grateful Dead 170

- Music Cut 63: "Piece of My Heart" (Bert Berns/ Jerry Ragovoy)—Big Brother and the Holding Company 171
- Music Cut 64: "Soul Sacrifice" (Carlos Santana/ Gregg Rolie/David Brown/Marcus Malone)— Santana 173
- Music Cut 65: "Break on Through" (Morrison/ Manzarek/Krieger/Densmore)—the Doors 177
- Music Cut 66: "The End" (Jim Morrison/Ray Manzarek/Robby Krieger/John Densmore)—the Doors 177
- Music Cut 67: "Who Are the Brain Police?" (Frank Zappa)—The Mothers of Invention 179
- Music Cut 68: "With a Little Help from My Friends" (John Lennon/Paul McCartney)—
 Joe Cocker 181
- Music Cut 69: "Strange Brew" (Eric Clapton/ Gail Collins/Felix Pappalardi)—Cream 185
- Music Cut 70: "Third Stone from the Sun"
 (Jimi Hendrix)—the Jimi Hendrix
 Experience 187

CHAPTER 8

- Music Cut 71: "Mr. Tambourine Man" (Dylan)—the Byrds 198
- Music Cut 72: "Carry On" (Stephen Stills)— Crosby, Stills, Nash & Young 201
- Music Cut 73: "Mrs. Robinson" (Paul Simon)— Simon and Garfunkel 202
- Music Cut 74: "It's Too Late" (Carole King/ Toni Stern)—Carole King 205
- Music Cut 75: "A Case of You" (Joni Mitchell)— Joni Mitchell 206
- Music Cut 76: "Brown Eyed Girl" (Van Morrison)—Van Morrison 208
- Music Cut 77: "The Weight" (Robbie Robertson)—the Band 211
- Music Cut 78: "Fortunate Son" (John Fogarty)— Creedence Clearwater Revival 212
- Music Cut 79: "Sweet Home Alabama" (Ed King/ Gary Rossington/Ronnie Van Zant)—Lynyrd Skynyrd 214
- Music Cut 80: "Take It Easy" (Jackson Browne, Glenn Frey)—the Eagles 217

CHAPTER 9

- Music Cut 81: "Iron Man" (Ozzy Osbourne/ Tony Iommi/Geezer Butler/Bill Ward)— Black Sabbath 227
- Music Cut 82: "Whole Lotta Love" (Willie Dixon/ Led Zeppelin)—Led Zeppelin 229
- Music Cut 83: "Stairway to Heaven" (Jimmy Page/ Robert Plant)—Led Zeppelin 230
- Music Cut 84: "Eruption" (Eddie Van Halen)— Van Halen 234
- Music Cut 85: "Nights in White Satin" (Justin Hayward)—The Moody Blues 237
- Music Cut 86: "Money" (Roger Waters)— Pink Floyd 238
- Music Cut 87: "Roundabout" (Jon Anderson/ Steve Howe)—Yes 240
- Music Cut 88: "I'm Eighteen" (Michael Bruce/ Vincent Furnier/Dennis Dunaway/Neal Smith/ Glen Buxton)—Alice Cooper 242
- Music Cut 89: "Ziggy Stardust" (David Bowie)—
 David Bowie 244
- Music Cut 90: "Candle in the Wind 1997" (Elton John/Bernie Taupin)—Elton John 246

CHAPTER 10

- Music Cut 91: "Could It Be I'm Falling in Love" (Melvin Steals/Mervin Steals)—the Spinners 253
- Music Cut 92: "Stayin' Alive" (Barry Gibb/Robin Gibb/Maurice Gibb)—the Bee Gees 255
- Music Cut 93: "Thank You (Falletin Me Be Mice Elf Agin)" (Sly Stone)—Sly and the Family Stone 258
- Music Cut 94: "Superstition" (Stevie Wonder)—
 Stevie Wonder 259
- Music Cut 95: "I Shot the Sheriff" (Bob Marley)—the Wailers 263
- Music Cut 96: "Rapper's Delight" (The Sugarhill Gang/Sylvia Robinson/Nile Rodgers/Bernard Edwards/Grandmaster Caz)—the Sugarhill Gang 267
- Music Cut 97: "The Message" (Ed "Duke Bootee" Fletcher/Grandmaster Melle Mel/Sylvia Robinson)—Grandmaster Flash and the Furious Five 268

Music Cut 98: "Walk This Way" (Steven Tyler/ Joe Perry)—Run-D.M.C. 269

Music Cut 99: "Bring the Noise" (Carl Ridenhour/ Hank Shocklee/Eric "Vietnam" Sadler/James Brown/George Clinton)—Public Enemy 270

Music Cut 100: "6 'N the Morning" (Andre Manuel/Tracy Marrow)—Ice T 271

CHAPTER 11

Music Cut 101: "I Wanna Be Your Dog"
(Dave Alexander/Ron Asheton/Scott Asheton/
Iggy Pop)—the Stooges 281

Music Cut 102: "I'm Waiting for the Man" (Lou Reed)—the Velvet Underground 282

Music Cut 103: "Sheena Is a Punk Rocker" (Joey Ramone)—the Ramones 284

Music Cut 104: "God Save the Queen"

(Paul Cook/Steve Jones/Glen Matlock/John
Lydon)—the Sex Pistols 288

Music Cut 105: "London Calling" (Joe Strummer/ Mick Jones)—the Clash 289

Music Cut 106: "Burning Down the House" (David Byrne/Chris Frantz/Jerry Harrison/Tina Weymouth)—Talking Heads 291

Music Cut 107: "Every Breath You Take" (Sting)—the Police 293

Music Cut 108: "Rise Above" (Greg Ginn)—Black Flag 294

CHAPTER 12

Music Cut 109: "Billie Jean" (Michael Jackson)—Michael Jackson 305

Music Cut 110: "Papa Don't Preach" (Brian Elliot/ Madonna)—Madonna 307

Music Cut 111: "Purple Rain" (Prince)—Prince 309

Music Cut 112: "Born in the U.S.A."

(Bruce Springsteen)—Bruce Springsteen 311

Music Cut 113: "I Still Haven't Found What I'm Looking For" (Bono)—U2 312

Music Cut 114: "I Will Always Love You" (Dolly Parton)—Whitney Houston 313

Music Cut 115: "Radio Free Europe" (Michael Stipe/ Peter Buck/Mike Mills/Bill Berry)—R.E.M 316

Music Cut 116: "Welcome to the Jungle" (Axl Rose/Slash)—Guns N' Roses 318

Music Cut 117: "Mr. Self Destruct" (Trent Reznor)—Nine Inch Nails 319

Music Cut 118: "(Just Like) Starting Over" (John Lennon)—John Lennon 320

CHAPTER 13

Music Cut 119: "Smells Like Teen Spirit" (Kurt Cobain/David Grohl/ Krist Novoselic)—Nirvana 328

Music Cut 120: "Paranoid Android" (Thom Yorke/Jonny Greenwood/Ed O'Brien/Colin Greenwood/Phil Selway)—Radiohead 331

Music Cut 121: "One Sweet Day" (Mariah Carey/ Walter Afanasieff/Wanya Morris/Nathan Morris/ Shawn Stockman/Michael McCary)—Mariah Carey, Boyz II Men 334

Music Cut 122: "Stan" (Marshall Mathers, Dido Armstrong, Paul Herman)—Eminem 336

Music Cut 123: "Single Ladies (Put a Ring on It" (Christopher "Tricky" Stewart/Terius "The Dream" Nash/Thaddis Herrel/Beyoncé Knowles)—Beyoncé 338

Music Cut 124: "Look What You Made Me Do" (Taylor Swift/Jack Antonoff/Fred Fairbrass/ Richard Fairbrass/Bob Manzoli)—Taylor Swift 339

Music Cut 125: "Poker Face" (Stefani Germanotta/ Nadir Khayat)—Lady Gaga 341

Music Cut 126: "Need You Now" (Hillary Scott/ Charles Kelley/Dave Haywood/Josh Kear)—Lady Antebellum 343

Music Cut 127: "The Big Three Killed My Baby" (Jack White)—the White Stripes 344

Music Cut 128: "Rope" (Foo Fighters)—
Foo Fighters 346

ock and roll is the music of youth, of rebellion, and of the common spirit that ties all that together. It is a uniquely American music and cultural form, but since its birth more than 50 years ago it has been embraced by the entire world. Its history is a compelling story of musical and cultural changes that like a tidal wave has changed the existing mores and conventions of life in the 20th century. Rock and roll's history is the story of controversy, tragedy, and self-indulgence; and also of love, peace, and the triumph of the human spirit. It is the stories of some of the most interesting and creative people of the last half-century. It is also the story of cities and scenes, and changing political climates, and economic self-interests. But it is primarily the story of young people creating and connecting with music at a time in their lives when they are searching for an identity.

The History of Rock and Roll is designed for the college non-music major, but can also be useful and interesting reading for anyone. Although at the current time there are not an abundance of college level rock history courses offered, it is the author's belief that in time this will change as the cultural impact of rock and roll becomes more self-evident. This book can be a useful resource for any rock music class whose intent is to make the connections between the music and the culture in which it interacted.

Included with the purchase of *The History of Rock and Roll* is a subscription to the online music service Napster, so the student can have unlimited access to the music identified in the book and listened to in class. In addition, 65 recordings are accompanied by synopses in the text, providing interesting insights and information that can assist in further understanding the music and the recording artists.

The History of Rock and Roll also details the most important rock styles, how they evolved, and their important artists, as well as a listing of key recordings in each. The text also contains biographical information on recording artists, composers, producers, DJs, record executives, and other figures relevant to the history of the music. It is my hope that any interested student of the music will find the text to provide a wealth of information that will nurture an understanding of the music and its place in our cultural fabric.

—Tom Larson

would like to gratefully thank the people who have assisted in some way with the completion of this book:

Kendall Hunt Publishing Company, and my Senior Project Coordinator Michelle Bahr.

Dr. Scott Anderson for knowing a lot of stuff and sharing a lot of it with me.

Dr. Randy Snyder for inspiration and mentoring.

All the musicians that I have come to know as friends and fellow travelers over the years in the course of rehearing, gigging, taking long road trips, and just hanging out.

Lastly, thanks to those with whom I am closest for their support: my wife, Kim; my children Kalie, Will, and Carolyn; and especially my mother, Shirley Larson, and my late father, Roger Larson, who back in my garage band days survived the bone rattling basement rehearsals, long hairs coming and going at all hours of the day and night, and the general sense of anxiety I'm sure they had of not knowing where it was all leading. Somehow they remained supportive, and I love them for that.

om Larson is Assistant Professor of Composition (Emerging Media and Digital Arts) at the Glenn Korff School of Music at the University of Nebraska-Lincoln. In addition to authoring The History of Rock and Roll, he is also the author of Modem Sounds: The Artistry of Contemporary Jazz, and The History and Tradition of Jazz, both published by Kendall Hunt Publishing. His first CD of original jazz compositions, Flashback, was released in 2003. He has studied jazz piano with Dean Earle, Fred Hersch, Bruce Barth, and Kenny Werner, jazz arranging with Herb Pomeroy and music composi-

tion with Robert Beadell and Randall Snyder. In addition to performing with jazz ensembles throughout the Midwest and East Coast, he has performed with Paul Shaffer, Victor Lewis, Dave Stryker, Bobby Shew, Claude Williams, Bo Diddley, Jackie Allen, the Omaha Symphony, the Nebraska Chamber Orchestra, the Nebraska Jazz Orchestra, and the University of Nebraska Faculty Jazz Ensemble.

Tom also writes and produces music for documentary films; among his credits are the scores for three documentaries for the PBS American Experience series (a production of WGBH-TV, Boston): In the White Man's Image, Around the World in 72 Days, and Monkey Trial. He also scored the documentaries Willa Cather: The Road Is All for WNET-TV (New York), Ashes from the Dust for the PBS series NOVA, and the PBS specials Most Honorable Son and In Search of the Oregon Trail. Tom has written extensively for the Nebraska Educational Telecommunications, South Dakota Public Broadcasting, and the University of Illinois Asian Studies Department. His music has also been used on the CBS-TV series The District. His commercial credits include music written for Phoenix-based Music Oasis, L.A.-based Music Animals, Chicago-based Pfeifer Music Partners and General Learning Communications, and advertising agencies in Nebraska.

A Lincoln native, Tom received a Bachelor of Music in Composition in 1977 from Berklee College of Music in Boston and a Master of Music in Composition in 1985 from the University of Nebraska-Lincoln. He is also an avid runner, and completed the Boston Marathon in 2005, 2006, and 2007. More information on Tom Larson can be found at tomlarsonmusic.net.

THE ROOTS OF ROCK AND ROLL

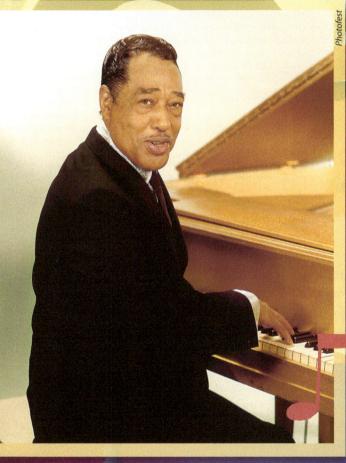

"It's like an act of murder; you play with intent to commit something."

—Duke Ellington on Jazz

KEY TERMS

Tin Pan Alley
The Swing Era
Race music
Hillbilly music
Cover
Acoustical/electrical
process
Album
Single
Major labels
Independent labels
Billboard magazine
RIAA
Gold, platinum &

DJ
The Moondog House Rock
and Roll Party
Top 40
The blues
Work song, shout, field
holler
Mississippi Delta
Country blues
AAB lyric form
Classic blues
Jazz
Gospel

Doo-wop
Hillbilly music
British folk tradition
The Bristol Sessions
Grand Ole Opry
Cowboy music
Western swing
Bluegrass
Honky tonk

KEY FIGURES

Bing Crosby Frank Sinatra Benny Goodman Pat Boone Alan Freed Moondog Todd Storz

diamond records

Bessie Smith
Robert Johnson
Thomas Dorsey
Louis Jordan and His
Tympany Five
Frankie Lymon and the
Teenagers

Ralph Peer The Carter Family Jimmie Rodgers Bill Monroe Lester Flatt/Earl Skruggs Hank Williams

ROCK AND ROLL: THE MUSIC THAT CHANGED THE WORLD

Melisma

Rhythm & Blues

When rock and roll exploded onto the American landscape in the mid 1950s, it marked nothing less than a defining moment in history. In many ways its birth was a manifestation of a seismic shift that was already taking place in our cultural fabric: from an elitist to a working class ethos; from an adult oriented society to one that glorified youth; and from one where art was defined by European standards to one where art was defined in purely American terms. Rock and roll was purely American, as were all of its musical ancestors, which included the blues, jazz, Rhythm and Blues, gospel, hillbilly, country, bluegrass and honky tonk. And like America, rock and rock didn't sit still for long; it very quickly began to evolve as it embraced a wide variety of influences that ranged from new technologies to interpretations by British imitators. As a result, within ten years or so there were a plethora of styles—folk rock, soul, psychedelic, hard rock, art rock, etc—that all fit under the rock umbrella.

The emergence of rock and roll also signaled a major shift in the nature of our popular music. Unlike the pop music of the first half of the 20th century, which was largely conceived by an industry based in New York City and watered down to appeal to the largest audience possible—in other words, white, middle class adults—rock and roll was from the South and Middle States, and was

decidedly more rural, more lower class, more dynamic, more African American and more youth oriented. Unlike the music of Tin Pan Alley, rock incubated in the streets in a grassroots fashion, so it had a mind of its own and would not easily take orders from anyone. Rock's sense of independence has remained intact—even today it continues to demonstrate a remarkable virus-like resistance to the constant meddling by the pop music industry. This is in fact one of the central themes that runs through the music's history: every time the corporate types appear to have harnessed the music for its own self-interest, rock seems to somehow wriggle free and reinvent itself. Like the musicians who create it, rock in this sense is rebellious and self-determined, resentful of authority, and defies subordination.

But above all, rock and roll, simply stated, is, always has been and always will be, the music of youth and all that goes with it. During the mid-1950s, it exploded onto the American cultural landscape through the insistence of small independent record labels, renegade radio DJs and a teen audience that wouldn't take the watered down industry product any more. For the first time in history, the music of the underprivileged and disaffected, the angry and unruly, the idealistic and discontented became America's most popular music. As rock and roll took its place on center stage, it changed our society, and in turn reflected those changes within itself.

Chapters 2–13 of this text chronicle the history of the music and the important events and personalities that shaped it. But before we get there, let's take a look at the American music scene in the first half of the 20th century and see how the groundwork was laid for the rock and roll revolution.

THE EARLY YEARS OF AMERICAN POP MUSIC

Tin Pan Alley

America's pop music industry was created in the late 1800s when the publishers and songwriters of Tin Pan Alley began to supply vaudeville and Broadway shows with popular songs. These songs were also made available in written form to the general public through the sale of sheet music. Tin Pan Alley was originally an actual place, on 28th Street between Broadway and 6th Avenue in New York, where many of the earliest publishing companies set up shop. Although most eventually moved uptown, the name stuck and today is generally used to describe the music publishing industry as it operated in the first half of the 20th century. The music of the Tin Pan Alley composers defined much of our popular song catalogue of the era, and was eventually used not only for theatrical shows but also for popular songs, Hollywood movies and jazz standards. Among the greatest Tin Pan Alley composers were Irving Berlin ("God Bless America," "White Christmas"); George and Ira Gershwin ("I Got Rhythm," "'S Wonderful"); Richard Rodgers, teaming with lyricists Lorenz Hart ("My Funny Valentine") and Oscar Hammerstein II (Broadway musicals South Pacific, Oklahoma, The Sound of Music); and Cole Porter ("I've Got You Under My Skin").

■ Irving Berlin

- George and Ira Gershwin
- Richard Rodgers
- Lorenz Hart
- Oscar Hammerstein II
- Cole Porter

The First Pop Singers

One of the first important pop singers in 20th century America was Al Jolson who, singing in blackface as minstrel singers had done in the mid-1800s became Broadway's biggest star in the early 1900s. In 1927 Jolson also starred in the first successful talking picture, The Jazz Singer. As recordings and radio began to replace sheet music as the most popular medium by which to distribute pop music, the first true pop singers, known as crooners emerged. Rudy Vallee, who used a megaphone to project his voice (before amplification was used), became one of the first entertainers to effectively use radio to reach stardom in the 1920s. Bing Crosby (1903–1977) became the most influential crooner with his easy-going charm and witty style of singing ballads. Starting his career in 1926 making records with the Paul Whiteman Orchestra (with whom he had his first #1 hit in 1928 with "Ol' Man River"), Crosby began working in network radio and film in 1931, eventually starring in more than 60 movies before his death in 1977. His recording of "White Christmas" from the 1942 movie Holiday Inn rose to the #1 spot on the charts, won a Grammy Award for best song of 1942, and eventually sold over 50 million copies, making it the best-selling vinyl single in history.

The first pop singer to create a unique personal style and image was **Frank Sinatra**. Influenced by jazz singers Louis Armstrong and Billy Holiday, Sinatra (1915–1998) took liberties with melodies and interpreted songs in his own way.

Starting as a big band singer with the Tommy Dorsey Orchestra, Sinatra became a solo artist and film star in the 1950s while developing a tough guy image that made him appear as both dangerous and admirable at the same time. Although he condemned rock and roll at first, Sinatra's public macho posturing, womanizing and associations with shadowy figures in fact became a sort of blueprint for many rock stars that followed him. He also spawned a whole generation of dark and handsome Italian singers such as Dean Martin, Tony Bennett and Vic Damone that also had considerable pop success.

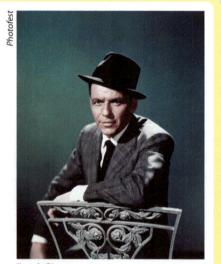

Frank Sinatra

SINATRA ON ROCK AND ROLL

Frank Sinatra, who was the object of shrieking female fans in the 1940s, originally dismissed rock and roll, commenting that "It is sung, played, and written for the most part by cretinous goons, and by means of its almost imbecilic reiteration and sly, lewd, in plain fact dirty, lyrics it manages to be the martial music of every side-burned delinquent on the face of the earth." However, his tune quickly changed, and by 1960 he cohosted a network TV special with Elvis Presley on which the two sang each other's signature songs, "Love Me Tender" and "Witchcraft."

"I'VE GOT YOU UNDER MY SKIN" (COLE PORTER)—FRANK SINATRA

Personnel: Frank Sinatra: vocal; Mannie Klein, Harry Edison, Conrad Gozzo, Mickey Mangano: trumpet; Jimmy Priddy, Milt Bernhart, Juan Tizol: trombone; George Roberts: bass trombone; Willie Schwartz, Harry Klee: alto sax; Justin Gordon, James Williamson: tenor sax; Mort Friedman: baritone sax; Felix Slatkin, Paul Shure, Mischa Russell, Paul Nero, Nathan Ross, Alex Murray, Henry Hill, Alex Beller, Walter Edelstein, Victor Bay: violin; Maxine Johnson, Milton Thomas, Alvin Dinkin: viola; Eleanor Slatkin, Edgar Lustgarten, Ennio Bolognini: cello; Kathryn Julye: harp; Bill Miller: piano; George Van Eps: guitar; Joe Comfort: bass; Irving Cottier: drums; Nelson Riddle: arranger, conductor. Recorded January 12, 1956, Capitol Records Studios, Hollywood, CA. Released on the Capitol LP *Songs for Swingin' Lovers*, March 5, 1956.

"I've Got You Under My Skin" has been called Frank Sinatra's "coup de grace of up tempo masterpieces." The arrangement was written by Nelson Riddle, with whom Sinatra had been working since the singer moved to Capitol Records in 1953. The album from which it appears, *Songs for Swingin' Lovers*, was the singer's fourth for Capitol, and is considered to be one of his best.

Frank Sinatra had been the object of shrieking female fans in the 1940's, and would later revive his career in the 1960s. Although today they are considered classics, his Capitol recordings from the 1950s showed him to be out of touch with the oncoming rock and roll craze. Sinatra originally dismissed rock and roll, commenting that "It is sung, played, and written for the most part by cretinous goons, and by means of its almost imbecilic reiteration and sly, lewd, in plain fact dirty, lyrics it manages to be the martial music of every side-burned delinquent on the face of the earth." However, he eventually embraced the music, and in 1960 co-hosted a network TV special with Elvis Presley on which the two sang each other's signature songs, "Love Me Tender" and "Witchcraft."

The Swing Era

During the Swing Era (1935–1946), big band jazz or swing music became the dominant form of pop music. Swing brought the recording industry back to life after it was almost killed by the Depression. It helped the country get through WWII, as many of the biggest Swing Era hits were sentimental in nature and reflected the mood of anxiety that accompanied the war. Swing also firmly established itself as music to dance to, and spawned dozens of dance fads such as the Fox Trot, Lindy Hop, Jitterbug and Rumba. The term 'swing' was used as a marketing ploy to overcome the negative connotations that still persisted about jazz in the 1930s. During the early years of the Swing Era, most of the hit records were of original material written and arranged by the bands themselves. As the music professionals began to increasingly treat the music as a consumer product, most of the hits were novelty and sing-along songs from Tin Pan Alley that featured the band vocalists. It was in this way that the careers of Frank Sinatra, Doris Day, Peggy Lee and others were launched.

The first star of the Swing Era was the unassuming **Benny Goodman** (1909–1986), whose meteoric rise to fame started at the Palomar Ballroom in Los Angeles on August 21, 1935. Hundreds of teens showed up that night to hear and dance to the music they had been hearing on the NBC network radio program *Let's Dance*. One secret of Goodman's success was the arrangements he had bought from black musicians such as Fletcher Henderson and Don Redman

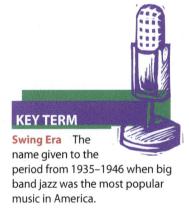

that up to that point had rarely been heard outside of Harlem. By virtue of being white, Goodman was able to bring the music of African American culture to the mass white audience, in much the same way that Elvis Presley would do 20 years later. In his wake, hundreds of other bands that looked like Goodman's and sounded like pale imitations of the Harlem musicians who created the music provided the country with the soundtrack to an era.

MUSIC CUT 2

"KING PORTER STOMP" (JELLY ROLL MORTON)— **BENNY GOODMAN ORCHESTRA**

Personnel: Goodman: clarinet; Bunny Berigan, Nate Kazebier, Ralph Muzzillo: trumpet; Red Ballard, Jack Lacey: trombone; Toots Mondello, Hymie Schertzer: alto sax; Dick Clark, Art Rollini: tenor sax; Frank Froeba: piano; George Van Eps: guitar; Harry Goodman: bass; Gene Krupa: drums; Fletcher Henderson: arranger. Recorded July 1, 1935.

If there were ever a textbook big band arrangement that exemplifies the joyous dance music of the swing era, it would have to be Fletcher Henderson's "King Porter Stomp." This Jelly Roll Morton tune became the first hit of the swing era and employs all the arranging techniques that had been developed in the Henderson band by Don Redman, Benny Carter, and Fletcher and Horace Henderson. Recorded just a few weeks before Goodman's famous successful opening at the Palomar Ballroom (which kicked off the Swing Era), this superb recording gives the listener a glimpse of what the Goodman Orchestra must have sounded like that night.

The Post War Transitional Years

From 1946 to 1954, the pop music business was in transition—essentially the calm years before the storm hit that changed everything. Race music (later known as Rhythm and Blues) and hillbilly music (later known as county) were becoming increasingly popular among a growing, albeit segmented audience. In spite of this, the major labels pretty much ignored these styles and their audiences, as they had done since the 1920s, and continued to promote their mainstream pop artists such as Patti Page, Perry Como, Rosemary Clooney and Sinatra. During this same time period a number of small independent record labels began to spring up, eager to find any kind of niche in the marketplace; R&B and country music fit the bill for many. In spite of the fact that by 1952 there were around 100 independents, their mark on the industry was still negligible—only five of the 163 singles that were million sellers during this period came from independent labels.

On the rare occasion that an R&B or country record did break through and become a hit, the strategy that major labels often employed was to quickly record a cover version by a pop singer that had a broad commercial appeal. Covers were usually stripped of anything that might be offensive to any segment of record buyers, including any traces of ethnic vocal delivery or off-color lyrics. As a result most often ended up sounding sanitized and antiseptic, even laughable. The poster child for this tactic could have been Pat Boone, whose watered down covers of Fats Domino's "Ain't That A Shame" in 1955 and Little Richard's "Tutti Frutti" in 1956 both outsold the original versions. Covers were an effective strategy for the 1946-54 period, and as a result were an obstacle to

and what would later be known as Rhythm and Blues.

Hillbilly music The traditional old time music of the rural southern United States, with origins in English folk music. Hillbilly music is the foundation of modern country music.

Cover A new recording of a charting song that seeks to 'cover' up the original song.

commercial success for many R&B and country artists and their independent labels. However, once white teenagers started demanding the real thing, covers were no longer an effective marketing approach.

THE RECORD INDUSTRY

Record Sales: 1920–1954

Although Victrola phonograph players had been around since the early 1900s, it took several years before they became popular with consumers and there were any significant record sales. Before 1920, two of the most popular artists were opera singer Enrico Caruso and concert bandleader John Phillip Sousa (composer of "The Stars and Stripes Forever"). The first jazz recording, "Livery Stable Blues" made in 1917 by the Original Dixieland Jass Band was one of the first records to sell over one million copies. Throughout the 1920s, record sales were generally strong, hovering around \$100 million a year. However, when radio first became popular in the mid-1920s and the Great Depression hit in 1929, record sales went into a tailspin, dropping to \$6 million almost immediately, causing most of the smaller labels to go out of business.

Helped by the popularity of crooners like Bing Crosby and the big band music of the Swing Era, record sales rebounded throughout the 1930s and 1940s. By 1945, sales were back up to \$109 million; after wartime restrictions on shellac were lifted, sales soared to \$218 million in 1946 where they leveled off for the next eight years. Helping the recovery was the introduction of the Duo Jr. in 1932, which selling for \$16.50 was the first affordable and portable electric turntable. By 1934 jukeboxes began popping up in thousands of restaurants and nightclubs around the country, which in some years accounted for as much as 40% of all record sales.

The mid-1920s saw a dramatic improvement in the technology used to make recordings. Before 1925, recordings were made using the **acoustical process**, in which an acoustical horn captured the sound of the musicians huddled in front of it and transferred the sound vibrations to a stylus that cut grooves onto a wax disc. Because the shellac records that resulted spun at 78 rpm, only three minutes of music could be recorded on a side. Because of the poor frequency response of the process, records also sounded tinny. In 1925, the **electrical process** was

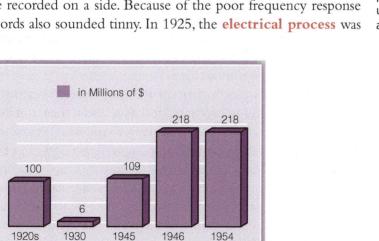

The process used before 1925 in which an acoustical horn captured and transferred sound vibrations to a stylus that cut grooves onto a wax disc.

Electrical process The recording process in which microphones are used to convert sound waves into an electrical signal.

introduced, where microphones were used to convert the sound waves into an electrical signal, greatly improving sound quality.

After World War II, magnetic tape was increasingly used to record the master tapes from which records were pressed. Among the many advantages of tape recording over disc recording is the ability to edit the master tape. An engineer could now construct a new version of a song by splicing two or more separate takes (or versions) together, eliminating any mistakes that may have been present in the original takes. This was a giant leap forward for recording artists, who previously had to strive for cutting a perfect take to disc, or settle for an imperfect one. Tape is also cheap, and can be reused many times, allowing an engineer could simply record over a bad take to further cut costs. It also allowed for longer songs to be recorded, as tape reels could hold up to 30 minutes of music, eliminating the 3-minute limit of the 78-rpm disc.

The post war years also saw dramatic changes in the way recordings were manufactured and sold to consumers. In 1948, Columbia introduced the 12-inch 33-1/3 LP (long playing) album format. In addition to an increased playing time of 23 minutes of music per side, LPs were made of vinylite (vinyl), which offered superior fidelity and made the records less breakable and easier to distribute. The next year, RCA Victor introduced a rival format, the 7-inch 45 rpm single format, also on vinyl (later on polystyrene). RCA also introduced a low cost portable turntable that included an attachment enabling several 45's to be stacked, allowing the listener a sequence of uninterrupted songs to play. Within a few years all the major record labels were releasing product on both formats. LPs became the choice of adults, who bought console hi-fi systems and placed them in the living room along with the TV set. The cheaper 45s became more popular with teens, who were able to buy the latest hit single and play them in their bedrooms on the more portable players. In 1958, the world standard for stereo was established and the first stereo LP's were sold soon after.

Record Labels: the Majors and the Independents

Over the early years of the 20th century, the largest corporate record labels (known simply as the major labels) had built up well-established distribution networks and alliances with radio stations, record stores and jukebox operators to distribute and promote their product. By virtue of their nearly total control of the marketplace in the pre-rock and roll era, the majors (of which there were six) were able to prevent most records that they did not distribute from making an impact on the national charts. Even though most majors had a few R&B and country artists on their rosters, these singers were considered to have a specialty market outside the mainstream, and as a result were not marketed as heavily. Thus, when Mercury Records decided to release "Tennessee Waltz" in 1950, it was given to pop singer Patti Page rather than a country singer who might have been a better fit for the song. Even though Page's record became a #1 hit, for the most part the majors simply ignored R&B and country. This provided an opening for smaller, independent labels, or "indies" to find a niche in the market, and by the mid-1950s there were literally hundreds of them scattered around the country. It was these indie labels that played an important role in fueling the growth of R&B and country music in the post war years.

Album The 33–1/3 rpm 12"LP (long playing) format introduced by Columbia Records in 1948.

Single The 45 rpm 7" format introduced in 1949 by RCA Victor.

Major labels The largest corporate record labels.

Independent labels The small startup labels that began emerging in large numbers in the 1940s and 1950s.

The Majors Labels in the Early 1950s

- Columbia—founded in 1885 in New York
- RCA Victor—1901, New York
- Decca—1934, New York

- Capitol—1942, Los Angeles
- Mercury—1946, Chicago
- MGM—1946, Hollywood

THE MAJOR LABELS IN THE EARLY FIFTIES

Important Independent Labels from the Late 1940s and Early 1950s

- King—founded in 1945 in Cincinnati by Syd Nathan
- Specialty—1945, Los Angeles by Art Rupe
- Modern—1945, Los Angeles by Jules and Saul Bihari
- Imperial—1945, Los Angeles by Lew Chudd
- Chess—1947, Chicago by Phil and Leonard Chess (originally named Aristocrat)
- Atlantic—1948, New York by Ahmet Ertigan and Herb Abramson
- Duke/Peacock—1949, Houston by Don Robey
- Sun—1953, Memphis by Sam Phillips

IMPORTANT
INDEPENDENT
LABELS FROM THE
LATE FORTIES AND
EARLY FIFTIES

The typical major was headquartered in New York, Chicago or Los Angeles with a team of producers, talent scouts, A&R (artist & repertoire) staff, song pluggers and advance men. Professional composers, arrangers and recording studios were also utilized to carefully craft the product to standards that would appeal to the widest possible audience to maximize sales potential. Independent labels on the other hand, could be found in any town, and might be operating out of the back room of a store, a basement, garage, or even the trunk of a car. The small staff (often less than five, usually just one or two) handled all details, from finding the talent to distributing the records in stores and meeting with disc jockeys to get airplay. Although some indies had their own small studios, storage rooms or garages were often used as makeshift studios. With their low overhead and constant struggle for survival, indies were more willing to take risks and quickly change business tactics to keep up with emerging industry trends. Despite their competitive disadvantages, the indie labels were perfectly positioned to grab a larger share of the record market as a growing number of white teenagers started to turn away from major label pop to listen to R&B. But to connect with this new audience they needed some help along the way, which they got from a group of renegade radio disc jockeys (more on that in a moment).

Hot 100s and Gold Records

The most reliable source for charting record sales throughout the rock era has been *Billboard* magazine. First published in 1894, *Billboard* began charting songs in 1940. In 1942 the magazine began to track the emerging country and R&B styles under a single category "Western and Race," but eventually split them into two separate charts, "Country and Western" and "Rhythm and Blues" in 1949. From 1955 until 1958 it published a number of separate charts, including the Top 100, Best Sellers in Stores, Most Played in Jukeboxes and Most Played by Disc Jockeys, all of which were merged into the new **Hot 100** in 1958. The

chart listings used in this book for singles are from the Hot 100 (or the Top 100 chart that preceded it) unless otherwise noted.

The Record Industry Association of America (RIAA—the trade group for the recording industry) began certifying singles with sales of one million as gold and two million as platinum in 1958; in 1989 the standards were lowered to 500,000 and one million respectively. (Keep in mind as you read this book how much more difficult it was for a single to achieve gold status before 1989.) The gold standard for albums was set in 1958 at 500,000; starting in 1976 albums with sales of one million were designated as platinum. In 1999 the RIAA also established the diamond certification for albums with sales of 10 million. As of this writing, 134 albums have achieved diamond status. In the early 2000s the RIAA, founded in 1952, filed a number of lawsuits against file sharing sites such as Napster and the users of such sites on behalf of the recording industry. This controversial maneuver, which ultimately became very nasty and a losing cause for the RIAA, is discussed at length in chapter 13.

Although the Beatles and Elvis Presley are the only artists listed today by the RIAA as having sales of one billion units worldwide, the 1970s pop/country group the Eagles certainly deserve credit for their own sales achievements. Because the 1976 platinum distinction for album sales of one million units was not applied retroactively, the first album to achieve this status was *Eagles/Their Greatest Hits: 1971–1975*, which achieved platinum status on February 24, 1976, just weeks after its release. Today the album holds the distinction of being the third best selling LP in US history with sales of 29 million (and more than 40 million worldwide). The Eagles currently have eight albums listed in the top 100 selling albums of all time (US), three of which have achieved diamond status. In all, 16 Eagles LPs have achieved platinum or multi-platinum status.

RADIO

The Birth of Radio and Important Early DJs

The first commercial radio station in America, KDKA in Pittsburgh began broadcasting in 1920. Throughout the early 1920s radio experienced explosive growth: by 1924 there were nearly 600 commercial stations broadcasting and three million receivers in homes. In the late 1920s, NBC and CBS established radio networks that provided programming to affiliate stations throughout the country. However, in the late 1940s and early 1950s, as television appeared on the scene many analysts were predicting radio's demise. Radio stations up to this point had programmed a variety of material, including live music, drama, variety shows, sporting events and news. With TV's dramatic growth in popularity, radio stations were forced into both concentrating their efforts on playing music and emphasizing local programming rather than relying on the network feed. These trends led to the rise in popularity of the local **disc jockey** or **DJ**. DJs often had complete control of the style of their show and the records that they played. After a time, it was not enough just to have a unique show, and many DJs started developing flamboyant and eccentric on-air personalities. They became

was injecting his own personality

into his show as early as 1932.

showmen; in fact, several early rock and roll artists actually began their careers as DJs, including one at WDIA in Memphis named Riley B. King. King was known on the air as the "Blues Boy"; he later adopted those initials and became known simply as B. B. King.

Like the nation itself, in the late 1940s and early 1950s radio was segregated: black stations programmed jazz and R&B to black audiences, while white stations played pop and country for white audiences. However, R&B was becoming increasingly popular during the 1946–54 transitional period with white teenagers, who responded to the way the music was more emotional and viscerally exciting than conventional pop. To get their R&B fix, these teens were at first tuning in to the larger "Negro stations" around the country such as WDIA in Memphis ("America's Only 50,000 Watt Negro Radio Station"), WERD in Atlanta and KXLW in St. Louis. Among the most popular black DJs in R&B radio were "Yo' Ol' Swingmaster" Al Benson in Chicago, "Jockey Jack" Gibson in Atlanta, Tommy "Dr. Jive" Smalls in New York and "Professor Bop" in Shreveport.

As the audience for R&B grew, the more attentive white DJs picked up on the trend and also began to play R&B records. Early white DJs who programmed R&B included Hunter Hancock (*Huntin' With Hunter*) at KFVD and KGFJ in Los Angeles, George "Cat Man" Stiles at WNJR in Newark, George "Hound Dog" Lorenz at WKBW in Buffalo and "Symphony Sid" Torin at WBMS in Boston and later WOV in New York. By connecting the rapidly expanding needs of the teenage nation with R&B and rock and roll records, these renegade DJs, both black and white, essentially saved radio from television's onslaught. For all its strengths as a medium for family entertainment, TV could not connect with the young in the same direct way that radio could. By playing rock and roll records (which was also—conveniently—cheap programming), radio could pinpoint it's audience with deadly accuracy. It was also portable: teens could listen at home or after school on the newly introduced transistor radio, or in their cars while cruising at night.

Alan Freed

The most famous and influential of all the white DJs was Alan Freed (1921–65). Freed was a former jazz musician from Pennsylvania who was entrepreneurial, flamboyant, a hard worker and a hard drinker. In June, 1951 he took over the late night Record Rendezvous show on Cleveland station WJW and turned it into an R&B program after seeing first-hand how white teenagers enthusiastically bought R&B records at a local store. Freed, who often drank while on the air, developed a wacky personality and renamed the show The Moondog House Rock and Roll Party (he sometimes howled like a dog during the show opening). Encouraged by the program's popularity, Freed's next move was to promote a dance that featured the same artists whose records he played. The Moondog Coronation Ball was set for the 10,000 seat Cleveland Arena in March 1952, but a near riot ensued as an overflow crowd of over 21,000 tried to get in, forcing the cancellation of the show. Later concert attempts proved successful however, and Freed's growing popularity led to his being hired by WINS in New York in September 1954. Freed named his new program The Rock and Roll Show, and began calling himself "Mr. Rock and Roll." Ratings for WINS soared, and Freed

became immensely popular; however, he also became an easy target for a growing backlash against rock and roll by conservative and religious groups. Freed eventually became the focus of a congressional investigation into the music business in 1959 that ultimately ended his career (more on that in chapter 3).

When Alan freed moved to WINS in 1954, he was forced to change the name of his show from *The Moondog House Rock and Roll Party* to *The Rock and Roll Show* by a blind street musician who dressed up in a Viking costume. Thomas Louis Hardin claimed that he had in fact used the name Moondog for many years, and that by using the name for his radio show, Freed was infringing on Hardin's right to make a living. After Hardin filed suit, Judge Carroll Walter awarded him \$7,500 and forbade Freed from using the name Moondog. Although Alan Freed did not coin the term Rock and Roll (it was a black euphemism for sex that had been around for at least 30 years), he undoubtedly helped connect the label to the music for an ever-widening audience.

Top 40

Just as DJs such as Alan Freed were playing important roles in the incubation of rock and roll, a new radio format was emerging that would ultimately undermine their influence. Top 40 was the brainchild of Todd Storz, the owner of a small group of radio stations, including ratings cellar-dweller KOWH in Omaha. While at a tavern located across the street from the station one night in 1955 (although some say the year was 1953), Storz and his companions noticed that patrons were plugging the jukebox to play the same songs over and over, and when the bar closed, the waitresses took their tip money and played those songs again. Storz and his program director wrote down the names of the top songs and began playing them throughout the day on KOWH, eliminating the classical, country and other programs the station had been playing. Within two years, KOWH went from last to first in the Omaha market, and Storz was able to buy other stations in New Orleans, Kansas City, Minneapolis and Miami, which he formatted in the same way. Top 40 was popular with listeners because they knew that they were never more than a few minutes away from hearing their favorite song played, and it quickly spread throughout the industry. Ultimately the Top 40 format had a homogenizing effect on radio, limiting playlists all over America to mainstream pop singles. It also further diminished the power of the DI, who in the end was shut out from selecting the songs that he played on his show.

KEY TERMS

Top 40 The radio format in which the 40 top selling songs are played in repetition, first developed by Todd Storz at KOWH in Omaha, Nebraska.

Blues The form developed in the Mississippi Delta and other Southern locales in the late 19th century that incorporates a 12-bar verse, AAB lyric form, and tonalities from the blues scale.

Work songs, shouts, and field hollers African song forms used to accompany work and other aspects of everyday life that were adapted by slaves on plantations and Southern work camps.

THE BLACK ROOTS OF ROCK AND ROLL

The Blues

The blues is a uniquely American musical form, born in the Southern middle states sometime between the years 1880 and 1900. It evolved from the work songs, shouts and field hollers sung by slaves in plantation fields and prison camps. Songs sung to accompany various daily jobs and duties are a functional part of everyday life in Africa and a celebration of doing work to improve the

quality of ones life. In the New World however, the very nature of the work song began to change, as the singer was no longer doing work for himself but for someone else—and the work did not improve his quality of life. Over time, the songs sung in the fields therefore became personal expressions of pain and oppression. Singing work songs and field hollers over time became a catharsis for feelings of lost love, sexual frustration, poverty, jealousy and hard times. It is from this context that the blues evolved.

After the Civil War, thousands of freed slaves began traveling through the South, looking for work, armed with no job skills to speak of other than as a common laborer. Once Reconstruction ended, life became increasingly bleak for many of them, as newly enacted Jim Crow laws and racial oppression became as commonplace as the hard work and poverty. Singing in work camps, street corners and juke joints for food and tips was one of the few professions available to a black man in which he wasn't directly working for the white man (preaching was another, and in fact many of the first blues singers were former preachers). Today many scholars speculate that the blues incubated in the Mississippi Delta, a 250-mile oval of land stretching south from Memphis, Tennessee to Vicksburg, Mississippi.

- Delta The 250 mile
- long area of Mississippi stretching from Memphis south to Vicksburg that is widely believed to be the birthplace of the blues.

- 1. 12 bar musical form
- 2. Three phrase, AAB lyrical form
- 3. Emotional, personal lyrics convey feelings of lust, lost love, jealousy, suffering, hard times, etc.

CHARACTERISTICS OF THE BLUES

THE FIRST BLUES SINGERS

The first blues performers were solo singers who accompanied themselves on the guitar in a rambling and spontaneous fashion that became known as country blues. These performers worked out the basic standard blues formula: a threephrase AAB lyric form of 12-bar length, with each phrase answered by the guitar in a call and response fashion. This evolution occurred in the backwoods away from almost everyone who might have been interested, and before there were any recording devices, so documentation of exactly how it happened is scarce. One of the first to archive the blues was W. C. Handy, a bandleader and former schoolteacher from Alabama who in 1903 heard a man playing and singing at the train station in Tutwiler, Mississippi. In his autobiography Handy wrote: "As he played, he pressed a knife on the strings of the guitar in a manner popularized by Hawaiian guitarists who used steel bars. 'Goin' where the Southern cross' the Dog'. The singer repeated the line three times, accompanying himself on the guitar with the weirdest music I had ever heard. The tune stayed in my mind." Realizing the commercial potential of this new music, Handy became the first to publish blues songs, including "Memphis Blues" in 1912 and "St. Louis Blues" in 1914. Both were huge hits through the sale of sheet music, and earned Handy the title "Father of the Blues." The blues sold on sheet music remained popular until 1917 when the first jazz recording started the jazz craze, and consumers began to buy more records.

earliest form of the blues, performed by solo male singers accompanying themselves on guitar.

AAB lyric form The format of most blues poetry, in which each verse is comprised of three lines, the second of which is a repeat of the first.

THE FIRST BLUES RECORDINGS

The blues remained popular throughout the 1920s with the first commercially sold blues recordings by what became known as the **classic blues** singers. When "Crazy Blues" by Mamie Smith sold one million copies within a year of its 1920 release, record companies realized that there was a huge untapped black consumer market. Most of the classic blues recordings were released on small independent labels such as Vocalion, Black Swan and Okeh that specialized in race music, a market that the major labels were largely unwilling to pursue. Although many of these female singers were merely singing pop tunes with a tragic delivery (and nearly all the classic blues records had the word "blues" in the title), some of them, such as **Bessie Smith** (the "Empress of the Blues" 1894–1937) and Ethel Waters were outstanding blues singers. In 1929 the Depression almost killed the record industry, and did manage to finish off the classic blues era.

It wasn't until 1925 that the first country blues singers began to record. It was that year that Blind Lemon Jefferson recorded "Black Snake Moan" in Chicago, after having worked his way north through the Mississippi Delta from his native Texas. Another Texan, Huddie Ledbetter, better known as Leadbelly surfaced in the 1940s New York City folk scene with Woody Guthrie and Pete Seeger after several troublesome years in and out of prison. But the most spine-tingling blues performances came from the haunting vocals and bottleneck guitars of the Delta bluesmen, such as Charley Patton, Willie Brown, Son House and **Robert Johnson** (1911–1938). Although Johnson only recorded 29 sides during his life, his songs are among the most influential in American history, including "Love in Vain," "Cross Road Blues," "Sweet Home Chicago" and "I Believe I'll Dust My Broom." Johnson's singing and guitar playing on these recordings is riveting even today. Unfortunately, his mythic life ended before he achieved any real national attention when a jealous husband poisoned him at a juke joint outside of Greenwood, Mississippi in 1938.

"CROSS ROAD BLUES" (ROBERT JOHNSON)— ROBERT JOHNSON

Personnel: Robert Johnson: guitar, vocals. Recorded on November 27, 1936 in the Gunter Hotel, San Antonio, TX; produced by Don Law and Art Satherley.

When Robert Johnson's recorded "Cross Road Blues" in a makeshift studio at the Gunter Hotel in San Antonio, he had already recorded 11 of the 16 songs that would come from the three sessions held during the week of November 22, 1936, including the classics "Sweet Home Chicago" and "Terraplane Blues." These sessions, along with a second round of sessions held on June 19 and 20, 1937 (which produced 13 more songs), produced what are arguably the most defining and influential blues recordings in history. With his haunting vocals and use of a bottleneck slide on the guitar, Johnson helps define the sound of Delta blues. The influence of Johnson's recording of "Cross Road Blues" can be found in the recordings of other artists who have covered it, which includes Cream, the Doors and Van Halen.

Jazz

An improvisational art form of individual expression, jazz developed as a parallel universe alongside the blues throughout the first half of the 20th century. Originally evolving as an ensemble form in New Orleans and other Southern locales around the turn of the century, like the blues it worked its way north to Chicago around 1920. It was in the 1920s that its first true innovator, trumpeter Louis Armstrong revolutionized jazz by turning it into a soloist's art form simply on the strength and drama of his virtuoso improvisations. The 65 sides that he recorded for Okeh as the leader of the Hot Five and Hot Seven between 1925 and 1928 are among the most important artifacts of American music. By the 1930s, the center of the jazz world had moved to New York, where composers and arrangers such as Fletcher Henderson and Duke Ellington helped develop the jazz big band that was to become the standard ensemble of the Swing Era. At the same time, bandleaders in Kansas City like Count Basie were developing an exciting riff-based boogie style that would further invigorate swing music with the blues.

MUSIC CUT 4

"KOKO" (CHARLIE PARKER)—CHARLIE PARKER'S REBOPPERS

Personnel: Charlie Parker: alto sax; Dizzy Gillespie: trumpet, piano; Curly Russell: bass; Max Roach: drums. Recorded November 26, 1945.

Charlie Parker's recording of "Koko" is one of the most remarkable and mysterious recordings in the history of jazz. A reworking of the swing era hit "Cherokee," the song displays Parker's astonishing technique in a solo that author Ted Gioia notes "few other saxophonists of the day could have *played*, let alone improvise." The session at which "Koko" was recorded was somewhat chaotic, and because of the confusion over the exact details of who played and who was there, it has achieved mythic status. Apparently, pianist Bud Powell was supposed to play but did not show, and was replaced by the little known Sadik Hakim. However, Hakim for some reason did not play on this tune. Also present was nineteen-year-old trumpeter Miles Davis, who played on the other recordings made that day but not on "Koko." "I didn't really think I was ready," he said later. "I wasn't going to get out there and embarrass myself." In the end, Dizzy Gillespie played both trumpet *and* piano on this legendary recording.

During the Swing Era, jazz became America's pop music, and music industry manipulation caused creative innovation and musical integrity to suffer. But jazz began to reinvent itself around 1940 in the late night jam sessions at tiny night-clubs in Harlem such as Minton's Playhouse. Modern jazz, or bebop, was created by a small group of young musical revolutionaries as a reaction against the banalities of swing. Bebop's architects were some of the most gifted musical talents America has ever produced, including alto saxophonist Charlie Parker, trumpeter Dizzy Gillespie and pianist Thelonious Monk. Although bebop infused a fresh new vitality into jazz, it also made it impossible for most people to dance or even listen to. In the post-bebop era, jazz musicians began to experiment with different stylistic approaches, including cool jazz, hard bop and free jazz. In1969 trumpeter Miles Davis, who had often been at the forefront of innovation throughout his music career, fused rock and jazz together with his seminal album *Bitches Brew*. Jazz continues to incorporate influences from rock and its offshoots to this day.

DELTA BLUESMEN

- Charley Patton
- Willie Brown
- Son House
- Robert Johnson

BEBOP'S ARCHITECTS

- Alto saxophonist Charlie Parker
- Trumpeter Dizzy Gillespie
- Pianist Thelonious Monk

Black Gospel

Black Gospel emerged as a style in the early 1930s from the traditional spirituals that had been a part of black religious culture since the days of slavery. The man most responsible for commercializing gospel music was Thomas Dorsey (1899–1993), who is often called the "Father of Gospel Music." Ironically, before turning his attention to religious music, Dorsey was known as "Georgia Tom," the piano playing half (along with guitarist Tampa Red) of the Hokum Brothers. Their hit recording "It's Tight Like That" from 1928 contained lewd, off color, humorous lyrics that presaged similar songs by Louis Jordan, Little Richard and Chuck Berry. In the 1930s Dorsey started writing songs of good news and salvation with blues influenced melodies and rhythms that eventually became popular at church services in the black community. Among his many gospel standards are "Take My Hand, Precious Lord," written in 1932. Later gospel stars include Sister Rosetta Tharpe and Mahalia Jackson.

KEY TERM Black Gospel A highly emotional evangelical vocal music that emerged from spirituals and was highly influential to Rhythm & Blues.

MUSIC CUT 5

"TAKE MY HAND, PRECIOUS LORD" (THOMAS DORSEY)— MAHALIA JACKSON

Personnel: Mahalia Jackson: vocals; Mildred Falls: piano; Ralph Jones: organ. Recorded March 27, 1956 in New York City.

Written in 1932 by Thomas Dorsey, "Take My Hand, Precious Lord" is the song that set the standard for modern gospel music. Dorsey wrote it as a response to the tragic death of his wife Nettie while giving birth to the couple's son. The unbearable anguish left Dorsey contemplating suicide, but he eventually turned his grief into a powerful plea to his savior. The song has a strong association with gospel great Mahalia Jackson, who sang it at the March on Washington in August 1963, and also at Dr. Martin Luther King, Jr.s funeral in 1968. In turn, Aretha Franklin sang it at Jackson's funeral in 1972. It has been performed or recorded by virtually every vocalist in any style, from Elvis Presley, to jazz singer Nina Simone, country artist Chet Atkins, bluesman B. B. King, and Beyoncé. The Jackson recording heard here was given the Grammy Hall of Fame Award in 2012.

Black gospel's influence on American popular music is immense. The **melismatic** singing of gospel can be heard throughout the entire history of rock music. Gospel backup bands often used the Hammond B3 organ, which became one of the most popular instruments in rock in the 1960s. Typically performed in church with large choirs, the male gospel quartets that started to become popular in the 1930s were ancestors to doo-wop groups in the 1950s. Many of the early crossover R&B stars of the 1950s had gospel roots, including Little Richard and Sam Cooke, whose career took off when he joined the venerable gospel group the Soul Stirrers. Gospel is also one of the foundational blocks of soul music, and its influence can be heard in the voice of the first soul singer, Ray Charles, and in every 1960s soul singer from James Brown to Otis Redding and Aretha Franklin.

Rhythm and Blues

Once the blues went electric, it was a natural progression to speed it up, put in a heavier beat and make it more danceable. Although the term Rhythm and Blues wasn't coined until 1949 (by Jerry Wexler of *Billboard Magazine*), the style developed in the 1940s out of jazz and blues roots. As the Swing Era came to an end in 1946, Rhythm and Blues, with its boogie-woogie bass lines and honking tenor sax solos increasingly replaced jazz as the music America wanted to dance to. Jazz veteran Lionel Hampton had one of the first R&B hits in 1942 with "Flying Home," and the biggest R&B hit of 1946, "Hey! Ba-Ba-Re-Bop." Omaha native Wynonie Harris had the #1 R&B hit of 1947 with "Good Rocking Tonight," a song that Elvis Presley would later cover. Joe Turner's 1954 hit recording of "Shake Rattle and Roll" was also covered by Presley and Bill Haley.

R&B styles ranged from the raunchy to the polished. On one end of the spectrum were the down and dirty bar blues bands that emerged from the urban blues of Chicago's South Side. The most prominent Chicago R&B performers were Muddy Waters, harmonica players Little Walter and Sonny Boy Williamson, guitarists Elmore James and John Lee Hooker, bassist and composer Willie Dixon and singer Chester Burnett, better known as Howlin' Wolf. These performers all recorded at Chess Records, where they were closely linked to the soon to emerge rock and roll styles of Bo Diddley and Chuck Berry. They were also highly influential to a number of rock bands in the 1960s, including the Rolling Stones and Cream. (One of Waters's more influential records was 1950's "Rolling Stone," which provided the English band with their name.)

KEY TERMS

Melisma The singing embellishment of a single syllable into several notes.

Rhythm and Blues An evolution of the blues that was more dance and commercially oriented. R&B bands often included electric instruments such as guitars, bass guitars and organs, vocalists and a horn section, often with a honking tenor saxophone soloist.

- Muddy Waters
- Little Walter
- Sonny Boy Williamson
- Elmore James

- John Lee Hooker
- Willie Dixon
- Howlin' Wolf

PROMINENT CHICAGO R&B PERFORMERS

Jump bands, which usually included a small horn section along with the rhythm section and vocalist played a smoother, more jazz-influenced type of R&B. Popular jump bands of this era included those of Johnny Otis, Louis Prima and **Louis Jordan** (1908–1975). As leader of the **Tympany Five**, Jordan scored

an unbelievable eighteen #1 and 54 Top 10 records on the R&B charts in the 1940s. He still holds the record for the total number of weeks at #1 on the R&B charts—113 (Stevie Wonder is second with 70). Jordan sang songs that often contained street-smart jive and humor, such as "Open the Door, Richard" and "Saturday Night Fish Fry." His biggest hits included "Choo Choo Ch' Boogie," "Caldonia" and "Ain't Nobody Here But Us Chickens." Jordan also made innovative short movies of the Tympany Five in performance that were shown between feature films at theatres—predecessors to the contemporary music video.

MUSIC CUT 6

"CHOO CHOO CH' BOOGIE" (VAUGHN HORTON/DENVER DARLING/MILT GABLER)—LOUIS JORDAN AND HIS TYMPANY FIVE

Personnel: Louis Jordan: alto sax, vocals; Aaron Izenhall: trumpet; Josh Jackson: tenor sax; Bill Davis: piano; Carl Hogan: guitar; Po Simpkins: bass; Eddie Byrd: drums. Recorded January 23, 1946 in New York City; produced by Milt Gabler. Released 1946 on Decca; 18 weeks on the charts, peaking at #1 R&B, #4 pop.

"Choo Choo Ch' Boogie" is a great example of the kind of R&B that made Louis Jordan the most popular black recording artist in the 1940s. Jordan's group the Tympany Five, a so-called jump band, played a smooth, jazz-influenced type of R&B that prominently featured riffing horns and a driving rhythm section. In addition to being a fine vocalist who could deliver his often-humorous lyrics with a clear, smooth enunciation, Jordan was also a first-rate alto saxophonist who had worked in the legendary Chick Webb Orchestra at the Savoy Ballroom in Harlem before going out on his own.

Rhythm and Blues would become one of the most prevailing influences in popular music in the last half of the 20th century. In the mid-1950s its most commercially successful practitioners would play important roles in shaping the sound of early rock and roll. The lives and music of these men, Bo Diddley, Chuck Berry, Little Richard, Fats Domino and others will be discussed in the next chapter.

Doo-Wop

In terms of record sales, doo-wop was the most popular style of R&B in the 1950s. Its origins go back as far as the 1930s and the popularity of male gospel quartets and commercial vocal groups such as the Mills Brothers and the Ink Spots. The Mills Brothers (who were in fact four brothers from Ohio) prided themselves in creating a tightly woven cross between jazz and barbershop vocal harmonies with only guitar accompaniment. The Ink Spots were also influential to doo-wop, featuring lead vocalist Bill Kenny singing in a melismatic, gospel-inspired high tenor voice that became a staple of doo-wop. Both groups were immensely popular throughout the 1930s and 1940s.

THE EARLIEST DOO-WOP GROUPS

During the late 1940s and early 1950s, it became fashionable for amateur teenage vocal groups to perform a cappella on street corners and on the stoops of apartment buildings, especially in New York. This was usually just for fun,

KEY TERM

Doo-wop An a cappella group vocal style that incorporates high falsetto vocal leads, scat singing, rhythmic vocal backings and sometimes lead vocals or spoken verse by the bass singer. Most doo-wop recordings added a rhythm section for more commercial dance appeal.

although the possibility of being discovered by a talent scout was never far from anyone's thoughts. The first of these groups to hit it big was the Ravens with their 1947 hits "Write Me A Letter" and "Old Man River." The latter song, which sold two million copies, was unusual in that bass singer Warren Suttles sang the vocal lead. This technique was to become one of the signature characteristics of the doo-wop genre. The Ravens also featured choreography in their shows—another first that was to become a staple of later soul acts such as the Temptations and Supremes.

Other groups started to copy these innovations. The Orioles (who, like the baseball team were from Baltimore) first pop hit was "It's Too Soon To Know," which hit the Top 20 in 1948. The song's huge crossover appeal was unprecedented for a race record and helped the group become regulars on the R&B charts over the next few years. Their biggest success came in 1953 with "Crying In The Chapel," which climbed to #11. With the success of the Orioles and the Ravens, other "bird" groups appeared, including the Penguins, Flamingos and Swallows. Later "car" names became popular, with the Cadillacs, T-Birds, Fleetwoods and Imperials to name just a few.

A PARTIAL LIST OF DOO-WOP GROUPS

FROM THE 1950s

Bird Groups:	Car Groups
Ravens	Cadillacs
Orioles	T-Birds
Penguins	Imperials
Flamingos	Fleetwoods
Swallows	Corvairs
Bluebirds	Galaxies
Crows	El Dorados
Robins	Impalas

Another doo-wop group that achieved notoriety of sorts was Hank Ballard and the Midnighters. In 1954 they had a series of "Annie" records ("Work With Me Annie," "Annie Had a Baby" and "Annie's Aunt Fanny") that sold over a million copies each despite being widely banned from radio play. Each song contained sexually suggestive lyrics—the "work" in the first hit was a thinly disguised metaphor for sex—that were as funny as they were risqué. Ballard also wrote "The Twist" in 1958, which became a #1 hit for Chubby Checker in 1960 and spawned the dance craze of the same name. In the context of the "Annie" records, one should reconsider what Ballard was writing about in the first line of "The Twist": "Well come on baby, *let's do the twist.*" It probably wasn't dancing he was singing about . . .

THE INDUSTRY MOVES IN

Although doo-wop originated as an a cappella style, recordings were most often made using instrumental accompaniment, as record labels tried to maximize the commercial appeal of the records and make them more danceable. Many labels also took advantage of the street singers, who most often had no business skills and were just happy to get a record contract. The classic example of this type of

exploitation is the story of **Frankie Lymon and the Teenagers**, who rose to fame in 1956 with "Why Do Fools Fall In Love" (#6) when Lymon was only 13 years old. Producer George Goldman paid Lymon a stipend of \$25 a week with the rest of his earnings going into a "trust fund." When Lymon's voice changed a few years later and his career went in decline, he discovered that there was no trust fund. He turned to heroin and died from an overdose at 26. Many other doo-wop groups were "one hit wonders," as bad business deals, competing cover versions and instability of the small independent labels took their toll. One of the best examples of the one hit wonder was the Chords, whose only hit "Sh-Boom" in 1953 was quickly buried by the Crewcuts cover.

MUSIC CUT 7

"WHY DO FOOLS FALL IN LOVE" (FRANKIE LYMON/MORRIS LEVY)—FRANKIE LYMON AND THE TEENAGERS

Personnel: Frankie Lymon, Jimmy Merchant, Sherman Garnes, Herman Santiago, Joe Negroni: vocals; Jimmy Wright: tenor sax; Jimmy Shirley: guitar; Al Hall: bass; Gene Brooks: drums. Recorded 1955 at Bell Sound Studios, New York, NY; produced by George Goldner. Released January 1956 on Gee; 21 weeks on the charts, peaking at #6.

The Teenagers, made up of five school buddies from New York, were the quintessential "unknowns discovered singing on the street corner" doo-wop group. After another singer named Richard Barrett discovered them in 1955, the group signed with George Goldner's Gee records. At their first recording session, they performed "Why Do Fools Fall in Love," a song that Teenagers Herman Santiago and Jimmy Merchant co-wrote. However, Santiago, who was supposed to sing lead, had a cold, and the job was handed to Lymon. Subsequently he and producer Goldman were given writing credits for the song (this was later overturned by a federal judge in the early 1990s). The song has been a Hot 100 hit four times, most recently in 1981 with Diana Ross's version.

One fledgling record company, Atlantic Records had unusual success with doo-wop. Although its primary focus was on jazz when it was founded in 1947, Atlantic signed Clyde McPhatter of the Dominos in 1953 and built a new group, the Drifters around him. They were an instant smash, with five hits that went to #1 or #2 on the R&B charts within the next two years. McPhatter was drafted into the military in 1955, and was replaced by a succession of lead singers until Ben E. King took over in 1958. At around the same time, the young songwriting duo of Jerry Leiber and Mike Stoller were assigned to the group, and their first production, "There Goes My Baby" went to #2 pop and stayed on the charts for 14 weeks. Between 1957 and 1959, Leiber and Stoller also wrote five Top 10 hits for another doo-wop group, the Coasters.

THE WHITE ROOTS OF ROCK AND ROLL

Traditional Rural Music

Traditional rural music in America evolved primarily from the folk music brought to the New World by British immigrants. The Appalachian region of Tennessee, Kentucky, Virginia and West Virginia were particularly fertile areas for

the survival of this music tradition, as the rural and isolated mountainous settings hampered contact with the changing outside world. By the early 20th century, city dwellers began to mockingly call the poor white inhabitants of this region "hillbillies," and the simple folk music they played hillbilly music.

The British folk tradition included ballads, which typically tell a story, some of them epic tales; lyric songs, which are often songs of love; and work songs. Unlike African work songs, British work songs often came in the form of sea chanteys, railroad songs and lumber songs. At first, folk music in America was simply sung verbatim by the new colonists as it had been in England; over time songs often underwent subtle changes as their original meanings and purposes were forgotten and singers adapted them to their new environment. New songs in the same tradition were also written. A good example of a traditional English ballad that survived in America is "Barbara Allen," a timeless song about young lovers and death believed to be from the 17th century. Although it has evolved over the years, it is still a folk standard that has been performed by everyone from Joan Baez to the Everly Brothers to Bob Dylan. On the other hand, "Sweet Betsy From Pike," written around 1870 using a traditional English melody, is a uniquely American song about the hard journey West, with lyrics that invoke the imagery of the Platte River, Salt Lake City and California.

Unlike blues and country musicians who eventually embraced the use of electric instruments, rural and folk musicians continued to use the traditional acoustic instruments from the past, such as the fiddle, acoustic guitar and banjo. After 1900 other acoustic instruments such as the mandolin, string bass, autoharp and Hawaiian steel guitar were also often included. To this day, many folk musicians typically use only these traditional instruments in their performances.

THE FIRST COUNTRY RECORDINGS

Traditional rural music was first recorded in 1923 when Okeh Records recorded Atlanta favorite Fiddlin' John Carson at a local radio station. The records sold surprisingly well throughout the region, much to the amazement of company officials. Sensing a business opportunity, **Ralph Peer** (1892–1960) of Victor Records went on a talent hunt for other rural musicians in August of 1927. Setting up his primitive mobile recording equipment in a warehouse in Bristol, Tennessee and offering \$50 per song to anyone that would audition, Peer struck gold. Among the many who came down from the hills to record at the **Bristol Sessions**, as they became known, were both the Carter Family and Jimmie Rodgers, who would become the first commercially successful and important performers of country music, as it was starting to be labeled by the late 1920s.

The **Carter Family**, led by A. P. Carter, his wife Sara and their sister-in-law Maybelle, had learned hundreds of traditional songs and performed them putting emphasis on their strong vocals and a revolutionary flat-picking guitar style that is still commonly used by folk guitarists. **Jimmie Rodgers** (1897–1933), known alternately as the "Father of Country Music," "America's Blue Yodeler" and the "Singing Brakeman," was indeed a railroad worker until his poor health forced him to quit and concentrate on music. Between 1927 and 1933 when he died from tuberculosis, Rodgers recorded over 100 songs, sold millions of records and became the first nationally known country star. His song topics and

Hillbilly music The traditional old time music of the rural South and Appalachian regions, with origins in English folk music. Hillbilly music is the foundation of modern country music.

British folk tradition The traditional folk music, including ballads, lyric songs and work songs, of the British Isles. British immigrants brought these songs to the New World.

Bristol Sessions The first important country music recordings made in Bristol, Tennessee in 1927 by Ralph Peer. Among the artists that Peer recorded were Jimmie Rodgers and the Carter Family.

vocal style (which included blues inflections and his signature yodeling) set the mold for later stars such as Ernest Tubb and Hank Williams. As one of the three original inductees into the Country Music Hall of Fame, Rodgers plaque identifies him as "the man who started it all."

MUSIC CUT 8

"BLUE YODEL #1 (T FOR TEXAS)" (JIMMIE RODGERS)— JIMMIE RODGERS

Personnel: Jimmie Rodgers: guitar, vocals. Recorded on November 30, 1927 at RCA Victor Studio 1, Camden, NJ; produced by Ralph Peer. Released February 3, 1928.

"Blue Yodel #1 (T for Texas)" was recorded in the RCA Victor Studio 1, the former Trinity Baptist Church in Camden, New Jersey. It was Rodgers's second session for the label and its producer Ralph Peer (the first being the famous August 4, 1927 session in Bristol, Tennessee), and the one that made him a star. Rodgers originally called his song "T for Texas," but Peer, impressed by the "oh-de-lay" yodels at the end of each verse, renamed it "Blue Yodel." It became a smash that ended up selling approximately one million copies, and instantly made Rodgers a household name. Rodgers became known as "America's Blue Yodeler," and went on to record ten more "Blue Yodels." His use of both blue-infused melodies and yodels made him a major influence to both the black and white vocalists of his day.

NASHVILLE AND THE GRAND OLE OPRY

Radio played an important role in popularizing country music. In 1923, the first "barn dance" program was broadcast on station WBAP in Dallas, featuring live performances by country artists. Other shows soon followed: in 1924 Chicago's WLS premiered its National Barn Dance program, and on November 28, 1925 the WSM Barn Dance began broadcasting in Nashville. In 1927 WSM (which still resides at 650Hz on the dial) changed the name of the program to the **Grand Ole Opry** and with the station's clear channel designation, the Opry became the most widely heard and influential radio show of its kind. Other "barn dance" programs included the Louisiana Hayride on KWKH in Shreveport, Louisiana, the Midwestern Hayride on WLW in Cincinnati and the Big D Jamboree on KRLD in Dallas.

Today the Grand Ole Opry is the longest continuously running radio program in the United States. It has influenced the course of country music by putting an emphasis on programming pop oriented and crooning country singers (and forbidding drums for many years). Careers were often made by a successful debut there. Because the Opry was a live broadcast, performers had to maintain a presence in Nashville at least one day each week, and throughout the 1940s and 1950s, many moved there permanently. Songwriters, publishers, recording studios and all the major record labels soon followed, and by the early 1950s Nashville became the capital of the country music industry—in large part because of the Grand Ole Opry.

COWBOY MUSIC, WESTERN SWING AND BLUEGRASS

Around the same time that radio was starting to make country music more accessible, Hollywood filmmakers were popularizing cowboy songs in Westerns, and stars such as Gene Autry ("The Singing Cowboy") and Roy Rogers rose to

the center of the country music

industry.

fame. Cowboy songs were dressed up and orchestrated to give them a smoother and more commercial sound; the singing cowboys themselves were also dressed up in hats, boots and ties to elevate them from the older and undesirable hillbilly image. Cowboy songs helped pave the way for other commercialized offshoots of country to emerge that would reinvent the genre. One of these was Western swing which became popular during the Swing Era, and whose biggest star was Texas fiddler Bob Wills. Wills began broadcasting on station KVOO in Tulsa, Oklahoma in 1934 with his band the Texas Playboys, which combined traditional country instruments with those found in a swing big band: trumpets, saxophones and drums. Despite their tendencies toward jazz, the Playboys wore the traditional country attire of cowboy hats, boots and string ties. Wills had his biggest hit in 1940 with "New San Antonio Rose," which went to #11 on the charts.

MUSIC CUT 9

"BLUE MOON OF KENTUCKY" (BILL MONROE)— BILL MONROE AND HIS BLUE GRASS BOYS

Personnel: Bill Monroe: mandolin, vocals; Lester Flatt: guitar; Earl Scruggs: banjo; Chubby Wise: fiddle; Howard Watts: bass. Recorded September 16, 1946 for Columbia Records.

Within a year after Bill Monroe founded the Blue Grass Boys in 1938, they landed a spot on WSM's Grand Ole Opry in Nashville. It was from their weekly performances on the program that the group began to captivate listeners with their carefully crafted arrangements and Monroe's jazzy mandolin playing. Monroe continued to tinker with the sound of the group, and with the addition of Lester Flatt and Earl Scruggs in 1944, the sound of classic bluegrass music was set. "Blue Moon of Kentucky" was written in 1946, and its performance on Opry broadcasts over the next few years are believed to have been heard by Elvis Presley, who in turn recorded it in 1954. Presley's recording of the song, in an up tempo, rockabilly style, proved to be the "big bang" moment in rock and roll history (see Chapter 2). Monroe later re-recorded the song in a style reminiscent of Presley's, and played it at virtually every live performance throughout his career.

Another stylistic development was bluegrass, which was invented and named by mandolin player **Bill Monroe**. With his band the Blue Grass Boys, which he formed in 1938, Monroe developed a unique genre that relied on faster tempos and jazz-like virtuoso solos that were spread evenly among mandolin, fiddle and guitar. When guitarist and vocalist **Lester Flatt** and banjo wizard **Earl Scruggs** joined the band in 1944, the Blue Grass Boys were in their prime. Scruggs did nothing less than reinvent banjo playing with his amazing fast picking style. Flatt and Scruggs left in 1948 (due to Monroe's stubbornness and difficult personality) and started their own band, which in time became more popular than Monroe's.

Southern Gospel

Southern, or "white" gospel had a parallel course of development to that of Black Gospel. Its beginnings can be traced back to the earliest white settlers from Britain, who along with folk songs brought their hymns. Throughout the 19th century a style of singing known as Sacred Harp or shape note music became

form of country
music that incorporates jazz swing
rhythm and instruments associated
with a jazz swing band.

Bluegrass A fast paced, acoustic music that incorporated virtuoso improvised solos similar to those found in jazz.

A Christian-based genre of music that first became popularized in the Southern United States in the early 20th century by male vocal quartets singing with piano or small group accompaniment.

Honky tonk The direct predecessor to country western that used a rhythm section, electric guitar and electric pedal steel guitar to create a louder and hard driving sound. Honky tonk lyrics often dealt with drinking, cheating, etc.

popular, especially in the South, which used a simple notation system that even illiterates could read. By the late 1800s a rebirth of hymn writing known as Gospel led to the creation of many hymns that are still sung today, including "Jesus Loves Me" and "Blessed Assurance." As hymn publishers began to flourish in the 20th century, it became fashionable for them to use traveling vocal groups known as Southern Gospel Quartets as sales representatives for songbooks. The man who is today known as the Father of the Southern Gospel music industry was James D. Vaughan, who started a publishing company in 1900, a music school in 1911, and one of the first radio stations in the South in 1922. In 1910 Vaughan became the first publisher to use a vocal quartet to sell songbooks.

As other publishers picked up the idea of using vocal quartets to sell books, the Southern Gospel industry took off. In addition to the early Vaughan groups, other popular Southern Gospel groups in the early to mid 1900s included the Blackwood Brothers, Oak Ridge Quartet, the Statesmen, the Statler Brothers, the Louvin Brothers, and the Gaither Vocal Band. The records from these groups were important influences on the earliest white rock and rollers, including Elvis Presley, Jerry Lee Lewis, Johnny Cash, and Carl Perkins. Southern Gospel was such an important part of Presley's musical background that he recorded three gospel albums during his lifetime, and sang "Peace in the Valley"—a song written by Thomas Dorsey and a standard among Southern Gospel groups—with the white gospel group the Jordanaires on *The Ed Sullivan Show* in 1957.

Honky Tonk

Honky tonk grew out of the bars and roadhouses (called "honky tonks") of Texas and the South, where the patrons were rough and rowdy and hard drinkers. The music is characterized by songs of drinkin' and cheatin', loves gained and lost. To be heard above the din of the crowded saloons, the honky tonkers developed a louder, driving sound by adding drums, electric guitar and electric pedal steel guitar that modernized country music and inched it closer in sound to the first rock and roll style, rockabilly. The first honky tonk artist was Ernest Tubb, who with his Texas Troubadours had been touring constantly and performing on radio since the early 1930s, achieving national celebrity in the 1940s with movie roles and Opry appearances. Another honky tonk artist, Texas born William "Lefty" Frizzell, is widely credited with creating a smoother singing style that became the blueprint for modern country singers. He was a regular on the country charts throughout the 1950s and early 1960s.

Although his recording career lasted only six years, the man who most personified honky tonk was undoubtedly **Hank Williams** (1923–1953), the "Hillbilly Shakespeare." Williams was a master poet with a knack for catchy melodies who wrote some of the most enduring tunes in country music history, including "Hey Good Lookin',""Jambalaya,""Cold, Cold Heart" and "Your Cheatin' Heart." Williams became so popular in the late 1940s and early 1950s that he had 11 records that sold a million copies or more and his concerts often resembled the near riots that Elvis Presley would endure a few years later. Unfortunately, his growing drinking problem paralleled that of his rising fame, and his life began to fall apart. He died of alcohol intoxication in the back seat of a car on the way to a gig on January 1, 1953. The last single released in his lifetime was his prophetic composition "I'll Never Get Out of This World Alive."

"YOUR CHEATIN' HEART" (HANK WILLIAMS/FRED ROSE)—HANK WILLIAMS

Personnel: Hank Williams: guitar, vocal; other musicians unidentified. Recorded September 23, 1952 at Castle Studios, Nashville, TN; produced by Fred Rose. Released January 1953 on MGM; a #1 hit on the country charts.

"Your Cheatin' Heart," the song that is often called the song that defines country music—and honky tonk—was recorded at Hank Williams's last recording session. According to legend, Williams, who had just separated from his first wife Audrey, wrote the song while driving around with the woman who would become his second wife, Billie Jean Williams. After Billie Jean wrote down the lyrics, Hank took them to Nashville songwriter Fred Rose, who edited them and produced the final version of the song. After recording the song, Williams told a friend, "It's the best heart song I ever wrote."

CHAPTER 1 TERMS AND DEFINITIONS

- **Sheet music**—music that is notated and sold in a loose, unbound sheet format. From the late 19th century to the present, popular music had been sold in this fashion, with lyrics, melody and piano accompaniment.
- Race music—a catchall term to describe any records or songs by black artists, including the blues and what would later be known as Rhythm and Blues (R&B).
- **Cover**—a new recording of a charting song that seeks to 'cover' up the original song.
- Work Songs, Shouts and Field Hollers—songs of African origin used to relieve the burden of working in Southern work camps.
- **Melisma**—the singing embellishment of a single syllable into several notes.
- **Hillbilly music**—The traditional old time music of the rural southern United States, with origins in English folk music. Hillbilly music is the foundation of modern country music.

Name ____

Date

1.	Describe Frank Sinatra's relationship to rock and roll, both his reaction to it and his influence on it.
2.	Describe how technology changed the way music was recorded and packaged in the years leading up to 1954.
3.	What were some differences between the major and independent labels, both in how they operated and what kind of music they specialized in?
4.	What role did radio play in the explosion of rock and roll, and who were the important personalities?
5.	Describe how the blues evolved from its beginning until the 1940s.

6.	Describe the music that influenced doo-wop and how doo-wop in turn influenced rock and roll.
7.	Describe how music from the British folk tradition changed after it was brought to America.
8.	Describe how Nashville became such an important music center.
9.	What were the musical influences on Western swing and how did they manifest themselves?
10.	Why is honky tonk music so important to early rock and roll?

THE ROCK AND ROLL EXPLOSION:

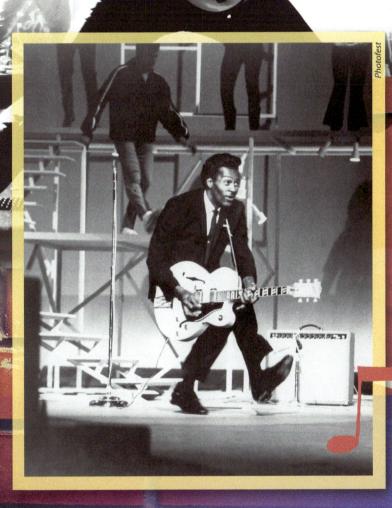

"I wrote about cars because half the people had cars, or wanted them. I wrote about love, because everyone wants that. I wrote songs white people could buy, because that's nine pennies out of every dime. That was my goal: to look at my bankbook and see a million dollars there."

KEY TERMS	Blackboard Jungle Sun Records Tape-delay echo Rockabilly	Crossover J&M Recording Studio Stop time Chess Records Bo Diddley rhythm	Nor Va Jak Studio Payola
KEY FIGURES	Bill Haley Sam Phillips Elvis Presley Col. Tom Parker Dave Bartholomew Fats Domino	Little Richard Willie Dixon Bo Diddley Chuck Berry Roy Orbison Carl Perkins	Jerry Lee Lewis Buddy Holly Norman Petty

POSTWAR AMERICA

Change and Prosperity

In the years after World War II, America found itself in a state of peace and prosperity for the first time since the late 1920s. Economic good times meant a dramatic expansion of the middle class. Household items and consumer goods like refrigerators and televisions changed from being luxuries to necessities: between the mid 1940s and the mid 1950s, the number of TV sets in the US increased from less than 10,000 to 50 million. Technological and scientific change was progressing at a stunning pace; computers, although new at the time, were becoming faster and more portable. Medicine brought us the polio vaccine, and electrical engineering made the introduction of the transistor radio possible. Research into the safe use of nuclear power was underway, resulting in the first commercial plant in 1957. When the Soviet Union sent Sputnik into orbit that same year, the world was ushered into a futuristic "space age" where space travel to space colonies was envisioned.

One of the biggest changes in our society was the increasing dependence on the automobile. By the mid 1950s there were nearly 70 million privately owned cars in America, and they began to change our lifestyles in profound ways. Suburban living became possible—and popular—as a way to attain the American dream of owning a home. Shopping centers sprang up, interstate highways were built, and families took more and more road trips and vacations. Disneyland opened, as did the first Holiday Inn and the first McDonald's, all of which catered to our new and fast paced mobile life. Cars became a national obsession: faster, bigger and shinier appealed to everyone, most of all teenagers.

Teenagers

Ah yes, teenagers—the word had been around since the 1940s, but teens in the 1950s were a different breed than any that preceded them. They were the first in American history that didn't have to work to help support the family—they could now take after school jobs to earn and spend their own money. Add to this the advent of modern mass marketing on television and radio, and teens became a consumer entity with unprecedented buying power. They began to develop

their own cultural values, social arrangements, fashions and awareness of the world around them. Teenagers had become a class all unto themselves.

Parents were not oblivious to all this and many were none too happy, either. In an era where anxiety about The Bomb, Communism and the Red Scare already had many adults feeling that they were heading straight for the Apocalypse, there was a growing concern that teenagers might get them there even sooner. With their new class status and independence, adults sensed that teens were flouting authority. Many were critical of a generation that had too much money and too much free time—teens had it too easy. Adults pointed to the growing problems of juvenile delinquency (although statistically there was no increase over previous years) and sexual permissiveness as the basis for their distrust. There seemed to be bored teenagers hanging out everywhere, just waiting to get themselves into trouble. The growing disapproval of adults only served to fuel any rebellious feelings that already existed in teens. Welcome to the generation gap.

Disconnect

In fact, a lot of teens were bored. There were strong feelings of disconnect for many: from parents, from authority, from each other. Television and suburbia fueled this isolation and loneliness, as did the usual problem of parents that didn't listen or understand. Cars with radios became essential to stay connected. Many teens looked to new role models that characterized their same feelings of alienation, such as the sarcastic and cynical anti-hero Holden Caulfield from J. D. Salinger's Catcher in the Rye. They also identified with young charismatic movie stars such as Marlon Brando and James Dean who wore leather jackets, sullen looks and sneers while playing troubled youth in popular films such as 1954's The Wild One, starring Brando. Dean's portrayal of Jim Stark in Rebel Without A Cause (released in 1955) made him a cult hero, and his death in a fiery auto accident before the movie even opened made him a legend. Rebel was one of the first movies to explore themes of alienation and despair from the vantage point of the teen rather than the adult. Many teens identified with Jim Stark, including a young wannabe singer living in Memphis named Elvis Presley.

As the 1950s unfolded, a new teenage nation had arrived. All it needed was its own music.

THE FIRST SOUNDS

Bill Haley

As discussed in chapter 1, observant white DJs around the country such as Alan Freed were tapping into this teen yearning and beginning to program R&B on their shows. Record distributors also caught wind what was going on, and started putting R&B records in jukeboxes, giving teens even more access to the music. White bands started to respond to the demand for the music by including a few R&B type songs into their repertoire. One of these was a country group called the Saddlemen, led by guitarist/vocalist **Bill Haley** (1925–1981). The Saddlemen in 1951 had recorded a cover of Jackie Brenston's "Rocket 88," giving it a slightly more country feel than the original. One of their next records

was "Rock The Joint," which attracted the attention of Alan Freed, who started giving the song airplay. By 1952, with their popularity growing, Haley and the band (who were now all in their late 20s and early 30s, playing for teenagers at school dances) decided to scrap the cowboy image and adopt a wilder R&B styled stage act. They also changed their name to Bill Haley and His Comets (a play on the Halley's Comet theme). When "Crazy Man Crazy," a Haley original whose inspiration came from hearing teens talk at a dance hit #15 on the pop charts in 1953, they became the first white band to hit the Top 20 with an R&B song. After signing with Decca Records in 1954, Haley recorded a cover of Joe Turner's "Shake, Rattle and Roll" (with cleaned up lyrics) that went to #7 in late 1954 and early 1955 and sold over a million copies.

The First Rock and Roll Band

But Haley's biggest hit was yet to come. On April 12, 1954 the Comets recorded "Rock Around the Clock" which hit #23 and sold 75,000 copies before dropping off the charts. However the song breathed new life when it was placed over the opening credits to the hit film *Blackboard Jungle*. Decca re-released "Rock Around the Clock" in May 1955 and it quickly shot up to #1 where it stayed for eight weeks, eventually selling over 20 million records. Haley went on to score two more Top 10 hits, "Burn That Candle" (#9) in late 1955 and "See You Later, Alligator" (#6) in early 1956. The band appeared on national television, and was featured in the fictionalized teen film *Rock Around the Clock*. For a short while, they were not just the most popular white rock and roll band in the world, they were the *only* one.

Unfortunately Haley was soon swept aside by Elvis Presley, who scored his first national hit in March 1956 ("Heartbreak Hotel"). Presley was ten years younger, leaner, surlier and more aggressively sexual than the rather pudgy and balding Haley. Nonetheless, Haley's calculated fusion of country and R&B was the same formula that Presley and many other early rock and roll stars would use.

"ROCK AROUND THE CLOCK" (JIMMY DE KNIGHT/ MAX C. FREEDMAN)—BILL HALEY AND HIS COMETS

Personnel: Bill Haley: rhythm guitar, vocals; Franny Beecher, Danny Cedrone: guitar; Billy Williamson: steel guitar; Johnny Grande: piano; Joey Ambrose: tenor sax; Marshall Lytle: bass; Billy Gussak: drums. Recorded April 12, 1954 at Decca Studio A, New York City. Produced by Milt Gabler.

"Rock Around the Clock" was written in 1953, and Bill Haley's new band the Comets began performing it live to great success soon afterward. Unable to get his current label Essex to record the song, Haley signed with Decca in early 1954, and was assigned to producer Milt Gabler. The song was recorded at Decca Studios at 135 West 70th Street in New York, in the building that was known as the Pythian Temple. The Knights of Pythias built the temple in 1927, but by the mid 1940s, the fraternal order had fallen on hard times. As a way to generate income, they rented out space to Decca Records, who converted the building's huge 3rd floor ballroom into a recording studio. "At the Pythian, you could blow, because there was this big high ceiling," remembered Gabler. "We had drapes hanging from the balconies, and a live wooden floor." Other artists that recorded at the Pythian Temple included Buddy Holly, Louis Jordan, and Billie Holiday. The building still remains today as a luxury condominium.

While Haley's music is often categorized with Presley and the other Sun Studio artists as rockabilly, his sound was slightly different than the sound heard on the very earliest Sun records. The Comets included saxophone and drums, instruments that were often used in R&B groups but not present in the early rockabilly records from Sun. Haley also used group vocal chants, a technique often used by western swing bands but not typically used at Sun, where there was usually only one vocalist. Regardless, Bill Haley played an important role in pushing rock and roll up a notch in popularity.

The Indies Take Over

Even though Bill Haley was signed to one of the industry majors (Decca), the prevailing industry thought was that rock and roll was a fad that would quickly burn itself out. In fact, Haley and Elvis Presley (RCA) were the only important rock and roll stars of the 1950s that were signed to major labels. By ignoring rock and roll, the majors inadvertently opened the door for the small independent labels, which were quick to jump on the bandwagon and grab control of the new market. Sales figures confirm this, as the following chart of *Billboard's* Top 10 rock and roll hits from 1955 to 1959 shows:

	1955	1956	1957	1958	1959
Top 10 major label rock and roll hits	3	9	14	11	9
Top 10 indie label rock and roll hits	5	10	29	28	29

These impressive gains were made in a five-year period (1954–59) where total record sales nearly tripled, from \$213 million to \$613 million. One of the more aggressive independent labels was Memphis based Sun Records, owned by Sam Phillips.

Sun Records and Sam Phillips

Sam Phillips (1923–2003) was a true musical visionary, and tremendously influential to the birth of rock and roll. He started his career as a DJ, but in early 1950 the allure of R&B enticed him to open the Memphis Recording Service in the vacant radiator shop at 706 Union Avenue. He had a great ear and an even better nose for talent, which the Memphis area, strategically located at the northernmost edge of the Mississippi Delta was loaded with. Although anyone could plunk down \$2 and make a record at the studio (which helped pay the rent in the early days), Phillips primary interest was in making authentic recordings of the many blues and R&B singers in the area. One of his early recordings was 1951's "Rocket 88" by Jackie Brenston and His Delta Cats, which, because of its theme (a hot Oldsmobile sports car with hints of sexual innuendo), its boogie beat and distorted guitar is regarded by many to be the first rock and roll record. Initially Phillips recorded singers such as Howlin' Wolf, B. B. King, Harmonica Frank Floyd, Sleepy John Estes and Elmore James and leased the master tapes to Chess and Modern. In 1953 he started his own label, Sun Records.

Phillips worked like a maniac to get his label off the ground. He not only owned the company, he served as engineer, producer, talent scout and advance man. He spent days and weeks on the road, driving thousands of miles with

innately natural, in the people that I wanted to work with—Southern black, Southern country white—than there was in the people who wrote the arrangements."

-Sam Phillips

"ROCKET 88" (JACKIE BRENSTON), JACKIE BRENSTON AND HIS DELTA CATS

Personnel: Jackie Brenston: vocal, baritone sax; Raymond Hill: tenor sax; Ike Turner: piano; Willie Kizart: guitar; Jesse Knight: bass; Willie Sims: drums. Recorded March 3, 1951 at Sun Studio, Memphis, TN; produced by Sam Phillips. Released April 1951 on Chess; peaking at #1 on the R&B charts.

"Rocket 88" was recorded at Sun Studio on March 5, 1951, was released as Sun single #1458 and reached #1 on the R&B charts in April. Although Jackie Brenston is officially listed as the leader, it was really Ike Turner who led the Delta Cats. Hailing from Clarksdale, Mississippi, the group ran into trouble on the one-hour drive north to Memphis when the guitar amp fell out of the car, tearing a hole in the speaker cone. When the group arrived at the studio, the resourceful Sam Phillips stuffed the amp with paper and actually featured the distorted sound in the mix. He later said, "It sounded like a saxophone." It stands today as one of the first examples of distorted guitar on record.

Sam Phillips created his tape-delay echo by feeding a sound source, such as a vocal, into the record head of a separate tape machine and back into the mix after it passed the playback head a split second later.

boxes of 45s in the trunk of his car to distribute to record shops and radio stations. Phillips' studio was a small room, so he experimented with an innovative **tape-delay echo** to enhance and fatten up the sound, a technique for which his Sun recordings would become famous. More importantly, he was on a mission to capture the passion and raw energy of the Memphis blues scene. He often spent hours in the studio with unknown performers to that end, while most other labels were trying to come up with a smooth, commercial sound. "My feeling was that there was more talent, innately natural, in the people that I wanted to work with—Southern black, Southern country white—than there was in the people who wrote the arrangements." Among the more unusual performers he took chances on in the early days were Joe Louis Hill, a one-man band, and The Prisonaires, a vocal group comprised of inmates from a local prison.

Phillips' first Sun hit came quickly: Rufus Thomas's "Bear Cat," the "answer" record to Big Mama Thornton's "Hound Dog," hit #3 on the R&B chart in 1953. Although he was hit with a copyright infringement lawsuit over the song (which he lost), it gave Phillips his first taste of success and put him on the map.

ROCKABILLY

Characteristics of Rockabilly

- 1. The earliest rock and roll style, influenced by R&B and honky tonk
- 2. Fast tempos and jumping, nervous beat
- 3. Sparse instrumentation: electric and acoustic guitar, upright bass played in 'slap' fashion to achieve percussive effect (in early Sun records); drums used in later Sun and other rockabilly records
- 4. Single vocalist using effects such as hiccupping and the use of heavy echo; backup vocals used in Haley and Holly recordings

Key Rockabilly Recordings

- "Rock Around the Clock"—Bill Haley, 1954
- "That's All Right"/"Blue Moon of Kentucky"—Elvis, Scotty and Bill, 1954
- "Blue Suede Shoes"—Carl Perkins, 1955
- "Be-Bop-A-Lula"—Gene Vincent, 1956
- "That'll Be the Day"—Buddy Holly, 1957

He was still looking for something new and different, however—something that would reflect the honesty and personality of the common folk. Phillips' instincts told him that combining R&B and country music properly would have a huge crossover appeal. Even though the early recordings of Bill Haley had done this to a certain degree, Phillips Sun recordings would codify what would eventually be known as **rockabilly**, the first style of rock and roll.

Phillips also knew that he needed a distinctive vocal stylist to synthesize the "Southern black, Southern country white" sound he was looking for—someone "you'd know the moment you heard him." But he knew that as a culture steeped in the racial conventions of the 1950s, that vocalist would have to be white. He often said in those days, "If I could find me a white man who sang with the Negro feel, I could make a million dollars." As fate would have it, in August 1953, an 18-year-old truck driver who could do just that walked in the front door of the Memphis Recording Service. Sam Phillips and Elvis Presley were about to change the world.

ELVIS PRESLEY

The Cat

Elvis Aaron Presley (1935–1977) was born in Tupelo, Mississippi to his parents Vernon and Gladys. The Presleys were dirt poor, moving frequently to stay a step ahead of missed rent payments; Vernon was even jailed for a brief time in 1938 for forgery. In 1948 the family moved to Memphis, and lived in various public housing tenements before finally renting a house of their own. By this time Elvis was showing an interest in music, and his singing won a talent contest as a tenyear-old. For his 11th birthday, his parents bought him his first guitar. He was also absorbing music from a variety of influences: country music from listening to the Grand Ole Opry on radio, gospel music from singing at church, and from Memphis' black radio stations, R&B. One particular favorite R&B show was

"Red, White, and Blue" on Memphis' WHBQ, hosted by "Daddy-O" Dewey Phillips (no relation to Sam). Of course, Elvis was also hanging out at the nightclubs along Beale Street in Memphis, where he heard artists like B. B. King and Wynonie Harris perform live.

Although he was painfully shy, by the time he had entered Humes High School, Elvis was becoming the personification of the Southern "cat": greasing his long hair back, wearing brightly colored jackets, pants and two-toned shoes which he bought at Lansky Brothers on Beale Street, a store with a primarily black clientele. He usually made an impression on those that met him, not only for his shyness and his clothes, but also for his sincere and burning desire to become somebody.

The Discovery

When Presley first showed up at the Memphis Recording Service in August 1953, he recorded two songs, which were supposedly a birthday gift for his mother (whose birthday was actually in April). Although Sam Phillips was only mildly impressed ("We might give

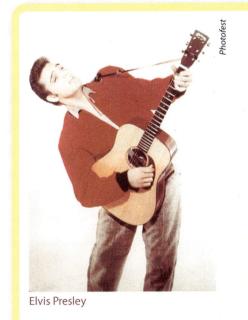

you a call sometime"), the next summer he teamed Elvis with country musicians Scotty Moore (guitar) and Bill Black (bass) of the Starlite Wranglers to begin rehearsing. At the trio's first recording session, on July 5, 1954, nothing was going particularly well. Finally they decided to take a break. Then, according to Scotty:

"All of a sudden Elvis just started singing this song, jumping around and acting the fool, and then Bill picked up the bass and he started acting the fool, too, and I started playing with them. Sam, I think, had the door to the control booth open . . . and he stuck his head out and said, 'What are you doing?' And we said, 'We don't know.' 'Well, back up,' he said, 'try to find a place to start, and do it again'."

The song Phillips captured on tape was an R&B tune by Arthur "Big Boy" Crudup called "That's All Right," but Elvis had reinvented it as an electrifying cross between country western and R&B. For the B-side, they recorded a Bill Monroe bluegrass tune, "Blue Moon of Kentucky" using the same formula. The sound was different, yet puzzling—no one was quite sure how to categorize it. But the reaction was instantaneous: two nights later, when Dewey Phillips played it seven times in a row on his radio show, the phone lines lit up. In Memphis, Elvis was literally an overnight sensation. Over the next several months, Elvis, Scotty and Bill performed around the region, including appearances at the Grand Ole Opry and Louisiana Hayride (they bombed at the conservative Opry, but were a hit at the Hayride). They also recorded a total of ten sides—five single releases—for Sun, which, over time, started to get the attention of *Billboard* magazine.

Promoting Presley presented Phillips with somewhat of a conundrum. Was he country or was he R&B? Because some listeners thought Elvis sounded "too black," in the beginning Phillips chose to market him as a country artist. Within a year, Presley had his first #1 hit on the country charts, "Mystery Train." Fueling his meteoric rise to fame were his electrifying live performances, in which he somehow combined surly bad boy fierceness and youthful charm that defied his off stage shyness. He wiggled his hips and kicked his legs like jackknives, eliciting an explosive effect on the crowd. Often he was forced to flee as young women rushed the stage, attempting to tear his clothes off. Jealous boyfriends were also chasing Elvis, but for different reasons.

MUSIC CUT 13

"THAT'S ALL RIGHT" (ARTHUR CRUDUP)—ELVIS PRESLEY, SCOTTY AND BILL

Personnel: Elvis Presley: acoustic guitar, vocal; Scotty Moore: guitar; Bill Black: bass. Recorded July 5, 1954 at Sun Studio, Memphis, TN; produced by Sam Phillips. Released July 19, 1954 on Sun; did not chart.

The song that some say started it all, the first recording made by Elvis Presley with Scotty Moore on guitar and Bill Black on bass at Sun Studio in Memphis on July 5, 1954. Bill Monroe's classic was first recorded by the composer in 1946, and it is believed that Presley learned the song after hearing Monroe's Blue Grass Boys perform it on WSM's Grand Ole Opry (see Chapter 1).

- "That's All Right"/"Blue Moon of Kentucky," 1954
- Mystery Train," 1955
- "Don't Be Cruel"/"Hound Dog," 1956
- "Love Me Tender," 1956

KEY ELVIS PRESLEY RECORDINGS

RCA and Col. Parker

Presley's sudden rise to fame caught the attention of **Col. Tom Parker** (1909–1997), a small-time promoter and former carnival hawker, and in mid-1955 Parker, an illegal immigrant from the Netherlands (real name: Andreas Cornelius van Kujik), become Presley's manager. Parker immediately went to work, with a four-pronged strategy to monetize Elvis Presley. First, he began shopping Elvis to major labels, and in November 1955 engineered a deal in which RCA bought Presley's contract from Sun Records for \$40,000. Parker also quickly began working to get the singer national TV exposure, Elvis-themed consumer products (Elvis perfume, Elvis sneakers, etc), and starring roles in Hollywood movies. Over time, the Colonel took complete control of all business decisions while taking a 50% cut (as opposed to the usual 10%), all with Presley's blessing. Parker was also instrumental in shielding Elvis from the public, believing that whetting the public's appetite with only occasional appearances was a good marketing strategy. In reality, this tactic only contributed to isolating Elvis in his own private hell.

Presley's initial RCA recordings were done in Nashville and New York, and the change of locale coincided with some other subtle changes that began to take place. RCA was at first very nervous about their new investment, and to make the recordings more accessible to a wide audience brought in veteran studio musicians such as Chet Atkins on guitar, Floyd Cramer on piano, and The Jordanaires, a gospel backup chorus. At first the musical changes are minimal, but over time Presley's recordings became slicker and more polished, and lost most of the raw energy that Sam Phillips had honed at Sun. Eventually Parker fired Scotty and Bill, leaving the two longtime sidemen bitter and Presley even more isolated and alone. Nonetheless, RCA produced stunning results: by April of 1956, Presley had his first two #1 hits, "Heartbreak Hotel" and "I Want You, I Need You, I Love You." In August, the songs "Don't Be Cruel" and "Hound Dog" were released as flip sides on the same single, and became the first record in history to simultaneously hit #1 on the pop, country, and R&B charts.

Elvis made his first national TV appearance on *The Dorsey Brothers Stage Show* on January 28, 1956, where he ultimately made six appearances. He then moved up to the higher rated *Milton Berle Show* on June 5, which prompted a deluge of angry protest letters. In response, Steve Allen had Presley appear on his show on July 1 as 'the new' Elvis Presley, dressed in tuxedo while singing to a real beagle, also dressed in a tux. Elvis finally moved up to the top rated variety program, *The Ed Sullivan Show* on September 9. Sullivan initially refused to put Presley on his show, but changed his mind after seeing the huge audience the singer had garnered on Berle's show. Although Presley's first two appearances drew an astounding 60 million viewers, Sullivan's producers decided that for his

Cruel" and "Hound Dog" became the first record in history to top the Billboard Pop, Country, and R&B charts. On the pop chart, "Hound Dog" was listed at #1 for five weeks, then "Don't Be Cruel" for six more weeks, for a total of 11 weeks at #1. The single also topped all the jukebox charts (pop, country, R&B) as well.

"HOUND DOG" (JERRY LEIBER/MIKE STOLLER)— ELVIS PRESLEY

Personnel: Elvis Presley: lead vocals; Scotty Moore: electric guitar; Bill Black: bass; D. J. Fontana: drums; Gordon Stoker: piano; The Jordanaires: backing vocals. Recorded July 2, 1956 at RCA Studios, New York City.

"Hound Dog" was written in 1953 by the songwriting team Leiber and Stoller for R&B singer Big Mama Thornton (see Chapter 3), who turned it into a #1 R&B hit. It was the pair's first hit song, and was one of 24 of their songs that Elvis Presley recorded in his lifetime. To get this recording, Presley and producer Steve Sholes went through 31 takes before Presley chose take 28 as the best. "Hound Dog" was released as the B side to the single "Don't Be Cruel" on July 13, just 11 days after the recording session. Presley performed the song on his initial appearance on *The Ed Sullivan Show* on September 9, and record sales took off. In time, the single with "Don't Be Cruel" backed with "Hound Dog" became the first record in history to top the *Billboard* Pop, Country, and R&B charts. On the pop chart, "Hound Dog" was listed at #1 for five weeks, then "Don't Be Cruel" for six more weeks, for a total of 11 weeks at #1. The single also topped all the jukebox charts (pop, country, R&B) as well.

third appearance on January 6, 1957 they would show only his upper body on screen—the famous "above the waist" show—because of the singer's suggestive hip movements. (They even shot his last song, the tame gospel ballad "Peace in the Valley" from the waist up!)

Sgt. Presley

Presley made his first movie, *Love Me Tender*, in 1956, and the title song produced yet another #1 hit. Eventually he made 31 films, and although many of them are of questionable value, the movies were commercially successful and Elvis did a creditable job with sub par scripts. Since Presley did not tour in the 1960s, it was mainly through his films that his fans were able to see him until the early 70s. In March 1957 he bought Graceland and moved in with his parents. It was one of the most prestigious properties in Memphis. In 1962, 17-year-old model/actress Priscilla Beaulieu moved in; the two were married in 1967 and had one child, Lisa Marie. Although Gladys Presley died in 1958, Vernon Presley lived at Graceland until his son's death in 1977.

On March 24, 1958, Presley entered the army, where he served in Germany with no special privileges until March 1960, when he was discharged after working his way up to the rank of sergeant. In the less than four years prior to being called up, Elvis remarkably had scored ten #1 hits and starred in four films. While in the service, Col. Parker continued to release Presley recordings, with ten hitting the Top 25 and two going to #1 ("Hard Headed Woman" and "A Big Hunk O' Love"). Elvis continued to sell consistently well throughout the 1960s, but under Parker's guidance his material became increasingly pop oriented, and he fell out of touch with the younger rock audience. Although he staged a comeback on February 1, 1968 with the powerful live TV special *Elvis*, in the 1970s Presley was reduced to performing in Las Vegas in increasingly gaudy jump suits and flamboyant shows that cultivated a following of devoted mostly middle-aged female fans. Unbeknownst to the world, Elvis' life was becoming increasingly insular and depressing. His use of prescription drugs such as barbiturates and tranquilizers, which began in the army, increased. The breakup of his

marriage to Priscilla in 1972 exacerbated the situation. His weight ballooned as his health declined, all of which contributed to his death of a heart attack in his second-floor bathroom at Graceland in the early morning hours of August 16, 1977. Laboratory reports indicated that there were 14 drugs present in his system, ten in significant quantity.

The Presley Legacy

Elvis Presley gave his last performance in Indianapolis on June 25, 1977, but he left a legacy that will live forever. Even though his synthesis of R&B and country was not the first (Bill Haley, for one, was doing the same thing at least three years before Elvis made his first record), Presley did it with the attitude and conviction that would define rock and roll for many years. In essence, he was the first rock star. His records not only galvanized the teenage nation, but also influenced and inspired young rock wannabes all over the world. He had youthful good looks and charm, but at the same time brought an element of excitement, rebelliousness and sexual energy to the stage that made his performances incendiary. Audiences weren't sure what he was going to do next, and it wasn't always clear how they would react to it. This explosive interaction between performer and audience, so common to rock performances every since, was something new in American popular culture.

Elvis symbolized the American dream of growing up poor and becoming unimaginably rich. However, he also symbolized a much darker side of life, one that has tragically been repeated over and over by rock performers: drug abuse, selfishness, decadence, corruption, greed and isolation. His performances in the last years of his career were sad, even pathetic, and unfortunately are the only memories that remain for many. But there is no doubt that he was a catalyst that changed our culture in ways that are perhaps incalculable. One thing is for sure: America in 1960 was a very different place than America in 1950. Elvis Presley was a major contributor to the changes that took place. He was, and will forever be, The King.

Elvis' sales figures dwarf everyone else in the history of rock music, including the Beatles. Some facts and figures:

- Over 500 million records sold worldwide, 134 million in the US
- In America alone, 131 different albums and singles that have been certified gold, platinum or multi-platinum by the Recording Industry Association of America.
- 149 songs on Billboard's Top 100 Pop Chart in America. Of these, 114 made the Top 40, 38 were in the Top 10, and 18 went to #1. His #1 singles spanned a total of 80 weeks at that position.
- Over 90 charted albums with nine reaching #1 (this figure is for the American pop charts only), and 16 reaching platinum or multi-platinum status. He was also a leading artist in the American country, R&B, and gospel fields, and his chart success in other countries was substantial.
- Eleven of his movie soundtrack albums went to the Top 10, and of those, four went to #1, and two, Loving You (1957), and G.I. Blues (1960) each stayed at the top for ten weeks. The album from Blue Hawaii was #1 for 20 weeks in 1961 and was on the chart for 79 weeks.

FACTS AND FIGURES

THE FIRST CROSSOVER ARTISTS

Rock and Roll Explodes

In the wake of Presley's success, record sales exploded and rock and roll became big business. The majors began to realize that they had misjudged the music entirely and were losing market share to the indies, who were busy scouring the South to find the next Elvis. Sam Phillips for one was well positioned, with a roster of explosive new talent that he was ready to unleash. Thousands of 'cats' from all over the country (and in the United Kingdom where they were called "Teddy boys") were getting into the act as well, forming bands and recording demos. Billboard and Cashbox magazines sensed an epochal moment. A March 1956 Cashbox editorial entitled "Rock and Roll May Be The Great UNIFYING FORCE" stated that "The overwhelming sensation in the record business this week is the fact that two records which started essentially in the country field," (Presley's "Heartbreak Hotel" and Carl Perkins' "Blue Suede Shoes"), "have become hits also in the pop and rhythm and blues area." This demonstrated that the "possibilities exist . . . of bridging all three markets with one record" (which Elvis Presley did just five months later with "Don't Be Cruel" and "Hound Dog.") On February 16, 1957, Billboard announced a new format category rock and roll. A revolution was underway.

Meanwhile, many in the industry were still uneasy with the growth of rock and roll. It was too sexual, vulgar and obscene; its singers and songs carried a defiant attitude toward authority; and, especially in the South, it sounded "too black." Nonetheless, many black R&B artists had been enjoying significant commercial success throughout the 1950s. Some adopted a strategy of singing more sentimental or sing-along type songs that would appeal to whites, the downside of which was to cut them off from much of their black audience. Others sang in a more intuitive style with great **crossover** success to both black and white audiences.

In the early days of rock and roll, regional differences were an important part of the story. Just as Sun Records had defined the rockabilly sound of Memphis, studios in New Orleans and Chicago helped define the sound of those cities, where Fats Domino, Little Richard, Bo Diddley and Chuck Berry—the first rock and roll crossover artists—made their most important records.

THE NEW ORLEANS SOUND

Antoine "Fats" Domino

As the birthplace of jazz, New Orleans has long been one of the most important music cities in America, with a rich mix of styles and influences from all over the world. The distinctive New Orleans R&B that emerged in the 1950s had loose shuffle rhythms (from jazz), tight bands (from gospel) and a preference toward walking bass lines (from boogie-woogie). The piano and tenor sax were the predominant instruments. Local bandleader Dave Bartholomew (1920-) became a key figure as a songwriter and producer for many of the hits from this era that were recorded in the city, most notably those of Fats Domino. Engineer Cosimo Matassa also played a seminal role in defining the New Orleans sound at his J&M Recording Studio on the corner of Rampart and Dumaine Streets (later at 525 Governor Nicholls Street). Often using Red Tyler and Lee Allen on sax, Earl Palmer on drums, Huey Smith on piano and Frank Fields on bass (all from Bartholomew's band), among the recordings made by Matassa were Roy Brown's original version of "Good Rocking Tonight" in 1947, Lloyd Price's "Lawdy Miss Clawdy" in 1952, Little Richard's "Tutti Frutti" in 1955 and many of Domino's hits.

- "Ain't That a Shame" (1955, #10)
- "I'm in Love Again" (1956, #3)
- "Blueberry Hill" (1956–1957, #2)
- "Blue Monday" (1957, #5)

FATS DOMINO'S GREATEST HITS

Except for Elvis Presley, **Fats Domino** (1929–2017) sold more records than any other rock pioneer from the 1950s—65 million of them! Born in New Orleans, he was playing the piano in juke joints and honky tonks in the city by the time he was ten years old. Domino's easygoing charm and demeanor made him likeable and non-threatening to white audiences, as was his distinctive Creole patois and his boogie-woogie piano playing. In the mid 1940s, Domino joined the band of trumpet player Dave Bartholomew, who helped him secure a contract with Lew Chudd and his newly formed Imperial Records in 1949. The first session produced the hit song "Fat Man" (#6) which ended up selling a million copies.

By the mid-1950s, Domino's records were already selling in the hundreds of thousands, but his greatest hits came between 1955 and 1960, including "Ain't That a Shame" (1955, #10), "I'm In Love Again" (1956, #3), "Blueberry Hill" (1956–57, #2) and "Blue Monday" (1957, #5). Since 1955, Domino has garnered nine gold singles and 37 Top 40 hits. Fats Domino was still living in New Orleans Lower 9th Ward when Hurricane Katrina hit in August 2005 and heavily flooded the neighborhood. He was thought to have died in the storm, but in fact a Coast Guard helicopter rescued him. His 2006 album *Alive and Kicking* was released as a benefit for the Tipitina's Foundation (www.tipitinasfoundation.org), which is dedicated to rebuilding the city's musical culture.

Characteristics of the New Orleans Sound

- 1. Shuffle 'swing-like' rhythm influence from jazz
- 2. Walking bass lines borrowed from boogie woogie
- 3. Extremely tight ensembles consisting of piano, bass, drums and horn section

Key New Orleans Recordings

- "Good Rocking Tonight"—Roy Brown, 1947
- "Fat Man"—Fats Domino, 1949
- "Lawdy Miss Clawdy"—Lloyd Price, 1952
- "Tutti Frutti"—Little Richard, 1955

Little Richard

Little Richard (1932–), born in Macon Georgia as Richard Wayne Penniman, was in many respects the opposite of Fats Domino—an aggressive, in your face wild man who shrieked and hollered and pounded the piano into submission. Growing up in a devout Seventh Day Adventist family, Richard learned to sing gospel music and play the piano at a local church. At age 13, he was kicked out of his family's house (reportedly because of his homosexuality); by 1951 he was performing on the radio with a jump band. In 1955 Richard sent a demo to Specialty Records in Los Angeles where it caught the attention of producer Bumps Blackwell. Blackwell brought him into New Orleans' J&M studio in September 1955 where Richard recorded his first hit, "Tutti Frutti." With its opening battle cry, "Awop bop a loo mop a lop bam boom!," "Tutti Frutti" went to #17 in early 1956 and set the mold for many of Richard's hits to come, including "Long Tall Sally" (1956, #2), "Lucille" (1957, #1 R&B) and "Good Golly, Miss Molly" (1958, #10).

"TUTTI FRUTTI" (RICHARD PENNIMAN, DOROTHY LABOSTRIE, JOE LUBIN)—LITTLE RICHARD

Personnel: Little Richard: piano, vocals; Alvin "Red" Tyler: baritone sax; Lee Allen: tenor sax; Earl Palmer: drums; Huey Smith: piano; Frank Fields: bass; guitarist unknown. Recorded September 14, 1955 at J&M Studio, New Orleans, LA; produced by Bumps Blackwell and Art Rupe; Dave Bartholomew, recording supervisor. Released December 1955 on Specialty; 12 weeks on the charts, peaking at #17.

The story of "Tutti Frutti" is one of the legends of early rock and roll. Signed by Art Rupe's Specialty Records, Richard's first day of recording at J&M Studio yielded nothing spectacular: four blues tunes. The next day, September 14, 1955, the results were pretty much the same. Finally the band took a break at a nearby club called the Drop. There, Richard sat down at the piano and belted out an obscene version of what was to become "Tutti Frutti." Up to this point, Huey "Piano" Smith had been playing piano on the session; after Richard took over on the keys, he was able to cut loose with his explosive vocal style. It took just three takes to come up with this jewel, after Dorothy LaBostrie was brought in to clean up Richard's lyrics. This recording shows off the tightly knit band of trumpeter Dave Bartholomew, who "supervised" this and many other sessions at J&M in the 1950s (the title "producer" had not been invented at this time, although that is essentially what Bartholomew was doing).

Little Richard's gospel influenced vocals and hard driving piano playing was augmented by one of the tightest and most dynamic bands in early rock and roll. He often used **stop time** to punctuate vocal parts and honking saxophone solos. His lyrics were among the most sexually suggestive of the era. (The original lyrics to "Tutti Frutti," which included lines such as "If it don't fit, don't force it" had to be cleaned up by local songwriter Dorothy La Bostrie at the session.) On stage he was wild and aggressive, standing up while playing the piano. He took Presley's sexuality one step further, becoming rock's first androgynous performer by wearing mascara, lipstick and a pompadour hairstyle combed high.

In 1957, at the height of his career, Richard left music to become an ordained minister. Among the reasons he gave were witnessing the Soviet satellite Sputnik fly overhead at an outdoor concert and a dream in which he claimed to have had a vision of the apocalypse. After throwing thousands of dollars worth of jewelry into the ocean, he entered a Seventh-day Adventist College in Alabama "to work for Jehovah and find that peace of mind." In 1962, Richard slowly began his return to music, but his greatest successes were behind him. His influence is undeniable, not only from his songs (which have been covered by the Beatles, Rolling Stones and many others) but also from his outlandish, over the top stage persona.

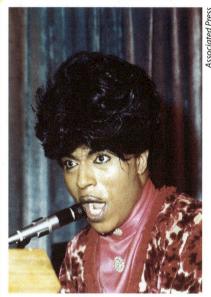

The flamboyant Little Richard in 1996.

CHICAGO R&B

Chess Records

Meanwhile, up north in Chicago, Chess Records was helping to define that city's R&B sound. Phil Chess and Leonard Chess were Polish immigrants who came to Chicago as children in 1928. After dabbling in various business ventures, they eventually went into the nightclub business, owning and operating the Macomba Lounge on the South Side. In 1947 they sold the Macomba and invested in Aristocrat Records, (which they later bought outright and renamed Chess in 1950) to record the artists they had seen performing in their club. Their earliest successes came with transplanted Delta musicians such as Muddy Waters and Howlin' Wolf, but by 1954 they were expanding into the growing crossover market, recording hits by doo-woppers such as the Moonglows and the Flamingos.

By 1957 business necessitated moving to a larger studio at 2120 South Michigan Avenue, where they remained until 1967 (the building remains today as a museum). Since South Michigan Avenue at the time contained the offices of several independent labels (such as Vee-Jay, Brunswick, and Constellation), distributors, rehearsal spaces and other studios, it became known as Record Row. Many of the Chess sessions included veteran players **Willie Dixon** (1915–1992) on bass, Fred Below on drums, Otis Spann on piano and Little Walter on harmonica. (Dixon was also influential as a composer, penning the blues standards "Hoochie Coochie Man" and "Spoonful." His songs have been covered by The Rolling Stones, Led Zeppelin and The Doors, to name a few.)

Bo Diddley

One of Chess's first hit records came from a native Mississippian who was making a name for himself playing South Side clubs. Ellas McDaniel, going by the name Bo Diddley (1928–2008), turned his first recording, "Bo Diddley" (released on Checker Records, a Chess subsidiary) into a #1 R&B hit. The song consisted almost entirely of a one-chord vamp set to a repeating rhythm—*chunk-ch*

"BO DIDDLEY" (ELLAS MCDANIEL)—BO DIDDLEY

Personnel: Bo Diddley: guitar, vocals; Otis Spann: piano; Billy Boy Arnold: harmonica; Jerome Green: maracas; James Bradford: bass; Clifton James: drums. Recorded March 2, 1955 at Universal Studios, Chicago. Produced by Phil and Leonard Chess. Released on Checker Records, b/w "I'm a Man" on April 30, 1955; 18 weeks on the R&B charts, peaking at #1.

The song the world knows today as "Bo Diddley," with the famous "Bo Diddley rhythm," began life as "Uncle John." While rehearsing the song at the Chess Brothers offices at 4750 South Cottage Grove in Chicago, Leonard Chess heard the lyrics to "Uncle John," which contained lyrics that were too lewd for the times. Chess demanded new lyrics for the song, and eventually the lyrics "Bo Diddley buy his baby a diamond ring," along with an incessant new rhythm emerged. That rhythm is a descendent of the West African hambone rhythm, which had already been appropriated by a few other early R&B artists. Ultimately the Bo Diddley rhythm snuck its way in to countless other rock songs, including most recently U2's "Desire," Bruce Springsteen's "She's the One," and George Michaels' "Faith."

Bo Diddley had a distinctive physical appearance, often wearing cowboy hats and huge horn-rimmed glasses and playing unusual rectangular-shaped guitars. Although he never achieved the fame of other 1950s crossover R&B artists, he was an important guitar innovator who is the link between T-Bone Walker and Jimi Hendrix. His use of reverb and tremolo to enhance the sound of his guitar

THE CHESS R&B SOUND

Characteristics of the Chess R&B Sound

- 1. Raunchy, powerful, defining the Chicago blues sound
- 2. Instrumentation: distorted electric guitar, bass, drums, piano, sometimes harmonica

Key Chess Rock R&B Recordings

- "Bo Diddley"—Bo Diddley, 1955
- "Maybellene"—Chuck Berry, 1955
- "Laura Lee"—Bobby Charles, 1956
- "Johnny B. Goode"—Chuck Berry, 1957

was as pioneering for the 1950s as the distortion and feedback that Hendrix used in the 1960s. He played his guitar as if it was a percussion instrument, giving his music a hypnotic, rhythmic feel. Diddley often propelled these rhythmic grooves with the unusual use of maracas. His bands frequently included female musicians, which was unusual for the time.

Chuck Berry

In 1955 Chess also signed the man who might easily qualify as the father of rock and roll. Chuck Berry (1926-2017) was born in St. Louis and grew up listening to gospel, country, blues, R&B and popular crooners such as Nat "King" Cole and Frank Sinatra. After becoming somewhat successful in the local club circuit, Berry went to Chicago in May 1955 with hopes of making a record. There he met Muddy Waters, who referred him to Leonard Chess, who in turn set up a session to record Berry's tune "Ida Red." Although Chess liked the song, he knew of another with the same title, so he suggested renaming "Ida Red." Combining scorching guitar work, a country beat and a compelling story line, "Maybellene" shot up the charts, hitting #5 by the end of August. Over the next three years Berry had four more Top 10 hits-"School Day" and "Rock and Roll Music" (#3 and #8 respectively, 1957), and "Johnny B. Goode" and "Sweet Little Sixteen" (#8 and #2, 1958).

Chuck Berry was the first great lyricist in rock and roll, with themes that often focused on three subjects that interested most teens: love, cars and school. His songs were interesting, humorous and often-ironic tales that transcended the usual boy-meets-girl story line. For instance, "School Day" told of racing down to the local juke joint as soon as the 3 o'clock bell rang."Roll Over Beethoven" contained the warning "tell Tchaikovsky the news" to "dig these rhythm and blues," while "Sweet Little Sixteen" told a tale of a girl all dressed up ready to go out and rock, but who still needed mommy and daddy's permission. Berry also occasionally tackled deeper issues, as in the condemnation of racial injustice in "Brown Eyed Handsome Man." Many of these songs not only told great stories, but also contained unforgettable sing-along hooks, such as "Go! Go! Johnny, Go! Go! Go!" and "Hail, Hail, Rock and Roll," which made them among the earliest

and roll.

MUSIC CUT 1

"MAYBELLENE" (BERRY/RUSS FRATTO/ALAN FREED)— CHUCK BERRY

Personnel: Chuck Berry: guitar, vocals; Johnny Johnson: piano; Willie Dixon: bass; Jasper Thomas: drums; Jerome Green: maracas. Recorded May 21, 1955 at Universal Studio, Chicago, IL; produced by Leonard and Phil Chess. Released July 30, 1955 on Chess; 11 weeks on the charts, peaking at #5 pop, #1 R&B.

Chuck Berry had originally titled his first hit—and his first recording for Chess Records—"Ida Red," but as pianist Johnny Johnson tells the story, Leonard Chess, who insisted on changing the name, came up with "Maybellene" after spotting a box of Maybellene mascara lying on the studio floor. All the essential Chuck Berry elements are here: proto-rock distorted guitar, a country twobeat, and a compelling story line, in this case about one of Berry's favorite subjects—cars ("As I was motorvatin' over the hill, I saw Maybellene in a Coupe de Ville..."). The record quickly worked its way up the R&B charts, and spent much of September and October at the #1 spot.

rock and roll anthems. Berry combined elements of blues and country in his songs, and while this was a reflection of his early influences, it was also a calculated effort on his part to capture the widest crossover audience. He also sang very clearly, as did his crooner idols.

Berry was also the archetypal rock guitarist, creating double note lead lines that are among the most copied in rock. It is not inconceivable to believe that every rock guitar player since 1960 has learned to play the introductions to both "Roll Over Beethoven" and "Johnny B. Goode." Berry used imaginative call and response interplay between vocal and guitar on "School Day," recorded live in an era before overdubbing was common. His signature duck walk also inspired generations of guitarists to put on a better show.

Berry's initial success was due in part to Alan Freed, who recognized the hit potential of "Maybellene" early on and gave the song constant airplay. In return for his help, Leonard Chess credited Freed with 1/3 of the song's authorship, therefore assigning him a third of the royalty payments (the other 1/3 was assigned to Chess' landlord, Russ Fratto)—all without Berry's knowledge. This and other forms of outright payola were typical of how the industry operated in the mid-1950s. Within a few years, the practice of paying off DJs to get airplay would erupt into a major scandal (more on the payola scandal in chapter 3).

In 1959 Berry ran into trouble. While on tour in the southwest, he met Janice Escalante, a 14-year-old Mexican-Indian girl, and brought her back to St. Louis to work at his nightclub, Club Bandstand. After Escalante was picked up on prostitution charges, police launched an investigation into Berry on charges of violating the Mann Act, which prohibits transporting minors across state lines for immoral purposes. After two blatantly racist trials (the first was overturned), Berry was convicted in 1962 and spent two years in federal prison. When the embittered Berry returned to music, the British Invasion was underway, sweeping him and many other R&B artists out of the limelight. However, there is no doubt that the Beatles, Rolling Stones and other British groups that came to prominence in the 1960s owed much of their success to the influence of Chuck Berry's musical genius.

OTHER IMPORTANT SUN ROCKABILLY ARTISTS

Meanwhile Back in Memphis . . .

Although it may have appeared that selling Elvis Presley's contract to RCA for only \$40,000 was a bad business decision, it was one that Sam Phillips needed to make. Sun was nearing bankruptcy as it struggled to keep up with the up front costs of pressing thousands of records. In addition, by virtue of his connection with Presley, Phillips found a number of talented young Elvis wannabes were beginning to show up at his door to audition. Keep in mind also that no one knew at the time that Elvis was going to end up becoming as enormously popular as he did. Now flush with cash and without the time commitment Presley required, Phillips was able to move forward and seize what to him was a new business opportunity. Sensing that a major musical shift was at hand, he began

turning away from the blues and R&B artists he had previously worked with and began turning his attention to country and rockabilly artists.

Although he did have success in launching the career of a few country artists such as Johnny Cash and Charlie Rich, most of Phillips' success in the last half of the 1950s came from his rockabilly artists. The biggest of these, Carl Perkins and Jerry Lee Lewis quickly exploded to the top of the charts, but could not sustain any commercial success. In hindsight we are able to see that their greatest records, like those of Elvis Presley, were those that were made early in their careers under Phillips' supervision. One exception was **Roy Orbison** (1936–1988), who achieved his greatest success after leaving Sun. Orbison had nine Top 20 records between 1960 and 1964 for Monument Records, including the number 1 hits "Running Scared" and "Pretty Woman." In trying to turn the balladeer Orbison into a rockabilly singer, Sam Phillips made one of the few artistic miscalculations in his career.

In spite of the stunning success that Sam Phillips had during the 1950s, the glory years for Sun Studios were over by 1960. That was the year that he moved into a brand new, state of the art studio just a few blocks from his original location. Even though the new facility was much larger, the atmosphere was sterile and lacked the creative warmth of the cramped former studio. Phillips grew tired of the recording business and sold Sun in 1969. For a time he owned and operated WHER-AM, an all-female radio station in Memphis; he also was one of the original investors in Holiday Inn. The studio at 706 Union Avenue was eventually reopened as a tourist attraction, but still remains open today as a recording studio. Sam Phillips spent the last 30 some years of his life as a sort of living rock and roll legend. He died at age 80 on July 30, 2003.

THE LATER YEARS
OF SAM PHILLIPS
AND SUN STUDIOS

Carl Perkins and Jerry Lee Lewis

Carl Perkins (1932–1998) was born to poor sharecropping parents in northwest Tennessee. Despite his impoverished youth, he was able to start a band with his brothers Jay and Clayton, playing the honky tonk circuit in the early 50s. During these years Perkins was composing his own songs and developing his own rockabilly guitar and singing style. After hearing Presley's "Blue Moon of Kentucky" on the radio in 1954, the Perkins brothers auditioned for Phillips, and released two very country sounding singles in 1955 with modest sales success. Their next release was a monster.

After a concert in Amory, Mississippi in which they both appeared in the fall of 1955, singer Johnny Cash suggested that Perkins write a song based on a saying he had often heard while in the service, "Don't step on my blue suede shoes." Amazingly, a few nights later, Perkins heard a patron make same comment on the dance floor in a Tennessee bar. At three o'clock the next morning, Perkins awoke with the song in his head, and wrote the lyrics down on an empty potato bag. Recorded and released in December 1955, "Blue Suede Shoes" shot up the charts, successfully fighting off numerous cover versions to end up at #2

(Presley's "Heartbreak Hotel" kept it from going to #1). By March 1956, the song was near the top of the country and R&B charts as well, becoming Sun's first million seller. Unfortunately, tragedy struck on March 21. Perkins and his brothers were on their way to make their network TV debut on *The Perry Como Show* in New York when their car slammed into a poultry truck in Delaware. Carl suffered a broken shoulder and cracked skull, was laid up for six months in the hospital and never made it to New York.

Carl Perkins was never able to come up with another hit, and his career floundered. Although he continued his career after recovering from the auto accident, his sound (and even his look) was just a little too country for the emerging rock and roll audience. However, on a tour of England in 1964, he was received as a conquering hero, and met his some of his most adoring fans, a certain moptop musical quartet. "I sat on the couch with the Beatles sitting around me on the floor," he later recalled. "At their request, I sang every song I had ever recorded. They knew each one. I was deeply flattered." The Beatles further showed their respect by covering both "Everybody's Tryin' To Be My Baby" and "Honey Don't" on their fourth album *Beatles For Sale*.

Jerry Lee Lewis (1935–) was the first bad boy of rock and roll. Born in Ferriday, Louisiana, Lewis' childhood, like Presley's and Perkins', was spent in poverty. The cousin of tele-evangelist Jimmy Swaggart, Lewis was thrown out of Bible College his first night after tearing into a boogie-woogie version of "My God Is Real." By the time he auditioned for Sam Phillips in 1956 at age 21, he had been married twice, in jail, and turned down by the Louisiana Hayride and every label he had auditioned for in Nashville. But Phillips took a chance on Lewis. In February 1957, after one lackluster release, Jerry Lee recorded "Whole Lotta Shakin' Going On," which quickly shot up the charts to #3, earning him a spot on *The Steve Allen Show* in July. He quickly followed up "Shakin'" with "Great Balls of Fire," which went to #2 in December, and "Breathless," which hit #7 in March 1958. After the Carl Perkins disappointment, Sam Phillips finally had a star that he could bank on.

MUSIC CUT 18

"BLUE SUEDE SHOES" (CARL PERKINS)—CARL PERKINS

Personnel: Carl Perkins: guitar, vocals; Jay Perkins: rhythm guitar; Clayton Perkins: bass; W. S. Holland: drums. Recorded December 19, 1955 at Sun Studio, Memphis, TN; produced by Sam Phillips. Released on Sun Records, January 1, 1956; 17 weeks on the charts, peaking at #2 pop, #2 R&B, #1 C&W.

Carl Perkins wrote "Blue Suede Shoes" on December 17, 1955, recorded it two days later, and saw it released two weeks later. By March it was on the charts, where it nearly reached the top spot. Unfortunately, because of the automobile accident he was in on March 22, 1956, and his subsequent hospitalization, he was not able to leverage the record's success into any substantial fame. Of course, the song has gone on to become a rock and roll standard, and has been recorded numerous times by artists ranging from The Beatles, Jimi Hendrix, and Black Sabbath.

"GREAT BALLS OF FIRE" (OTIS BLACKWELL/JACK HAM-MER)—JERRY LEE LEWIS

Personnel: Jerry Lee Lewis: piano, vocals; Roland Janes: guitar; Sidney Stokes: bass; possibly J. M. Van Eaton: drums. Recorded October 8, 1957 at Sun Studio, Memphis, TN; produced by Sam Phillips. Released on Sun Records, November 11, 1957; 13 weeks on the charts, peaking at #2 pop, #3 R&B, #1 C&W.

The recording session that produced "Great Balls of Fire" is legendary, as it marked the moment when Jerry Lee Lewis had to reconcile his conservative Christian upbringing with the moral implications of his burgeoning career in rock and roll. According to witnesses, Lewis began to believe that the song—with the sexual innuendo of the title—was too sinful for him to record and would lead him straight to hell. Thus, began a heated exchange with producer Sam Phillips that reportedly lasted for more than an hour. Lewis pleaded that "I got the devil in me," to which Phillips replied "You can save souls," arguing that the song could have an ironic positive influence on listeners. In the end of course, Phillips won out, and the single, Sun 281, became a multi-million seller.

But again, disaster struck. In May 1958, Lewis arrived in England for a promotional tour. With him was his newlywed third wife, Myra Gale Brown. She was 13 years old—and his second cousin! To make matters worse, Lewis married her before he was even divorced from his second wife. As the British press honed in on the scandal, Lewis was taken off the tour. Assuming that the Brits were just being their usual haughty selves, Lewis and his entourage retreated back to the safety of the states. Unfortunately, the American music industry reacted in much the same way as the British, and he was blacklisted from the Top 40 and cancelled from bookings on Dick Clark's American Bandstand. Even though Sam Phillips tried to make a quick buck off of the situation by releasing the novelty song "The Return of Jerry Lee" (which included lines from Lewis records such as: "What did Queen Elizabeth say about you?/Goodness, gracious, great balls of fire!"), Lewis' career went into a tailspin less than a year after it started.

Despite his short stay at the top, Jerry Lee Lewis carved a niche for himself as one of rock and roll's originals. His story is of the very essence of rock and roll: a rebellious spirit, a natural-born performer, with an outrageous personality. Driven by one of the biggest egos in history, and an ongoing conflict with his lifestyle and his religious upbringing, he nicknamed himself "The Killer" (ironically, there is suspicion that he in fact killed his fifth wife, who was mysteriously murdered in their New Orleans home). He literally attacked his instrument, or as rock journalist Andy Wickham noted, "Elvis shook his hips; Lewis *raped* his piano." Jerry Lee Lewis drank too much, abused drugs, avoided paying taxes but not a number of scandals. And he is still alive to tell about it.

BUDDY HOLLY

Unlike many of the early rock and roll pioneers, Buddy Holly (1936–1959) grew up in a stable middle class home in Lubbock, Texas. His was a musical family, and the aspiring musician won \$5 playing the violin in a talent contest

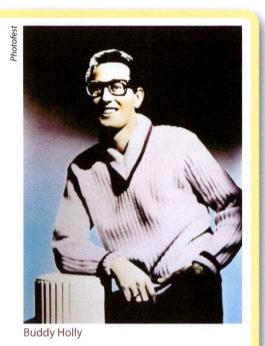

when he was just five years old. Buddy soon gravitated to first the piano and ultimately the guitar. Most of his early musical influences came from listening to country music on the numerous barn dance radio programs; he in fact made his own radio debut in 1955 on local station KDAV playing songs like "Your Cheatin' Heart." Before long, his country-oriented group the Rhythm Playboys was gigging locally at nightclubs and public events. But like many other teenagers around the country in the mid-1950s, Holly was also fond of listening to R&B on black radio stations, and often times would venture into Lubbock's black neighborhood to listen to it performed live in cafés and juke joints. Then, in early 1955, Elvis Presley, Scotty and Bill came to town, and Buddy saw firsthand how Elvis intermingled R&B and country into rockabilly."The day after Elvis left town, we turned into Elvis clones," his friend Sonny Curtis later remarked.

Over the next year, Buddy Holly experienced dramatic growth as a musician. He assembled three high school friends into a group that would eventually become the Crickets; he worked on his guitar playing and his stage appearance; he also began writing songs. Becoming supremely confident that he

had what it takes to become famous, Holly was sure he had made it big when he signed a contract with Decca in early 1956. However, the sessions, held in Nashville, went badly, and even though Decca released a few of his singles, the contract was terminated early the next year. One of the recordings that the label refused to release was a Holly original entitled "That'll Be the Day."

MUSIC CUT 20

"PEGGY SUE" (BUDDY HOLLY/JERRY ALLISON/NORMAN PETTY)—BUDDY HOLLY

Personnel: Buddy Holly: guitar, vocals; Joe B. Mauldin: bass; J. I. Allison: drums. Recorded June 30, 1957 at Nor Va Jak Studio, Clovis, New Mexico; produced by Norman Petty. Released September 1957 on Coral; 22 weeks on the charts, peaking at #3.

Buddy Holly's "Peggy Sue" was recorded during three days of sessions at Norman Petty's NorVa Jak Studio in Clovis, New Mexico. Holly originally titled the song "Cindy Lou," but as a favor, agreed to rename the song for drummer J. I. Allison's girlfriend. Allison's unusual part—played primarily on the tom toms—is a departure from the standard snare backbeat and one of the distinguishing features of the song. Despite the fact that The Crickets rhythm guitarist Niki Sullivan is not used on this recording, the remaining three members manage to produce a full sound. Although producer Petty added his name to the writing credits of all of Holly's Clovis recordings (in an agreement made between the two beforehand), he did contribute to writing this song, coming up with the idea for the interesting chord change in the chorus behind the "Pretty, pretty, pretty Peggy Sue" line in the bridge.

Around the time Buddy and his band mates were giving up on Nashville, they began recording in Clovis, New Mexico at Nor Va Jak Studio, which was owned and operated by producer Norman Petty. Being that the young musicians were broke, Petty and Holly worked out a quid pro quo agreement to pay for the sessions: in exchange for giving Holly unlimited access to the studio and his technical expertise, Petty would be listed as co-composer and publish the songs with his Nor Va Jak Publishing Company. At the first session, held on February 25, 1957 the Crickets recorded two songs, including a revamped, faster version of "That'll Be the Day." While the group spent the next few weeks hard at work recording more of Buddy's originals, Petty worked out distribution deals to get the records released. The results were astonishing: "That'll Be the Day" entered the Top 40 in August and hit #1 in September. Two more singles, "Peggy Sue" and "Oh, Boy" followed in quick succession, peaking at #3 and #10. By the end of the year, the Crickets were booked into tours of the US, England and Australia (the US tour included a stop at Harlem's Apollo Theatre, where the audience was surprised to find out the group was white). By 1958 Buddy Holly was a rock and roll star and living in New York's Greenwich Village.

By this time, important changes were beginning to take place in Holly's life. In August, he married Maria Elena Santiago after proposing to her on their first date. He recorded "True Love Ways," a song written for his new bride that was produced by Paul Anka and orchestrated with an 18-piece orchestra. The Crickets, tiring of being relegated to secondary roles and sensing a loss of camaraderie with the newlywed Holly, parted ways with him to form their own band, managed by Norman Petty. Holly's own relationship with the controlling Petty was becoming strained, and he took steps to sever their composing and publishing agreements. And suddenly without warning, the hits stopped coming. Struggling to get some momentum back in his career and the prospects of a lengthy and costly legal battle with Petty, Buddy Holly reluctantly agreed to join the Winter Dance Party tour in early 1959 that was to include several Midwestern stops.

On the tour, Holly was featured with Ritchie Valens (Richard Valenzuela) and Beaumont, Texas DJ The Big Bopper (Jiles Perry Richardson), both up and comers with hits on the charts ("Oh, Donna" and "Chantilly Lace"). After the sixth show at the Surf Ballroom in Clear Lake Iowa, the three stars chartered a plane to take them to the next show in Moorhead, Minnesota. They were supposed to take a bus, but wanted to arrive early to get their laundry done and get some extra rest. Flying into a quickly forming winter storm with a young pilot that was not certified to fly with navigational instruments, the plane crashed eight miles north of Clear Lake in the early morning hours of February 3, 1959, killing everyone on board.

Buddy Holly left an immense legacy, especially considering the brevity of his two-year career. He pioneered the four-piece combo of two guitars, bass and drums that would be widely copied throughout the 1960s. Influences of his well-crafted, innocent love songs can be heard in the early works of the Beatles, the Hollies (who named themselves in his honor) and other groups. When the Beatles (who in fact renamed themselves from the Quarry Men to something that they thought would sound more like Holly's Crickets) made their first record in a small studio in Liverpool, the song they recorded was "That'll Be the Day." As an artist, Holly was the complete package: guitarist, singer, songwriter and producer. He was the first of many rock guitarists to use the new Fender Stratocaster guitar. Holly was also one of the first rock musicians to push the limits of studio technology to enhance his recordings.

The End of an Era

Even though rock and roll created a musical and cultural revolution, the initial shock wave did not last long. A variety of forces came into play in the late 1950s and early 1960s that brought sweeping changes to the music—changes that were not all good. The transitional second phase of the history of rock music is the subject of the next chapter.

CHAPTER 2 TERMS AND DEFINITIONS

- **Tape-Delay Echo**—Sam Phillips created his tape-delay echo by feeding a sound source, such as a vocal, into the record head of a separate tape machine and back into the mix after it passes the playback head a split second later.
- **Crossover**—refers to a record or an artist who has appeal in more than one audience segment, such as some early R&B singers such as Fats Domino, whose fan base included both blacks and whites.
- **Rockabilly**—the first style of rock and roll, characterized by merging elements of R&B and country (the word is a contraction of the words rock and hillbilly), slap bass, hiccupping vocals and a fast, nervous beat.
- **Stop time**—the interruption of a regular beat pattern in the rhythm section.
- **Bo Diddley Rhythm**—a repeating rhythm—*chunk-chunk-chunk-a-chunk, chunka-chunk*—that was first used in the song "Bo Diddley" that has subsequently been used in many rock and pop songs.
- **Payola**—a term coined by *Variety Magazine* in 1938 to describe the practice of payments made to DJ's in the form of gifts, favors or cash by record labels to entice the playing of a record.

Date

Name

1.	Describe some of the changes that were taking place in American society in the years leading up to the birth of rock and roll.
2.	Why was Bill Haley important to the rock and roll explosion?
3.	Why was Sam Phillips important to the rock and roll explosion, and in what ways was he a visionary?
4.	Why are Elvis Presley's Sun recordings considered to be more important than his RCA recordings?
5.	How did Sam Phillips and Col. Tom Parker differ in their nurturing of Elvis Presley's career?

6.	Why is Elvis considered to be	a pivotal figure in American culture?
----	-------------------------------	---------------------------------------

- 7. Describe the differences between the R&B that emerged from New Orleans and the R&B that emerged from Chicago in the 1950s.
- **8.** What are some of the important contributions that Chuck Berry made to rock and roll?
- 9. What are some of the important contributions that Buddy Holly made to rock and roll?
- 10. Name the most important non-musicians in this chapter and what roles they played to make them so.

THE TRANSITION TO MANSTREAM POP

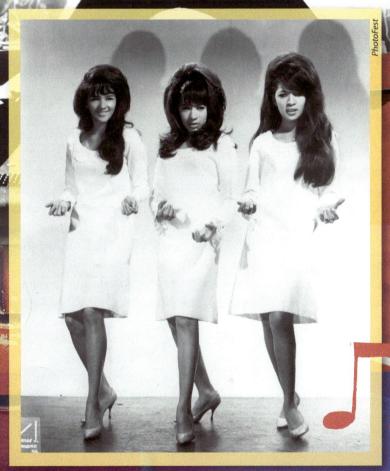

"We played a show for the American troops in Germany and the guys were having orgasms on the floor. I was like, 'What are they doin'? Ain't no dance I recognize.'"

—Ronnie Spector (The Ronettes)

Teen idols
American Bandstand
The Ed Sullivan Show
Payola
Brill Building Pop

Aldon Music Girl groups Wall of Sound Gold Star Studios The Wrecking Crew Bubblegum Surf A&M Records

Dick Clark Chubby Checker Carole King/Gerry Goffin Jerry Leiber/Mike Stoller Phil Spector The Righteous Brothers Burt Bacharach/Hal David Dionne Warwick Doc Pomus/Mort Shuman The Monkees Dick Dale and the Del-Tones The Beach Boys Brian Wilson The Monkees

Pet Sounds—the Beach Boys

THE CHANGING LANDSCAPE

The Death of Rock and Roll

As the 1950s came to an end, America was poised to enter a decade of dramatic change that would become one of the most traumatic in its history. After eight years of the conservative and staid administration of President Dwight D. Eisenhower, the young charismatic John F. Kennedy was elected president. With his now famous call to action from his inaugural address, "Ask not what your country can do for you, ask what you can do for your country," Kennedy's youthful vigor and idealism made the nation's young people feel that they could make a difference in making the world a better place. His social programs included the Alliance for Progress, the Peace Corps and new legislation to promote civil rights and fight poverty. With his pretty wife Jacqueline and two small children, the Kennedys represented a changing of the guard—old was out, young was in.

Rock was changing as well. A series of unrelated events that can only be chalked up to bad luck and bad timing caused the rebels of the first or 'classic' rock era to disappear from the scene. It was almost as if someone from central casting had decided that the fun was over. Elvis went into the army in early 1958, and would never regain the energy and excitement of his early career. Carl Perkins' career went unfulfilled after the car accident that almost killed him in 1956. Little Richard retired to the ministry in 1957; Jerry Lee Lewis was shunned after news of his scandalous marriage broke in 1958; Chuck Berry was arrested in 1959 for violating the Mann Act. Tragic accidents claimed the lives of Buddy Holly in 1959 and Eddie Cochran in 1960.

These events were remarkably well timed for the major labels, which by 1960 were busy packaging a more refined and less vulgar product to a maturing audience. By this time, many of the teens that had originally embraced rock and

roll were becoming adults and entering the world of mortgages, jobs, marriage and children. They weren't so rebellious any more, and their music tastes were changing. Suddenly they were buying more LP's than singles (like their parents had done in the 1950s), and were 'turning down the volume' so to speak, listening to music that wasn't quite as wild as five years ago. With a maturing audience, an increasingly watered down product and the exiting of an entire generation of rock stars, many were inclined to believe that rock and roll was dead.

While this chapter focuses on how the pop music industry reclaimed its audience, two other important strains of pop were also emerging at the same time that will be covered in subsequent chapters. Chapter 4 will cover soul music, which emerged from the fusion of gospel and R&B in the 1950s to become a major force in pop music in the 1960s. Chapter 5 will cover folk music, which after breaking through to a mainstream audience after languishing for decades in the backwoods of rural America would have a profound effect on the future of rock.

The Backlash

At the same time that the first generation of rock and rollers were fading from view, several conflicts associated with the music were beginning to emerge. The first of these was a backlash from alarmed religious, parental and white supremacist groups who began warning about the breakdown of morals and the poisoning of impressionable young minds that rock and roll was causing. To these groups, this was nothing less than an all-out culture war, and a many sided one at that. To some, rock and roll was a Communist plot; others placed the blame on the rock and roll DJs, while still others blamed the schools, government, or whatever other culprit was convenient. Pamphlets were distributed, meetings were held, "I Hate Elvis" clubs sprang up, and boycotts and record burnings were organized. The ugliest side of this backlash occurred where sex and race intersected, a particularly inflammatory hot button issue for many conservative-minded whites, especially in the segregated South. Many of these folks found it disturbing to see white girls shrieking and hyperventilating over black singers and white singers emulating black singers. Rock and roll is "sexualistic, unmoralistic, and brings people of both races together," warned the Alabama White Citizens Council, which took it upon themselves to publish a disciplinary guide for parents entitled A Manual for Southerners. "Help save the Youth of America. Don't buy Negro records," threatened a leaflet distributed throughout the South. Another moralized that "The entertainment world decides how our children will dress, speak, their moral conduct, and even their manners. At present their theme is inter-racial friendship and tolerance. Now is the time to rise up in mighty protest."

Whether rock and roll was "unmoralistic" is a matter of opinion, but it was definitely bringing the races together. At many early rock and roll concerts black and white kids regularly mingled and even danced together despite the best efforts by security to keep them separate. This was a marked contrast from the traditional segregated audiences that Southerners were used to seeing. Chuck Berry described a concert where "Twice as many young whites as blacks rushed toward the stage . . . we knew the authorities were blazing angry, but they could

only stand there and watch." In the end it was the kids who decided whether there should be any race mixing, and not surprisingly they broke stride with their parents. Even Pat Boone, a pop singer that any parent could love, cast his lot with the kids when he remarked that, "Racial segregation is sickening."

PAYOLA

The Pay For Play Scandal

The backlash against rock and roll soon spilled over into the world of politics. Although **payola**, the practice of DJs accepting cash (known euphemistically in the business as the "\$50 handshake"), favors and other gifts from record companies to play their songs was not technically illegal at the time, it was at the very least a dubious enterprise. It was also so widely accepted as standard business practice that the entire industry shuddered when congress decided to investigate the issue in 1959. The timing of the probe was convenient for politicians who wanted to score points among their constituents who hated rock and roll: 1960 was an election year. When the Special Subcommittee on Legislative Oversight, chaired by Arkansas Democratic Representative Oren Harris found that 335 DJs had been paid "consulting" fees totaling \$263,245, a witch-hunt commenced to find out who the guilty ones were. Although a few DJs were fired and some stations produced affidavits showing they were monitoring their jocks, the focus of the committee quickly turned to the two most highly visible rock entrepreneurs, Dick Clark and Alan Freed.

There were a number of issues suggesting that Clark had improper deals going on, including his ownership of publishing companies, 162 song copyrights (145 which had been given to him as gifts) and co-ownership of Swan Records. Since Clark often played songs on American Bandstand that benefited these business arrangements, it appeared that he was manipulating the system for his own profit. Clark was called to testify in April 1960, and although the questioning at times seemed to implicate that there was a case to be made against him, the committee could not prove that he actually accepted cash for playing songs. Clark defended himself as a businessman who was merely profiting from the performance royalties and taking advantage of legal business opportunities. He had also by this time divested himself from most his various interests—except Bandstand of course. After two days the clean cut and youthful looking Clark was dismissed without further investigation. Committee chairman Harris even called him "an attractive and successful young man." Dick Clark stayed in the music business, amassing a vast entertainment portfolio that included one of the industry's largest independent production companies, and was worth hundreds of millions of dollars at the time of his death in 2012.

Alan Freed was not as fortunate. His problems began in 1958 when he was arrested for inciting a riot at a concert he promoted in Boston. He was promptly fired by his employer, WINS. By 1959, Freed was working at WABC radio in New York and facing new problems in light of the impending payola investigation. Although at the time he denied accepting payola, he refused to sign an ABC Network affidavit saying as much, and was fired by WABC in November.

He was indicted by Congress on May 19, 1960 and charged with bribery, and although he eventually admitted to accepting a total \$2,500 in gratuities, he claimed that the money did not impact his decision to play any specific songs. But by this time, the shifty-eyed and controversial Freed had become the scapegoat of the entire scandal; Cashbox Magazine noted as much with an editorial stating he had "suffered the most and was perhaps singled out for alleged wrongs that had become a business way-of-life for many others." After pleading guilty to two counts of bribery in December 1962, Freed was fined \$300 and dismissed. But unable to get a job in radio and cultivating a growing drinking problem, his career was essentially over; he died penniless and broken from the emotional and financial toll of the scandal in 1965 at age 43.

THE MAJOR LABELS STAGE A COMEBACK

The Teen Idols—The Boy and Girl Next Door

We have seen in Chapter 2 how the independent labels were quick to jump on the rock and roll bandwagon in the mid-1950s, while the major labels were slow or unwilling to do the same. By the late 1950s it was becoming all too clear to the majors that they needed to get back into the game for control of the fast growing youth record-buying market that the independent labels had so successfully taken away. One strategy was to open their wallets and buy out the contracts of the artists signed to indie labels, as RCA had done with Elvis Presley. Or better yet, they could just buy the independent labels outright—if you can't beat 'em, buy 'em! It worked—by the end of the 1960s most of the important indies had been either bought out (including Atlantic, Sun and Chess) or run out of business entirely (Modern) by the major labels.

Another way to win back the youth audience was for the majors to develop their own artists that were—for the purpose of maximizing sales—as non-controversial and as socially acceptable as possible. (In other words, Little Richard wannabes need not apply.) This new crop of singers, who started to appear as early as the late 1950s, was a clean-cut and wholesome bunch—and conspicuously, they all were white. The Teen Idols, as they became known, were groomed for stardom not on the basis of their talent, but instead on their 'boy-next-door' good looks. Many of them were of Italian ancestry who Anglicized their names to present a more All-American image—accordingly, Francis Avalone became Frankie Avalon, Walden Robert Cassotto became Bobby Darin, Concetta Franconero became Connie Francis. Unlike most of the classic rock and rollers, the teen idols did not write their own songs, but instead recorded songs written by professional songwriters who consciously smoothed out the rough edges of earlier rock and roll. The typical teen idol song contained little or no beat, lavish orchestration, and non-sexual, safe romantic themes of idealistic teen love. Among the most popular teen idols were Avalon, who had thirteen Top 40 hits between 1958 and 1962; Paul Anka, with 22 during the same period; and Francis, with 28. Other popular teen idols included Fabian (Fabiano Forte), Bobby Rydell (Robert Ridarelli) and Freddy Cannon (Frederick Picariello).

instead on their "boy-next-door" good looks.

The clean cut wholesome singers that the major labels promoted in the late 1950s and early 1960s to counter the success of independent label R&B and rock and roll.

RECORDINGS

- "Who's Sorry Now?"—Connie Francis, #4, 1958
- "Venus"—Frankie Avalon, #1, 1959
- "Puppy Love"—Paul Anka, #2, 1960

Powered by the success of American Bandstand, Philadelphia played an important role in the pop music industry in the early 1960s.

One teen idol whose career extended beyond the early 1960s was Ricky Nelson. Nelson had grown up in front of the nation as a cast member of the popular family TV program *The Adventures of Ozzie and Harriet*, named for his parents, the stars of the show. Although Nelson's popularity was strongest before the British Invasion swept all the teen idols aside, he remained popular until his death in an airplane accident in 1985. Between 1957 and 1964 he had 33 Top 40 hits, two of which went to #1 ("Poor Little Fool" in 1958 and "Travelin' Man," 1961).

Philadelphia, Dick Clark and American Bandstand

One reason for the huge success of the teen idols was their constant exposure on a television program that began broadcasting on Philadelphia's WFIL-TV in 1952. Originally called *Bandstand* and hosted by Bob Horn, the show was taken over by station staff announcer **Dick Clark** (1929–2012) in 1956 after Horn was arrested for drunk driving (ironically right in the middle of a 'Don't Drink and Drive' promotion). In 1957 the show was picked up by the national ABC-TV network and renamed *American Bandstand*. Within two years it was being broadcast on over 100 stations to an audience of 20 million. It aired until 1987.

The format of *American Bandstand* was simple: pack a TV studio with 150 clean-cut teenagers who danced to the latest hit singles, with weekly appearances

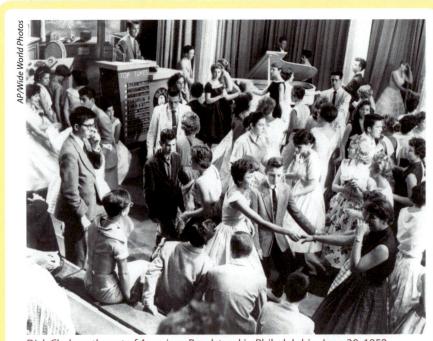

Dick Clark on the set of American Bandstand in Philadelphia, June 30, 1958

by pop singers who lip-syncing along with their records. Clark, who looked like a teenager himself, wielded enormous power by picking which songs were played and how often, and his choices frequently favored the pop oriented teen idols and other non-threatening singers, including local Philadelphia boys Fabian, Avalon and Rydell. Dick Clark also began building a music empire by investing in local record companies, publishing firms, a management company and a pressing plant. Powered by the success of *American Bandstand*, Philadelphia played an important role in the pop music industry in the early 1960s.

Dance Crazes and Novelty Tunes

The most important record labels in Philadelphia at this time were Cameo/ Parkway, Chancellor and Swan (which was half owned by Clark). For a few years in the late 1950s and early 1960s, these companies were among the industry leaders in creating a pop music product, sometimes (in the case of the teen idols) literally creating stars out of less than stellar talents. Said Chancellor owner Bob Marcucci of meeting Fabian; "Somehow I sensed that here was a kid who could go. He looks a little bit like Presley. . . . I figured he was a natural. It's true that he couldn't sing. He knew it, and I knew it." Cameo/Parkway hit upon a tremendously successful strategy by producing a series of novelty dance tunes, starting with the 1960 #1 hit "The Twist" by **Chubby Checker**. Checker (1941–) was local unknown singer Ernest Evans; his new name was conceived by Dick Clark's wife Bobbie as a play on the name Fats Domino. The label followed up "The Twist" with other dance tunes, including "The Hucklebuck," "Pony Time," "The Fly" and "Limbo Rock" by Checker, and "The Fish," "The Wah Watusi," the "Mashed Potato" and several more by other artists. The dance craze scheme worked so well that "The Twist" returned to the #1 spot again in 1962, the only single since charting began in 1955 to top the charts twice. Usually instructions for the dance were found somewhere in the lyrics, and with exposure on American Bandstand, they quickly spread throughout the teenage nation.

Twist Pony Fly DANCES CRAZES Dog Madison Popeye FROM THE Watusi Loco-Motion Hitch-Hike Harlem Shuffle Limbo Swim **EARLY 1960s** Wiggle Wobble **Bristol Stomp Boston Monkee** Hully Gully Cool Jerk Duck Mashed Potato Monkee Funky Chicken

Novelty tunes appeared from time to time as well, including Sheb Wolley's "The Purple People Eater" (#1, 1958), Brian Hyland's "Itsy Bitsy Teenie Weenie Yellow Polka Dot Bikini" (#1, 1960) and Bobby "Boris" Pickett's "Monster Mash" (#1, 1962). Dave Seville came up with one of the best pop gimmick of all time when he created The Chipmunks by recording overdubs of his own voice at half speed and playing them back at full speed (making them sound an octave higher). He had two #1 hits in 1958 alone: "Witch Doctor" and "The Chipmunk Song."

MUSIC CUT 21

"THE TWIST" (HANK BALLARD)—CHUBBY CHECKER

Recorded 1960; released June 1960 on Parkway. Produced by Dave Appell. Released June 1960 on Cameo-Parkway; 15 weeks on the charts, peaking at #1 in 1960; re-entered the charts for 18 weeks in 1962, also peaking at #1.

Dick Clark played Hank Ballard's original version of "The Twist" on *American Bandstand*, and when it proved popular, he had Chubby Checker, nee Earnest Evans, record a cover. The song was written by Hank Ballard (of the "Annie" records (see Chapter 1), whose version had peaked at #28 earlier in the year. After Checker performed the song on *American Bandstand* on August 6, 1960, it became a runaway #1 hit. It returned to the #1 spot again in 1962.

TRIVIA NOTE

The Ed Sullivan

Show was particularly important for rock artists to gain national visibility. Appearances on the Sullivan show were milestones in the early careers of Elvis Presley, the Beatles, and the Rolling Stones.

Along with American Bandstand, other national TV programs began presenting rock and roll as well, albeit in small doses. At the time, variety shows were popular that presented comedians, acrobats and jugglers as well as musical groups. Although they attracted some criticism from conservatives, the variety shows of Arthur Godfrey, Jackie Gleason, Steve Allen, Milton Berle and Ed Sullivan all made a point of putting rock on their shows once they realized it increased ratings. The Ed Sullivan Show, on the air from 1948 to 1971 and one of the most watched programs on TV, was particularly important for rock artists to gain national visibility. Sullivan was notoriously strict with his censorship policies (see Elvis Presley's "above the waist" appearance in 1957 in Chapter 2), so he was often at odds with rock acts that appeared on the show. (In one of the most famous incidents involving an altercation between Sullivan and an artist, Bob Dylan walked off before his scheduled appearance in May 1963 when he was told his song "Talkin' John Birch Paranoid Blues" was too controversial to perform.) Nonetheless, appearances on the Sullivan show were milestones in the early careers of Elvis Presley, The Beatles, The Rolling Stones, and many other pop artists from the 1950s and 1960s. The 1960s also saw a number of TV series emerge that were dedicated specifically to pop music. These included Hullabaloo, Shindig!, Where the Action Is, and The Happening.

BRILL BUILDING POP

Leiber and Stoller

In New York, where the Tin Pan Alley composers had ruled pop music since the 1880s, a new breed of songwriters was beginning to emerge in the late 1950s. Rock and roll had presented a paradigm shift in the pop music business, and show tunes written in the Tin Pan Alley mold would not work anymore. New songs had to be written with a rock beat with story lines that related to teenagers but were not offensive to adults. Many of the older, established songwriters were simply not up to the task, leaving the door open for a new crop of younger writers. By the early 1960s this new pop songwriting scene was centered around

the Brill Building, at the corner of West 49th and Broadway. It was here that more than 150 music businesses that employed hundreds of songwriters and other music professionals eventually located. These songwriting shops became so influential to the industry that the pop music they created in the late 1950s and early 1960s became known as **Brill Building Pop**.

Among the key players in the creation of Brill Building Pop was a songwriting team that helped define what was to become one of the most important roles in the music business—the independent producer. When Jerry Leiber and Mike Stoller met each other in Los Angeles in 1950, they discovered that they had remarkably similar backgrounds: both were from the East Coast, Jewish, 17 years old, and big fans of R&B and the blues. They hit it off right away, and began writing songs together. Their first taste of success came in 1953 with "Hound Dog," which Big Mama Thornton turned into #1 R&B hit. After forming their own Spark record label in 1954, Leiber (1933–2011) and Stoller (1933–) began to write songs for the R&B vocal quartet The Robins, including the classics "Smokey Joe's Café" and "Riot in Cell Block 9." Their first #1 pop hits came in 1956 when Elvis Presley recorded his own version of "Hound Dog" along with "Love Me Tender." Presley's version of "Hound Dog," (backed by Otis Blackwell's "Don't Be Cruel") became the first record in history to simultaneously hit #1 on the pop, country and R&B charts. Presley had another #1 Leiber and Stoller hit in 1957with "Jailhouse Rock"; in all, he recorded 24 of their songs.

In the mid-1950s Leiber and Stoller moved back to New York and the Brill Building area and began an unusual (for the time) association with Atlantic Records as independent producers. By this time they had hit upon a formula of telling mini-stories with humorous lyrics, which they referred to as "playlets." Their songs most often fell into two categories: 1) those with R&B derivative melodies, rhythms, and chord progressions (such as "Hound Dog"), and 2) those with rich orchestration that were almost symphonic in scope (such as "On Broadway"). The second variety required the pair to pay meticulous attention to every detail in the recording process, spending hours in the studio recording as many as 50 takes of a song if necessary. Claiming that "We don't write songs, we write records," Leiber and Stoller pushed the art of record production into new uncharted territory with the use of string orchestration, Spanish guitars, marimbas and other exotic percussion instruments and Latin rhythms.

MUSIC CUT 22

"ON BROADWAY" (JERRY LEIBER/MIKE STOLLER/CYNTHIA WEILL/BARRY MANN)—THE DRIFTERS

Personnel: Rudy Lewis: lead vocal; Johnny Moore: tenor vocal; Charlie Thomas: tenor vocal; Gene Pearson: baritone vocal; Johnny Terry: bass vocal; Phil Spector: guitar solo; other musicians and singers unidentified. Recorded January 22, 1963 in NYC; produced by Jerry Leiber and Mike Stoller. Released April 1963; 8 weeks on the charts, peaking at #9.

"On Broadway" was the twelfth Top 40 hit for the Drifters in a four-year period. Notable in the Leiber/Stoller production of this record are the percussion instruments (including castanets and timpani), vibes, rhythm guitar playing a propulsive *chunk-chunk-chunk*, string section and female backup singers and brass section. And of course, Phil Spector's memorable twangy guitar solo.

Their formulas were well served in the string of nine Top 40 hits between 1957 and 1959 for The Coasters (the name given the newly reorganized Robins). These included the classics "Searchin" and its flipside "Youngblood," "Yakety Yak" (#1, 1958), "Charlie Brown," "Along Came Jones" and "Poison Ivy." In addition to their success with another vocal group, The Drifters ("There Goes My Baby," "On Broadway," both Top 10 hits), they had two more Top 10s with Ben E. King—"Spanish Harlem" (written by Leiber with Phil Spector) and "Stand By Me." In 1964 they founded another label, Red Bird, which produced many of the hits of the so-called "girl groups." Although their songwriting productivity fell in the mid 1960s, many artists continued to record their songs, including The Beatles ("Kansas City"), Peggy Lee ("Is That All There Is?") and Luther Vandros ("I [Who Have Nothing]").

Leiber and Stoller helped make the independent producer an important part of the production process. Their songs are still among the most enduring in rock history, using clean, witty lyrics teenagers could relate to, set to R&B chord progressions, rhythms and melodies. They were also tremendously influential to the next generation of producers and songwriters such as Phil Spector, Barry Gordy of Motown and Brian Wilson of The Beach Boys.

Aldon Music

One of the most important businesses in the era of Brill Building Pop was **Aldon Music**, located just across the street from the Brill Building at 1650 Broadway. Aldon was founded in 1958 by songwriters Al Nevins and Don Kirshner, who preferred their writers to work in teams of two. Nevins and Kirshner assembled a stable of pop songwriting superstars that included the teams of Neil Sedaka and Howard Greenfield, Barry Mann and Cynthia Weil (who would marry soon after teaming up), and Carole King and Gerry Goffin, two 19-year-olds who were already married. (Interestingly, there was yet another highly successful Brill Building husband and wife team, Ellie Greenwich and Jeff Barry, although they didn't work for Aldon.)

"WILL YOU LOVE ME TOMORROW" (CAROLE KING/GERRY GOFFIN)—THE SHIRELLES

Personnel: Shirley Owens, Addie Harris, Beverly Lee, Doris Coley: vocals; other musicians unidentified. Recorded 1960 in NYC; produced by Luther Dixon. Released November 1960 on Scepter; 19 weeks on the charts, peaking at #1.

"Will You Love Me Tomorrow" was the first hit for newlyweds Gerry Goffin and 18-year-old Carol King. At the time he was working as a chemist; he and Carole (who were also new parents) would write songs at night in their cramped apartment in Brooklyn. Beverly Lee of The Shirelles at first rejected the song's demo as too white and too country, but once the group heard the final production with string arrangement by Carole, they were sold. "The song was completely different than the one on the demo. It was beautiful. All those strings! It blew our minds!" Lee later said. This record became a #1 hit for The Shirelles in December 1960, the first ever by a black female group. Soon after, Gerry quit his day job.

Working at Aldon Music was typical of the Brill Building scene: each day writers worked out song ideas in cubicles with upright pianos, often soliciting suggestions and criticisms from other company writers at the end of the day. The songs were then pitched to record companies, whose A&R men, arrangers and producers cranked out product. It had all glamour of an assembly line, but with impressive results. By 1962 Aldon had 18 writers on staff who had placed hundreds of hits on the radio, led by the top three writing teams of Sedaka/ Greenfield, Mann/Weil and King/Goffin. They were not only good, they were young—none were over the age of 26.

Neil Sedaka/Howard Greenfield:

- "Stupid Cupid"—recorded by Connie Francis, #14, 1958
- "Breaking Up Is Hard to Do"—Neil Sedaka, #1, 1960
- "Calendar Girl"—Neil Sedaka, #4, 1960

Barry Mann/Cynthia Weil:

- "On Broadway" (with Jerry Leiber and Mike Stoller)—the Drifters, #9, 1963
- "You've Lost That Lovin' Feelin' " (with Phil Spector)—the Righteous Brothers, #1, 1964
- "We Gotta Get Out of This Place"—the Animals, #13, 1965

Carole King/Gerry Goffin:

- "Will You Love Me Tomorrow"—the Shirelles, #1 1961
- "The Loco-Motion"—by Little Eva, #1 1962
- Go Away Little Girl"—Steve Lawrence, #1, 1963

"Will You Love Me Tomorrow," while extremely popular, was also revolutionary for its time. While most songs of the era were stories of idealistic teenage love, this song was more direct. Being pressured by her boyfriend to "do it," the girl wants assurance that he will still love her in the morning—after all, her reputation was at stake. "The Loco-Motion" was inspired by King and Goffin's babysitter, 17-year-old Eva Narcissus Boyd, who was dancing while the two were working on some new material. Goffin asked what the name of the dance was—to him it looked like a locomotive train. After finishing the song, Goffin and King let Eva—who became "Little Eva"—sing it, and it became the first of her four Top 40 hits.

Burt Bacharach and Hal David

One of the most prolific pop songwriting teams of the last half of the 20th century has been that of **Burt Bacharach** and **Hal David**. Bacharach (1928–) and David (1921–2012) met each other at the Brill Building in 1957, and their first hit together, Marty Robbins' "The Story of My Life" (#15) soon followed. The two soon developed a songwriting formula with Bacharach writing the music and David the lyrics that would serve them throughout their more than 15 years together. After writing a few hits for Perry Como, the Drifters and

A SHORT LIST
OF ALDON HITS
THAT HELPED
DEFINE BRILL
BUILDING POP

others, the two began to focus their attention on writing songs for **Dionne Warwick** (1940–), who was at the time a session singer aspiring to be a star. Between 1962 and 1972, Warwick recorded more than 60 of their songs, 23 of which hit the Top 40.

A PARTIAL LIST OF BACHARACH/ DAVID HITS RECORDED BY DIONNE WARWICK

■ "Don't Make Me Over"	#21, 1962
, ■ "Walk on By"	#6, 1964
■ "Alfie"	#15, 1967
■ "I Say a Little Prayer"	#4, 1967
"Do You Know the Way to San Jose"	#10, 1968
"This Girl's in Love with You"	#7, 1969
■ "I'll Never Fall in Love Again"	#6, 1969

Other artists found success with Bacharach/David tunes as well, including Jackie DeShannon with "What the World Needs Now Is Love" (#7, 1965); Tom Jones with "What's New Pussycat?" (#3, 1965); Sergio Mendes & Brasil '66 with "The Look of Love" (#4, 1968); Herb Alpert with "This Guy's in Love with You" (#1, 1968); Aretha Franklin with "I Say a Little Prayer" (#10, 1968); B.J. Thomas with "Raindrops Keep Fallin' on My Head" (#1, 1969) and The Carpenters with "(They Long to Be) Close to You" (#1, 1970). The final tally for the duo was 66 Top 40 hits, 28 Top 10, with six going to #1.

"WALK ON BY" (BURT BACHARACH/HAL DAVID)— DIONNE WARWICK

Recorded November 1963 at Bell Sound Studios, New York City; produced by Burt Bacharach, Hal David. Released April 1964 on Scepter; 13 weeks on the charts, peaking at #6.

Hitting the Top 10 in 1964, this record became one of the astounding 66 Top Forty hits written by Burt Bacharach and Hal David (23 of which were sung by Dionne Warwick). This downcast R&B ballad set to a bossa-nova beat was originally relegated to the B side of "Any Old Time of the Day." But New York DJ Murray the K thought better of it and asked listeners to vote about the single's two sides. The winning cut scaled the charts during the heady exuberance of Beatlemania, which provided an unwitting foil for the understated perseverance of "Walk On By." "I didn't get the guy very often in those days," Warwick said.

While Bacharach and David never wrote about social or political change, their songs provided the soundtrack for much of the pop music world in the 1960s and 1970s. David's lyrics usually contained adult storylines that were straightforward and clever, while Bacharach's music often included interesting key changes and odd meters; his arrangements were usually pop savvy yet idio-syncratic. Although they split up in 1973, they reunited in 1993 for a project with Warwick. In the late 1990s Bacharach began collaborating with Elvis Costello.

Doc Pomus and Mort Shuman

Doc Pomus (1925–1991) began his career as a white blues singer in the 1940s before turning his attention to songwriting. In 1958, he teamed up with writer Mort Shuman (1936–1991), with whom he set up shop in the Brill Building. Over the next few years Pomus and Shuman wrote for Dion and the Belmonts ("Teenager in Love," #5, 1959), the Drifters ("This Magic Moment," #16, and "Save the Last Dance for Me," #1, both 1960) and Andy Williams ("Can't Get Used to Losing You," #2, 1963) among others. Elvis Presley recorded more than 20 of their songs, including "Surrender" (#1, 1961), "Little Sister" (#5, 1961), "(Marie's the Name) His Latest Flame" (#4 1961) and "Viva Las Vegas" (#29, 1964). Although Pomus was 11 years older than Shuman, the two died within months of each other in 1991, Pomus from cancer, Shuman from complications after liver surgery.

POP MUSIC GOES WEST

Los Angeles in the 1960s

If you've been paying attention, you've noticed that most of what we've discussed in Chapter 2 and thus far in Chapter 3 concerning the pop music industry has taken place on the East Coast, and to a lesser degree in Nashville and Chicago. But among the many other changes taking place in the music business in the 1960s was a gradual move west to Southern California. The Los Angeles music scene had long been vibrant throughout the 20th century as the home of hundreds of jazz, blues, and R&B nightclubs scattered along Central Avenue and elsewhere across the city. But it was as home to Hollywood and the burgeoning television industry that the seeds were planted that eventually allowed it to surpass Nashville, Chicago, even New York as the center of record production by the end of the 1960s. LA was already equipped with an existing infrastructure of recording studios, talent agencies, major record labels, publishing companies, and of course musicians and wannabe pop singers just as the pop music industry began to explode, and so perhaps it was only inevitable that it was to eventually become home to the entire entertainment industry. (In perhaps a tacit acknowledgement that there was an eminent changing of the guard, Aldon Music, the most important player in the Brill Building Pop scene in New York, opened an office in LA in the early 1960s.)

As we move onward through Chapter 3 and the rest of the book (albeit with a slight detour through Detroit and Memphis in Chapter 4, Greenwich Village in Chapter 5, and London in Chapter 6), the producers, behinds the scenes record executives and of course artists themselves will increasingly have LA as their home base. Having said that, we will first take a look at the man who became the most important independent producer in pop music in the early 1960s, and perhaps more than anyone else helped create the Los Angeles record industry.

PHIL SPECTOR

Of all the producer/songwriters in the early years of rock and roll, the most influential was **Phil Spector**. Spector (1940–) was born in the Bronx, but his mother moved the family to Los Angeles in 1953 after Phil's father committed suicide. In

KEY "GIRL GROUPS"

- Crystals
- Chiffons
- Dixie Cups
- Shangri-Las
- Ronettes

high school, he learned to play guitar, which helped the diminutive and socially awkward Spector gain respect from his classmates. After graduation, he formed a musical group with three friends called the Teddy Bears. At their very first recording session, Spector produced a song he had written called "To Know Him Is to Love Him," the title being a modification of "To Know Him Was to Love Him," the epitaph on his father's tombstone. Released on the tiny Dore label, the song (helped in part by airplay on American Bandstand) hit #1 in December 1958, just weeks before Spector turned 18. It eventually sold over one million copies. Around this time Spector came to realize that his future was in producing rather than performing, so in early 1960 he moved to New York to understudy with Jerry Leiber and Mike Stoller.

The first song Leiber and Stoller gave him to produce, "Corrina, Corrina," became a #9 hit for Ray Peterson. His next project was co-writing "Spanish Harlem" with Jerry Leiber; it became a #10 hit for the Drifters. After working on a number of other records for the songwriting duo as both producer and session guitarist, Spector moved back to LA in late 1960, started his own label, Philles, and began looking around for new talent. He soon discovered a group made up of five schoolgirls called the Crystals, and sensing that an all-female group—a girl group—might succeed after years of male-dominated doo-wop groups, began producing records for them. Their first two releases, "There's No Other" and "Uptown" charted respectably at #20 and #13. The next two to chart were monsters: "He's a Rebel," went to #1 in 1962 and "Da Doo Ron Ron" (written by Spector with Ellie Greenwich and Jeff Barry) went to #3 in 1963.

Although the Crystals were not the first girl group, a genre characterized by young females singing songs of innocent love and devotion to their boyfriends, they were the first to achieve popular success, thereby created the mold that others would copy. Other girl groups soon materialized, including the Chiffons ("He's So Fine,"#1, 1963, and "One Fine Day," #5, 1963), the Dixie Cups ("Chapel of Love," #1, 1964), and the Shangri-Las ("Leader of the Pack," #1, 1964). Spector himself soon focused his attention on a new group, a trio of inter-racially mixed girls from Spanish Harlem called the Ronettes. At only their second session in July 1963, the group recorded a song he had written with Ellie Greenwich and Jeff Barry entitled "Be My Baby." As it rose to its peak at #2, Phil and Ronnie began a romance that eventually led to their marriage in 1968 (they were divorced in 1974).

KEY TERM The Girl **Groups** The

name given to the young female vocal groups that emerged in the early 1960s, primarily through the promotion of Phil Spector. Story lines for girl group songs usually included references to boyfriends and the worthlessness of the girl's lives without them.

KEY GIRL GROUP RECORDINGS

- "He's a Rebel"—the Crystals, #1, 1962
- "Da Doo Ron Ron"—the Crystals, #3, 1963
- "Be My Baby"—the Ronettes, #2, 1963
- "Leader of the Pack"—the Shangri-Las, #1, 1964

MUSIC CUT 25

"HE'S A REBEL" (GENE PITNEY)—THE CRYSTALS

Personnel: Darlene Love, Edna Wright: lead vocals; Fanita James, Gloria Jones, Gracia Nitzsche, Jean King, Bobby Sheen: backup vocals; The Wrecking Crew: instrumental backing. Recorded at Gold Star Studio, July 1962; produced by Phil Spector, arrangement by Jack Nitzsche. Released August 1962 on Philles; 12 weeks on the charts, peaking at #1.

The story of "He's a Rebel" is an interesting commentary on Spector's role as visionary, and the record industry as well. Convinced the brand-new song (written by Gene Pitney) was going to be a #1 hit for the Crystals, he quickly booked time at LA's Gold Star Studio, even though the Crystals themselves were unavailable. Spector brought in another group, the Blossoms (led by Darlene Love) to sing the song but released it as the Crystals anyway, since they already had name recognition. No one seemed to notice. In essence, the song and the production (in fact, *the producer*, Phil Spector) had become more important than the singers themselves.

The Wall of Sound

By this time Spector was setting new standards in popular music with a production style that became known as the **Wall of Sound**. Spector wanted his records to sound like a symphony orchestra playing the 1812 Overture, or as he once said, "Like God hit the world and the world hit back." The Wall of Sound began to evolve with "He's a Rebel" in 1962, and by the time he produced "Da Doo Ron Ron" in 1963, he had developed a system for creating it. Recording took place at Gold Star Studios in LA; although it was small by New York standards (25'x35') and primitively equipped, it was where Spector had had always recorded in LA, going back to his Teddy Bear days. Spector also packed the studio with as many as 20 musicians at a time—usually using an informal collection of studio pros known as **The Wrecking Crew**. Rhythm sections usually contained three to five guitars (all playing the same part), three or four pianos (ditto), two bass guitars, a drummer and several percussionists. To this he added string and horn sections. Vocals were done at a second session; studio veteran Jack Nitzche did arrangements. Spector also doused his productions with liberal amounts of reverberation from the studio's echo chamber. After the recording was finished, he mixed everything down to monaural rather than stereo. "Back to mono" became his slogan.

Wall of Sound sessions generally took at least 3 to 4 hours as Spector meticulously tinkered with the parts, the mix, and microphone placement. But when

Although Phil Spector used dozens of session musicians, his favorites were collectively known as the Wrecking Crew. Members of the Crew included Carol Kaye on bass, Hal Blaine on drums, guitarists Barney Kessel, Glen Campbell and Tommy Tedesco, pianists Don Randi, Larry Knechtel and Leon Russell, horn players Nino Tempo and Jay Migliori, and percussionists Victor Feldman and Sonny Bono. The Wrecking Crew musicians played on literally thousands of recordings during the 1960s and 1970s, including pop, rock, TV themes songs and film scores. They were also a favorite of Brian Wilson of The Beach Boys, who used them on his monumental album *Pet Sounds*.

THE WRECKING CREW

The Monkees unleashed a short-lived strand of insipid pop that became known as bubblegum. Aimed at pre-teens, bubblegum was generally produced in the studio by session players working from carefully crafted sing along songs. Among the "classics" of the genre are the unforgettable hits "Yummy, Yummy, Yummy" by the Ohio Express, "Simon Says" by the 1910 Fruitgum Co., and "Sugar, Sugar" by the Archies. Other bubblegum groups besides the Monkees that had their own TV shows were the Archies (an animated cartoon), the Partridge Family and the Osmonds.

SURF

Surf Culture

Meanwhile, another pop music scene was developing in that would soon assume a major role in making Southern California a metaphor for laid-back lifestyles, blondes, bikinis and beaches. Surf music was not the brainchild of the record industry; rather, it was the offshoot of a lifestyle that was unique to its time and place. During the early 1960s, the sport of surfing spawned an entire subculture in Southern California that included carefree laid-back lives, hot rods, wood paneled station wagons (called "woodies"), Hawaiian shirts and sandals, its own vernacular and its own music. Surfing was brought to California from Hawaii around the turn of the 20th century, where it was enjoyed by a relatively few hardy souls until Hollywood brought it to the rest of the country with a series of bikini beach party movies made between 1959 and 1963. The first, Gidget, was followed by others such as Beach Blanket Bingo, Bikini Beach and Beach Party, starring Annette Funicello and Frankie Avalon. These movies tended to portray surfers and their girls as clean cut, blonde, wholesome and good looking, leading affluent lives free of adult supervision. Unfortunately, the surf music in these movies was generally watered down, once again to offend as few viewers as possible.

CHARACTERISTICS OF SURF

- Instrumental music (except the Beach Boys and other later groups), with combo consisting of guitar, bass and drums, with an occasional organ or horn player. Guitar usually plays the melody.
- 2. 'Garage band' what-you-hear-is-what-you-get sound
- 3. High energy

KEY SURF RECORDINGS/ INSTRUMENTAL ROCK RECORDINGS

- "Miserlou"—Dick Dale and the Del-tones, 1962
- "Wipe Out"—the Surfari's, #2, 1962
- "Surfin' U.S.A."—the Beach Boys, #3, 1963

The real music of the surf culture was driving, high energy and primarily instrumental, dominated by the electric guitar. It had a raw, garage-band edge to it and was not overly produced. The first important surf band was Dick Dale and the Del-tones, who had what is considered to be the first surf hit in 1961 with "Let's Go Trippin'." Of Lebanese descent, Dale (1937-) often employed downward glissandos in his guitar playing to imitate the sound of waves, and tremolos that were reminiscent of the oud music of his native culture. These tricks are evident in the 1962 hit "Miserlou," which is based on a Middle Eastern folk song. Dale worked closely with Leo Fender, the creator of the first solid body electric guitar, to develop the Dual Showman amplifier, which had two 15" speakers that made it possible to play loud with distortion. It also employed a metal spring to create a reverb effect. Because the Del-tones were extremely popular in Southern California, they were reluctant to tour and therefore never achieved any substantial recognition in other parts of the country. It was up to other Southern California groups to take surf music to national prominence. Among the first to do so were the Marketts, whose "Surfer's Stomp" went to #31 in 1962, the Chantays with "Pipeline" (#4, 1963), and the Surfari's with "Wipe Out" (#2, 1963). Although Dick Dale was dubbed the "King of Surf Guitar," he became disillusioned with music after the surf boom died out and retired in 1965. He later returned to performing and developed a new fan base when "Miserlou" was included in the 1994 Quentin Tarantino film Pulp Fiction.

MUSIC CUT 28

"MISERLOU" (TRADITIONAL/NICK ROUBANIS/FRED WISE/MILTON LEEDS/BOB RUSSELL)—DICK DALE AND THE DEL TONES

Personnel: Dick Dale and The Del-tones. Recorded 1962. Released April 1962 on Deltone Records. Released August 16, 1966 on Colgems; did not chart.

Although "Miserlou" (sometimes spelled "Misirlou") is a traditional folk song from the Eastern Mediterranean region, it authorship was claimed by Nick Roubanis with his 1941 jazz recording of the song. In later years Fred Wise, Milton Leeds, and Bob Russell wrote words for the song; today all four are credited as composers. Although the song has been recorded many times over the years (the earliest going back to 1927), Dick Dale's version heard here is the definitive version. Dale's recording helped cement the sound of surf in American pop culture. The Beach Boys also recorded the song in 1963.

The Beach Boys

Although surf first appeared as instrumental music, ironically the most famous of the surf groups was known for its beautiful vocal harmonies. Hailing from Huntington Beach, California, the Beach Boys consisted of three brothers—**Brian Wilson** (1942–), Dennis Wilson (1944–1983), and Carl Wilson (1946–1998)—their cousin Mike Love and family friend Al Jardine. The Wilson's father Murry was a frustrated part time songwriter who was physically and emotionally abusive to his sons, often punishing them with beatings or humiliation. (Brian's deafness in one ear reportedly came from one such childhood beating. This may have been a factor in his preference for monaural mixes, although he was also a devotee of Phil Spector, who also preferred monaural over stereo.)

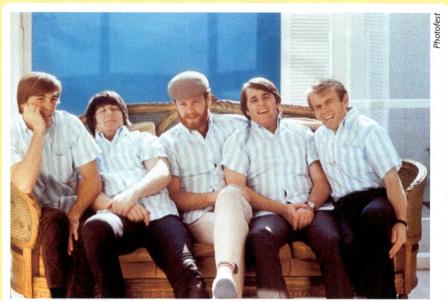

The Beach Boys. From left: Dennis Wilson, Brian Wilson, Mike Love, Carl Wilson, Al Jardine

The one salve in the Wilson household was music. Murry built a music room in the garage, and with his encouragement the boys all learned to sing and play instruments at an early age. It soon became clear that the most talented son was Brian. For his sixteenth birthday, Murry gave Brian a Wollensak tape recorder, which he used to record himself singing vocal arrangements that were inspired by the popular 1950s vocal group the Four Freshmen. With their parents out of town for the Labor Day weekend in 1961, the Wilson Boys, Jardine and Love (who were by now informally a band, calling themselves the Pendletones) wrote and recorded "Surfin'" to try to cash in on the burgeoning surf craze. The song became a regional hit and helped secure a contract with Capitol Records. They also changed their name around this time at the suggestion of a local record distributor. In the beginning, Murry served as their manager.

The Beach Boys formula was simple: combine the driving rock and guitar licks of Chuck Berry with the lush vocal harmonies of the Four Freshmen. Over the next four years, they released seven albums with an impressive string of 17 Top 40 singles, including their first hit, "Surfin' Safari" (#14, 1962), and two #1's, "I Get Around" (1964) and "Help Me Rhonda" (1965). The subjects were girls, cars, hanging out with schoolmates, and of course, surfing. The primary songwriter was Brian, who also arranged the intricate vocal harmonies and produced the records. During these years Capitol put intense pressure on Brian to write as many songs as possible before the surf craze passed, and his output was astonishing. Eventually however, the emotional stress of writing hit songs, producing, arranging, singing and touring became overwhelming, and in December 1964 Brian made the decision to stop touring with the band. By this time he had begun to use marijuana and other hallucinogens heavily, and in the next few years would become reclusive and increasingly unstable mentally. Despite his deteriorating state of mind, in late 1965 he began working on the monumental achievement of his career, the album Pet Sounds.

MUSIC CUT 29

"WOULDN'T IT BE NICE" (BRIAN WILSON/MIKE LOVE/TONY ASHER)—THE BEACH BOYS

Personnel: Brian Wilson: lead vocal; Mike Love: lead and backup vocals; Carl Wilson, Dennis Wilson, Al Jardine, Bruce Johnston: backup vocals; Larry Knetchel: piano; Al de Lory: piano; Bill Pitman: guitar; Jerry Cole: guitar; Barney Kessel: 12-string mandolin; Carl Fortina, Frank Marocco: accordion; Roy Caton: trumpet; Steve Douglas, Jay Migliori, Plas Johnson: saxophone; Ray Pohlman: 6-string bass guitar; Lyle Ritz: acoustic bass; Carol Kaye: bass guitar; Frank Capp: percussion; Hal Blaine: drums. Recorded January 22, 1966 (instrumental tracks) at Gold Star Studios, Los Angeles, March 10, 1966 and April 11 (vocal tracks) at Columbia Studios, Los Angeles; produced by Brian Wilson. Released July 18, 1966 on Capitol; 11 weeks on the charts, peaking at #8.

"Wouldn't It Be Nice" is the opening track on the Beach Boys highly praised *Pet Sounds*, and one of four singles released from the album. Brian Wilson composed the music to the song, with band mate Mike Love and lyricist Tony Asher writing the lyrics. The instrumental tracks—done in a very "Wall of Sound" fashion that included two pianos, two guitars, two accordions, mandolin, three basses, horns, drums and percussion—were recorded at Gold Star Studios, a favorite of both Wilson and his mentor, Phil Spector. The song was finished up at two later sessions at Columbia Studios, with backup vocals recorded at the first and lead vocals at the second. The lyrics address the sweet sentiment of youth, "Wouldn't it be nice if we were older and we wouldn't have to wait so long . . ." from an era when young adults still 'saved themselves for marriage.' Wilson later said that the song, "Expresses the frustrations of youth, what you can't have, what you really want and you have to wait for." Lines like "We could be married/And then we'd be happy" earned the song a #5 spot on the National Review's 2006 list of top 50 conservative rock songs.

Pet Sounds

Pet Sounds (released May 16, 1966) was inspired upon hearing the newest Beatles release, Rubber Soul. Intrigued that they could record an album that contained only good songs and no "fillers," Brian set out to make "the greatest rock and roll album ever." The LP is a tour de force of Brian's writing, arranging and producing skills (although his friend Tony Asher wrote the lyrics, they were inspired by Brian). By this time, he had become a studio perfectionist, and spent many hours meticulously crafting the album at three studios—Gold Star (where his idol Phil Spector often recorded), Western and Sunset Sound—at an unheard-of cost of \$70,000. For the instrumental tracks Wilson used the famed 'Wrecking Crew', including Hal Blaine, Carol Kaye and Barney Kessel, since the other Beach Boys were on tour. An array of unconventional (for rock) instruments and sounds were used, including tympani, Japanese percussion, harpsichord, glockenspiel, bass harmonica and even barking dogs. The songs are generally all short in length with intricate and difficult vocal melodies and arrangements; most have a quiet, reflective or otherworldly nature to them. The lyrics are about a young man's difficult coming of age—that young man being Brian Wilson, who was 24 years old.

Pet Sounds initially sold roughly half million copies (it eventually went platinum in 2000), and two of its songs hit the charts, "Sloop John B" (#3), and "Wouldn't It Be Nice" (#8). Still, by Beach Boys standards, those figures were a disappointment. Although critics hailed it as a masterpiece, the public by now expected a certain type of song from the group, and generally did not find them

1.	What were some of the factors that made some observers believe that rock and roll was dead by the early 1960s?
2.	Describe the influence that Dick Clark and American Bandstand had on the music business.
3.	What is payola and how did it affect the music and radio industries?
4.	Describe the Brill Building scene and the major figures involved with it.
5.	Why are Leiber and Stoller important?

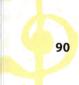

The Assembly Line

Motown was a tightly controlled business run by Berry Gordy, but his family played important roles as well. His father helped renovate the offices; two sisters worked as fiscal officers; brother-in-law Harvey Fuqua worked in production. Family outsiders were also drawn into the fold, some of whom eventually became stars: both Martha Reeves and Diana Ross started at the company as secretaries; Marvin Gaye originally was a session drummer who later married Gordy's sister Anna. Another important aspect of Motown was the attention to quality control. Gordy and his producers held meetings each Friday morning at 9:05 to vote on whether to release each of that weeks recordings. A no vote meant the song either died or had to be redone. Although there were producers and songwriters on staff that were in competition with each other (much like Aldon Music and the Brill Building scene), Gordy closely supervised every major decision that was made. This tight control of power later contributed to dissention within the company.

Because Motown was actively involved in the artistic development of each of its stars, careers were often patiently nurtured over a period of years. For instance, both the Temptations and the Supremes were signed in 1961, a good three years before either group had a hit single. The Motown process of transforming street singer into pop star was a model of assembly line efficiency that gave their artists a consistent look and sound that was innovative in the music business at the time. The process:

- **Step 1:** Finishing School. Modeling expert Maxine Powell taught the proper way to walk, talk and dress as successful young debutantes and debonair gentleman.
- **Step 2:** Dance Lessons. Choreographer Cholly Atkins, a well-known dancer from the heydays of the Swing Era in 1930s and 1940s Harlem, taught dance steps and graceful body moves coordinated to the music.
- **Step 3:** Stage Presence. Maurice King, executive musical director, taught stage patter, presence and projecting a friendly, non-confrontational persona.
- **Step 4:** Music Production: In-house songwriters, arrangers, producers, session musicians and engineers produce the music to fit the individual sound of each artist.
- **Step 5:** Record Distribution. Records are pressed and distributed throughout the country by the various Motown labels.
- **Step 6:** Talent Agency. Artist contracts, management and touring schedules are overseen by the in-house talent agency.

The results were stunning: during its peak years, from 1964 to 1967, Motown had 14 #1 pop singles, 20 #1 R&B singles, 46 more Top 15 pop singles and 75 more Top 15 R&B singles. In 1966 alone, its best year, 75 percent of Motown's releases made one or more of the charts, far above the industry average of less than 15 percent.

The Sound of Young America

Above all else, Motown's greatest achievement was the music it produced. Gordy looked to the success of Phil Spector and the 'wall of sound' to produce music that was thick in horns, strings and background vocals, backed by a rhythm section

with a hard driving back beat. Gordy called it "The Sound of Young America." Motown's recording studio, located in the basement of 2648 West Grand was a tiny room affectionately called the 'Snakepit'. Although at first all the musicians and singers were recorded together using two and three track recorders, in 1964 the Snakepit installed an eight-track recorder that allowed Motown producers to record more elaborate productions in stages, overdubbing strings, horns and percussion on top of the rhythm section and vocals.

- 1. Pop oriented, smoothing over most of the rough edges of other soul music
- 2. Rock solid groove, anchored by Benny Benjamin's drums and James Jamerson's innovative syncopated electric bass
- 3. Heavy use of string and horn orchestration and reverberation, á la Phil Spector's Wall of Sound
- 4. Use of added percussion to emphasize the backbeat
- 5. Vocal harmonies used extensively

Key Motown Recordings

- "My Girl"—the Temptations, 1965
- "You Keep Me Hangin' On"—the Supremes, 1966
- "Reach Out I'll Be There"—the Four Tops, 1966
- "I Heard It Through the Grapevine"—Marvin Gaye, 1968

From the very beginning, the core of the Motown sound was the in-house rhythm section, known as the Funk Brothers. Although the personnel changed somewhat over the years, the core of the Funk Brothers was James Jamerson on electric bass, leader Earl Van Dyke on piano, drummer Benny Benjamin and guitarist Robert White. Jamerson in particular was important in creating a syncopated bass style that helped define soul music and has been widely copied over the years by nearly all that have played the instrument. Gordy kept tight control over the Funk Brothers, not allowing them to go on tour or play sessions at other studios (although he did pay them well, reportedly \$50,000 each per year).

Holland Dozier Holland

Although Gordy used a variety of writers and producers, including Smokey Robinson, Barrett Strong, Norman Whitfield and Nicholas Ashford and Valerie Simpson (Ashford and Simpson), the most successful was the team of Lamont Dozier and brothers Brian and Eddie Holland, known as **Holland/Dozier/Holland** (or simply HDH). From their first hit, 1963's "Mickey's Monkey" (recorded by the Miracles) to the end of 1967 when they left the company, HDH racked up an astonishing 46 Top 40 hits, including 12 that went to #1. Although HDH's credits include hits for Martha and the Vandellas ("Heat Wave," # 4, 1963) and Marvin Gaye ("How Sweet It Is [To Be Loved by You])," (#6, 1964), their best material was written for the Four Tops and the Supremes. Their hits for The Four Tops included "I Can't Help Myself" (#1, 1965), "Reach Out

independently of each other while listening to previously recorded

tracks with headphones.

I'll Be There" (#1, 1966), "Standing In the Shadows of Love" (#6, 1966) and "Bernadette" (#4, 1967). When Gordy assigned HDH to the Supremes in 1964, they pulled off an amazing string of ten #1 hits over the next three years. HDH not only wrote the songs (melodies primarily by Dozier, lyrics primarily by Eddie Holland) but produced the sessions as well, with Brian Holland engineering at the mixing console.

HOLLAND /DOZIER/ HOLLAND #1 HITS RECORDED BY THE SUPREMES

1964: "Where Did Our Love Go"

"Baby Love"

"Come See About Me"

1965: "Stop! In the Name of Love"

"Back in My Arms Again"

"I Hear a Symphony"

1966: "You Can't Hurry Love"

"You Keep Me Hangin' On"

1967: "Love Is Here and Now You're Gone"

"The Happening"

"WHERE DID OUR LOVE GO" (BRIAN HOLLAND/LAMONT DOZIER/EDDIE HOLLAND)—THE SUPREMES

Personnel: Diana Ross, Mary Wilson, Florence Ballard: vocals; the Funk Brothers: rhythm section; Mike Valvano: foot stomps. Recorded April 8, 1964 at Motown Studios, Detroit, MI; produced by Holland/Dozier/Holland. Released June 17 1964 on Motown; 13 weeks on the charts, peaking at #1 for two weeks.

"Where Did Our Love Go" was the first #1 hit for both the Supremes and the legendary production team of Holland/Dozier/Holland. It is an interesting song in that it consists of a simple, repeating three-chord, 8-bar progression, without a bridge or contrasting chorus. The arrangement, unlike later heavily orchestrated H/D/H productions, is simple and sparse, with the primary instrument being the foot stomping provided by teenager Mike Valvano. The song was originally pitched to the Marvelettes, who rejected it. It is also the title track to the Supremes second album, which was released in August 1964.

IMPORTANT MOTOWN ARTISTS

- Smokey Robinson and the Miracles
- The Marvelettes
- Stevie Wonder
- Marvin Gaye
- The Four Tops
- The Temptations
- The Supremes
- Martha and the Vandellas

IMPORTANT MOTOWN ARTISTS

Smokey Robinson and the Miracles

William 'Smokey' Robinson (1940–) has been called "America's greatest living poet" by no less than Bob Dylan. His work as lead singer and primary writer/producer for the Miracles produced 27 Top 40 singles, six of which hit the Top 10. Robinson also made significant contributions to the Motown catalogue as a songwriter for other artists, including the Temptations ("My Girl," "The Way You Do the Things You Do" and "Get Ready"); Mary Wells ("My Guy"); and the Marvelettes ("Don't Mess With Bill"). Robinson was able to write love songs that spoke directly to such subjects as passion, loneliness and forgiveness, as well as using clever rhyming schemes and metaphor. His **falsetto** singing was among the most soulful of all the Motown artists.

Robinson formed the Miracles (originally called the Matadors) in 1955 when all four singers were attending Detroit's Northern High School. It was when they auditioned for Jackie Wilson's manager Nat Tarnopol in 1957 that they met Berry Gordy, which led to their signing with Motown and eventually their first Top 10 hit, "Shop Around" in 1960. Among the other Miracles Top 10 hits to follow were "You Really Got a Hold On Me" (#8, 1963), "I Second That Emotion" (#4, 1967) and "The Tears of a Clown" (#1, 1970). Robinson left the group in 1972 to pursue a solo career that produced nine more Top 40 hits. He was inducted into the Rock and Roll Hall of Fame in 1987.

Falsetto A technique where male singers sing in a very high "head" voice that is beyond their natural vocal range.

MUSIC CUT 35

"THE TRACKS OF MY TEARS" (SMOKEY ROBINSON/PETE MOORE/MARV TARPLIN)—SMOKEY ROBINSON AND THE MIRACLES

Personnel: Smokey Robinson: lead vocals; Claudette Robinson, Pete Moore, Ronnie White, Bobby Rogers: backup vocals; the Funk Brothers: rhythm section; members of the Detroit Symphony Orchestra: orchestral backing. Recorded 1965 at Motown Studios, Detroit, MI; produced by Smokey Robinson. Released June 23 1965 on Tamla; 8 weeks on the charts, peaking at #16.

While "Tracks of My Tears" was nowhere near the most popular record the Miracles ever released, it is a perfect example of Smokey Robinson's gift for writing catchy pop hooks and sweet, innocent lyrics of love. The song, according to Robinson, "was actually started by Marv Tarplin, who is a young cat who plays guitar for our act. So, he had this musical thing [sings melody], you know, and we worked around with it, and worked around, and it became 'Tracks of My Tears'." Despite its relatively poor chart showing, the song has been honored with many accolades, including a 2007 induction into the Grammy Hall of Fame.

The Marvelettes

The Marvelettes were formed in 1960 by five schoolgirls attending Inkster High in suburban Detroit. After signing with Motown in 1961, they had their biggest hit with their first release, "Mr. Postman," which also became the company's

first #1 pop hit. Over the next seven years, nine more Top 40 hits followed. The Marvelettes were in some ways a link to the past as the most purely 'girl group' of any of the Motown vocal groups, and were ultimately swept aside by the more contemporary sound of such groups as the Temptations and the Supremes. Interestingly, the group refused to record Holland/Dozier/Holland's "Baby Love" when it was presented to them in 1964; the song was given to the Supremes, who turned it into a #1 hit.

Stevie Wonder

The blind and multitalented Steveland Morris (1950–) was rechristened "Little Stevie Wonder" by Berry Gordy soon after he signed with Motown at age ten in 1960. In less than three years Wonder had his first #1 hit with "Fingertips—Pt 2." The record is a live recording that features Wonder's harmonica playing and singing—which along with playing drums, piano and organ were staples of his live performances. Presented initially in the Ray Charles mold (partly because both were blind), Wonder eventually forged his own unique and soulful singing style. He had 20 more Top 40 hits over the next eight years, including 11 Top 10s. Then, when turning 21 in 1971, he renegotiated his contract, giving him complete artistic control of his recordings, as well as more money (he had only earned \$1 million up to that point, while Motown had kept over \$30 million of his profits for themselves). By this time Wonder was playing nearly all of the instruments himself on his records, as well as producing, singing, arranging and writing the songs.

MUSIC CUT 36

"FINGERTIPS PT. 2" (CLARENCE PAUL/HENRY COSBY)— STEVIE WONDER

Personnel: Stevie Wonder: vocal, harmonica, bongos; James Jamerson: bass; Marvin Gaye: drums; other musicians: unknown. Recorded June 1, 1962 at the Regal Theater, Chicago, IL; produced by Berry Gordy. Released May 21 1963 on Tamla; 12 weeks on the charts, peaking at #1 for three weeks.

"Fingertips—Pt 2" was Stevie Wonder's first hit single, and the first of 10 that would hit #1 on the *Billboard* charts. The recording comes from a Motown Revue performance at Chicago's Regal Theater. Wonder's show was to be immediately followed by The Marvelettes, and that groups bass player had already taken the stage when Wonder unexpectedly decided to return for an encore. On the recording you can hear bassist Joe Swift yelling "What key? What key?" at the 2:22 point. This record also demonstrates a fact often overlooked about Stevie Wonder: he is one of the greatest harmonica players in history.

With his new contract, Wonder's career after 1972 blossomed well into the 1980s as he explored the possibilities of synthesizer layering and fusing funk, jazz, reggae, R&B, soul, pop and African rhythms. Beginning with the #1 singles "Superstition" and "You Are the Sunshine of My Life," he had 24 more Top 40 hits, nine of which went to #1, and placed nine albums in the Top 10. He also won an amazing 15 Grammy Awards.

Marvin Gaye

The son of a Washington DC minister, Marvin Gaye (1939–1984) grew up singing and playing organ in his father's church. As a member of the Moonglows (led by Berry Gordy's brother-in-law Harvey Fuqua), Gaye was discovered and signed by Gordy in 1961; soon afterward, he married Gordy's sister Anna. Working at first as a session drummer on Miracles recordings, Gaye began his solo career in 1962, which yielded a remarkable 40 Top 40 hits, including three that went to #1: "I Heard It Through the Grapevine" (1968), "Let's Get It On" (1973) and "Got to Give It Up (Pt. I)," (1977). From 1967 until 1970, he often teamed with Tammi Terrell, with whom he had seven Top 40 hits. Terrell died in 1970 from a brain tumor, three years after collapsing in Gaye's arms onstage during a concert in Virginia.

Like Stevie Wonder, Marvin Gaye was able to renegotiate his contract in 1971, bringing him more artistic control. That same year he released the album *What's Going On*, which contained three Top 10 singles that were politically charged statements on Vietnam ("What's Going On"), the environment ("Mercy Mercy Me [The Ecology]") and civil rights ("Inner City Blues [Make Me Wanna Holler]"). His bitter divorce from Anna required him to give her the proceeds of his next album, resulting in 1978's dark and very personal *Here, My Dear*. The album so clearly detailed their marriage and subsequent breakup that Anna for a time considered suing him for invasion of privacy. Gaye's conflicts with his hedonistic, cocaine abusing lifestyle and his religious upbringing brought much self-inflicted anguish to his later life. In 1983, he moved in with his father, with whom he quarreled constantly. After one such heated argument on April 1, 1984, his father shot him to death from point blank range.

The Four Tops

After meeting at a birthday party in 1954 while all four were high school students in Detroit, Levi Stubbs, Lawrence Payton, Renaldo Benson and Abdul Fakir began singing together and soon secured a contract from Chess Records. After several years of record flops and countless appearances in Detroit area supper clubs, the group signed with Motown in 1963. Berry Gordy originally had the group record a jazz oriented album, which was never released; he then switched their style back to R&B and hooked them up with producers Holland/Dozier/Holland in 1964. The results were immediate: their first release, "Baby I Need Your Loving" went to #11; the next year they hit the Top 40 four times, including the #1 "I Can't Help Myself." By the end of 1971, they had 13 more Top 40 hits, including another #1, "Reach Out I'll Be There" in 1966.

With their distinct sound of the gritty lead vocal of Stubbs pleading and wailing over the creamy backup vocals, the Four Tops have remained together for nearly 50 years without a single change in personnel. Although they stagnated for a while when HDH left the label in 1967 (they resorted to recording cover tunes for a few years, such as "If I Were a Carpenter"), they continued on with a variety of other Motown producers before leaving the label in 1971.

- Levi Stubbs
- Lawrence Payton

- Renaldo Benson
- Abdul Fakir

The Temptations

Formed in 1960 by three Southerners, a Los Angeles transplant and one Detroit native, the Temptations were the most commercially successful male vocal group of the 1960s. The group came together when two existing groups, the Primes and the Distants combined, initially calling themselves the Elgins. By 1961 they had changed their name to the Temptations and signed with Motown. After languishing with poor record sales for several years, the groups luck changed in late 1963 when lead vocalist David Ruffin was added and Berry Gordy assigned them to producer Smokey Robinson. Their next release, "The Way You Do the Things You Do" hit #11, the first of 38 Top 40 hits, 15 of which went Top 10 and four to #1. The group's primary attractions were their precise choreography, the best of any of the Motown groups, and the alternating lead vocals of Eddie Kendricks' high falsetto and David Ruffin's low husk.

Things began to change for the Tempts in 1966, when Norman Whitfield began producing with an eye toward a rougher hewn soul style, evidenced by the #13 hit "Ain't Too Proud to Beg." In 1968, David Ruffin quit the group to pursue a solo career, and the group recorded the socially conscious song "Cloud Nine" (#6). Although "Cloud Nine" contained drug allusions, it became Motown's first Grammy Award winner. More socially aware songs followed, including "Message From a Black Man," "War" and "Papa Was a Rolling Stone," which went to #1 in 1972. Like many of the other original Motown groups, the Temptations left the label in the mid-1970s.

The Supremes

Unquestionably the most commercially successful of all the Motown groups, the Supremes hit the American radio waves in 1964 with unprecedented fury: ten

of their first 14 releases, all produced by Holland/Dozier/Holland, went to #1, including a run of five in a row in 1964–65. By the time Diana Ross left the group in 1970, their Top 40 total had reached 25, with two more #1 hits, "Love Child" in 1968 and Ross' 1969 farewell, "Someday We'll Be Together."

Originally known as the Primettes, the sister group to the Primes (later the Temptations), **Diana Ross** (1944–), Mary Wilson and Florence Ballard grew up in Detroit's Brewster housing project. Rejected at their first audition with Berry Gordy because they were still in high school, the girls hung around Hitsville and sang in backup roles on recording sessions before Gordy finally signed them in 1961. After nine unsuccessful singles over the next three years, Gordy assigned the HDH team to produce the group in 1964. By focusing on Ross' sultry and dramatic vocal style, HDH hit on a winning formula for the group, which Gordy skillfully parlayed into weekly TV appearances and nightclub shows in Las Vegas and at the Copacabana in New York. As the attention increasingly centered on Ross (in 1967 they became

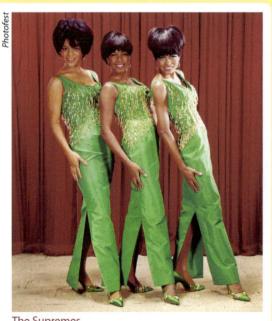

The Supremes

known as "Diana Ross and the Supremes"), Ballard became disenchanted and left, replaced by Cindy Birdsong. Following her departure from the group, Ross went on to a successful film career (managed by Gordy) which included starring roles in 1972's *Lady Sings the Blues* (for which she received an Oscar nomination), *Mahogany* and *The Wiz*.

- Diana Ross
- Mary Wilson

 Florence Ballard (later replaced by Cindy Birdsong)

THE SUPREMES

Martha and the Vandellas

Martha Reeves (1941–) and her friends Annette Beard and Rosalind Ashford began singing together in high school in Detroit as the Del-Phis and had one single under their belt when in 1961 Reeves began working as a secretary at Motown. One day on short notice they were called in as background singers on a session for Marvin Gaye, which eventually led to their signing with the label as Martha and the Vandellas. With 12 Top 40 hits (including 1963's #4 "Heatwave" and 1964's #2 "Dancing in the Street"), the Vandellas were not one of the most commercially successful Motown groups, but were one of the earthiest and most soulful.

STAX RECORDS

Back to Memphis

At the same time that Motown was establishing itself in Detroit, a small record company was emerging in Memphis that would one day become its most formidable soul challenger. Unlike Motown, there was no advance business plan laid out for Stax Records—the company just sort of evolved with large doses of luck, being at the right place at the right time and of course, hard work. Stax also benefited from the unique "transracial" (as historian Peter Guralnick has called it) environment in Memphis at the time. Although the city was as segregated as any Southern city in the early 1960s, there existed a harmonious relationship between blacks and whites that allowed them to mingle socially at many of the nightclubs around town. Especially among musicians, there were no prejudices based on the color of one's skin; the only thing that mattered was whether or not you could play.

The Stax story begins in 1957 when **Jim Stewart** (1930–), a country fiddler who worked at Memphis' First National Bank during the day began a small record label out of a friend's garage at night. He named the company Satellite—"satellites were big at the time" he later recalled in reference to the Soviet Union's Sputnik. By 1958 he had piqued the interest of his sister **Estelle Axton** (1918–2004), more than ten years his senior, to the point where she invested in the company by buying a monaural Ampex 350 tape machine in which to make better recordings. The fledgling business quickly became a passion for the two, who spent all of their off hours (she worked at Union Planters Bank) working with local talent producing records, none of which made any significant sales.

Stax is Born

In the summer of 1960, the operation moved to the abandoned Capitol Theatre at 926 East McLemore Ave, where a recording studio was set up in the theatre and a recording booth on the stage. Because money was tight, the sloped floor of the theatre was not leveled out. There was also no heating or air conditioning, which meant that summer sessions were stifling hot while winter sessions were so chilly that musicians often wore their coats. A record store, the Satellite Record Shop, was set up in the popcorn concession area to bring in extra money. Around this time, local legend and DJ Rufus "Bear Cat" Thomas (see Chapter 2) recorded a duet with his daughter Carla called "Cause I Love You," which sold around 30 thousand records. The record caught the attention of Jerry Wexler of Atlantic Records, who for \$1000 leased the master and took out a five-year option on all other duets by Rufus and Carla (or at least that's how Jim and Estelle interpreted it—more on that later). Wexler was impressed with the raw energy that came from the studio, something that was lacking from the professional arrangers and session musicians he was used to working with in New York. The association between the two companies that started with "Cause I Love You" would last until 1967, by which time the small mom and pop studio was firmly established as a major music production center.

Meanwhile, two recordings established the foundation for what would become the Stax sound. In the summer of 1961 a band of high school students calling themselves the Royal Spades (which included Estelle Axton's son Packy) released a single called "Last Night," which to everyone's surprise, went all the way to #3 on the national pop charts. With national exposure, the Royal Spades decided to change their name to the Mar-Keys; simultaneously, Jim and Estelle changed the name of the studio to Stax (derived from their last names: **St**ewart and **Ax**ton) to avoid a lawsuit with a label in California also named Satellite. The second important recording came in the summer of 1962 when two members

MUSIC CUT 37

"GREEN ONIONS" (BOOKER T. JONES/STEVE CROPPER/LEWIE STEINBERG/AL JACKSON, JR.)—BOOKER T. & THE MG'S

Personnel: Booker T. Jones: Hammond organ; Steve Cropper: guitar; Lewie Steinberg: bass; Al Jackson, Jr: drums. Recorded 1962 at Stax Studios, Memphis, TN; produced by Booker T. Jones/Steve Cropper/Lewie Steinberg/Al Jackson, Jr. Released September 1962 on Stax; 12 weeks on the charts, peaking at #3.

Despite being a simple riff-oriented 12-bar blues, Booker T. & the MG's "Green Onions" not only helped put Stax Records on the map, it has become one of the most enduring recordings of the 1960s. The song came about in a rather spontaneous fashion in the studio, which was not too unusual for Stax. As the group was waiting for singer Billy Lee Riley to show up for a session, Booker T. Jones told NPR that the song was "something of an accident. We used the time to record a blues which we called 'Behave Yourself,' and I played it on a Hammond M3 organ. Jim Stewart, the owner, was the engineer and he really liked it and wanted to put it out as a record. We all agreed on that and Jim told us that we needed something to record as a B-side, since we couldn't have a one-sided record. One of the tunes I had been playing on piano we tried on the Hammond organ so that the record would have organ on both sides and that turned out to be 'Green Onions.' "Although the song was originally on the B side of "Behave Yourself," once radio DJs started playing "Green Onions" instead, subsequent releases of the record had it on the A side.

of the Mar-Keys, guitarist Steve Cropper and bassist Donald 'Duck' Dunn joined two other local musicians, Booker T. Jones on Hammond organ and Al Jackson on drums and recorded a simple blues jam which they called "Green Onions." Again, surprisingly, "Green Onions" rose to #3 on the national charts. The quartet began calling themselves Booker T. & the MG's (MG stood for 'Memphis Group' or the English sports car, depending on who is telling the story), and became established as the house band for most of the recordings that came out of Stax over the next several years. Unusual for the times, but mirroring the unique workplace environment that emerged at Stax, the MG's were an integrated band: both Cropper and Dunn were white, Jones and Jackson black.

Soulsville, U.S.A.

Stax grew quickly. Realizing that their destiny was in soul music, the company put up the words "Soulsville, U.S.A." on the theatre marquee outside the studio. Over the next 15 years more than 800 singles and 300 albums were released that comprise one of the most enduring catalogues of American music. More than 160 singles made the Top 100 pop chart, while nearly 250 of them made the Top 100 R&B chart. By the start of the 1970s, the label (which included the subsidiary Volt Records) had over 100 artists signed and more than 200 employees. Like Motown, a variety of in house songwriters were used to crank out songs, the most important of which were Isaac Hayes (1942-2008) and David Porter (1941–). The Hayes/Porter team wrote more than 20 hits for Sam and Dave, including "Hold On, I'm Comin'" (#21, 1966), "Soul Man" (#2, 1967), "I Thank You" (#9, 1968) and "When Something Is Wrong with My Baby." Steve Cropper of Booker T. & the MG's was also an important contributor, co-writing such soul classics as "634-5789" (#13, 1966) and "Knock on Wood" (#28, 1966) with Eddie Floyd, "In the Midnight Hour" (#21, 1965) with Wilson Pickett and "(Sittin' on) The Dock of the Bay" (#1, 1968) with Otis Redding.

Sessions at Stax were conducted very differently than they were at Motown. Everything was done in a live and spontaneous environment, rather than the

Characteristics of the Stax Sound

- 1. Raw, gritty, powerful, emotional
- 2. Bare bones instrumentation of bass, drums, guitar, piano or organ, horn section
- 3. Very tight yet uncluttered groove in rhythm section
- 4. Horns scored in punchy unison lines and chords
- 5. Generally no vocal harmonies or backup vocals; vocalists have more 'elbow room' with bare bones arrangements

Key Stax Recordings

- "Green Onions"—Booker T. & the MG's, 1962
- "In the Midnight Hour"—Wilson Pickett, 1965
- "Soul Man"—Sam and Dave, 1967
- (Sittin' on) The Dock of the Bay"—Otis Redding, 1967

assembly line production using composers, arrangers and overdubbing. Songs were often composed on the spot, as was the case with "Green Onions," "In the Midnight Hour" and others. As Jerry Wexler said, "Memphis was a real departure, because Memphis was a return to head arrangements, to the set rhythm section, away from the arranger. It was a reversion to the symbiosis between the producer and the rhythm section, and it was really something new." Compared to Motown, the Stax sound is punchier, more direct and emotional, and not as overly produced, and in effect, more authentic.

IMPORTANT STAX ARTISTS

- Booker T. and the MG's
- Otis Redding
- Wilson Pickett
- Sam and Dave

IMPORTANT STAX ARTISTS

Booker T. & the MG's

The MG's were the Memphis version of Motown's Funk Brothers, serving as the in-house rhythm section for many of the Stax classic soul recordings. They also had their own chart successes, with six more singles beside "Green Onions" hitting the Top 40, including "Hang 'Em High" (#9, 1968) and "Time Is Tight" (#3, 1969). In 1967 the MG's performed in a backup role for many of the label's stars on the "Hit the Road, Stax!" European tour, and also appeared with Otis Redding at the Monterey International Pop Festival. The band paid tribute to the Beatles with one of their last albums, 1970s McLemore Avenue, which featured covers of 13 songs from Abbey Road. The cover photo shows them crossing the street in front of the Stax studios in a take-off on the famous Abbey Road cover.

BOOKER T. AND THE MG'S

- Steve Cropper
- Donald "Duck" Dunn
- Booker T. Jones
- Al Jackson

Otis Redding

Otis Redding (1941–1967) was born in Dawson, Georgia, 100 miles south of Macon. As a youth he sang gospel music at church and played the drums in a school band. As he grew older, he became a Little Richard-inspired lead singer with the group the Pinetoppers, and it was with them that Redding first recorded at Stax in October 1962. Although the song, "These Arms of Mine" only cracked the R&B chart at #20, Redding began to make a name for himself over the next several years as one of the hottest performers on the chitlin' circuit, performing with the Memphis based backup band the Bar-Kays.

Redding's career was flourishing through the mid 1960s, especially after his electrifying performance at the July 1967 Monterey Pop Festival, which introduced him to a much larger white fan base. He by this time had chalked up seven Top 40 hits, including his classic "Respect" (#35, 1965). Just as his career was beginning to take off, on December 9, 1967 his private plane crashed on the way to a concert in Madison, Wisconsin, killing Redding and most of the members of the Bar-Kays. Three days before his death, Redding made his last recording, the melancholy "(Sittin' on) The Dock of the Bay." Released posthumously, the song became his only #1 hit.

Wilson Pickett

Although Wilson Pickett (1941–2006) signed with Atlantic in 1964, his records were not selling until Jerry Wexler brought him to Stax in May 1965. That session resulted in the soul classic "In the Midnight Hour," the first of 16 Top 40 hits over the next seven years. After his second hit, "634–5789" in late 1965, Pickett recorded at Fame Studio in Muscle Shoals, Alabama as the Stax/Atlantic association began to dissolve. Pickett was known as the "Wicked Pickett" for his roughly hewn aggressive style and husky voice.

"IN THE MIDNIGHT HOUR" (WILSON PICKETT/ STEVE CROPPER)—WILSON PICKETT

Personnel: Wilson Pickett: vocals; Steve Cropper: guitar; Joe Hall: piano; Wayne Jackson: trumpet; Andrew Love, Charles Axton: tenor sax; Floyd Newman: baritone sax; Donald "Duck" Dunn: bass; Al Jackson, Jr: drums. Recorded May 12, 1965 at Stax Studios, Memphis, TN; produced by Jerry Wexler. Released June 1965 on Atlantic; 6 weeks on the charts, peaking at #21.

Written, recorded, and produced all within a 24-hour period, "In the Midnight Hour" become singer Wilson Pickett's signature song. As he and Booker T. & the MGs guitarist were preparing for the next day's session at Memphis' Lorraine Motel, Cropper came up with the idea to put an unusual twist on one of Pickett's favorite go-to live performance lines. "Wilson says he wrote the song," Cropper later recalled, "but, you know, I listened to some old church stuff he sang on and he was singing 'See my Jesus in the midnight hour, see my Jesus in the midnight hour' over and over, and I said, 'I'm gonna see my girl in the midnight hour, what about that?" "Once at the session, Atlantic Records producer Jerry Wexler insured the record's success when he had the band change the groove slightly so it could work with the Jerk, a dance that was popular in New York at the time. Cropper: "It probably was one of the most influential sounds that we had because we started cutting a lot of records with what we called a delayed backbeat." (Note: the Lorraine Motel is where Dr. Martin Luther King, Jr. was later assassinated on April 4, 1968.)

Sam and Dave

Sam Moore (1935–) and Dave Prater (1937–88) were a hot Miami based night-club act when Wexler signed them to Atlantic and brought them to Stax in early 1965. There they were assigned to the Hayes/Porter writing team, who wrote more than 20 hits for the duo over the next two years, including the classic soul anthem "Soul Man." Despite the fact that their live shows were among the most

exciting in the industry, the two became estranged after Prater shot his wife in a domestic dispute and did not talk to each other offstage for several years. They broke up in 1970. Both experienced drug problems over the next several years; Prater died in an automobile accident in 1988.

MUSIC CUT 39

"SOUL MAN" (ISAAC HAYES/DAVID PORTER)— SAM AND DAVE

Personnel: Sam Moore, Dave Prater: vocals; Isaac Hayes: piano; Steve Cropper: guitar; Donald "Duck" Dunn: bass; Al Jackson, Jr.: drums; Wayne Jackson: trumpet; Andrew Love: tenor sax. Recorded August 10, 1967 at Stax Studios, Memphis, TN; Produced by Isaac Hayes and David Porter. Released September 1967 on Stax; 15 weeks on the charts, peaking at #2.

"Soul Man" was the highest charting hit (#2) for Sam and Dave, but stalled at #2 for three weeks in the fall of 1967 and never quite made it to the top. Recorded on August 10, it featured Stax Records two session groups—Booker T. & the MG's and the Memphis Horns—although Booker T. Jones himself was away at college and missed the session. "Soul Man" did manage to hit #1 on the R&B charts for seven weeks, and over the years has become a soul anthem that has transcended its time and place to become a part of American culture.

IMPORTANT MEMBERS OF MUSCLE SHOALS RHYTHM SECTION

- Roger Hawkins
- Jimmy Johnson
- Junior Lowe
- David Hood
- Spooner Oldham
- Barry Beckett

MUSCLE SHOALS AND ARETHA FRANKLIN

Fame Studios

Nestled in the northwest corner of Alabama, 150 miles east of Memphis lies the sleepy metropolitan area known as Muscle Shoals. Actually made up of four small towns—Florence, Sheffield, Tuscumbia, and the township of Muscle Shoals (where Sam Phillips was born in 1923)—the area started on its way to becoming an unlikely music center in 1959 when local guitarist and entrepreneur **Rick Hall** (1932–) opened a small recording studio and named it Fame Music (Fame being an acronym for Florence Alabama Music Enterprises). After a number of regional hits allowed him to move into a larger custom built studio, Hall began to attract clients from Atlanta and Nashville, and eventually Jerry Wexler from Atlantic Records. Like Motown and Stax, one of the chief attractions to the recording environment at Fame was its house band, which through the 1960s

became well known simply as the Muscle Shoals Rhythm Section. Important members of the MSRS were drummer Roger Hawkins, guitarist Jimmy Johnson, bassists Junior Lowe and David Hood, and pianists Spooner Oldham and Barry Beckett.

Muscle Shoals first came to the pop world's attention in the spring of 1966 with the release of "When a Man Loves a Woman" by local R&B singer Percy Sledge. With the help of local DJ Quinn Ivy, a copy of the song was sent to Jerry Wexler, who bought the distribution rights. "When a Man Loves a Woman" shot up to #1 and became Atlantic's first gold record. Once Wexler realized the benefits of recording at Fame (at a time when Stax was getting too busy with their own artists), he began bringing his Atlantic artists to Muscle Shoals. The most notable of these were Wilson Pickett, and in the spring of 1967, Aretha Franklin.

Aretha Franklin

Although Aretha Franklin (1942–) was born in Memphis and grew up in Detroit, her first recording contract came from neither Motown nor Stax, but Columbia Records. Her father, the Reverend C. L. Franklin, was the nationally known pastor of the 4,500-member New Bethel Baptist Church in Detroit, where Aretha began singing at age eight. By the age of 14, she released her first album, comprised entirely of gospel music recorded live at her father's church. At age 18 she was signed by the legendary John Hammond of Columbia, who tried to make her into the jazz/pop mold of his earlier discovery, jazz great Billie Holiday. After six years and ten albums that resulted in only one hit (the unremarkable "Rock-a-bye Your Baby with a Dixie Melody"), Aretha left Columbia and signed with Atlantic. Jerry Wexler immediately scheduled a session in Muscle Shoals in January 1967.

Although the session was the only one Aretha ever did in Muscle Shoals, it produced the landmark "I Never Loved a Man (the Way I Love You)," a #9 hit. Under Wexler's direction, for the first time Franklin was allowed the freedom to do what she did best, and her career took

off. Following the Muscle Shoals session, Aretha moved to Atlantic's New York studios (taking the Muscle Shoals Rhythm Section with her) and recorded Otis Redding's "Respect," her first #1 hit. Over the next three years she sold millions of records, hitting the Top 10 constantly with hits like "Baby I Love You" (#4), "(You Make Me Feel Like) a Natural Woman" (#9) and "Chain of Fools" (#2), all from 1967 alone. Franklin has the ability to take a remarkably wide variety of songs and give them definitive soul renditions, as in Carole King's "Natural Woman," the Beatles' "Eleanor Rigby," or Simon and Garfunkel's "Bridge Over Troubled Water." She is also a fine pianist and composer in her own right, having penned "Think," "Since You've Been Gone" and many others. Like Ray Charles, her ecstatic, gospel filled voice is an American institution, and one of the most recognizable and influential in the history of pop music. She also did a credible acting job in her role in the 1980 movie *The Blues Brothers*, singing both "Respect" and "Think."

Aretha Franklin

"RESPECT" (OTIS REDDING)— Aretha Franklin

Personnel: Aretha Franklin: piano, vocals; Carolyn Franklin, Erma Franklin: backup vocals; Melvin Lastie: trumpet; King Curtis: tenor sax; Charles Chalmers: tenor sax; Willie Bridges: baritone sax; Jimmy Johnson: guitar; Spooner Oldham: keyboards; Tommy Cogbill: bass; Gene Chrisman: drums. Recorded on February 14, 1967 at Atlantic Studios, New York, NY; produced by Jerry Wexler. Released April 1967 on Atlantic; 12 weeks on the charts, peaking at #1.

Although "Respect" was written and originally recorded by Otis Redding for Stax/Volt in 1965, Aretha Franklin took possession of the song with her 1967 cover. Describing the differences in the two interpretations, producer Jerry Wexler said, "For Otis, respect had the traditional connotation, the more abstract meaning of esteem. The fervor in Aretha's voice demanded that respect; and more respect also involved sexual attention of the highest order. What else would 'sock it to me' mean?" Recorded in Atlantic's New York studio with the famed Muscle Shoals Rhythm Section just one month after her successful debut recording for the label, the song became her first #1 single.

CHAPTER 4 TERMS AND DEFINITIONS

- Minimalism—the use of short repeating musical phrases to create a hypnotic effect.
- **Falsetto**—a technique where male singers sing in a very high 'head' voice that is beyond their natural vocal range.

Name	C)ate
1.	Describe how Ray Charles created the first soul recording.	
2.	Describe the close connection between the civil rights movement and soul	music of the 1960s.
3.	How did James Brown influence soul and later black music styles?	
4.	Describe the key elements to the way business was run at Motown.	
5.	What were some of the right and wrong things that Berry Gordy did in runni	ing Motown?

wasn't.

10. Briefly describe why Atlantic was successful in making a star out of Aretha Franklin but Columbia

THE FOLK INFLUENCE

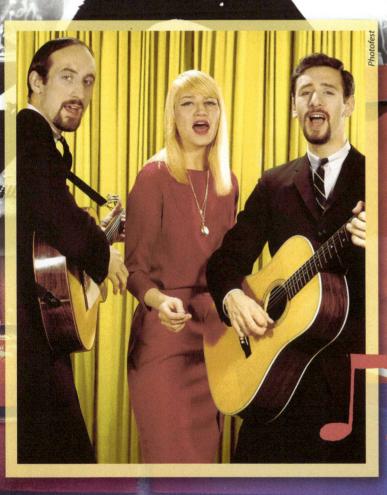

"I think folk music's impact really was more about substance than style. I think folk music gave pop music the awareness that it could speak about many different subjects."

—Paul Stookey (Peter, Paul and Mary)

KEY TERMS	Left wing folk song conspiracy Wobblies Hootenanny	Fifties folk revival Calypso Newport Folk Festival Beat writers	Hammond's Folly <i>Don't Look Back</i> The Basement Tapes
KEY FIGURES	John and Alan Lomax Woody Guthrie Pete Seeger	The Kingston Trio Joan Baez Peter, Paul and Mary	Bob Dylan Paul Butterfield Blues Band The Hawks/The Band Traveling Wilburys
KEY ALBUMS	The Freewheelin' Bob Dylan—Bob Dylan Bringing It All Back Home—Bob Dylan	Blonde on Blonde— Bob Dylan	Blood on the Tracks— Bob Dylan

THE FOLK TRADITION

The Left-Wing Folk Song Conspiracy

Just after the turn of the 20th century, there was a growing interest in traditional American folk music. Part of this interest came from preservationists who feared that the music would disappear due to the increasing urbanization of the country. However, folk music was also becoming popular as a tool for political organizations and labor unions to rally support and foster solidarity among their members. One union in particular, the International Workers of the World (IWW, or popularly known as the "Wobblies"), used folk songs to build morale, recruit new members and stir up publicity for their cause. In 1911, the Wobblies published the first of 30 editions of their songbook entitled IWW Songs: Songs of the Workers to Fan the Flames of Discontent, which unofficially became known as The Little Red Songbook. Because many folk songs were protest songs against big business and government policies (such as America's involvement in World War I), and were often used by socialist groups and the fledgling Communist Party, by the 1920s conservatives began to speak of a "left wing folk song conspiracy." This association between folk music, social activism and liberal politics endured well into the 1960s.

By the 1930s folk radio shows began appearing, such as *The Wayfaring Stranger* hosted by folksinger Burl Ives on the CBS network. Folk songs also began to get published in newspapers. In 1933, **John and Alan Lomax**, a father and son team of musicologists from the Library of Congress began taking trips through the backwoods of the South with a portable recording device to find and preserve folk songs. On their first trip they discovered an inmate at the Angola State Prison in Louisiana named Leadbelly (Huddie Ledbetter) who was a gifted singer, songwriter and guitarist. Through the Lomax's persistence, Leadbelly was released in 1934 and went on to become an important influence to folk and blues performers until his death in 1949. Leadbelly also wrote countless numbers of folk songs, including his two most famous, "Goodnight Irene" and "Midnight Special."

Woody Guthrie and Pete Seeger

The 1930s also saw the emergence of the most important early folk singer, Woody Guthrie (1912–1967). Guthrie's impoverished childhood was spent in Oklahoma and Texas, where he witnessed first hand the tough life of the lower class during the depression. He saw how easily banks were willing to evict farm families whose crops had been ruined by dust storms and other calamities. Guthrie himself was the victim of several tragedies in his youth, including his sister's death in an explosion and his mother's commitment to an insane asylum. He was on his own and living on the streets by age 13, singing and playing the harmonica to earn a living. At the age of 25, Guthrie began a lifelong crusade to help band the common folk together to fight for their rights through unions and other organizations. He traveled the country, often hobo style on trains, talking to people and singing the songs he wrote. Guthrie's songs included dust bowl ballads, pro-union songs, anti-Hitler songs and songs about the plight of migrant workers and common people. In all, it is estimated that he wrote well over 1,000 songs during his lifetime, including "The Great Dust Storm," "Pastures of Plenty," "Roll On Columbia" and his most famous, "This Land Is Your Land." Guthrie also developed a unique talking blues style of half singing and half speaking the lyrics to his songs while accompanying himself on guitar. With his songs, his idealism and his working class blue jeans and uncombed hair, Guthrie became a hero and a legend in the folk community.

Hootenannies and Witch Hunts

In 1940, Guthrie met 21-year-old singer/guitarist **Pete Seeger** (1919–2014) at a benefit concert for migrant workers. Seeger's father Charles was a university professor who had registered as a conscientious objector during World War I, and had exposed his son to folk music at an early age. Throughout the 1940s

"PRETTY BOY FLOYD" (WOODY GUTHRIE)— WOODY GUTHRIE

Personnel: Woody Guthrie: guitar, vocals. Recorded April 26, 1940 at RCA Victor Studio 1, Camden, NJ.

During his life, Woody Guthrie wrote a number of epic ballads about outlaws, often celebrating them as populist heroes that, like Robin Hood, stole from the rich and gave to the poor. "Pretty Boy Floyd" is just such a tale, about the real life bank robber Charles Floyd. After growing up in the dust bowl years on a small farm in Oklahoma, Floyd was inadvertently involved in a murder that forced him into a life of crime. Living in Kansas City during the corrupt years of the Pendergast administration, Floyd made connections with organized crime elements and learned to use a machine gun. As his reputation grew and federal agents began pursuing him, he hid out in the backwoods, often protected by the locals who viewed him as a folk hero. He was eventually killed by FBI agents in an open Ohio farm field.

Guthrie's song captures the essence of Floyd the folk hero with lines such as, "Well, you say that I'm an outlaw/You say that I'm a thief/Here's a Christmas dinner/For the families on relief". It is sung with Guthrie's characteristic 'talking blues' style that became so influential to Bob Dylan and other folk artists. It is also performed in the traditional folk style, with only acoustic guitar accompaniment.

Guthrie and Seeger traveled the country as part of the Almanac Singers, singing original and traditional folk songs at **hootenannies** and rallies. In 1949 Seeger went on to form the Weavers, one of the first folk groups to break into mainstream visibility when their recording of Leadbelly's "Goodnight Irene" became a #1 hit in 1950. But both men fell on harder times in the 1950s, as did the folk community in general. Guthrie fell ill to Huntington's chorea, a central nervous system disorder that leads to distorted speech and progressive degeneration of the brain that kept him in and out of hospitals until it finally killed him in 1967. Seeger ran into problems of a political nature.

MUSIC CUT 42

"WE SHALL OVERCOME" (TRADITIONAL)— PETE SEEGER

As the preeminent anthem of the Civil Rights Movement, "We Shall Overcome" has been recorded dozens of times by an array of artists and sung at countless rallies, marches, and protests. Although authorship of the song is often attributed to Pete Seeger, the truth is much more complicated, and in fact has not yet been legally resolved (a case to resolve the conflict is scheduled to go to trial in December 2017). Conventional wisdom among many scholars is that the song originally evolved from "I'll Overcome Some Day," a hymn first published by Charles Tindley in 1900. By 1947 a version of the song entitled "We Will Overcome" was published in *People's Songs Bulletin*, a broadside that Seeger helped oversee. Seeger later claimed that it was he who changed the "will" to "shall" sometime soon after, and from there its popularity began to take off. Soon it became a staple at union rallies and civil rights protests. In August 1963, folksinger Joan Baez sang the song at the March on Washington, and President Lyndon Johnson used the phrase in a speech to Congress on March 15, 1965. Dr. Martin Luther King, Jr. recited the words to the song in his final sermon, delivered on Sunday, March 31, 1968, and the song was sung by the tens of thousands who attended his funeral just days later.

The conservative and Cold War climate of the early 1950s did not bode well for the folk community. With Senator Joseph McCarthy of Wisconsin on the prowl trying to 'out' Communist infiltrators in the government, fingers began to point in all directions at those who were suspected of being Soviet spies or Communist sympathizers. Among those blacklisted were Hollywood writers, actors and directors as well as journalists and of course, folk singers. Pete Seeger's liberal politics eventually caught the attention of the FBI, and he was blacklisted in the 1950 publication Red Channels: The Report of Communist Influence in Radio and Television. Among other charges, the book exposed that he had joined the Young Communist League while a student at Harvard in the 1930s. In light of the revelations, Decca Records dropped the Weavers, as the group was suddenly too controversial. Seeger left the Weavers in 1953 to tour college campuses across the country as a soloist, singing political songs and inviting audience participation. But by 1955 Congress was on his trail: he was asked to testify before the House Un-American Activities Committee, which by now was on their own Communist witch-hunt. Seeger appeared, but refused to cooperate. He was indicted, tried and convicted on ten counts of contempt of Congress, although he was cleared in 1962 after a lengthy court battle. Seeger continued to be a political activist and went on to write some of the most important songs of the folk movement, including "If I Had A Hammer," "Where Have All The Flowers Gone," "Turn, Turn, Turn" and reworking an old spiritual into the civil rights anthem "We Shall Overcome."

THE FIFTIES FOLK REVIVAL

The Calypso Fad

The anti-Communist furor that engulfed the nation's attention for much of the early and mid-1950s forced many folk musicians to go underground. However, by the late 1950s, there was another popular folk revival. Many who were turned off by the vulgarities of R&B and rock and roll were drawn to the socially conscious nature of folk music. College students in particular saw folk as music that addressed the need for positive change in society, and much of its groundswell of support was fostered at coffeehouses and study halls on campus. One of the first signs that folk was about to have a revival came when actor and singer Harry Belafonte scored a series of calypso hits in 1956 and 57. **Calypso**, a folk music of Trinidad, has a different rhythmic quality than traditional American folk, but the narrative verse structures and storylines are similar. Belafonte's commercial success included the 1957 #5 hit "Banana Boat (Day-O)," which started a short-lived calypso fad that was instrumental in renewing interest in folk. Belafonte's *Calypso* spent 31 weeks at #1 on the Billboard Top 100 Album chart.

"BANANA BOAT SONG (DAY-O)" (TRADITIONAL)— HARRY BELAFONTE

Personnel: Harry Belafonte: lead vocals; Millard J. Thomas: guitar; other musicians: unknown. Recorded 1955 at the Grand Ballroom, Webster Hall, New York City, produced by Ed Welker, Herman Diaz, Jr., and Henry René. Released on RCA Victor in 1956 on the album *Calypso* and as a single, which spent 17 weeks on the charts, peaking at #5.

Although "Banana Boat Song (Day-O)" or "Day-O (Banana Boat Song)" as it was originally titled, is the lead song on Harry Belafonte's album *Calypso*, it is not technically a *calypso*, but instead a traditional Jamaican folk song. In any event, the song's popularity helped propel *Calypso* to reportedly become the first album to sell one million copies. It also helped kick start the 1950s folk revival as a song with folk origins that was not connected with left-wing politics. (Ironically, Belafonte became very involved in progressive causes, including the Civil Rights Movement, and later became very critical of U.S. foreign policy and president George W. Bush.)

The real start to the 1950s folk revival came in 1958 when the record "Tom Dooley" by **the Kingston Trio** became a #1 hit. The song was a traditional folk song about a convicted murderer named Tom Dula who was sentenced to death by hanging in 1866. The group was obviously influenced by the calypso fad (naming themselves after the Jamaican capital city), but played folk music that was pop oriented and without much trace of political protest. To help foster a squeaky clean image, they wore crew cuts and matching clothes. By 1963 the group had racked up ten Top 40 hits.

"TOM DOOLEY" (TRADITIONAL)— THE KINGSTON TRIO

Personnel: Dave Guard: banjo, vocals; Bob Shane: guitar, vocals; Nick Reynolds: guitar, vocals. Recorded 1958 in Los Angeles, released on Capitol; 18 weeks on the charts, peaking at #1.

As discussed in chapter 1, major components of the English folk tradition in America were ballads and lyric songs that often told tales of love and love lost. "Tom Dooley" is such a song, inspired by the 1866 murder of Laura Foster in North Carolina and subsequent hanging in 1868 of her lover and convicted murderer, Tom Dula (pronounced "Dooley"). Although details of the exact origins of the song are murky, the first recording of the song apparently was made by Gilliam Grayson and Henry Whitter in 1929. Several recordings of the song exist, but by far the most popular was The Kingston Trio's 1958 version, which hit #1 on the charts and eventually sold more than six million copies. The song was so popular that it helping renew interest in folk music, and helped kick-start what is today called the Fifties Folk Revival. It also earned the group a Grammy Award at the 1959 ceremonies.

The Queen of Folk

In the summer of 1959 the first **Newport Folk Festival** was held in Newport, Rhode Island. One of the artists that performed was angel-voiced **Joan Baez** (1941–), who had been a favorite at Cambridge's Club 47 while a student at Boston University. Baez was beautiful, wore plain peasant clothes, sang traditional folk songs and was committed to political and social issues. By embracing the values of the common person, Baez became the darling of the traditional folk crowd, who began calling her the "Queen of Folk." She also quickly developed a large mainstream audience as well—her second album *Joan Baez 2* went gold in 1961. Around this time she met Bob Dylan, with whom she fell in love and brought on her concert tour in the summer of 1963, introducing him to her loyal fans. Because Baez stuck to traditional folk songs and resisted commercial pressures, she did not have any chart success until 1971 when her cover of The Band's "The Night They Drove Old Dixie Down" went to #3.

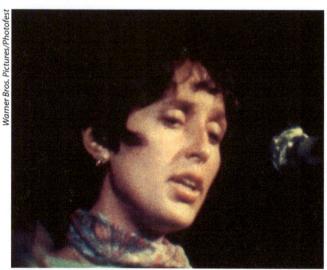

Joan Baez

In 1961 Peter, Paul and Mary made their debut performance at New York's Bitter End. Peter Yarrow, Noel Paul Stookey and Mary Travers came from different backgrounds—only Yarrow was a folksinger; Travers was an off-Broadway singer, Stookey a comedian. They ended up becoming the most popular folk group of the 1960s with 12 Top 40 hits, including two—"Lemon Tree" (#35) and Pete Seeger's "If I Had A Hammer" (#10)—from their eponymous first album. Like Baez, Peter, Paul and Mary were involved with the social issues of their songs. Although Seeger wrote "Hammer" as a pro-union song, it became a civil rights anthem in the 1960s partly because of Peter, Paul and Mary's recording. The group appeared at numerous protests, rallies and marches, including the August 28 1963 March on Washington where Dr. Martin Luther King gave his famous 'I Have A Dream'

"HOUSE OF THE RISING SUN" (TRADITIONAL)— JOAN BAEZ

Personnel: Joan Baez: acoustic guitar, vocals. Recorded July 1960 at the Manhattan Towers Hotel Ballroom, New York City; produced by Maynard Solomon. Released October 1960 on the album *Joan Baez* on Vanguard; not released as a single.

"House of the Rising Sun" is one of the most traditional of all English folk ballads, and therefore its origins are hard to pin down. By the time Joan Baez recorded it in 1960 however, it was undoubtedly in the repertoire of every contemporary folk singer. Baez recorded it and all the songs on her first album in the ballroom of the Manhattan Towers Hotel, apparently to cut down on recording costs. As she later told *Rolling Stone*: "It took four nights. We were in some big, smelly ballroom at a hotel on Broadway, way up by the river. We couldn't record on Wednesday nights because they played bingo there. I would be down there on this dirty old rug with two microphones, one for the voice and one for the guitar. I just did my set; it was probably all I knew. Just put 'em down. I did "Mary Hamilton" once, that was it. That's the way we made 'em in the old days. As long as a dog didn't run through the room or something, you had it."

speech. Also like Baez, Peter, Paul and Mary gave a boost to the early career of Bob Dylan, recording two of his songs in 1963 that outsold Dylan's own versions: "Blowin' in the Wind" (#2) and "Don't Think Twice, It's All Right" (#9).

The Greenwich Village Scene

In the wake of the commercial success of performers like the Kingston Trio, Joan Baez and Peter, Paul and Mary came other popular folk groups such as the Highwaymen ("Michael Row The Boat Ashore," #1, 1961), the New Christy Minstrels ("Green Green," #14, 1963) and the Rooftop Singers ("Walk Right In," #1, 1963). Coffeehouses, cafés and small clubs all over the country began to hire folk performers, and important folk scenes sprang up in New York, the Boston/Cambridge area, Ann Arbor, Michigan, Berkeley, California and other cities. The most important of these was in New York's Greenwich Village.

establishments in the Village was Izzy Young's Folklore Center on MacDougal Street. It was a place where you could buy instruments, sheet music, books, and records, or just hang out and listen to records and talk.

MUSIC CUT 46

"IF I HAD A HAMMER" (PETE SEEGER/LEE HAYS)—PETER, PAUL AND MARY

Personnel: Peter Yarrow, Noel Paul Stokey: guitar, vocals; Mary Travers: vocals. Recorded 1962; produced by Albert Grossman. Released July 1962 on Warner Brothers; 8 weeks on the charts, peaking at #10.

Written in 1949, "If I Had a Hammer" is a song with deep connections to workers and civil rights movements, with the hammer being a metaphor for political power. The song's composers, Pete Seeger and Lee Hays, were members of The Weavers, a folk group that had a history of performing overtly political songs at rallies and protests. The group made the first recording of the song in 1950, known at the time as "The Hammer Song." By the time Peter, Paul and Mary recorded it in 1962, the song was titled "If I Had a Hammer (The Hammer Song)," and had become a folk standard. The single was included in the group's self-titled debut album and proved to be their first Top 10 hit. Fueled by "Hammer" and "Lemon Tree," their first hit (#35), Peter, Paul and Mary went to #1 on the charts and won two Grammies in 1963. Singer Trini Lopez had an even bigger hit when his recording of the song hit #3 in 1963.

POPULAR FOLK GROUPS FROM THE EARLY SIXTIES

- Highwaymen
- The New Christy Minstrels
- Rooftop Singers

IMPORTANT EARLY SIXTIES GREENWICH VILLAGE FOLK ARTISTS

- Dave Van Ronk
- Tom Paxton
- Odetta
- Ramblin' Jack Elliott
- Tim Hardin
- John Sebastian

The Village had long been a magnet for artists, musicians, writers and bohemians, and by 1960 young aspiring folk musicians seemed to be everywhere. It was a compact and nourishing scene, where everyone knew and supported each other. Among the struggling folk performers in the Village at this time were Dave Van Ronk, Tom Paxton, Odetta, Ramblin' Jack Elliott, Tim Hardin, John Sebastian and Phil Ochs. These and other folk singers often took part in impromptu hootenannies on Sunday afternoons in Washington Square Park. These gatherings routinely drew so many listeners that police had to stop traffic. Folk music was heard in the many clubs and coffeehouses in the area, most of which had open-mic policies on Tuesday nights where singers, both unknown and famous, could get up and perform. These venues were known as 'basket houses' because the musicians were paid in tips that were collected in baskets that were passed around. The most important were The Gaslight, a basement coffeehouse on MacDougal Street; Café Wha?, which often hired up and coming comedians like Bill Cosby and Richard Prior, and where Bob Dylan made his first New York appearance; Gerde's Folk City on West 4th Street and Mercer (an Italian restaurant during the day); and the Bitter End on Bleecker Street. Folk music was so popular that for a while even the Village Vanguard, New York's premier jazz club was featuring it on off nights.

One of the most important establishments in the Village was Izzy Young's Folklore Center on MacDougal Street. Young was a folk enthusiast who opened the center in 1957 as a sort of clearinghouse for folk musicians. It was a place where you could buy instruments, sheet music, books and records, or just hang out and listen to records and talk. Young was one of Bob Dylan's most enthusiastic early supporters, and produced Dylan's first concert at Carnegie Chapter Hall in 1961.

Broadside

The Village had a long-standing tradition of publications that supported the folk scene. In 1946 *People's Songs*, a bulletin that promoted progressive causes through music was first published by Pete Seeger and Oscar Brand. This gave way in May

1950 to Sing Out!, which was dedicated to keeping folksingers and songwriters in touch by publishing left-leaning political songs, a risky endeavor at the time. It is still published on a quarterly basis. In February 1962, Pete Seeger and three other folk musicians began publishing a mimeographed biweekly newsletter called Broadside. Designed to showcase new folk and protest songs and provide articles about protests, festivals and recent record releases, Broadside provided a forum for the new generation of folk musicians to get their original songs noticed. Newsletters like People's Songs, Sing Out! and Broadside also provided outlets for the folk community to weigh in with criticisms and opinions of songs, events and new artists. Broadside gave a struggling young songwriter like Bob Dylan to write topical songs inspired by current events and get them published. One of Dylan's first songs, "Talkin' John Birch Paranoid Blues," a satirical piece about searching for communists was printed in the inaugural issue of the magazine. The next few years would be some of the most prolific in the long career of one of the most important figures in the history of American music.

BO3 DYLAN

Boy from The North Country

Bob Dylan was born Robert Zimmerman in Duluth Minnesota on May 24, 1941 to Abe and Beatty Zimmerman. Bob received a good Jewish upbringing, although his father made sure he was well versed in the New Testament as well.

The family moved north to Hibbing in 1947, where Bob stayed until he finished high school. He became interested in music, playing the piano and guitar and forming a rock and roll combo called the Golden Chords. His musical idols included Hank Williams, Little Richard and Elvis Presley. It was in high school that he began to experiment with various pseudonyms before eventually settling on Bob Dylan in honor of an idol, Welsh poet Dylan Thomas (he would also go by the names Blind Boy Grunt, Bob Landy and Robert Milkwood Thomas at various times in his life). Dylan enrolled at the University of Minnesota in the fall of 1959 and quickly became a fixture of the hip bohemian section next to campus known as Dinkytown. Because the Dinkytown coffeehouse scene was heavily tilted toward folk, Bob's interest in it supplanted his rock and roll leanings. He learned the traditional folk songs and performed them in his own idiosyncratic and sometimes humorous style, unlike the solemn way in which most Dinkytown folkies presented themselves. During this time Dylan read and was inspired by the works of the beat writers, but his biggest influence was Woody Guthrie's memoir Bound for Glory. In the book Guthrie created fictional characters that used unusual speech patterns such as clipped

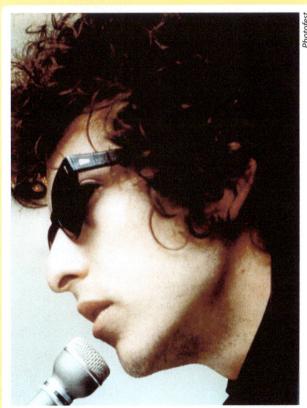

Bob Dylan

BEAT WRITERS

Writers such as Jack Kerouac, William S. Burroughs and Allen Ginsberg who gained notoriety in the 1950s and espoused a philosophy of existentialism and a rejection of materialism. Kerouac himself coined the phrase Beat Generation, and defined it for the Random House Dictionary: "Members of the generation that came of age after World War II, who, supposedly as a result of disillusionment stemming from the Cold War, espouse mystical detachment and relaxation of social and sexual tensions."

words, double negatives and non-sequiturs. Dylan began to adopt these in his own speech, along with a fascination for Guthrie and his music. Deciding he had to meet the folk hero, Dylan left for New York in late 1960.

Dylan arrived in Greenwich Village in late January 1961 and performed an open-mic set at the Café Wha? his first night in town. Within a week he succeeded in meeting Guthrie, who by this time was bedridden and delusional from his battle with Huntington's chorea. After the meeting Dylan wrote his first important song, "Song to Woody" and began to write other songs in Guthrie's talking blues style. Performing open-mic night sets and hanging out in the Village, Bob started to establish himself and make friends with locals such as Dave Van Ronk, Ramblin' Jack Elliot, Paul Stookey and Joan Baez. Even though he impressed the locals as intelligent and engaging, he was also mysterious, with far-fetched stories of his past. He soon worked his way into a Harry Belafonte recording session playing harmonica, which helped him get noticed by Columbia Records executive John Hammond. His big break came when New York Times writer Robert Shelton gave him a glowing review of a performance at Gerde's Folk City on September 29, 1961. Entitled "Bob Dylan: A Distinctive Song Stylist," the column convinced Hammond to sign Dylan to a five-year contract.

Hammond's Folly

Dylan's first album was a vocal, guitar and harmonica recording done in two days called simply *Bob Dylan* (released March 19, 1962). It contained two originals, including "Song to Woody" and an assortment of blues and traditional folk songs. The album sold poorly; around the Columbia offices it became known as **'Hammond's Folly'**. In spite of the setback, Dylan began to compose new songs with a fervor. They came through him with ease, as if he was channeling them from some unknown source. As Tom Paxton said, "He felt he wasn't writing songs, he was [just] writing them down. They were there to be captured." He kept notebooks and wrote everywhere, all the time; songs of topical interest, social commentaries, protest songs, love songs. "The Death of Emmett Till" was

RECORDINGS

- The Freewheelin' Bob Dylan, 1963
- The Times They Are A Changin', 1964
- Bringing It All Back Home, 1965
- "Like A Rolling Stone," 1965
- Blonde on Blonde, 1966

about the gruesome unsolved murder of a 14-year-old black boy in Mississippi. "Let Me Die in My Footsteps" was a commentary on America's preoccupation with fallout shelters and air raid drills. Two were strong anti-war songs, "Masters of War" and "A Hard Rain's A-Gonna Fall." Two more were about failing relationships, "Don't Think Twice, It's All Right" and "Tomorrow Is a Long Time." Writers of good, original songs were unusual in the Village, and word spread quickly. "Everybody's talking about him," said none other than Pete Seeger.

MUSIC CUT 47

"BLOWIN' IN THE WIND" (BOB DYLAN)—BOB DYLAN

Personnel: Bob Dylan: guitar, harmonica, vocals; Recorded July 9, 1962 at Columbia 7th Street Studio A, New York, NY; produced by John Hammond. Released May 27, 1963 on the Columbia LP *The Freewheelin' Bob Dylan*; released August 1963 as a single, did not reach Top Forty.

"Blowin' in the Wind," the opening track on Side A of Bob Dylan's second album The Freewheelin' Bob Dylan, is Dylan's first great anthem, and the song that is perhaps most associated with him to this day. It is an adaptation of the Negro spiritual "No More Auction Block," and is one of many examples of Dylan's appropriation of traditional songs for his own purposes (another song from the album, "A Hard Rain's A-Gonna Fall" was based on the folk ballad "Lord Randall"). Dylan himself admitted as much in 1978, saying, "Blowin' in the Wind' has always been a spiritual. I took it off a song called 'No More Auction Block'—and 'Blowin' in the Wind' follows the same feeling." He first performed the song at Gerde's Folk City in Greenwich Village on April 16, 1962, where several audience members recorded it. In May it was published for the first time in Pete Seeger's Broadside magazine, and in June it was published in Sing Out! In that magazine, Dylan said of the song, "There ain't too much I can say about this song except that the answer is blowing in the wind . . . Too many of these hip people are telling me where the answer is but oh I won't believe that. I still say it's in the wind and just like a restless piece of paper it's got to come down some." The song has an interesting verse structure, in that each verse contains a series of rhetorical questions that are usually interpreted as addressing human dignity, peace, and freedom. Each verse concludes with the ambiguous, "The answer my friend, is blowin' in the wind/The answer is blowin' in the wind." It has been widely regarded as an anthem to the civil rights era, and inspired Sam Cooke to write "A Change is Gonna Come" in 1964. "Blowin' in the Wind" has been covered many times, most famously by Peter, Paul and Mary, whose version went to #2 and sold over one million copies.

Dylan's second album, *The Freewheelin' Bob Dylan* (released May 27, 1963) consisted almost entirely of his new original material, including his first great anthem "Blowin' in the Wind." "Blowin' in the Wind" was composed in a café across the street from the Gaslight Club in just a few minutes, and within weeks it was being played throughout the Village by other folk singers. The song struck a chord with many in the community who pondered the meaning of its lyrics, set in the form of a series of rhetorical questions. Peter, Paul and Mary's 1963 cover of "Blowin' in the Wind" went to #2 on the charts, putting Bob Dylan on the national map for the first time. When they performed the song at the Newport Folk Festival in July, Peter, Paul and Mary brought Dylan onstage, introducing him as "the most important folk artist in America today" to a thunderous ovation. Bob had also endeared himself to the folk community in May when he refused to appear on the *Ed Sullivan Show* on May 12 when the CBS censors, fearing a lawsuit, requested that he not perform his intended selection

Name ____

Date

1.	Why did folk get a reputation as the music of left wing radicals?
2.	Why were Woody Guthrie and Pete Seeger so important, and what were some of their contributions to folk music?
3.	Who were some of the important players in the 1950s folk revival and what roles did they play?
4.	How did Jamaican music influence the folk scene in the 1950s?
5.	Why was the Greenwich Village scene so important?

Trad jazz Skiffle Pirate radio stations Teddy boy Reeperbahn Cavern Club Abbey Road Studios Beatlemania Our World Altamont Speedway Free Festival Mods Mersey Beat

The Beatles Brian Epstein George Martin The Rolling Stones Andrew Loog Oldham Jimmy Miller
The Who
Meher Baba
Herman's Hermits
The Hollies

The Dave Clark Five The Kinks The Yardbirds The Animals

Revolver—the Beatles
Sgt. Pepper's Lonely Hearts
Club Band—the Beatles
The Beatles—the Beatles
Abbey Road—the Beatles

Aftermath—the Rolling Stones Beggar's Banquet—the Rolling Stones Sticky Fingers—the
Rolling Stones
Tommy—the Who
Who's Next—the Who

THE BRITISH POP SCENE IN THE 1950S

Postwar England

In early 1964, the Beatles came to America for the first time. Their arrival had been highly anticipated for weeks: bumper stickers reading "The Beatles Are Coming" were popping up; grown men suddenly started wearing moptop wigs; the press was reporting the group's every move. When they finally touched down at New York's Kennedy Airport on February 7, there were approximately 10,000 screaming fans waiting (mostly teenage girls) who would have literally torn the group apart if not for the 100 police officers on duty. By the last week in March, they held the *top five* positions on the *Billboard* pop chart, with seven more records in the Hot 100, while their first two LP's were positioned at #1 and #2 on the album chart. But the Beatles were just the beginning. Like a dam bursting open, a flood of other English groups soon followed, sweeping American rock stars aside as they took control of radio playlists and record sales. The British Invasion of America had begun in earnest. And the music the Brits were playing? Their own unique brand of good old American rock and roll.

Throughout the years following WWII, English youth had absorbed whatever American music they could get their hands on. One of the first manifestations of this was a fascination with **trad jazz**—traditional New Orleans jazz. Trad jazz bands became popular throughout the country for a while, and a few recordings even became hits in the US. Somewhere in the mid-1950s, tastes changed to **skiffle**, an English adaptation of traditional American jug band music. The most popular English skiffle musician was Lonnie Donegan,

KEY TERMS

Trad jazz

Traditional New Orleans jazz, sometimes called Dixieland.

Skiffle A do-it-yourself music played by small groups, using guitars, washboards, empty jugs, etc.

whose "Rock Island Line" also became an American hit in 1956. Skiffle was easy to play, and the fad encouraged many British youth to start playing music, including Liverpudlians John Lennon and George Harrison. Once the skiffle fad wore out, British music fans turned to other indigenous American music styles, most notably the blues and R&B. By the late 1950s there was an entire generation of young people who were turning on to Muddy Waters, Chuck Berry, Little Richard, Bill Haley and Elvis Presley. Many were learning to play the songs they heard on the American records—and some were forming their own bands.

English Pop Culture

The English popular music culture in the 1950s and early 1960s was very different than in America. There were only three radio stations to choose from, all of which were run by the government sponsored British Broadcasting Corporation (BBC). The closest any of these came to programming pop was the BBC Light, which played light opera, musical comedy, and light orchestral music for dancing—but it was hardly the kind of station where one might hear American R&B. There were only four major record labels, the largest of which were EMI and Decca. There were few independent labels willing to take risks on wannabe pop stars like there were in America, and American records heavily dominated the English pop charts. With few opportunities to break into the national music scene, up until the early 1960s most rock and roll bands in the UK were pale imitations of their American counterparts. However, the Beatles proved that Brits *could* rock, and after their 1964 landing on American soil, they and other bands from across the pond began to have a dramatic impact on the American music industry. The chart below is indicative:

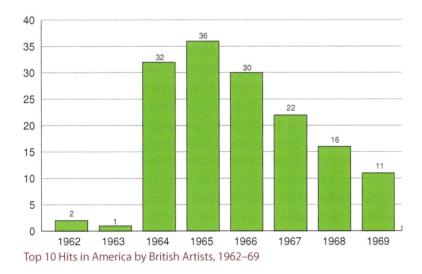

Of course, the British Invasion started with the Beatles, and our story begins with them.

THE BEATLES MPACT ON ROCK

- 1. The Beatles are the most popular rock group in history, with worldwide sales of all albums, singles, music videos and downloads estimated at 600 million.
- More than anyone or any group, the Beatles made rock the dominant pop music format that transcended age and demographic. It was no longer music just for teens.
- 3. The Beatles changed the way music was recorded and presented; they constantly pushed the envelope with their use of studio technology; they pioneered the basic format for contemporary music videos; and they were innovative in their music packaging.
- 4. The Beatles transcend generation and era; although they are a symbol of the 1960s, their music does not sound out of date today. It is still fresh and meaningful, and still appeals to all ages.
- 5. They combined exceptional songwriting and performing both live and in the studio as no other artist(s) in the 20th century.
- 6. They forced the recognition of pop music as art, and were the forerunners of art rock.

At the heart of the Beatles' magic is the coming together of two powerful yet very different musical forces that in friendly competition brought out the best in each other. John Lennon and Paul McCartney could never have achieved the greatness they did on their own. They clicked immediately.

While the Beatles were influential to music and culture of the 1960s, it's clear that from the beginning they absorbed influences from everything and everywhere, including the blues, American R&B, doo-wop, Tin Pan Alley, country, European classical music and Indian music. It's easy to hear the Little Richard in the "oooooo" of "She Loves You," the Bob Dylan in the raspy vocals of "You've Got to Hide Your Love Away," the Carl Perkins in the jangly guitar of "Run For Your Life" and the Brian Wilson in the intricate melody of "Here, There and Everywhere." They absorbed the psychedelic zeitgeist of the San Francisco scene and the larger than life production ethic of Phil Spector. But perhaps the greatest influence on the group came from producer George Martin. It was he who guided the band in their formative early years, offering gentle suggestions without being overbearing or heavy handed. Martin turned them on to the possibilities of new instruments and orchestration, studio effects and technology. He was smart enough to never say, "You can't do that!" to the curiosity, creativity and imagination that emerged from the band. The Beatles without the steadying hand of George Martin simply would not have been the Beatles as we know them today.

At the heart of the Beatles magic is the coming together of two powerful yet very different musical forces that in friendly competition brought out the best in each other. John Lennon and Paul McCartney could never have achieved the greatness they did on their own. They clicked immediately—they were inseparable in the early days, writing songs together, harmonizing together, or letting the other finish a song when they got stuck. But the competitive nature of their friendship was also hard work, and in the end, when it finally burned itself out, the group broke up.

- 1. All four were great musicians; even Ringo, albeit not the greatest drummer of the era, made impressive contributions to the band.
- 2. The variety of instruments they played was staggering: Paul, the bassist, also played piano, acoustic and electric guitar, and drums; John played guitar, piano, harmonica and banjo; George played guitar, sitar, tamboura, bass, violin, synthesizer and organ; and Ringo played drums and all sorts of percussion instruments.
- 3. They were great singers—John and Paul were simply two of rocks best. The combination of John, Paul and George singing harmony was powerful and exciting on rockers, gorgeous on ballads.
- 4. Their compositions cover a diversity of styles that was unprecedented: from hard rockers ("Helter Skelter"); to tender ballads ("She's Leaving Home"); world music ("Within You, Without You"); the avant-garde ("Revolution 9"); children's songs ("Yellow Submarine"); folk ("Blackbird"); and Tin Pan Alley ("When I'm Sixty-Four"). Although Lennon and McCartney often wrote together to one degree or another, each had unique styles. John tended to write songs that were more complicated rhythmically, simpler melodically and often more avant-garde. Paul was a superior pop craftsman in the Brill Building mold, writing some of the most endearing pop tunes of the last 50 years ("Yesterday" has been covered by more artists than any song in history), while also bringing a classical music influence.
- 5. The lyrics, among the most meaningful of their generation (along with those of Bob Dylan), reflect the different styles of the two main writers. (One way to identify the authorship of a Beatles song is by identifying the lead singer.) John tended to write songs about himself, asking questions and seeking answers that were both personal, yet could be viewed in the larger communal sense as well. Paul tended to write songs about other people, pointing out the peculiarities of their lives or situations they were in. Of course, there were exceptions to this rule—John's "Good Morning, Good Morning" is written in the fashion of Paul; Paul's very direct and personal "Let It Be" is more typical of John.
- 6. Often the important contributions of George and Ringo are overlooked. George Harrison was without exaggeration one of the best guitarists in the 1960s, creating some of the most melodic and lyrical solos of the era. He was a master of studio technology, utilizing a huge variety of sounds and effects. By the time the group broke up, he had also turned into a great songwriter—his "Something" is the second most covered Beatles tune. In addition, he turned in several other masterpieces, such as "Here Comes The Sun," "Taxman" and "Within You, Without You." His interest in Indian music and culture inspired the conception of the world music movement. Ringo was the perfect compliment for the other three, never competing for attention, often playing understated but perfect parts. And, he contributed some of the most memorable lead vocals as well ("Yellow Submarine").

THE CONTRIBUTIONS OF JOHN, PAUL, GEORGE AND RINGO

The Early Years

The story of the Beatles begins in Liverpool in the early 1940s as Britain was engaged in World War II. As an important seaport on Britain's northwest shore, the city was a target for German bombers and had suffered mightily during the Battle of Britain in the fall of 1940. The very night John Lennon was born, October 9, 1940, bombs were falling outside the maternity home where he lay with his mother Julia. Sunken ships littered the Mersey River. But the city survived.

Liverpool in the 1950s was an interesting town: despite its working-class ethic and depressed economy, it was a sponge for pop culture from America, especially the rock and roll records brought over by sailors. As the rock and roll culture of American youth flourished, the English counterpart of the 'cat' was born: the **Teddy boy**. Teddy boys greased their hair up and wore leather jackets, boots and sneers. Although young John Lennon was not yet a Teddy boy in 1956, he was so completely taken with Elvis Presley that he put together his own group called the Quarry Men—named after the Quarry Bank Grammar School he attended. Sometime after Paul McCartney first heard the group play on July 6, 1957, he ended up auditioning for them—and got the job. Lennon and McCartney had one thing in common besides their love for music: both of their mothers had recently died, and their pain clearly had a bonding effect on them. Each would later write love songs to their mums—Lennon's "Julia," and McCartney's "Let It Be." McCartney soon brought along his schoolmate, George Harrison to play lead guitar. Even though he was only 14 years old at the time, George could play solos, while John and Paul could only strum chords. The drummer was Lennon's friend Pete Best, who stayed with the group until 1962.

The Audition

By 1960, the group had changed its name to the Beatles, and added Stu Sutcliff on bass (Sutcliff quit the next year to pursue a career in art). Beginning in August, they played the first of a string of engagements over a two-year period in the raunchy clubs in the **Reeperbahn** section of Hamburg, Germany. It was here that the Beatles honed their group sound, as they were often required to play for up to eight hours a night. In early 1961 they first appeared at Liverpool's **Cavern Club**, a dank, underground pub where they performed nearly 300 times over the next two and a half years. By the time they played their last Cavern Club show, they were drawing long lines to see their polished, high-energy shows. The Beatles were becoming a phenomenon, both locally and regionally.

In late 1961, **Brian Epstein** (1934–1967), the manager of the nearby NEMS record store became the Beatles manager and quickly went to work. Over the next few months, the groups Teddy boy image changed to more upscale matching mohair suits with white shirts, thin ties and mop top haircuts. Although Epstein searched for a record contract for the group, his initial efforts were in vain: the only label that expressed any interest at all was industry giant Decca, who quickly turned them down. Finally, as Epstein was exhausting his options, he managed to get his foot in the door at EMI's small Parlophone subsidiary. His contact was **George Martin** (1926–2016), a classically trained composer and staff producer at EMI, who was willing to give the group an audition. On June 6,

1962, the Beatles went into the London office building on Abbey Road where the EMI studio (later referred to as **Abbey Road Studios**) was located and recorded four songs. Martin decided to sign them, although he was admittedly not so much impressed with their music as he was with their personal charm. "It was love at first sight . . . we hit it off straight away . . . the most impressive thing was their engaging personalities."

Beatlemania!

After the Beatles signed with Parlophone, things began to happen very quickly. The band went to work on their first album amid a hectic touring schedule. After the audition, Martin told them they had to replace Best, which they did with their friend Richard Starkey, who went by the name Ringo Starr. Four songs were recorded on various off days, and the other ten were recorded in one ten-hour marathon on February 11, 1963. The resulting album was called *Please Please Me*. Eight of the songs on the LP were originals, highly unusual at the time for a debut album. At this point, many of the songs were written by John and Paul 'eyeball to eyeball'; however, even in the early days, the two were also writing apart from each other, often only getting help from the other for a hook or extra phrase. The Beatles first single, "Love Me Do," (written by Paul) and their first #1 (UK), "Please Please Me," (written by John) came from these sessions. Ringo did not play on two of the songs—producer Martin felt that his playing wasn't up to par, so session drummer Andy White was used instead.

The band continued their hectic touring schedule as their popularity soared throughout England. By July 1963, they went back into the studio to start on the second album entitled *With The Beatles*. It was released on November 22, 1963, (the day that John F. Kennedy was assassinated) and immediately went to #1 (UK) where it stayed for 21 weeks. The album is a mix of originals (including "All My Loving" and "I Wanna Be Your Man") and covers (such as "Roll Over Beethoven" and "You Really Got a Hold on Me"). By this time fans all over England were constantly mobbing the group whenever they appeared in public. After a performance at London's Palladium in October, the *Daily Mirror* coined the term 'Beatlemania!' in a headline, and it stuck.

Coming to America

Initially, Beatlemania went largely unnoticed in America (due in large part to the preoccupation with the Kennedy assassination), but it hit with sudden and tremendous impact. The group's first appearances on *The Ed Sullivan Show* on February 9th, 16th and 23rd were viewed by approximately 73 million people each, the largest audiences in the 23-year history of the program. EMI's American subsidiary, Capitol Records, had been slow to release any Beatles singles, but when the first, "I Want to HoldYour Hand" was finally released in January 1964, it shot straight to #1 where it stayed for seven weeks. By the end of March, the Beatles held the top five records in America: #1: "Can't Buy Me Love," #2: "Twist and Shout," #3: "She Loves You," #4: "I Want to Hold Your Hand" and #5: "Please, Please Me."

July 10, 1964 saw the release of the third album, A Hard Day's Night, which stayed at #1 for 21 weeks (only to be knocked off by the group's next album).

A Hard Day's Night is significant on several accounts: it is the first Beatles album in which a 4-track tape machine was used, which allowed them to overdub parts and begin using the studio in more innovative ways. It is also their only album consisting entirely of Lennon and McCartney songs. A Hard Day's Night was a tie-in to the pioneering feature film of the same name, whose jocular plot evolves around whether the Fab Four would make it through another madcap day of being chased by fans. Directed by Richard Lester, the film is a blue-print for many of the first music videos made in the 1980s. The album itself is a tour de force for Lennon, who wrote most of the songs, including the title track (inspired by one of Ringo's favorite catch phrases), the lovely "If I Fell" and "I Should Have Known Better." McCartney's contributions, while fewer in number, were still noteworthy, including "Can't Buy Me Love" (a beautifully disguised 12-bar blues) and the tender "And I Love Her."

MUSIC CUT 51

"HARD DAY'S NIGHT" (LENNON/MCCARTNEY)— THE BEATLES

Personnel: John Lennon: vocals, guitars; Paul McCartney: vocals, bass; George Harrison: 12-string electric guitar; Ringo Starr: drums, percussion; George Martin: piano. Recorded April 16, 1964 at Abbey Road Studios, London; produced by George Martin. Released July 10 (UK), July 13 (US), 1964 on Parlophone (UK), Capitol (US); 13 weeks on the charts, peaking at #1.

There is so much to unpack about the title cut to the Beatles' third album, from how it got its name, to the opening chord, to how it inspired the group's first feature film, that a short synopsis will only scratch the surface. So, let's just say that above and beyond everything else, the song perfectly embodies all the qualities that made the early Beatles music so irresistible. By the time "Hard Day's Night" was released, Beatlemania was in full force, and it became the fifth of seven singles by the group that hit #1 in a one year period. In early August, both the album and the single achieved #1 status in both the UK and the US, a feat that had never been accomplished before. The title is attributed to Ringo, who supposedly said after a concert, "Phew, it's been a hard day's night." Inspired by what he called Ringo's malapropism, John apparently wrote the song in one evening, and with a writing little help from Paul the next day at the studio, the band completed the recording just in three hours. And about that opening chord: better Google it.

The fourth album, *Beatles For Sale*, released on December 4, 1964 was the first Beatles LP to receive luke-warm critical acclaim. In many ways it is a reflection of the rigors of Beatlemania—constant touring, constant screaming mobs, no privacy—which made writing difficult. As George Martin put it, the band was "war weary." However, there were still some gems: "Eight Days a Week," a collaborative effort from John and Paul actually fades *in*, on of the first examples of the group trying out new ideas in the studio. John's "I'm a Loser" philosophically questions the high price of fame. The album was filled out with several covers, including Chuck Berry's "Rock and Roll Music," Leiber and Stoller's "Kansas City" and two Carl Perkins tunes, "Everybody's Tryin' to Be My Baby" and "Honey Don't."

Meeting Dylan

The first album to signal the experimental future of the Beatles recordings was *Help!*, released on August 6, 1965. Part of the evolution was the result of the famous meeting with Bob Dylan in the summer of 1964 at New York's Hotel Delmonico. Dylan and the Beatles reportedly spent several hours hanging out and smoking marijuana. The meeting was an epochal moment in rock, as Dylan's influence was immense and immediate, revitalizing the group at the very moment that they were ready to evolve both musically and lyrically (as mentioned in chapter 5, the Beatles also had a profound influence on Dylan). From this point on, the lyrics of McCartney and particularly Lennon and Harrison began to take on increasing social, political, and cultural significance. The group also began to expand into more musically diverse styles, evidenced on *Help!* by the use of outside session musicians for the first time (a flautist at the end of "You've Got to Hide Your Love Away" and strings on "Yesterday"). Lyrically and musically from this moment on the Beatles would begin to change rock into an art form.

Help! was the first album in history to have an advance order of over one million copies. It was also a tie in to the group's second movie, once again directed by Richard Lester. The title song, composed by John, was written as an expression of his self-loathing 'Fat Elvis' period: tiring of the trappings of wealth and fame, he was drinking and eating too much, bored with his marriage and with living in the suburbs. Dylan's influence is overpowering on Lennon's "You've Got to Hide Your Love Away." Tucked away near the end of Side B is McCartney's masterpiece "Yesterday," uniquely set to only acoustic guitar and string quartet accompaniment (arranged by Martin). It became the most performed pop song in the world for the next several years.

Coming of Age

Rubber Soul is often considered the Beatles 'coming of age' album. Released on December 3, 1965, it is comprised of 14 original songs written over a four-week period. With a number of songs tackling social issues, Rubber Soul shows more lyrical depth and intelligence than any previous release. Musically and instrumentally the album is a harbinger of things to come, as the Beatles introduce a variety of new instruments, including sitar on Lennon's "Norwegian Wood" and fuzz bass on Harrison's "Think For Yourself." There is also a baroque piano solo played by George Martin on John's autobiographical "In My Life" recorded at half speed to make it sound like a harpsichord when played back at normal speed.

On August 5, 1966, the Beatles released *Revolver*, an album that many call their finest work. It is also considered to be the first album of the psychedelic era because of its use of exotic instruments, studio effects and several drug allusions. Where *Rubber Soul* headed, *Revolver* continued on to the next level. There are no 'fillers' on the album, as every song has merit, and most are brilliant. George Harrison contributed three strong tracks: "Taxman," a social commentary about the high taxes in Britain for the wealthy; "Love You To," written specifically for sitar and tablas (recorded using only himself and Indian musicians), possibly the first piece of the coming 'world music' movement; and "I Want to Tell

"TOMORROW NEVER KNOWS" (JOHN LENNON/ PAUL MCCARTNEY)—THE BEATLES

Personnel: John Lennon: organ, tambourine, tape loops, lead vocals; Paul McCartney: bass, drums, tape loops, guitar; George Harrison: guitar, sitar, tape loops; Ringo Starr: drums, tape loops; George Martin: piano, tape loops. Recorded April 6, 1966 at Abbey Road Studios, London; produced by George Martin. Released August 5, 1966 on the Parlophone LP *Revolver*; not released as a single.

As the first song recorded for *Revolver*, "Tomorrow Never Knows" set the tone for the album and for the psychedelic era. The foundation for the song, a one-chord drone, was made by creating a tape loop of John and Ringo playing a simple riff that engineer Geoff Emerick configured to play continuously. On to this was added such otherworldly effects as a sitar drone, cut up tape loops of Paul laughing (which sound like science fiction seagulls) and a backwards guitar solo. One of the more interesting effects came as a result of John's request to, "Make me sound like the Dalai Lama chanting from the mountaintop." Emerick, in his first of many sessions as engineer for the group, responded by running John's voice (in the verse after the guitar solo) through the rotating speakers of a Leslie tone cabinet, which is normally used for a Hammond organ.

You." Lennon contributed six, including three with drug references ("She Said She Said," "Dr. Robert" and "Tomorrow Never Knows"). "Tomorrow Never Knows" was inspired by Timothy Leary's *The Psychedelic Experience*, a guide to spiritual enlightenment through the use of LSD based on *The Tibetan Book of the Dead*. McCartney's contributions were more of his usual well-crafted pop gems, including the haunting "Eleanor Rigby," the tender "Here, There, and Everywhere" inspired by Brian Wilson's "God Only Knows," and the sing-along children's song "Yellow Submarine."

Sgt. Pepper's

After the release of *Revolver*, the Beatles announced their decision to discontinue touring. Although they had toured worldwide since 1963 with spectacular success, live concerts were plagued by poor sound reinforcement and screaming mobs; now their music was getting too dependent on studio technology to be reproduced adequately in a live setting. Their last concert was at Candlestick Park in San Francisco on August 30, 1966. The announcement fueled rumors that the Beatles were about to break up, which the lack of their expected year-end album release only intensified. To silence critics, on February 17, 1967 the band released "Penny Lane" and "Strawberry Fields Forever" as two A sides on one single. Both songs are remembrances of real places in Liverpool from McCartney and Lennon's childhoods.

"Penny Lane" and "Strawberry Fields Forever" were originally supposed to be included on the group's next album, the highly anticipated *Sgt. Pepper's Lonely Hearts Club Band*, released on June 1, 1967. Restless fans and critics were overjoyed, and for several months in the summer of 1967, it captivated the world of popular culture. The album took five months and 700 hours to record and cost an unheard of \$100,000. Stemming from Paul's idea to fabricate an alter ego band where each Beatle could assume the role of another musician, the

album was originally intended to give the experience of having attended a royal performance, with each song segueing into the next. In the end, only the first two songs were done this way, but with an overture to open Side A, a reprise of the overture and an encore to close out Side B, the effect is nearly the same. *Sgt. Pepper's* also contains what is arguably the most famous music album cover in history, showing celebrities and famous people gathered around the Beatles in costume. It is the first album to print song lyrics on the inside cover. *Sgt Pepper's* is also noteworthy for the stunning use of studio technology, used with great skill and effect throughout. The album's encore, the Lennon/McCartney collaboration "A Day in the Life" is a chilling commentary on bureaucracy, materialism and the specter of nuclear annihilation, and is perhaps their finest work.

All You Need Is Love

After the release of *Sgt. Pepper's*, the Beatles took part in the first worldwide satellite TV broadcast on the program *Our World*, performing Lennon's "All You Need Is Love" live to 350 million viewers. Then, in August, the band suffered a major setback when manager Brian Epstein died from an accidental drug overdose. From this point on the Beatles would try to manage themselves, one of the first of many bad business decisions that ultimately contributed to the group's downfall. In February 1968, the band, along with actress Mia Farrow and her sister Prudence, the singer Donovan, Mick Jagger, the Beach Boys' Mike Love and assorted girlfriends all went to the ashram of guru Maharishi Yogi in Rishikesh, India to learn about Transcendental Meditation. Within just a few weeks the group ascertained that the Maharishi was a charlatan, and one by one returned home to England. Lennon later wrote the vindictive "Sexy Sadie" about the experience, which appeared on the upcoming *White Album*.

Magical Mystery Tour, a six-song double EP (an 'extended play' 45-rpm) was released on December 8, 1967, accompanying the film of the same name. The movie and artwork of the EP was inspired by the cross-country journey of Ken Kesey and his Merry Pranksters in their psychedelic bus Further (see chapter 7). Although the EP was panned by the critics as too self indulgent, sloppy and not very good, it did contain John's brilliantly bizarre and surrealistic "I Am the Walrus," whose two note melody was inspired by the sound of an English police siren. In the months following the release of Magical Mystery Tour, the Beatles released two singles written by Paul, "Lady Madonna," and "Hey Jude," the latter ultimately becoming their best selling single with sales of nearly ten million copies.

Impending Doom

By the time *The Beatles* (aka *The White Album*) was released on November 22, 1968, the inner tensions that would eventually break the band apart were surfacing. Lennon and McCartney were losing control of their song publishing rights, and Apple, their new but poorly managed production company was losing money. John's new loverYoko Ono was a constant presence, and an often-unwelcome one at that (she would often submit criticisms at recording sessions, and at one point when she was ill, John even rolled a bed into the studio for her). Other signs of impending dissolution were becoming apparent: George began recording a solo album, Ringo quit for a few days when he discovered that Paul

was re-recording the drum parts himself after Ringo left the studio. Nonetheless, *The White Album* is a remarkable double album with 30 songs that cover a wide range of styles. Many of the songs were recorded without the full group in attendance, giving the effect of John, Paul and George essentially taking turns doing solo pieces with backing musicians. Some of the groups best material can be found on *The White Album*, including John's "Happiness is a Warm Gun," "Julia" and the avant-garde "Revolution 9;" Paul's "Blackbird," "I Will" and "Ob-la-di, Ob-la-da;" and George's "While My Guitar Gently Weeps" (featuring his friend Eric Clapton on guitar) and "Piggies."

1969 saw the release of *Yellow Submarine*, which is often called the worst Beatles album, a manifestation of the ever-worsening band morale. Only six songs are on the album, two of which had already been released. Side B of the album contains orchestral scorings by George Martin from the accompanying movie.

The End

The next album recorded was not immediately released. Let It Be was originally planned as a no overdubs, back-to-live concept to be called Get Back. To get a truly live recording, the Beatles staged a surprise noontime concert on the rooftop of Apple's Savile Row offices on January 30, 1969 and performed five songs (including Paul's "Get Back") before the police shut them off because of neighbor's complaints. The concert was filmed, as were most of the sessions, and were included in the accompanying documentary of the same name. However, with tempers flaring over Paul's overbearing control and the worsening management situation, the task of finishing the project was just too much for the band. George Martin quit; George Harrison walked out for a few days. By the time the recording was done, no one wanted to stick around to mix it, so the job was left to a session engineer. The resulting mixes were sloppy with too many mistakes, so Phil Spector was brought in to re-produce the entire album. Spector added lush string orchestration to some of the songs, including Paul's "The Long and Winding Road," which angered McCartney. In the end, Let It Be was unsatisfying to everyone involved, and not released until May 8, 1970, after the Beatles had broken up.

The last album recorded by the Beatles was *Abbey Road*, (released September 26, 1969) and it is perhaps their finest work. George Martin was persuaded to return as producer, and by this time the studio had installed a new eight-track recorder for the band to use for the first time. Synthesizers were also used for the first time on several of the songs. Once again, George Harrison contributed two very fine songs, "Something" and "Here Comes the Sun." Lennon's contributions include "Come Together," based loosely on Chuck Berry's "You Can't Catch Me" and "Because," inspired by hearing Yoko play Beethoven's "Moonlight Sonata" backwards. The centerpiece and masterstroke of Abbey Road is the 16-minute, eight-song medley that closes Side B. The songs, written mostly by Paul, seamlessly segue together and cover a variety of styles, from the serenely beautiful "Sun King," the polka-like "Mean Mr. Mustard," the tonguein-cheek "Polythene Pam" and ending up with the rocking "The End." The last song features a jam session where Lennon, McCartney and Harrison trade twobar guitar solos before closing with the words, "And in the end, the love you take/Is equal to the love you make." A fitting finale to leave their millions of fans.

"HERE COMES THE SUN" (GEORGE HARRISON)— THE BEATLES

Personnel: George Harrison: lead and backup vocals, guitars, harmonium, Moog synthesizer, hand claps; Paul McCartney: backup vocals, bass, handclaps; Ringo Starr: drums, handclaps; studio orchestra of four violas, four cellos, bass, two piccolos, two flutes, two alto flutes, two clarinets is uncredited. Recorded July 7-August 19, 1969 at Abbey Road Studios, London; produced by George Martin. Released on the album *Abbey Road*, September 26, 1969 on Apple Records; not released as a single.

"Here Comes the Sun" was written in the Beatles final year, and at a time when being a Beatle was taking its toll on the group, especially George Harrison. Of its origin, he wrote that the song, "was written at the time when Apple (their self-owned production company) was getting like school, where we had to go and be businessmen: 'Sign this' and 'sign that.' Anyway, it seems as if winter in England goes on forever, by the time spring comes you really deserve it. So, one day I decided I was going to sag off Apple and I went over to Eric Clapton's house. The relief of not having to go see all those dopey accountants was wonderful, and I walked around the garden with one of Eric's acoustic guitars and wrote "Here Comes the Sun." The song was recorded over several sessions in the summer of 1969 without full participation by the group, which by this point in time was their standard operating procedure. (John Lennon did not participate in the recording at all.) "Here Comes the Sun," along with his other contribution to *Abbey Road*, "Something," reveals Harrison to be at the height of his songwriting prowess, on par with the more celebrated Lennon and McCartney.

The Beatles breakup was messy. Although Paul had lobbied the others on the idea of a return to performing live at small clubs without public announcement, John had had enough. In September he announced to the rest of the band that he "wanted a divorce," but was persuaded by McCartney to remain silent to keep from jeopardizing pending business dealings. In the ensuing months, McCartney went to work on his solo album debut, and ultimately came to the conclusion that he too wanted out. When McCartney was released on April 10, 1970, its liner notes included a faux self-interview in which Paul implied that the Beatles were done. Lennon, who had kept his desire to quit a secret out of respect for Paul, felt betrayed. Business entanglements, lawsuits and Lennon's anger would continue on for years, but one thing was clear: the Beatles would never record or perform together again.

The Aftermath

After the breakup of the band, solo albums were forthcoming from Lennon and McCartney. Now that they were no longer chained together, each was free to pursue his natural musical instincts. McCartney continued to write well-crafted pop tunes, but without Lennon's gravity they became lightweight and sugary sweet. In 1972 he formed Wings with wife Linda Eastman, whom he married in 1969. Nine #1 hits followed, including duets with Stevie Wonder and Michael Jackson. In 1971, George Harrison organized the first ever All-star concert to raise money for a cause, the Concert for Bangladesh, which raised over \$10 million for the people of that country. In 1988 he formed the Traveling Wilburys with friends Bob Dylan, Tom Petty, Jeff Lynne and Roy Orbison. Harrison died

"MY GENERATION" (PETE TOWNSHEND)— THE WHO

Personnel: Roger Daltry: lead vocals; Pete Townshend: guitar, backup vocals; John Entwistle: bass, backup vocals; Keith Moon: drums. Recorded October 13, 1965 at IBC Studios, London; produced by Shel Talmy. Released October 29, 1965 on Brunswick (UK); 13 weeks on the charts, peaking at #2 (UK). Highest chart position in the US: #74.

"My Generation" was written by Pete Townshend on his 20th birthday as he rode a train from London to Southampton for a television appearance. He was coming of age and confronting the vulnerabilities of youth, and the song "was very much about trying to find a place in society. I was very, very lost. The band was young then. It was believed that its career would be incredibly brief." What Townshend and the band ended up with is more than just a manifesto of youth; it is nothing less than a f*** you to their elders and the establishment. Much has been made of the line "Hope I die before I get old," of course, but there is so much else packed into this performance. The gnarly guitar chords that open the song, Roger Daltry's angry vocal delivery, complete with stutters, Keith Moon's hyper frenetic drumming, John Entwistle's bass solo . . . a bass solo on a pop record? And then there is the end; the song literally self-destructs before our very ears. A perfect aural complement to the live stage destruction the Who were becoming famous for. This is punk before punk was cool.

Monterey

In December, 1966 the second album A Quick One was released (titled Happy Jack in the US) which featured a ten-minute mini-opera and the single "Happy Jack." With little success in the US market up to that point, the Who embarked on a tour of America in the summer of 1967 that included a stunning performance at the Monterey Pop Festival. Their show concluded with Townshend and Moon again destroying their equipment while playing "My Generation." The band capitalized on the media stir that followed with the hit "I Can See for Miles," which at #9 became their best ever US chart appearance. With Townshend's deafening power chords and Moon's bombastic drumming, "I Can See for Miles" is a predecessor to heavy metal. The song was part of the December 15, 1967 album The Who Sell Out, a concept album built on the premise of being a broadcast from the offshore pirate station Radio London that included faux radio jingles and ad parodies on the cover.

By this time the Who's stage act was a flurry of perpetual motion: Townshend attacked his guitar with a windmill right hand as he leapt across the stage; Moon was a wild man on his huge drum set which included two bass drums; when not screaming into the microphone, Daltrey would swing it by the cord as if he was roping cattle. In the midst of all this, bassist Entwistle stood statue-like, seemingly oblivious to everything. Much of the fury on stage was fueled by the constant amphetamine and alcohol usage by the band members, which also intensified the frequent personality clashes between Daltrey and Townshend, who battled over control of the band. (At one point, Daltrey was even kicked out of the band for a while and was not let back in until he promised to become less combative.)

Tommy

In 1968, Pete Townshend became a follower of the Indian guru **Meher Baba** (1894–1969), stopped taking drugs and began to reflect upon ways in which to define his new spirituality through music. He came up with the idea of

telling a story of spiritual enlightenment through song lyrics rather than the conventional spoken narrative accompaniment. It would be in effect, a rock opera, the first of its kind. Released in 1969 and named after its main character, *Tommy* is the story of a boy who traumatically loses all sensory skills—becoming deaf, dumb and blind—and becomes famous for his superior skills at playing pinball. After he is miraculously cured, he is manipulated into selling his secrets and exposed as a fraud. The story line was one that could be interpreted on several levels by a wide range of people; but most of all, the music in the 90-minute *Tommy* is exceptional, from "Underture," "Pinball Wizard," "See Me, Feel Me," "We're Not Gonna Take It" and others. *Tommy* became a critically acclaimed hit and put the Who at the front of the creative vanguard in rock. It was turned into a controversial film in 1975 and a Broadway musical in 1993.

In August 1969 the band appeared at Woodstock, and their set is one of the highlights of the documentary film. In 1970 *Live at Leeds* was released, capturing the Who live in concert and cementing their reputation as one of the most dynamic live acts in history. Not taking time to bask in the glory of *Tommy*, Townshend began work on his next project, which was to be an album and science fiction film entitled *Lifehouse*. Because the enormous scope of the project proved to be too much for Townshend, *Lifehouse* was never fully realized. However, four of the songs were included in the 1971 LP *Who's Next*, which like *Tommy* and *Live at Leeds* went to #4 on the album charts. Included on *Who's Next* are two stunning and innovative pieces, "Baba O'Riley" (named for Meher Baba and minimalist composer Terry Riley) and "Won't Get Fooled Again," in which Townshend programmed an ARP 2600 synthesizer to provide a sequenced foundation for the songs to be built upon. Both songs became staples of FM radio playlists.

MUSIC CUT 58

"WON'T GET FOOLED AGAIN" (PETE TOWNSHEND)— THE WHO

Personnel: Pete Townshend: guitars, synthesizer programming (Arp 2500, EMS VCS 3), organ; Roger Daltry: vocals; John Entwistle: bass guitar; Keith Moon: drums. Recorded April-May 1971 at Rolling Stones Mobile Studio, Stargroves, Berkshire, England, and Olympic Studios, London; produced by the Who and Glyn Johns. Released June 25, 1971 MCA; 10 weeks on the charts, peaking at #15.

"Won't Get Fooled Again" is one of two innovative songs (the other being "Baba O'Reilly") built around synthesizer foundations from the 1971 LP *Who's Next*. The signature sound of the song is the repeating organ sequence that continues through most of its 8-1/2 minutes. Townshend created the sound by playing chords on a Lowrey organ and feeding its output into a sample and hold filter on an Arp 2500 synthesizer and then a low frequency oscillator (LFO) on an EMS synthesizer. For its single release the song was edited down to 3-1/2 minutes. Of the song's meaning, Townshend has said, "It is not precisely a song that decries revolution—it suggests that we will indeed fight in the streets—but that revolution, like all action can have results we cannot predict. Don't expect to see what you expect to see. Expect nothing and you might gain everything." However, he also acknowledged the impact that Daltrey's inspired performance had on the song: "When Roger Daltrey screamed as though his heart was being torn out in the closing moments of the song, it became something more to so many people. And I must live with that."

Final Triumph, Tragedy

In 1973 Townshend completed his second rock opera, the double album *Quadrophenia*, which charted at #2. The hero, Jimmy is a member of the mid 1960s London mod scene with a four-way split personality, which reflected the personalities of each of the Who's band members. The story is a "study in spiritual desperation" which leads Jimmy to the realization that "the only important thing is to open [his] heart." Like *Tommy*, *Quadrophenia* was critically hailed and turned into a film in 1979. In 1978, the aptly named *Who are You* was released as Townshend began to experience somewhat of an identity crisis as he agonized over becoming an elder statesman in the wake of the punk movement. Almost simultaneously, on September 7, 1978, Keith Moon died of an overdose of a sedative he had been taking to treat alcoholic seizures. Although the group continued on for another three years with Kenney Jones on drums (formerly of the Small Faces), the group was never the same again.

Although Townshend at first downplayed it, Keith Moon's death affected him deeply, and he returned to heavy drug and alcohol abuse in the early 1980s (although he eventually cleaned up and became active in drug rehab projects). In the post Moon years, the remaining members of the Who involved themselves in solo album projects and regrouped periodically to tour. In October 2001 they played the Concert for NYC, a benefit concert for families of the victims of the September 11 attack on the World Trade Center. Since the June 2002 death of bassist John Entwistle, Townshend and Daltry have continued to tour as the Who with a variety of backing musicians.

OTHER BRITISH INVASION BANDS

The Mersey Beat Groups

In the wake of the Beatles success, many of the first wave of British Invasion bands sounded predictably very much like the Fab Four. Because there were reportedly more than 300 bands in Liverpool alone in the early 1960s, it was inevitable that a few would make it to the charts. The style of these bands—upbeat and joyous, with a relentless drive—became known as **Mersey Beat** (from the Mersey River), or simply beat. One of the first Liverpool groups was Gerry and the Pacemakers, who like the Beatles, were signed by Brian Epstein, played Hamburg and the Cavern Club, and produced by George Martin. Formed in 1959 as a skiffle band, the Pacemakers had three UK #1 hits in 1963 and hit in the States with "Don't Let the Sun Catch You Crying" (#4) in 1964 and "Ferry Across the Mersey" (#6) in 1965. Also from Liverpool were the Searchers, whose sound could best be described as a precursor to the Byrds—tight, four-part harmony and chiming guitars. Their biggest hit came in 1964 with "Love Potion Number Nine" (#3 US). Billy J. Kramer and the Dakotas were another Epstein/Martin group from Liverpool, although Kramer was more of a 1950s-type pub crooner than a rock singer.

By 1964, groups from other English cities had emerged. Manchester was home base to **Herman's Hermits**, the Hollies and Freddie and the Dreamers. Freddie Garrity, with Buddy Holly-nerdish looks, started out playing skiffle; with the Dreamers, his biggest hit was "I'm Telling You Now" (#1 US, 1965).

- Gerry and the Pacemakers
- The Searchers
- Billy J. Kramer and the Dakotas
- Herman's Hermits
- The Hollies
- Freddie and the Dreamers
- Dave Clark Five

MERSEY BEAT

MUSIC CUT 59

"ON A CAROUSEL" (CLARKE/HICKS/NASH)— THE HOLLIES

Personnel: Allen Clarke: vocals; Graham Nash: guitar, vocals; Tony Hicks: guitar, vocals; Bernie Calvert: bass; Bobby Elliot: drums. Recorded January 11, 1967; released as Parlophone R5562 on February 1, 1967; 9 weeks on the charts, peaking at #4 in the UK and #11 in the US.

"On a Carousel" was written and recorded while the Hollies were on tour in 1966/67, during the band's most popular era when they had nearly twenty Top Twenty hits in the UK and three Top Ten hits in the US. The song, which just missed the Top Ten in the US, features the distinctive sound of the Hollies, built around jangly guitar riffs and tight vocal harmonies that are reminiscent of the Everly Brothers. It also evokes comparisons with the light-hearted pop of the early Beatles Mercy Beat sound, which the Beatles themselves had largely abandoned by the time this song was released. Soon after the release of "On a Carousel," the Hollies embarked on a more psychedelic direction, while Graham Nash left the group in December 1968 to become a founding member of Crosby, Stills, Nash & Young, Amazingly, the Hollies (sans Nash of course) are still together.

The Hermits, led by Peter Noone, were as cute and cuddly as the Beatles, with whom they actually went toe to toe with in record sales for a while. Between 1964 and 1967, they had 11 Top 10 hits, six of which were in 1965, when they practically dominated the charts. They hit with two #1's that year: "Mrs. Brown You've Got a Lovely Daughter" and "I'm Henry the Eighth, I Am." When the Hermits were unable to musically evolve out of lightweight pop, they quickly fell from grace. The **Hollies**, led by Graham Nash, formed in 1962 and became best known for their Everly Brothers influenced harmonies and jangly guitars. They began making inroads into the American market in 1966 with Top 10 hits "Bus Stop," "Stop Stop Stop" and "On a Carousel," but by 1968 Nash had become unhappy with the group's direction and left for the US (and helped start Crosby, Stills and Nash). From Tottenham came the **Dave Clark Five**, whose peak years also were from 1964 to 1967. Their first hit, 1964's "Glad All Over" (#6 US) was the first of 17; they also were the second British group (after the Beatles) to appear on Ed Sullivan, and ultimately did so a total of 18 times.

The Blues Oriented Groups

Also starting around 1964, groups with a rougher, blues orientation started emerging from Britain. These groups tended to be sinister and menacing looking, with rude and defiant attitudes—definitely more Rolling Stones than Beatles. The most prominent and influential were the Kinks, the Yardbirds and the Animals.

BLUES-ORIENTED ROUPS STATE AND STATE OF THE PROPERTY OF THE PR

Brothers Ray Davies and Dave Davies (vocals and guitars), Mick Avory (the original Rolling Stones drummer) and Peter Quaife (bass) formed the **Kinks** in London in 1963. Their first hit single came the following year, "You Really Got Me" (#1 UK, #7 US), which was followed in 1965 with "All Day and All of the Night" (#7 US) and "Tired of Waiting for You" (#6 US). The Kinks sound was heavily based on blues-based distorted power chords—making them an important predecessor to hard rock and heavy metal. Even though the group continued to record and perform after their early hits, for the next ten years or so they went largely unnoticed until punk and metal bands rediscovered their power chord-filled catalogue of songs (Van Halen recorded "You Really Got Me" in 1978). That catalogue also includes one of rocks all time sing along anthems, 1970's "Lola."

The Yardbirds have achieved immortal status by virtue of the three legendary lead guitarists that passed through the band. Soon after forming in 1962, they became the house band at London's Crawdaddy Club with a repertoire of Chicago blues standards such as Howlin' Wolf's "Smokestack Lightning" and Bo Diddley's "I'm a Man." In October 1963 18-year-old Eric Clapton joined, and the band released the first important live British rock album, Five Live Yardbirds. When the group decided to become more pop-oriented, Clapton quit in 1965; his replacement was Jeff Beck, a virtuoso guitarist with a volatile personality. Propelled by their hit "For Your Love" and the eventual addition of Jimmy Page on bass, the band gradually moved from pop to psychedelic, as exemplified by their 1966 LP Roger the Engineer. In October 1966 Beck was forced out, and Page became the groups lead guitarist and leader. A disagreement over the bands direction ultimately led to its demise: singer Keith Relf and drummer Jim McCarty wanted to go folk; Page wanted to get heavier. After the final Yardbirds gig in mid 1968, Page reformed the group as the New Yardbirds with the lineup that ultimately became known as Led Zeppelin.

Led by singer Eric Burdon, the **Animals** were formed in Newcastle in 1962. In addition to Burdon the group included Alan Price (keyboards), Bryan "Chas" Chandler (bass), Hilton Valentine (guitar) and John Steel (drums). Most of the groups first album, *The Animals*, was recorded in one day in 1964 at EMI's Abbey Road studio and included their only #1 hit (UK and US), "House of the Rising Sun." The song is one of two traditional folksongs from the album that were also on Bob Dylan's first album—an indication of one of the group's main influences. However, it was the reciprocal influence that ultimately had the biggest impact

"HOUSE OF THE RISING SUN" (TRADITIONAL)— THE ANIMALS

Personnel: Eric Burdon: vocals; Alan Price: keyboards, arranger; Hilton Valentine: guitar; Chas Chandler: bass; John Steel: drums. Recorded May 18, 1964 in London; produced by Mickie Most. Released July 1964 on MGM; 11 weeks on the charts, peaking at #1.

As much credit as Bob Dylan is given for infusing folk traditions into rock music, The Animals did it first with their version of the venerable folk standard "House of the Rising Sun." Dylan had actually recorded the song on his debut album in 1962, but it was done in the traditional fashion using only acoustic guitar as accompaniment. The Animals decided to add it to their repertoire while on tour with Chuck Berry in 1964. "We were looking for a song that would grab people's attention," said singer Eric Burdon. However, to make their rendition work, Burdon had to adapt the song lyrics to a male perspective from the traditional confessional of a "poor girl" trapped in a whorehouse in New Orleans. Burdon sang the new lyrics with a blues drenched howl, which, combined with the menacing guitar and jazzy organ riffs make this one of the most ominous records in early rock.

on rock history: upon hearing the Animals play "House of the Rising Sun" while touring England in 1964, Dylan is reported to have said, "My God, ya oughta hear what's going down over there. Eric Burdon, the Animals, ya know? Well, he's doing 'House of the Rising Sun' in rock. Rock! It's fucking wild! Blew my mind." The group disbanded in 1966; Burdon reformed it as Eric Burdon and the Animals later that same year. Chandler went on to a management career, and played an important role in the discovery of Jimi Hendrix.

CHAPTER 6 TERMS AND DEFINITIONS

- **Trad jazz**—the English term to describe traditional New Orleans jazz, sometimes called Dixieland.
- **Skiffle**—a do-it-yourself music played by small groups using guitars, washboards, empty jugs, etc.

Name

Date

1.	What were some of the differences between the British and American pop scenes in the 1950s and early 1960s?
2.	Describe how John Lennon and Paul McCartney wrote songs in the early years.
3.	In what ways did songs written by Lennon differ from those written by McCartney?
4.	Name three significant things about the album <i>Revolver</i> .
5.	What were some of the factors that led to the breakup of the Beatles?

After two less successful album releases, the Airplane in 1969 released the anti-establishment manifesto *Volunteers*, which included the call to action song "We Should Be Together." By this time, the group was at its creative peak, and performed at the Woodstock and Altamont festivals. The 1970s brought shifting personnel and several name changes. In 1970, drummer Spencer Dryden (who had replaced Spence) left to form New Riders of the Purple Sage, Kaukonen and Casady left to form Hot Tuna, while Slick and Kantner had a baby together. Founder Marty Balin left in 1971. After taking some time off, in 1974 the group reformed as Jefferson Starship, and released *Red Octopus* in 1975, which became the group's (Airplane or Starship) only #1 album. When Kantner departed in 1984, he took the legal rights to the word "Jefferson," so the group continued on as simply "Starship" until 1989 when Jefferson Airplane regrouped once more with nearly all the original members. In all, the various renditions of the band placed 21 albums in the Top 40 charts.

SAN FRANCISCO ACID ROCK PERFORMERS

- Jefferson Airplane
- Grateful Dead
- Big Brother and the Holding Company/Janis Joplin
- Charlatans
- Quicksilver Messenger Service
- Country Joe and the Fish
- Santana

THE GRATEFUL DEAD

- Jerry Garcia
- Mickey Hart
- Ron "Pigpen" McKernan
- Bob Weir
- Phil Lesh
- Bill Kreutzman

The Grateful Dead

By more or less defining the sound of acid rock, the Grateful Dead became the heart and soul of the San Francisco music scene in the late 1960s. Although they will forever be remembered as the quintessential communal-hippie-tripping-acid rock band, they outlived that era and continued to perform well into the 1990s, becoming a privately held corporation that grossed millions of dollars annually and provided an employee pension fund and health insurance. With a relentless touring schedule that took only one year off between 1965 and 1995 (1975), they also cultivated one of the most die-hard followings in history—the **Deadheads**. The roots of the band go back to 1961 and the coffeehouses of Palo Alto, where bluegrass banjo player **Jerry Garcia** (1942–1995), having just been

discharged from the army, began playing in a variety of informal groups. Garcia had the sort of personality that brought people together, a gentle soul with an insatiable curiosity, an interest in existentialism as well as intense musical ambitions. After several years on the scene, his musical circle had grown to include Robert Hunter, an aspiring guitarist/lyricist; Ron 'Pigpen' McKernan, a blues loving, Harley Davidson riding piano/harmonica player; and the athletic and dyslexic washtub bass/jug player Bob Weir. In January 1964, Garcia, McKernan, Weir and two other friends (minus Hunter, who had temporarily left the band), began gigging as Mother McCree's Uptown Jug Champions.

By early 1965, Garcia and Co. decided to go electric. Heavily influencing their decision were the Rolling Stones (who were just starting to break into the US market), Bob Dylan (especially his Bringing It All Back Home album), and LSD, with which they had began experimenting. Filling out the new band, now called the Warlocks, was Phil Lesh on bass, a classically trained trumpeter and violinist who had studied composition and jazz in college (and had never played bass before), and Palo Alto's hottest jazz drummer Bill Kreutzman. In November, learning of another band with the same name (who later became ZZ Top), they again changed their name to the Grateful Dead, a phrase that Garcia had stumbled upon in a dictionary. Among the first gigs that the Dead played were the now famous acid tests staged by Ken Kesey's Merry Pranksters. Playing in the trippy, anything goes environment of the acid tests where they were not the main focus of the evening's entertainment (the hallucinations were) allowed the band to experiment musically in long free-form jam sessions. This, along with the eclectic musical backgrounds of the band members and their common interest in jazz saxophonist John Coltrane's recent experimental recordings produced some truly idiosyncratic results. As their music began to gel, in September 1966 the band members moved into a large Victorian mansion at 710 Ashbury Street in the Haight, where they famously resided until the following May.

In 1967 the Dead added second drummer Mickey Hart, who brought an interest in Native American and world music, and signed with Warner Brothers. After recording an unsatisfactory first album (*The Grateful Dead*), the group released the innovative *Anthem of the Sun* (1968), in which they attempted to capture the essence of their jam sessions by interweaving studio recordings with those of live performances. The third album, *Aoxomoxoa* (1969), was a continuation of the experimental phase of the band, which now included second keyboardist Tom Constanten and the return of Garcia's old friend Robert Hunter as lyricist. Also from 1969 came *Live/Dead*, comprised of live recordings made at the Fillmore and Avalon Ballrooms. Among the songs on the double album was Hunter's 23-minute anthem "Dark Star." Although by the summer of 1969 the Dead had become nationally known through appearances at Monterey and Woodstock, their albums were not selling and they were nearly \$200,000 in debt to Warners.

In 1970 the Dead responded to their dire financial situation by releasing two of their finest albums, *Workingman's Dead* and *American Beauty*. Both albums signaled a dramatic change of direction by focusing on their musical roots with songs that were surprisingly tightly structured, including "Uncle John's Band" and "Casey Jones" from *WMD* and "Friend of the Devil" and "Truckin" from *AB*. Over the next several years the band experienced limited personnel changes,

including the departures of Constanten and Hart (the drummer returned in 1975), the addition of Keith and Donna Godchaux on keyboards and vocals respectively, and the departure of McKernan, who died in 1973 due to complications from alcohol abuse. In 1973 the Dead revealed the **Wall of Sound**, an innovative sound reinforcement system that consisted of 604 speakers and 26,400 watts of power. Designed and built by Owsley Stanley and Dan Healy, the 75-ton Wall was the largest portable sound system ever built (requiring four semi trucks and 21 crew members to haul and assemble), and could be heard distortion-free for distances up to a quarter mile.

MUSIC CUT 62

"TRUCKIN" (JERRY GARCIA/PHIL LESH/BOB WEIR/ROBERT HUNTER)—THE GRATEFUL DEAD

Personnel: Bob Weir: lead vocals, rhythm guitar; Jerry Garcia: lead guitar, backup vocals; Phil Lesh: bass, backup vocals; Howard Wales: organ; Bill Kreutzman, Mickey Hart: drums. Recorded September 1970 at Wally Heider Studios, San Francisco, CA; produced by The Grateful Dead and Steve Barncard. Released November 1, 1970 on Warner Bros.; eight weeks on the charts, peaking at #64.

Even though the Grateful Dead were still in their infancy when they recorded "Truckin'," somehow the song's climactic line, "What a long strange trip it's been" seems apropos. "Truckin' " is the last cut on side B of the band's seventh album *American Beauty*. *AB* is the last of three albums the group released in 1970, preceded by *Workingman's Dead* and the live *Vintage Dead*. These albums effectively marked a change of direction for the group, not only in their sound, but how they made records in the first place. As Jerry Garcia said in a 1970 interview: "What we tried to do with the first bunch of records is to successfully transfer, you know, the live Grateful Dead sound to a record in the studio, but it never worked . . . So then we decide, "Well, why don't we do something that we can do in the studio and make it work?' And that's what worked." Not only were the songs written for *Workingman's Dead* and *American Beauty* more focused and pop-oriented, but the band was more focused in the studio, and worked quickly. With less production cost and more record sales, the Grateful Dead was able to turn around their dire financial situation. Although "Truckin'" did not do particularly well on the Top 40, it received heavy airplay on progressive rock stations.

The Grateful Dead continued to tour and record prolifically throughout the 70s, 80s and 90s. However, Jerry Garcia, the founder and spiritual leader of the band began to suffer health problems in 1985 from his prolonged drug usage. He died of a heart attack at a drug treatment center on August 9, 1995. Although the final Grateful Dead concert was at Soldier Field in Chicago on July 9, 1995, their legacy continues to this day in the form of jam bands such as Phish and the String Cheese Incident, and the continued popularity of their music. As band biographer Dennis McNally put it, "As long as there are Dead Heads, they will be guided by the principles of freedom, spontaneity, caring for each other and their planet, fellowship, and fun."

Big Brother and the Holding Company/Janis Joplin

Big Brother and the Holding Company emerged out of the 1965 Wednesday night jam sessions that Family Dog member Chet Helms was running out of the basement of a condemned mansion on Page Street in Haight-Ashbury. The band (Sam Andrews and Jim Gurley on guitars, Peter Albin on bass and Dave Getz

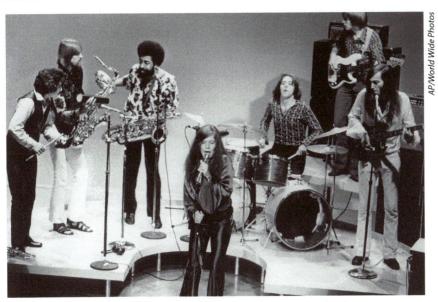

Janis Joplin performing with the Kozmic Blues Band in December 1969.

on drums) quickly became a fixture on the local scene, performing at the Trips Festival and as the house band at many of the Helms produced Avalon Ballroom shows. By early 1966 however, they felt the need for a strong lead vocalist, and Helms recommended Texas blues singer **Janis Joplin** (1943–1970), whom he had met when they hitchhiked together from Austin, Texas to San Francisco in early 1963.

Joplin was born in Port Arthur, Texas. Although she tried to fit in with the conservative mores of her hometown for much of her childhood, in high school she began to exhibit streaks of wild and independent behavior that increasingly labeled her as a non-conformist. She found solace painting and reading the writings of the beats, and also began to love the music of black blues singers. Eventually she developed enough courage to begin singing in local coffeehouses.

MUSIC CUT 63

"PIECE OF MY HEART" (BERT BERNS/JERRY RAGOVOY)— BIG BROTHER AND THE HOLDING COMPANY

Personnel: Janis Joplin: vocals; Sam Andrew: guitar, vocals; James Gurley: guitar, vocals; Peter Albin: bass; Dave Getz: drums. Recorded at Columbia Studio B in New York, April 1968; produced by John Simon. Released September 28, 1968 on Columbia; 12 weeks on the charts, peaking at #12.

"Piece of My Heart" was the only hit from Big Brother and the Holding Company's debut album *Cheap Thrills*. One of the most anxiously awaited albums of its day, *Cheap Thrills* (whose working title was *Sex*, *Dope*, *and Cheap Thrills*) quickly went gold and stayed at #1 for eight weeks. To capture the raw energy of Janis Joplin and BB&HC's live shows, producer John Simon recorded the band live rather than with the more conventional (and laborious) overdubbing method. Co-written by Bert Berns (who also wrote "Twist and Shout" and "Hang On Sloopy" under the name Bert Russell), "Piece of My Heart" was originally recorded by Aretha Franklin's sister Erma, who had a #10 R&B hit with the song in 1967. Big Brother's version was recorded in Studio B of Columbia's complex at 799 7th Avenue (next door to where Bob Dylan recorded "Like a Rolling Stone" in the larger Studio A).

Music emboldened her, allowing her to develop a tough as nails non-conformist persona to hide her vulnerabilities. She developed a singing style inspired by blues singers Bessie Smith and Big Mama Thornton that was rough edged, gritty and raw. In late 1962 she moved to Austin where she became a student at the University of Texas and began assimilating into the local folk scene. After one semester she left school, and traveled around the country before moving to the Bay Area in June 1966 to sing with Big Brother.

Janis Joplin revitalized the band. With her dynamic ability to move from a barely audible whisper one moment to full tilt screaming the next, she transfixed audiences. When Big Brother performed at the Monterey Pop Festival in June 1967, Joplin stole the show with her amazing performance, and the band was rewarded with a contract from Columbia Records. After a six-month delay getting out of an earlier contract with a small label, the album *Cheap Thrills* (with a cover designed by cartoonist R. Crumb) was released in August 1968 and promptly went gold, staying at #1 on the charts for eight weeks. The album's strongest track "Piece of My Heart" was released as a single and also charted at #12. But at the height of their success, the world was changing quickly for Janis. After months of being told that she was better than the rest of the band, she left Big Brother at the end of 1968 to pursue a solo career. By this time she had also began drinking heavily and using heroin.

Joplin's new band, the Kozmic Blues Band, a classic soul revue, was much tighter and more professional than Big Brother. Although they appeared with her at Woodstock, they disbanded in January 1970 after one album release. In April Joplin assembled a new band, the Full Tilt Boogie Band and began work on what would be her last album, *Pearl* (her nickname). However, before the album was completed, Joplin's body was found in her room at the Landmark Hotel in Los Angeles on October 4, 1970. Like Brian Jones and Jimi Hendrix who died before her, and Jim Morrison who would die the following July, Janis Joplin died of a drug overdose at age 27. *Pearl* was released posthumously and went to #1 in early 1971. The single "Me And Bobby McGee" (written by Kris Kristofferson) also hit #1. Two other songs from *Pearl* left chilling legacies: "Buried Alive in the Blues" is missing the vocal overdub that Joplin did not live to record, and the a cappella "Mercedes Benz," a demo recorded three days before her death is simultaneously full of pain and whimsy—and is perhaps her greatest recording.

Janis Joplin embodied the spirit of the 1960s 'liberated' woman who took control of her life and her career, becoming a star and role model for future women rockers in a male dominated field. Her extroverted stage image (which included a constant companion bottle of Southern Comfort and wildly colorful clothes) and her soulful, passionate voice will live on forever as icons of a unique time and place in rock.

BIG BROTHER AND THE HOLDING COMPANY

- Sam Andrews
- Jim Gurley
- Peter Albin
- Dave Getz
- Janis Joplin

Other Bay Area Acid Rock Bands

Even though the Charlatans were more or less an amateur group, they set the tone both musically and stylistically for the Bay Area music scene. On June 29, 1965 they began playing in Virginia City, Nevada at the Red Dog Inn, a bar they had remodeled to resemble an Old West style saloon. Throughout the summer, the Charlatans played the Red Dog while donning cowboy outfits, dropping acid and using a crude sound sensitive light box. They also attracted hippies from San Francisco with eye-catching psychedelic posters. Quicksilver Messenger Service, formed in 1965, was on par with the Grateful Dead as a quintessential acid rock jam band. Led in its early years by guitarist John Cipollina, one of the finest guitarists to emerge from the Bay Area, QMS was a fixture in the electric ballroom scene throughout the late 1960s. In 1970, Dino Valenti joined as vocalist and became the group's main songwriter. QMS is perhaps best known for the song "Fresh Air" (1970), which became an FM radio staple. Country Joe and the Fish, also formed in 1965 by Joe McDonald and Barry Melton, was the most political of the Bay Area bands. Originally a loose knit skiffle-type band, in 1966 the band electrified and released what was to become their most famous recording, the Vietnam protest song "Feel Like I'm Fixin'To Die Rag." The Fish appeared at Monterey and Woodstock, and their performance of "Fixin' To Die" preceded by the famous 'Fish Cheer' ("Give me an F, give me a U, give me a $C \dots$ and so on) is one of the highlights of the Woodstock documentary film.

MUSIC CUT 64

"SOUL SACRIFICE" (CARLOS SANTANA/GREGG ROLIE/DAVID BROWN/MARCUS MALONE)—SANTANA

Personnel: Carlos Santana: guitar, backup vocals; Gregg Rolie: Hammond organ; David Brown: bass; Michael Shrieve: drums; Michael Carabello: congas, percussion; José Chepito Areas: timbales, congas, percussion. Recorded May 1969 at Pacific Recording, San Mateo, CA; produced by Santana and Brent Dangerfield. Released on the album *Santana*, August 1969 on Columbia; not released as a single.

The studio recording of "Soul Sacrifice" heard here is the last song on side B of Santana's eponymous debut album. However, many rock fans are probably more familiar with the dynamic live recording of the song on the *Woodstock: Music from the Original Soundtrack and More* album. Santana was little known before the festival; their debut album had not yet hit the stores. Nonetheless, they were up to the task. As Michael Lang, the festival organizer later recalled: "Santana was really the first group that really got everyone up and dancing . . . Michael Shrieve played one of the most amazing drum solos I have ever heard, with Carlos' soaring guitar building everything to a crescendo. The audience went nuts—it was obvious another star was being born."

One group from the San Francisco Bay Area that lent a slightly different slant to the local music scene was **Santana**, led by Mexican guitar virtuoso Carlos Santana (1947–). Santana put together his band in 1967 from musicians that he jammed with regularly in San Francisco's Latin district. Their public debut at the Fillmore in 1968 electrified the audience and won them a spot at Woodstock, where their performance of "Soul Sacrifice" had a similar effect. In the ensuing years the group had ten Top 40 hits, including 1970's "Evil Ways" and "Black

Magic Woman" (#9 and #4 respectively). The Santana sound is steeped in Afro-Latin instruments and rhythms, the Hammond B-3 organ and Carlos Santana's unique guitar styling. It is one of the few bands to reach pop superstar status without a clearly defined lead vocal identity—their popularity stems from their infectious dance rhythms and the guitar wizardry of their leader. Santana has remained one of rock's most venerable bands, and scored a dramatic comeback in 1999 with their multi-Grammy Award winning album *Supernatural*.

Other Bay Area bands from the 1960s include the Sons of Champlin, Sopwith Camel, the Vejtables, the Beau Brummels, the Great Society and Moby Grape.

THE SIXTIES LOS ANGELES PSYCHEDELIC SCENE

The Strip

The Strip was a 24/7 party atmosphere for young people. The LA hipster scene had its own dress code: boots and bellbottoms for girls and tunics for boys. ("The girls all looked like Cher, and the boys like Brian Jones," according to author Barney Hoskins.) But like the scene in San Francisco, the good times ethos of the Strip would not last. By November 1966 traffic congestion and the constant influx of teenagers grew so bad that area businesses began requesting police intervention, and confrontations between the two sides quickly escalated. A protest held on the night of November 12 attracted several thousand demonstrators; the so-called "Riot on Sunset Strip" that ensued resulted in nothing more than a few fistfights and broken windows. Nonetheless, it inspired both the film *Riot on Sunset Strip* and Buffalo Springfield's "For What It's Worth" ("There's something happening here/What it is ain't exactly clear ..."). By the end of the decade, things turned ugly when the zeitgeist of the Strip became more about drugs than music and having a good time.

LA's music scene was more musically diverse than San Francisco's—and definitely more commercial oriented. As an important center of the record industry,

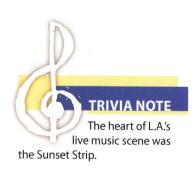

The LA Psychedelic Scene

- 1. More theatrically oriented than San Francisco bands
- 2. Instrumentation included electric guitar, keyboards, drums, bass
- 3. Darker lyrics, eschewing the peace and love ethos of San Francisco bands
- 4. Wide variety of styles and influences, including folk, the blues and hard rock

Key LA Psychedelic Recordings

- Freak Out!—Frank Zappa and the Mothers of Invention, 1966
- The Doors—the Doors, 1967

LA was home to a well-established pop scene in the early 1960s consisting of recording studios, music publishers, production companies, and record labels. Whereas the San Francisco scene eschewed commercialism as part of its ethic, Los Angeles drew many musicians, arrangers, and producers who specifically wanted to be part of the mainstream pop scene. Starting in 1965, Los Angeles-produced singles began to take control of the pop charts away from New York and London. That same year, the folk rock movement (discussed in Chapter 8) was finding its legs with the emergence of groups like the Byrds ("Mr. Tambourine Man," #1) and the Mamas and the Papas ("California Dreamin"," #4).

Of course, Los Angeles is home to Hollywood and the television industry, and an entire ecosystem of thespian activity, and this also had an impact on the psychedelic music scene. Two groups in particular, the Doors and the Mothers of Invention (and later, Alice Cooper) made great use of theatre in making their performances among the most provocative of the 1960s. Both the Doors and the Mothers rejected the peace and love ethos of the San Francisco scene and explored darker messages in their lyrics, and both explored a wide variety of musical approaches and influences as well.

The Doors

The Doors were one of the most unique groups of the era, with no bass player and a sound that owed more to the haunting sound of the Vox Continental combo organ than the electric guitar. However, the most identifying attribute of The Doors sound came from their enigmatic lead vocalist, **Jim Morrison** (1943–71). Even though he had never sang before joining the Doors at age 21, Morrison's hypnotic rich baritone voice is instantly identifiable even today, more than 30 years after his death. Morrison was the most charismatic and controversial rock performer of his era. His performances were at times mesmerizing and hypnotic, at other times menacing and dangerously out of control. Off stage he was an impossible drunk, an insatiable bisexual, a loner and a drifter. In spite of all this, Jim Morrison was one of the most important and gifted rock poets, and published two books of his writings during his lifetime.

Morrison's childhood was rocky: his father, Captain Steve Morrison was a naval commander whose job kept the family moving constantly. Young Jim was smart—with an IQ of 149—but rebellious, and did not take well to the authoritarian discipline of his parents. Detached and alienated as a teen, he was drawn to the writings of the beats, Friedrich Nietzsche and eventually French Symbolist

poet Arthur Rimbaud. After moving from school to school, he graduated from UCLA in June 1965 with a degree in cinematography. One day in July, Morrison ran across former classmate Ray Manzarek on the beach at Ocean Park and read to him several poems he had written, including "Moonlight Drive." Manzarek, a classically trained pianist, immediately saw that Morrison's talent along with his Greek god looks would be a natural for his rock band, Rick and the Ravens. Once the moody and temperamental Morrison joined the band, the other original members quit; replacing them were guitarist Robby Krieger and jazz drummer John Densmore. They could not find a bass player to their liking, so Manzarek played

bass with his left hand on a small bass keyboard. With a new lineup came a new name, inspired by the book *The Doors of Perception*, Aldous Huxley's account of his hallucinogenic drug experiences. The group also began to write their own songs.

In March, 1966 the Doors secured a steady gig at the low rent London Fog; by May they had improved enough to get hired by the Whisky a Go Go as the house band. Despite being inconsistent—with dynamite shows often followed by incredibly bad ones—the band drew the attention of Elektra Records, who signed them on August 18. Just three nights later Morrison went into a spontaneous chant during the hypnotic 15-minute song "The End" that included a spellbinding poetic retake on the Oedipus myth. It was an incendiary moment was for the band and the audience; the Whisky exploded into what Manzarek later called "a Dionysian frenzy." The band was banished forever from the Whisky at the end of set. "The End," as it appears as the last song of the Doors' eponymous first album, contains a riveting recreation of Morrison's oration. *The Doors* is one of the 1960s most dynamic debut albums; in the summer of

1967 it peaked at #2, fueled by the #1 smash hit single "Light My Fire."

THE DOORS

- Jim Morrison
- Ray Manzarek

- Robby Krieger
- John Densmore

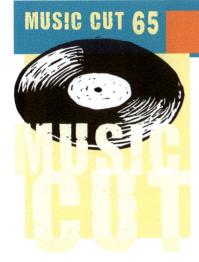

"BREAK ON THROUGH" (MORRISON/MANZAREK/KRIEGER/DENSMORE)—THE DOORS

Personnel: Jim Morrison: vocals; Ray Manzarek: Vox Continental organ; Robby Krieger: guitar; John Densmore: drums. Recorded August 19–24, 1966 at Sunset Sound Studios, Los Angeles, CA; produced by Paul Rothchild. Released on the album *The Doors*, January 4, 1967 on Elektra; not released as a single.

As the opening cut from their 1967 debut album *The Doors*, "Break on Through" seems to summarize the Doors' innovative musical strategy: to "break on through to the other side"—as if there was some creative barrier to smash. Buoyed by the #1 hit "Light My Fire," the album was a sensation, and eventually sold more than four million copies. "Break on Through" contains all the characteristics that gave the Doors such an exotic sound: driving ostinato bass line, jazz-influenced drums, ominous combo organ, and most of all, Jim Morrison's spellbinding vocals. The group was also one of the decade's most explosive and dynamic, as they prove here by going from a soft bossa nova intro to the highly charged middle section where Morrison screams "She gets high" four times.

Over the next four years the group released seven more albums, including the psychedelic masterpiece *Strange Days* (1967), and *The Soft Parade* (1969), the latter having an innovative multi-movement suite title as its track. During this time, Morrison's behavior became increasingly unpredictable due to his excessive drinking, and as a result the band was not invited to perform at either Monterey or Woodstock. However, they did appear on *The Ed Sullivan Show* on September 17, 1967, and despite warnings not to sing the word 'higher' during their live performance of "Light My Fire," Morrison did just that—twice. Morrison was a quick study on how to use his charisma on stage, and invented the **Lizard**

"THE END" (JIM MORRISON/RAY MANZAREK/ROBBY KRIEGER/ JOHN DENSMORE)—THE DOORS

Personnel: Jim Morrison: vocals; Ray Manzarek: Vox Continental organ, Fender Rhodes piano bass; Robby Krieger: guitar; John Densmore: drums. Recorded August 19–24, 1966 at Sunset Sound Recorders, Los Angeles, CA; produced by Paul Rothchild. Released on the album *The Doors*, January 4, 1967 on Elektra; not released as a single.

The Doors' immensely successful debut album closed out with one of the most creative—and eerily dramatic—songs of the era. The song began life as a Jim Morrison reflection on breaking up with a girlfriend, but through months of live performances it evolved into an extended raga with an open-ended middle section where Morrison could improvise spontaneously. It was at the Whisky a Go Go that he first introduced his Oedipal rant, "Father, I want to kill you . . . Mother, I want to . . . (unintelligible screaming)." Once in the studio, Morrison, who had reportedly dropped acid, became transfixed and delivered the spellbinding performance heard here. At the end of the two takes that were recorded, Morrison spun out of control and tried unsuccessfully to throw a TV set through the control room window. After the session ended, he returned to the studio and hosed down all the equipment with a fire extinguisher. It was the collateral damage required to get one of rock's great performances on record. Organist Ray Manzarek later summed it up: "He was giving voice in a rock 'n' roll setting to the Oedipus complex, at the time a widely discussed tendency in Freudian psychology. He wasn't saying he wanted to do that to his own mom and dad. He was re-enacting a bit of Greek drama. It was theatre!"

King, a shaman-like alter ego he used to incite audiences and drive the band to explosive heights. From late 1967 through much of 1968, the Doors were the top band in America, and played to sell out crowds in huge indoor and outdoor venues, essentially pioneering arena rock in the process.

However, Morrison's public drunkenness and confrontational stage behavior eventually caught up to him and the band. On March 1, 1969 the Doors played a concert in Miami in which the singer reportedly exposed himself and simulated masturbation. Although authorities could produce no photographs or actual witnesses of him doing any such thing, Morrison was arrested, tried in August 1970 and convicted of misdemeanor counts of indecent exposure and open profanity. During the year and a half between the Miami concert and the trial, the Doors were blacklisted by many concert promoters and found touring increasingly difficult. Their last gig, on December 12, 1970 in New Orleans, ended early after Morrison had a mental breakdown on stage. Soon after completing L. A. Woman, his last album with the Doors, Morrison moved to Paris with his long-time girlfriend Pamela Courson, ostensibly to take a break from his turbulent life. It was there that he died in the bathtub of his apartment in the early morning hours of July 3, 1971. His body was quickly sealed in a coffin and buried at Pere-Lachaise cemetery in Paris. Because there was no autopsy and the police and doctor who arrived at the scene could not be traced, rumors have persisted that he is still alive. The mysterious circumstances surrounding his death have only served to enhance the legendary status of one of rocks most charismatic and mysterious figures.

Frank Zappa/The Mothers of Invention

Frank Zappa (1940–1993) was a musical anarchist who tore down convention and accepted norms in creating some of rocks most sophisticated and intellectual music. Zappa's lyrical themes were often dark, but he effectively used humor, biting satire and vulgarity, and in some cases his lyrics were downright gross. He was an admirer of 20th century avant-garde composers, surrealist artists such as Salvador Dali, 'sick' comics like Lenny Bruce and Mort Sahl, and the musical comedian Spike Jones. He also had great love and respect for R&B and jazz. His great accomplishment is that somehow he managed to bring all these influences into his highly original and idiosyncratic music. Because Zappa received much critical acclaim in his life as a composer, arranger and studio innovator, the fact that he was also a brilliant and inventive guitarist is often overlooked.

Zappa's father was a guitar-playing government research scientist who worked a variety of jobs that forced the family to move frequently during Frank's childhood. In 1954 the Zappas settled in Lancaster, California, and Frank began to develop an interest in 20th century classical music after hearing recordings of Edgard Varese's *Ionisation* and Igor Stravinsky's *The Rite of Spring*. As he grew older he started listening to doo-wop, R&B and the blues, began playing guitar in a series of garage bands. After high school he composed music for two low budget films and briefly flirted with college. In late 1963, on his own and struggling to get by, he lived for a while in a small studio he bought and named Studio Z, and often spent 12 hours a day or more learning the art of audio engineering and tape editing. In 1964, Zappa joined the Soul Giants, which he ultimately took control of and renamed the Mothers (appropriately on Mothers Day, 1965).

L

After moving to LA, the Mothers began working their way up the club circuit playing Zappa's original music. Once they made it to the Whisky, they caught the attention of MGM-Verve producer Tom Wilson, who signed the band in March 1966. As a precondition to releasing any recordings, MGM insisted that the words "of Invention" be added to "Mothers"—apparently to make the name less offensive. Their debut, *Freak Out!* (July 1966), one of the first ever double albums, is a manifesto on individual freedom, non-conformity and the hypocrisy of American society. The music ranges from electronic sci-fi to doo-wop parody to an eight-minute collage of sound called "Help, I'm A Rock." The album was unlike anything that came before it, and a harbinger of things to come from Zappa. It received critical acclaim but attracted little attention from buyers.

MUSIC CUT 67

"WHO ARE THE BRAIN POLICE?" (FRANK ZAPPA)—THE MOTHERS OF INVENTION

Personnel: Frank Zappa: guitar, vocals; Jimmy Carl Black: drums, vocals; Ray Collins: vocals, harmonica, "bobby pin and tweezers," sound effects, percussion; Elliot Ingber: alternate lead and rhythm guitar with "clear white light"; Roy Estrada: bass, vocals; additional session musicians also used. Recorded March 8–12, 1966 at Sunset-Highland/TTG Studios, Los Angeles, CA; produced by Tom Wilson. Released June 27, 1966 on the Verve album *Freak Out!*; later released as a single in 1966, did not chart.

Freak Out!, the first album by the Mothers of Invention, is one of the most inspired debut albums in history. It is one of rock's first double-albums, and is arguably the first rock concept album. The variety of music on the record is astonishing, from the sci-fi psychedelia of "Who Are the Brain Police?" to the social commentary of "Trouble Every Day" to the collage-like minimalism of "Help, I'm a Rock" to the indescribable madness of "It Can't Happen Here." It is also the album that unleashed Frank Zappa's satiric brilliance on the world. Zappa, who wrote all 14 of the albums songs, declared in the liner notes that the album is a celebration of freakdom. "WHAT IS 'FREAKING OUT'," he asked. "On a personal level, Freaking Out is a process whereby an individual casts off outmoded and restricting standards of thinking, dress, and social etiquette in order to express CREATIVELY his relationship to his immediate environment and the social structure as a whole"... "We would like to encourage everyone who HEARS this music to join us... become a member of The United Mutations... FREAK OUT!" Of "Who Are the Brain Police?" Zappa writes, "At five o'clock in the morning someone kept singing this in my mind and made me write it down. I will admit to being frightened when I finally played it out loud and sang the words."

A prolific composer, Zappa began recording his music at an exhausting rate, eventually releasing more than 60 albums during his lifetime. 1968's We're Only in It for the Money (a Sgt. Pepper's parody) satirized hippies and eerily foretold the Kent State massacre of 1970. In 1968 Zappa also released two other albums—Lumpy Gravy, in which he experimented with mixing spoken word, taped noise and sound effects (a Varese influence) into the music of a 50-piece orchestra, and the doo-wop parody Cruising With Ruben & The Jets. In 1969 the Mothers released the mostly instrumental double album Uncle Meat, a compositional tour de force with 28 tracks, some of which include spoken dialogue. After its release, Zappa abruptly disbanded The Mothers, who were by this time receiving attention for their live shows that combined incredible musicianship with zany, anarchic humor. In October 1969, with a new jazz-influenced band, Zappa released

Hot Rats, one of the first albums recorded using a 16-track recorder and which some consider to be the first jazz/rock fusion album. Soon after, Zappa reformed the Mothers and hired vocalists Mark Volman and Howard Kaylan from the pop group the Turtles, who for contractual reasons had to go by the pseudonyms Flo and Eddie. Flo and Eddie brought an increased emphasis on theatrics and gross, sophomoric humor to the group, which can be heard in 1970's Chunga's Revenge.

Zappa worked on several film projects during his life, most notably 1971's 200 Motels, a self-parody about a band playing a series of one-nighters that starred Ringo Starr and Keith Moon. 1971 also marked two tragic events for Zappa. On December 4, a fire broke out during a concert at Montreux, Switzerland that destroyed the band's equipment and became the inspiration for Deep Purple's "Smoke on the Water." One week later in London, a lunatic pushed Zappa into the orchestra pit, damaging his spine, fracturing his skull and crushing his larynx, lowering his singing voice by a third of an octave. His new baritone voice was featured in 1973's Overnight Sensation, which included the cult hit "Don't Eat the Yellow Snow." In 1975 Zappa once again disbanded the Mothers—this time for good—and released all future recordings under his own name. In the 1980s he began working with the Synclavier, a state of the art digital synthesizer that allowed him to compose, edit and orchestrate music by himself in his home studio. Albums such as The Perfect Stranger (1984) and Jazz from Hell (1985) are innovative ventures into computer-based music.

Zappa used innovative editing and studio techniques in the creation of his recordings, often splicing together snippets from many different live recordings and adding studio overdubs to create a finished song. A good example of this technique is in the title track of 1982's Ship Arriving Too Late To Save a Drowning Witch, which used 15 edits, some of which lasted only two bars. He was known for his unusual and sometimes silly album covers. His orchestral works, including "Pedro's Dowry" from Orchestral Favorites brought critical acclaim from heavyweights in the classical music world. In the years preceding his death, Zappa became a politically active voice against the censorship of rock lyrics. In 1985 he appeared as a dissenting voice before a Senate subcommittee inspired by the Parents Music Resource Center (PMRC), a group led by Tipper Gore (wife of future Vice President Al Gore) that advocated warning labels on CD's whose lyrics were determined to be offensive (see Chapter 12). For a short while he also became a trade representative for the Czech Republic, named to the post by Czech President Vaclav Havel, a longtime fan. In 1991, Frank Zappa was diagnosed with the inoperable prostate cancer from which he died in 1993.

WOODSTOCK AND THE ERA OF THE ROCK MUSIC FESTIVAL

The psychedelic era also marked the beginning of an era when large outdoor music festivals became popular. The first of these was the **Monterey International Pop Festival** in June 1967, which drew an audience of approximately 30,000 and was both an artistic and a financial success (with a profit of nearly \$250,000). In addition, the resulting documentary film *Monterey Pop* showed the rest of the rock world just how much fun a three-day marathon of

music, psychedelia, peace and love could be. In Monterey's wake, other festivals in Palm Springs, Toronto, Los Angeles, Atlanta and other cities were held, some of which drew upwards of 150,000 fans. Although there were occasional problems—bad drug trips, not enough restroom facilities or first aid, trouble with local authorities over the influx of longhaired youth—in large part most went off without major disruptions.

The landmark event of the era was the Woodstock Music and Arts Fair, held from August 15-18, 1969. Originally scheduled for the small artist's community in upstate New York, problems with local townsfolk forced a last-minute move to Max Yasgur's farm in nearby Bethel, 50 miles away from Woodstock. Despite assurances by festival organizers Michael Lang and Artie Kornfeld that no more than 50,000 would attend, an estimated 450,000 showed up, creating a mini-nation of counter-culture youth who for the most part enjoyed the music and behaved themselves (and closed down the New York State Thruway with one of the worst traffic jams in history). More than 30 artists were signed, including many of the top names in the business: Jimi Hendrix, the Who, the new supergroup Crosby, Stills, Nash & Young, the Grateful Dead, Janis Joplin and Jefferson Airplane. New groups that made stunning debuts included Sly and the Family Stone, Santana and English blue-eyed soul singer Joe Cocker. The festival in time became an indelible icon of the hedonistic 1960s peace-love generation, and a cultural bookmark of the times. The documentary film and accompanying soundtrack double album were also released to great fanfare, capturing many of the remarkable musical moments of the festival.

"WITH A LITTLE HELP FROM MY FRIENDS" (JOHN LENNON/ PAUL MCCARTNEY)—JOE COCKER

Personnel: Joe Cocker: lead vocals; Henry McCullough: lead guitar; Neil Hubbard: rhythm guitar, backup vocals; Chris Stainton: organ; Alan Spenner: bass, backup vocals; Bruce Rowland: drums. Recorded August 17, 1969 live at the Woodstock Music and Arts Fair.

One of the more iconic moments from Woodstock saw Joe Cocker perform the Beatles' "With a Little Help from My Friends" in a slowed down 3/4 time, soulful reworking of the song that has actually become the definitive version for many. This was the closer of an 11-song set on the festival's final day.

Although Woodstock left many with a renewed hope in the goodwill of the human spirit, much of the innocence of the entire 1960s era was shattered with the disaster of the Altamont Festival outside San Francisco just four months later (discussed in Chapter 6). Even if Altamont wasn't the only event that sent counter culture spirits crashing, it was much closer to home for many in the rock audience.

Jimi Hendrix

Although Jimi Hendrix (1942-1970) was only an international superstar for less than four years, in that time he expanded the sonic possibilities of the electric guitar as well as redefined the relationship between music and noise with his startling use of feedback and other guitar effects. In addition to establishing himself as perhaps the most innovative guitarist in history, he became the premier showman and studio technician of his generation. Although his musical universe included electric psychedelia, jazz, hard rock,

> R&B and folk, he was always deeply rooted in the blues. When he died in 1970 at age 27, Jimi Hendrix left a profound legacy that is still highly influential to musicians of all stripes.

> He was born in Seattle as John Allen Hendrix. His childhood was difficult: John's father was away in the military much of the time, and his mother abandoned the family when he was ten. He taught himself to play the guitar from listening to his father's jazz and blues records, and by 15 he was playing in mediocre cover bands in area clubs. Down on his luck, in 1959 Hendrix joined the army and served in the 101st Airborne as a paratrooper, but in 1962 got a discharge after feigning homosexual tendencies. (In later years he often claimed that was discharged for breaking an ankle on a jump.) He then moved to Nashville where he played in a variety of R&B and soul bands on the chitlin' circuit, but was often fired for ad libbing "wild stuff that wasn't part of the song," as one-time employer Solomon Burke put it. In early 1964 he moved to Harlem, and by this time was good enough to get employment with the Isley Brothers, Little Richard, King Curtis and at occasional recording sessions. Eventually he began to write

songs, using influences from Delta blues, R&B and his idol Bob Dylan, especially Dylan's newly released Blonde on Blonde. Around this same time (early 1966) Hendrix also began experimenting with LSD, and his experiences with the drug had a profound effect on his look, his music and his poetry. When he began playing Greenwich Village clubs in mid 1966 under the name Jimi James (with a pickup band he called the Blue Flames), he was an immediate smash, although with his outlandish psychedelic clothes, Dylan-esque hair and whacked out feedback-laced solos, no one knew quite what to do with him. Playing at the Café Wha? in August, Hendrix was heard by Chas Chandler of the Animals, who advised him that he would become a star if he moved to England and let Chandler be his manager. In September, Hendrix left New York for London.

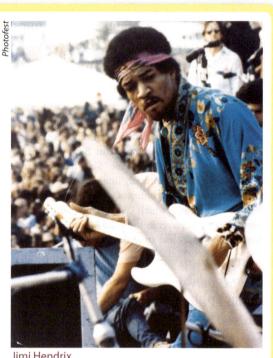

Jimi Hendrix

The Experience

In England, Hendrix quickly made the rounds and was introduced to the Beatles, Eric Clapton, Pete Townshend and other members of the London rock elite. Seeking a power trio format as a working band, he and Chandler put together the Jimi Hendrix Experience with Mitch Mitchell on drums and Noel Redding on bass. After playing their debut gig in October 1966, the trio recorded three singles, "Hey Joe" (#6 UK), "Purple Haze" (#3) and "The Wind Cries Mary" (#6). The success of these records—along with several BBC-TV appearances—made Hendrix a national sensation. In May 1967 the Experience released their debut LP Are You Experienced?, a stunning showcase for Hendrix' talents as a composer (with ten original songs), guitarist and studio experimentalist. The musical styles on the LP cover jazz jams ("Third Stone from the Sun," "Manic Depression"), Dylan influenced electric folk ("The Wind Cries Mary"), hard rock ("Purple Haze," "Fire"), the blues ("Red House") and Beatles influenced psychedelia ("Are You Experienced"). Hendrix also makes innovative use of spoken poetry, backward tapes, occasional Dylan-esque 'talking blues' style vocals, and an array of guitar-produced sound effects, along with his distinctive use of feedback and noise. Redding and particularly Mitchell also make substantial contributions with powerful supporting roles.

"THIRD STONE FROM THE SUN" (JIMI HENDRIX)— THE JIMI HENDRIX EXPERIENCE

Personnel: Jimi Hendrix: guitar, vocals; Noel Redding: bass; Mitch Mitchell: drums; Chas Chandler: voice of "Scout Ship." Recorded October 1966-April 1967 at De Lane Lea Studios and Olympic Studios, London; produced by Chas Chandler. Released August 23, 1967 on the MCA LP *Are You Experienced?*; not released as a single.

"Third Stone from the Sun" is an innovative mash up of styles and studio techniques, all designed to create the illusion that Jimi Hendrix is some sort of alien space captain contemplating the destruction of Earth (the third planet from the Sun) as he approaches. The song is one of the first fusions of jazz and rock, as it alternates back and forth between the two styles. What is perhaps most interesting about the song is that there is no singing—only spoken word. After an slowed-down opening dialogue between Hendrix and producer Chas Chandler and vocal sound effects, Hendrix reads a poem ("Strange beautiful, grass of green . . ."); later on during the free jazz jam in the song's middle section, Hendrix reads another poem, ending ominously with "Your people I do not understand, so to you I must put an end. Then you'll never hear surf music again." The song is one of the reasons why Hendrix's debut LP *Are You Experienced?* is such a masterpiece.

As a live performer, Hendrix is perhaps unparalleled to this day. Left-handed, he played the Fender Stratocaster upside down, strung in reverse order, although he was equally at ease playing a normally strung guitar in the same fashion. He played the guitar behind his back, over his head, while doing somersaults, and with his teeth, all with ease and proficiency. Being self-taught, Hendrix developed an unusual technique of using his thumb to hold down strings on the neck of the guitar instead of the more conventional use of the thumb on the back of

the neck to support the hand. His startling feedback effects were created with an array of processing pedals, including a Vox wah-wah, a Fuzz Face (for distortion) and a Univox Univibe (for a phasing effect). He also played with incredible volume produced by stacking English made Marshall amplifiers on top of each other, in what became known as the Marshall stack. Hendrix was also adept at getting an astounding range of sounds and effects in the studio, and often spent endless hours doing multiple takes to achieve perfection.

THE JIMI HENDRIX EXPERIENCE

- Jimi Hendrix
- Mitch Mitchell
- Noel Redding

Coming To America

Even though he was becoming a star in England in 1967, Hendrix was still pretty much unknown in his native America until his June performance at the Monterey Pop Festival. Performing on the last night of the festival before final act the Mamas and the Papas, the Experience played an electrifying show of six songs that concluded with a slow, psychedelic version of the Troggs' "Wild Thing." Watching "Wild Thing" (it is included in the documentary film of the festival), one gets to see the complete Hendrix package: coaxing feedback out of his guitar, playing it behind his back and while doing somersaults, using it as a phallic symbol, and ultimately setting it on fire and smashing it. Even though the performance got mixed reviews from critics, it put Jimi Hendrix on the map in America. *AreYou Experienced?* hit #5 on the US charts, and the Experience began their first tour of the US as the unlikely warm up band for the Monkees (they were quickly dropped however, as the band was too psychedelic for Monkees audiences).

The year 1968 saw Hendrix busy releasing two new albums, touring extensively and beginning construction on his dream studio, Electric Lady in Greenwich Village. The albums Axis: Bold as Love, released in January, and Electric Ladyland, released in November were commercial successes, hitting #3 and #1 respectively. The critics, who were divided on the merits of Are You Experienced? were coming around as well: Rolling Stone reviewer Jon Landau called for Hendrix to win the magazine's Performer of the Year Award for Electric Ladyland. Ladyland is the apotheosis of Hendrix's short career, and a continuation of the variety of musical styles, guitar artistry and studio wizardry that first appeared on Are You Experienced? It also contains a cover of Bob Dylan's "All Along the Watchtower" that has become the definitive version of the song (Dylan himself has adopted this version for his own live shows).

In 1969, Redding and Mitchell left the Experience and returned to England. Hendrix, in a portent of things to come, was arrested in Toronto in May for possession of heroin, a charge that was later dismissed. The highlight of the year came at Woodstock where with a loosely organized band he called "Gypsy, Sun, and Rainbow," Hendrix performed his now legendary version of "The Star Spangled Banner" as the festival's headline act. (Because the Sunday night

program, which Hendrix was supposed to close ran long, his performance took place on Monday morning in front of just 40,000 fans.) On New Year's Eve, he played New York's Fillmore East Ballroom with a new trio, Band of Gypsys, consisting of Billy Cox, an old army buddy on bass and Buddy Miles on drums, a band mate from his days playing as a sideman for Wilson Pickett. In the audience that night was jazz legend Miles Davis, with whom Hendrix was making plans to record. Unfortunately the recording never materialized when Miles demanded \$50,000 in advance of the first session.

Electric Lady Studios were finally completed in August 1970, but Hendrix only spent a few weeks actually recording there. On August 27 he headed to England to perform in front of 600,000 fans at the Isle of Wight Festival. By this time his health was rapidly deteriorating due to his increasing use of alcohol and a reckless intake of drugs. His last performance was at the Love and Peace Festival on the German island of Fehman on September 6. Exhausted and sick, he returned to London where he was found dead on the morning of September 18 at the Samarkand Hotel. Although the circumstances surrounding his death are still mysterious, it is believed that he took nine tablets of the sleeping aid Vesperax (recommended dosage: ½ tab) after a night of heavy drinking and drug taking. His body was returned to Seattle where he is buried at Greenwood Memorial Park in suburban Renton.

Name	Date
1.	What were some of the social issues that led to the formation of a youth counter culture in the 1960s?
2.	How and why did San Francisco give birth to the hippie movement?
3.	What were some of the events and cultural trappings that resulted from the San Francisco scene and the Summer of Love?
4.	What were some of the musical and non-musical influences on acid rock?
5.	Name some similarities and differences between the early careers of the Jefferson Airplane and the Grateful Dead.

6.	What were some of the differences between the psychedelic scenes in San Francisco and Los Angeles?
7.	Describe some of the reasons that the Doors' sound was unique.
8.	Describe some of the different music styles that Frank Zappa experimented with and the albums that they are found on.
9.	What were some of the hallmarks of Cream's sound, and why did they break up after such a short existence?
10.	Describe how Jimi Hendrix got such a unique sound, both in terms of his equipment and his playing technique.

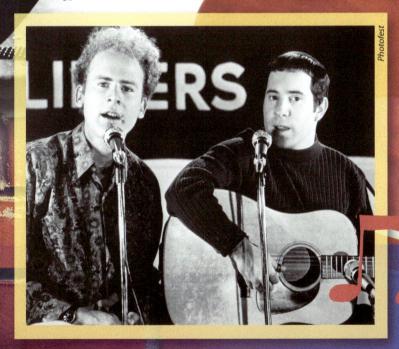

"[Rock 'n roll] really is not given to thinking—and resents thinking. It's always aspired to be the music of the working class. And it's never been looked upon as a vocabulary for art and artistic thinking. . . . We have to be able to expand the vocabulary to express more complex thoughts."

—Paul Simon (Simon and Garfunkel)

KEY TERMS	Folk rock Laurel Canyon The Troubadour	Singer/songwriter Country rock The Basement Tapes	The Last Waltz Southern rock
KEY FIGURES	The Allman Brothers Band The Byrds The Mamas and the Papas Crosby, Stills, Nash & Young Simon and Garfunkel Carole King	Joni Mitchell Carly Simon James Taylor Van Morrison Gram Parsons The Band	Creedence Clearwater Revival Lynyrd Skynyrd Buffalo Springfield The Eagles Fleetwood Mac
KEY ALBUMS	Sweetheart of the Rodeo— the Byrds Déjà vu—Crosby, Stills, Nash & Young Bridge Over Troubled Water—Simon and Garfunkel Tapestry—Carole King	Blue—Joni Mitchell Sweet Baby James—James Taylor Astral Weeks—Van Morrison The Gilded Palace of Sin—the Flying Burrito Brothers	Music from Big Pink—the Band At Fillmore East—the Allman Brothers Band Eagles/Their Greatest Hits 1971–1975—the Eagles Rumours—Fleetwood Mac

THE SEVENTIES

The Changing Landscape

As we have seen, the 1960s were a time when dramatic changes were taking place in American society—changes which often did not come easily. Entering the 1970s, it seemed as if the turmoil from the past decade had spoiled the chances for any hope or optimism from the upcoming decade. The assassinations of Dr. Martin Luther King and Senator Robert Kennedy in 1968 had certainly thrown their share of cold water on any momentum that had been gained by the anti-war and civil rights movements. In November 1968, Republican candidate Richard M. Nixon, who campaigned on a promise of bringing an end to the Vietnam War, was elected President. However, many young people viewed Nixon with suspicion, and their fears seemed to be justified when he ordered the invasion of Cambodia by US troops in 1970—an obvious expansion of the war. In response, protests intensified on college campuses all over the country, and the mainstream media increasingly began to question the motives for continuing the war. With his shifty eyes and perennial 5 O'clock shadow, Nixon was a polarizing agent who stoked the fears and angers of many young people, and as the nation would soon find out, for good reason. Although the 1960s were over, America still had many troubling questions to answer as it entered the 1970s.

Rock was going through a similar rite of passage, and there seemed to be a convergence of tragic events in 1969 and 1970 indicating that its Aquarian age was over. The first came on the night of August 8, 1969, when the "family" members of Charles Manson, a wannabe songwriter who had befriended the Beach Boys' Dennis Wilson and had become a regular presence among Southern

California rock circles, brutally murdered seven wealthy Los Angelos. Five of the victims were stabbed to death in the former home of producer Terry Melcher, who had repeatedly rejected Manson's songs. Was Manson sending a message to Melcher and others in the LA music industry? It would take four months for police to crack the case, during which time the city's music scene became decidedly less friendly and more guarded and suspicious. Up north in the Bay Area on December 6, the Altamont Festival was marred by violence and murder, and seemed to kill the good vibes created by the Woodstock Nation just four months earlier. While all this was going on—although no one knew it at the time—the Beatles, the group that had essentially started and led the pop-cultural side of the 1960s, were breaking up. And just as the rock community was adjusting to life without them, Janis Joplin, Jimi Hendrix and Jim Morrison all died from drug overdoses within nine months of each other, all at the age of 27. For many, the cumulative effect of all these events was a loss of innocence, a darker outlook on life, retreat, and a reevaluation of what had been and what might lie ahead.

Fragmentation

For a variety of reasons, rock was also beginning to fragment into a number of different styles and musical paths by the 1970s. It had matured significantly during the 1960s, and the pursuit of different paths of expression is a natural part of the growing process of any art form, which rock by now had indeed become. Through the leadership of the Beatles and others at the creative vanguard, musicians had witnessed the expansion of rocks musical boundaries, and many were ready to begin pursuing their own musical paths. The breakup of the Beatles actually encouraged the fragmentation of rock, as there was no longer a clear-cut leader for musicians to line up behind and follow. The rock audience had also expanded tremendously during the 1960s, and by 1970 rock was no longer the music of the counterculture, but the music of the mainstream culture. This larger audience, which now cut across two generations, was itself much more diverse and fragmented, and also willing to accept a number of different forms of expression within the rock context.

The radio and record industries also contributed to the fragmentation. Late 1960s progressive rock radio, with its free form, anything goes programming was by 1970 deemed too haphazard and inefficient; radio executives began to tightly format their stations to target specific segments of the audience. These new formats included soft rock (target group: women), urban contemporary (blacks), oldies (mature adults) and AOR, or album-oriented rock (young white males). The expanded rock audience was also buying more records: in the early 1970s the record industry was growing at an astounding 25 percent a year. A gold record (sales of 500,000) was no longer a benchmark—the biggest selling records were now expected to go platinum (sales of one million) or even multi-platinum. Like the radio industry, record companies also bought into the strategy of marketing rock as a *product*, and assigned user friendly labels to the newly emerging music styles: folk rock, singer/songwriters, country rock, soft rock, art rock and so on.

This chapter will examine the new mainstream pop styles and artists that began emerging in the late 1960s and early 1970s that changed the face of the rock world. Other styles that emerged in the 1970s will be covered in later chapters: heavy metal and art rock in Chapter 9; black pop in Chapter 10; and punk in Chapter 11.

essential elements of folk musicsocially relevant lyrics, strumming guitars and a softer manner—with

the electric instruments of rock.

Laurel Canyon The mountainous wooded area north of West Hollywood where many rock artists lived in the mid to late 1960s.

FOLK ROCK

The Dylan Influence

Folk rock actually had its beginnings well before the onset of the 1970s; as discussed in Chapter 5, Bob Dylan's first experiments into combining the folk philosophy with rock occurred in early 1965 with Bringing It All Back Home. In April the Byrds released their cover of "Mr. Tambourine Man," the record that is generally considered to have started the folk rock movement. It peaked at #1 in June, just one month before Dylan's infamous appearance at the Newport Folk Festival with the Paul Butterfield Blues Band. Later that year Dylan released Highway 61 Revisited, which included the #2 single "Like a Rolling Stone," and in December Simon and Garfunkel's "The Sounds of Silence," a folk song with an overdubbed rhythm section went to #1. Although folk purists vilified Dylan for abandoning traditional folk and "selling out," folk rock became a popular style in the late 1960s and early 1970s with that segment of the audience looking for music containing a meaningful message. That most essential element of folk rock—socially relevant lyrics—combined with strumming acoustic guitars and beautiful vocal harmonies to define the new genre.

Ground zero for folk rock was Los Angeles, which by the mid-1960s was wresting control of the pop music industry from New York and London. Around this time the rock royalty, especially the folk rockers and singer/songwriters, were beginning to nestle into what became an artistic sanctuary or sorts in the mountainous wooded area north of West Hollywood known as Laurel Canyon. The Canyon was "the holy hills of the hip," a place where "bungalows perched precariously on Lookout Mountain, Wonderland Avenue, Ridpath Drive, and a handful of other dusty Canyon roads became a de facto rock and roll colony," writes author Fred Goodman. During its heyday, the Canyon was home to Roger McGuinn and Chris Hillman of the Byrds, David Crosby, Graham Nash and Neil Young, all four members of the Mamas and the Papas, Carole King, Joni Mitchell (who shared a cottage with Nash), Frank Zappa, Brian Wilson and

Characteristics of Folk Rock

- 1. Commercial pop oriented, combining elements of rock and folk
- 2. Instrumentation built around strumming acoustic guitar with rock rhythm section
- 3. Generally softer dynamics
- 4. Emphasis on rich choral vocal harmonies, often three and four part
- 5. Emphasis on lyric story lines, which could include romantic love, social or political themes, traditional folk songs, etc.

Key Folk Rock Recordings

- Bringing It All Back Home—Bob Dylan, 1964
- "Mr. Tambourine Man"—the Byrds, 1965
- "The Sound of Silence"—Simon and Garfunkel, 1965
- "For What It's Worth"—Buffalo Springfield, 1967
- Déjà Vu—Crosby, Stills, Nash & Young, 1970

- The Byrds
- Buffalo Springfield
- The Nitty Gritty Dirt Band
- The Mamas and the Papas
- The Lovin' Spoonful
- Crosby, Stills, Nash & Young

FOLK ROCK GROUPS

many others. Doors it seemed were always open; parties always commencing; and live, informal music making was a way of life. One of the Canyon's legends has it that David Crosby, Stephen Stills and Graham Nash first sang together at Mama Cass' Canyon bungalow. Another has it that Stills wrote his protest anthem "For What It's Worth" at a party there. "Stephen picked up his guitar and started playing this little riff—and he started singing," recalled singer Robin Lane. "He just wrote the song right there in front of everybody."

The Los Angeles club circuit was as varied as the city was sprawling. As we saw in chapter 7, the clubs on and around Sunset Strip such as the Whisky a Go Go and Pandora's Box supported the psychedelic scene. Folk rock also had its venues, some of which had traditions dating back to the 1950s of hiring folk performers and hosting open mic nights that generally nurtured a growing folk scene. These included the Ice House, the Unicorn, and the Ash Grove, but the most important was **the Troubadour**, located just a few blocks away from the Whisky, on Santa Monica Boulevard. Starting in 1961 the Troub started hosting Monday night hootenannies, where big names like Judy Collins and Phil Ochs might intermingle performances with unknown up-and-comers. The club was also where networking was done, acquaintances made, and bands formed. It was at the Troubadour in 1964 that folksinger Jim McGuinn met David Crosby and Gene Clark, who together started the Byrds.

KEY TERM The Troubadour The preeminent Los Angeles nightclub for folk music in the 1960s.

The Byrds

The Byrds were led by Jim McGuinn (who in 1967 began going by the first name Roger), a singer/guitarist from Chicago who had worked with folk groups the Limelighters and the Chad Mitchell Trio before moving to Los Angeles in early 1964. While hanging out and playing at the Troubadour he met former New Christy Minstrel singer/guitarist Gene Clark and folksinger David Crosby. Inspired by seeing A Hard Day's Night in the summer of 1964, the three decided to form an electric band and enlisted bass player Chris Hillman and drummer Michael Clarke to fill things out. After rehearsing for a few months as the Jet Set and then as the Beefeaters, in November they signed with Columbia Records and changed their name to the Byrds (the name being misspelled purposely in homage to the Beatles). In January 1965, after receiving a demo tape of Dylan singing his unreleased song "Mr. Tambourine Man," the group recorded their innovative cover of the song. By smoothing out the rough edges of Dylan's original version with Beatle-esque vocal harmonies and adding a rock rhythm section (mostly LA studio musicians), the group defined the folk rock style. Their sound was new, but familiar: rock columnist Lillian Roxon asked

"MR. TAMBOURINE MAN" (DYLAN)— THE BYRDS

Personnel: Jim McGuinn: vocals, Rickenbacker electric 12-string guitar; Gene Clark: vocals; David Crosby: vocals; Leon Russell: electric keyboards; Jerry Cole: rhythm guitar; Larry Knechtel: bass; Hal Blaine: drums. Recorded January 20, 1965 at Columbia Studios, Hollywood, CA; produced by Terry Melcher. Released April 12, 1965 on Columbia; 13 weeks on the charts, peaking at #1.

Widely credited with starting the folk rock movement, the Byrds recording of Bob Dylan's anthem was actually recorded before Dylan's own version was released in March on his seminal LP *Bringing It All Back Home*. For this recording, producer Terry Melcher (son of actress Doris Day) augmented Byrds McGuinn, Clark and Crosby with musicians of the famed Wrecking Crew (Blaine, Cole, Knechtel and Russell). With this rhythm section, the now famous sound of the Rickenbacker electric 12-string guitar and Everly Brothers inspired vocals, the Byrds completely transformed Dylan's own diamond-in-the-ruff version and created the template for their early sound. Just as this record was climbing to the #1 spot, the Byrds released their first LP, *Mr. Tambourine Man*, which contained three other Dylan songs and eventually reached the #6 spot on the charts during its 38-week stay.

rhetorically whether the Byrds were a 'Dylanized Beatles' or a 'Beatlized Dylan.' "Mr. Tambourine Man" hit #1 in June. Interestingly, it was McGuinn's prominently featured Rickenbacker electric 12-string guitar and not the group's vocals that was their most distinctive feature.

- Jim (Roger) McGuinn
- Gene Clark
- David Crosby
- Chris Hillman
- Michael Clarke

In November 1965 the Byrds scored a second #1 hit, "Turn! Turn! Turn! (To Everything There Is a Season)," a song whose lyrics were adapted from Ecclesiastics with a melody written by Pete Seeger. In early 1966 the Byrds retooled slightly with a more psychedelic sound, and released the LP Fifth Dimension, which included the #14 hit "Eight Miles High." The song, which included a trippy John Coltrane-influenced 12-string guitar solo, would have charted even higher if not for being blacklisted by many radio stations for using the word "high" in the title and supposedly having drug references in the lyrics (even though the group denied it). Unfortunately, Fifth Dimension and the follow up The Notorious Byrd Brothers (1968) were not well received by the general public. Meanwhile, internal squabbling began to tear the group apart, and by 1967 both Gene Clark and the quarrelsome David Crosby were gone. In early 1968 the Byrds began working with country singer/songwriter Gram Parsons, who attempted take control of the band and revamp them into a country/rock hybrid. In mid-year the group moved to Nashville and spent three months recording their next LP, Sweetheart of the Rodeo. They also became the first rock group to

play at the Grand Ole Opry, although their set was controversial. *Sweetheart* is a pioneering album, one of the first in the country/rock vein, but in a sense it was the last gasp of the Byrds. Soon after its release, Parsons quit after refusing to accompany the group on tour in apartheid South Africa, and the group sputtered along without much success until finally disbanding in 1973.

The Mamas and the Papas

The Mamas and the Papas were made up of Denny Doherty, 'Mama' Cass Elliot and husband and wife John Phillips and Michelle Phillips, all of whom were regulars in the early 1960s Greenwich Village folk scene. Originally known as the New Journeymen, the group moved to the Virgin Islands to rehearse new material before relocating in Southern California. After serving as backup vocalists in recording sessions, in 1965 the group changed their name to the Mamas and the Papas and signed with Dunhill. Their first release, "California Dreamin'" peaked at #4 later that year; the group eventually went on to release five albums and have ten Top 20 singles, including 1966's #1 "Monday, Monday" and 1967's #2 "Dedicated to the One I Love." The M&P's were known for their strong four part multi-tracked vocals and their good time hippie look; however, by 1968 the good times were coming to an end as the Phillips' began having marital problems that ultimately broke up the group. Mama Cass went on to have a successful solo career before dying of a heart attack in 1974. John Phillips wrote a number of hit songs (including most of the M&P's) before his death in 2001, including Scott McKenzie's 1967 #4 hit "San Francisco (Be Sure to Wear Flowers in Your Hair)" and the Beach Boys 1988 #1 hit "Kokomo." The Phillips' had three daughters, including actress McKenzie (who starred in TV's One Day at a Time) and singer Chynna of the popular 1990s group Wilson Phillips.

- Denny Doherty
- "Mama" Cass Elliot
- John Phillips
- Michelle Phillips

THE MAMAS AND THE PAPAS

Buffalo Springfield

One of the most promising but shortest-lived folk rock groups was Buffalo Springfield, who despite having a lineup that at one time or another included future stars Stephen Stills and Neil Young (later of Crosby, Stills, Nash & Young), Richie Furay (later of Poco), and Jim Messina (later of Poco and Loggins and Messina), only managed to last two years before internal bickering broke them up. The group formed in 1966 after Stills and Furay coincidentally happened to see Young stuck in traffic on the Sunset Strip in his black'59 Pontiac hearse. The three had met in Young's native Canada more than a year earlier, and now finding themselves all living in LA trying to make it, decided the logical thing to do was to start a band. Naming themselves after a steamroller parked outside their producers house, Stills, Young, Furay added Canadians Dewey Martin on drums and Bruce Palmer on bass to form the groups first lineup. Their debut gig was at the Troubadour in April, and

by mid-year they were gigging at the Whisky a Go Go and touring with the Byrds. By the end of 1966 the band had signed with Atlantic and released their eponymous debut album. In the meantime, Stills had written what would prove to be the band's only lasting artifact "For What It's Worth" about the November 1966 Sunset Strip riots; unfortunately it was recorded too late to be included on the LP. After the song rose to #7, *Buffalo Springfield* was repressed, this time with "For What It's Worth" included. They further solidified their reputations as up and comers with a successful appearance at the Monterey Pop Festival. But infighting (ironically mostly between Stills and Young) and bad management ultimately took their toll, and the group folded in May 1968 after releasing three commercially unsuccessful albums.

Crosby, Stills, Nash & Young

Supergroup Crosby, Stills, Nash & Young, perhaps the most influential folk rock band, was formed by four of the genre's most talented and decorated singers and songwriters. Their intricately crafted high four part harmonies are among the most distinctive of the genre. In May 1968, former Byrd David Crosby began jamming with Stephen Stills of the recently disbanded Buffalo Springfield; they were soon joined by Graham Nash, a former member of The Hollies. Their first LP, Crosby, Stills & Nash, recorded in early 1969, went to #6 and contained two minor hits, "Marrakesh Express" and "Suite: Judy Blue Eyes" (which Stills wrote for singer Judy Collins). Canadian singer/songwriter and ex-Springfielder Neil Young joined the band as a sort of part time member (already leading his own group, Crazy Horse) in time for their summer tour, which included a performance at Woodstock. In early 1970 CSN&Y released what is perhaps their finest recording, **Déjà Vu**, which went to #1 on advance orders of two million copies. The album also contained two hit singles, "Woodstock" (written by Joni Mitchell, #11) and "Teach Your Children" (#16). Déjà Vu features songs written by each of the members that encompass a wide assortment of musical influences, including acoustic folk, rock, country and pop.

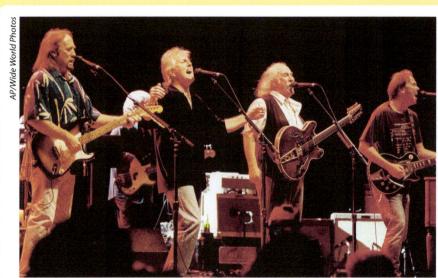

Stephen Stills, Graham Nash, David Crosby, and Neil Young perform in Los Angeles on February 12, 2000.

"CARRY ON" (STEPHEN STILLS)—CROSBY, STILLS, NASH & YOUNG

Personnel: Stephen Stills: lead and backup vocals, keyboards; David Crosby: backup vocals; Graham Nash: percussion, backup vocals; Neil Young: backup vocals; Greg Reeves: bass; Dallas Taylor: drums. Recorded July-December 1969 at Wally Heider's Studio C, San Francisco, CA; produced by Crosby, Stills, Nash & Young. Released March 11, 1970 on the album *Déjà Vu*; not released as a single.

In the liner notes to the 1991 CSN&Y boxed set, drummer Dallas Taylor describes how "Carry On" came together: "The song was written in the middle of the *Deja Vu* sessions, when Nash told Stephen they still didn't have an opener for the album. It was something of a message to the group, since it had become a real struggle to keep the band together at that point. Stephen combined two unfinished songs and stuck them onto a jam we'd had out in the studio a few nights before, me on drums and Stephen on a Hammond B-3 organ. As the track begins I'm playing bass drums and high hat, and Graham is playing congas. Then we go into a 6/8 groove, which is rather obscure—Stephen loved to change gears that way. The sessions would go on all night, sometimes three or four days non-stop. The thing I loved about the studio was you could never tell if it was day or night, and we hid all the clocks so no one knew what time it was."

Soon after the release of *Déjà Vu*, the Kent State massacre inspired Young to write "Ohio" ("Tin soldiers and Nixon's comin"..."), a #14 single release. Young later reflected on the song: "It's still hard to believe I had to write this song. It's ironic that I capitalized on the death of these American students. Probably the biggest lesson ever learned at an American place of learning. My best CSN&Y effort. Recorded totally live in Los Angeles. David Crosby cried after this take." The group toured again in the summer of 1970, but afterward broke up due to internal conflicts (Stills and Young had a history of feuding going back to their days in Buffalo Springfield). A live album from the tour, *Four Way Street* was released in 1971 and like *Déjà Vu* went to #1. A brief reunion tour in 1974 resulted in their third straight #1 LP, a greatest hits compilation entitled *So Far.* Since 1977 the group has reunited from time to time without Young and has released three Top 20 albums as well as three Top 20 singles.

Simon & Garfunkel

Paul Simon (1941–) and Art Garfunkel (1941–) first got to know each other as classmates in the sixth grade in Forest Hills, New York. Singing together as the folk duo Tom and Jerry throughout their schooldays, they recorded a single called "Hey, Schoolgirl" in 1957 that went to #49 and earned them an appearance on *American Bandstand*. After their next records flopped, both went off to college, Garfunkel to study architecture and Simon to study English literature. In 1962 they reunited and began working the Greenwich Village folk club scene. Around this time Simon took one of his originals to Columbia Records producer Tom Wilson (Bob Dylan's producer at the time), who bought the song and signed the duo. The resulting album, *Wednesday Morning, Three A.M.*, a combination of traditional folk songs, Simon originals and Dylan covers, went nowhere. Once again, the two went their separate ways, with Simon moving to England to try to get his career back on track.

"MRS. ROBINSON" (PAUL SIMON)— SIMON AND GARFUNKEL

Personnel: Paul Simon: guitar, vocals; Art Garfunkel: vocals; Hal Blaine: drums. Recorded February 2 1968 at Columbia Studio A, New York City; produced by Paul Simon, Art Garfunkel, and Roy Halee. Released April 5, 1968 on Columbia; 12 weeks on the charts, peaking at #1.

"Mrs. Robinson" hit the #1 spot on the Billboard chart on June 1, 1968, where it stayed for three weeks. It was the second #1 hit for the group, after 1966's "The Sound of Silence." It was also included on S&G's album *Bookends*, which is widely considered to be one of the group's finest. "Mrs. Robinson" was highly acclaimed by the industry as well, winning two Grammies for Record of the Year and for Best Contemporary Pop Performance—Vocal Duo or Group. However, what most people remember the song for is its use in the movie *The Graduate*. Director Mike Nichols had asked Simon to write one or two songs for the movie, and after initially balking at the idea came up with two songs, both of which Nichols rejected. Then, according to Art Garfunkel, "Paul had been working on what is now 'Mrs. Robinson,' but there was no name in it and we'd just fill in with any three-syllable name [. . .] and one day we were sitting around with Mike talking about ideas for another song. And I said 'What about Mrs. Robinson.'" Mike shot to his feet. 'You have a song called "Mrs. Robinson" and you haven't even shown it to me?' So we explained the working title and sang it for him. And then Mike froze it for the picture as 'Mrs. Robinson." There is also a famous reference to former Yankee slugger Joe DiMaggio in the last chorus.

Meanwhile, sensing a trend was afoot with the successes of "Mr. Tambourine Man" and "Like a Rolling Stone," Columbia's Wilson took one of the songs from Wednesday Morning, Three A.M., "The Sound of Silence," and added a rock rhythm section and electric guitar without Simon or Garfunkel's knowledge. Within six months "The Sound of Silence" was the #1 song in the country. Simon immediately returned from England and reunited with Garfunkel to tour and record a new album in the folk rock vein. In 1966 the duo placed five singles and three albums in the Top 30, including the Top Five hits "Homeward Bound" (#5) and "I Am a Rock" (#3). Although their two voices blended perfectly, the real magic in the group came from Simon's songwriting, which mixed pop oriented melodies with intelligent, relevant lyrics that appealed to a wide audience base. However, after their initial success Simon's output slowed and the duo did not have another major hit until 1968 when the soundtrack album from the film The Graduate and its single release "Mrs. Robinson" both went to #1. The Graduate was followed by Bookends, which also went to #1 (the two albums occupied the top spot on the charts for a combined 16 weeks). In 1970, after another two-year drought, Simon and Garfunkel released Bridge over Troubled Water, which also went to #1 for ten weeks and contained the hit singles "The Boxer" (#7) and "Bridge over Troubled Waters" (#1) and won the 1970 Grammy for Album of the Year. Unfortunately, Bridge over Troubled Water would be Simon and Garfunkel's last album, as they separated to pursue individual interests.

Other Folk Rock Artists

Other important folk rock groups include the Lovin' Spoonful, led by John Sebastian; Ian and Sylvia, led by Ian and Sylvia Tyson; the Turtles, and the Beau Brummels.

SINGER/SONGWRITERS

The Dylan Influence (Again!)

By the end of the 1960s, a new label was being given to solo performers who wrote and sang original songs that tackled personal issues and emotional struggles. Singer/songwriters were nothing new to rock: Buddy Holly, John Lennon, Paul McCartney, and Paul Simon had all fit that description, but they first became established stars as members of the bands they belonged to. The new breed of songpoets eschewed the traditional route of joining a band, and instead found fame on their own singing and composing merits. Up to this point, the only artist who had really established himself in this fashion was Bob Dylan, who, because of his emergence in the early 1960s was labeled a folk singer. In fact, many of the new singer/songwriters might have been called folk singers if they had come along ten years earlier, but in the new era of selling rock as a retail product, labels were an essential part of a record company's marketing strategy. Whatever they were called, the singer/songwriters owed a mountain of indebtedness to Dylan's influence.

Having said that, there were important differences between the new singer/songwriters and the folkies that were due specifically to their timing. Although the 1960s were a time of communal thought, sharing, and a spirit of working together to change society, by the 1970s many people were ready for a moment of introspection and reflection, and to focus on making their own lives better and more meaningful. This attitude was widespread enough that many observers began calling the 1970s the 'me first' decade. The singer/songwriters reflected this mood, and tended to write about themselves rather than socially conscious issues, as the earlier folkies would have done. The personal and confessional themes of these songs—along with a soft, slow and soothing musical context—connected with the maturing rock audience. Pianos and acoustic guitars rather than drums and distorted electric guitars became the prominent instruments. Other instruments such as orchestral strings and light percussion were also used to soften the sound.

But one of the most important developments that the singer/songwriters brought to rock was as a voice for female performers to reflect on the dramatic cultural changes that were taking place for women regarding their sexuality, independence, and their roles in the workplace. True, there had been previous instances of women who sang feminist manifestos of sort-Aretha Franklin's "Respect" and Grace Slick of Jefferson Airplane with "Somebody to Love" come to mind—but the songs were usually written by male songwriters (as in the examples given) and given a female perspective only by virtue of who was doing the singing. Even "Will You Love Me Tomorrow," a song about a girl asking for assurance that her boyfriend will still love her the day after "doing it" had lyrics written by a man (Gerry Goffin). The women singer/songwriters— Carole King, Joni Mitchell, Carly Simon, et al-wrote their own songs, and their lyrics reflected the new era of enlightenment and opportunities that characterized the emerging women's liberation movement. Songs like Simon's "That's the Way I've Always Heard It Should Be" and King's "It's Too Late," both of which hit the Top 10 with messages of criticizing marriages and ending relationships connected with young women of the day in powerful ways. Of course, lyrical topics were not limited by any means: there was always love (Mitchell's "Help

developments that the singer/ songwriters brought to rock was as a voice for female performers.

Characteristics of the Singer/Songwriters

- 1. Solo artists who recorded and performed with backup bands
- 2. Personal, confessional, reflective, narcissistic lyrics
- 3. Soft, soothing music, with acoustic pianos and acoustic guitars prominent
- Willingness to experiment with influences from a variety of styles, including jazz, r&b, folk, etc.
- 5. Important outlet for women performers and their viewpoints

Key Singer/Songwriter Recordings

- Astral Weeks—Van Morrison, 1968
- Sweet Baby James—James Taylor, 1970
- Blue—Joni Mitchell, 1971
- Tapestry—Carole King, 1971

- Buddy Holly
- John Lennon
- Paul McCartney

- Paul Simon
- Bob Dylan

Me"), companionship (King's "You've Got a Friend"), the meaning of life (Laura Nyro's "And When I Die"), and regret (Mitchell's "Big Yellow Taxi").

Carole King

By the mid-1960s Carole King (1942-) was already a legend in the music business, with a solid resume as a respected Brill Building songwriter with her husband Jerry Goffin. But when her marriage to Goffin broke up in 1967, she moved to Laurel Canyon to reinvent herself. Once in Los Angeles she released one album with a recording only group, The City, and a commercially unsuccessful solo album, Writer. In January 1971 King went back into the studio to record Tapestry, one of the decade's defining albums. With heartfelt songs and sparse production, King emotionally was at the right place at the right time with songs like "It's Too Late," "You've Got a Friend," and soulful reworkings of her earlier hits "Will You Love Me Tomorrow" and "(You Make Me Feel Like) A Natural Woman." Tapestry peaked at #1 for 15 weeks and stayed on the charts for six years; it also won four Grammies, including Album of the Year and Best Female Pop Vocal Performance. "It's Too Late," b/w "I Feel the Earth Move" peaked at #1; the former song also won a Grammy for Record of the Year. King remained popular throughout the 1970s: two more albums, Music and Fantasy both hit #1, while another, Rhymes and Reasons peaked at #2. She also had 13 Top 40 singles in the decade. King's songs have also been popular for other artists to cover; "You've Got a Friend" alone has been covered by everyone from jazz singer Ella Fitzgerald to Michael Jackson to James Taylor, whose version went to #1. The Beatles also covered her song "Chains" on their first album.

"IT'S TOO LATE" (CAROLE KING/TONI STERN)—CAROLE KING

Personnel: Carole King: vocals, keyboards; Danny "Kootch" Kortchmar: guitar; Ralph Schuckett: electric piano; Curtis Amy: soprano sax; Charles Larkey: bass; Joel O'Brien: drums. Recorded January 1971 at A&M Studio B, Los Angeles, CA; produced by Lou Adler. Released April 1971 on Ode; 17 weeks on the charts, peaking at #1.

"It's Too Late" was one of three songs recorded (along with "You've Got a Friend" and "I Feel the Earth Move") on the first day of sessions for Carole King's blockbuster album *Tapestry*. It was the first single released from the album, and the only to reach #1, where it stayed for five weeks. The single was named Record of the Year at the 1972 Grammy Awards, one of four Grammies King won for *Tapestry*, including Album of the Year. Part of *Tapestry*'s appeal is its straightforward production, which was completed in less than three weeks. With its heartfelt lyrics and soothing music, "It's Too Late" is a perfect representation of the album as a whole, which struck a chord with the pop audience and spent 15 weeks at #1. "Carole spoke from the heart, and she happened to be in tune with the mass psyche," wrote songwriter Cynthia Weil. "People were looking for a message, and she came to them with a message that was exactly what they were looking for."

Joni Mitchell

With stunning Nordic looks and beautiful soprano voice, Joni Mitchell (1943–) made an indelible first impression on people—especially men—when she moved to Los Angeles in 1967, but it was her songs that first won her rave reviews. Born Roberta Joan Anderson, she was raised in the wide-open prairies of Alberta and Saskatchewan, Canada where she survived a bout with polio at age nine and learned to play the guitar while recuperating. After moving to Saskatoon to enter college, Joni began to sing and write songs, and became a fixture in the local coffeehouse scene. It was there that she met and married fellow folksinger Chuck Mitchell, with whom she moved to Detroit in 1965 and began performing with as Chuck & Joni. The next two years were intensely creative for Joni as she went on a prolific songwriting tear, and because the Mitchell's apartment was a way station for traveling folksingers, her songs began to get heard by the likes of Buffy Sainte-Marie, Tom Rush and others. By early 1967 the Mitchells had divorced, and Joni moved to New York to pursue a career as a solo artist. By this time her songs were being enthusiastically received and recorded by other artists, including Sainte-Marie, Rush, and Judy Collins, who had a #8 hit with "Both Sides, Now."

Late in 1967 Mitchell moved to LA, where new boyfriend David Crosby used his clout to secure a contract with Reprise Records. Her eponymous debut LP (later known as *Song to a Seagull*) was released to positive reviews but modest sales in 1968; 1969's *Clouds*, containing Mitchell's own version of "Both Sides, Now," sold even better, peaking at #31 and winning a Grammy for Best Folk Performance. Around this time, she bought a cottage in Laurel Canyon in which she lived with new boyfriend Graham Nash. Traveling with Nash to New York in August 1969 while CSN&Y appeared at Woodstock, Mitchell wrote her classic anthem "Woodstock" after watching the festival on TV from a hotel room in New York City; the group's cover of the song became a #11 hit. Mitchell's own version of the song was included on her next album, 1970's *Ladies of the Canyon*.

"A CASE OF YOU" (JONI MITCHELL)— JONI MITCHELL

Personnel: Joni Mitchell: vocals, Appalachian dulcimer; James Taylor: guitar; Russ Kunkel: drums. Recorded 1971 at A&M Studios, Los Angeles, CA; produced by Joni Mitchell. Released June 22, 1971 on the album *Blue* on Reprise; not released as a single.

Joni Mitchell's fourth album *Blue* is often considered to be her best, and it is songs like "A Case of You" that make it so. The album's intimacy and transparency reminded critics of Carole King's *Tapestry*, released just months before *Blue*, and in fact both James Taylor, drummer Russ Kunkel, and Joni herself performed on both albums. But *Blue* is the more intimate album, often with just two or three musicians recording on a song. Whereas Carole brings a soulful and deliberate vocal style, Joni's voice is vulnerable, and she often sings in her falsetto range, making it sound beautifully fragile. *Tapestry* ended up outselling *Blue* 10 to 1, but *Blue* established Joni as one of pop music's most intelligent songwriters. Kunkel later said that on the basis of this album, he believed that "Joni was as distinct a woman performer as Jimi Hendrix was a male performer, and her effect on the music scene was as bold."

Her 1971 album *Blue*, written and recorded during the twilight of her relationship with James Taylor, is often considered to be her best. Mitchell writes sometimes painfully confessional, sometimes subtly humorous lyrics, which she sings with an idiosyncratic, playful vocal style. Along with "Both Sides, Now" and "Woodstock," her most popular songs include "The Circle Game," "Big Yellow Taxi," and "Help Me," a #7 hit in 1974.

Carly Simon

As the daughter of Richard Simon, co-founder of Simon and Shuster, Carly Simon (1945-) grew up in a world of wealth and privilege in the West Village of New York City. The Simon's were a musical family, and Carly and her two sisters recorded three albums as the Simon Sisters in the 1960s. After briefly attending the exclusive Sarah Lawrence College, Carly returned to New York and in 1968 sang in the jazz-flavored pop group Elephant's Memory, for which she also wrote songs. By 1969, after intensifying her songwriting efforts, she signed with Elektra Records, and in 1970 began working on her eponymous debut album. Her first single release, "That's the Way I've Always Heard It Should Be" struck a nerve with many women who were becoming disillusioned with the institution of marriage, and became a #10 hit. To promote the single, she made her LA debut at the Troubadour on April 6, 1971 and was warmly received. Her second album, Anticipation, was released in 1971, and propelled by the #3 charting title track (written while waiting for singer Cat Stevens to pick her up for a date), peaked at #30. 1972's No Secrets, was Simon's pop breakthrough; both the album and its signature song, "You're So Vain" hit #1. "Vain" has ignited a controversy of sorts as to who the song is about. Many have suggested Mick Jagger, with whom Simon reportedly had a brief fling, and who sang backup vocals on the song. Simon has never revealed the identity of the mystery person, however.

Carly Simon was a role model for many women in the 1970s and 1980s who were rethinking their status at home, work, and society as a whole. "Women adored her," said her manager Arlyne Rothberg. "Women looked at her and said: 'Oh, you can be gorgeous and smart and educated . . . and be a rock star?' "In 1972 Simon married James Taylor, and the two immediately became rock's *über* couple. *Rolling Stone* depicted them as embodying the "intelligent, self-conscious style and sex appeal that characterized soft-rock stardom in the Seventies." The couple divorced in 1983 after having two children.

James Taylor

Boston born James Taylor's (1948-) life has certainly seen its ups and downs, but he has managed to persevere and become a successful and often imitated star. He first garnered fame as the quintessential sensitive soft rock performer, but he has worked in a variety of musical settings over the course of his career. Taylor began writing songs after being admitted to a mental institution as a teen. Upon his discharge in 1966, he moved to New York and put together the Flying Machine with guitarist Danny Kortchmar. The group split up the next year due to Taylor's heroin addiction, which would plague him until 1969. In 1968 he moved to London and was signed to the Beatles' Apple Records, which produced his little noticed debut LP. After another stay at an institution to clean up his drug habit, he appeared at the 1969 Newport Folk Festival and signed with Warner Brothers. His next album, 1970's Sweet Baby James was his breakthrough, peaking at #3 with the help of the autobiographical single "Fire and Rain," which also hit the #3 spot on the charts. Taylor has since gone on to record 13 more Top 40 albums and 13 more Top 40 singles, including Carole King's "You've Got a Friend," a #1 hit in 1971, and 1974's "Mockingbird," a duet with his then wife Carly Simon, which peaked at #5.

Van Morrison

The career of George Ivan Morrison (1945–) has been chameleon-like, ranging from writing enigmatic song stories to poignant love songs to enduring Top 10 classics. His soulful, quirky vocal style and intelligent lyricism have been widely copied, while he in turn has been influenced by a wide range of styles including folk, jazz, soul and the blues. Morrison was born and raised in a working class family in Belfast, Northern Ireland. At 16 he quit school to tour Europe for a year with an r&b band; when he returned he formed the group Them, which secured a steady gig as the house band at Belfast's Maritime Hotel. Cut in the mold of the Rolling Stones and the Animals, Them became extremely popular in Ireland playing rough R&B influenced rock. In 1964 the group moved to London where they released two albums, the #2 UK single "Here Comes the Night" and Morrison's classic "Gloria" before breaking up in 1966. In 1967 Morrison returned to Belfast before moving to New York, where he signed with Bang Records, who against his wishes released his first solo LP, Blowin'Your Mind. Despite the fact that the album contained the #10 hit single "Brown Eyed Girl," it sold poorly and Morrison retreated back to Belfast.

In 1969, Parsons formed the Flying Burrito Brothers with ex-Byrd Chris Hillman. Their first album release, *The Gilded Palace of Sin*, is yet another example verifying Parsons' influence on early country rock. Around this time he began hanging out with the Stones' Keith Richards and using heroin and cocaine, habits that grew worse and untimely led to his death from an overdose in 1973. Before his death, Parsons recorded one more album with the Flying Burrito Brothers and two solo albums. He is remembered today not only for his work with the ISB, the Byrds and the Burritos, but for the classic country rock songs that he wrote including "One Hundred Years from Now," "Do You Know How It Feels," and "\$1000 Wedding."

The Band

Never fully appreciated by the public but loved by rock critics, the Band nonetheless made a unique musical statement in the late 1960s and early 1970s that while influential, has never quite been replicated. Their music was an eclectic mix of folk, blues, country, classical and rock and roll that managed to bring out the unique talents of each individual member. The Band evolved between 1958 and 1963 as the Hawks, the backup band for Arkansas-born rockabilly singer Ronnie Hawkins. One by one, Hawkins assembled the core of the group, adding fellow Arkansan Levon Helm in 1958, guitarist Robbie Robertson in 1959, and bassist Rick Danko, pianist Richard Manuel and organist Garth Hudson in 1961. Robertson, Danko, Manuel and Hudson were all Canadians, picked up as the group played its way through the rough and tumble bars in the mining towns in the middle of the country. The band members' various musical influences meshed well, and the Hawks developed a reputation as one of the hardest rocking bands around. By 1963, the egotistical Hawkins was forced out of his own group, and the group became at various times Levon and the Hawks or the Canadian Squires, with Helm as the de facto leader. In 1964, John Hammond Jr. heard them

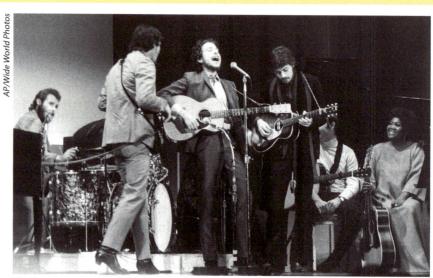

The Band appearing at Carnegie Hall on January 20, 1968 with Bob Dylan. From left: Levon Helm, Rick Danko, Dylan, Robbie Robertson.

"THE WEIGHT" (ROBBIE ROBERTSON)—THE BAND

Personnel: Levon Helm: drums, lead and backup vocals; Rick Danko: bass, vocals; Garth Hudson: piano; Richard Manuel: organ, vocals; Robbie Robertson: acoustic guitar. Recorded January 1968 at A&R Recorders Studio A, New York, NY; produced by John Simon. Released July 1, 1968 on the Capitol LP *Music from Big Pink*; single release peaked at #63.

"The Weight" is the last song on Side A of the Band's seminal 1968 album *Music from Big Pink*, and is one of the few single releases from the group to ever enter the Hot 100 chart. The lyrics reveal a song full of what appears to be biblical imagery, starting with the opening line, "I pulled into Nazareth," and references to the Devil, Miss Moses, and Luke. But in a later interview, songwriter Robbie Robertson revealed his real inspiration came at least partly from filmmaker Luis Bunuel. "People like Bunuel would make films that had these religious connotations to them but it wasn't necessarily a religious meaning. In 'The Weight', it was this very simple thing. Someone says, 'Listen, will you do me this favor? When you get there will you say "hello" to somebody or will you pick up one of these for me? Oh, you're going to Nazareth, that's where the Martin guitar factory is. Do me a favor when you're there.'This is what it's all about."The song is an example of what made the Band so unique, in that it simultaneously sounds like the blues, country, folk, and pop. Or, as Robertson said, "It was North American folklore in the making."

perform at a Canadian club and arranged a series of recording sessions with him in New York. It was there that they were introduced to Bob Dylan.

The Hawks toured with Dylan in late 1965, and after his motorcycle accident in the summer of 1966, they moved to Woodstock, NY to collaborate with him on the informal recording sessions that would in time be known as the Basement **Tapes.** Those recordings, many of which were done in the basement of their sprawling pink house, provided the inspiration for the group to begin working on their own material and the eventual release of their first album, Music from Big Pink in 1968. The album was a revolutionary surprise; coming at a time when the rest of the rock world was immersed in psychedelia, Big Pink is unadorned and earthy, and lacking the flash of albums such as Sgt. Peppers or Are You Experienced? Following its release, the group moved to Hollywood where in 1969 they released The Band, the album that proved to be their commercial breakthrough, peaking at #9, and containing their only Top 40 single, "Up on Cripple Creek" (#25). As the Band's popularity increased, the focus increasingly turned to the charismatic Robertson, the group's primary songwriter, and the egalitarian inner dynamics of the group began to change. Although they released six more LPs, including Stage Fright from 1970 and Rock of Ages in 1972, their days were numbered. The Band toured for the last time in 1976, concluding with a gala concert on Thanksgiving Day at San Francisco's Winterland Ballroom that included guest appearances by Dylan, Van Morrison, Eric Clapton, Muddy Waters and many others. The documentary film of that concert, The Last Waltz, directed by Martin Scorsese, is one of rock's best.

Creedence Clearwater Revival

Formed in 1959 by four junior high school classmates from El Cerrito, California, Clearwater Revival was one of America's most popular bands from 1969 to 1971. Led by brothers John Fogarty (guitars/vocals/chief songwriter/producer) and Tom Fogarty (guitars/vocals), with Stu Cook (bass) and Doug Clifford (drums),

CCR signed with Fantasy Records in 1964 when they were known as the Blue Velvets. After briefly calling themselves the Golliwogs, the band adopted their permanent name in 1967. CCR scored 13 Top 40 hits beginning in 1969 with the release of their LP *Bayou Country*, including 11 in the Top 10 and five that went to #2: 1969's "Proud Mary" (from *Bayou Country*), "Bad Moon Rising" and "Green River," and 1970's "Travelin' Band" and "Lookin' Out My Back Door." The band's sound was easily identifiable with strumming, country influenced rockabilly guitars and John Fogarty's raspy blues enriched voice. Although most of their songs have rather down to earth and non-political storylines, 1969's "Fortunate Son" was an attack on the privileged class who could afford to stay out of Vietnam through college draft deferments.

MUSIC CUT 78

"FORTUNATE SON" (JOHN FOGARTY)— CREEDENCE CLEARWATER REVIVAL

Personnel: John Fogarty: lead vocals, lead guitar; Tom Fogarty: rhythm guitar, backup vocals; Stu Cook: bass, backup vocals; Doug Clifford: drums. Recorded 1969 at Fantasy Studios, Berkeley, CA; produced by John Fogarty. Released in September 1969 as the B-side of "Down on the Corner"; 15 weeks on the charts, peaking at #3.

One of the hallmarks of music in the 1960s was the protest song. While many dealt with the Civil Rights Movement (see chapters 4 and 5), as the decade wore on many protest songs began to address the Vietnam War. "Fortunate Son," from Creedence Clearwater Revival's fourth album Willy and the Poor Boys, does not directly address the war, but instead the selective service draft, which allowed young men with connections—say, the son of a senator—to get deferments and avoid going into combat. When asked by Rolling Stone what had inspired him to write the song, John Fogarty replied: "Julie Nixon [daughter of president Richard Nixon] was hanging around with David Eisenhower [grandson of former president Dwight Eisenhower], and you just had the feeling that none of these people were going to be involved with the war. In 1969, the majority of the country thought morale was great among the troops, and like eighty percent of them were in favor of the war. But to some of us who were watching closely, we just knew we were headed for trouble." In another interview he added, "The song speaks more to the unfairness of class than war itself. It's the old saying about rich men making war and poor men having to fight them." (Note: presidents Clinton, George W. Bush, and Trump all used deferments to avoid serving in Vietnam. President Obama wasn't old enough: he was only 8-years-old when "Fortunate Son" was written.)

Other Country Rock Bands

Other bands and artists that played music in the country rock style include Linda Ronstadt, Poco, the Nitty Gritty Dirt Band, the Stone Canyon Band, Pure Prairie League and Loggins and Messina.

- John Fogerty
- Tom Fogerty
- Stu Cook
- Doug Clifford

SOUTHERN ROCK

The Rural Cousin

Southern rock is the rural cousin to the citified country rock. Whereas many country rock groups had a close musical connection to folk with strumming guitars and harmonious vocals, Southern rock bands were deeply rooted in country music and the blues. They were grittier and played louder and harder than their country rock cousins. Their lyrics reflected less emphasis on intellectual subjects and more on identifying with the legacy of the South and the 'good old boy' Southern stereotypes of male posturing and swagger. The bands were often bigger as well, sometimes including two lead guitarists (Lynyrd Skynyrd had three), and in the case of the Allman Brothers, two drummers. With its harder edge and blues base, Southern rock is conceptually somewhere between country rock and hard rock, and like hard rock, its audience was predominantly young, white and male. The power and drive of Southern rock also made the music popular in concert settings.

Characteristics of Southern Rock

- 1. Heavier instrumentation, often including two drummers, two or three lead guitar players
- 2. Harder edge than country rock, similar to hard rock
- 3. Deep roots in the blues
- Lyric themes identifying with Southern 'good old boy' image: male swagger, drinking, cheating, fighting, etc.

Key Southern Rock Recordings

- At The Fillmore—the Allman Brothers, 1971
- "Free Bird"—Lynyrd Skynyrd, 1973
- Second Helping—Lynyrd Skynyrd, 1974
- My Home's in Alabama—Alabama, 1980

Lynyrd Skynyrd

Formed in 1965 in Jacksonville, Florida, Lynyrd Skynyrd was the prototypical Southern rock band, combining the rebellious attitude of rock and roll with the blues and a country twang. In 1965 while still in high school, classmates Ronnie Van Zant (vocals), Allen Collins (guitar), Gary Rossington (guitar), Leon Wilkeson (bass) and Billy Powell (keyboards) formed a band they named in mock honor of their gym teacher, Leonard Skinner, who was known to punish students with long hair. After adding drummer Bob Burns, the band spent the next several years playing bars throughout the South before they were discovered and signed to MCA Records by producer Al Kooper. After adding third guitarist Ed King, the band recorded their debut album *Pronounced Leh-Nerd Skin-Nerd* in 1973, which included the anthemic tribute to Duane Allman, "Free Bird." They also became the warm-up act on the Who's Quadrophenia Tour. By the time their second album *Second Helping* was released in 1974, Lynyrd Skynyrd

"SWEET HOME ALABAMA" (ED KING/GARY ROSSINGTON/ RONNIE VAN ZANT)—LYNYRD SKYNYRD

Personnel: Ed King: lead guitar, backup vocals; Gary Rossington: rhythm guitar; Allen Collins: rhythm guitar, acoustic guitar: Leon Wilkeson: bass, backup vocals; Billy Powell: piano; Bob Burns: drums; Ronnie Van Zant: lead vocals; Al Kooper, Clydie King, Merry Clayton, Sherlie Matthews: backup vocals. Recorded June 1973 at Studio One, Doraville, GA; produced by Al Kooper. Released April 1974 on MCA; 17 weeks on the charts, peaking at #8.

"Sweet Home Alabama" was inspired by Neil Young's disparaging lyrics about racism and slavery in the South found in the songs "Southern Man" (from *After the Gold Rush*, 1970) and "Alabama" (*Harvest*, 1972). Although Lynyrd Skynyrd, in mentioning him by name in the lyrics, appear to be provoking Young into a war of words, there was in fact a mutual respect between the two adversaries. Young later said, "I'd rather play 'Sweet Home Alabama' than 'Southern Man' anytime"; Skynyrd lead singer Ronnie Van Zant responded by wearing a Neil Young T-shirt on the cover of the band's final album *Street Survivors*. "Sweet Home Alabama" was the highest charting record for Skynyrd, peaking at #8, and was included on their second LP *Second Helping*.

was acquiring a devoted fan base. The album went multi-platinum, and also contained what was to be their highest charting hit, "Sweet Home Alabama" (#8), a reply to Neil Young's songs "Southern Man" and "Alabama." Three more albums were forthcoming by late 1976, topped by the triple-platinum double live *On More from the Road*. Then, tragedy struck.

On October 20, 1977, three days after the release of Lynyrd Skynyrd's sixth album *Street Survivors*, the plane carrying the band to a gig in Baton Rouge, Louisiana crashed outside of Gillsburg, Mississippi, killing Van Zant, new guitarist Steve Gaines and Gaines' sister Cassie, a backup singer. The other members were injured but lived to continue on with the band. Ironically, the *Street Survivors* cover showed the band surrounded by flames; after the crash, the flames were removed on a redesigned cover. *Street Survivors* ultimately peaked at #5, becoming their biggest seller.

LYNYD SKYNYRD

- Ronnie Van Zant
- Allen Collins
- Gary Rossington

- Leon Wilkeson
- Leon Wilkeson
- Bob Burns

The Allman Brothers Band

Although they weren't as commercially successful or typical a Southern rock band as Lynyrd Skynyrd, the Allman Brothers Band became one of America's greatest rock bands, forging a unique combination of blues, boogie, r&b, country and jazz. Their legendary onstage jamming outdid even the Grateful Dead, with songs that often lasted 30 minutes or more and featured the tasteful playing of their three main soloists, the brothers themselves and guitarist Dickey Betts. The band was formed in 1969 in Macon, Georgia, the hometown of guitarist Duane

Allman (1946–1971) and his organist brother Greg Allman (1947–2017). At the time, Duane was a session guitarist at Fame Studios in Muscle Shoals, Alabama, where he had earned a solid reputation by playing on records by Wilson Pickett, Aretha Franklin and others. At the suggestion of Phil Walden, head of the newly formed Capricorn Records, Allman put together the band by recruiting friends Dickey Betts on guitar, Jai Johanny Johanson and Butch Trucks on drums, Berry Oakley on bass and Greg. After some touring to jell their sound, they released their eponymous debut album, which garnered respect from critics and sold modestly, mainly in the South. Two more releases followed in the next two years, 1970's *Idlewild South*, which sold moderately well and peaked at #38, and the double live *At Fillmore East* from 1971, recorded at the Fillmore East Ballroom. By this time the Allmans were being praised as "America's best rock and roll group," while Duane was further cementing his reputation as a guitar hero by appearing on Eric Clapton's *Derek and the Dominos* album.

On October 29, 1971, as the band was working on its third album, Duane was killed in a motorcycle accident in Macon. Determined to continue, the rest of the members completed *Eat A Peach*, which climbed to #4, and added pianist Chuck Leavell as a quasi replacement for Allman. But tragedy struck again—before they could finish their next album, bassist Oakley was also killed in a motorcycle accident on November 11, 1972, only three blocks from where Duane had died. Forging ahead once again in the face of misfortune, Dickey Betts assumed the leadership of the band and wrote most of the band's new material while steering them away from their deep blues roots to a more pop friendly sound. 1973's *Brothers and Sisters* became their only #1 album and contained the Allman's highest charting single, "Ramblin' Man" (#2). The band began to break apart in the mid-1970s: Greg married actress Cher (who had a disruptive influence) and later was forced to testify against a band employee in a federal drug trial, alienating him from the other band members.

Other Southern Rock Bands

With the success of the Allman Brothers Band and Lynyrd Skynyrd, other Southern rock bands emerged in the 1970s that achieved commercial staying power. They include the power trio ZZ Top from Texas, with ten Top 40 albums beginning in 1973; South Carolina's the Marshall Tucker Band, with eight Top 40 albums starting in 1973; Florida based .38 Special, led by Donnie Van Zant (younger brother of the late Ronnie from Lynyrd Skynyrd), five Top 40 LPs; the Charlie Daniels Band, led by the former Nashville session guitarist (Daniels' credits include Dylan's *Nashville Skyline*), five Top 40 albums; Georgia's Atlanta Rhythm Section, also with five Top 40 LPs; and the LA based Black Oak Arkansas.

CORPORATE ROCK

Mergers and Megahits

By the time the 1970s rolled around, rock had become the dominant music format of the mainstream culture, a fact that is reflected in the explosive sales growth of records and tapes. In 1973, music was a \$2 billion a year industry; by 1978, sales

had grown to \$4 billion. As rock was becoming big business, the industry began to consolidate: large corporations started to merge with and acquire major record labels, small independent labels and other music related businesses. By the end of the 1970s, 80 percent of all record and tape sales were controlled by six of these conglomerates: Columbia/CBS, RCAVictor, United Artists-MGM, Capitol-EMI, MCA and Warner Communications. In this new climate of lawyers, accountants and corporate control, it became imperative to turn a profit, and record labels responded by minimizing their risk whenever possible. Often this meant relying on well-established artists to produce records designed to have the greatest sales potential. These artists became the beneficiaries of massive advertising campaigns and huge contracts as the major labels poured their resources behind them, often with impressive results. Several albums from the 1970s are among the best selling of all time, including (all figures for US only) the Eagles' Eagles / Their Greatest Hits 1971–1975 (29 million), Fleetwood Mac's Rumours (19 million), Saturday Night Fever and Pink Floyd's The Dark Side of the Moon (15 million each) and Carole King's Tapestry (ten million). One of the most bankable stars was Elton John, who held the #1 album spot for a combined total of 39 weeks with seven of his 18 Top 40 LP's during the decade. Other groups, including Air Supply, Paul McCartney and Wings, Journey, Chicago and Foreigner fell back on predictable but stale pop formulas to sell a lot of records that were less than inspiring on a creative level.

The end result of all the fast money being made was that the 1970s marked the beginning of an era of greed, corporate hubris and personal lust for power in the industry that would last for nearly 30 years. Billions of dollars would be made during this time, not only by the labels and their artists, but also by fast talking industry moguls. Men such as David Geffen of Asylum (who, with shrewd investments in the record and movie industries is now estimated to have a personal fortune of more than six billion dollars), Walter Yetnikoff of CBS/ Columbia, Neil Bogart of Casablanca and Tommy Mattola of Sony made behind the scenes deals and decisions that shaped this business ethos, often driven by nothing more than personal gain. Investigative books such as Fredric Dannen's Hit Men and Steve Knopper's Appetite for Self-Destruction offer fascinating and sometimes juvenile accounts of maneuvering, backstabbing and vindictiveness that these and other industry operatives would engage in from time to time just to make a buck, and often just to even a score or exact revenge on a rival. With the accumulation of such staggering amounts of money also came lavish lifestyles, expensive homes and cars, and excessive usage of cocaine.

Ultimately this corporate climate would create a bloated and inefficient business model that could not adapt to the fast-changing technology that the Internet would bring in the new millennium. These changes will be discussed at length in chapter 13. In the meantime, two bands that perhaps best represent the ethos of corporate rock in the 1970s, the Eagles and Fleetwood Mac, will be discussed at this time.

The Eagles

With 16 albums achieving platinum or multi-platinum status, the Eagles are one the most commercially successful rock bands in history. In spite of this they have attracted their share of criticism as symbolizing the manufactured corporate rock

of the 1970s and the self-indulgent California lifestyle. Ironically, none of the original members were from the Golden State: bassist Randy Meisner hailed from Scottsbluff, Nebraska; guitarist Bernie Leadon from Minneapolis; drummer Don Henley from Texas; and guitarist Glenn Frey from Detroit. The group came about as the four worked their way through a variety of influential bands after moving to Los Angeles in the mid-1960s. Meisner was a founding member of Poco and worked briefly in Rick Nelson's Stone Canyon Band. Leadon had briefly been a member of the Flying Burrito Brothers, while Fry had worked with Bob Seger and J. D. Souther. In 1971, after they found themselves working together on a Linda Ronstadt album, the four decided to start a new band—not just any band, but a wildly successful one. "We'd watched bands like Poco and the Burrito Brothers lose their initial momentum, and we were determined not to make the same mistakes," recalled Frey. "Everybody had to look good, sing good, and write good. We wanted it all. Peer respect. AM and FM success. No. 1 singles and albums, great music, and a lot of money." After David Geffen signed them to Asylum and sent them off to an Aspen, Colorado club to tighten their sound, work commenced on their first album. Propelled by three Top 40 singles, The Eagles went gold within a year and a half.

MUSIC CUT 80

"TAKE IT EASY" (JACKSON BROWNE, GLENN FREY)— THE EAGLES

Personnel: Glenn Frey: lead vocals, acoustic guitar; Don Henley: drums, backup vocals; Bernie Leadon: lead guitar, banjo, backup vocals; Randy Meisner: bass, backup vocals. Recorded 1972 at Olympic Sound Studios, London; produced by Glyn Johns. Released May 1, 1972 on Asylum; 11 weeks on the charts, peaking at #12.

"Take It Easy" was the first single ever released by the Eagles, and the leadoff track on Side A of their debut album, *Eagles*. The song's creation begins with singer/songwriter Jackson Browne, who began working on it for his own debut album, but couldn't quite finish it. He played what he had for Glen Frey, a neighbor at the time, who liked it so much he offered to finish it. "And after a couple of times when I declined to have him finish my song, I said, 'alright'," Browne later said. "I finally thought, 'this is ridiculous. Go ahead and finish it. Do it.' And he finished it in spectacular fashion. And, what's more, arranged it in a way that was far superior to what I had written." The song is pure Eagles, in that it is music that perfectly reflects the laid back mood of the post-1960s and pre-Watergate years. On the other hand, it also reflects what many critics disliked about the Eagles. As Robert Christgau wrote, their music was, "suave and synthetic--brilliant, but false. And not always all the brilliant, either."

In early 1973 the group returned to the studio to record their second album, *Desperado*, which also went gold and contained the hit "Tequila Sunrise." By this time the Eagles were slowly abandoning the country flavor that characterized their early releases in favor of a more mainstream rock sound. The next two albums, *On the Border* and *One of These Nights* (both 1974) hit the Top 10, with the latter being the first of their five #1 LPs. In spite of their success, the shift away from country alienated Leadon, who quit the group in late 1975 and was replaced by Joe Walsh of the James Gang (another guitarist, Don Felder had also

joined for On the Border). In 1976 they released of the blockbuster Eagles/Their Greatest Hits 1971-1975, which became the first certified platinum album and today has the distinction of being the third best-selling album in US history with 29 million copies sold, and sales of 42 million worldwide. The next album, Hotel California, was released in December 1976 and went platinum within one week. Using California as a metaphor, Henley's lyrics paint a dark picture of excesses that yield unsatisfying pleasure. Eventually the album sold an estimated 32 million copies worldwide, and contained the #1 singles "New Kid in Town" and "Hotel California." The albums title track was the group's fourth #1, and their tenth Top 40 single. Although their next album took nearly three years to complete, The Long Run (1979) hit #1 and contained three more Top 10 singles, including the #1 "Heartache Tonight." However, by this time diminishing creative energies and inner tensions were beginning to take their toll, and after Frey began work on a solo album, the Eagles broke up in 1980. The group reunited in 1994 and continues to record and tour. In 2007 they released Long Road Out of Eden, which, with sales of over seven million copies, proved that the band is still immensely popular. The final sales tally for the Eagles: more than 150 million albums sold (U.S.), three diamond LPs, five #1 singles and five Grammies.

Fleetwood Mac

Fleetwood Mac helped define the sound of 1970s rock with its mega-hit LP Rumours, which is today the ninth best selling album in US history. The band was formed out of London's blues scene in 1967, fronted in the beginning by former Bluesbreakers guitarist Peter Green, with a rhythm section of Mick Fleetwood on drums and John McVie on bass. Although their first three blues-oriented albums sold well in the UK, commercial success across the pond was nonexistent. In 1970 Green had a spiritual crisis, and decided that all band profits should be donated to charities. Fleetwood and McVie balked at the idea, so Green left the band and subsequently gave away nearly all his money. Around this same time, McVie's new wife Christine joined the band on keyboards and vocals, and the band moved toward a more pop-friendly sound. Still, success in America proved elusive, in part because of poorly produced albums and a virtual revolving door of musicians going in and out of the band. However, fortunes began to change in the early 1970s. First the band moved to Los Angeles to increase their visibility in the city. Next, new producers were brought in, most notably Ken Caillat and Richard Dashut. Finally, longtime guitarist/vocalist/primary songwriter Bob Welch quit, which led to the hiring of two Californians, guitarist/ vocalist/songwriter Lindsey Buckingham and his girlfriend/musical collaborator, vocalist Stevie Nicks. Now with two women in the band, Fleetwood Mac had a unique sound and stage presence, with Christine McVie's sultry alto voice contrasting Nicks' little girl sweetness and "space cadet/sexpot" persona.

In 1975, the new lineup—Fleetwood, the McVies, Buckingham and Nicks—released *Fleetwood Mac*, sometimes called the "White Album" because of its cover. Although the album was slow to catch on, it finally peaked at #1 more than a year after its release and eventually went 5x platinum. It also contained the band's first Top 20 singles, "Over My Head," "Rhiannon," and Say You Love Me." The next album was the blockbuster *Rumours*. Containing four Top 10 singles ("Go Your Own Way," "Don't Stop," "You Make Loving Fun," and the

#1 "Dreams"), the LP stayed at the #1 spot for 31 weeks in 1977 and 1978 and won the Album of the Year Grammy. It went gold within two weeks of its release, platinum within a month, and eventually sold an estimated 40 million copies. It was the band's creative apotheosis, in spite of the fact that the two inter-band relationships were falling apart during production (the McVie's divorced and the Buckingham/Nicks romance ended following the *Rumours* tour). The next album, *Tusk*, was an experimental endeavor that included, among other things, African Burundi drumming and the USC Trojan Marching Band; although it sold four million copies, it was deemed a failure. In the late 1970s and early 1980s Fleetwood Mac underwent more personnel changes, and in 1983 took a sabbatical so the members could pursue solo projects. They disbanded in 1995, but have reunited from time to time since then for tours.

Name _

1.	What were some of the reasons that rock began to fragment in the 1970s?
2.	Describe the significance of Laurel Canyon and other landmarks of the L.A. scene in the late 1960s and early 1970s.
3.	What were the three style phases of the Byrds and the important contributors to each?
4.	Name three important characteristics of Crosby, Stills, Nash & Young.
5.	What are some of the common characteristics of the music of the singer/songwriters that emerged in the 1970s?

Queen

Queen's roots go back to 1967, when guitarist Brian May and drummer Roger Taylor joined a group called Smile. After several years of struggle, singer Freddie Mercury (Frederick Bulsara) and bassist John Deacon joined the group, which by now had been renamed Queen. Forsaking live performances for two years while the four were enrolled in college, they released three albums in 1973 and 74: Queen I, Queen II and Sheer Heart Attack, the last of which broke through in the American charts at #12. The band's live act focused on May's astonishing chops and Mercury's Liza Minnelli-influenced flamboyant preening. In the studio, their music was highly produced, using heavy doses of overdubbing on vocals to create a unique and highly identifiable sound. Their breakthrough came in 1975 with A Night at the Opera (#4 US, #1 UK), which contained the opera spoof "Bohemian Rhapsody" that reportedly used as many as 180 overdubs of Mercury's voice. The song was such a smash that it stayed at #1 in England for a record-breaking nine weeks. The band also recorded two stadium rock anthems, 1977's "We Will Rock You," and 1980's "Another One Bites the Dust" (#1). Although Mercury and the group never publicly revealed the singer's homosexuality, by the late 1980s rumors were flying that he was ill with AIDS. Finally, on November 22, 1991 he released a statement confirming his illness; he died two days later. "Bohemian Rhapsody" hit the charts again in 1992 after its inclusion in the film Wayne's World.

- Brian May
- Roger Taylor
- Freddie Mercury
- John Deacon

Aerosmith

America was also getting into heavy metal, as it too had its share of disaffected youth who were sick of the peace and love generation. One of the most popular American metal bands of the 1970s was Aerosmith, who despite enduring attacks from critics as a cheap imitation of the Rolling Stones and lingering drug problems have maintained a solid fan base and have sold more than 66 million albums (US). The band formed in 1970 in Sunapee, New Hampshire as a power trio with drummer/vocalist Steve Tyler, guitarist Joe Perry and bassist Tom Hamilton. By the end of the year, the group added Brad Whitford on guitar and Joey Kramer on drums (allowing Tyler to front the band as lead vocalist), and moved to Boston, where they signed with Columbia Records in 1972. Although their self-titled debut album sold poorly, its power ballad single "Dream On" was a minor hit that peaked at #59. The second LP, *Get Your Wings*, did slightly better, benefiting from a hectic tour schedule, but still did not break the Top 40.

The groups commercial breakthrough came with 1975's *Toys in the Attic* which, helped by the #10 single "Walk This Way," went gold and hit #11 (it has since been certified 8x platinum). Meanwhile, "Dream On" was re-released

- Steve Tyler
- Joe Perry
- Tom Hamilton
- Brad Whitford
- Joey Kramer

AEROSMITH

and charted again at #6. In spite of their phenomenal success, Aerosmith was falling apart from their drug problems. Perry quit in 1979, Whitford in 1980, and the group floundered until both returned in 1984 and Perry and Tyler completed drug rehabilitation programs. Aerosmith's long road back to the top was bolstered by their appearance on Run-D.M.C.'s 1986 cover of "Walk This Way" and the prominent airplay the song's video received on MTV. Reintroduced to a new younger audience, Aerosmith had three subsequent Top 10 LP's: Pump (#5, 1989), Get a Grip (#1, 1993) and Big Ones (#6, 1994), all of which have since gone multi-platinum. Their song about incest, "Janie's Got a Gun," won the 1990 Grammy Award for Best Rock Performance by a Duo or Group.

KISS

Heavily influenced by Alice Cooper, KISS formed in 1970 when guitarist Paul Stanley and bassist Gene Simmons found drummer Peter Criss and guitarist Paul "Ace" Frehley through ads they had taken out in music magazines. Rehearsing in a loft in Manhattan, the band began wearing makeup around their eyes; over time they decided to completely cover their faces with designs that reflected their personalities. In 1973 they were close to a record contract with Warner Brothers, but when the label asked them to abandon their makeup (which they refused to do), the deal fell through and they signed instead with newly formed Casablanca Records. Although critics dismissed them, KISS quickly formed a bond with the 'KISS Army', their loyal fan base. In 1975 they scored their first Top 10 LP, Alive!; their first Top 10 single "Beth" came the following year. In 1977 Marvel Comics published a KISS comic book that reportedly contained blood from band members in the red ink. It sold more than 400,000 copies. In 1978 a second comic book was released, and NBC broadcast an animated TV special entitled KISS Meets the Phantom of the Park. KISS at this time also began to market their albums on TV and radio, do in-store appearances and offer promotions through their fan club, all of which were unusual at the time but are common today. After their popularity began to wane in the late 1970s, they changed their image in 1983 and appeared without makeup for the first time. To date, the group has sold more than 19 million albums (US).

- Paul Stanley
- Gene Simmons
- Peter Criss
- Paul "Ace" Frehley

Van Halen

Van Halen emerged from the Sunset Strip bar scene in the late 1970s to become one of the most popular American metal bands in history. Brothers Eddie Van Halen (guitar) and Alex Van Halen (drums) were born in Nijmegen, Holland, where their father Jan was a part time clarinet player. Both boys received extensive classical piano training in their youth. In 1963, when Eddie was eight and Alex ten, the family moved to Pasadena, California, where the brothers developed a love for rock and roll. In 1973, while playing in a bar band, they came across the flamboyant singer David Lee Roth, who sang in a rival band. Roth and the Van Halens joined forces, added bassist Michael Anthony, and began playing at Gazzari's, the Starwood and other bars along the Strip. In 1977, Gene Simmons from Kiss heard them and financed a demo tape that resulted in a contract from Warner Brothers. Roth's good looks and rock and roll swagger combined with Eddie Van Halen's unbelievable self-taught guitar technique (which includes hammer-ons, pull-offs and two-hand fret board tapping) were irresistible to casual pop fans and serious musicians alike. Since their self-titled debut album from 1978, the group has produced nine straight Top 10 LPs, including three #1's in a row (5150 from 1986, OU812 from 1988 and For Unlawful Carnal Knowledge from 1991), and the #1 single "Jump" from 1984. In 1985, Roth left to start a successful solo career and was replaced by singer Sammy Hagar.

- Eddie Van Halen
- Alex Van Halen
- David Lee Roth
- Michael Anthony

MUSIC CUT 84

"ERUPTION" (EDDIE VAN HALEN)— VAN HALEN

Personnel: Eddie Van Halen: guitar; Michael Anthony: bass; Alex Van Halen: drums. Recorded 1977; produced by Ted Templeman. Released February 10, 1978 on the Warner LP *Van Halen*; not released as a single.

From Van Halen's eponymous debut album, "Eruption" was the shot heard 'round the world for guitar players in 1978. Eddie Van Halen throws his entire repertoire of hammer-ons, pull-offs, fret board tapping and whammy bar bending into this 1:42 solo display of technical virtuosity and electronic wizardry. It is considered to be one of the most influential guitar solos in history, and helped *Van Halen* achieve diamond status in 1996.

Other Metal Bands From the 70s

Other important heavy metal bands from the 1970s include Blue Oyster Cult, Cactus, Ted Nugent and the Amboy Dukes, Uriah Heep, Quiet Riot, and Mountain.

ART ROCK

The Origins of Art Rock

Art rock (or progressive rock) is a designation for a diverse and eclectic mix of rock styles that are bound together more by common philosophy—to incorporate elements of other forms of music generally described as art or high culture into a rock context—than by musical style. These borrowings usually come from European classical music, although they occasionally included American jazz and the musical avant–garde as well. The first stirrings of art rock came from England, where class distinctions and separation of 'highbrow' and 'lowbrow' art and their audiences are more pronounced than in the US. When musicians from the upper classes of English society began developing an interest in rock and roll, they brought a completely different set of social experiences and circumstances to the music than lower and middle-class musicians, and their music reflected it.

Although the Beatles were not from the upper class themselves, their association with the classically trained producer George Martin gave them the opportunity to experiment with influences from classical music. As early as 1965 the band was using classical instruments and influences, including the chamber string ensemble arrangement on "Yesterday" and the baroque-like piano solo on "In My Life," both of which were conceived by Martin. By the time Sgt. Pepper's was released in 1967, the Beatles were making extensive use of classical influences, including the album's quasi-opera setting. A few weeks before the release of Sgt. Pepper's, London-based Procol Harum released "A Whiter Shade of Pale," whose prominent feature was an organ solo co-opted from baroque composer J. S. Bach's "Aire on a G String." Also in 1967, Birmingham's Moody Blues released the influential Days of Future Passed, which utilized a symphony orchestra as well as the Mellotron, an early synthesizer capable of reproducing the sound of violins, cellos and flutes. With the release of the Who's Tommy in 1969, the first rock opera, a number of groups and artists on both sides of the Atlantic were incorporating highbrow art music into rock.

KEY TERMS

Art rock A diverse and eclectic mix of rock styles that were bound together by the common philosophy to incorporate elements of other forms of music generally described as art or high culture (such as classical and jazz) into a rock context. Also referred to as progressive rock.

Mellotron A keyboard instrument that was capable of playing taped sounds of violins, cellos, flutes and other orchestral instruments.

Characteristics of Art Rock

- 1. Umbrella term to describe the philosophy of incorporating elements of European classical music, American jazz and the avant-garde into rock
- 2. Predominant use of keyboards and synthesizers
- 3. Use of classical forms such as operas, multi-movement suites; concept albums
- 4. Use of classical instruments such as string orchestras, flutes, oboes, etc.
- 5. Virtuoso performers with classical music training

Key Art Rock Recordings

- "A Whiter Shade of Pale"—Procol Harum, 1967
- Days of Future Passed—the Moody Blues, 1967
- Sgt. Pepper's Lonely Hearts Club Band—the Beatles, 1967
- Tommy—the Who, 1969
- In the Court of the Crimson King—King Crimson, 1969
- The Dark Side of the Moon—Pink Floyd, 1973

In addition to the use of classical instruments and forms, art rock is also typically characterized by the prominent use of keyboards such as the Mellotron and the Mini-Moog, one of the first commercially available portable synthesizers developed by electronic music pioneer Dr. Robert Moog. Many of the musicians that played the music were virtuoso performers with classical music training, which often contributed to excessive displays of showmanship. Concept albums were common, in which songs were thematically or otherwise related and often connected through the use of segues. In some cases, works of classical literature influenced the lyrics of art rock songs as well.

As in the case of heavy metal, critics who felt that rock and roll was supposed to be simple, lowbrow and rebellious held art rock in contempt. Art rock was too preoccupied with empty complexity and pretentiousness; it was too clinical. Many young rock musicians felt the same way, and disdain for the music ultimately boiled over in Britain's lower class and disenfranchised youth. The backlash by this faction of society against art rock and other 'corporate' rock from the 1970s contributed to the rise of the English punk movement, whose mantra was to return rock and roll to its most rebellious state. Nevertheless, art rock had many fans, and several art rock bands enjoyed high levels of commercial success in the 1970s. Yes scored five Top 10 albums between 1972 and 1979; two Moody Blues albums have reached #1; Pink Floyd's *The Dark Side of the Moon* went to #1 and stayed on the Top 200 album chart for 741 weeks—more than 14 years! With claimed sales of 45 million, it is the second biggest selling album of all time.

IMPORTANT ART ROCK BANDS

The Moody Blues

Formed in 1964 in Erdington, Birmingham, the Moody Blues could be called the archetype art rock band. They started life with a fairly typical British Invasion formula of Mersey beat style originals and American R&B covers, and both their first hit single "Go Now" (#1 UK, #10 US) and their debut album The Magnificent Moodies reflected this musical direction. However, personnel changes in 1966 led them to pursue the progressive musical direction that would make them international superstars. The group at this point consisted of the classic lineup of Justin Hayward on vocals and guitar, John Lodge on bass, Graeme Edge on drums, Ray Thomas on flute and vocals, and Mike Pinder on keyboards. In 1967 the group released their second album, Days of Future Passed, which might be called the first progressive art rock album. Moored by the success of the singles "Nights in White Satin" and "Tuesday Afternoon," the album became an instant classic for its use of the Mellotron and accompaniment by the London Festival Orchestra. In 1974, after releasing eight albums and seven Top 40 singles, the group went on hiatus. They reunited in 1977 and resumed performing and recording until 1990.

MUSIC CUT 85

"NIGHTS IN WHITE SATIN" (JUSTIN HAYWARD)— THE MOODY BLUES

Personnel: Mike Pinder: Mellotron, piano, backup vocals; Ray Thomas: flutes, percussion, backup vocals; Justin Hayward: lead vocals, guitars, piano; John Lodge: bass, backup vocals; Graeme Edge: drums; The London Festival Orchestra. Recorded October 8, 1967 at Decca Studios, London; produced by Tony Clarke, Michael Dacre-Barclay, Hugh Mendl. Released November 10, 1967 on Deram; re-released in 1972, 14 weeks on the charts, peaking at #2.

"Nights in White Satin" has an interesting chart history, in that it was first released in 1967 (barely denting the *Billboard* charts at #103), and then re-released in 1972 when it went all the way to #2. The song features one of the staple instruments of the art rock movement, the Mellotron, a keyboard instrument in which tape loops were activated by playing the keys. The Mellotron's sounds included violins, cellos, and flutes, and the instrument is used here in the distinctive counter melody heard during the verses. (You can also hear a Mellotron with its flute setting at the beginning of the Beatles "Strawberry Fields Forever.") "Nights in White Satin" is included on the Moody Blues' second album, *Days of Future Passed*, released in 1967.

Perhaps more so than any other band, Pink Floyd was the embodiment of art rock in the 1970s. They were at the vanguard of electronic special effects

in their recordings. Their music and lyrics took on a grand scale normally associated with classical music or opera, and their concert performances became spectacles of lasers, lights and props. And it was Pink Floyd that produced the single most significant artifact of the art rock movement, 1973's The Dark Side of the Moon. The band was formed in 1965 in London by guitarist Syd Barrett, bassist Roger Waters, drummer Nick Mason and keyboardist Rick Wright. At first they were a very typical English R&B cover band; in fact, their name was derived from two obscure blues singers from Georgia, Pink Anderson and Floyd Council. However, under the de facto leadership of Barrett, the band soon began to experiment in performance with electronic effects, free-form instrumental breaks, feedback and psychedelic light shows. By 1967 they had won a devoted following of fans and a record contract from EMI, and their first single "Arnold Layne" made the Top 20. Their debut album, The Piper at the Gates of Dawn was an experimental psychedelic epic that some critics put on a par with Sgt. Peppers. Unfortunately, Barrett, the group's mastermind, began to exhibit signs of mental instability that ultimately forced him to leave the group in mid-1968.

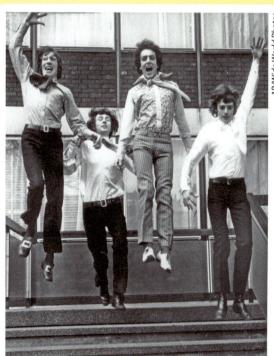

Pink Floyd, 1967. From left: Roger Waters, Nick Mason, Syd Barrett, Richard Wright

P/Wide World Pho

Just as Barrett was leaving, guitarist Dave Gilmour was brought in, and with the changeover, group leadership shifted to Waters, who reshaped Pink Floyd into a darker, grander and more experimental unit. Although albums from this period such as *Atom Heart Mother* (#1, UK) were appealing to a growing underground rock audience, Pink Floyd did not have much luck penetrating the American market until the release of *The Dark Side of the Moon*. The album is a state of the art concept album that utilized innovative stereo effects, taped sounds and spoken voices, synthesizers and dreamy, conceptual pop oriented songs. By hitting #1 in the US and yielding a #13 hit ("Money"), *Dark Side* made Pink Floyd international superstars. Subsequent albums *Wish You Were Here* (dedicated to former leader Barrett, 1975) and *Animals* (1977) continued the themes of isolation and insecurity of modern life first expressed on *The Dark Side of the Moon*, and struck a responsive chord with listeners, going to #1 and #3 respectively.

MUSIC CUT 86

"MONEY" (ROGER WATERS)— PINK FLOYD

Personnel: David Gilmour: guitars, vocals; Roger Waters: bass; Richard Wright: Wurlitzer electric piano; Nick Mason: drums; Dick Parry: tenor sax. Recorded June 1972—January 1973 at Abbey Road Studios, London; produced by Pink Floyd. Released June 23, 1973; 9 weeks on the charts, peaking at #13.

It's remarkable that "Money," the one hit from *The Dark Side of the Moon*, even made it into the Top 40, considering its unusual 7/4 time signature and use of cash register and coins sound effects at the beginning of the track. Also unusual is that the signature hook of the song is the distinctive bass line, played by the song's composer, Roger Waters. At 3:59 the song is also long by AM radio standards, and that was editing it down by more than two minutes from the album version. Guest tenor saxophonist Dick Parry also played on "Us and Them," the track following "Money." Floyd guitarist Dave Gilmour also contributes a rollicking solo on the song.

In 1979 the group released their best-selling album, the epic rock opera *The Wall* (23 million copies, US), an autobiographical double album in which Waters examines the emotional wall that he built up around himself. The album contained a scathing attack on the British educational system in "Another Brick in the Wall, Pt. 2." Tours during this period included animated films, laser light shows and elaborate staging—*The Wall* tour featured the building of an actual wall that by shows end had completely obscured the audience's view of the band. In spite of their unparalleled successes, the group began to unravel (due in part to Waters overbearing control), and broke up in 1983 after the release of the LP *The Final Cut*. They reassembled in 1986 without Waters and continued to be nearly as commercially successful as they had in the 1970s, including 1994's #1 LP release, *The Division Bell*.

PINK FLOYD

- Syd Barrett, 1965–68
- Roger Waters
- Nick Mason
- Rick Wright Dave Gilmour, 1968–

King Crimson

The brainchild of guitar experimentalist **Robert Fripp** (1946–), King Crimson is one of rock's most far-reaching musical ventures. Incorporating influences from every corner of the musical universe, the sound of King Crimson is perhaps best articulated by Fripp himself when he asked, "What would Hendrix sound like playing Bartok?" During their glory years in the late 1960s and early 1970s, King Crimson's live performances were some of the most explosive ever witnessed, as evidenced by a common refusal of other top bands to share the same stage with them. During these shows, Fripp eschewed the swagger and posturing common to heavy metal performers, and often sat impassively on a stool while churning out bone-crunching metal. Besides Bartok and Hendrix, Fripp's influences also included composer Gustav Holst (King Crimson often performed "Mars" from Holst's symphonic work *The Planets*), Joni Mitchell and the Beatles. Fripp was particularly intrigued at how the Beatles could "achieve entertainment on as many levels" as they did, revealing new and interesting things with each repeated listening.

King Crimson began rehearsing in January 1969 with Fripp, Michael Giles on percussion, Ian McDonald on woodwinds and keyboards, Greg Lake on guitar and bass and lyricist Peter Sinfield. The group's first performance was on July 5 at the Hyde Park concert that was headlined by the first Brian Jones-less Rolling Stones. Soon after, they went to work recording their debut album, In the Court of the Crimson King, an epic, symphonic effort that mapped out the future direction of art rock. The album contains diverse elements that range from the orchestral grandeur of the title track, the free form improvisation of "Moonchild," ethereal melancholy of "I Talk to the Wind," and distorted, metal chaos of "21st Century Schizoid Man." Sinfield was a master conceptualist whose lyrics were at various times dark, surreal and tender. Almost immediately after the release of In the Court of the Crimson King, Giles, McDonald and Lake left, (Lake to become a member of Emerson, Lake and Palmer), setting the stage for the constant personnel changes that would plague the group throughout 1970s and 1980s. (At last count there were 16 former members of King Crimson.) Notable in their 1970s output were the albums Lizard (1970) and Larks' Tongues in Aspic (1973). Still performing, now as a quartet that includes guitar wizard Adrian Belew, King Crimson has developed a cult-like following, complete with websites and pod casts that celebrate the groups history and upcoming events.

- Robert Fripp
- Michael Giles
- Ian McDonald
- Greg Lake
- Peter Sinfield

KING CRIMSON

Yes

As one of the most well-respected art rock bands among musicians, Yes has become legendary for its superior musicianship, high three part vocal harmonies and intricate and complex compositions. The group has endured a number of personnel changes over the years; the original lineup in 1968 included vocalist Jon Anderson, bassist Chris Squire, drummer Bill Bruford, guitarist Peter Banks and keyboardist Tony Kaye. Although they achieved instant acclaim in England, it was not until 1971's The Yes Album (#40) that they broke through in the US. By this time Banks had left and was replaced by guitar virtuoso Steve Howe; shortly thereafter Kaye left and was replaced by keyboard wiz Rick Wakeman. In 1972, Yes released two Top 10 albums, Fragile and Close to the Edge that included increasingly adventurous pop oriented songs, including "Roundabout" (#13). Close to the Edge was a paradigm of the progressive rock movement, consisting of three extended pieces, including the four-movement title cut. After its release, Bruford left to join King Crimson, and was replaced by session drummer Alan White.

MUSIC CUT 87

"ROUNDABOUT" (JON ANDERSON/STEVE HOWE)—

Personnel: Jon Anderson: vocals; Steve Howe: guitars, backup vocals; Rick Wakeman: keyboards; Chris Squire: bass; Bill Bruford: drums, percussion. Recorded September 1971 at Advision Studios, London; produced by Yes and Eddie Offord. Released January 4, 1972 on Atlantic; 13 weeks on the charts, peaking at #13.

"Roundabout" comes from the Yes album Fragile, the second of five produced by engineer Eddie Offord. These five albums, recorded between 1971-74 represent what is arguably the bands most creative period. Made up of musicians known for their great musicianship and great songwriting abilities, "Roundabout" gives Yes a chance to show off both. Although the band has gone through many personnel changes over the years (and they are still together), this period contains what might be considered the classic lineup. While the album version of "Roundabout" (heard here) is 8-1/2 minutes long, it was cut down to 3-1/2 minutes for its single release. The song was written by Jon Anderson and Steve Howe while on tour in Scotland, and many of the lines, such as "Mountains come out of the sky and they stand there" refer to the beautiful scenery they were witnessing.

The band's next two albums, the live Yessongs and Tales from Topographic Oceans were Wakeman's last; he was replaced in 1974 by Patrick Moraz. Tales was another epic that was loved by some critics and ridiculed by others; it was followed by the jazz/rock fusion undertaking Relayer. After a world tour, Wakeman rejoined Yes for the remainder of the decade, but the band broke up in 1980. Subsequently the band has reformed and continued touring, achieving their only #1 hit in 1983 with "Owner of a Lonely Heart."

- Jon Anderson
- Chris Squire
- Bill Bruford
- Peter Banks
- Tony Kaye

FOUNDING MEMBERS OF YES

Other Important Art Rock Bands

Other English bands of the era that helped define art rock include Jethro Tull, led by vocalist/flautist Ian Anderson; the innovative organ trio Emerson, Lake and Palmer, led by keyboard virtuoso Keith Emerson; Genesis; and Gentle Giant.

SHOCK ROCK: ARENAS, THEATRICS AND GLAM

As previously mentioned in chapter 8, rock in the 1970s was undergoing a period of fragmentation for a variety of reasons that were discussed at that time. We have also seen that the business of rock was growing exponentially, the ever-expanding audience was more and more willing to part with their entertainment dollars to see and hear their favorite bands. In addition to selling records, concert appearances were becoming increasingly lucrative for bands as a way to make money. By the 1970s the most popular bands were performing in large outdoor arenas in front of 50,000 or more fans, backed with huge sound and lighting systems. Because video projection systems had not yet been perfected and were not used, some performers began devising different forms of stagecraft to create larger-than-life personas that were visible to even those in the back rows. Although some performers—especially Alice Cooper—were developing outrageous stage acts before they began playing arenas, it was a natural fit that made Cooper, for one, a trendsetter. "David Bowie used to come to our shows in England when he was a folk singer," he recalled. "Elton John was this nice piano player who came to our show at the Hollywood Bowl. The next time I saw him he was in a Donald Duck outfit, wearing huge glasses and doing Dodger Stadium."

Although heavy metal and art rock bands were both early adopters of this trend, the most flamboyant shock tactics were employed by what became known as glam bands and later in the 1980s, hair bands. But before we discuss the glam rockers, we need to give credit where credit is due.

Alice Cooper: Godfather of Gruesome Rock Theatre

Alice Cooper (along with George Clinton, who is discussed in chapter 10) was a dominant force in the early development of rock as theatre. He was bornVincent Furnier (1948–), and for much of his early life in Detroit and later Phoenix he

The group's 1971 release *Electric Warrior* is considered one of the pioneering albums of glam. Bolan disbanded the group in 1975 after 11 British and one American ("Bang a Gong," #10) Top 10 hits, and then spent the next two years overindulging himself before dying in an automobile accident in 1977. Other bands that followed in the T. Rex mold were Gary Glitter, Slade and Sweet. Although Sweet made the biggest impact in America with four Top 10 hits, Glitter had the most enduring song of the era, the sports stadium staple "Rock and Roll Part II" from 1972.

David Bowie

The most influential glam performer was David Bowie (1947-2016). Born David Robert Jones (he renamed himself after the Bowie knife to avoid confusion with the Monkees' Davy Jones), during the 1960s Bowie released three singles in the mod vein, spent time in a Buddhist monastery, and formed his own mime and experimental art troupes. In 1969 he released the singer/songwriter album Man of Words, Man of Music as a way to raise money for his Beckenham Arts Lab. Because the LP and its single release "Space Oddity" (in which he portrayed himself as an extraterrestrial) were hits, Bowie decided to focus his creative energies solely on music. In 1972, Bowie disclosed for the first time in a Melody Maker interview that he was gay; around the same time he introduced his new alter ego, the androgynous, bisexual alien rock star Ziggy Stardust. Backed by his band the Spiders from Mars, Bowie in late 1972 introduced his new persona in The Rise and Fall of Ziggy Stardust and the Spiders from Mars. His extravagantly decorated concerts that followed in London and New York in which he dyed his hair orange and wore women's clothing were smash hits. By the end of 1973, Bowie had released two more LPs, Aladdin Sane and Pin Ups, produced albums for Lou Reed, the Stooges and Mott the Hoople, and then unexpectedly retired briefly from live performing.

Bowie's vocal style—crooning through clenched jaws in the manner of pub singer Anthony Newley—would in time prove to be immensely influential. In

MUSIC CUT 89

"ZIGGY STARDUST" (DAVID BOWIE)— DAVID BOWIE

Personnel: David Bowie: guitar, vocals; Mick Ronson: guitar, piano, vocals; Trevor Bolder: bass; Mick Woodmansey: drums. Recorded November 1971 at Trident Studios, London; produced by Ken Scott and David Bowie. Released June 6, 1972 on the RCA LP *The Rise and Fall of Ziggy Stardust and the Spiders from Mars*. Not released as a single.

"Ziggy Stardust" introduces listeners to the main character of Bowie's album cum stage show *The Rise and Fall of Ziggy Stardust and the Spiders from Mars.* Bowie himself describes the plot: "The time is five years to go before the end of the earth. It has been announced that the world will end because of lack of natural resources. Ziggy is in a position where all the kids have access to things that they thought they wanted. The older people have lost all touch with reality and the kids are left on their own to plunder anything. Ziggy was in a rock-and-roll band and the kids no longer want rock-and-roll." Although the album did not chart well in the US, peaking at #75, it was a hit in the UK, where it peaked at #5. It was certified gold by the RIAA in 1974.

his 1974 American tour (after coming out of retirement) Bowie showed a new obsession with soul music, which he repackaged and named "plastic soul." His 1975 album *Young Americans* reflected his new interest, and yielded the #1 single "Fame," co-written with John Lennon. Bowie would subsequently have one more #1, 1983's "Let's Dance." In 1977 he moved to Berlin where he collaborated with synthesizer pioneer Brian Eno on two innovative electronica-pop albums. By this time he had also launched an acting career, appearing in 1976's *The Man Who Fell to Earth*; later roles included the lead in the Broadway production of *The Elephant Man*.

David Bowie remained active throughout his final years. After releasing no new albums from 2003–2013, he released *Reality, The Next Day,* and *Blackstar* over the next three years. (Total album output for his career: 25 studio, 10 live, and 51 compilation.) His death at age 69 on January 10, 2016 caught nearly everyone by surprise; however, it was later disclosed that he had been diagnosed with liver cancer 18 months earlier. Bowie's last video, for the song "Lazarus" from *Blackstar* was released just three days before his death. The opening scene shows Bowie lying blindfolded in a hospital bed singing. "Look up here, I'm in heaven." As the video ends he retreats backward into a closet. *Blackstar's* co-producer Tony Visconti released a statement saying that the video was deliberately created as a "parting gift" for Bowie's fans. "He always did what he wanted to do. And he wanted to do it his way and he wanted to do it the best way. His death was no different from his life—a work of Art. He made Blackstar for us, his parting gift."

Other Important Glam Rockers

Far and away the most commercially successful glam rocker has been Reginald Kenneth Dwight, better known as **Elton John** (1947–). Growing up in London, Reginald worked his way into the music scene, working occasionally as a solo pianist in pubs, and at one point forming a band called Bluesology. He also began writing songs, and in 1967 worked with his long time collaborator and lyricist Bernie Taupin for the first time. In 1969 the fledgling singer/songwriter adopted a new stage name borrowed from the names of saxophonist Elton Dean and British R&B singer Long John Baldry, and released his debut album, Empty Sky. Since his successful American debut at LA's Troubadour in August 1970, Elton John has been one of the most prolific and enduring recording artists in history. He has released 29 studio and four live albums; 28 have hit the Top 40, 15 have been certified platinum, and seven have hit #1. He has also racked up more than 50 Top 40 singles, including eight #1s. According to the RIAA, he has to date sold 70 million albums in the US, and it is estimated that he has sold more than 200 million worldwide. He has also won five Grammies, a Tony Award, an Oscar, and was inducted into both the Songwriters and Rock and Roll Halls of Fame. He also holds a record that most likely will never be broken. On September 6, 1997 John performed a version of his 1973 hit "Candle in the Wind" at the funeral of his friend Princess Diana of England that included lyrics rewritten for the occasion by Taupin. The single release of the song, "Candle in the Wind 1997" subsequently sold more than 33 million copies worldwide, making it the second biggest selling single in history.

"CANDLE IN THE WIND 1997" (ELTON JOHN/BERNIE TAUPIN)—ELTON JOHN

Personnel: Elton John: vocals, piano; Peter Manning, Keith Pascoe, Levine Andrade, Andrew Shulman: strings; Pippa Davies: oboe. Recorded September 1997 at Townhouse Studios, London; produced by George Martin. Released September 13, 1997 on Rocket/A&M; 42 weeks on the charts, peaking at #1.

"Candle in the Wind" was first released on the 1973 album *Goodbye Yellow Brick Road*, which today stands as the biggest selling LP of Elton John's career, going 8x platinum. At the time, "Candle in the Wind" was released only in the UK, where it reached a respectable #11. In 1987 a live version of the song was released in the US where it reached #6 on the charts. Upon the death of Princess Diana in 1997, Bernie Taupin rewrote the lyrics (which had originally made reference to Marilyn Monroe), and John re-recorded the song, resulting in the song's third release. "Candle in the Wind 1997" was first performed at Diana's funeral to a worldwide TV audience of an estimated 2.5 billion, and the CD single went on to sell 33 million copies, trailing only Bing Crosby's "White Christmas" in single sales. (Since singles are today only sold as digital downloads, the #1 and #2 rankings of these songs as physical singles will remain on the books in perpetuity.) Proceeds from "Candle in the Wind 1997"—estimated to be around \$15 million—all went to charities favored by Diana.

Another glam rocker, Rod Stewart, has released 19 Top 40 LPs and 33 Top 40 singles, including four #1's. Roxy Music, formed in 1971 in London, led by keyboardist Bryan Ferry and synthesizer pioneer Brian Eno, and Mott the Hoople, formed in Hereford, England in 1968 were two other important glam groups that achieved popularity in their native country without making an impact in America.

	Date	
Describe some of the social and musical influences on the birth of heavy r	netal.	
What are the main differences between hard rock and heavy metal?		
Why is Black Sabbath considered to be the first heavy metal band?		
Name three things (musical or non-musical) that influenced Led Zeppelin.		
	Describe some of the social and musical influences on the birth of heavy real. What are the main differences between hard rock and heavy metal? Why is Black Sabbath considered to be the first heavy metal band?	Describe some of the social and musical influences on the birth of heavy metal. What are the main differences between hard rock and heavy metal?

5. Why is Led Zeppelin not considered to be the prototypical heavy metal band?

- 6. What are some of the reasons that Deep Purple is unique?
- 7. What was Alice Cooper's most important contribution to the rock canon?
- **8.** What were some reasons that art rock originated in England instead of America?
- **9.** Describe the evolution of Pink Floyd from its beginnings to the present.
- 10. Name some common practices used by glam rockers to make themselves outrageous.

BEYOND SOUL

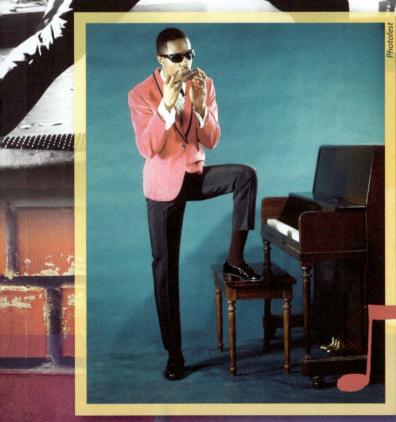

"My music actually speaks closer to me than anything I could ever do. If you listen to the songs I've written, or to the songs of others I record, you will hear how I feel. I guess it's the deepest me."

—Stevie Wonder

Soft soul Philadelphia International Records Disco

Funk Slap-bass technique **Blaxploitation film**

Reggae Riddim

Rastafarianism **Burru Mento**

Ska **Rock steady Toasting** Dubbing **Island Records**

Rap

Hip-hop Crew/posse Scratching **Back spinning Punch Phrasing** Old school rap

Gangsta rap

GURES

Dr. Martin Luther King, Jr. **Kenny Gamble Leon Huff Thom Bell** Giorgio Moroder **Steve Dahl George Clinton** Parliament/Funkadelic Sly and the Family Stone

Sly Stone **Larry Graham Stevie Wonder** Earth. Wind and Fire **Chris Blackwell Bob Marley** The Wailers **Muhammad Ali** Run-D.M.C.

Beastie Boys Public Enemy 2 Live Crew The Notorious B.I.G. Ice-T N.W.A. **Snoop Doggy Dog**

Tupac Shakur (2pac)

BUMS

Saturday Night Fever soundtrack album featuring the Bee Gees Talkina Book—Stevie Wonder Hot Buttered Soul—Isaac Haves

Burnin'—Bob Marley and the Wailers Raising Hell—Run-D.M.C. It Takes a Nation of Millions to Hold Us Back—Public Enemy

As Nasty as They Wanna Be—2 Live Crew Straight Outta Compton—NWA Doggystyle—Snoop Doggy Dog

THE CHANGING SOUL LANDSCAPE

As we have seen so far in chapters 8 and 9, the late 1960s and early 1970s saw a number of new music styles emerge as the rock industry began to expand and fragment. In case the reader hadn't noticed, the styles discussed in those chapters (folk rock, heavy metal, singer/songwriters, etc.), were largely performed by white artists for white audiences. But what about black pop in the 1970s? How was soul music, the dominant black pop style of the 1960s, holding up at decade's end? As it turns out, black popular music was undergoing a similar fragmentation process for several reasons. For one, the two biggest soul powerhouses, Motown and Stax, were starting to show the early signs that they were going into decline. Motown's problems started in 1967 when the Holland/ Dozier/Holland production team left the company in a dispute over money. It was a harbinger of things to come—Berry Gordy's stingy contracts and royalty agreements were also becoming sticking points for his artists. Although Stevie Wonder and Marvin Gaye renegotiated their contracts and stayed with the company, many would soon leave, including Mary Wells, the Temptations, Four Tops, Jackson 5, Ashford and Simpson and Martha and the Vandellas. Gordy

himself seemed to be losing interest in the constraints of the music business; in 1971 he shut down the company's Detroit operations and moved to Los Angeles to be closer to the Hollywood film industry. In 1982 he signed a distribution agreement with media giant MCA, and in 1988 sold the company outright for \$61 million. Ever the shrewd businessman, Gordy held onto Jobete Music, the hugely profitable publishing firm that holds the copyrights for virtually all the hits from the Motown catalogue.

Unfortunately for the owners Stax, things did not turn out nearly so well. When **Dr. Martin Luther King, Jr.** was assassinated at the Lorraine Motel on April 4, 1968 just a few blocks from the Stax studios, tensions increased between black and white employees. Sadly, the casual atmosphere of racial harmony that the company had enjoyed since its inception began to unravel. Around the same time, owners Jim Stewart and Estelle Axton became aware of the fact that in the fine print of their distribution contract with Atlantic Records, they had inadvertently sold the rights to the master tapes of records that Atlantic distributed. Realizing that they had been tricked into essentially giving away the store, Stewart and Axton promptly ended their association with Atlantic's wily Jerry Wexler and eventually sold the company to Gulf and Western for just under \$3 million, far less than what it was worth. Under it's new owners, Stax floundered; questionable business and accounting practices led to a 1973 IRS investigation and the eventual bankruptcy in January 1976.

After Stax closed, federal marshals seized the theatre at 926 East McLemore Ave and Union Planters Bank (ironically where Stax former co-owner Estelle Axton used to work) sold the building to a church for \$10 in 1980. Eight years later it was torn down. However, like a phoenix rising up from a deserted vacant lot, the Stax Foundation, spearheaded by former employee Deanie Parker has built an exact replica of the theatre (including the famous marquee) at its former location as a museum and civic landmark. It is called the Stax Museum of American Soul Music.

THE REBIRTH OF STAX

King's assassination was in many ways the Altamont of the civil rights movement. In spite of the many gains that had been made, the turbulence of assassinations and race riots did not sit well with what was becoming a generally quieter mood of the country. Soul music had always been inescapably linked with the movement, and they both seemed to be running out of steam by the early 1970s. On the other hand, with radio networks and record companies adapting to the growing and changing pop market, it was only inevitable that soul music would change as well. Radio programmers were reluctant to play music that was confrontational, or even reminiscent of the conflicts of the 1960s, and were only too glad to play anything new that wasn't. Some record labels responded by shifting their attention to white acts and away from black artists. Exhibit A on this point was Atlantic, which despite its well-earned reputation as one of the finest jazz, R&B and soul labels in the 1950s and early 1960s began to focus more of their attention on signing white acts such as Led Zeppelin, Cream and Crosby, Stills, Nash and Young by the 1970s.

Black pop was nonetheless expanding and fragmenting into nearly as many styles in the 1970s as white pop, and this chapter will take a closer look at those styles.

highly produced and polished soul style from the early 1970s that emphasized lush string and horn arrangements and smooth vocal harmonies.

SOFT SOUL/DISCO

The Sound of Philadelphia

One of the most popular new black pop styles became known as **soft soul**, or romantic soul. It is, as its name suggests, a smoother, more sophisticated style than 1960s soul, designed to be danceable and listener friendly, with non-confrontational romantic lyrics. Soft soul records were often orchestrated with lush strings and horns, extra percussion, and rich vocal harmonies. The style was the logical extension of the Motown sound, as and the predecessor to disco, it represented a move toward a more important role of the producer. Because the most important soft soul producers lived in Philadelphia, soft soul records are sometimes referred to as reflecting a "Philadelphia Sound." It was a fitting return to prominence in pop music for the City of Brotherly Love, the birthplace of *American Bandstand* and so many dance and novelty records in the early 1960s.

The architects of soft soul were the songwriting/producing team of **Kenny Gamble** (1943–) and **Leon Huff** (1942–), and independent producer **Thom Bell** (1943–). Gamble had apprenticed with Leiber and Stoller in New York before returning to his hometown where he teamed up with Huff. The two began working as independent producers, and scored a #4 hit in 1967 with their song "Expressway (to Your Heart)" by the white group Soul Survivors. In the wake of that success, they began assembling acts for their own Excel, Gamble and Neptune labels, before forming **Philadelphia International Records** (PIR) in 1971. Over a five-year period beginning in 1968, Gamble and Huff produced 30 records that went gold. The most important artists at PIR were Harold Melvin and the Blue Notes ("If You Don't Know Me By Now," #3, 1972), the O'Jays ("Love Train," #1, 1973), MFSB (an acronym for Mother Father Sister Brother, a band consisting of the studio musicians at Philadelphia's Sigma Sound Studios where Gamble and Huff worked) and the Three Degrees ("When Will I See You Again," #2, 1974).

Characteristics of Soft Soul

- 1. Highly produced and orchestrated; smooth vocals
- 2. Medium tempo dance tunes; slow, torchy romantic ballads
- 3. Predecessor to disco and more recent romantic soul styles
- 4. Center of development: Philadelphia
- 5. Great commercial and crossover appeal

Key Soft Soul Recordings

- "If You Don't Know Me By Now"—Harold Melvin and the Blue Notes 1972
- "Then Came You"—Spinners 1974
- "For the Love of Money"—the O'Jays 1974

MUSIC CUT 91

"COULD IT BE I'M FALLING IN LOVE" (MELVIN STEALS/MERVIN STEALS)—THE SPINNERS

Personnel: Bobby Smith, Philippé Wynne: lead vocals; Pervis Jackson, Henry Fambrough, Billy Henderson, Linda Creed, Bobby Smith, Philippé Wynne: backup vocals; Sigma Sweethearts (Barbara Ingram, Carla Benson, Yvette Benton): additional backup vocals; MFSB: instrumentals. Recorded at Sigma Sound Studios, Philadelphia, PA; produced by Thom Bell. Released December 1972 on Atlantic; 12 weeks on the charts, peaking at #4.

The group that eventually became the Spinners in 1961 was first formed in Detroit in the mid-1950s. The group put out their first record in August 1961, and "That's What Girls Are Made For" was a #27 hit. Future successes were few and far between for the group throughout the 1960s, but by the 1970s they were a constant presence on the radio, with 13 Top Forty singles (including 1974's #1 "Then Came You") and 10 album releases. "Could It Be I'm Falling in Love" was produced by legendary Philadelphia producer Thom Bell, and recorded at Sigma Sound Studios, where many of the romantic soul hits were made.

Bell's rise to fame paralleled Gamble and Huff's, with his first hit coming in 1968 with the Delfonic's "La La Means I Love You," which went to #4). Among his biggest acts were the Stylistics ("Betcha By Golly, Wow," #3, 1972), the Spinners ("Then Came You," #1, 1974 and six other Top 10 hits between 1972 and 1980). Other soft soul artists that rose to fame in the wake of the success of soft soul included Al Green ("Let's Stay Together," #1, 1971), Billy Paul ("Me and Mrs. Jones," #1, 1972), Roberta Flack ("Feel Like Makin' Love," 1974, one of three #1 hits in the 1970s) and Barry White ("Can't Get Enough of Your Love, Babe," #1, 1974).

Disco—The Underground Revolution

Soft soul was just a warm up for what would become the biggest trend in pop music history in terms of record sales. In fact, from 1976 to 1979, disco became such an enormous cultural phenomenon that it transcended music in a way that mirrored the swing era of the 1930s and 1940s. Disco's most important feature was that it was intended—like swing—to be dance music, and nothing more. Its musical ancestors included the minimalism of James Brown; lush string and horn orchestrations from Motown and Philadelphia International Records; percolating percussion from Latin music; and vocal chants and honking saxophones from rhythm and blues. It also incorporated new technology, making extensive use of synthesizers and drum machines. Disco emerged at a time when much of rock had seemingly become too artsy (art rock), too pretentious (heavy metal), or too self absorbed (singer/songwriters) to care about dancers any more. By the mid 1970s, public dancing as a popular activity was seemingly a distant memory from the early 1960s. In reconnecting pop music to dancing, disco paved the way for the dance-oriented MTV Generation of the 1980s and its superstars Michael Jackson, Madonna and Prince. Disco also was an important influence on new wave, rap and hip-hop culture.

oriented pop that incorporates synthesizers, drum machines, and lush orchestrations that emerged in the late 1970s.

Characteristics of Disco

- Pop oriented dance music whose most important characteristic is the relentless pounding emphasis on every beat
- 2. Produced in the studio using synthesizers, drum machines
- 3. Lush strings orchestrations, predominant use of percussion instruments, vocal chants

Key Disco Recordings

- "Love to Love You Baby"—Donna Summer 1975
- Saturday Night Fever Soundtrack—the Bee Gees/Tramps 1977

Disco's origins were in the European and East Coast dance clubs known as discotheques that first became popular during the early 1960s. These clubs generally employed DJ's to play records rather than hire live bands out of economic necessity. By the early 1970s, discos had fallen out of favor with rock's mainstream audience and went underground, catering primarily to the black, Hispanic and gay subcultures. Around 1973 their popularity started to rebound, a trend that was due in part to the ever-increasing skills of DJ's to seamlessly merge one song into the next, using two turntables while keeping the beat constant (disco records often had the beats per minute—bpm—marked on the label). This technique enabled dancers (who were often worked into a frenzy by ingesting cocaine and other uppers) to stay on the dance floor for extended periods of time. Discos initially did not impose dress codes, but it became fashionable for patrons to dress to the nines, enabling them to fantasize that they were the featured performers while they did their best dance moves. As a result of this environment, disco's cultural ethos was able to turn the tables on the established rock culture and let the DJ's, producers and dancers become the stars instead of the rock singers and instrumentalists.

Disco Conquers The Airwaves

Disco records were initially ignored by radio, but around 1974 began to get extensive airplay. It was in that year that the first bona fide disco hits emerged, "Rock the Boat" by the Hues Corporation and George McCrae's "Rock Your Baby." Both entered the Top 40 on June 15th; on July 6th "Rock the Boat" hit #1 and was replaced the following week by "Rock Your Baby," which stayed there for two weeks. By the following year disco hits were popping up with regularity, with Van McCoy's "The Hustle," Elton John's "Philadelphia Freedom" and KC and the Sunshine Band's "Get Down Tonight" and "That's the Way (I Like It)" all hitting #1. Late in 1975 Donna Summer, the 'queen of disco' emerged for the first time with the hit "Love to Love You Baby" (#2). Produced by European record producer Giorgio Moroder (1940–), who created a symphony of synthesized sounds over a drum machine beat, "Love to Love You Baby" featured Summer repeating the title over and over in fake orgasmic ecstasy. She later went on to hold the #1 spot for a cumulative 13 weeks in a one year stretch in 1978 and 1979 with four #1 hits, including "Bad Girls," which stayed at the top for five weeks in the summer of 1979. Summer later became a born-again Christian and renounced her disco heritage.

By 1976, disco ruled the airwaves, as everybody and everything in pop culture came under its influence. Among the #1 hits of the year were Walter Murphy's adaptation of Beethoven's Fifth Symphony, "A Fifth of Beethoven;" Johnny Taylor's "Disco Lady;" and LA DJ Rick Dees' "Disco Duck." Even Paul McCartney got into disco mode with "Silly Love Songs" (#1) with his group Wings. 1976 was also the year that the established-but-floundering English group the Bee Gees introduced their new revamped disco sound with "You Should Be Dancing," also a #1 hit. The song proved to be merely a warm-up for the group, who the following year appeared on the soundtrack LP to the disco movie Saturday Night Fever starring John Travolta, which eventually sold an estimated 40 million copies worldwide. The Bee Gees had three #1 singles generate from the album—"How Deep Is Your Love," "Stayin' Alive" and "Night Fever"—and had three more #1's the following year. The movie itself grossed a stunning \$130 million. Throughout 1978 and 1979, disco dominated films TV, radio and advertising. There were all-disco radio stations; remakes of Beatles, Beach Boys and classical music set to disco beats were common; even the Rolling Stones couldn't escape disco fever, and profited handsomely with 1978's #1, "Miss You." For a brief moment at the start of 1979, the most popular band in America was the gay-novelty group the Village People.

MUSIC CUT 92

"STAYIN' ALIVE" (BARRY GIBB/ROBIN GIBB/MAURICE GIBB)—THE BEE GEES

Personnel: Barry Gibb: lead and backup vocals, rhythm guitar; Robin Gibb: backup vocals; Maurice Gibb: backup vocals, bass; Alan Kendall: lead guitar; Blue Weaver: keyboards; Joe Lala: percussion; Dennis Bryon: drums. Recorded in 1977 at Château d'Hérouville, Hérouville, France; produced by the Bee Gees, Albhy Galuten, Karl Richardson. Released December 13, 1977 on RSO Records; 22 weeks on the charts, peaking at #1 for four weeks.

"Stayin' Alive" is one of six Bee Gees songs released on the *Saturday Night Fever* soundtrack album; five were released as singles, and all five went to #1 on the charts, totaling up 18 weeks at the top. Such was the dominance of disco in the late 1970s. (Two other songs from the album, "A Fifth of Beethoven" by Walter Murphy, and "If I Can't Have You" by Yvonne Elliman also went to #1.) Recording "Stayin' Alive" required a little studio trickery. The band decided to use a one-bar snippet of the drum track from their song "Night Fever" to create a loop. As producer Albhy Galuten later recalled: "Barry and I listened carefully to find a bar that felt really good. Everyone knows that it's more about feel than accuracy in drum tracks. To make the loop, we copied the drums onto one-quarter-inch tape. Karl [engineer Karl Richardson] spliced the tape and jury rigged it so that it was going over a mic stand and around a plastic reel. At first, we were doing it just as a temporary measure. As we started to lay tracks down to it, we found that it felt really great—very insistent but not machinelike. It had a human feel. By the time we had overdubbed all the parts to the songs . . . there was no way we could get rid of the loop."*

*Copyright © 2002 by Berklee College of Music, Inc. Reprinted by permission.

The Backlash

However, it didn't take long before a disco backlash began, and "Death To Disco" and "Disco Sucks" T-shirts and buttons began popping up around the country. It all seemed harmless enough at first, but on the night of July 12, 1979, one of the most surreal events in the history of pop culture revealed just how hated the

music had become. When Chicago DJ Steve Dahl first came up with the idea for a "Disco Demolition Night" during a nighttime double header at the White Sox' Comiskey Park, it was more of a gimmick than anything. Dahl, after all, was one of the disco haters, and he let his listeners on WLUP know it daily. But even he was shocked when 59,000 other disco haters showed up (the White Sox were averaging 16,000 fans at home games), wearing Led Zeppelin and Black Sabbath T-shirts, shouting, "disco sucks!" and throwing empty bottles and records around. When the first crate of disco records was dynamited between games, it ignited a riot as thousands of fans stormed the field, tearing up turf and causing so much chaos and destruction that the second game had to be cancelled. From that moment on, disco just seemed to lose its cool. Before long, Casablanca Records, the leading disco label, was in serious financial trouble and Studio 54, New York's hippest discotheque, closed. By 1980, disco was dead.

Surely the anti-disco backlash was caused in part by the music's overwhelming popularity and the inevitable pendulum swing away from it. There was also the natural dislike of the music by those fans that held the musical virtuosity of real performers in high regard, since disco was created largely in the studio using synthesizers and overdubbing technology. But there was also an uglier side to the backlash as well, fueled by homophobic and racist sentiments. Because disco was perceived by many as gay or black music, it was an easy target for the invective for many of the young white males who made up the base of the heavy metal audience. But the death of disco was a shock to the system for the music business, which experienced an 11% drop in sales in 1979 after a decade of unprecedented growth.

FUNK

Black Pop Gets a Brand New Bag

Even as soft soul and disco were smoothing out the grittiness of soul, a more primal form of black pop was emerging that became known as **funk**. The most important element in funk is the groove, formed by layers of syncopated patterns that form a tightly woven rhythmic fabric. Minimalism—simple one and two-bar repeating phrases that create a trance-like effect—is often used. Funk is also loosely structured, with extended jams, long improvisations and stream of consciousness lyrics common. Funk singers employ all kinds of vocal tricks, from shrieks and screams, guttural noises and grunts, sometimes locked in rhythmically to the band, sometimes floating above it out of rhythm. Group vocal chants are also common. Funk was the most intense and powerful form of black pop music to date, and yet artists such as Sly Stone and Stevie Wonder experienced great crossover success. It was also highly influential to jazz/rock fusion, hip-hop and rap, as well as to a number of alternative rock bands in the 1980s and 1990s.

The godfather of funk is James Brown. His work in the mid-1960s codified the style, especially 1965's "Papa's Got a Brand New Bag" and 1967's "Cold Sweat." Some scholars view his 1970 recording of "Get Up (I Feel Like Being a) Sex Machine" as the single defining recording of the style. These recordings paved the way for other artists to also make innovative contributions to the genre. Besides James Brown (see Chapter 4), the two most prominent funk pioneers were George Clinton and Sly Stone.

Characteristics of Funk

- 1. Most important element: the rhythmic groove, especially between the bass and drums
- 2. Typical instrumentation: bass, drums, guitar, electric keyboards, horns
- 3. Minimalism: simple two and four bar repeating phrases that create a trance-like effect
- 4. The rawest and earthiest form of black pop to date
- 5. Vocalists employ shrieks, screams, grunts, etc; group vocal chants common

Key Funk Recordings

- "Get Up (I Feel Like Being a) Sex Machine"—James Brown, 1970
- "Thank You (Falettinme Be Mice Elf Agin)"—Sly and the Family Stone, 1970
- Shaft—Isaac Hayes, 1971
- Talking Book, Innervisions—Stevie Wonder, 1973
- "Tear the Roof Off the Sucker (Give Up the Funk)"—Parliament, 1976

George Clinton

George Clinton (1940–) is one of the most eccentric and colorful musicians of all time. Leading a loose aggregation of musicians known at various times as Parliament, Funkadelic, the P-Funk All Stars and the Mothership Connection, Clinton produced some of the most adventurous recordings of the 1960s and 1970s. Growing up in Plainfield, New Jersey, he founded a vocal group called the Parliaments at age 15; 12 years later, Clinton was working as a staff writer at Motown when the group had their first hit with "(I Wanna) Testify" (#20). After leaving Motown, Clinton began recording a blend of funk rock and psychedelic music on the Westbound label with two different bands, Funkadelic and Parliament (dropping the 's' in 'Parliaments' after a legal dispute with Motown over the name).

Throughout the 1970s, Clinton built up a cult following through innovative concept albums and dazzling concert experiences. Performances would often include Clinton, dressed in elaborate costumes (rivaling those of David Bowie), jumping out of a coffin while other band members at various times wore diapers, smoked marijuana and simulated sex acts. A giant flying saucer named the Mothership descended from a huge denim cap. It was an African American parody of cartoon and science fiction. Musically, Clinton mixed influences from psychedelia, funk, R&B and jazz; lyrically he created cosmic and imaginary worlds with characters such as the Cro-Nasal Sapiens, the Thumpasorus People and Dr. Funkenstein, all of whom engaged in a sort of primeval struggle for existence. One critic described all this as either James Brown on acid or a black Frank Zappa. As you might imagine, Clinton had a limited crossover appeal to white audiences, although two Parliament albums from the 1970s, Mothership Connection and Funkentelechy vs. the Placebo Syndrome peaked at #13 and are certified platinum. Clinton's highest charting single came in 1976 with Parliament's "Tear the Roof Off the Sucker (Give Up the Funk)" (from Mothership Connection), which peaked at #15. His groups over the years have

Sly Stone, making a rare public appearance at the Grammy Awards on February 8, 2006, in Los Angeles

included such heavyweight musicians as former James Brown band members Bootsy Collins, Maceo Parker and Fred Wesley. His musical motto is "Free your mind and your ass will follow."

Sly and the Family Stone

Like George Clinton's groups, Sly and the Family Stone created a hybrid of soul, R&B, psychedelic rock and jazz, but were able to do it with a much greater degree of crossover success with 11 singles hitting the Top 40 between 1968 and 1974, three of which peaked at #1. The Family Stone was led by Sylvester Stewart (aka Sly Stone, 1944–), who started his career in the Bay Area as a DJ on soul station KSOL and record producer for Autumn Records. In 1966 he formed the Family Stone with his brother Freddie on guitar, sister Rose on vocals and keyboards, Larry Graham on bass, Gregg Errico on drums, Jerry Martini on sax and Cynthia Robinson on trumpet. The group's members created a unique multi-gender, multi-ethnic chemistry with two women and two white musicians (Errico and Martini). Their first national hit came in 1968 with the

#8 "Dance to the Music." Within two years, the band had two #1's ("Everyday People" and "Thank You [Falettinme Be Mice Elf Agin]"), a #2 ("Hot Fun in the Summertime"), and had performed at the 1969 Newport Jazz Festival and Woodstock. A third #1 single came in 1971 with "Family Affair."

Sly's success was due to his ability to combine irresistible sing-along hooks, infectious dance rhythms, a unique blend of different styles (who knew that soul could be psychedelic?), and lyrics that generally preached of love, peace and understanding. Occasionally Sly engaged in harsh social commentary, as evidenced by his singles "Don't Call Me Nigger, Whitey," "Sex Machine" and

MUSIC CUT 93

"THANK YOU (FALLETIN ME BE MICE ELF AGIN)" (SLY STONE)— SLY AND THE FAMILY STONE

Personnel: Sly Stone: guitar, vocals; Freddie Stone: guitar, vocals; Rose Stone: vocals; Jerry Martini: tenor sax; Cynthia Robinson: trumpet; Larry Graham: bass, vocals; Greg Errico: drums. Recorded 1969; produced by Sly Stone. Released December 1969 on Epic; 12 weeks on the charts, peaking at #1.

In late 1969, Sly and the Family Stone were on a roll, propelled by their breakthrough performance at Woodstock in August, four single releases and a #13 album release (*Stand!*) during the year. Their last single release of the year was "Thank You (Falletin Me Be Mice Elf Agin)," which quickly rose up the charts and hit #1 on February 14, 1970 where it stayed for two weeks. The song is the very definition of 1970s funk, with it's hard-baked groove, group vocal chants, horn pops, and soulful minimalism. But the one element that puts the song over the top is Larry Graham's bass popping and thumping, which virtually reinvented bass playing forever and influenced every bass guitar player since. This record is on everyone's top five list of funkiest songs ever.

"Stand," and the 1971 album *There's a Riot Going On*, the groups only #1 LP. One of the key elements to the sound of the Family Stone was the bass playing of Graham, the creator of an innovative **slap-bass technique** that has become a staple of all subsequent funk and jazz/rock fusion. Graham left the group in 1972 to start Graham Central Station. Around this time, Sly was becoming notorious for no-shows at concerts, and as rumors of drug addiction flourished, the Family Stone began to unravel. By the mid-1970s, they disbanded. Recent years have found many of the Family Stone's most memorable hits being used for high profile national advertising campaigns.

Other Important Funk Bands

Other funk artists also achieved enormous crossover success during the 1970s. **Stevie Wonder** (1950–) reinvented himself as a singer/songwriter/synthesizer conceptualist with an amazing creative streak between 1972 and 1976 in which he had four Top 5 albums (*Talking Book*, *Innervisions*, *Fulfillingness' First Finale*, and *Songs in the Key of Life*), eight Top 40 singles—five of which hit #1—and won 11 Grammy Awards. Among the funk classics that Wonder penned during this period were "Superstition," "I Wish," "Higher Ground," and "Living for the City," as well as the pop-friendly "You Are the Sunshine of My Life." **Earth, Wind and Fire**, formed in 1969, used Latin rhythms, jazzy horn lines and an interest in Egyptology to achieve 14 Top 40 hits (including the #1 "Shining Star" in 1975) and eight platinum albums between 1974 and 1979. Other popular funk groups include Kool and the Gang, with 22 Top 40 hits in the 1970s and 1980s, including "Funky Stuff" and "Jungle Boogie," the Ohio Players ("Funky Worm," 1973), the Commodores ("Brick House," #5, 1977) and the Isley Brothers ("It's Your Thing," #2, 1969).

"SUPERSTITION" (STEVIE WONDER)— STEVIE WONDER

Personnel: Stevie Wonder: vocals, drums, clavinet, Moog bass; Steve Madaio: trumpet; Trevor Laurence: tenor sax. Recorded 1972 at Electric Lady Studios, New York City; produced by Stevie Wonder, Robert Margouleff, Malcolm Cecil. Released October 24, 1972 on Tamla; 13 weeks on the charts, peaking at #1.

1972's *Talking Book* is a tour de force for Stevie Wonder. He wrote or co-wrote nine of the ten songs, played all the keyboard parts (which included piano, electric piano, clavinet, and synthesizers), harmonica, did all the drumming, and sang lead. Two of the songs, "Superstition" and "You Are the Sunshine of My Life" went to #1 on the charts. Wonder came up with the idea for "Superstition" while on tour with the Rolling Stones in 1972. Once in the studio it came together in short order, as he explained to NPR:

"I was sitting on the drums," he says, "and the first thing that I put down were the drums and then after that I put the Clavinet down, and really, I just starting singing the melody. Probably the first thing—the only thing I can remember that I said that I remember keeping was the line 'Wash your face and hands.' I think that was from when I was real little, I remember hearing this song saying 'Get out of that bed, wash your face and hands.' [It was the song] 'Shake, Rattle & Roll.'"

He continues, "I think that the reason that I talked about being superstitious is because I really didn't believe in it. I didn't believe in the different things that people say about breaking glasses or the number 13 is bad luck, and all those various things. And to those, I said, 'When you believe in things you don't understand, then you suffer.'

© 2000 National Public Radio, Inc. Excerpt from NPR news report titled "The Story Of Stevie Wonder's 'Talking Book'" by Deborah Williams was originally published on npr.org on December 30, 2000, and is used with the permission of NPR. Any unauthorized duplication is strictly prohibited.

Two other artists, Isaac Hayes and Curtis Mayfield achieved pop success scoring music for what became known as **blaxploitation films**, movies made by black directors and actors that had inner city themes of drug deals and ghetto shootings. Hayes, the former Stax writer who broke out onto his own with the landmark LP *Hot Buttered Soul* in 1969, became the first black composer to win an Academy Award for Best Score for 1971's *Shaft* soundtrack LP. Mayfield scored the highly successful *Superfly* in 1972, emphasizing his high, falsetto vocals and a smooth, pop oriented brand of funk.

– KEY TERM

Reggae A
Jamaican style
that evolved from the country's
indigenous folk music, American
R&B, and traditional AfroCaribbean music; it is associated
with the Rastafarian movement.

REGGAE

What Is Reggae?

Reggae is an indigenous Jamaican music that evolved in the late 1960s from native folk music, American R&B and traditional Afro-Caribbean music. Soon after its emergence on the island, Jamaican reggae recordings began to make a presence in the US, and in 1969 two, Desmond Dekker's "Israelites" and Jimmy Cliff's "Wonderful World, Beautiful People" hit the American Top 40. By the early 1970s, American and British rock musicians such as Johnny Nash and Paul Simon were co-opting infectious reggae rhythms into their own music. Nash had a #1 hit with his "I Can See Clearly Now" and a #12 hit with his cover of Bob Marley's "Stir It Up"; Simon hit #4 with "Mother and Child Reunion," recorded in the Jamaican capital city of Kingston. In 1973 the Jamaican film The Harder They Come was released, introducing American audiences to the music and its star, Jimmy Cliff. In Boston, a city with a large student population, the film was so popular that one theatre ran it for more than seven years without interruption. In 1974, Eric Clapton's cover of Marley's "I Shot the Sheriff" became the most popular reggae song in American pop history when it went to #1. Throughout the 1970s and 1980s, other artists and bands, including the Clash, Elvis Costello and the Police recorded reggae-inspired music. Reggae in the 1970s became the latest form of black music to become trendy in England, following the trad jazz-skiffle-R&B-blues lineage. Two Birmingham groups, the English Beat and UB40, were among the many that formed in the UK in response to the popularity of the Jamaican music.

Characteristics of Reggae

- 1. Combines influences from Jamaican folk (mento), American R&B, Afro-Caribbean
- 2. Intertwined patterns played by the bass, drums and guitar known as 'riddim'
- 3. Lyrics often refer to social injustices, political dissent, racism
- 4. Identification with Rastafarian movement

Key Reggae Recordings

- "Israelites"—Desmond Dekker and the Aces 1969
- Burnin'—Bob Marley and the Wailers 1973
- "I Shot the Sheriff"—Eric Clapton 1974

The primary rhythmic feature of reggae is the **riddim**, or the intertwined patterns played by the bass and drums. Each instrument in the band has a clearly defined role to play: while the guitar provides choppy, 'up stroke' strumming on beats two and four, the bass and drums are locked into a syncopated beat that often de-emphasizes the downbeat of each measure. Most reggae is played slowly, allowing the resulting polyrhythms and lyrics to be clearly heard. Because reggae came from the oppressed lower class in the ghettos of the capital city of Kingston, its lyrics often convey themes of political protest, social injustices, racial equality and the Rastafarian movement.

Rastafari Culture

Reggae is closely tied to Rastafarian culture. Rastafarianism is a movement whose followers believe they will be repatriated to their African homeland and escape Babylon (a metaphor for their oppressors in the New World). It was inspired by the writings of Marcus Garvey, a writer and political activist who wrote of the "crowning of a black king" who will "be the redeemer." In 1916 he moved to Harlem and started a "Back to Africa" movement before eventually moving to the continent himself. When Ras Tafari Makonnen was crowned king of the African nation Ethiopia in 1930 and took the name Haile Selassie, many clergymen in Jamaica saw this as a sign that Garvey's predictions had come true. (The word "Ras" is a title that loosely translates to prince or duke.) Rastafarians reinterpreted the Bible to suit their needs, and in time developed their own cultural values that included songs of social and political protest, the smoking of ganja (marijuana) as a sacramental herb and wearing the hair in dreadlocks. As the movement spread throughout Jamaica, Rastafarian songs were slowed down and mixed with an African drumming style known as burru. At this point in time, roughly the mid 1960s, the Rastafarian culture began to intermingle with the popular music of Jamaica to provide the basis for reggae.

Historical Background To Reggae

Reggae's roots go back to the indigenous folk music of Jamaica known as mento, which first appeared in rural areas in the 19th century. Mento's popularity began to fade in the 1940s, when American swing bands such as those of Benny Goodman and Count Basie rose to popularity in the urban dancehalls of Kingston. To emulate them, local musicians formed road bands that played their version of swing music at public dances. By the late 1950s Jamaican youth began copying the R&B records of Fats Domino and Louis Jordan they were hearing on radio broadcasts from New Orleans, Miami and Memphis, and developed their own variation of the music known as ska. Ska (an onomatopoeic word originating from the sound of the strong, sharp offbeat accents) is an up tempo music that combines an R&B influenced walking bass with accents on the offbeats (beats 2 & 4) from mento. It was extremely popular on the island in the early 1960s, and one ska record—Millie Small's "My Boy Lollipop" (#4)—even hit the American charts in 1964. The most popular ska band in Jamaica at this time was the Skatalites, led by trombonist Don Drummond.

In the summer of 1966, temperatures soared on the island, making ska too fast to play or dance to, and a slower, updated version emerged known as **rock**

KEY TERMS

Riddim The intertwined patterns played by the bass, guitar, and drums that is a characteristic of reggae.

Rastafarianism A religious movement originating in Jamaica espousing African repatriation; characterized by songs of political protest, smoking of ganja and wearing of dreadlocks.

Burru A drumming style adopted by and associated with Rastafarian musicians.

Mento The indigenous folk music of rural Jamaica dating back to the 19th century; an ancestor of reggae.

Ska A Jamaican precedent to reggae characterized by R&B influences, walking bass and strong, sharp offbeat accents played on the guitar.

Hip hop A cultural form of expression consisting of rap music, graffiti art, and break-dancing that emerged in the South Bronx and other inner city neighborhoods in the late 1970s.

Rap A style characterized by the use of spoken word (rather than singing) with funk oriented rhythm accompaniment, often using sampled sounds and minimalism; one element of hip hop culture.

RAP

Muhammad Ali and the Beginnings of Hip-Hop Culture

Hip-hop is a cultural form that emerged in the mid to late 1970s as a form of self-expression for the largely black and Hispanic communities of New York City's South Bronx. It was a response to the oppressive and dismal living conditions in the inner city, and became a way to negotiate the hardships of daily life. In its earliest years, hip-hop's components included rap music, break-dancing, and graffiti art. **Rap** is a late 20th century extension of the blues-jazz-R&B lineage of musical expressions that have emerged from the black cultural experience in America. It's most obvious musical connections to previous rock styles are funk (especially James Brown's) and disco; however, rap is an entirely different animal altogether that continues to evolve and assimilate other musical influences. Because of the violent and graphic nature of the lyrics of much contemporary rap, the genre and its purveyors have been at the center of an enormous amount of controversy, perhaps more than any other style in pop music history. But a closer look at the origins of rap and its motivations reveals that perhaps not all of the anger and outrage directed toward it is warranted.

Hip-hop has been described as the most sweeping American cultural movement of the late 20th century, and it is through rap music that the message of black life in the inner city has been transmitted to the American mainstream audience. In the years leading up to the emergence of rap, black youth culture was nearly invisible to the rest of the country, the exceptions consisting primarily of athletes and crime reports. In addition, before the 1960s, black athletes for the most part lived in a conservative sports climate, without a true cultural identity of their own, and often did not identify with the black youth of the streets.

A pivotal figure in changing this scenario was boxer Cassius Clay, who burst into the national spotlight in 1964 as the brash young challenger to heavyweight champion Sonny Liston. Clay taunted Liston before the fight with boasts that he could "float like a butterfly and sting like a bee," and beat the champ in one of the biggest upsets in boxing history. Clay, who soon after the fight joined the Nation of Islam and changed his name to Muhammad Ali (1942-2016), became an entertaining yet polarizing figure with his slam-like poetry, rhetoric of racial justice and religious freedom, and a macho bravado ("I am the greatest!") that ultimately would be taken up by rappers and black professional athletes. In this way, he was an important catalyst that connected sports, black culture, and music. As ESPN's Chuck Klosterman has written, Ali's "overt self-promotion, indifference toward authority, and confidence that hemorrhages into arrogance" have been emulated by many contemporary rap artists as well as athletes. Or as noted by The Examiner's Eric Montgomery, "Ali wasn't a traditional sense that we've come to recognize, but his attitude and 'flow' are predecessors of what would come in the late '70s."

Once this provocative prose and attitude was set into the context of hip-hop and rap music, a new black cultural presence emerged. As Bakari Kitwana states in his authoritative book *The Hip Hop Generation*: "Because of rap, the voices,

images, style, attitude, and language of young Blacks have become central in American culture, transcending geographical, social, and economic boundaries." Today, because of rap, hip-hop is omni-present in national TV ads, fashion, movies and movie stars, and professional sports, particularly basketball. Rap lyrics have also articulated the issues that confront many young blacks, such as police brutality, unemployment, drugs and gangs. Of course, civil rights leaders from previous generations had also addressed these issues, but not in such a confrontational manner.

The Jamaica-South Bronx Connection

It could be said that the foundations for what would eventually become rap music were laid in the dancehall culture of Kingston, Jamaica in the 1960s. The many dancehalls in the overcrowded slums of the city had by this time become 'safe houses' where the lower class could gather, form community associations (in lieu of non-existent government services), and listen and dance to music provided by DJs with portable sound systems equipped with turntables. In an attempt to liven up their shows, these DJs began to deliver spontaneous commentary on the proceedings, usually in some creative way that involved rhyming, interesting verbal sounds, the use of different dialects and nonsense syllables. This practice became known as toasting. In addition, DJs began to mix interesting sections of different songs together—a process known as dubbing—to create even more excitement, and often toasted over the top of the dub. Eventually these styles made their way into recording studios, resulting in hit songs from artists such as King Stitt and U Roy. In the 1970s, Caribbean expatriates such as Kool Herc and Grandmaster Flash took the techniques of dub music and toasting to New York City where they played important roles in the incubation of hip-hop culture.

New York in the 1970s could well be described as a terrifying and dangerous place. The city was experiencing industrial decline and economic stagnation that led to a fiscal crisis in 1975 which nearly brought it to bankruptcy. In addition, crack cocaine and heroin infested the city, which drove crime rates sky high. Conditions were particularly bad in the Bronx, one of the most poverty-stricken of the city's five boroughs. The Bronx had been devastated by the ravages of reduced federal funding, shifting and disappearing job opportunities, and the diminished availability of affordable housing. To further complicate matters, the borough had been literally cut in half in the 1960s by the construction of the Cross-Bronx Expressway, which destroyed more than 60,000 homes in stable neighborhoods and effectively isolated the southern half of the borough. The resulting infestation of slumlords and toxic waste dumps, increase of illegal drugs and violent crime, and the loss of city services such as fire and police protection, created an urban crisis that left the South Bronx in squalor. When a two-day citywide power outage occurred on July 13 and 14, 1977, hundreds of stores in the area were looted and vandalized, resulting in hundreds of millions of dollars in damage. After President Jimmy Carter made a highly publicized tour of the destruction, the South Bronx was characterized as a war zone in the media and through sensationalized films like Fort Apache, The Bronx.

Crew/Posse An informal inner city neighborhood group formed as a means of providing identity and support for its members.

Scratching Moving a record back and forth quickly to create a scratching sound.

Back spinning Using the same record on two turntables, a DJ can extend the break of a song by alternating back and forth between records.

Punch phrasing Rhythmically punching in short musical segments (such as a horn hit) from one record onto the beat from another record.

The Beginnings of Rap

In response to these sordid living conditions and the destruction of traditional institutions such as neighborhood associations and community centers, residents of the area began to fashion their own cultural values and identities. By the late 1970s, informal neighborhood groups called crews or posses began forming as a means of providing identity and support for their members. (This kind of group identity remains deeply rooted in hip-hop culture, and references to crews or posses are frequent in rap recordings.) At parties and other social gatherings, it became fashionable for crews to display graffiti art, break-dancing moves and play records as a way to gain notoriety and celebrity. In the earliest stages of rap's development (around 1977), DJ's such as Bronx native Afrika Bambaataa (Kevin Donovan) and two Caribbean expatriates, Kool Herc (Clive Campbell) and Grandmaster Flash (Joseph Saddler) would spin records in innovative ways to create excitement. Kool Herc in particular was instrumental in developing the art of mixing smooth transitions between two turntables to feature the break, or the most danceable, instrumental sections of records. Kool Herc also began to recite rhymes to accompany his mixing, a technique he inherited from his native Jamaica, where it was called toasting. Grandmaster Flash is given credit for perfecting the practice of scratching, back spinning, and punch phrasing. He is also credited for creating the crossfader to seamlessly switch between records, an essential tool for DJs every since. At this early stage of raps existence, it was the DJs and their turntable prowess that commanded the audience's attention at live shows. Eventually however, MCs (master of ceremonies) were added to take over most of the rhyming and vocal interactions, and they began to attract the most attention from audiences. These were the earliest rappers.

Characteristics of Rap

- Rhythmic and rhyming spoken lyrics with rhythmic accompaniment heavily influenced by funk and disco
- 2. Use of sampled sounds and pieces of existing songs that are repeated to create a minimalist, hypnotic effect
- 3. Early rap (old school) included the use of scratching and back spinning of turntables to create percussive effects
- 4. Often has a shuffle or swing beat, with heavy accent on the backbeat (beats two and four)

Key Rap Recordings

- "Rapper's Delight"—the Sugarhill Gang, 1979
- "The Message"—Grandmaster Flash and the Furious Five, 1982
- Raising Hell—Run-D.M.C., 1986
- As Nasty As They Wanna Be—2 Live Crew, 1989

MUSIC CUT 96

"RAPPER'S DELIGHT" (THE SUGARHILL GANG/SYLVIA ROBINSON/NILE RODGERS/BERNARD EDWARDS/GRANDMASTER CAZ)—THE SUGARHILL GANG

Personnel: Wonder Mike (Michael Wright), Big Bank Hank (Henry Jackson), Master Gee (Guy O'Brien): vocals; Albert Pittman or Brian Morgan: guitar; Moncy Smith: piano; Chip Shearin: bass; Bryan Horton: drums. Recorded August 2, 1979; produced by Sylvia Robinson. Released September 16, 1979 on Sugarhill; 12 weeks on the charts, peaking at #36.

Before "Rapper's Delight" hit the airwaves in the fall of 1979, rap music was confined to block parties and neighborhood events where DJs would dub records while MCs would add live vocals and others would break dance. When producer and former R&B singer Sylvia Robinson caught wind of the trend, she produced what is now regarded as the first rap hit. "Rapper's Delight" cops its bass line, basic groove, and string "samples" from the song "Good Times," written by Nile Rodgers and Bernard Edwards of the group Chic. It also borrows elements from a rap created by Curtis Fisher, a local rapper going by the name Grandmaster Caz. The Sugarhill Gang were three local teens that Robinson found with the help of her teenage son. Surprisingly, Robinson ran up against some stiff opposition to the notion of recording rap, a music that was at the time considered to be only for live performance. "Sylvia Robinson could not convince any of the real hip-hop stars of New York to record with her," said author Oliver Wang. "Rap existed in clubs, and trying to encode it on records made no sense to them. So, she decided to find someone to cut it. "The story goes that her son heard a guy rapping to tape in a pizza parlor. So, they brought him and his friends into the studio and put together this mesh of rhymes they'd basically stolen from elsewhere over a loop of Chic's 'Good Times.'"

Throughout this stage of development, rap was still pretty much contained to the Bronx, Harlem and a few other neighborhoods in New York City. In September 1979, the outside world got its first glimpse of the new style when "Rapper's Delight" by the Sugarhill Gang of Sugarhill Records hit #36 on the pop chart and eventually sold over a million copies. Sugarhill Records was owned by Sylvia Robinson, a former R&B singer ("Pillow Talk," #3, 1973) who had noticed how street MC's that added lyrics and chants to funk and disco records were becoming popular in New York City. To capitalize on the fad, in September 1979 she put together three New Jersey teens who recorded a rap over a rhythm track derived from Chic's early summer #1 hit "Good Times." Not only did the song popularize the word 'rap', but "Rapper's Delight" also alerted MC's and DJ's to the commercial potential of the new style. Within the next few years, more rap singles—all on small, independent labels such as Sugarhill—became big sellers, including "The Breaks" by Kurtis Blow, and Afrika Bambaataa and the Soul Sonic Force's "Planet Rock." This first generation of rappers performed what has become known as old school rap, most of which had themes of fun and partying. However, one record from this era that signaled a significant change of direction was Grandmaster Flash and the Furious Five's "The Message" from 1982. A graphic (and controversial) description of the harsh realities of ghetto life in the South Bronx, "The Message" was the first rap record to address social issues, and laid the groundwork for an essential part of rap's future development.

address social issues, and laid the groundwork for an essential part of rap's future development.

The first generation of rap, characterized by party themes and the use of turntables to achieve scratching and back spinning effects.

MUSIC CUT 97

"THE MESSAGE" (ED "DUKE BOOTEE" FLETCHER/GRANDMASTER MELLE MEL/SYLVIA ROBINSON)—GRANDMASTER FLASH AND THE FURIOUS FIVE

Personnel: Grandmaster Melle Mel, Ed "Duke Bootee" Fletcher: vocals; Ed "Duke Bootee" Fletcher: instrumental track. Recorded 1982; produced by Ed "Duke Bootee" Fletcher, Clifton "Jiggs" Chase, and Sylvia Robinson. Released July 1, 1982 on Sugarhill Records; did not break into the Top Forty, peaking at #62.

Even though "The Message" is credited to Grandmaster Flash and the Furious Five, only two of the group's members—and not Flash himself—appear on the record. The group got their start playing at street parties in the South Bronx in the late 1970s. In 1979 they released their first single "Superappin'," a party record typical of most early rap efforts. "The Message" however, is something altogether different, arguably the first rap record to detail the harsh realities of life in the ghetto. Before this, rap was comprised of feel good party/dance songs. The song was created by combining an instrumental track by Duke Bootee called "The Jungle" with Grandmaster Melle Mel's (Melvin Glover) lyrics. With the opening line, "It's like a jungle sometimes it makes me wonder/How I keep from going under," and early references to "broken glass everywhere", "rats in the front room, roaches in the back," and "junkies in the alley with the baseball bat," "The Message" caught the attention of the rap audience and went platinum in less than a month. The most foreboding line: "Don't push me, 'cause I'm close to the edge." "The Message" is considered to be a pivotal record in the early development of rap.

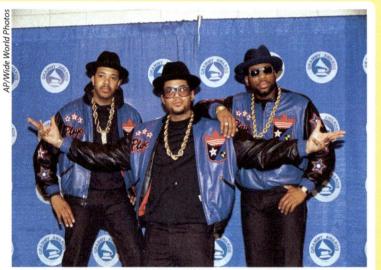

Run-D.M.C. at the Grammy Awards in 1988. From left: Joseph "Run" Simmons, Darryl "DMC" McDaniels, and Jason Mizell "Jam Master Jay."

East Coast Rap

Throughout the early 1980s, rap expanded further into the pop charts, and its influence began to extend outside of the Bronx and into other urban areas such as Roxbury in Boston, the Fifth Ward in Houston, Overtown in Miami and Watts and Compton in Los Angeles. In 1986 rap albums by two New York groups achieved Top 5 status, Raising Hell (#3) by Run-D.M.C. and Licensed to Ill (#1) by the Beastie Boys, signaling a new level of commercial appeal of the music. Both albums went platinum almost immediately. Run-D.M.C., consisting of three middle class and college educated rappers (Run, aka Joseph Simmons; DMC, aka Darryl McDaniels; and Jam Master Jay, aka Jason Mizell), had

already achieved the first gold rap album with 1984's *Run-D.M.C. Raising Hell* was propelled by an ingenious piece of marketing, a rap remake of Aerosmith's 1976 hit "Walk This Way," recorded with that band's Steve Tyler and Joe Perry. "Walk This Way" hit #4 and sold over a million records to fans of both rap and metal, and its innovative video was the first of the genre to receive airplay on MTV. Run-D.M.C. had a harder edge than earlier rap groups, and featured an innovative vocal technique: Simmons and McDaniels would often finish each other's lines instead of trading verses. The Beastie Boys, the first important white rap group, had a #7 hit with "You've Got to Fight for Your Right to Party" from *Licensed to Ill*.

- Run-D.M.C.
- Beastie Boys
- Public Enemy
- L.L. Cool J.
- Salt-n-Pepa
- Queen Latifa
- 2 Live Crew

EAST COAST RAPPERS

"WALK THIS WAY" (STEVEN TYLER/JOE PERRY)—RUN-D.M.C.

Personnel: Joseph "DJ Run": vocals; Darryl "D.M.C." McDaniels: vocals; Jason "Jam Master Jay" Mizell: turntable; Steve Tyler: vocals; Joe Perry: guitar. Recorded 1986; produced by Rick Rubin and Russell Simmons. Released July 1986 on Profile; 16 weeks on the charts, peaking at #4.

Run D.M.C.'s innovative reinterpretation of Aerosmith's "Walk This Way" was a milestone in the development of rap. Not only did it appeal to fans of both metal and rap music, it was instrumental in showing that the two music styles were not incompatible and paved the way for other rock and pop artists to begin incorporating rap and hip-hop elements into their own music. In addition, the music video of the song, which shows Run D.M.C. and Aerosmith's Steve Tyler and Joe Perry dueling on opposite ends of a revolving stage, was in itself an innovation and the first hybrid rap video played in heavy rotation on MTV. This recording of the song was included on Run D.M.C.'s 1986 LP *Raising Hell*, which went platinum the day it was released.

Other East Coast rappers also emerged during this time, including Public Enemy, L.L. Cool J. (Ladies Love Cool James), the female trio Salt-n-Pepa, Queen Latifa and Miami's 2 Live Crew. By this time rap was becoming more militant, aggressive, contentious and controversial. One of the pioneers of what would eventually become known as gangsta rap was Philadelphia's Schoolly D (Jesse Weaver), whose 1986 narrative about a Philadelphia gang, "PSK — What Does It Mean?" is widely credited with inventing the style. In 1987, the Bronx's Boogie Down Productions (KRS-One and DJ Scott LaRock) released the classic *Criminal Minded*, an album that was also influential in gangsta rap's development. LaRock was shot to death later in the year in an eerie foreshadowing of rap's future violence.

CNN for Black Culture

In 1988, **Public Enemy**, led by rapper Chuck D, his sidekick Flavor Flav and the Bomb Squad production team, released the controversial album *It Takes a Nation of Millions to Hold Us Back*, which stepped up the rhetoric of black anger to levels above and beyond Schoolly D and BDP. Calling themselves the "prophets of rage," PE combined the politically charged rhymes of Chuck D with the Bomb Squad's heavily layered avant-garde rhythm tracks. Chuck D was also critical of the white controlled media (as related in 1988's "Don't Believe the Hype"), and called rap "CNN for black culture." PE has encountered more than its share of controversy, from 1988's volatile "Bring the Noise," to the statement by Professor Griff, the groups 'minister of information', that Jews are responsible for "the majority of wickedness that goes on across the globe."

"BRING THE NOISE" (CARL RIDENHOUR/HANK SHOCKLEE/ERIC "VIETNAM" SADLER/JAMES BROWN/GEORGE CLINTON)—PUBLIC ENEMY

Personnel: Chuck D, Flavor Flav: vocals; The Bomb Squad: production. Recorded 1987 at Chung King Studios, Greene Street Recording, Sabella Studios, New York; produced by Chuck D, Rick Rubin, Hank Shocklee. Released November 6, 1987 on Def Jam; 10 weeks on the Hot R&B/Hip-Hop chart, peaking at #56.

Among other notable achievements, Public Enemy's 1988 album *It Takes a Nation of Millions to Hold Us Back* raised the bar significantly in hip hop production techniques. On this album PE's production team, The Bomb Squad, was experimenting with a denser, more chaotic sound than previous records. According to The Bomb Squad's Hank Shocklee, "We took whatever was annoying, threw it into a pot, and that's how we came out with this group. We believed that music is nothing but organized noise. You can take anything—street sounds, us talking, whatever you want—and make it music by organizing it. That's still our philosophy, to show people that this thing you call music is a lot broader than you think it is." Among the elements found in "Bring the Noise" are samples from several James Brown records, "It's My Thing" by Marva Whitney, and "Get Off Your Ass and Jam" by George Clinton's group Funkadelic. It also begins with a sample of Malcom X repeating, "Too black, too strong."

The 1989 LP *As Nasty as They Wanna Be* by 2 Live Crew became the first recording ever to be declared obscene by an American court, even though the group included a warning label on the cover and simultaneously released an edited version called *As Clean As They Wanna Be*. Led by founder Luther Campbell, the group's #26 hit "Me So Horny" created a moral outrage that prompted evangelical Christian attorney Jack Thompson of Miami to file suit against Campbell. In 1990 a Broward County judge declared the album to be legally obscene, making it illegal to sell, and in short order record retailers in Ft. Lauderdale and Huntsville, Alabama were arrested for selling it (both were prosecuted but acquitted). The band was also arrested for performing the songs in a Hollywood, Florida nightclub. Eventually *Nasty* sold more than two million copies (eight times as many as the clean version), a jury cleared 2 Live Crew after 13 minutes of deliberation, and in 1992 the 11th US Circuit Court of Appeals reversed the obscenity ruling. However, by that time 2 Live Crew had disbanded.

West Coast and Gangsta Rap

Meanwhile, California was becoming a hotbed of rap development. Oakland's M.C. Hammer (Stanley Burrell) released the pop-accessible LP *Please Hammer Don't Hurt 'Em* in 1990 (containing the #8 hit "U Can't Touch This" and two other Top 10 singles), which stayed at #1 for 21 weeks sold ten million copies, making it one of the bestselling rap albums of all time. But other West Coast rappers from the ghettos of Los Angeles were turning up the threatening and menacing tone of **gangsta rap** to the boiling point. The West Coast gangsta rap that emerged in the 1990s is among the most controversial music ever produced. The main point of contention was the use of the first-person accounting of vivid descriptions of violence, rage and sexist degradation rather than the more passive third person used in previous rap narratives such as "The Message." One of the first

- M.C. Hammer
- Ice-T
- NWA
- Ice Cube
- Dr. Dre
- Snoop Doggy Dog

WEST COAST RAPPERS

instances of the style on the West Coast came from Ice-T (Tracy Morrow), who assumed the persona of a hardened Los Angeles criminal in his 1986 record "6 'n the Mornin'." This and subsequent other Ice T recordings were criticized as glorifying violence, when in reality the songs usually sent a not-so-subtle message that crime and violence doesn't pay. His newly formed group Body Count received national notoriety with the release of its self-titled debut album in 1992, which contained the track "Cop Killer." The song was denounced by police departments all over the country, as well as President George H. W. Bush, Vice President Dan Quayle and the Parents Music Resource Center, and was ultimately dropped from the album by Time Warner, owner of Sire Records. In response, Ice T left the label.

MUSIC CUT 100

"6'N THE MORNING" (ANDRE MANUEL/TRACY MARROW)—

Personnel: Ice-T: vocals; The Unknown DJ: production. Recorded 1986. Released 1986 on Techno Hop as the B-side of "Dog 'N the Wax (Ya Don't Quit-Part II)"; did not chart.

Ice-T's "6 'N the Morning" is widely considered to be one of the defining tracks in the development of gangsta rap. The song starts off with Ice-T (Tracy Morrow) proclaiming "6 in the morning, police at my door/fresh Adidas squeak across the bathroom floor" as he escapes out the back window to escape. Although never a gang member in his youth, Marrow had associations with the Crips while attending Crenshaw High School in Los Angeles. After serving a stint in the Army, Marrow turned his attention to the entertainment industry. After hearing Schoolly D's pioneering single "P.S.K. What Does It Mean?" he produced "6 'N the Morning," which led to a contract with Sire Records. After a successful career that including leading his group Body Count, Ice-T began an acting career that has landed him major roles in television and the movies.

The controversy over gangsta rap escalated further with 1989's double platinum *Straight Outta Compton* by **NWA** (Niggaz with Attitude), a Los Angeles based group led by Ice Cube (O'Shea Jackson) and Dr. Dre (Andre Young). Although the album went multiplatinum, it incensed rap's detractors with its narratives of gang violence, drive-by shootings and drug dealings in songs like "Gangsta Gangsta" and the title cut. The most offensive song, "Fuck tha Police" caused the FBI to send a warning letter to the groups label, Priority. Unlike Ice T's earlier recordings, the songs on *Straight Outta Compton* offer no social commentaries, but instead are vicious tirades directed toward women, the police, and the group's adversaries. Although NWA began to unravel in the early 1990s, they had another smash hit with 1991's *Efil4zaggin* (Niggaz 4 Life spelled backwards), which hit #1 two weeks after it's release and went platinum.

Characteristics of Gangsta Rap

- 1. Lyrics use first person accounting of gang related themes that include violence, rage and sexual degradation
- 2. Hard hitting, angry vocal delivery
- 3. Guns, sirens and other urban sound effects often used

Key Gangsta Rap Recordings

- Straight Outta Compton—NWA, 1989
- "Cop Killer"—Body Count, 1992
- The Chronic—Dr. Dre, 1993
- "Hit 'Em Up"—2pac Shakur, 1996

In 1992 Dr. Dre, along with producer Marion "Suge" Knight started the independent label Death Row, which released Dre's landmark debut LP *The Chronic* in 1993. The album went triple platinum, hit #3 on the charts, spawned two Top 10 singles, and introduced Dre's understudy, **Snoop Doggy Dog** (Calvin Broadus) (1971–). Reviews of Snoop and his lazy drawl style of rapping were enthusiastic, which fueled excitement about his own forthcoming debut LP. However, while recording the album in August, Snoop and his bodyguard were arrested for the murder of a man they claimed was a stalker. When *Doggystyle* was finally released in November, the pent-up anticipation resulted in it becoming the first debut album in history to enter the *Billboard* pop chart at #1 (it eventually went quadruple platinum). After a lengthy trial in late 1995 and early 1996, Snoop was cleared of all charges. His second album, *The Doggfather* was released later that year. Snoop has since become a celebrity beyond the scope of rap, with his numerous movie and TV roles.

The East Coast-West Coast Rivalry

In the mid-1990s, an ugly East Coast-West Coast rivalry developed from an ongoing feud between **Tupac Shakur** (2pac) (1971–1996) and **the Notorious** B.I.G. (Christopher Wallace, aka Biggie Smalls) (1972–1997) that ended with the brutal murders of both artists. The feud started after 2pac was shot and robbed outside a New York recording studio in November 1994. 2pac implicated B.I.G. for the attack, and after some back and forth bickering between the two camps released the single "Hit Em Up," a malicious attack that boasted of sleeping with B.I.G.'s estranged wife, Faith Evans. Shakur was murdered in a drive-by shooting on September 7, 1996; B.I.G. was also subsequently murdered in a similar shooting on March 9, 1997. Although conspiracy theorists believed that B.I.G.'s death was retribution for 2pac's and amid reports of LAPD corruption, neither case has been solved. The Notorious B.I.G.'s final album Life After Death was released within days of his murder, and sold 700,000 copies in the first week and went diamond in less than two years. It also spawned two #1 singles that were both certified platinum, making B.I.G. the first entertainer in history to have two posthumous #1 hits. Like B.I.G., 2pac has achieved a degree of immortality: his

By the mid-1990s, an ugly East Coast-West Coast rivalry began to develop that consumed the attention of the entire rap community and in the end turned violent and tragically lethal.

The Notorious B.I.G. was the first entertainer in history to have two posthumous #1 hits.

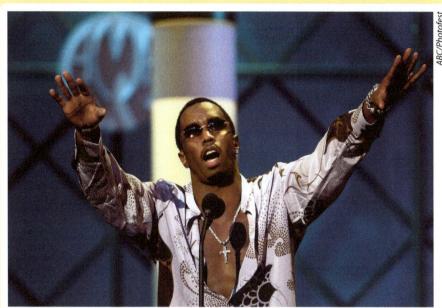

Rapper, producer, and fashion designer Sean Combs, who has also been known as Puff Daddy, P. Diddy, and Diddy earlier in his career

death has prompted somewhere in the vicinity of 15 compilations and reissues. In 2002, filmmaker Nick Broomfield made a documentary of the tragic story of these two artists entitled *Biggie and Tupac*.

With so much common talent and perspective to share, the murders of 2pac and the Notorious B.I.G. were tragic and unnecessary. While their music was difficult for many Middle Americans to listen to, it is important to remember that the stories that 2pac, B.I.G., NWA and others related were not fictional ones. These artists did not invent the miserable conditions in the ghetto, or the gang related warfare, or drive-by shootings. Like the first blues singers from the Mississippi Delta that came nearly one hundred years before them, rappers are their generation's voice of the downtrodden and oppressed, of people who otherwise aren't being heard. When miserable living conditions exist for some Americans, like they did in the South Bronx in the 1970s and still do in many urban areas, the results can have far reaching effects. As rock critic Mikal Gilmore states: "The America that we are making for others is ultimately the America we will make for ourselves. It will not be on the other side of town. It will be right outside our front door."

CHAPTER 10 TERMS AND DEFINITIONS

- **Soft soul**—a highly produced and polished soul from the early 1970s that emphasized lush string and horn arrangements and smooth vocal harmonies.
- **Disco**—dance oriented pop that incorporates synthesizers, drum machines and lush orchestrations that emerged in the late 1970s.

- Funk—the more primal evolution of R&B and soul that emerged in the early 1970s whose most important characteristic is the rhythmic groove.
- **Reggae**—the Jamaican music that evolved from the combination of indigenous folk, American R&B and traditional Afro-Caribbean music.
- **Rap**—the musical expression of hip-hop culture whose most distinguishing characteristic is the use of rhyming, melodic spoken words instead of sung lyrics.

Name	Date
	What were some important differences between soft soul and funk?
2.	Name three reasons why there was a backlash against disco.
3.	In what ways did James Brown influence funk?
4.	Name three differences between the music, bands, and careers of George Clinton and Sly Stone.
5.	How did American music and Jamaican reggae cross influence each other?

KEY TERMS

Punk Pogo The Exploding Plastic Inevitable CBGB's
Pub rock circuit

New wave Hardcore

KEY FIGURES The MC5
The Stooges
Iggy Pop
Andy Warhol
The Velvet Underground
New York Dolls

Patti Smith
The Ramones
The Sex Pistols
Malcolm McLaren
The Clash

Blondie Talking Heads Elvis Costello The Police Black Flag

KEY ALBUMS The Velvet Underground and Nico—the Velvet Underground The Ramones—the Ramones

Never Mind the Bollocks, Here's the Sex Pistols the Sex Pistols Fear of Music—Talking Heads Damaged—Black Flag

THE ORIGINS OF PUNK

The Anti-Revolution

On November 6, 1975 a new band played their first show at London's St. Martin's School of Art. Bands had been performing at schools like St. Martin's for years, and so in the days leading up to the performance there was no reason to believe that anything out of the ordinary would happen—just some good old rock and roll played by an unknown group looking for a little recognition. However it soon became apparent that this was indeed going to be a very different type of show. Within minutes, the band members—all scrawny teenagers—began to angrily insult their audience. Their music was raw, noisy, and offensive—that is, if you wanted to call it music. The members of the band made no attempt to hide the fact that they could barely play their instruments. The performance was a combination of noise, anger, invective, chaos and rebellion. It was also short—after ten minutes the school's social programmer pulled the plug and cut off their power. But in those ten minutes the world got its first glimpse of the Sex Pistols.

The Sex Pistols were not the first punk rock band, but they certainly were the most notorious. Punk emerged in the mid 1970s as a backlash reaction against nearly everything that rock had brought to the decade: the conservative and self-indulgent tendencies of folk rock and the singer/songwriters; the pretentiousness of art rock and heavy metal; the slick studio production of funk; and the control and manipulation of the marketplace by the rock establishment. To punks, rock at age 20 was middle aged, soft and irrelevant. To their eyes, there were too many pampered millionaire rock stars, and too many flashy guitar and keyboard solos that served no purpose other than to let the performers show off. More and more, rock had become the music of the mainstream rather than the

KEY TERM

Punk A style emerging simultaneously in New York and London in the late 1970s that is characterized by an angry, nihilistic do-it-yourself attitude; also refers to the culture that sprang up around the music.

music of the outsiders; it had become safe rather than dangerous; and worst of all, it had lost the rebellious attitude that had been its birthright. Punk brought rock back to the streets, back to its primeval days, and in doing so, it dramatically influenced its future evolution.

Punk Culture

Punk was more than just a musical trend, however—it was a culture, defined by its rejection of any and all conventional norms of society. Its mantra was simple: to shock, disrespect, disrupt, offend and destroy anything in its path, using whatever means possible. But because these nihilistic tendencies were so passionate and universal, punk culture was also full of contradictions. For instance, punks rejected traditional pop fashion trendiness, but turned right around and created their own fashion statement of torn jeans, spiked hair, dog collars and safety pins. Some punks embraced progressive social issues while others adopted racist and fascist stances. And ultimately punk became attractive enough to the rock establishment that major labels began signing groups like the Sex Pistols, in effect making them a part rather than a rejection of the status quo. When this happened, the punk movement suddenly lost its credibility.

back to the streets.

Characteristics of Punk

- 1. Raw, angry, nihilistic; characterized by a do-it-yourself attitude
- 2. Typical instrumentation: electric guitars, bass, drums, vocalist
- 3. Lyrics with themes of nihilism, anger, alienation, desperation and darkness
- 4. Counter culture associated with clothing styles, body pins, etc.

Key Punk Recordings

- The Velvet Underground and Nico—Velvet Underground, 1967
- Fun House—the Stooges, 1970
- Never Mind the Bollocks, Here's the Sex Pistols—the Sex Pistols, 1977
- London Calling—the Clash, 1979

Even though punk's moment on earth was brief—roughly from 1975 to 1978—it has inspired more journalistic efforts than any other subject in rock (with the possible exception of the Beatles). And rightfully so: punk was one of the most fascinating trends in modern pop culture. Punk's lifetime also roughly paralleled that of disco, and many writers have pointed out the contrasts between the two movements. Disco's origins were in black music, punks in white (the "whitest music ever" according to historian Jim Curtis). Disco was smooth and sensual—punk jagged and dissonant. Disco was constructed in the studio using sophisticated studio technology—punk was the ultimate anyone-can-do-it music. Disco dancing was coordinated and stylish—in punk, dancing (if you want to call it that) was a pushing, jostling, shoving match called pogo. Disco fashion was leisure suits, dresses and high heels—punk fashion was leather and safety pins. Finally, disco was dismissed by the rock press as escapist while punk was embraced by many of the same writers as a long awaited return to the rebellious spirit of rock and roll.

THE EARLIEST PUNK BANDS

Protopunk

By definition, the unruly attitude of punk can be traced back to the beginnings of rock and roll. In the broadest definition of the word, many of the early rock and rollers can be described as punks, especially rebel rousers like Jerry Lee Lewis, Little Richard and Link Wray. By the 1960s, punk attitude could be found in "My Generation" by the Who ("Why don't you all f-f-f-fade away") and a growing number of garage bands that were populating the suburban American landscape. Garage bands were typically after school endeavors put together by friends for fun and to play for an occasional school dance. Every now and then a garage band's self-produced single would become a local hit; sometimes these records would even get regional or national attention. Examples of national hits by what were essentially local garage bands include "Louie, Louie" (1963) by Seattle's the Kingsmen, "Psychotic Reaction" (1966) by San Jose, California's the Count Five, and "96 Tears" (1966) by the Flint, Michigan based? and the Mysterians. The prevailing attitude of the 1960s garage band was that anybody could buy a guitar and an amp, learn three chords and start a band. This is also fundamental to the principles of punk.

The case can be made that the seeds of the 1970s punk movement germinated in Michigan in the mid-1960s with two now legendary bands. Detroit the Motor City—has always been a tough blue-collar and industrial city, but even in the heyday of the US auto industry, economic conditions were often harsh and offered little hope for local youth. There were however, a lot of bands for them to play in; this was, after all, the home of Motown and a thriving club scene. The MC5 (short for Motor City Five) was formed in the city in 1964 with the idea that they would be a white man's version of James Brown. "Our show was based on the dynamic of James's shows," stated guitarist Wayne Kramer. "It was going to start at ten-and-a-half and go up from there." Aligning high-energy music with radical political ranting and sloganeering, the band had a recipe for mischief that earned them a devoted following, and in 1968 a contract with Elektra Records. Unfortunately their debut album Kick Out the Jams immediately immersed the band in hot water with the label. As if the opening track "Ramblin' Rose" wasn't controversial enough with its evangelical call for revolution ("Brothers and sisters, I wanna see a sea of hands out there . . ."), the title track opens with the following proclamation: "Right now it's time to. . . . kick out the jams, motherfucker!" As one might imagine, radio stations, retailers and Elektra were all less than excited to hear this sort of disrespectful language; kids however, thought it was way too cool. After Hudson's, Detroit's largest record store refused to sell the album and shipped their stock back to Elektra, the band took out an ad in a local underground rag that included the following in giant letters: "FUCK HUDSON'S!" When Elektra began making plans to re-release a cleaned up version of the LP, the band had what Elektra president Jac Holzman later described as "a hemorrhage." He dropped them soon afterward. Although the MC5 later signed with Atlantic and recorded two more albums, including the highly regarded *High Time*, the label dropped them in 1972 and they fell apart soon after.

The Stooges formed in Ann Arbor, Michigan after guitarist Ron Asheton and bassist Dave Alexander witnessed an electrifying performance by the Who and decided to start their own band. Enlisting Asheton's brother Scott to play drums and James Osterberg to sing lead, the group, (initially calling themselves the Psychedelic Stooges) played their first gig at a Halloween party in 1967. By this time Osterberg, a rough and tumble youth who had been raised in a trailer park in nearby Ypsilanti, began calling himself Iggy Pop (1947-). Driven by Iggy's outrageous stage antics, which included stage diving, exposing himself, and rubbing meat, peanut butter and shards of glass over his naked torso, Stooges concerts became an onslaught of noise and anarchy. With help from the MC5, the group signed with Elektra in 1968, and over the next two years released The Stooges and Fun House. Although neither album sold well or were well received by critics, the primal nature of the music and the despairing lyrical themes essentially created the blueprint for punk. The Stooges' "1969" takes would become a common punk theme—boredom—and proclaims that, "Last year I was 21/I didn't have a lot of fun" and "Another year of nothing to do/It's 1969." On the musical side, "I Wanna Be Your Dog" from the same album is three minutes of the same three heavily distorted notes repeated over and over. "L.A. Blues" from Fun House is five minutes of aural nihilism. By the time Fun House was released, the group was deep in the throes of the heroin and alcohol addiction that led to their breakup in 1971. They later regrouped as Iggy and the Stooges and released a third and final album, 1973's highly regarded Raw Power. The band briefly reunited again in 2003. Today Iggy Pop is often referred to as the Godfather of Punk, and with good reason.

"I WANNA BE YOUR DOG" (DAVE ALEXANDER/RON ASHETON/ SCOTT ASHETON/IGGY POP)—THE STOOGES

Personnel: Iggy Pop: vocals; Ron Asheton: guitar; Dave Alexander: bass; Scott Asheton: drums; John Cale: piano, percussion. Recorded April 1–10, 1969 at The Hit Factory, New York City; produced by John Cale. Released August 5, 1969 on Elektra; did not chart.

"I Wanna Be Your Dog" comes from the Stooges 1969 eponymous debut album. It is considered to be one of the recordings that foreshadowed the coming punk movement. The album was produced by John Cale, whose own group the Velvet Underground pre-dated even the Stooges with their own protopunk. *The Stooges* is today considered a landmark album in rock history.

The Velvet Underground

The Velvet Underground was the first important band to adopt the lyric themes of despair, drug addiction and violence that would later be commonly associated with punk. During their existence they never sold many records—they were too crude for anything more than a cult following. However, their influence was

THE VELVET UNDERGROUND

- Lou Reed
- John Cale
- Nico (1966–67)

- Sterling Morrison
- Maureen Tucker

great, and it has often been said that everyone who bought a Velvets record went out and started a band. Taking their name from an S&M novel, the group was formed in New York in 1965 by two fixtures of the city's avant-garde art scene, poet Lou Reed (vocals, guitar) and composer John Cale (vocals, violin), with the addition of guitarist Sterling Morrison and drummer Maureen Tucker. The band's dissident music quickly earned them a reputation as an outlier to the current state of rock, but a performance at the Café Bizarre caught the attention of artist Andy Warhol (1928–1987), who invited them to take part in his traveling mixed media show the Exploding Plastic Inevitable and perform at his art loft the Factory. On Warhol's insistence, European model/singer Nico joined the Velvets, and with her they recorded the Warhol-financed *The Velvet Underground* and Nico on MGM/Verve. Containing such plaintive Reed compositions as "I'm Waiting for the Man," a song about a white kid trying to get a heroin fix in Harlem, and "Venus in Furs," a song about sado-masochism, sales of the LP were poor. The now famous album cover, designed by Warhol, was a simple peel-off sticker of a banana that could be removed to reveal an erotically peeled pink banana. With its lack of success, Warhol and Nico both abandoned the group after the album's release, but the band nonetheless followed it up with an even more experimental album, White Light/White Heat. Two more albums were eventually released, but internal bickering forced the band to brake up in 1970.

MUSIC CUT 102

"I'M WAITING FOR THE MAN" (LOU REED)— THE VELVET UNDERGROUND

Personnel: Lou Reed: vocals, guitar; John Cale: piano; Sterling Morrison: bass; Maureen Tucker: drums. Recorded May 1966 at T.T.G. Studios, Hollywood, CA; produced by Andy Warhol and Tom Wilson. Released March 1967 on the Verve LP *The Velvet Underground and Nico*. Not released as a single.

Recorded when it seemed the rest of the music world was going psychedelic, the songs on *The Velvet Underground and Nico* often deal with the dark side of life. With the sponsorship of Andy Warhol, the band was able to record an album without the usual interference from record peeps trying to make it more marketable. Today the album stands as one of the most influential of all time, creating a blueprint for future alternative rock music. (*Rolling Stone* ranked it as #13 on its list of 500 Greatest Albums.) "I'm Waiting for the Man" is one of the more depressing songs on the album, with its theme of making a drug purchase and its incessant, hypnotic pounding. There is no flashy playing or production on the song, just straight ahead garage band simplicity, reinforced by Lou Reed's expressionless vocals.

With their crude sound, lyrics of alienation, desperation and darkness, and their association with the New York arts community, the Velvet Underground was perhaps the most influential of the pre-punk era bands. From them, the torch would soon be passed to a new crop of New York bands that would create a bona fide punk movement.

THE NEW YORK SCENE

CBGB

By the 1970s, a bona fide punk scene began to take shape in New York City. This burgeoning punk movement was connected to the city's conceptualist art scene, known as the New York School. Conceptualist art, such as that created by abstract expressionist painters such as Jackson Pollock (who laid his canvas on the floor and threw paint at it), eschews technique for an "I-did-it-my-way" approach to creativity. Early pre-punk bands in New York used this tie in with high culture as an excuse for their own lack of musical technique as well as their lack of commercial success (Pollock himself was largely dismissed until after his death in 1956). The Velvet Underground were championed by pop artist Andy Warhol, while the **New York Dolls** first gained notoriety playing at the Mercer Arts Center on the lower East Side. Formed in 1971, the Dolls combined a glam look with an amateurish approach to performing (see Chapter 9). For a brief period before they started to fall apart in early 1975, they were managed by Malcolm McLaren, a London clothier who was fascinated with the French situationist's strategy of staging media events for the sole purpose of disrupting everyday life. Before returning to England later that year, McLaren had the Dolls perform in red with a communist flag as a backdrop.

Around this time, a grimy little bar at 315 Bowery in New York's Lower East Side renamed itself CBGB and started to book underground rock bands. Within months, CBGB's (actually named CBGB and OMFUG for Country, Bluegrass and Blues, and Other Music for Urban Gourmets) became the center of the burgeoning New York punk scene. (The only other major club supporting punk at this time was Max's Kansas City in Greenwich Village.) One of the first groups to play at CBGB's was Television, a band that included bassist Richard Myers, who went by the name Richard Hell, and guitarist Tom Miller, who went by the name Tom Verlaine (after the French symbolist poet). Television's influences included avant-garde saxophonists John Coltrane and Albert Ayler, the Rolling Stones and French impressionistic composer Maurice Ravel. Hell was also influential to punk fashion as the first to wear the ripped clothes and just-fell-out-of-bed hairstyle, and as the writer of the first punk anthem, "Blank Generation," whose lyrics seemed to express the hopelessness that many in the rock underground felt. Hell later went on to play with the Heartbreakers and led the seminal band the Voidoids, which recorded "Blank Generation."

Another early CBGB artist was **Patti Smith** (1946–), a painter, poet and rock journalist who began experimenting in 1971 with setting her poems to the musical accompaniment of guitarist Lenny Kaye and pianist Richard Sohl. In early 1974, the trio recorded "Hey Joe," backed with Smith's "Piss Factory," a song about her experience working at an assembly line job in New Jersey. With the release of the single, Smith's group began a residency at Max's Kansas City alongside Television, after which both bands moved to CBGB's. These successes were instrumental in securing a contract with newly formed Arista Records and the 1975 release of *Horses*. Produced by John Cale, *Horses* is an amalgamation of rock and roll, poetry and primal experimentation. In spite of this, it was one of the few punk albums of the era that actually charted, going to #47. Smith also made an alternative punk fashion statement of her own with a white button-down shirt and men's tie.

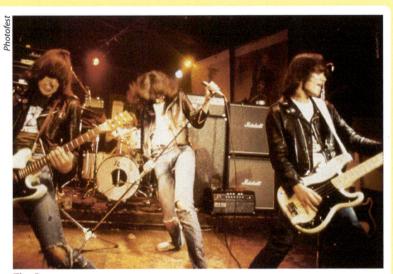

The Ramones

The Ramones

The band that is considered by many to be the first true punk band was the Ramones, a group of high school buddies from the Forest Hills section of Oueens, New York. The Ramones played rock and roll that was simple (four chords maximum per song), fast (most songs were played at breakneck tempos and were over in less than two and a half minutes), raw, energetic and fun. Their music was intense and unrelenting (a sort of punk version of Phil Spector's Wall of Sound), while their shows, rarely lasting over 20 minutes, have been called the most powerful in rock history. Taking a surname used by

Paul McCartney in his early years, the group was formed in 1974 by Jeffrey Hyman, John Cummings, Doug Colvin and Tom Erdely, who became Joey, Johnny, Dee Dee and Tommy Ramone, respectively. With a uniform of torn jeans and leather jackets, the Ramones played their first show on March 30, 1974 at New York's Performance Studio. Later that summer they began a year-long off and on residency at CBGB's, which played an important role in developing a small cult following. Near the end of 1975, they signed a contract with Sire Records and in early 1976 recorded their debut album *The Ramones* for just over \$6,000.

THE RAMONES

- Jeffrey Hyman, Joey
- John Cummings, Johnny
- Doug Colvin, Dee Dee
- Tom Erdely, Tommy

MUSIC CUT 103

"SHEENA IS A PUNK ROCKER" (JOEY RAMONE)— THE RAMONES

Personnel: Johnny Ramone: guitar; Joey Ramone: vocals; Dee Dee Ramone: bass; Tommy Ramone: drums. Recorded 1977 at Media Sound, NYC; produced by Tony Bongiovi and T. Erdelyi. Released May 1977 on the Sire LP *Rocket to Russia*; 13 weeks on the charts, peaking at #81.

"Sheena Is a Punk Rocker" from *Rocket to Russia* is a great example of the distinctive punk cum bubblegum sound of the Ramones, meaning it is two and a half minutes of mindless fun. Composer and Ramones lead singer Joey Ramone later said, "I combined Sheena, Queen of the Jungle with the primalness of punk rock. It was funny, because all the girls in New York seemed to change their names to Sheena after that." Although "Sheena Is a Punk Rocker" never cracked the Top 40 (*Rocket to Russia* also sold poorly), it is a classic recording by one of punk's most influential bands.

In the summer of 1976, the Ramones toured England and created a sensation in the rock underground that helped ignite the British punk movement. Later that year they recorded their second album, Ramones Leave Home, which had limited success in the US (like their first LP) but became somewhat of a hit in England. Capitalizing on their newfound celebrity in the UK, the Ramones released "Sheena Is a Punk Rocker" in early 1977, which became a Top 40 hit there. Key to the success of the Ramones among punks was their amateurish musical abilities and the fact that they only played their own material. The band wrote their own songs not out of an artistic undertaking but because they couldn't learn other people's. As Johnny Ramone admitted in an interview, "We put records on, but we couldn't figure out how to play the songs, so we decided to start writing songs that were within our capabilities." Their lyrics. often containing biting sarcasm and mindless humor, also held great appeal to punkers. Songs such as "I Don't Care," "I'm Against It," "I Wanna Be Sedated" and "Teenage Lobotomy" offered welcome relief from the soul-searching confessionals of the singer/songwriters and other types of narcissistic 1970s rock.

THE LONDON SCENE

No Future

While New York punk was linked to the city's art scene, the British punk movement was driven primarily by the country's poor economy. In 1975, with unemployment at more than one million and inflation at a record 18%, many British kids had no future to look forward to when they finished school. Many went on 'the dole' (welfare) and there was a general mood of cynicism, despair and boredom. From these grievances, punk emerged as a legitimate social protest. But dissatisfaction went beyond the economy. There was also a tremendous amount of resentment directed toward the record industry, which was enduring hard times of its own. In 1976, sales of singles leveled off and album sales actually declined in England for the first time in years. To be sure, part of the problem was that kids had less disposable income, but there was also a growing dissatisfaction with the continued promotion of aging British Invasion stars ("boring old farts" as they were called), whose best work was years behind them. When sales started to sag, many in the industry, mindful of how the Beatles had revitalized the entire industry back in the early 1960s, began looking for the 'next big thing', the 'new Beatles' that could rev things up again. As industry A&R men and talent scouts started to snoop around, many turned their attention to the small but flourishing pub rock scene.

London's **pub rock circuit** was the 1970s version of the city's 1960s R&B scene, where little known and unsigned bands were free to experiment with new music in an intimate club environment. Among the popular pubs in the scene were the Nashville, the Tally Ho, the Hope and the Anchor. By focusing on live performances rather than the more controlled environment of the studio, pub bands were more exciting and energetic than many established recording bands. Although their repertoire often included R&B covers, many pub bands began to put an emphasis on original material, and the scene became a training ground of sorts for new songwriters. The essence of pub rock was from the beginning

PUBS FROM LONDON'S ROCK CIRCUIT

- Nashville
- Tally Ho
- Hope
- Anchor

POPULAR PUB ROCK BANDS

- Brinsley Schwarz
- Dr. Feelgood
- Bees Make Honey

- Eddie and the Hot Rods
- City
- 101ers

a back-to-basics, stripped down guitar-oriented music. Over time, pub bands started to adopt a more aggressive stage attitude, the music got faster and louder, and the beginnings of British punk began to emerge.

Among the more popular pub bands were Brinsley Schwarz (featuring songwriter Nick Lowe), Dr. Feelgood, Bees Make Honey, Eddie and the Hot Rods, City, and the 101ers. 101ers guitarist Joe Strummer left the band in 1976 to start his band the Clash soon after hearing the Sex Pistols in concert. New wave artist Elvis Costello also got his start in the pub scene. There were also a number of small independent record labels that sprang up for pub bands and the burgeoning punk movement, the most important of which were Stiff and Rough Trade. As is usually the case, the major labels were resistant to taking a risk on the new music. However, as pub rock evolved into punk, it was only a matter of time before one band would emerge that would be so offensive and so disruptive that the majors could no longer afford to ignore them. That band was the Sex Pistols.

The Sex Pistols

The Sex Pistols were either the perfect antidote for everything that was wrong with rock or a clever act of fraud played on the record industry, the media and the establishment. In a period of slightly more than two years, they managed to outrage the British press, offend the Royal Family, confound the radio and record industries, and take punk beyond the limits of anyone's sensibilities. And most importantly, they had a deep impact on the future course of rock music. The Pistols were the brainchild of London clothier **Malcolm McLaren** (1946–2010), who got his first taste of band management with a short-lived stint with the New York Dolls in early 1975. After the Dolls broke up, McLaren returned to London and his Kings Road boutique Let It Rock, which at the time sold neo-teddy boy clothing. Anticipating a new trend, McLaren changed the name

- **SEX PISTOLS**
- Paul Cook
- Steve Jones
- Glen Matlock, 1975–77

- John Lydon
- Sid Vicious, 1977–78

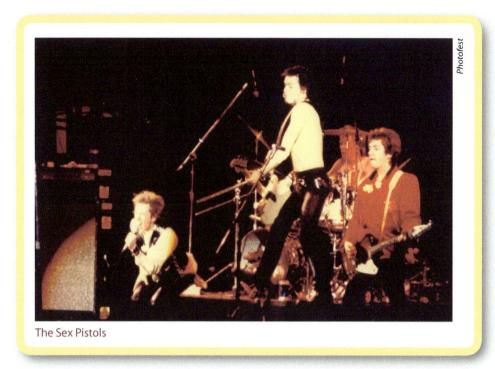

of the store to Sex and began selling leather and metal S&M fashions. Among the frequent store patrons were drummer Paul Cook, guitarist Steve Jones and bassist Glen Matlock of a band called the Strand. At some point the three approached McLaren to manage them and to find a suitable (as in, having the right look and attitude) vocalist. In one of McLaren's many strokes of genius, he found the perfect fit in John Lydon (1956—), an out of work janitor whose teeth were green from neglect and who had such a nasty attitude that the others began calling him Johnny Rotten. It is also worth noting that Lydon had never sung before. At first, McLaren saw the band as a means to advertise his store (hence the name Sex Pistols), but he soon saw the potential in using them as mercenaries in his own nihilistic agenda.

After their first gig in November 1975, the Pistols began playing college campuses in England and writing their own material. One of their first songs, "Anarchy in the UK" is a three and a half minute diatribe that begins with "I am an antichrist" and ends with "Get pissed, destroy." It was also a rallying cry that effectively put the Sex Pistols at the vanguard of Britain's punk movement. In September 1976, McLaren staged the Punk Rock Festival at London's 100 Club as a showcase for the Pistols and other punk bands, including the Clash, the Buzzcocks and the Vibrators. The strategy worked: in October the Pistols signed with EMI and received a £50,000 advance; in November they released "Anarchy in the UK" as a single. In December 1976 the group encountered their first scandal when they appeared live on the nationally broadcast Today TV program. Host Bill Grundy seemed intent on provoking the band; they in turn seemed bent on causing trouble. The fun started when Rotten muttered the word "shit" under his breath; Grundy responded by asking Steve Jones to "say something outrageous." Then, this exchange followed (remember, this is being broadcast live on the state-run BBC):

Jones: You dirty bastard. Grundy: Go on again. Jones: You dirty fucker! Grundy: What a clever boy. Jones: You fucking rotter!

The uproar that followed caused EMI to drop the Pistols in January 1977, thereby forfeiting their advance to the band. In March the Pistols were signed by A&M, and given another £50,000 advance; one week later they were fired and given £25,000 more as a buyout fee. Around this time, bassist Matlock decided to quit the group; his replacement was John Ritchie (1957–1979), a friend of Rotten's who went by the name Sid Vicious. The band signed with Virgin in May and released their second single "God Save the Queen," a malicious attack on the monarchy that came just as the country was gearing up for the queen's Silver Jubilee in June, marking Elizabeth's 25th year on the throne. In spite of being banned from the BBC and the refusal of many stores to sell it, "God Save the Queen" quickly sold 200,000 copies and became the #1 single in Britain, although the BBC would not play it and the title was covered with a black bar on the official printed chart. By the end of the year the Pistols released their only LP, *Never Mind the Bollocks, Here's the Sex Pistols* on Virgin in the UK and on Warner in the US.

"GOD SAVE THE QUEEN" (PAUL COOK/STEVE JONES/ GLEN MATLOCK/JOHN LYDON)—THE SEX PISTOLS

Personnel: John Lydon (Johnny Rotten): vocals; Steve Jones: guitar, vocals; Glen Matlock: bass; Paul Cook: drums. Recorded 1976/77 at Wessex Sound Studios, London; produced by Chris Thomas and Bill Price. Released May 1977 on Virgin; peaked at #2 (UK).

With "God Save the Queen," the Sex Pistols managed to offend just about every facet of polite English society during the year celebrating the Queen's 25th anniversary on the throne. With a title mocking the British national anthem, lyrics accusing the Queen of running a "fascist regime" that left the underclass with "no future" and a sleeve picturing Her Majesty's eyes and mouth obscured with cutout letters, the BBC banned the song for "gross bad taste." In spite of the banishment (or perhaps *because* of it), the song rose to the top of the charts. But the Pistols were determined to get their just deserts. On June 7, 1977 during the celebration of the Silver Jubilee, they attempted to play the song from a boat on the River Thames outside the Palace of Westminster. Authorities thwarted the stunt. Said lead vocalist Johnny Rotten, "Watching her on telly, as far as I'm concerned, she ain't no human being. She's a piece of cardboard they drag around on a trolley." The song also appears on the LP *Never Mind the Bollocks, Here's the Sex Pistols*.

In January 1978 the Sex Pistols undertook a disastrous 14-day tour of the Southern and Western US. After the last concert in San Francisco, Rotten quit (or was fired, depending on who you talk to), and the group broke up. Sid Vicious, a heroin addict, was charged in October with the stabbing death of girlfriend Nancy Spungen in their room at New York's Chelsea Hotel. Although he was released on bail, he died of a heroin overdose in February 1979 before he was brought to trial. After dismissing the Sex Pistols as a farce, John Lydon in 1978 formed the group Public Image, Ltd. Whether or not they were indeed a

farce is still being debated; however there is universal agreement that as the most notorious and outrageous British punk band, the Sex Pistols had a major impact on the future of rock and roll.

- John Mellor, aka Joe Strummer
- Mick Jones
- Paul Simonon
- Terry Chimes, aka Tory Crimes, 1976–77
- Topper Headon, 1977–86

THE CLASH

The Clash

The Clash have always occupied a secondary role to the Sex Pistols in the annals of British punk (and after all, who could top the Pistols?), but in fact they took punk beyond its early narrow focus and outlived the Pistols by nearly ten years. The Clash were also the most political of the English punk bands (working for change rather than just destruction), and incorporated a broad base of musical styles into their recordings. The group formed in 1976 when guitarist/vocalist John Mellor, aka Joe Strummer left his band the 101ers to join forces with guitarist Mick Jones and bassist Paul Simonon of the London SS. The 101ers were a pub band whose name was taken from the torture room number in George Orwell's novel 1984. The name for the new band was chosen from a commonly used newspaper term for racial and class conflicts. Also included in the initial lineup was drummer Terry Chimes, aka Tory Crimes, and 101ers guitarist Keith Levene, who left shortly after their first show. Managed by Malcolm McLaren associate Bernard Rhodes, the Clash opened for the Sex Pistols in their 1976 summer tour of England, which led to a contract with British CBS in February 1977. After securing a \$200,000 advance, the group released its eponymous debut album, after which Chimes left and was replaced by Topper Headon.

MUSIC CUT 105

"LONDON CALLING" (JOE STRUMMER/MICK JONES) —THE CLASH

Personnel: Joe Strummer: lead vocals, rhythm guitar; Mick Jones: lead guitar, backup vocals; Paul Simonon: backup vocals, bass; Topper Headon: drums. Recorded August, September, November 1979 at Wessex Studios, London; produced by Guy Stevens. Released December 7, 1979 on CBS; did not chart.

"London Calling" is the title cut from the Clash's third album, released in late 1979. The song features the strong musicianship the group was known for, with a reggae-tinged groove that sounds ominous and upbeat at the same time. The lyrics depict an apocalyptic scenario of world doom based on the news reports lyricist Joe Strummer had been reading. The song began to take shape after a conversation with his fiancée. "There was a lot of Cold War nonsense going on, and we knew that London was susceptible to flooding. She told me to write something about that," he told *Uncut* magazine. (Hence the line "London is drowning and I live by the river.") There are also lines referencing the recent Three Mile Island nuclear reactor meltdown—"Meltdown expected, the wheat is growing thin," and "A nuclear error, but I have no fear." The band began rehearsals for the album at a rehearsal space called the Vanilla, and then moved to Wessex Studio for the recording. The album ended up selling a million copies and rising to #27 on the US charts.

Although the Clash by this time were becoming popular in Britain, they were virtual unknowns in the US. However, in 1979, buoyed by their Pearl Harbor Tour of America and the release of their third album London Calling (which went to #27), they began to make inroads into the American market. That same year they appeared in the semi-documentary film Rude Boy, which featured extensive footage of their live shows. In 1980 the triple album Sandinista! was released, an experimental mix of styles that drew mixed reviews (although it was named album of the year by the Village Voice). The Clash were not afraid to tackle political and social issues in their music, including racism ("Police and Thieves"), rebellion ("White Riot"), unemployment ("Career Opportunities"), and class consciousness ("What's My Name"). Their music incorporated influences that were beyond the scope of most punk bands, including reggae, gospel, Euro-pop, funk, jazz, R&B and rap. The fact that they were influenced at all by black American music set them worlds apart from the Sex Pistols and most other punk bands. The Clash also managed to find some commercial success, most notably with 1982's Combat Rock (#7), which included the #8 single "Rock the Casbah." Another song from Combat Rock, "Should I Stay or Should I Go" was re-released in 1991 after it was featured in a Levi's TV commercial and went to #1 in the UK. The band broke up in 1986.

Other Important Punk Bands

The Sex Pistols and the Clash inspired hundreds of other punk bands to form in England and America in the late 1970s. Among the most important were the Damned, the Vibrators, the Buzzcocks, Joy Division, Generation X and Siouxsie and the Banshees.

THE PUNK AFTERMATH

New Wave

Even before the record industry could recover from the initial wave of punk bands, a second or "new wave" of artists began to appear that took elements of punk and fused them with a more pop oriented sensibility. New wave bands also began to incorporate other stylistic strains into their music, including American R&B, reggae and even synthesizer based techno-pop. Two American bands that were early adopters of this strategy were Blondie and the Talking Heads. Blondie, led by bleached blonde singer and former Playboy bunny Deborah Harry, made their debut at CBGB's in August 1974, and became regulars there for the next several years. After recording two albums for Chrysalis in 1976 and 1977, the band had made impressive inroads into the European and Australian markets, but were pretty much unknown in the US. They finally broke through in their native country with 1978's Parallel Lines, which peaked at #6 and yielded their first #1 single, the disco-infused "Heart of Glass" in 1979. Over the next two years they had seven more Top 40 singles, including three #1s. They broke up in 1982.

- Blondie
- Talking Heads
- Cars
- Pretenders

- Devo
- Romantics
- Elvis Costello
- The Police

NEW WAVE BANDS

Talking Heads first came together in 1973 as the Artistics, in homage to the Rhode Island School of Design, where David Byrne (guitar, vocals), Chris Frantz (drums) and Tina Weymouth (bass) were students. After the band broke up in 1974, the three moved to New York and made their debut at CBGB's as the Talking Heads in May 1975, where they became regulars over the next few years. In 1976 the group added keyboardist Jerry Harrison, and eventually signed with Sire Records in 1977. Later that year they released their debut album Talking Heads '77, which yielded the single "Psycho Killer," inspired by the Norman Bates character from Alfred Hitchcock's film Psycho. In the song Byrne sings in a clipped, almost stuttering sing/speak that in a strange sense fit his stage persona. Their 1979 release Fear of Music is often called their best, with its innovative production and use of rhythm. The Talking Heads were one of the most unusual bands to come out of the CBGB's scene in the late 1970s, and for good reason. All had attended college, which no doubt had an influence on their more sophisticated look and sound. All were accomplished musicians, and drew influences from such disparate sources as punk, R&B, and New York minimalist composers Philip Glass and Terry Riley. They also rejected the leather and jeans punk dress code and wore slacks and sweaters, giving them a nerdy-smart college student image. Lead singer Byrne's on-stage moves were also out of the ordinary, and were described by one rock critic this way: "Imagine an out-of-it kid practicing Buddy Holly moves in front of a mirror." In time, Byrne's self-conscious awkwardness became fashionably cool. The band continued recording until their breakup in late 1991.

MUSIC CUT 106

"BURNING DOWN THE HOUSE" (DAVID BYRNE/CHRIS FRANTZ/ JERRY HARRISON/TINA WEYMOUTH)—TALKING HEADS

Personnel: David Byrne: guitar, keyboards, percussion, lead vocals; Jerry Harrison: keyboards, guitar, backup vocals; Tina Weymouth: bass, backup vocals; Chris Frantz: drums, backup vocals; Bernie Worrell: clavinet. Recorded 1982 at Sigma Sound, Philadelphia; produced by Talking Heads. Released 1983 on Sire; 11 weeks on the charts, peaking at #9.

The leadoff track to Talking Heads fifth studio album *Speaking in Tongues*, "Burning Down the House" became the bands only single to crack the Top Ten. The song started out as an instrumental jam by husband and wife band members Chris Frantz and Tina Weymouth. After some crafting by the entire band into a more song-like form, vocalist David Byrne began chanting nonsense syllables to fit the phrasing of the music. Later, he wrote words to fit the phrasing. Chris Frantz has commented that the title of the song (and perhaps the group vocals) were inspired by a George Clinton performance he attended in 1979. And in fact, Clinton's keyboard player Bernie Worrell plays the clavinet on this recording.

Characteristics of New Wave

- 1. A post punk style with commercial pop sensibilities
- 2. Utilizes influences from R&B, reggae, techno-pop
- 3. Synthesizers frequently used

Key New Wave Recordings

- My Aim Is True—Elvis Costello, 1978
- Fear of Music—Talking Heads, 1979
- "Whip It"—Devo, 1980
- Synchronicity—the Police, 1983

From Boston, the Cars emerged as a major commercial success, with eight Top 40 albums and four Top 10 singles before their breakup in 1988. Akron, Ohio born songwriter/singer/guitarist Chrissie Hynde hooked up with three Londoners to form the Pretenders, which had five Top 40 LPs in the 1980s. Also coming from Akron was Devo (short for de-evolution), who combined a futuristic robotic image with techno-pop sensibilities. Devo's 1986 LP *Freedom of Choice* yielded the #14 hit "Whip It," which was made into a innovative music video in which the members wore pots on their heads. Another band that relied heavily on image was Athens, Georgia's the B52's, whose two female vocalists wore bouffant hairdos. Their biggest hit was 1990's "Love Shack" (#3). From Detroit, the Romantics contributed one of the 1980s more memorable anthems, "What I Like About You."

The English new wave movement was just as strong as its American counterpart. In addition to the Pretenders, the most important artists in the British scene were Elvis Costello and the Police. In 1975, **Elvis Costello** (DeClan Patrick McManus) (1954–) was married and worked as a computer programmer when he suddenly quit his job to work as a roadie for Brinsley Schwartz. After submitting demos of his own songs, he secured a contract with Stiff Records in 1976, and eventually released his debut LP *My Aim Is True* in 1978. It was a hit (#32 in the US) and won critical raves. Since then Costello's musical focus has been remarkably eclectic, with influences ranging from jazz, R&B, reggae, punk and lounge music. His intelligent, witty and sometimes hostile lyrics owe a debt to Dylan. Since his debut, 12 albums and two singles have hit the Top 40, making him one of the most commercially successful post–punk artists.

The Police were formed in 1977 by bassist Gordon Sumner, aka Sting, drummer Stewart Copeland and guitarist Andy Summers. The group name is thematically related to a number of other Stewart family concerns: his father at one time worked for the CIA, and his brother owned a small record label, Illegal Records Syndicate (I.R.S.) and a talent agency, Frontier Booking, International (FBI). After forming in 1977, the Police's first self-produced single sold 70,000 copies in Britain. After signing a lucrative contract with A&M Records, the group toured small clubs in America in a rented van and developed a strong grass roots following. By mixing strong pop melodies, reggae influenced dance music and blond good looks, over the next ten years the group scored six albums and nine singles in the Top 40. The high point of their popularity came in the

"EVERY BREATH YOU TAKE" (STING)— THE POLICE

Personnel: Sting: lead and backup vocals, bass; Andy Summers: guitars, piano; Stewart Copland: drums. Recorded December 1982-February 1983 at Air Studios, Montserrat and Le Studio, Morin-Heights, Quebec; produced by The Police, Hugh Padgham. Released May 20, 1983 on A&M; 20 weeks on the charts, peaking at #1 for eight weeks.

"Every Breath You Take" was the biggest hit single of 1983, and the Police's biggest hit of their career. It comes from their blockbuster final album *Synchronicity*. The song won two Grammies in 1984, including Song of the Year. The album also won a Grammy. Most of *Synchronicity* was recorded at George Martin's AIR Studio on the Caribbean island of Montserrat. Sting's original idea for the song had no guitar part; when Andy Summers went in the studio to add one, he was inspired by 20th century classical composer Béla Bartók to come up with the song's signature riff. "I'd been making an album with Robert Fripp [of King Crimson], and I was kind of experimenting with playing Bartók violin duets and had worked up a new riff. When Sting said 'go and make it your own', I went and stuck that lick on it, and immediately we knew we had something special." In spite of the song's interpretation by many to be a love song, it is actually about an obsessive stalker. A Sting told the *New Musical Express*: "I think it's a nasty little song, really rather evil. It's about jealousy and surveillance and ownership."

summer of 1983, when "Every Breath You Take," from the LP *Synchronicity* stayed at #1 for eight weeks. The album eventually went 8x platinum and stayed at the #1 spot for 17 weeks.

Hardcore

At the same time that new wave was exploring a more pop-friendly side of punk, a harder-edged offshoot was also emerging. **Hardcore** incubated in Los Angeles, although another important albeit smaller scene also developed in Washington, DC. Hardcore music, like punk, reflected a culture of angry and frustrated white teenagers who "began devising an ultra-punk—undiluted, unglamorous, and uncompromising—that no corporation would ever touch," states Michael Azerrad. Hardcore is darker, angrier, faster and louder than punk, and was accompanied by a fashion ethos of tattoos, buzz cut haircuts and Army boots. Audience members often engaged in moshing, in which participants would form pits in front of the stage and smash into each other. Diving into the mosh pit from the stage was also common. Hardcore concerts often erupted in chaos and violence, often at the incitement of the bands.

Characteristics of Hardcore

- 1. A harder edged, darker and angrier evolution of punk
- 2. Counter culture associations with fashion, slam dancing, mosh pits
- 3. Scene centered in Los Angeles

Key Hardcore Recordings

- Fresh Fruit for Rotting Vegetables—the Dead Kennedys, 1980
- Damaged—Black Flag, 1981

Important Hardcore Bands

Azerrad describes Black Flag as "the flagship band of American hardcore itself," and "required listening for anyone who was interested in underground music." Founded in 1977 in Hermosa Beach, California by guitarist Greg Ginn and vocalist Keith Morris, the band originally called themselves Panic before changing to Black Flag after discovering another band named Panic. Since they initially has trouble finding a reliable bass player, Ginn devised a distinctive playing style that was rhythmic and emphasized lower pitches. Because the band initially had trouble finding a label to release they're recordings, Ginn started SST Records in 1979, which in time became the most important independent hardcore label. Morris left that year, and further personnel changes over the next two years led to a permanent Black Flag lineup of Ginn, Chuck Dukowski on bass, Dez Cadena on rhythm guitar, Roberto Valverde, going by the name Robo on drums, and Henry Garfield, who assumed the name Henry Rollins on vocals. Black Flag shows had always incited trouble between fans and police, but Rollins's skinhead, tattoos and angry stage presence added a whole new level of disorder. One critic labeled him "a cross between Jim Morrison and Ted Nugent"; another called the Rollins-led band "a gruesome and intimidating display of rock aggression and frustration," that "like a high-speed car crash, you couldn't keep your eyes—or ears—off." The sound and fury of Black Flag was best captured in their 1981 LP *Damaged*, which is today considered one of the defining hardcore albums. Despite their influence and renown among the hardcore faithful, Black Flag never was able to make anything resembling even a meager income, and eventually broke up in 1986.

"RISE ABOVE" (GREG GINN)—BLACK FLAG

Personnel: Henry Rollins: lead vocals; Greg Ginn: lead guitar, backup vocals; Dez Cadena: rhythm guitar, backup vocals; Chuck Dukowski: bass, backup vocals; Roberto Valverde (Robo): drums, backup vocals. Recorded August 1981 at Unicorn Studios, Los Angeles; produced by Spot, Black Flag. Released December 1981 on the SST LP *Damaged*; not released as a single.

Damaged, Black Flag's debut album on SST Records, has been called "a key hardcore document, perhaps the hardcore document" by writer Michael Aserrad (Our Band Could Be Your Life). "It boiled over with rage on several fronts: police harassment, materialism, alcohol abuse," and, "the stultifying effects of consumer culture." The band had made two previous attempts to record material for a first album with singers Ron Reyes and Dez Cedena, but were unhappy with the results. It wasn't until the addition of vocalist Henry Rollins, who managed to channel the pent up rage from an unhappy childhood, that Black Flag found their muse. The refrain to "Rise Above" pretty much sums up the sentiments of the album—and hardcore, for that matter: "We are tired of your abuse/Try to stop us, it's no use!"

Minor Threat is often called the definitive hardcore band. They were formed in Washington, DC in 1980 by vocalist Ian MacKaye, drummer Jeff Nelson, bassist Brian Baker and guitarist Lyle Pressler. Initially calling themselves the Teen Idles, they were inspired by the established local hardcore band Bad Brains, who not only played punk at incredibly fast speeds but "were the coolest-looking, most

heavy-looking dudes," according to MacKaye. Around the time they changed their name to Minor Threat, MacKaye and Nelson—in true hardcore spirit—decided to start their own label, which they called Dischord Records. The label's first release was the eight-song EP *Minor Disturbance* from the Teen Idles that comprised all of ten minutes of music. As Minor Threat, the band released two EPs and one LP, 1983's *Out of Step*, which turned out to be their last release. The band broke up that year over personal disagreements.

Other hardcore bands included LA's X, the Circle Jerks and the Minutemen; Washington, DC's Bad Brains and Fugazi; Hüsker Dü from Minneapolis, the Minutemen from San Pedro, California, and San Francisco's the Dead Kennedys, led by political activist Jello Biafra.

Name	ne Dat	te
	• Who were some of the people and bands that were influential to the creation r contributions?	of punk, and what were
2.	Why was punk so influential to rock, and why did it lose its credibility?	
3.	• What were some important differences between the New York and London pu	ink scenes?
	 Describe how the Velvet Underground were unique for their time and why the k bands. 	ey were influential to later
5.	Why did New York punk musicians feel it was not necessary to be virtuoso per	formers on their

instruments?

- **6.** Describe a show by the Ramones.
- 7. How was London's pub rock scene instrumental in the development of the city's punk scene?
- **8.** In what ways did the Sex Pistols manipulate the music industry and how did they contribute to the end of the punk era?
 - 9. In what ways were the Clash unique among punk bands of the era?
- 10. In what ways were the Talking Heads an out of the ordinary band for the CBGB scene in the late 1970s?

THE EIGHTIES

"I really remember John Lennon's 'Imagine.' I guess I'm twelve; that's one of my first albums. That really set fire to me. It was like he was whispering in your ear—his ideas of what's possible. Different ways of seeing the world."

-Bono

MIDI, an acronym for the Musical Instrument Digital Interface protocol, has transformed the world of music production since it was introduced to consumers in 1984. As commercially produced music synthesizers were becoming increasingly digital in the late 1970s and early 1980s, the limitation of their interconnectivity was becoming painfully apparent. In the early 1980s, engineers from manufacturers Sequential Circuits, Roland and Oberheim began work on a standard that would allow digital instruments to be controlled remotely. The MIDI 1.0 Standard, which was first published in 1983, was an instant success and has become an industry standard that is used by professionals and part-time enthusiasts alike.

number of small, home-based studios that could produce music much quicker and less expensively than the large commercial studios, many of which went out of business. Over the years the technology has improved and the software has become much more user-friendly; today, MIDI is a ubiquitous production tool in the music industry.

The 1980s also saw advancements in digital audio recording technology. Digital multi-track tape recorders, although extremely expensive, allowed never before heard of sonic quality and clarity. Because recorded information stored on digital tape required less space than it did using analog technology, more tracks became available to record on—as many as 48 in some cases. The introduction of Digital Audio Tape (**DAT**) recording technology in the late 1970s allowed for a low-cost solution to stereo (two-track) digital recording on tiny tapes that could store up to two hours of material. Throughout the 1980s and early 1990s, most music recording studios were busy replacing their analog tape recorders with digital ones. By the end of the 1990s, digital tape itself began to get phased out in favor of hard disc recording.

MTV

One of the most significant developments in the music business in the 1980s came ironically from an old technology: television. On August 1, 1981, Music Television (MTV) began broadcasting on cable, and almost overnight changed everything about how music was packaged, sold, and consumed. Marketed to the largest record-buying demographic—ages 12 to 34—MTV became the fastest-growing cable channel in history when its subscription went from 2.5 million to 17 million within two years, despite the fact that only 40 percent of the country was wired for cable. When it premiered, MTV was essentially a visual version of radio, with non-stop broadcasting of music videos hosted by VJs (video jockeys). At first, music videos from Britain dominated MTV's programming because many British bands had already been experimenting with the genre throughout the 1970s. (The very first music video shown on the station was the appropriately named "Video Killed the Radio Star" by the British group the Buggles.) The popularity of other British bands such as Duran Duran (with five platinum LPs between 1983 and 1986), Human League, Eurythmics, and Flock of Seagulls in the early 1980s can be directly attributed to their exposure on MTV.

TRIVIA NOTE
One of the
most significant
developments in the music
husiness in the 1980s came

developments in the music business in the 1980s came ironically from an old technology: television. On August 1, 1981, Music Television (MTV) began broadcasting on cable, and almost overnight changed everything about how music was packaged, sold, and consumed.

The consequence of MTV as a new pop music medium is that the music video essentially became an advertisement for the record, the band, and the record label. Simply stated, a catchy and memorable video that people liked to watch sold records. American labels that had previously looked at music videos as an intangible expense now viewed them as marketing necessities. Although the nonmusical attributes of artists—how they looked, what clothes they wore, how well they danced—had always been important in pop music, they suddenly took on even greater significance, and became perhaps even more important than the artist's talent. MTV rapidly became the most powerful player in the industry, since their programmers decided which videos to play and which not to play. In the first few years those choices were overwhelmingly white: a mid-1983 survey by Billboard found that of the 100 videos in heavy or medium rotation the week of July 16, none were of black artists. MTV, under heavy criticism from just about everyone, feebly tried to defend their programming as the result of extensive market research. But they could not explain how an artist like Rick James, whose most recent album Street Songs had sold nearly four million copies couldn't get his video for "Super Freak" shown on their network. MTV was "taking black people back 400 years," said James.

It wasn't until the incredible success of Michael Jackson's *Thriller* album and the three videos that accompanied it that the network was forced to change its programming. Although the songs "Beat It," "Billie Jean" and "Thriller" all became Top 10 hits and their videos set new standards for production quality, it wasn't until Columbia Records president Walter Yetnikoff threatened to yank all of the label's videos off the network that MTV capitulated and put "Billie Jean" into heavy rotation. It has since become known as the 'video that broke the color barrier'. This story may be apocryphal, as there have been several different tellings of it. But wherever the truth lies, MTV played a small but significant role in the rise of an artist that did nothing less than dominate pop music in the early 1980s and in the process revitalized a sagging industry. As Steve Knopper writes in *Appetite for Self-Destruction:* "In late 1982, Michael Jackson almost magically restored the music industry's superstar clout by releasing one record."

MICHAEL, MADONNA, AND PRINCE: POST-DISCO DANCE DOMINANCE

The King of Pop

Michael Jackson (1958–2009) was the second youngest of the Jackson brood of five boys and three girls (sister Janet is the youngest). Hailing from Gary, Indiana, Michael and his brothers (Tito, Jermaine, Jackie and Marlon) began performing together in the early 1960s under their father Joe's tutelage. Joe Jackson was a former part-time musician whose relentless rehearsal of the boys bordered on abuse; nonetheless they developed quickly into a dynamic act playing the chitlin' circuit and winning regional music contests such as the famous Apollo Theatre Amateur Night in August 1967. In 1968 they auditioned for Motown Records and were signed in 1969. Once in his stable, Motown president Berry Gordy put them through the usual developmental process, and decided to mold the

group as an updated version of Frankie Lymon and the Teenagers. At this point in time Michael was only 11 years old, but it was already becoming apparent that he was a superstar in the making. The Jackson 5's first single, "I Want You Back" was released in November 1969, and it, along with the next three singles "ABC,"

Michael Jackson

"The Love You Save" and "I'll Be There" all went to #1, the first time in history such a feat had been accomplished. Although he officially stayed with the group until the early 1980s, Michael began his solo career in 1972 with the release of his album *Got to Be There*, whose title cut went to #4 on the charts. The title cut from his second LP *Ben* gave Michael his first #1 single in 1972. In 1975 Michael and his brothers left Motown and signed with CBS, and all future recordings by both the group (now calling themselves the Jacksons) and Michael were released on Columbia's Epic label.

Michael released two more albums in the mid-1970s, but it wasn't until 1979, when the 21-yearold singer teamed up with veteran producer **Quincy Jones** that he began his meteoric rise to the top. Their first collaboration, *Off the Wall* is a well-crafted fusing of funk, post-disco pop and soul that sold seven million copies and produced four Top 10 hits, two of which, "Don't Stop 'Til You Get Enough" and "Rock with You" hit #1. The next Jackson/Jones collaboration was the blockbuster of all blockbusters. *Thriller*, released in 1982, became the album that made Michael Jackson an international superstar. All in all, it won eight Grammy Awards (not including the four that Quincy Jones

won as producer), yielded an unprecedented seven Top 10 singles out of its nine songs (including two #1's, "Billie Jean" and "Beat It") and stayed on the charts for 91 weeks, 37 at #1. The three videos from the album elevated the genre to new levels, and were so popular that Jackson produced a documentary entitled *The Making of Michael Jackson's Thriller* that sold nearly half a million copies. Michael-mania had arrived.

Thriller was groundbreaking on several levels. The music is superbly produced, arranged and impeccably recorded with state of the art digital technology. There are a remarkable variety of songs, from heavy funk grooves ("Thriller") to heavy metal ("Beat It") to light pop ("The Girl Is Mine"). Jackson also brought in a strong supporting cast of guest artists, including Eddie Van Halen, who played a scorching solo on "Beat It;" Paul McCartney, who sang in duet with Michael on "The Girl Is Mine," (a song McCartney co-wrote); and horror movie veteran Vincent Price, who did a semi-comical rap on the title cut. Jackson's vocals are also perfect, ranging from breathless and high energy to fragile and poignant. Jackson did such a good job of connecting to nearly every segment of the record buying public that it became the first album in history to simultaneously top

"BILLIE JEAN" (MICHAEL JACKSON)— MICHAEL JACKSON

Personnel: Michael Jackson: vocals; Greg Smith, Bill Wolfer: synthesizers; Greg Phillinganes: electric piano, synthesizer; David Williams: guitar; Louis Johnson: bass; Ndugu Chancler: drums; Michael Boddicker: Emulator; Tom Scott: lyricon; Michael Jackson: vocal, rhythm and synthesizer arrangement; Jerry Hey: string arrangement. Recorded 1982 at Westlake Recording Studios, Los Angeles, CA; produced by Quincy Jones. Released January 2, 1983 on Epic; 17 weeks on the charts, peaking at #1.

"Billie Jean" was one of two #1 hits (along with "Beat It") from Michael Jackson's blockbuster album *Thriller*, and the winner of 1984 Grammy Awards for Best R&B Song and Best R&B Male Vocal. "I knew it was going to be big while I was writing it," Jackson later said. "I was really absorbed in writing it." The storyline for "Beat It," about a fabricated paternity case, was reportedly inspired by Jackson's own experience with overzealous female fans, both on his own and with his older brothers from the Jackson 5 days. Jackson nailed his vocal track in one take. The song spent seven weeks at #1, 17 weeks in all on the Top 40, and is one of seven songs from *Thriller* to hit the Top 10. To say that Michael Jackson was hot in 1983 is understating the case—he even snuck a non-*Thriller* single in, "Say Say Say" (with Paul McCartney) and it became his third #1 of the year. In all, Jackson held the top spot on the charts in 1983 for 16 weeks. Of course, perhaps the most remarkable—certainly the most historic—aspect of "Billie Jean" is the music video, which is often referred to as "the video that broke the color barrier" on MTV.

the singles and album charts in both the R&B and pop categories. The music videos that accompanied "Beat It," "Billie Jean" and "Thriller" more or less revolutionized the genre, as Jackson made each of them into epic mini-dramas of Hollywood proportions. The "Thriller" video, in which Jackson leads a troupe of ghoulish dancers in late night choreography, is often rated as the best music video of all time.

Thriller's success was bolstered by the aura that surrounded Michael throughout most of 1983, which he created through his innovative music videos and an incredible performance on the national TV special Motown 25: Yesterday, Today, Forever. During his solo appearance on the NBC program, which aired on May 16, 1983, Michael sang and danced his way through "Billie Jean" with a variety of unbelievable break-dance moves and introduced his now famous moonwalk, all while wearing a black fedora and one white sequined glove. Up to this point in time, many Americans had not yet heard Thriller, and many still had a vision of Michael as an 11-year-old phenom. After that night, Jackson became a pop legend, and sales of Thriller went through the roof.

Thriller is today listed as the best selling album in history, with estimated sales somewhere between 51 and 65 million copies worldwide and 29 million in the U.S. Although it was the apex of Michael Jackson's career, he was still able to conjure up two #1 multi-platinum albums, 1987's Bad and 1991's Dangerous, and seven more #1 singles before 1995. By the late 1980s however, his personal life increasingly became the focal point of his career. In 1988 he bought a ranch outside SantaYnez, California and for 17 million dollars built an amusement park he

called Neverland where he invited busloads of children to come play. He underwent several cosmetic surgeries to reshape and thin his nose. He was accused by some in the black community of undergoing treatments to lighten his skin, although he claimed that he had a disorder known as vitiligo, which destroys skin pigmentation. An alarming weight loss made some speculate that he suffered from anorexia nervosa. Most troubling were the 1993 accusations of molesting a 13-year-old boy that had been a frequent overnight visitor to Neverland, which resulted in an out of court settlement reported to be nearly 20 million dollars. In 2003 Jackson was charged with seven counts of child molestation with another 13-year-old boy, but was acquitted of all charges after a five-month trial in 2005. Amidst all the weirdness, he had two short-lived marriages, the first to Elvis Presley's daughter, Lisa Marie, and the second to Debbie Rowe, an unknown nurse. Michael also fathered three children.

The last years of Michael Jackson's life were spent in a financial free fall with dramatically worsening health problems. Although he had made many astute business decisions, including the 1988 purchase of the Northern Songs catalog containing nearly all of John Lennon and Paul McCartney's Beatles songs, Jackson was also a habitual shopaholic who sometimes spent hundreds of thousands of dollars in a single shopping spree. His worsening financial situation caused him to give up the Neverland Ranch in 2008 and struggle to hold on to the Northern Songs holdings. It is believed that the 50 concert tour that he was scheduled to perform in the summer of 2009 was planned more as a way to pay off past bills than to reinvigorate his career. Jackson was also becoming increasingly dependent on prescription pain medication, reportedly Deprivan, Demerol, Oxycodone and a wide assortment of others. Some have speculated that his drug use began after his scalp caught on fire during the filming of a Pepsi commercial in 1984; the progressive affects of vitiligo and lupus, another disease he was known to be suffering from, have also been mentioned as possible causes.

As we now know, Jackson's final tour never happened. On June 25, 2009 he was found not breathing in the bedroom of his rented Los Angeles home, and although CPR was performed and he was transferred to the UCLA Medical Center, Jackson, 50, was pronounced dead at 2:26 P.M. from cardiac arrest. The shock was immediate and felt around the world; many fans will long remember where they were when they heard the news. In the week that followed, 422,000 Jackson albums were sold, including 101,000 copies of Thriller. 2.3 million digital downloads of his single tracks were also purchased, the first time in history that any artist has had more than one million within a week. The song "Thriller" alone had 167,000 downloads, "Billie Jean" 158,000. It was the final act in a career that was larger than life and at times seemed to be scripted and staged by the pop gods. As Newsweek's David Gates so aptly said in one of the many Jackson eulogies: "In retrospect, so much of what Jackson achieved seems baldly symbolic. This was the black kid from Gary, Ind., who ended up marrying Elvis's daughter, setting up Neverland in place of Graceland, and buying the Beatles' song catalog—bold acts of appropriation and mastery, if not outright aggression." Long live the King of Pop.

The Material Girl

Like Michael Jackson, Madonna (Madonna Ciccone, 1958-) combined innovative dancing and choreography, dramatic visual artistry and strong post-disco dance grooves to become a pop sensation. Since her self-titled debut album in 1983, more than 30 of her singles have reached the Top 40, with 11 #1's and five more hitting #2. Every one of her 13 albums has gone platinum, with five of them hitting #1. Madonna has also elicited strong negative reactions to her at times brazen eroticism and sexuality, making her one of the most controversial pop figures since Elvis Presley. She has managed to keep herself in the public eye for more than 20 years through an unwavering ambition and an iron fisted control over her career. After starting out as a dancer in her native Detroit, Madonna moved to New York in 1977 and slowly began to make an impression in the city's trendy club scene as a singer. In 1982 she signed with Sire Records (owned by Warner Entertainment) and the following year released Madonna, which included the #10 hit

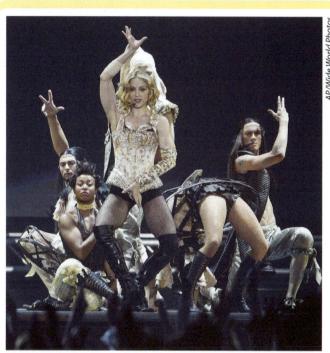

Madonna performs at the Forum in Los Angeles on May 24, 2004.

"Borderline." Her next two albums, *Like a Virgin* and *True Blue* both went to #1 and yielded nine more Top 10 singles. In 1985 she appeared in the film *Desperately Seeking Susan*, and continued to pursue acting roles in other films such as *Shanghai Surprise* (with then husband Sean Penn), *Dick Tracy* (with then boyfriend Warren Beatty) and Andrew Lloyd Webber's *Evita* in 1996, for which

Music Cut 110

"PAPA DON'T PREACH" (BRIAN ELLIOT/MADONNA)—MADONNA

Personnel: Madonna: vocals; David Williams, Bruce Gaitsch, John Putnam: guitars; Fred Zarr: keyboards; Stephen Bray: drums, keyboards; Johnathan Moffett: percussion; Siedah Garrett, Edie Lehmann: backup vocals. Recorded 1985/1986; produced by Madonna and Stephen Bray. Released June 11, 1986 on Sire/ Warner; 13 weeks on the charts, peaking at #1.

"Papa Don't Preach" is certainly the most controversial of the five Top 5 and three #1 singles from Madonna's 1986 album *True Blue*. The subject matter: a young unwed woman becomes pregnant and must tell her father, with whom she has a very close relationship, that she is keeping the baby. Coming right in the thick of the conservative Reagan years, the song created a firestorm of debate between those on both sides of the emotional abortion issue. The song is interesting in musical ways as well, in that it combines a heavily synthesized dance-pop beat with a tinge of classical baroque-ness. In the video made to accompany the song Madonna appears as a tomboy with short hair, and Hollywood actor Danny Aiello plays her father. "Papa Don't Preach" eventually achieved gold status, *True Blue* 7x platinum.

her starring role as Evita Peron won a Golden Globe Award for Best Actress (Musical or Comedy).

Madonna has been adept at pushing the controversy button throughout her career, beginning with her first hit "Borderline," which explored the topic of inter-racial love. Her 1985 #1 hit "Like a Virgin" was sometimes performed while simulating masturbation. In her 1986 single "Papa Don't Preach," a young unwed pregnant woman defiantly decides to keep her baby, against her father's wishes. In her video to "Open Your Heart" she is shown scantily clad on display at a peepshow before a crowd of men. In 1989, the music video of "Like a Prayer" featured burning crosses and an erotic black Jesus figure, which prompted Pepsi to cancel her lucrative endorsement deal and the Vatican to censure her. In 1991 she produced an X-rated documentary film entitled Truth or Dare, and in 1992 she published the coffee table book Sex, which featured nude and S&M clothed photos of herself. In 1994 she engaged in a profanity-laden shouting match with the host on The Late Show with David Letterman. Her 2003 LP American Life received mixed reviews, in part because Madonna for the first time rapped on record and in part for the sometimes confessional and sometimes political nature of the songs. However the reviews did not keep the album from hitting #1 and going 4× platinum. Her most recent studio albums are 2008's Hard Candy, which reached #1 and is certified gold and 2012's MDNA. Her career so far has garnered nine Grammy Awards, 37 Top 10 singles, 25 of which achieved gold status, 12 multi-platinum LPs with total album sales of 63 million (U.S.).

The Artist Formerly Known As . . .

Prince (1958–2016) was perhaps the most talented and innovative pop star of the last half century. His music absorbed an astounding variety of influences, from funk to jazz, R&B, punk, hard rock and disco. He was an incredibly prolific songwriter and record producer who released 39 studio albums and 97 singles during his life, and reportedly left hundreds of unreleased recordings in his studio vault. He also released 17 video albums and directed and starred in four feature length movies. He was a master showman who channeled the androgynous vibe of Little Richard and challenged Michael Jackson and Madonna with his dance moves. He was an amazing guitarist who could trade licks with the best, and played a number of other instruments including drums, bass, and keyboards. He was a virtuosic singer with an incredibly wide vocal range. And, he maintained remarkable control over many aspects of his career, overseeing it all from his hometown of Minneapolis.

Prince Rogers Nelson signed his first contract with Warner Bros. at age 18, and released his first two albums *For You* and *Prince* in 1978 and 1979. In 1980, he released his first masterpiece, *Dirty Mind*, an eclectic mix of funk, R&B, new wave and pop in which he played nearly every instrument. His fifth album, 1983's *1999* went triple platinum, and was followed up by his biggest seller, 1984's *Purple Rain*, which achieved Diamond status. The album was the soundtrack to the film of the same name, in which he also starred. Five of the songs from the album hit the Top 25, and two of them, "When Doves Cry" and "Let's Go Crazy" went to #1. During this period of time, Prince's working band was **the Revolution**, which he disbanded in 1986. In 1988, he built Paisley Park Studios in the Minneapolis suburb of Chanhassen, and from that point in time it served as his home base.

In 1993 Prince fell into a contract dispute with Warner's, which led him to remove his name from all of his forthcoming recordings and replace it with a "Love Symbol" &, a combination of the medical symbols for male and female. This controversial move resulted in declining record sales and derision from critics and the press, many of whom began referring to him as TAFKAP (The Artist Formerly Known as Prince). After his contract with Warner's ran out in 1999, he signed with Arista and on May 16, 2000 began referring to himself once again by his given name. In the 2000s, Prince remained highly visible, with sustained record sales, extensive touring, a Super Bowl XLI half time performance in 2007, and an induction into the Grammy Hall of Fame in 2010. (During his life, he was nominated for 38 Grammies, winning seven.) Throughout his last years, he held a public image of a hard-working and vibrant star, but as the world would later find out, he was developing an opioid addiction. On the morning of April 21, 2016, emergency personnel responding to a 911 call found him unresponsive at Paisley Park, and minutes later pronounced him dead. Cause of death was determined to be an accidental overdose of fentanyl. In the days following of his death, record sales spiked, with five of his albums hitting the Ton 10 simultaneously, a first in Billboard history. During his lifetime Prince sold more than 100 million albums, with six platinum singles, and 12 platinum albums.

Prince's music has absorbed a variety of influences, from funk, jazz, R&B, punk, hard rock, and disco. He followed *Purple Rain* with another #1 album, the bizarre *Around the World in a Day,* but did not have another #1 until 1989's *Batman,* the soundtrack to Tim Burton's film. During the 1990s he released ten LPs, all of which went either gold or platinum. During this time he also had ten singles hit the Top 40, including 1991's #1 "Cream." Prince has also been active as a talent promoter in the careers of many up-and-coming artists, including percussionist Sheila E, Carmen Electra, the Time, and the female vocal trio Vanity 6.

MUSIC CUT 111

"PURPLE RAIN" (PRINCE)—PRINCE

Personnel: Prince: lead and backup vocals, lead guitar; Wendy Melvoin: rhythm guitar, backup vocals; Lisa Coleman: keyboards, backup vocals; Matt Fink: keyboards; Brown Mark: bass; Bobby Z.: drums, percussion; Novi Novog: violin, viola; David Coleman, Suzie Katayama: cello. Recorded live at First Avenue, Minneapolis, MN, August 3, 1983; produced by Prince and the Revolution. Released September 26, 1984 on Warner Bros.; 18 weeks on the charts, peaking at #2.

Prince's megahit single "Purple Rain" was recorded live at a benefit concert for the Minnesota Dance Theatre, held at the First Avenue club in Minneapolis on August 3, 1983. The single release sold over a million copies upon its initial release, while the soundtrack album went on to go 11x platinum, the biggest selling of his career. While in production, Prince had concerns that the song sounded too much like Journey's "Faithfully," so he called up that song's composer, Journey keyboard player Jonathan Cain. Cain recalled in *Billboard* that Prince message was. "I want to play something for you, and I want you to check it out. The chord changes are close to 'Faithfully,' and I don't want you to sue me." Cain said that "I thought it was an amazing tune," and "I told him, 'Man, I'm just super-flattered that you even called. It shows you're that classy of a guy. Good luck with the song—I know it's going to be a hit." After Prince's death in April 2016, "Purple Rain" returned to the charts and peaked at #4.

THE BOSS, BONO, AND THE REST: BACK TO BASICS

The Boss

Bruce Springsteen (1949–) is the latest version of rock and roll's working-class hero. A prolific writer of songs that tell romanticized stories of the underprivileged, downtrodden, and those who are somehow missing out on the American Dream, Springsteen has been compared to Bob Dylan and Woody Guthrie, and hailed as the savior of rock and roll. By casting himself as hard-working, small town, and blue collar, Springsteen in many ways was the antithesis of the 1980s superstar, although that is exactly what he became. However, by continuing to write relevant music that perfectly reflects our times and putting on lengthy, high-energy concerts, he has remained a vital and important rock and roll artist.

Born in Freehold, New Jersey, to a bus driver and a secretary, Springsteen worked his way through a variety of local bands and as an aspiring folksinger in Greenwich Village before successfully auditioning for Columbia Records' legendary John Hammond in 1972. Springsteen released his debut album *Greetings from Asbury Park*, N.J. in 1973, which contained a combination of folk and R&B influences and had modest sales. Later that year he released his second LP, *The Wild, the Innocent, and the E Street Shuffle,* which garnered rave reviews but little interest from buyers. Then, in 1974 while playing at a club in Cambridge, Massachusetts, critic Jon Landau (his future manager) heard him, and wrote in

the local rag *The Real Paper*: "I saw rock & roll's future and its name is Bruce Springsteen." Springsteen responded with his harder-edged third album in the fall of 1975, *Born to Run*, which hit #3, included his first Top 40 hit (the title track, #23) and garnered cover stories from both *Time* and *Newsweek* magazines. Although his star dimmed somewhat for a few years in the wake of the punk, new wave, and disco crazes, Springsteen released two noteworthy albums that eventually went platinum, *Darkness on the Edge of Town* (1978) and *The River* (1980). In 1982, he released the dark and stripped-down *Nebraska*, a collection of demos that he recorded with his four-track cassette recorder. Even though the songs on *Nebraska* typically told well-developed stories, the album was demanding for his established audience to listen to, and a somewhat risky career move.

Springsteen finally rose to superstar status in 1984 with the release of *Born in the U.S.A.*, which has sold 15 million copies (U.S.) and yielded seven Top 10 hits from its 12 songs, including the platinum-selling "Dancing in the Dark" (#2). The album's title cut is a pained story of a Vietnam veteran who is unable to find a job or rebuild his life on returning home from war. Ironically, Ronald Reagan's 1984 presidential campaign used the song as a patriotic rallying cry, apparently unaware of the song's real message and focusing only on the anthem-like sing-along

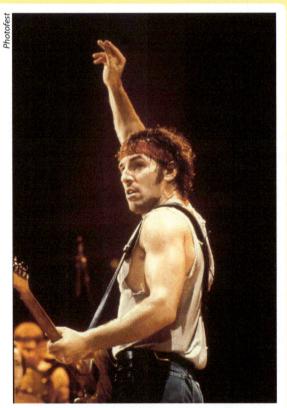

Bruce Springsteen: rock & roll working class hero.

CHAPTER 12 The Eighties

MUSIC CUT 112

"BORN IN THE U.S.A." (BRUCE SPRINGSTEEN)—BRUCE SPRINGSTEEN

Personnel: Bruce Springsteen: guitar, vocals; Steve Van Zandt: guitar, vocals; Roy Bitten: piano; Danny Federici: organ, piano; Garry W. Tallent: bass; Max Weinberg: drums. Recorded May 1982 at The Power Station, New York, NY; produced by Bruce Springsteen, Jon Landau, Chuck Plotkin and Steve Van Zandt. Released October 30, 1984 on the Columbia LP *Born in the U.S.A.*; 17 weeks on the charts, peaking at #9.

"Born in the U.S.A." is Bruce Springsteen's heartfelt story of a working-class youth's induction into the army, service in Vietnam, and disillusioned return home with "nowhere to run, ain't got nowhere to go." Springsteen empathized with the dilemma faced by embittered returning vets, and was inspired to write the song after reading Vietnam veteran Ron Kovic's memoir Born on the Fourth of July and filmmaker Paul Schrader's movie script entitled Born in the U.S.A. Originally the song was envisioned as an acoustic piece to be included in the Nebraska LP, but eventually Springsteen brought it to a recording session where the E Street Band quickly rendered the version on the album. "We played it two times, and our second take is the record," Springsteen said. "That thing in the end with all the drums, that just kinda happened." "Born in the U.S.A." was the third of seven Top 10 songs from Born in the U.S.A. the album, peaking at #9. The single is certified gold, while the album is certified 15× platinum.

hook, "Born in the U.S.A!" Springsteen wisely distanced himself from such boosterism. His next album was the intensely personal Tunnel of Love (1987), which went triple platinum within months despite its Nebraska-like stark and pessimistic tone. While his most political album, 1995's The Ghost of Tom Joad, condemned the growing divide between America's rich and poor, perhaps his most poignant was 2002's The Rising, a timely reflection on life written in the aftermath of the September 11, 2001, attacks on the World Trade Center.

Springsteen's music is riveted to rock's past. His band, the **E Street Band**, which he used exclusively in the studio and on tours from 1974 through 1989, is your basic 1960s garage band styled guitar-bass-drums-Hammond organ combo, with a nod to 1950s R&B with the addition of the honking tenor saxophone of Clarence Clemons. Springsteen's lyric writing is clearly indebted to Bob Dylan and the 1960s folk ethos. At times even his arrangements have an unmistakable Dylanesque quality, with gruff vocals and country-ish harmonica playing. Although record sales have slowed for Springsteen in recent years, his popularity cuts across generational lines and he remains a top concert attraction. In July 2003 he kicked off a yearlong "Rising" tour that included a ten-night sold-out run at New Jersey's 55,000 Giants Stadium, which grossed \$79 million and set a record for the most tickets ever sold in a concert series at one venue—more than half a million.

U2

Dublin, Ireland's **U2** made their mark in the pop world in the 1980s with a unique sound that blended sweeping operatic-like instrumentals, searing guitar work, and passionate vocals with socially conscious lyrics. The band formed in 1976, and after the usual sorting out period they settled on a personnel lineup of Paul Hewson (**Bono** (1960–) on vocals and guitar, David Evans (The Edge) on

guitar, keyboards and vocals, Adam Clayton on bass and Larry Mullen on drums. In the beginning they were all students at Dublin's Mount Temple High School, and none of the four were particularly proficient on their instruments, but learning in a self-taught fashion slowly began to pay off with innovative results. In 1980 they signed with Island Records and released their debut album *Boy*, which explored themes of adolescence. 1981's *October* examined issues of faith, as Bono, the Edge and Mullen were all practicing Christians. 1983's *War* saw U2 tackle the conflict in Northern Ireland, best addressed on the single "Sunday Bloody Sunday," and the album's #12 U.S. chart position was evidence that the group was finally breaking into the American market. The next two releases from 1984 and 1985, *The Unforgettable Fire* and *Wide Awake in America* (a four song EP) were the first of several collaborations with producers Brian Eno and Daniel Lanois, and yielded their first U.S. hit single, "Pride (In the Name of Love)." The group also made appearances at Live Aid and the Conspiracy of Hope Tour benefiting Amnesty International.

U2's next album put them into the pop mainstream. 1987s' *The Joshua Tree* quickly went platinum (and eventually diamond in 1995), produced two #1 singles ("With or Without You," "I Still Haven't Found What I'm Looking For") and stayed in the Top 40 for more a year. The album was another Eno/Lanois production, and won two Grammy Awards. At this point, U2 had become one of the most popular bands in the world. Of their seven albums released since *The Joshua Tree*, six have hit #1 in the U.S., and six are certified platinum or multi-platinum. Bono has also become one of the foremost humanitarians on the world stage, lending his visibility and support to Amnesty International, AIDS relief efforts, world economic forums, disaster, hunger and disease relief, Product Red, and African aid organizations. For his efforts, he has been nominated for the Nobel Peace Prize and was granted honorary knighthood by Queen Elizabeth II of England.

MUSIC CUT 113

"I STILL HAVEN'T FOUND WHAT I'M LOOKING FOR" (BONO)—U2

Personnel: Bono: vocals, harmonica; The Edge: guitar, keyboards, vocals; Adam Clayton: bass; Larry Mullen Jr.: drums, percussion. Recorded at Windmill Lane Studios, Dublin, Ireland; produced by Brian Eno, Daniel Lanois. Released March 9, 1987 on Island; 17 weeks on the charts, peaking at #1.

The anthemic "I Still Haven't Found What I'm Looking For" was one of two #1 singles (along with "With or Without You") from U2's multi-platinum *The Joshua Tree*. The album was the second and last produced for the group by Brian Eno and Daniel Lanois, and became their most commercially successful, hitting #1 in the spring of 1987 and staying there for two months. It eventually went on to sell ten million copies in the U.S., and (according to virginmedia.com), 25 million copies worldwide. The album also won Grammy Awards for Album of the Year and Best Rock Performance by a Duo or Group with Vocal. Although lead vocalist Bono is listed as the composer of "I Still Haven't Found What I'm Looking For," producer Daniel Lanois claims some credit. "I remember humming a traditional melody in Bono's ear," Lanois later recalled. "He said, 'That's it! Don't sing any more!'—and went off and wrote the melody as we know it."

Whitney Houston

Whitney Houston (1963–2012) exploded onto the scene in 1985 with the most successful debut album ever by a female artist, and has since gone on to sell nearly 200 million albums worldwide, chart 11 #1 singles and win seven Grammy Awards. The cousin of Dionne Warwick and the daughter of Cissy Houston (a former backup singer for Aretha Franklin), she signed with Arista Records in 1983 after company president Clive Davis heard her sing at New York's Sweetwaters supper club. At the time, Houston was somewhat of a work in progress, but under Davis' guidance, she progressed quickly, and as she neared completion of her debut album, hopes rose that it might sell 150,000 copies at best. However, buoyed by the success of three #1 singles ("Saving All My Love for You," "How Will I Know" and "Greatest Love of All") Whitney Houston went on to sell approximately 25 million copies worldwide after staying on the charts for an amazing 162 weeks, with 14 at #1. Her second album Whitney from 1987 did nearly as well with sales of 20 million, and her next three studio albums have each been certified multi-platinum as well. Houston's biggest selling album came in 1992 with The Bodyguard, the soundtrack album from the film of the same name, which she also starred in opposite Kevin

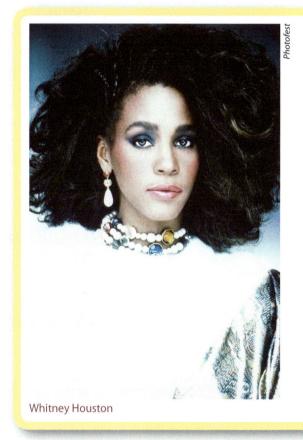

Costner. To date it has estimated sales of 40 million worldwide, and an RIAA certified 17 million in the U.S. Houston's singles output was as impressive as her album sales, with 11 #1's, 23 Top 10's and 30 Top 40 hits. Her accidental death at the Beverly Hilton Hotel on February 11, 2012 was a shock to the world, although she had been experiencing personal problems for a number of years.

MUSIC CUT 114

"I WILL ALWAYS LOVE YOU" (DOLLY PARTON) —WHITNEY HOUSTON

Personnel: Whitney Houston: vocals; Dean Parks, Michael Landau: guitars; David Foster: keyboards; Neil Stubenhaus: bass; Ricky Lawson: drums; Kirk Whalum: alto saxophone; Tony Smith, Claude Gaudette: synthesizer programming; Ronn Huff: string arrangement. Recorded Spring 1992; produced by David Foster. Released November 3, 1992 on Arista; 29 weeks on the charts, peaking at #1.

The story of one of the most successful pop hits of all time is an interesting one that spans nearly four decades. Many pop music fans who first heard "I Will Always Love You" were surprised to learn that the song was written and first recorded in 1973 by ... Dolly Parton! Parton's record went to #1 on the country charts, and then hit #1 again in 1982 when it was included in the movie The Best Little Whorehouse in Texas. As successful as Parton's record was, it was Whitney Houston version that became the definitive one. Recorded for the movie The Bodyguard soundtrack, the new R&B version went to #1 on the pop charts, where it stayed for 14 weeks, a record at the time. It also won Grammies for Record of the Year and Best Female Pop Vocal Performance. After Houston's death in 2012, the record once again returned to the charts, peaking at #3. Parton's song is truly one of the most popular hits of all time.

Other artists that achieved extraordinary success in the 1980s include singer/songwriter/pianist Billy Joel, who had 20 Top 40 hits in the decade including nine Top 10's and two #1's; former Genesis drummer Phil Collins, whose 1985 LP *No Jacket Required* (#1, seven million copies, two #1 singles) won the Album of the Year Grammy. Also among the tops in 1980s pop were Americans Huey Lewis and the News (12 Top 10 hits, including three #1's and three platinum selling albums); and future *American Idol* judge Paula Abdul (six #1 singles between 1988 and 1991 and the seven million selling *Forever Your Girl* from 1989).

EIGHTIES ALTERNATIVE

The Cultural Underground Railroad

As we have seen throughout this chapter, the music business was alive and well during the 1980s. The introduction of the compact disc, MTV and Michael Jackson's blockbuster LP Thriller all helped to bring the industry out of its postdisco doldrums; in addition, the number of multi-platinum albums from the decade is so large that it is hard to imagine by today's standards. But there was another side to rock music in the 1980s that was virtually invisible to the mainstream pop fan, and whose own fan base was so intensely devoted to the cause as to adopt a near religious fervor. Alternative rock (or simply alternative), as author Michael Azerrad describes in the definitive text Our Band Could Be Your Life, was music that spawned a "cultural underground railroad," a network of "fanzines, underground and college radio stations, local cable access shows, mom-and-pop record stores, independent distributors and record labels, tip sheets, nightclubs and alternative venues, booking agents, bands and fans" that flourished under the radar screen throughout the decade. Alternative was more than just music however; it was the ideology of DIY (do-it-yourself), of seeking your own path, of investigating what was out there rather than buying into what corporate powers that be were feeding you. It was about taking control.

If this sounds a bit like the cultural revolution of the 1960s, well it was, kinda. Obviously there was no war going on in the 1980s and the civil rights movement was over, but since Alternative Nation was the offspring of the peace/love/flower power generation, they obviously had grown up with its culture to some extent. Politically the 1980s were in many ways like the 1950s—conservative

ALTERNATIVE ROCK

Characteristics of Eighties Alternative

- Umbrella term encompassing a wide variety of stylistic approaches with a decidedly DIY (do-it-yourself) independent attitude
- 2. Influences from punk, psychedelia, folk and hard rock
- 3. Lyrics are often angst-ridden or reflecting punk attitudes

Key Eighties Alternative Recordings

- Murmur—R.E.M., 1983
- Let It Be—the Replacements, 1984
- Daydream Nation—Sonic Youth, 1988

and Republican—and that in itself was enough to organize many to go in an opposite direction. And like the 1950s, the key players in the alternative scene were the independent labels and renegade radio stations: just like corporate rock, alternative rock needed to be documented and distributed, heard and promoted to keep its ecosystem nourished. The Suns and Chess's of the 1980s were SST and Sub Pop; the Alan Freeds and Dewey Phillips' were university students working at campus stations in Athens, Georgia, Boston and Austin, Texas and other college towns.

Alternative rock is not so much a particular style as it is a spirit of independence from the major labels and mainstream styles. Alternative groups favored a garage band approach that incorporated influences from punk, psychedelic music, folk rock and hard rock.

Important Alternative Bands

When **R.E.M.** released their debut album *Murmur* in 1983, they instantly rose from obscurity to become "America's Hippest Band" and win Rolling Stone's awards for Band of the Year, Best New Artist and Album of the Year. Formed in Athens, Georgia by University of Georgia student Michael Stipe (vocals), record store manager Peter Buck (guitar), and Macon, Georgia natives and boyhood friends Mike Mills (bass) and Bill Berry (drums), the band played their first gig at a birthday party in 1980 as the Twisted Kites. Within a year they had changed their name, nurtured a jangly, Byrds-like sound, and made their first recording of an original song called "Radio Free Europe." The record quickly became a staple of college radio stations, and the band's exhaustive touring schedule in their rundown van helped develop a cult-like albeit underground following. When the president of I.R.S. Records heard them in New Orleans, he signed them to the label, and in 1983 they released Murmur, which included a re-recorded version of "Radio Free Europe." Murmur spent 30 weeks on the charts and led to tours warming up for the Police and an appearance on The David Letterman Show. Four more albums between 1984 and 1987, including the platinum Document allowed the band to sign a \$10 million, five-record deal with Warner in 1988. Between 1991 and 1994 R.E.M. released three multi-platinum albums (Out of Time, Automatic for the People and Monster) and had two Top 10 hits, "Losing My Religion" and "Shiny Happy People." The band has continued to tour and record, with their most recent LP release coming in 2008 with Accelerate. As the first 1980s alternative rock band to breakthrough to superstardom, they played a crucial role in the genre's development.

More than any other alternative band from the 1980s, **Sonic Youth** incorporated the energy of New York's downtown music scene, as manifested in the works of Philip Glass, Steve Reich and Glenn Branca, and in the process produced some of alternative's most innovative and textured music. The band's

- R.E.M.
- Sonic Youth
- Replacements
- Red Hot Chili Peppers

- The Cure
- The Violent Femmes
- The Pixies
- The Feelies

BANDS

"RADIO FREE EUROPE" (MICHAEL STIPE/PETER BUCK/MIKE MILLS/BILL BERRY)—R.E.M

Personnel: Michael Stipe: vocals; Peter Buck: guitar; Mike Mills: bass; Bill Berry: drums. Recorded January 6– February 23, 1983 at Reflection Studio, Charlotte, NC; produced by Mitch Easter and Don Dixon. Released July 1983 on I.R.S.; 5 weeks on the charts, peaking at #78.

"Radio Free Europe" was one of the first songs R.E.M. ever recorded, but the version that ended up on the 1983 album *Murmur* is actually its second recording. The first was made in tiny Drive-In Studios in Winston-Salem, North Carolina in 1981 and was released on the indie Hib-Tone label. Unhappy with the recording, the band rerecorded the song after signing with I.R.S. Records in 1982 and included it as the opening track on their debut album. With its jangly guitars from Peter Buck and muffled vocals from Michael Stipe, "Radio Free Europe" is exemplar of the R.E.M. sound that made them one of the most influential alternative bands of the 1980s.

beginnings date to 1981 when college dropout Thurston Moore (guitar, vocals) became friends with art student Lee Renaldo (guitar, vocals) and artist/bassist Kim Gordon (who married Moore in 1985). Although the three were in different bands, their common interest in the music of Glenn Branca's experimental guitar ensemble, which explored unique tunings and high volume to create sonically intense music, led them to join forces. Between 1981 and 1984 they went through several drummers before Steve Shelley joined in 1985 as the permanent drummer. By the time the band made their CBGB debut in 1982, they were combining the energy of punk with the experimental leanings of the Branca ensemble, which led them to using alternative guitar tunings that were sometimes achieved wedging screwdrivers or drumsticks between the strings and fret board. In the early 1980s they made several recordings with tiny indie labels and toured extensively while they further developed their innovative sound through trial and error. In 1986 they signed with the alternative label SST, and released EVOL (1986), Sister (1987), which along with **Daydream Nation** (1988, Enigma) became enormously influential alternative rock documents. By the late 1980s as their music became progressively more pop friendly, Sonic Youth had developed a larger audience and positive reviews, and in 1990 they signed with major label Geffen. Since then they have released ten albums and achieved a place of prominence among the alternative community. Says bassist Gordon: "We were influential in showing people that you can make any kind of music you want."

The Replacements formed in 1980 in Minneapolis and fronted by Paul Westerberg, were critically lauded but received little in the way of commercial success. In spite of a well-deserved reputation for drunk and disorderly conduct on stage ("Getting fucked up is what rock bands did, right?" said Westerberg), the band delivered one of alternative's defining albums with 1984's *Let It Be.* They broke up in 1991. The Red Hot Chili Peppers have managed to capture the essence of punk while incorporating funk influences from the likes of George Clinton and Sly and the Family Stone, and have won seven Grammies since their inception in 1983. Their self-named first album was released in 1984 to mixed reviews. In 1985 they released the Clinton produced *Freaky Styley*, which bassist Flea described in the liner notes as, "More than any other record we ever made it

falls into the category of `too funky for white radio, too punk rockin' for black'." With the release of 1989's *Mother's Milk*, the Peppers were receiving airplay on MTV for their videos of their cover of Stevie Wonders "Higher Ground" and "Knock Me Down," a tribute to former guitarist Slovak, who died from a heroin overdose in 1988. Their 1991 LP *Blood Sugar Sex Magik* is considered by many to be their best, and has been certified 7× platinum.

Other influential alternative bands from the 1980s include the Cure, the Violent Femmes, the Pixies, and the Feelies.

THE EDGIER SIDE OF THE EIGHTIES

1980s Metal

Metal continued to become more popular in the 1980s as a second generation of bands began to emerge to take the place of early stalwarts such as Led Zeppelin and Black Sabbath. Once again it was the Brits that led the way in this renewal, with what became known as the **New Wave of British Heavy Metal** (NWOBHM). According to Allmusic.com, "The NWOBHM kicked out all of the blues, sped up the tempo, and toughened up the sound, leaving just a mean, tough, fast, hard metallic core." Among the new metal bands that rode in with this wave were Iron Maiden, Motörhead, Def Leppard, and Grim Reaper. Even though these and other NWOBHM bands proved to be popular with metalheads, the most popular and enduring metal bands from the 1980s came from America, and in one case, Australia.

Metallica was formed in Los Angeles in 1981, when guitarist James Hetfield answered an ad posted in a local paper by drummer Lars Ulrich, who was looking for metal musicians to jam with. The band came together over the next couple of years, which also saw them move to the San Francisco Bay Area. After signing with Megaforce Records, they released their debut album Kill 'Em All in 1983, which went—like all future Metallica albums—multi-platinum. The band's best selling effort was 1991's Metallica, which ranks as the best selling album of the Soundscan Era (see chapter 13) with 16 million copies sold (US). It was also the first of five consecutive albums to debut at #1 on the Billboard charts, a feat that no other band has accomplished. Metallica gained some negative notoriety in 2000 when they filed suit against Napster for copyright infringement. The beginnings of Bon Jovi go back to 1982, when singer/songwriter Jon Bon Jovi (John Bongiovi, Jr.) began recording song demos at Power Station Studios in New York where he worked. In 1983, after one of the songs, "Runaway," started to get airplay by a few radio stations, Jon Bon Jovi began assembling a band, which eventually included Richie Sambora on guitar. The success of "Runaway," which hit #39 led to the band signing with Mercury in 1984. Bon Jovi released four albums and 16 singles in the 1980s, including 1986's 28 million selling album Slippery When Wet. Four of the singles hit #1. The band has remained popular, with total album sales in the 1990s and 2000s of nearly 100 million.

Guns N' Roses formed in 1985 in Los Angeles. Led by vocalist Axel Rose and guitarist Slash (Saul Hudson), the band was signed by Geffen in 1986 and released their debut album in 1987. That album, *Appetite for Destruction*, has to date worldwide sales of 35 million copies, the largest selling debut album of all

"WELCOME TO THE JUNGLE" (AXL ROSE/SLASH)—GUNS N' ROSES

Personnel: Axl Rose: lead vocal; Slash: lead guitar; Izzy Stradlin: rhythm guitar, vocals; Duff McKagan: bass, vocals; Steven Adler: drums. Recorded March and April 1987 at Rumba Studios, Canoga Park, CA; Take One Studio, Burbank, CA; and the Record Plant, Los Angeles, CA; produced by Mike Clink. Released October 3, 1987 on Geffen; 12 weeks on the charts, peaking at #7.

"Welcome to the Jungle" was one of seven singles released from the album, and one of two that made it to the top 40 (along with "Paradise City," which charted at #5). Appetite for Destruction, Guns N' Roses debut, hit #1 in 1988 and eventually became the best selling debut album of all time. The lyrics were written by lead singer Axl Rose to fit the main riff and music written primarily by guitarist Slash with some assistance from bassist Duff McKagan.

time. Except for 1993's The Spaghetti Incident (6 million), the next five albums all sold a minimum of 15 million copies. They also spawned three Top Ten hits, including "Welcome to the Jungle." Beginning in 1993, internal conflicts in the band led to a number of personnel changes and no new studio albums until 2008's Chinese Democracy, which, at a cost of \$13 million, is reportedly the most expensive rock album ever produced. Formed in Australia in 1973 by brothers Angus and Malcolm Young, AC/DC released a remarkable eight albums between 1975 and 1978, although because four of them were released in their home country only, they did not have much impact on the US market. That all changed in 1979 with the release of Highway to Hell, which hit #17 on the charts. However, their real breakthrough came with 1980's Back in Black, which with sales to date of 40 million copies worldwide is the fourth highest selling album of all time. The band began work on the album just two days after the death of singer Bon Scott as a form of therapy to get over the tragedy. Brian Johnson replaced Scott. To date, AC/DC has released 18 studio albums and 46 singles, and has sold more than 200 million albums worldwide.

Industrial

At the same time that alternative rock was becoming established, industrial emerged in the later 1970s as yet another way for post-punk musicians to express themselves. Its main tenet is the use of non-traditional sounds from synthesizers, avant-garde electronics and mechanical sources to infuse the sounds and ethos of modern industrial life into the music. Industrial is usually abrasive and aggressive, suggestive of a factory or heavy machinery. Many of the earliest industrial bands were European, such as England's Cabaret Voltaire and Throbbing Gristle, Germany's Einstürzende Neubauten (English translation: collapsing new buildings), and Belgium's Front 242. The leading American industrial band is **Nine Inch Nails**, the one-man band of writer/arranger/ producer/performer Trent Reznor. The band's origins go back to 1988, when Reznor recorded a demo at a local Cleveland studio where he worked as an engineer, playing all the instruments himself except the drums. (This recording/production method would become

Characteristics of Industrial

- 1. Abrasive and relentlessly mechanical; pounding jackhammer beat
- 2. Use of digital samples, avant-garde electronics, taped music and white noise
- 3. Use of industrial materials (power tools, etc) in performance
- 4. Lyrical themes of alienation, despair and dehumanization

Key Industrial Recordings

- Halber Mensch—Einstürzende Neubauten, 1985
- Mind Is a Terrible Thing to Taste—Ministry, 1989
- Pretty Hate Machine—Nine Inch Nails, 1989
- Last Rights—Skinny Puppy, 1991

the standard for nearly all future Nine Inch Nails recordings.) His first full-length album release, *Pretty Hate Machine*, came in 1989. NIN's breakthrough LP was 1994's *The Downward Spiral*, which Reznor produced while living in the home where the Manson Family murdered actress Sharon Tate. He has also written scores for film, including *Lara Croft: Tomb Raider* and Oliver Stone's *Natural Born Killers*. In all, NIN has released eight albums.

MUSIC CUT 117

"MR. SELF DESTRUCT" (TRENT REZNOR)—NINE INCH NAILS

Personnel: Trent Reznor: vocals, guitar, bass, keyboards, programming; Adrian Belew: guitar; Flood: co-production. Recorded 1993 at Le Pig, Los Angeles, CA; produced by Trent Reznor and Flood. Released March 8, 1994 on the album *The Downward Spiral* on Nothing/Interscope; not released as a single.

Nine Inch Nails has always been more or less Trent Reznor's project band, so he chooses his collaborators carefully. For *The Downward Spiral*, Reznor invited King Crimson's Adrian Belew to the studio to add some guitar parts. Reznor's modus operandi was to give Belew creative freedom, as he later recalled to *Guitar Player*. "Adrian showed up and said, 'Hi, what do you want me to do?' We said we didn't know, so he scratched his head and asked what key it was in. We looked at each other and said, 'Probably E. Here's the tape, do whatever you want. Go!" Reznor was blown away with the results: "Adrian is the most awesome musician in the world. I've never seen anybody play guitar like that." "Mr. Self Destruct" was recorded at Le Pig Studio, located in the house where the Manson family murdered actress Sharon Tate in 1969. Reznor: "I won't lie, the first night there was pretty fucking creepy."

OTHER EIGHTIES GOINGS ON

The 1980s started off with one of the saddest events in the history of pop music: the murder of John Lennon outside his New York City apartment on December 8, 1980. Lennon had more or less retired from music in 1976 but had returned to recording new material with his wife Yoko Ono in the summer of 1980. The resulting album, *Double Fantasy* had entered the charts on December 6; its single release "(Just Like) Starting Over" had entered in early November at #38.

INDUSTRIAL

As he and Yoko walked home from a late night recording session, Lennon was gunned down by deranged fan Mark David Chapman. In the wake of his death, a worldwide ten-minute silent vigil was held on December 14 at 2:00 PM EST; on December 27, both *Double Fantasy* and "(Just Like) Starting Over" hit #1 (where they stayed for eight and five weeks, respectively). For many, Lennon's death, along with the fallout from disco and punk, represented an ending of sorts to a confusing time, while leaving a great amount of uncertainty about the future of rock music.

MUSIC CUT 118

"(JUST LIKE) STARTING OVER" (JOHN LENNON)— JOHN LENNON

Personnel: John Lennon: vocals, rhythm guitar; Earl Slick, Hugh McCracken: lead guitars; George Small: keyboards; Tony Levin: bass; Andy Newmark: drums; Arthur Jenkins: percussion; Michelle Simpson, Cassandra Wooten, Cheryl Manson Jacks, Eric Troyer: backup vocals. Recorded at the Hit Factory, New York City, August 7-September 22, 1980; produced by John Lennon, Yoko Ono, Jack Douglas. Released October 24, 1980 on Geffen; 22 weeks on the charts, peaking at #1 for five weeks.

When John Lennon decided to begin work on the album that eventually materialized as *Double Fantasy*, he had been pretty inactive for the past five years. The 1970s had been a tumultuous time for Lennon and his wife Yoko Ono; they had even separated for a while. But by 1980, his life and his marriage seemed to be back on track. "It was kinda obvious what 'Starting Over' was about," said journalist David Sheff, who did the last major interview with Lennon, to *Mojo*. "He'd been untrusting of Yoko, she'd been untrusting of him, all that kind of stuff. But in that one song was this incredible optimism and joy." After its October 24 release, "(Just Like) Starting Over" began slowly climbing up the charts, and was sitting at the #6 spot when Lennon was killed on December 8. Ultimately both the album and the single reached #1, and *Double Fantasy* won the Album of the Year Grammy in 1982.

As America experienced a period of political conservatism marked by the presidency of Ronald Reagan (1981–1989), the watchdog group known as the Parents Music Resource Center (PMRC) was born in May 1985 to "to educate and inform parents of this alarming new trend . . . towards lyrics that are sexually explicit." The group also claimed that rock music glorified violence, drug use, suicide, and criminal activity. Formed by a group of "Washington Wives" that included Susan Baker (wife of Secretary of the Treasury James Baker), Tipper Gore (at the time, the wife of then Senator Al Gore of Tennessee), Peatsy Hollings (wife of Senator Ernest Hollings of South Carolina), the PMRC immediately garnered considerable influence in the nation's capital and the backing of many religious and conservative political groups. On September 19, only four months after the PMRC's founding, the Senate Commerce, Technology and Transportation Committee began hearings to investigate the pornographic content of rock music.

The PMRC advocated the use of warning labels to inform parents as to the graphic nature of the lyrics contained in a record that were similar to the movie rating system: X for sexually explicit material, O for occult, V for violence, and so on. Among those who testified against the idea were Frank Zappa, Dee Snider of

Twisted Sister and country singer John Denver. Zappa was particularly articulate in his opening remarks, calling the warning labels, "an ill-conceived piece of nonsense which fails to deliver any real benefits to children, infringes the civil liberties of people who are not children, and promises to keep the courts busy for years." In spite of his testimony, the mere threat of government intervention prompted the RIAA (Recording Industry Association of America) to ask its members on November 1, 1985 to either affix a warning label or actually print the lyrics on the sleeve of the objectionable records. Over the next three years, 49 new albums (out of 7500 released by RIAA members) displayed a warning label. The PMRC has remained in existence, although it has lost considerable clout in recent years. But the warning labels still exist.

There was also a flurry of charity events staged during the decade, ranging from "We Are the World," Live Aid, Sun City and tours supporting Amnesty International. Modeled after the successful single "Do They Know It's Christmas" to assist famine relief in Ethiopia by the British group Band Aid, "We Are the World" was written by Michael Jackson and Lionel Ritchie to benefit the relief agency U.S.A. for Africa. A group of 45 artists were assembled at A&M Studios in Hollywood on the night of January 28, 1985 under the supervision of producer Quincy Jones, who insisted that they "check their egos at the door." The song hit #1 three weeks after its release and went multi-platinum. Some of the singers who participated in the recording included Michael Jackson, Lionel Ritchie, Stevie Wonder, Paul Simon, Bruce Springsteen, Tina Turner, Dionne Warwick, Bob Dylan, Diana Ross, Cyndi Lauper, Ray Charles, Willie Nelson, Billy Joel, Smokey Robinson, and Harry Belafonte.

Live Aid, the simultaneous concerts held at London's Wembley Stadium and Philadelphia's JFK Stadium on July 13, 1985 was the largest staged event in history. Conceived by promoter Bob Geldorf (the brainchild behind Band Aid) to again assist famine relief in Ethiopia, the concerts lasted 14 hours and featured a host of stars, including Paul McCartney, Eric Clapton, Elton John and Mick Jagger, and were broadcast by 14 satellites to 160 countries. Phil Collins performed twice—first in London, then in Philadelphia after hopping a Concorde for the trans-Atlantic flight. Ultimately the effort raised over \$100 million. Live Aid spawned a number of music benefit telethons, including the Farm Aid concerts spear-headed by Willie Nelson to benefit and draw attention to American farmers caught up in difficult economic times. The first Farm Aid concert was held in Champaign, Illinois on September 22, 1985 and featured Bob Dylan, Billy Joel, B.B. King, Loretta Lynn, Roy Orbison, Tom Petty and others. Subsequent concerts have been held yearly at stadiums around the country.

Name	Date
1.	Name four significant changes in technology in the music business in the 1980s.
2.	Describe the programming on MTV in its early years and some of the controversies surrounding it.
3.	Describe some reasons why <i>Thriller</i> became the best selling album of all time.
4.	Name four instances in which Madonna pushed herself into a position of controversy.
5.	Name four ways in which Prince has carved out a unique and successful career.

- **6.** Describe the influences on Bruce Springsteen's songwriting and E Street Band.
- **7.** Name one unique characteristic of three of the members of U2 and how it has possibly affected Bono's non-musical contributions to the world.
 - 8. Describe the sound and culture of 1980s alternative music.
 - 9. What was the PMRC and what was its effect on rock?
- 10. Name two important music related news events from the 1980s.

AND BEYON

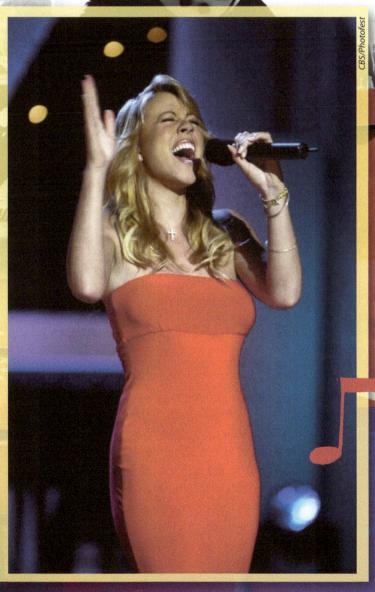

"I think one of the reasons I pushed myself so hard and worked so hard is because I never felt special. Like, the one thing that made me feel special was my music."

—Mariah Carey

KEY TERMS

Grunge Soundscan Boy bands Napster Mp3 iTunes Music Store Music streaming

KEY FIGURES Nirvana/Kurt Cobain
Pearl Jam
Phish
Radiohead
Dave Matthews Band
Beck
Weezer
New Kids on the Block
Boyz II Men
Backstreet Boys
'NSync
TLC
Mariah Carey

Britney Spears
Eminem
Jay-Z
Kanye West
Beyoncé
Justin Timberlake
Miley Cyrus
Nickelback
Coldplay
Maroon 5
Lady Gaga
Adele
Garth Brooks

Shania Twain
Dixie Chicks
Taylor Swift
Lady Antebellum
Wilco
Bright Eyes
Death Cab for Cutie
The White Stripes
Creed
Linkin Park
The Foo Fighters
Shawn Fanning

KEY ALBUMS Nevermind—Nirvana
Ten—Pearl Jam
OK Computer—Radiohead
Pinkerton—Weezer
Daydream—Mariah Carey
... Baby One More Time—
Britney Spears
The Marshall Mathers
LP—Eminem

Reasonable Doubt—Jay-Z
The College Dropout—
Kanye West
I Am...Sasha
Fierce—Beyoncé
Born This Way—Lady Gaga
21—Adele
Come On Over—Shania
Twain

Wide Open Spaces—the
Dixie Chicks
Icky Thump—the White
Stripes
Human Clay—Creed
Hybrid Theory—Linkin
Park

THE 1990S: THE TRIUMPH OF ALTERNATIVE NATION

Nirvana

On January 11, 1992, Michael Jackson's multi-platinum album *Dangerous* was knocked out of the #1 spot on the *Billboard* charts by an album released by a relatively unknown band from Seattle. There seemed to be some sort of cosmic significance to the moment: the King of Pop, his sequined glove and highly produced post-disco dance music was dethroned by a group wearing torn jeans and T-shirts who were uncomfortable with stardom, and played music that eschewed glitz and glamour and embraced the do-it-yourself attitude of post punk alternative rock. Although Nirvana's *Nevermind* would end up spending only two weeks at #1, it effectively sent a clear message to the music industry: the 1980s were over. As discussed in chapter 12, Alternative Nation was alive and growing in the 1980s, it just wasn't very visible to the major labels. With the success of *Nevermind*, the gulf between "what people said was hip to listen to" and "the

kind of stuff which we all really listened to" had finally been bridged, according to Nirvana guitarist Kurt Cobain. In many ways it was the perfect album to come along at the perfect time to wipe the slate clean once and for all of the dominance of Michael, Madonna and Prince and let Alternative Nation finally emerge.

Nirvana's beginnings go back to 1987 and the tiny town of Aberdeen, Washington, 100 miles southwest of Seattle, where guitarist/vocalist/songwriter Kurt Cobain (1967-1994) grew up. Cobain's early years could easily be described as miserable. At age eight, his parents divorced, forcing him to move back and forth from one set of relatives to another. Growing older, he grew increasingly sullen, resentful and withdrawn. As an artistic youth who did not fit in with most people in the redneck logging town, Cobain was often beat up by other kids just because he was 'different', including once for befriending an openly gay fellow student. But he found solace in music: first the Beatles, then metal, and finally punk. In 1987, around the time he turned twenty, Cobain and fellow Aberdonian Krist Novoselic (bass) formed what would eventually become Nirvana, moving to nearby Olympia to work the Olympia-Tacoma-Seattle bar circuit. While working its way through a series of drummers, the band signed with local independent label Sub Pop and in spring 1989 recorded its debut LP Bleach at a cost of \$606.17. Containing 12 Cobain original songs, Bleach received favorable reviews from the underground rock press, and sold an impressive 35,000 copies. Along with a number of other Seattle bands that included Mudhoney and Soundgarden, Nirvana was defining a style that journalists were beginning to identify with the city's music scene and call grunge. Shortly after recording Bleach, Nirvana finalized their lineup with the addition of drummer Dave Grohl.

During the summer of 1989, Nirvana recorded several song demos with producer ButchVig, with the intention of shopping them around to major labels. After eventually signing with Geffen imprint DGC for \$287,000, they recorded *Nevermind* in the summer of 1991 and released it in September. Propelled by Cobain's brilliant, generational songwriting and the powerful, dynamic playing of Grohl and Novoselic, *Nevermind* quickly sold out its initial printing of 50,000 copies and hit the charts in early November, where it stayed for the next 50 weeks. Propelling the album was the Gen X anthem "Smells Like Teen Spirit," which peaked on the charts at #6 on its way to a platinum certification. In the heady months that followed the album's release, the band toured heavily, released three more singles, and appeared on *Saturday Night Live*, giving the program its highest ratings in months.

In February 1992, Cobain married singer Courtney Love, with whom he fathered a daughter. The relationship was turbulent, and with persistent rumors of heavy drug usage, became the focus of a relentless paparazzi harassment that put the couple in constant media spotlight. Cobain had at this point become the de facto spokesman for Alternative Nation, a role he loathed and was ill prepared to assume, and this pressure no doubt contributed to his early death. In the last year of his life, there were no less than five incidents that were either suicide attempts or could be perceived as such, including three drug overdoses. The last of these occurred on March 4, 1994 while the band was on tour in Europe; after a short hospitalization, Cobain returned to the US and checked into the Exodus

journalists were beginning to identify with Seattle's music scene and call grunge.
Kurt Cobain has become one of the most commercially successful

songwriters in pop music history.

"SMELLS LIKE TEEN SPIRIT" (KURT COBAIN/DAVID GROHL/KRIST NOVOSELIC)—NIRVANA

Personnel: Kurt Cobain: vocals, guitar; David Grohl: drums, vocals; Krist Novoselic: bass, vocals. Recorded May 1991 at Sound City Studio, Van Nuys, CA; produced by Butch Vig. Released September 10 1991 on DGC; 20 weeks on the charts, peaking at #6.

The opening track and biggest hit from Nirvana's monster LP *Nevermind*. Kurt Cobain wrote the basic four-chord riff, but the song didn't come together until the group jammed on it for nearly an hour, tinkering with dynamics and the arrangement. Cobain's main influence was the Boston-based alternative band the Pixies, who often used stop-start dynamics in their songs. "This really sounds like the Pixies," bassist Krist Novoselic commented after hearing the playback in the studio. "People are really going to nail us for it." "I was trying to write the ultimate pop song," Cobain later told *Rolling Stone*. "I was basically trying to rip off the Pixies. I have to admit it. When I heard the Pixies for the first time, I connected with that band so heavily that I should have been in that band—or at least a Pixies cover band. We used their sense of dynamics, being soft and quiet and then loud and hard." Much has also been made of the song's lyrics, which are indecipherable enough as to cause rock journalist Dave Marsh to call it "the 'Louie Louie' of the 1990s." What is plainly heard is the repeating plaintive cry, "Here we are now/Entertain us," which are widely interpreted to be a call for Generation X revolution, a "My Generation" for the 1990s. It certainly became an anthem for many X-ers, as it very quickly sold a million copies and helped propel Nirvana to superstardom.

Recovery Clinic in Los Angeles. On April 1, after telling security he was going out for some cigarettes, Cobain escaped from the clinic and disappeared. After several days of frantic searching by family and police, his body was discovered on April 8 in a small room above the garage of his Seattle home. The cause of death was a self-inflicted gunshot wound to the head, estimated to have occurred on April 5. Although a suicide note was found, speculation that he was murdered has persisted to this day. As the primary composer for a group that has now sold more than 50 million records worldwide, Kurt Cobain became one of the most commercially successful songwriters in pop music history. His death was mourned by millions of fans, and he was eulogized by numerous tributes on radio and MTV in the weeks and months that followed.

Grunge and the Seattle Scene

In spite of Cobain's personal traumas, Nirvana had managed to finish their fourth album, *In Utero* in the summer of 1993, and posthumously released *MTV Unplugged in New York*, recorded from the TV special taped the previous year. Both LPs hit #1 and went multi-platinum, and *Unplugged* won the 1995 Alternative Music Grammy Award. By this time Nirvana had succeeded in almost single-handedly returning the rock mainstream to a punk esthetic with an updated style that became known as **grunge**. Grunge eschewed the virtuosic artistry and pretentiousness of metal; songs were often slow and plodding, and usually contain very little in the way of chord progressions. Choruses often are set apart from verses simply by start-stop dynamic contrasts. The style had evolved in the mid to late 1980s in Seattle's thriving underground rock scene, with support from local radio stations, a prospering underground rock press

KEY TERM

Grunge A
style associated
with Seattle in the 1990s that
incorporates elements of punk and
heavy metal; also associated with a
fashion statement of flannel shirts
and ripped jeans, etc.

Characteristics of Grunge

- 1. Punk influences, both in music and in attitude
- 2. Slow, plodding tempos
- 3. Simple chord progressions
- 4. Avoidance of virtuosity, pretension or posturing
- 5. Start-stop dynamics
- 6. Lyrics are often of dark and murky themes, sung in a plaintive, lamenting manner
- 7. Accompanying fashion included plaid flannel shirts, ripped jeans, stocking caps and mountain boots.

Key Grunge Recordings

- Nevermind—Nirvana, 1991
- Ten—Pearl Jam, 1991

and the indie label Sub Pop. Other Seattle bands signed to Sub Pop included Soundgarden, Mud Honey, Screaming Trees and Alice in Chains. **Pearl Jam**, another Seattle band formed in 1990, was able to benefit from the growing interest in the city's music scene and sign with major label Epic. Their debut LP **Ten** was certified 13× platinum and stayed on the charts for 100 weeks.

Other Nineties Alternative Rock

The success of the Seattle bands gave a huge boost to the already existing alternative rock scene that had flown mostly under the radar during the 1980s. Among the more creative and inspired alternative artists from the 1990s are Phish, Radiohead, the Dave Matthews Band, and Beck. Phish could be described as a Grateful Dead redux, with it's eclectic mix of bluegrass, country, folk, and rock and roll, all tied together with a whimsical sensibility and improvisational spirit. The group formed in late 1983 while its four members, guitarists Trey Anastasio and Jeff Holdsworth, bassist Mike Gordon and drummer Jon Fishman, were students at the University of Vermont. Early on, keyboardist Page McConnell joined the band and Holdsworth left, giving the group its permanent lineup. Over the next several years, Phish toured extensively, and cultivated a devoted fan base by interacting with them during performances and becoming one of the first rock bands to create an Internet Usenet newsgroup in 1991. In the late 1980s the group released three self-produced albums, including The Man Who Stepped Into Yesterday, which was based on Anastasio's senior thesis. In 1991 they signed with Elektra Records, and have since been one of the most prolific recording bands ever, releasing 14 studio albums, seven conventional live albums, and CDs of twenty-seven live concerts; they have also released six videos on DVD. The group also has a website, livephish.com that allows fans to download many of their recent concerts in mp3 or FLAC format. However, like the Grateful Dead, Phish has always put their primary focus on their live shows, and have developed a fan-based community similar to the Dead's 'Deadheads' that often follow the band faithfully from one show to the next.

The Girls Respond

Boys weren't the only ones getting in on the teen pop gravy train. TLC, the female counterpart to Boyz II Men broke big in 1994 with CrazySexyCool achieving diamond status, the first album by a female group to do so. They also racked up four #1 singles between 1994 and 1999. But TLC was just a warm up for Mariah Carey (1969-), whose amazing career has so far generated 18 #1 singles, 14 platinum or multi-platinum albums (including two that are diamond certified), five Grammy Awards and an estimated 200 million albums sold. Carey was an unknown 18-year-old in 1988 when her demo tape fell into the hands of Columbia Records president Tommy Mottola at a party. Mottola, who had a hunch that Carey was destined for greatness, immediately signed her. Over the next couple of years, Mottola spent \$800,00 producing Carey's self-titled debut album, \$500,000 on her first video, and another \$1 in promotion. The two also became romantically involved and married in 1993 (and subsequently divorced in 1997). Carey's first five single releases went to #1, the first artist ever to accomplish the feat. Her two biggest selling albums, 1993's Music Box and 1995's Daydream, both peaked at #1 and achieved diamond status. Carey left Columbia in 2001 and signed with Virgin, but was dropped from the label after an emotional breakdown. She has since signed with Island and had another multi-platinum album in 2005 with The Emancipation of Mimi.

Carey's emotional problems pale in comparison to those of **Britney Spears** (1981–), who has very publicly gone from "schoolgirl to snake-wielding burlesque dancer to Kevin Federline's wife to head-shaving mom to MTV awards show bust to suicide risk," as author Steve Knopper humorously notes. She signed with Jive Records in 1997 as a 15-year-old former Mouseketeer on Disney's *The New Mickey Mouse Club*. Her first album, 1999's ... **Baby One More Time** debuted at #1 and yielded the smash #1 hit of the same name. Her next three albums also debuted at #1, making her the first female artist to accomplish the feat. Spears has also included Madonna-influenced tightly choreographed dance

"ONE SWEET DAY" (MARIAH CAREY/WALTER AFANASIEFF/WANYA MORRIS/NATHAN MORRIS/SHAWN STOCKMAN/MICHAEL MCCARY)—MARIAH CAREY, BOYZ II MEN

Personnel: Mariah Carey: vocals; Boyz II Men: vocals; Walter Afanasieff: synthesizers, programming; Tristan Avakian: guitar; Babyface: keyboards; Terry Burrus: piano; Loris Holland: organ; David Morales: bass; Dan Shea, Gary Cirimelli, Satoshi Tomiie: keyboards, programming. Recorded 1994–1995; produced by Mariah Carey, Walter Afanasieff. Released November 14, 1995 on Columbia; 46 weeks on the charts, peaking at #1.

"One Sweet Day" debuted on the charts at #1 on November 26, 1995, where it stayed for 16 continuous weeks (which means it was #1 throughout the months of December, January, February and half of March!). That makes it the longest running #1 hit in *Billboard* history, and just one of Mariah Carey's incredible 18 #1 hits. The song was a collaboration between Carey and Boyz II Men, who were independently working on songs celebrating friends who had recently died. The song is included on Carey's diamond certified album *Daydream*.

routines into her shows that include fist jabbing, pounding feet and provocative hip movements. Although her personal life went through some turbulent times in the early 2000s, she became a pop icon that as *Rolling Stone* declared "cultivated a mixture of innocence and experience that broke the bank."

ROCK IN THE NEW MILLENNIUM

One good sign of the health of pop/rock music in the 2000s is that it has become so fragmented and diverse that today it is nearly impossible to even come up with classifications to describe the music. As Bruce Springsteen said in his 2012 South by Southwest Keynote address, "Pop has become . . . a series of new languages, cultural forces, and social movements. There are so many subgenres and factions: two-tone, acid rock, alternative dance, alternative metal, alternative rock, art punk, avant-garde metal, black metal," he said continuing on with several dozen more styles before concluding with "...garage rock, blues rock, death and roll, lo fi, jangle pop . . . folk music!" He then wrapped up by saying, "Just add neo- and post- to everything I said and mention them all again." While Springsteen got a couple of good laughs from the crowd, he spoke the truth. And never before has it been easier to make music, either on your own or collaboratively, and make it available to anyone, anywhere at any time. That is not to say everything is hunky dory, because the 2000s have been a time of turbulence for the music business. We will address some of the troubling issues facing the industry later in this chapter.

With so many styles, and by extension, artists out there, it becomes prohibitive to try to cover everything in a history text such as this. Instead, we will take a look at some of the performers representing five of the most important contemporary categories: Rap/Soul/Hip Hop, Pop/Rock, Country, Indie/Alternative, and Contemporary Hard Rock/Metal

Rap/Soul/Hip-Hop

When rap first emerged in the late 1970s, many observers believed that it would be a short-lived fad. Instead, rap, and its broader classification of hip-hop, has grown into a dominant force in popular music and culture today. In addition to continuing the tradition of bringing other styles into the rap fold (the first of which being the 1986 Run-D.M.C./Aerosmith rap/metal mashup "Walk This Way"), hip hop artists today are experimenting with innovative production techniques, alternative rapping styles, and new marketing strategies. Some, most notably Jay-Z and Kanye West, have used their fame to build impressive business empires. Gangsta rap continues to be popular, albeit less controversial, and today coexists with more commercially oriented styles. And hip-hop has also branched out from the New York—L.A. domination of the 1990s to develop other new regional styles, including Southern and Midwestern rap.

At the turn of the millennium, raps newest lightening rod for controversy was white rapper **Eminem** (Marshall Mathers III) (1972–). With lyrics that include graphic depictions of violence and bizarre sexual exploits, misogyny and homophobia, Eminem has drawn some of the harshest criticism of any artist in

"STAN" (MARSHALL MATHERS, DIDO ARMSTRONG, PAUL HERMAN)—EMINEM

Personnel: Eminem: vocals; Dido: vocals; John Bigham: guitar; Mike Elizondo: bass. Recorded 1999–2000 at The Record Plant; produced by Eminem and The 45 King. Released May 23, 2000 on Aftermath/Interscope; 15 weeks on the charts, peaking at #51.

"Stan," from Eminem's *The Marshall Mathers LP*, is the scary tale of an obsessed fan that writes a series of letters to Eminem that get increasingly frustrated, angry, and finally rage-filled over the star's lack of response. By the third verse, Stan is speeding down the freeway, speaking into a tape recorder while "on a thousand downers" with his pregnant girlfriend screaming and locked in the trunk. In the final verse, Eminem finally responds, only to realize that it is too late. "He's crazy for real, and he thinks I'm crazy, but I try to help him at the end of the song," said Eminem about the fictional Stan. "It kinda shows the real side of me." "Stan" also cleverly mixes in a hook from Dido's song "Thank You," which is heard at the beginning of the song and between each verse.

recent history. Mathers endured an impoverished and troubled childhood, took up rapping at age 14, and by his early 20s first developed his alter ego Slim Shady, through whom he began to comment on his own troubled personal life. After catching the attention of producer Dr. Dre, the two began collaborating in the studio, leading to Eminem's major label debut *The Slim Shady LP*, released in 1999. The album, fueled by the success of the hit single "My Name Is," was a breakthrough effort that turned the rapper into an international star, with worldwide sales of 15 million and praise from the critics. In 2000 he released his next album, *The Marshall Mathers LP*, which became the fastest selling rap album in history, selling nearly two million copies in its first week alone and eventually selling 27 million worldwide. 2002's *The Eminem Show* did nearly as well, selling 25 million copies worldwide. Although Eminem's creative output waned mid-decade, he came back in 2009 and 2010 with two albums that have sold a combined 16 million so far. He has also announced plans to release his eighth album later in 2013.

While Eminem has focused on controversy to stay relevant, **Jay-Z** has parlayed his musical successes into a business empire that is today estimated to be worth \$500 million. Shawn Carter (1969–) grew up poor and fatherless in the projects of Brooklyn, but began working his way up the musical food chain with cameo appearances on recordings and shows produced by local rappers, including his mentor, Jaz-O. When Jay-Z (a stage name adopted in part as homage to Jaz-O) began producing his own recordings, he was unable to land a deal with a major label, so in 1995 he created his own, Roc-A-Fella Records. His debut album **Reasonable Doubt** was released in 1996, and is today considered a rap landmark, helping to create the genre known as Mafioso Rap, characterized by imagery of rappers with lavish lifestyles and expensive tastes. A 1997 distribution deal with Def Jam (where he later became CEO) helped turn Jay-Z into a superstar: his next 13 albums charted no lower than #3, with 11 of them hitting the top spot—the record for most by a solo artist.

His latest release, *Magna Carta . . . Holy Grail* was released on July 4, 2013. Jay-Z has to date sold approximately 50 million albums and won 17 Grammy Awards. Jay-Z's business interests include Roc-A-Fella Records, the entertainment agency Roc Nation, and the full-service sports management company Roc Nation Sports. He also co-owns the sports bar chain 40/40 Club, is co-founder of the clothing designer Rocawear, and has a minority interest in the NBA's Brooklyn Nets. In 2008 he married Beyoncé Knowles, and together they have a daughter, Blue Ivy Carter.

Kanye West (1977-) was born in Atlanta but spent most of his youth in Chicago. He began rapping in the third grade, and by his early teens was selling original songs to local rappers. He eventually formed a close friendship with producer DJ No I.D., who became his mentor. Although West aspired to become a rapper, his first success came as a producer for a number of Chicago area rap artists. In 2000 he began working for Roc-A-Fella Records, and first gained wide recognition for his production work on Jay-Z's 2001 album The Blueprint. His first taste of fame as a performer came in 2003 when he appeared along with Jamie Foxx on rapper Twista's single "Slow Jamz," which hit #1. West had by this time signed an artist contract with Roc-A-Fella, and released his debut album on the label, The College Dropout in early 2004. TCD was an instant success, debuting at #2 on the charts, yielding five charting singles, and winning the 2005 Grammy for Best Rap Album. The album also featured Kanye's patented "chipmunk soul" technique of using sped-up vocal loops (as in the track "Through the Wire"). West has since released six more albums (including 2013's Yeesus), and while sales figures do not compare to Eminem or Jay-Z, all have gone platinum. He has also released an astonishing 93 singles and 87 music videos. His business ventures include his own record label GOOD Music, and the women's fashion label DK Kanye West. West is in a relationship with the celebrity Kim Kardashian, with whom he has a daughter.

Beyoncé Knowles (1981–) has largely eschewed rap to focus her career on a more traditional R&B style, and has in the process become one of the most successful recording artists of all time. Her first successes came as a member of Destiny's Child, a group originally called Girl's Tyme that she put together in 1990 when she was 9 years old. Changing their name to Destiny's Child in 1993, the group, comprised of Beyoncé, Kelly Rowland, and Michelle Williams, released four studio albums and 23 singles (four hitting #1) and sold approximately 60 million records before breaking up in 2005. Beyoncé released her debut album Dangerously in Love in 2003, which went on to sell 11 million copies worldwide. Her third album IAm . . . Sasha Fierce introduced her alter ego Sasha Fierce and won five Grammy Awards. In all, Beyoncé has released four studio albums (all hitting #1), four live albums, and 38 singles (five #1s), with total record sales exceeding 100 million copies. Her stage performances feature highly choreographed dance moves that have drawn much critical praise. She has also released 38 music videos, and starred in seven Hollywood films, including playing the role of Etta James in 2008's Cadillac Records. 2008 was also the year that she married rap mogul Jay-Z.

"SINGLE LADIES (PUT A RING ON IT" (CHRISTOPHER "TRICKY" STEWART/TERIUS "THE DREAM" NASH/THADDIS HERREL/BEYONCÉ KNOWLES)—BEYONCÉ

Personnel: Beyoncé: vocals, vocal production; Jim Caruana: backup vocals; Jim Caruana, Tricky Stewart, The Dream, Kuk Harrell, Brian "B Luv" Thomas, Dave Pensado, Andrew Wuepper, Randy Urbanski, Jaycen Joshua: production, engineering, mixing. Recorded April 2008 at The Boom Boom Room, Burbank, CA; produced by Christopher "Tricky" Stewart, Terius "The Dream" Nash, Beyoncé. Released October 13, 2008 on Columbia; 27 weeks on the charts, peaking at #1.

Looking into the recording of "Single Ladies (Put a Ring on It)" and its host album $IAm \ldots Sasha$ Fierce gives one the opportunity to get a glimpse of contemporary pop music production. The album was worked on at 13 studios and the liner notes list no less than 72 people involved in one or another aspect of production (Lady Gaga is listed as one of the assistant engineers!). There is only one singer listed beyond Beyoncé—and no musicians. There are four co-writers for "Single Ladies (Put a Ring on It)," and that is pretty typical for the rest of the songs on the album. Considering the sales figures and awards won for both the album and the single, it seems as if Ms. Knowles and team have come up with a winning strategy. Which is: collaborate, collaborate, collaborate.

Pop/Rock

For the purposes of this book, we will define pop/rock as the most mainstream form of popular music, making it by definition the most commercially successful as well. Pop music in the 2000s embraces everything from oldies acts such as the Eagles and Rolling Stones to new sensations including Katy Perry, Bruno Mars, Ke\$ha, Rihanna, Will.i.am, and Robin Thicke. Oh yeah, in-betweeners like Michael Jackson and Mariah Carey continue to sell lots of records as well.

In the last several years, Taylor Swift (1989-) has successfully made the transition from teen country sensation to the biggest pop star on earth. Raised in Pennsylvania, she made her first trip to Nashville at age 11 when her mother drove her there to drop off some of Taylor's demo tapes; three years later the entire family packed up and moved to the city. In 2005 Taylor, now 16, signed with Big Machine Records and released her eponymous debut album the following year. It sold 5 million copies. From that lofty beginning Swift's career has literally exploded. Her 2007 single "Our Song" made Swift at age 18 the youngest person to solely write and sing a #1 country record. Her second album, 2008's Fearless became the most decorated album in country music history by winning Album of the Year at the Grammy Awards, American Music Awards, Country Music Association, and Academy of Country Music. Swift's next three albums all debuted at #1 on the Billboard charts, a reflection of her by now immense popularity. Although Speak Now (2010) and Red (2012) were both considered as country pop albums, 1989 (2014) marked her move into mainstream pop. On it she collaborated with pop super producers Max Martin and Shellback, who utilized a heavy dose of synthesizers, sampled drums, and vocal processing. The album sold nearly 1.3 million copies in its first week, an amazing accomplishment in this era of declining CD sales. Three single releases from the album have all hit #1.

2017 will see the release of Swift's sixth studio album, *Reputation*. Although the album is not due to be released until November 10, on August 25 Swift released a single from the album, "Look What You Made Me Do." The single gives us some numbers with which to gauge Swift's popularity: the most Spotify streams ever in a 24-hour period by any artist; the fastest record by a female artist to reach the #1 slot on US iTunes; the largest sales lead ever (95%) on iTunes versus the #2 record; the largest sales and streaming figures of 2017 on *Billboard*, sending it to #1 on the Hot 100; and, its video was viewed 43.2 million times in a 24-hour period on YouTube, the most in history. In addition to her albums, which have sold more than 40 million copies, Swift has released more than 40 singles that have sold more than 130 million copies. Her awards so far are many: 10 Grammies, 19 American Music Awards, 21 *Billboard* Music Awards, 11 Country Music Association Awards, and eight Academy of Country Music Awards.

After starting his solo career in 2002, former 'N Sync member **Justin Timberlake** (1981–) has released three platinum certified albums and 32 singles, all while nurturing a successful acting career. Timberlake was also involved in one of the most famous (infamous/bizarre?) recent music-related incidents when he tore off part of Janet Jackson's costume at the end of their performance at the halftime of the 2004 Super Bowl. The "wardrobe malfunction" (as Timberlake called it) was seen live by more than 140 million TV viewers worldwide. In the wake of the controversy that ensued, Timberlake issued an apology. **Miley Cyrus** (1992–) has had a remarkable career turnaround after starting off as the star of the Disney Channel's successful *Hanna Montana* children's TV series. As a 13-year-old Disney star with a good deal of acting and singing talent, Cyrus quickly became a teen idol sensation. To most observers, Miley Cyrus was Hanna Montana during the show's four-year run (2006–2009), as she maintained a

"LOOK WHAT YOU MADE ME DO" (TAYLOR SWIFT/JACK ANTONOFF/FRED FAIRBRASS/RICHARD FAIRBRASS/BOB MANZOLI)—TAYLOR SWIFT

Personnel: Taylor Swift: vocals; produced by Jack Antonoff. Released August 24, 2017 on Big Machine; it hit the charts immediately after release, peaking at #1.

Because her album *Reputation* was not yet released at the time of publication, there is little available information about the recording. We do know that the early-released song "Look What You Made Me Do" broke all sorts of records upon its release on August 24, 2017. And that it uses fragments of the melody to Right Said Fred's 1991 song "I'm Too Sexy," giving the band members (Fred Fairbrass, Richard Fairbrass, and Bob Manzoli) partial writing credit to the song. Critical reaction to the record was mixed. Perhaps the most provocative came from *Vulture's* Mark Harris, whose review was entitled "Taylor Swift's 'Look What You Made Me Do' Is the First Pure Piece of Trump-Era Pop Art." The song is just, Harris says, "A clever, irritating, hyperself-aware pop earworm . . . we should probably pause to remember that none of this fame-enthralled solipsism emerged from a vacuum. It's the big bang from which Trump the self-selling celeb was spawned. And his presidency didn't invent this grim and cynical strain of pop culture; it's just given it a good home. None of this exists without our complicity. This is also our fault. Look what we made us do."

very Disney-esque wholesome image. But in a very calculated career move as she moved into her late teens, Cyrus began to tweak—or should we say *twerk*—her image into one that was considerably more controversial. After a series of teenage risqué photos, provocative concert outfits, live performance and other off-stage incidents (see Britney Spears), Cyrus began to serve notice that she wasn't Hanna Montana anymore. Perhaps the highpoint (low point?) came at the 2013 MTV Video Music Awards show, in which she "twerked" Robin Thicke's crotch while he performed his hit "Blurred Lines." Although many called the performance an embarrassment, it became the most tweeted event in history, with Twitter users generating around 360,000 tweets per minute during the show. (Mission accomplished!) To date Cyrus has charted five #1 albums, nearly all of which have gone platinum or multi-platinum

A number of pop/rock groups have enjoyed commercial success in the 2000s. Nickelback was formed in Canada in 1995, and has released seven studio albums since 1996 that cumulatively have sold more than 50 million copies. This despite the fact that the group is often the target of criticism from the music press for what is referred to as an uninspiring, formulaic sound. Coldplay formed in London in 1996 and have released five studio albums since their debut in 2000, with total sales of nearly 60 million copies worldwide. 2002's A Rush of Blood to the Head has sold 16 million copies on its own. Los Angeles's Maroon 5 was formed in 2001 when the four original members of the recently broken up Kara's Flowers regrouped and added Lincoln, Nebraska native James Valentine on guitar. Their debut album Songs About Jane was released the following year, and propelled by three charting singles, went 4x platinum. The band won the Grammy Award for Best New Artist in 2005. Three subsequent studio albums have all charted at no lower than #2, and three of their 17 singles have reached #1, including 2011's "Moves Like Jagger." Lead vocalist Adam Levine was also a judge on the reality TV show The Voice.

Unquestionably the most interesting storyline for any new major pop artist belongs to Stefani Germanotta, aka Lady Gaga (1986-). Germanotta was born in New York City, where early on she became involved with a number of music related activities in and out of school. After attending NYU for two years, she quit to focus on her music career. A series of demo tapes created with producer Rob Fusari (who gave her the moniker "Lady Gaga" inspired by the Queen song "Radio Ga Ga") led to a short-lived contract with Def Jam Records. In 2007 she was signed by Streamline Records, which led to a music publishing deal with Sony/ATV, where she wrote songs for among others, Britney Spears and Fergie. Gaga released her debut album The Fame in 2008, and supported its release with club performances with a carefully crafted act that was a stylized updating of burlesque, performance art, and general insanity. By 2009, two singles from the album had become huge #1 hits, "Just Dance" and "Poker Face," which helped the album sell 15 million copies worldwide. "Poker Face" won the Grammy Award for Best Dance Recording in 2010 and has gone on to become one of the best-selling singles in history with more than 12 million copies sold. In 2011 Gaga released her second album Born This Way, which spawned four Top Ten singles, including the #1 title track. But record sales alone are not what Lady Gaga is about. She has in her own way redefined the essence of pop culture. Her music, according to pop writer James Parker, is, "top-quality

"POKER FACE" (STEFANI GERMANOTTA/NADIR KHAYAT)— LADY GAGA

Personnel: Lady Gaga: lead and background vocals; RedOne: production. Recorded 2008 at the Record Plant Studios, Los Angeles, CA; produced by RedOne. Released September 23, 2008 on Streamline, Kon Live, Cherrytree, Interscope; peaked at #1 for one week on April 11, 2009.

One of two singles from her debut album *The Fame* that went to #1, "Poker Face" was a huge international hit that sold 12 million copies and won the 2010 Grammy Award for Best Dance Recording. The song was written by Gaga and Nadir Khayat, who goes by the name RedOne. Originally from Morocco, RedOne first achieved fame in Sweden, where he worked on music for Britney Spears, Shakira, and Wyclef Jean among others. After moving to New York in 2007 he was introduced to Lady Gaga, and they soon began writing songs together. Although Gaga has given a variety of interpretations of the song, we'll go with the one given England's *Daily Star* in 2009: "I've dated a lot of guys that are really into sex and booze and gambling so I wanted to write a record that my boyfriends would like," Gaga added. "But something I don't really talk about is if you listen to the chorus I say 'he's got me like nobody' then 'she's got me like nobody.' It's got an undertone of confusion about love and sex ..."

revenge-of-the-machines dance-stomp with beefy, unforgettable choruses," but the Gaga phenomena is more about what he calls "Gaga-dom." "Gaga-dom is the thing: a persona, something like the incarnation of Pop stardom itself, that she has foisted upon the world. In wigs and avant-garde getups she appears, strange-eyed, her large, high-bridged nose giving a hieroglyphic otherness to her face. On red carpets the presence manifests, where Gaga, like a dome of many-colored glass, refracts the white radiance of Pop. And who will be post-Gaga? Nobody. She's finishing it off, each of her productions gleefully laying waste to another area of possibility. So let's just say it: she's the last Pop star. Après Gaga, the void." Gaga announced in July 2013 that her new album *ARTPOP* would be released November 11th, and will be accompanied by an app that is "a musical and visual engineering system that combines music, art, fashion and technology."

England's latest super diva is Adele Adkins (1988-). Adele began singing at age four, wrote her first song when she was 16, and was signed to the XL label in 2006 at age 18. By this time her singing had evolved in to an R&B/ Blue Eyed Soul style that was heavily influenced by jazz singer Ella Fitzgerald, R&B legend Etta James, and contemporary pop singers such as Beyoncé, the Spice Girls, and Pink. Her debut album 19 (named for her age at the time) was an immediate hit that hit #1 in the UK and eventually sold more than six million copies worldwide. Her most recent album 21, from 2011, was a genuine blockbuster, with sales of 26 million and five charting hits, including the #1s "Rolling in the Deep," "Someone Like You," and "Set Fire to the Rain." All three songs hit the top of the singles chart while 21 was at #1 on the album chart, making Adele the first artist in history to accomplish such a feat. 21 also won six Grammy Awards in 2012. Being a plus size, Adele has been criticized for her weight, which she has defended as a response to the sexualization of the pop industry. "I would only lose weight if it affected my health or sex life, which it doesn't."

Country

Country music has retained wide popularity in the new millennium in part because, "Its appeal is deeply rooted and directly relevant," according to the Country Music Association. Country artists have also learned that the more they incorporate pop elements into their music, the more records they will sell. This is nothing new of course—the "Nashville Sound" was created in the late 1950s by producers Chet Atkins of RCA, Owen Bradley of Decca, and Don Law of Columbia to do just that, and before long artists like Glen Campbell, John Denver, Kenny Rogers, and Dolly Parton were scoring huge hits that crossed over onto the pop charts. The 1980s saw a huge spike in country's popularity, helped in no small measure by the 1980 movie *Urban Cowboy* and its #3 charting soundtrack album. But it was the 1990s that saw country explode into the realm of pop bring a new wave of superstars to the music, including LeAnn Rimes, Reba McEntire, Faith Hill, Martina McBride, Tim McGraw, and Kenny Chesney. In the new millennium, Taylor Swift, who began her career as a country artist, has continued this trend with even more successful results.

In the 1990s, two names stood above all others in country music. Garth Brooks (1962–) began his music career in 1984 after graduating from Oklahoma State University, which he attended on a track scholarship. His eponymous first album, released in 1989, was an immediate smash, going diamond (US sales of 10 million) and containing two country #1 hits. The next seven albums sold a total of over 100 million copies (US), and contained 77 single releases, 19 of which went to #1 on the country charts. His biggest selling album was 1991's Ropin' the Wind, which debuted at #1 and has sold 17 million copies worldwide. It is estimated that he has sold 200 million records worldwide, making him one of the best selling recording artists in history. Brooks is also the top selling artist of the Soundscan Era (1991–); the Beatles are in second place. **Shania Twain** (1965–) first rose to fame in 1995 with her second album The Woman in Me, which went to #1 on the country charts and eventually sold 20 million copies worldwide. Her next album, 1997s Come On Over put her into superstar status with sales of more than 40 million worldwide, making it the best selling country album in history and the best selling studio album by a female artist in any category. Twain released 12 of the album's 16 songs as singles, with eight hitting the Top Ten. Today she is known as The Queen of Country Pop, has five Grammy Awards under her belt, and has her own TV show on the Oprah Winfrey Network.

Propelled by the success of Brooks and Twain, by the late 1990s a new group of country stars began to emerge. The **Dixie Chicks** formed in 1989 in Dallas and recorded three well-received albums in the early 1990s. With the addition of new lead vocalist Natalie Maines in 1995, the group established a more contemporary pop/country sound. The first album with Maines, 1998's *Wide Open Spaces*, proved to be their breakthrough, selling 14 million copies worldwide and winning two Grammy Awards, including Best Country Album. The next album *Fly* went to #1 and won two more Grammies. *Home*, from 2002, debuted at #1 on the pop charts, and won four more Grammies. Clearly the Dixie Chicks were on a roll! Then, on March 10, 2003, on the eve of the Iraq War, Maines told an audience in London, "Just so you know, we're on the good side with y'all. We do not want this war, this violence, and we're ashamed that the President of the

"NEED YOU NOW" (HILLARY SCOTT/CHARLES KELLEY/DAVE HAYWOOD/JOSH KEAR)—LADY ANTEBELLUM

Personnel: Hillary Scott, Charles Kelley: lead vocals; Dave Haywood: acoustic guitar, backup vocals; Jason "Slim" Gambill: electric guitar; Rob McNelley: electric guitar solo; Paul Worley: acoustic, electric guitar; Michael Rojas: piano, synthesizer; Craig Young: bass guitar; Chad Cromwell: drums. Recorded 2009 at Warner Music Studios, Nashville, TN; produced by Lady Antebellum and Paul Worley. Released August 24, 2009 on Capitol Nashville; peaked at #2 pop, #1 country.

"Need You Now" was the fourth single release by Nashville-based Antebellum, and the first and title track from their second album. The song hit #1 on the country charts on November 28, 2009, and stayed there for five weeks. To say that the song and the album achieved commercial and critical success would be an understatement; the single has sold more than six million copies, while the album became the #2 selling album in 2010. The song won four awards at the 2011 Grammies, for Record of the Year, Song of the Year, Best Country Performance by a Duo or Group with Vocals, and Best Country Song. It is also the most downloaded country song in history. The song came together quickly when the group met for the first time with songwriter Josh Kear for the first time. "Actually, it was the second song we wrote that day," said Kear. "We were only together for 2-1/2 hours. We finished the first one in the first 45 minutes. Charles had a guitar thing and an opening line for a song and we wrote 'Need You Now' really fast and went, 'great, that was fun.' It was the first day I'd ever spent with them." What's the song about? Hillary Scott gives us the scoop: "All three of us know what it's like to get to that point where you feel lonely enough that you make a late night phone call that you very well could regret the next day. But you do it anyway because it's the only thing that's going to give you any relief in that moment."

United States is from Texas." Although she later apologized for her comments, the negative reaction was intense and record sales suffered, with several radio stations staging boycotts of their CDs. **Lady Antebellum** formed in Nashville in 2006, and forged a unique multi-genre vocal sound with the harmonies of band members Hillary Scott, Charles Kelley, and Dave Haywood. They have released six studio albums, three of which have hit #1 on the pop charts, and 13 singles. Their second album *Need You Now* debuted at #1 on the pop charts and won five Grammies, including Best Country Album and Song of the Year and Record of the Year for the title track.

Indie/Alternative

We first identified the term "Alternative" back in chapter 12 in reference to the fiercely independent, DYI underground scene that emerged in the 1980s that included such bands as R.E.M., Sonic Youth, and the Replacements. We have also seen that in the 1990s Alternative emerged from the underground with the popularity of the Seattle grunge scene and the spectacular success of Nirvana. And just like every other genre, in the 2000s, Alternative, or Indie, or Post-Punk—whatever you want to call it—has become increasingly diverse in sound. As described in chapter 12, Alternative music is hard to categorize, but one underlying characteristic is still the DIY, 1960s garage band esthetic.

Formed in Chicago in 1994, **Wilco** has carried on the alternative tradition with a willingness to experiment with avant-garde sounds and combine

diverse musical influences. The band is led by Jeff Tweedy on vocals and bassist John Stirratt on bass (the only original members), with Tweedy the primary songwriter. The group has released eight studio albums between 1995-2011, with their last four breaking into the Top Ten. One of their most interesting albums was a 1998 collaboration with singer/songwriter Billy Bragg called Mermaid Avenue, which consists of previously unrecorded Woody Guthrie lyrics set to music by Bragg and Wilco. Bright Eyes is the name given to the musical endeavor of Omaha guitarist/singer/songwriter Conor Oberst (1980-). Oberst began his music career by releasing self-produced cassettes of original songs at age 13 and forming a variety of short-lived bands to play his music. He formed Bright Eyes in 1995 with Mike Mogis on guitar, and Nate Walcott on keyboards and trumpet. Soon after, the band signed with Omaha indie label Saddle Creek Records and released their first album, A Collection of Songs Written and Recorded 1995–1997. It had generally poor reviews. However, their 2002 album Lifted or The Story Is in the Soil, Keep Your Ear to the Ground received very positive reviews in Rolling Stone and several other publications, and brought the group national attention. Conor Oberst was suddenly an alternative celebrity. Bright Eyes was further pushed into the spotlight when they toured with R.E.M. and Bruce Springsteen in 2004's Vote for Change tour.

Death Cab for Cutie is a four-piece group that formed in 1997 in Bellingham, Washington. The band was originally a solo project for guitarist/vocalist Ben Gibbard, who decided to expand into a group format after securing a contract with the small Seattle-based indie label Barsuk Records. The group released their debut *Something About Airplanes* in 1998, the first of four on Barsuk. DCFC burst into the mainstream after signing Atlantic in 2004, with their last three albums charting no lower than #4 on the pop charts. Their 2008 album *Narrow Stairs* hit #1 and was generally very received by the music press. **The White Stripes** were formed in Detroit in1997 by husband and wife Jack and Meg White, and have been one of the new century's most interesting and influential bands. What's interesting about them? For starters, the only primary instruments are drums (played by Meg) and guitar (played by Jack). In addition,

MUSIC CUT 127

"THE BIG THREE KILLED MY BABY" (JACK WHITE)— THE WHITE STRIPES

Personnel: Jack White: guitar, vocals, production; Meg White: drums. Recorded January 1999 at Ghetto Recorders and Third Man Studios, Detroit, MI; produced by Jack White, Jim Diamond. Released March 1999 on XL Recordings; did not chart.

"The Big Three Killed My Baby" was the third single release by the White Stripes, and the only one from their eponymous debut album. The "big three" referenced in the song title and lyrics are the Big Three automakers from Detroit—GM, Ford, and Chrysler. The song is a rant against the carmaker's lack of innovative yet expensive products ("People are burnin' for pocket change/And creative minds are lazy"), coziness with big oil ("And oil company faces are grinnin'/Now my hands are turnin' red"), and planned obsolescence. The song's production is a great example of the White Stripes "lo-fi" production technique, and was recorded at Detroit's Ghetto Recorders, which bills itself as having "All the Amenities of Prison." The album was co-produced by studio owner Jim Diamond.

the Whites divorced in 2000 but continued to record and tour together until disbanding in 2011. The band's music is rooted in the blues and punk, and they are fully committed to a "lo-fi" production style. There is also a serious fascination with red, white, and black (Google "White Stripes images" and you'll get the idea!). Their eponymous debut album, released in 1999, was dedicated to Mississippi Delta bluesman Son House, one of Jack White's primary musical influences. The band went on to record five more albums, the last being 2007's *Icky Thump*, which won a Grammy for Best Alternative Music Album.

Contemporary Hard Rock/Metal

Another enduring genre with a large stylistic umbrella, hard rock/metal continues to be a part of the genetic code of pop music in the 2000s. Established metal bands such as AC/DC, Metallica (whose 1991 album Metallica is the top selling album of the Soundscan era), and Bon Jovi (whose 11 2000s era albums have sold well over 30 million copies worldwide) continue to be very popular, while new bands have continued to evolve the style. Formed in 1995 in Tallahassee, Florida, Creed released four studio albums between 1997-2009 that have collectively sold over 24 million copies. The band is led by Scott Stapp on vocals and Mark Tremonti on guitar, former Tallahassee high school classmates who also are the primary songwriters. After the self-produced album My Own Prison became popular in their home state, Creed was signed by Wind-Up Records, who re-mixed and re-released the album and four singles from it. The singles all hit #1 on the Hot Mainstream Rock Tracks chart, and My Own Prison went 6x platinum. The next album, Human Clay, did even better, with sales of nearly 12 million (US), and the track "With Arms Wide Open" reaching #1 on the pop charts and winning a Grammy. The band dissolved in 2004, but reunited in 2009 with a new album release.

Linkin Park was formed in 1996 in Agoura Hills, California by high school classmates Mike Shinoda, Brad Delson, and Rob Bourdon. In the early years, the band went through several personnel changes before adding three more members. They also had a series of name changes, going from Xero to Hybrid Theory to finally Linkin Park, a spelling play on Santa Monica's Lincoln Park. After much struggle, the band signed with Warner Bros. in 1999 and released their debut Hybrid Theory in 2000. Astonishingly, the album was one of the most successful debuts in history, becoming the biggest selling album of 2001 and eventually selling 24 million copies worldwide. Linkin Park has to date released five studio albums with sales of 60 million worldwide, and released 24 singles. Foo Fighters were founded in 1994 as the one-man project band of former Nirvana drummer Dave Grohl after the April 5, 1994 death of Nirvana front man Kurt Cobain. The band's 1995 self-named debut album featured songs composed by Grohl, who, with the exception of one guitar part and a few backup vocals, played all the instruments and sang all the vocal parts. The album debuted at #23 on the pop charts and received generally good reviews. Upon its release, Grohl put together a four-piece band to play the music live. Six more studio albums were forthcoming between 1997-2011, all of which have hit the Top Ten. The band became a five-piece unit in 2010 when original member Pat Smear rejoined. Foo Fighters have won 11 Grammy Awards, including Best

"ROPE" (FOO FIGHTERS)—FOO FIGHTERS

Personnel: Dave Grohl: lead vocals, rhythm guitar; Chris Shiflett: lead guitar, backup vocals; Pat Smear: rhythm guitar; Nate Mendel: bass guitar; Taylor Hawkins: drums, backup vocals; Rami Jaffee: keyboards; Drew Hester: cowbell. Recorded September 6—December 21, 2010 in Dave Grohl's garage, Encino, CA; produced by Butch Vig. Released on March 1, 2011 on RCA as a digital download and on vinyl, peaking at #68.

"Rope" is the first single release from Foo Fighters seventh album *Wasting Light*. The album was noteworthy for a couple of reasons; it reunited leader Dave Grohl with producer Bitch Vig (producer of Nirvana's 1991 album, on which Grohl played drums), and it was recorded old school with analog equipment in Grohl's garage. Grohl has long been a critic of how digital recording makes it possible to "fix" studio performances with sophisticated software. "You have the ability to completely manipulate and change the performance with the digital stuff. You don't really have that with analog... [but] I don't want to even know I can do that. I don't want to know I can tune my voice, because I want to sound like me," Grohl said. "It all came together as one big idea. Let's work with Butch, but let's not use computers, let's only use tape. Let's not do it at 606 (Grohl's professional studio), let's do it in my garage. And let's make a movie that tells the history of the band as we're making the new album, so that somehow it all makes sense together in the grand scheme of things. What we're doing here is in some ways making sense of everything we've done for the last 15 years." The movie, *Foo Fighters Back and Forth* debuted March 15, 2011 at the SXSW festival in Austin, Texas. At the 2012 Grammies, the film won the award for Best Long Form Music Video.

Rock Album for 2001's *There Is Nothing Left to Lose*, 2004's *One by One*, 2008's *Echoes, Silence, Patience & Grace*, and 2012's *Wasting Light*. In 2013 Grohl produced and directed the documentary film *Sound City*, about the legendary San Fernando Valley studio where Nirvana's *Nevermind* and many other legendary albums were recorded.

THE MUSIC INDUSTRY IN THE EIGHTIES AND NINETIES: LIVING LARGE IN LA

The Majors Rule

As we discussed back in chapter 12, the music industry—and in particular the major labels—had experienced tremendous growth in the 1970s, only to suffer a debilitating post-disco crash that sent sales figures plummeting. As painful as that medicine was, to say the record business rebounded nicely would be a gross understatement. The 1980s and 1990s were the best of times for the major labels, a time when new sales records were constantly being set, new technologies emerging, and new stars were being made, sometimes overnight. Consider this: of the Top 100 Albums compiled by the RIAA, 61 were released in the 1980s or 1990s. By comparison, a grand total of only 11 have come from the 2000s, the highest ranked being *Up!* by Shania Twain, which sits at #54. For the major labels, the 1980s and 1990s was a time for getting fat and living large.

Industry wide, sales figures for records, tapes and CDs jumped from \$3.5 billion to nearly \$13.5 billion between 1982 and 2000. Growth like that naturally caught the attention of Wall Street investors, who jumped in with a series of mergers and corporate takeovers that ultimately put the industry into the hands of a small number of large multi-national conglomerates. Although consolidation of the music industry had been going on since the beginning of the rock era, by the late 1970s six super-major labels had emerged that controlled the lion's share of record sales and distribution. Four of those six, CBS, Warner, RCA and MCA were American owned; of the other two, PolyGram was owned by German and Dutch interests while Capitol-EMI was British. Further consolidation in the 1980s and 1990s reduced the number of majors to five when the German owned BMG bought RCA, Sony bought CBS, and PolyGram and MCA were bought by the Canadian owned Seagram Company and renamed Universal Music Group. The latest round of consolidation occurred 2008 when Sony bought BMG, creating the "Big Four," and in 2011 when EMI was cut up and sold off to Sony and Universal. In 2012 Universal sold its share of EMI to Warners. As a result, today there is a "Big Three": Universal Music Group, which has a 39% share of the market, Sony with 30%, and Warner, 19%. (The rest of the market—approximately 11% - is from sales by independent labels.) To even refer to these companies as record labels is somewhat of a misnomer, as they are actually huge multinational umbrella corporations that have made investments in companies that make records.

What did consolidation mean for artists and consumers? Fredric Dannen, author of the 1990 industry exposé *Hit Men* described the majors at that time as the "sovereign states" of pop music. "Today, there is virtually no American pop singer or rock band of national stature that a major does not, in one way or another, have a piece of. The days are gone in which a pint-sized company can launch [a national act] with independent distribution." By the mid-1990s, artists had fewer places to go to get a contract signed, the independent labels that still existed were essentially shut out of distribution networks, and consumers were left with fewer choices as to what to buy. After years of battling with independent labels and fickle consumers, it seemed as if the major labels had finally achieved market dominance.

Hubris

But we must not underestimate the power of hubris, in this case the pop music industry's collective ability to screw up a good thing. Let's start with the drug-induced decadence that came with the good times in the 1980s and 1990s, because many executives seemed hell bent on outdoing their artists in living the rock and roll lifestyle. Exhibit A was Casablanca Records president Neil Bogart. Bogart had the company offices palatially designed to match Rick's Café in the movie Casablanca (get it: Humphrey Bogart—Neil Bogart?), had music blare from giant speakers, and made drugs—and lots of them—available at all times. Casablanca, which was heavily invested in disco artists, crashed in the early 1980s and Bogart died of cancer soon after. The industry also made a number of strategic mistakes that seemed like good ideas at the time but in fact weren't. One was the mid-1990s decision to stop selling singles. Once the single was killed off in 1998,

consumers had no choice but to buy a \$17 CD if they wanted to buy their favorite song. Initially this was great for business, but eventually buyers became embittered and felt they were getting ripped off. "If you only sold hand lotion in five-gallon bottles, pretty soon people would be tired of it," says producer Albhy Galuten. "You can't go around forcing people to buy something they don't want."

Another major blunder the industry made was to allow the killing off of the mom and pop record store. Brick and mortar record stores had traditionally fostered a sense of community as a hangout for music lovers, musicians, and other hipsters; in addition, they were the only place where records could be purchased. However, that all changed in the 1990s when big box stores like Wal-Mart and Best Buy began selling records at deeply discounted prices that the small stores could not match. Consumers flocked to the boxes, which before long accounted for 65% of CDs sold. The first casualties of the box store bargains were the small locally owned record stores, but eventually even the large chains like Tower and Musicland (Sam Goody) went out of business. With their newfound clout the big boxes began to dictate the terms of what they would and wouldn't sell, which meant that labels sometimes had to airbrush over risqué album covers or produce clean versions of CDs with explicit lyrics. Once Wal-Mart and Best Buy decided to reduce the shelf space in their record sections, consumers were left with soullessly sterile purchasing environments with a limited selection of only the biggest selling pop CDs.

THE MAJORS MEET THEIR MATCH

Napster

The cumulative effect of the drugs, decadence, arrogance, corporate consolidation and bad business decisions left the music industry completely unaware of the fact that they were in a very vulnerable situation by the end of the 1990s. This vulnerability was soon exposed. In 1998, Northeastern University student **Shawn Fanning** (1980–) created **Napster**, a file-sharing website that allowed users to log on and see a display of the music titles on the hard drives of everyone else who was currently logged on. Then, using the program's search engine, they could easily find a specific piece of music by artist or title, and download it to their own computer. Napster worked because it used highly compressed mp3 files, a music file format developed in the early 1990s. And because the record store had suddenly been neatly excised from the transaction, the music was free! Once someone bought a CD, stored the music from it on his or her computer as mp3 files and logged on to Napster, that CD was now available to anyone anywhere that was currently logged on. The ramifications of this new way of obtaining music were enormous, and could possibly bring down the entire music industry as it currently existed.

Now, it is important to keep in mind that at this time record industry executives were so out of touch with things outside of their world that most didn't even know what an mp3 file was. Once the R.I.A.A. started figuring out what was going on, they became alarmed—in fact, very alarmed. After all, consumers were stealing their product! By October 1999 there were already 150,000 Napster

that compresses sound files to approximately 1/10 normal size

with little apparent loss of fidelity.

registered users sharing 3.5 million files, and it was expanding at an astonishing rate. After demands by the R.I.A.A. for Napster to remove all their signed artists were ignored, the R.I.A.A. filed suit on December 6, 1999, claiming the site was guilty of "contributory and vicarious copyright infringement." Napster countered by claiming it was not unlike manufacturers of copying machines or VCRs, who were not held responsible for the potential illegal use by the owners of their products. The one-day trial was held on July 26, 2000, with Judge Marilyn Hall Patel of the Federal Court in San Francisco ruling that Napster was in fact violating copyright laws. Although appeals would drag the case on for another year, in the end Napster was shut down. In the meantime, Shawn Fanning became a generational folk hero as the kid who single-handedly "stuck it to the man." As Steve Knopper writes in *Appetite for Self-Destruction*, Fanning became "a symbol, a rebellious David-vs.-Goliath type who invented the coolest slingshot ever."

But by this time other file-sharing sites had sprung up like weeds, and no self-respecting college student was going to go back to paying \$17 for a CD when he or she could get the music online for free, albeit illegally. New statistics showed that sales of CDs, albums and tapes in 2000 fell by nearly 10% from the previous year, the first downturn since 1982. At the same time, blank CDs outsold prerecorded ones for the first time ever. It seemed pretty clear to music executives that instead of buying CDs, consumers were downloading music illegally and burning their own custom CDs. It was also clear that shutting down Napster had not solved the digital piracy problem. Meanwhile, record labels began laying off hundreds of employees and severing the contracts of many artists to cut costs. The R.I.A.A. returned to the courtroom to shut down new file-sharing sites like Grokster, LimeWire, and Morpheus. In 2003 they also began serving subpoenas to hundreds of suspected copyright violators, with the threat of fines of up to \$150,000 per illegally copied song on their computers. To actually bring lawsuits against the very consumers they were trying to turn into customers was an extreme step to take, but one the RIAA felt they had no choice in doing. "We didn't want to be suing, but there weren't a lot of alternatives," said one industry source. "It's one thing when you're looking from the outside and saying how stupid this is, but it's another thing when you're seeing half your company laid off." It was a public relations mess, but the lawsuits continued on until late 2008, by which time more than 35,000 had been filed, with an average settlement of \$3,500.

The iTunes Music Store and Beyond

The fact that the RIAA started suing customers in 2003 was only partly due to the fact that the industry struggled to come to grips with online piracy and to figure out a plan of attack. But the bottom line was that until Apple Computer launched the **iTunes Music Store**, consumers had no convenient, inexpensive and legal option to buy music online. The iTunes software was first made available for Macintosh computers in 2001 to interconnect with the Apple iPod mp3 player. After wrangling out complicated licensing agreements with the major labels, Apple CEO Steve Jobs introduced the iTunes store on April 28, 2001 as a site where consumers could conveniently buy legal mp3 files for 99ϕ a song and typically \$9.90 per album. On that day 200,000 songs were available from nearly every major artist (major exceptions included Led Zeppelin and the Beatles,

both of whom have since come on board), and it was an instant smash hit. Today there are more than 26 million songs available on iTunes, and as of February 2013, 26 billion songs have been downloaded from the site, which currently accounts for 64% of all online legal digital music sales worldwide.

Of course, the iTunes Music Store did not immediately stop the illegal downloading, although at first it was difficult to gauge how much piracy was still going on. But it was pretty clear that the genie had been let out of the bottle. Record sales immediately started to fall: in 2000 there were 730 million CDs sold; by 2014 that number had dropped to 140 million. But increasingly, consumers did in fact start buying music legally online. In 2004 (the first year they were tracked), 141 million single tracks were purchased and downloaded; by 2012 the number was at 1.336 billion, an increase of nearly 1000%. With Amazon, Xbox Music and others getting into the online music store business, it is easier than ever to buy music legally online. But in recent years digital downloads have begun to decline, with a drop of 9.4 percent in 2014 alone.1 This seemed to indicate that perhaps consumers were somehow getting their music in some other way. And in fact, they were. What's become the new trend is to not actually buy music in any form but instead to stream it directly to computer, tablet device, or smartphone. Streaming services such as Rhapsody offer millions of songs available for a monthly subscription fee. Internet "radio stations" such as Pandora, Spotify, and Rdio offer endless streaming of free music in the form of listener customizable "stations" based on a specific artist, genre, or song. YouTube and Vevo are major players in streaming music videos, and they are also free. By 2014, consuming music through streaming audio and video was literally exploding, with 78.6 billion audio streams and 85.3 video views. These numbers represent an eye-popping 54.5 percent increase over the previous year. The introduction of Jay-Z's Tidal in March 2015 and Apple Music and its curated Internet radio station Beats 1 in June 2015 is further proof that the money is in streaming. However, this is not necessarily true for the artists whose music is the product for these services, who receive ridiculously low royalty percentages. Currently there is litigation in progress between music licensing agencies such ASCAP and BMI and the streamers, and it would come as no surprise if a landmark court case or major new legislation comes out of Washington in the near future to help mitigate this problem.

THE FUTURE

The End of the World as We Know It?

So, where does the digital age leave the music industry? Well, you could ask the newspaper, publishing, and radio industries the same thing. The short answer is, because we are in a time when tremendous economic changes are occurring

¹ Ironically, the only sales category besides digital downloads to increase in recent years is vinyl records. Yes, vinyl . . . you know—records. Vinyl had sales in 2007 of 990,000, 4.5 million in 2012, and 9.2 million in 2014. What appeared to be a fluky backlash against digital music consumption seems to be turning into a bona fide market trend. While vinyl records may not be as convenient as mp3s or streaming music, there is certainly a more communal culture of getting a record out of the jacket, putting it on the turntable, and admiring the 12" album cover with its artwork and liner notes while listening to the music. This does not exist in the iPhone/earbuds world; even the most diehard digital fan must admit to that!

because of the Internet, we simply don't know yet. We do know that the CD is dying, as consumers have clearly shown a preference for having convenient access to their music, whether in the form of an mp3 or having it streamed. And while the album is not dead, its relevance as a creative document seems to be, as consumers have also shown that they prefer buying singles "cafeteria style" rather than albums. One could also make the assumption that sales in the 1990s—when consumers had to buy \$17 albums—were artificially high and were bound to fall eventually. A similar sales downturn occurred in the early 1980s, but the industry had the trifecta of Thriller, MTV and the introduction of the CD to pull it out of that slump. The coming of the digital age revealed an industry that was woefully inefficient and ill prepared to respond to the changes afoot, and one that was extremely slow to respond to those changes. When the music industry finally did get around to addressing online piracy, it was astonishingly off target. "They left billions and billions of dollars on the table by suing Napster—that was the moment the labels killed themselves," says Jeff Kwatinetz, CEO of The Firm, a management company. "The record business had an unbelievable opportunity there. They [consumers] were all using the same service [Napster]. It was as if everybody was listening to the same radio station. Then Napster shut down, and all those thirty or forty million people went to other [file sharing services]." However, one industry insider says there were pressures from other sources as well." A lot of people say, 'the labels were dinosaurs and idiots, and what was the matter with them?" said Hilary Rosen, who was CEO of the RIAA at the time. "But they had retailers telling them, 'You better not sell anything online cheaper than in a store,' and they had artists saying, 'Don't screw up my Wal-Mart sales."

But enough about the labels and the business; what about the music itself? What lies ahead for rock and pop music? There's a lot of complaining going on today about the quality of pop music, so perhaps the case could be made that it is the music itself, and not the industry, that is in trouble. Some say there is nothing good anymore; others say that it's all derivative of something from the past; while still others complain that there is no new movement or style, no rap, punk or grunge to unite the field and lead the way. In reality, all these things are true to one extent or another, but a larger truth is that the term pop music itself may be oxymoronic in today's world. With the gatekeepers (the major labels) out of the way, consumers are free to control exactly what they want to be entertained with, how to search for it, and how to be kept abreast of any new developments in it. And they can move on to something else whenever they want. "Pop music is the music that the most people are listening to most of the time," writes Helium.com contributor Gordon Ashley. "But the sheer volume of content that can be sifted from the mind-boggling expanse of the Internet will make that idea obsolete. And without the money-makers tightly holding the strings and manipulating what the most people are digging on most often, the idea of a definable pop culture will disappear."

And with the Internet and the technology available today, more people than ever are making music. Digital Audio Workstations (DAW) such as ProTools, Apple Logic Pro X, and Digital Performer are becoming less expensive, more comprehensive and easier to use. Getting your music "out there" is also simpler than ever with YouTube and other sites. And when it is out there, who knows who is going to hear it and what they're going to do with it. "Music now has the

possibility of having a much larger gene pool," says Robert Thompson, professor of pop culture at Syracuse University. "There are more mutations out there than before simply because there are more opportunities for something to actually get into the distribution system." And as we have seen, the new distribution system is radically different than the old one where CDs were sold in record stores. Today it is possible for an artist to "easily bypass the traditional infrastructure—going into the studio, sending singles to radio stations—and make songs available for download almost as soon as they're written," according to Dan Brown of CBC News Online. It is even possible for stars to be made by bypassing the traditional radio route. Just ask Justin Bieber, who became famous on YouTube, or Kelly Clarkson, whose first album sold more than two million copies after she won *American Idol* in 2005.

Whether all of this is a good thing or just going to lead to the creation of a clutter of crappy music is yet to be seen. A similar revolution has already taken place in the video world, where inexpensive, easy to use technology has allowed almost anyone to make and edit movies. (You only have to look as far as YouTube to see whether or not that has produced anything interesting.) However, as Chris Anderson writes in The Long Tail: Why the Future of Business is Selling Less of More, "Talent is not universal, but it's widely spread: give enough people the capacity to create, and inevitably gems will emerge." Perhaps the future of rock and pop music is best summed up by Peter Rojas, founder of Engadget and co-founder of RCRD LBL, a free, online-only music label launched by Downtown Records. "I don't pretend to know what the industry will look like in ten years, but the funny thing about all of this is that music itself is healthier than ever. The Internet, combined with low-cost (or even no-cost) digital tools, has led to an explosion of creativity, with millions of amateurs making music for every conceivable genre, sub-genre, and microgenre, and then sharing their creations online. We have an infinite number of choices available to us, and when content is infinitely abundant, the only scarce commodities are convenience, taste, and trust. The music companies that are successfully shaping the Internet era are recognizing that the real value is in making it easier to buy music than to steal it, helping consumers find other people who share their music tastes, and serving as a trusted source for discovering new music."

As one wise and prescient man first said back in 1963, "The times they are a-changin"." Indeed they are.

Date

Name

70000	Why was Nirvana's album <i>Nevermind</i> hitting #1 in 1992 so significant?	
2.	What are some of the reasons that Seattle was important to grunge?	
3.	Which album proved to be the commercial breakthrough for Radiohead, and what influences on its music?	were some of the
4.	Describe emo and how it came about.	
5.	Describe how Mariah Carey was discovered and some of her successes and failures.	

future holds.

6.	What are some of the controversies that Eminem has embroiled himself in?
7.	Describe the culture of the music business in the 1980s and 1990s.
8.	Describe exactly what MPEG Audio Layer III is and its role in changing the record business in the late 1990s and early 2000s.
9.	Who is Shawn Fanning and why did he play such an important role in the evolution of the record business?
9.	

10. Describe some of the ways that the music industry is changing. Give your thoughts on what the

Altschuler, Glenn C.: All Shook Up: How Rock and Roll Changed America; Oxford University Press, New York, 2003

AMG: All Music Guide

Azerrad, Michael: Our Band Could Be Your Life: Scenes from the American Indie Underground 1981–1991; Back Bay Books, New York, 2001

Barkley, Elizabeth F.: Crossroads: Popular Music in America; Prentice Hall, Inc, Upper Saddle River, NJ, 2003

Bianco, David, editor: Parents Aren't Supposed to Like It: Rock & Other Pop Musicians of the 1990s; UXL, Detroit, MI, 1998

Bronson, Fred: *The Billboard Book of Number One Hits;* Billboard Publications, New York, 1992

Browne, David: Fire and Rain: The Beatles, Simon and Garfunkel, James Taylor, CSNY, and the Lost Story of 1970; DaCapo Press, NY, 2012

Brown, Mick: Tearing Down the Wall of Sound: The Rise and Fall of Phil Spector; Vintage Books, New York, 2007

Christgau, Robert: Any Way You Choose It: Rock and Other Pop Music 1967–1973; Penguin Books, Baltimore, MD, 1973

Clapton, Eric: Clapton: The Autobiography; Broadway Books, New York, 2007

Cogan, Brian: The Encyclopedia of Punk; Sterling, New York, 2006

Cogan, Jim and Clark, William: Temples of Sound: Inside the Great Recording Studios; Chronicle Books, San Francisco, CA, 2003

Cohodas, Nadine: Spinning Blues Into Gold: The Chess Brothers and the Legendary Chess Records; St. Martin's Press, New York, 2000

Cross, Charles R.: Room Full of Mirrors: A Biography of Jimi Hendrix; Hyperion Books, New York, 2005

Curtis, Jim: Rock Eras: *Interpretations of Music and Society, 1954–1984*; Bowling Green State University Press, Bowling Green, OH, 1987

Dannen, Fredric: Hit Men; Vintage Books, New York, 1991

Davis, Francis: The History of the Blues; Hyperion Books, New York, 1995

Davis, Stephen: Hammer of the Gods: The Led Zeppelin Saga; Ballantine Books, New York, 1985

Davis, Stephen: Jim Morrison: Life, Death, Legend; Gotham Books, New York, 2004

Doggett, Peter: Are You Ready For The Country: Elvis, Dylan, Parsons and the Roots of Country Rock; Penguin Books, New York, 2000

Emerick, Geoff: Here, There and Everywhere: My Life Recording the Music of the Beatles; Gotham Books, New York, 2006

Escott, Colin with Hawkins, Martin: Good Rockin' Tonight: Sun Records and the Birth of Rock 'n' Roll; St. Martins Press, New York, 1991

Farley, Christopher John: Before the Legend: The Rise of Bob Marley; Amistad, NY, 2006 Fletcher, Tony: Moon; HarperCollins, New York, 1999

Fong-Torres, Ben: The Hits Just Keep on Coming: The History of Top 40 Radio; Miller Freeman Books, San Francisco, CA, 1998

Friedlander, Paul: Rock & Roll: A Social History; Westview Press, Boulder, CO, 1996 Gaines, Steven: Heroes and Villains: The True Story of the Beach Boys; Da Capo Press, New York, 1995

Garofalo, Reebee: Rockin' Out: Popular Music in the USA; Prentice Hall, Inc, Upper Saddle River, NJ, 2002

Gillett, Charlie: The Sound of the City: The Rise of Rock and Roll; Outerbridge & Dienstfrey, New York, 1970

Gilmore, Mikal: Night Beat: A Shadow History of Rock and Roll; Doubleday, New York, 1998

Goodman, Fred: The Mansion on the Hill: Dylan, Young, Springsteen, and the Head-On Collision of Rock and Commerce; Vintage Books, New York, 1997

Greenwald, Andy: Nothing Feels Good: Punk Rock, Teenagers, and Emo; St. Martin's Griffin, New York, 2003

Guralnick, Peter: Last Train to Memphis: The Rise and Fall of Elvis Presley; Little, Brown and Company, Boston, MA, 1994

Guralnick, Peter: Sweet Soul Music: Rhythm and Blues and the Southern Dream of Freedom; Back Bay Books, Boston, MA, 1986

Halberstam, David: The Fifties; Fawcett Books, New York, 1993

Harry, Bill: The Ultimate Beatles Encyclopedia; MJF Books, New York, 1992

Hermes, Will and Michel, Sia, editors: 20 Years of Alternative Music: Original Writing on Rock, Hip-hop, Techno and Beyond; Three Rivers Press, New York, 2005

Hertsgaard, Mark: A Day in the Life: The Music and Artistry of the Beatles; Delacorte Press, New York, 1995

Heylin, Clinton: From the Velvets to the Voidoids: The Birth of American Punk Rock; A Cappella Books, Chicago, IL, 1993

Holm-Hudson, Kevin: Progressive Rock Reconsidered; Routledge, New York, 2002

Hoskyns, Barney: Waiting for the Sun: Strange Days, Weird Scenes and the Sound of Los Angeles; St. Martin's Press, New York, 1996

Isis Productions: The Grateful Dead: Anthem to Beauty; Eagle Rock Entertainment, New York, 2005

Joplin, Laura: Love, Janis; HarperCollins, New York, 1992

Kitwana, Bakari: The Hip Hop Generation: Young Blacks and the Crisis in African-American Culture; Basic Civitas Books, New York, 2002

Klosterman, Chuck: Did Ali Invent Rap; ESPN.com, 2006

Knopper, Steve: Appetite for Self-Destruction: The Spectacular Crash of the Record Industry in the Digital Age; Free Press, New York, 2009

Konow, David: Bang Your Head: The Rise and Fall of Heavy Metal; Three Rivers Press, New York, 2002

Kostelanetz, Richard: The Frank Zappa Companion: Four Decades of Commentary; Schirmer Books, New York, 1997

Laing, Dave: One Chord Wonders: Power and Meaning in Punk Rock; Open University Press, Milton Keynes, UK, 1985

Lang, Michael: The Road to Woodstock; HarperCollins, New York, 2009

Lang, Michael: The Road to Woodstock; Ecco Books, New York, 2010

Lomax, Alan: The Land Where the Blues Began; New Press, New York, 1993

- Marcus, Griel: *The Doors: A Lifetime of Listening to Five Mean Years*; Public Affairs, New York, 2011
- Markoff, John: What the Dormouse Said: How the 60s Counterculture Shaped the Personal Computing Industry; Viking, New York, 2005
- Marmorstein, Gary: The Label: The Story of Columbia Records; Thunder's Mouth Press, New York, 2007
- Marsh, Dave: The Heart of Rock & Roll: The 1001 Greatest Singles Ever Made; Plume Books, New York, 1989
- McNally, Dennis: A Long Strange Trip: The Inside History of the Grateful Dead; Broadway Books, New York, 2002
- Miles, Barry: Zappa; Grove Press, New York, 2004
- Montgomery, Eric: Float Life a Butterfly, Rap Like Jay-Z? Muhammad Ali's Rap Legacy; The Examiner, 1/17/2012
- Norman, Philip: Shout, The Beatles in Their Generation; Fireside Books, New York, 1981
- Norman, Phillip: Rave On: The Biography of Buddy Holly; Fireside Books, New York, 1996
- Palmer, Robert: Dancing in the Street: A Rock and Roll History; BBC Books, London, 1996
- Phinney, Kevin: Souled American: How Black Music Transformed White Culture; Billboard Books, New York, 2005
- Perry, Charles: The Haight-Ashbury: A History; Wenner Books, New York, 2005
- Richards, Keith: Life; Little, Brown and Co.; Boston, MA, 2010
- Rolling Stone Magazine: 50 Moments That Changed the History of Rock and Roll; Issue 951, June 24, 2004
- Romanowski, Patricia and George-Warren, Holly: The New Rolling Stone Encyclopedia of Rock & Roll; Fireside, New York, 1995
- Rose, Tricia: Black Noise: Rap Music and Black Culture in Contemporary America; Wesleyan University Press, Hanover, NH, 1994
- Rotolo, Suze: A Freewheelin' Time: A Memoir of Greenwich Village in the Sixties; Broadway, New York, 2008
- Schaefer, G. W. Sandy, Smith, Donald S., Shellans, Michael J.: Here to Stay: Rock and Roll through the '70s; GILA Publishing Co. 2001
- Scorsese, Martin: Bob Dylan—No Direction Home; Paramount Pictures, Los Angeles, CA, 2005
- Shelton, Robert: No Direction Home: The Life and Music of Bob Dylan; Ballantine Books, New York, 1986
- Simons, David: Studio Stories: How the Great New York Records Were Made: From Miles to Madonna, Sinatra to the Ramones; Backbeat Books, New York, 2004
- Smith, RJ: The One: The Life and Music of James Brown; Gotham Books, New York, 2012
- Snyder, Randall: An Outline History of Rock and Roll; Kendall/Hunt, Dubuque, IA, 2001
- Sounes, Howard: Down the Highway: The Life of Bob Dylan; Grove Press, New York, 2001
- Starr, Larry and Waterman, Christopher: American Popular Music: From Minstrelsy to MTV; Oxford University Press, New York, 2003
- Stuessy, Joe and Lipscomb, Scott: *Rock and Roll, Its History and Stylistic Development*; Prentice Hall, Inc, Upper Saddle River, NJ, 2003
- Sullivan, James: The Hardest Working Man: How James Brown Save the Soul of America; Gotham Books, New York, 2008
- Thompson, Dave: Never Fade Away: The Kurt Cobain Story; St. Martin's, New York, 1994

- Thompson, Dave: Alternative Rock; Miller Freeman Books, San Francisco, CA, 2000 Walker, Michael: Laurel Canyon: The Inside Story of Rock and Roll's Legendary Neighborhood; Faber and Faber, London, 2006
- Ward, Ed, Stokes, Geoffrey, and Tucker, Ken: Rock of Ages: The History of Rock and Roll; Prentice Hall, Inc, Englewood Cliffs, NJ, 1986
- Weller, Sheila: Girls Like Us: Carol King, Joni Mitchell, Carly Simon—and the Journey of a Generation; Washington Square Press, New York, 2008
- Whitburn, Joel: *The Billboard Book of Top 40 Albums*; Billboard Publications, New York, 1995
- Whitburn, Joel: *The Billboard Book of Top 40 Hits*; Billboard Publications, New York, 1996
- White, Armond: Rebel For the Hell of It: The Life of Tupac Shakur; Thunder's Mouth Press, New York, 1997
- Wicke, Peter: Rock Music: Culture, Aesthetics and Sociology; Cambridge University Press, New York, 1987
- Woliver, Robbie: Hoot! A 25-Year History of the Greenwich Village Music Scene; St. Martins Press, New York, 1986

AAB lyric form—the lyric form used in blues verses in which there are three lines, the first two being identical.

Abbey Road Studios—the EMI recording studio located on Abbey Road in London where most of the Beatles' recordings were made in the 1960s.

Acid rock—the umbrella term to describe the folk and blues influenced music of the psychedelic era.

Acoustical process—the recording process used before 1925 that used acoustical horns instead of microphones.

Altamont Speedway Free Festival—the music festival held at the Altamont Speedway on December 6, 1969 that became infamous for the murder of a participant by a member of the Hells Angels.

Album—the 33½ rpm 12" LP (long playing) record format introduced by Columbia Records in 1948.

Aldon Music—a songwriting company founded in New York in 1958 by Al Nevins and Don Kirshner.

Alternative rock—an umbrella term describing music from the 1980s with a wide variety of stylistic approaches and a decidedly DIY (do-it-yourself) independent attitude.

American Bandstand—the television show began in 1952 and hosted by Dick Clark from 1956 to 1987 that featured teens dancing to popular hit songs.

Art rock—an umbrella term to describe the philosophy of incorporating elements of European classical music, American jazz and the avant-garde into rock.

Audio Home Recording Act—a law passed by Congress in 1992, which among other things, allowed consumers to make personal copies of copyrighted material.

Basement Tapes—a series of recordings made by Bob Dylan and members of the Band in Woodstock, NY in early 1967.

Beatlemania—the word first coined by the *Daily Mirror* in 1963 to describe the huge popularity of the Beatles.

Beat writers—a name given to authors and poets such as Jack Kerouac, William S. Burroughs and Allen Ginsberg who gained notoriety in the 1950s and espoused a philosophy of existentialism and a rejection of materialism.

Billboard magazine—the industry magazine that charts record sales.

Blackboard Jungle—a 1955 fictional film about juvenile delinquency that inadvertently turned Bill Haley's "Rock Around the Clock" into a hit by using it under the opening credits.

Blaxploitation films—movies made by black directors and actors with inner city themes of drug deals and ghetto shootings.

- **Bluegrass**—a fast paced, acoustic music that incorporated virtuoso improvised solos similar to those found in jazz.
- Blues, the—the form developed in the Mississippi Delta and other Southern locales in the late 19th century that incorporates a 12-bar verse, AAB lyric form, and tonalities from the blues scale.
- **Bo Diddley rhythm**—a rhythm first used by Bo Diddley in his first hit of the same name.
- Boy bands—a popular 1990s and 2000s group format led by young male vocalists; examples include New Kids on the Block and Boyz II Men.
- **Brill Building Pop**—the term to describe the pop songs that emerged from professional songwriters based in and around New York's Brill Building in the late 1950s and early 1960s.
- Bristol sessions, the—the first important country music recordings made in Bristol, Tennessee in 1927 by Ralph Peer. Among the artists that Peer recorded were Jimmie Rodgers and the Carter Family.
- **British folk tradition**—the traditional folk music, including ballads, lyric songs and work songs, of the British Isles. British immigrants brought these songs to the New World.
- **Bubblegum**—a short-lived strand of carefully crafted sing along pop songs aimed at pre-teens that was generally produced in the studio by session players.
- Calypso—the traditional folk music of Trinidad.
- Cassette tape—a tape storage media introduced in the 1960s in which the tape was enclosed in a small plastic molding, or cassette.
- Cavern Club—the underground pub in Liverpool, England where the Beatles often performed in the early 1960s.
- **CBGB**—a club located at 315 Bowery in New York's Lower East Side that was the focal point of the city's punk scene.
- Chess Records—the Chicago studio and independent label run by brothers Phil and Leonard Chess from 1950 to 1967.
- Classic blues—the first recorded blues from the 1920s; characterized by the use of female singers such as Bessie Smith.
- Compact disc—a digital storage media introduced in 1982 by Sony and Philips.
- Country blues—the first form of the blues.
- Country rock—a style that combined influences from country music with rock.
- Cover—a new recording of a charting song that seeks to "cover" up the original song.
- Cowboy songs—traditional country and hillbilly songs used in Hollywood films that were orchestrated to create a more commercial pop sound.
- Crew/posse—informal neighborhood groups formed as a means of providing identity and support for their members.
- **DAT**—an acronym for digital audiotape, a stereo digital tape media introduced in the 1980s.
- Deadheads—the ardent followers of the Grateful Dead.
- **Digital sampler**—a synthesizer that digitally records (samples) sounds that can then be played back and manipulated from a MIDI instrument.
- **Disc jockey** (**DJ**)—a radio announcer who spins records (discs) interspersed with lively banter. The first DJ is believed to have been Al Jarvis of KFWB in Los Angeles, who was injecting his own personality into his show as early as 1932.
- **Disco**—dance oriented pop that incorporates synthesizers, drum machines and lush orchestrations that emerged in the late 1970s.
- **Doo-wop**—a cappella group vocal style that incorporates high falsetto vocal leads, scat singing, rhythmic vocal backings and sometimes lead vocals or spoken verse by the bass singer. Most doo-wop recordings added a rhythm section for more commercial dance appeal.

- **DRM**—digital rights management, the term for any one of several technologies designed to limit the number of digital copies that can be made of a file.
- **Dub**—a technique of mixing interesting sections of different songs together first used by Jamaican DJs.
- **Electrical process**—the recording process used after 1925 that used microphones to transduce sound waves into electrical signals.
- **Electric ballrooms**—older ballrooms in San Francisco such as the Fillmore and Avalon that staged youth dances in the early years of the city's psychedelic movement.
- **Electric Lady**—the Greenwich Village recording studio built by Jimi Hendrix in the late 1960s.
- Emo—an umbrella term describing a 1990s music style that combined a hardcore punk musical esthetic, poetic and self-indulgent lyrics, and a go-for-it live performance attitude.
- **Exploding Plastic Inevitable**—a 1960s traveling mixed media show led by Andy Warhol.
- **Falsetto**—a technique where male singers sing in a very high "head" voice that is beyond their natural vocal range.
- Fame Studios—the recording studio founded in Muscle Shoals, Alabama in 1959 by Rick Hall. The name is an acronym for Florence Alabama Music Enterprises.
- **Fifties folk revival**—refers to the renewed interest in folk music that occurred in the late 1950s after an earlier anti-Communist furor had pushed it underground.
- **File sharing**—the transferring of digital files, usually mp3, from one computer to another via the Internet.
- **Folk rock**—the pop style characterized by strumming acoustic guitars, rock rhythm sections, vocal harmonies, and lyric story lines.
- Fret board tapping—a guitar technique first popularized by Eddie Van Halen.
- **Funk**—the more primal evolution of R&B and soul that emerged in the early 1970s whose most important characteristic is the rhythmic groove.
- **Gangsta rap**—a rap style emerging in the 1990s characterized by lyrics using first person accounting of gang related themes that include violence, rage and sexual degradation.
- **Girl groups**—a genre characterized by young females singing songs of innocent love and devotion to their boyfriends.
- **Glam rock**—an umbrella term encompassing a wide variety of styles held together by the use of flamboyant fashions and assaults on sexual conventions.
- Gold, platinum, and diamond records—designations of 500,000, one million and ten million units sold, as certified by the RIAA.
- Gold Star Studios—a Los Angeles studio often used by Phil Spector, the Beach Boys and others in the early 1960s.
- **Gospel**—a highly emotional evangelical vocal music made popular by Thomas Dorsey that emerged from spirituals and was highly influential to rhythm and blues.
- **Grand Ole Opry**—the radio program that began broadcasting in 1925 from WSM in Nashville that essentially made that city the center of the country music industry.
- **Grunge**—a 1990s post-punk style that incubated with Seattle bands such as Nirvana, Soundgarden and Mud Honey.
- **Haight-Ashbury**—the district in San Francisco that became ground zero for the city's 1960s youth movement.
- **Hammond's Folly**—the nickname given to Bob Dylan's eponymous debut album, produced by the legendary John Hammond.
- **Hardcore**—a harder edged, darker and angrier evolution of punk that evolved in Los Angeles, and to a lesser degree, Washington, D.C., in the 1980s.

Hard rock—a forerunner style to heavy metal characterized by distorted guitar, blues riffs and power chords.

Heavy metal—a late 1960s evolution of hard rock characterized by intense volume, distortion, and a preoccupation with themes of evil, death, the occult, etc.

Hillbilly music—the traditional old time music of the rural South and Appalachian regions, with origins in English folk music. Hillbilly music is the foundation of modern country music.

Hip-hop—a cultural expression that includes rap music, break-dancing and graffiti art that first emerged in the South Bronx neighborhoods of New York City in the late 1970s.

Hippie—the term first coined by reporter Michael Fellon in 1965 to describe young people who wore long hair, headbands, tie-dyed shirts and bell-bottom pants.

Honky tonk—a country-oriented predecessor to rock and roll that uses a rhythm section, electric guitar and electric pedal steel guitar to create a louder and hard driving sound. Honky tonk lyrics often deal with drinking, cheating, etc.

Hootenanny—a folk jam session where traditional folk songs are sung.

Human Be-In—an event held in Golden Gate Park in San Francisco on January 14, 1967 that featured speakers, poets and live music.

Independent labels—the small startup labels that began emerging in large numbers in the 1940s and 1950s.

Industrial—a 1980s punk style that incorporated non-traditional sounds from synthesizers, avant-garde electronics and mechanical sources to infuse the sounds and ethos of modern industrial life.

Island Records—the record label founded in 1961 by Chris Blackwell that initially became known for its reggae releases.

iTunes Music Store—the online music store introduced in 2003 by Apple Computer.

Jazz—the improvisational art form of individual expression first developed in New Orleans in the first years of the 20th century.

J&M Recording Studio—a studio in New Orleans owned and operated by Cosimo Matassa where many early R&B hits were recorded, including "Tutti Frutti."

Last Waltz, The—the concert film directed by Martin Scorsese that chronicles the last performance of the Band on Thanksgiving Day, 1976.

Laurel Canyon—the mountainous wooded area north of West Hollywood where many rock artists lived in the mid to late 1960s.

Left wing folk song conspiracy—describes the association between folk music and liberal politics throughout much of the early 20th century.

Lifehouse—an ill-fated album and science fiction film conceived by the Who's Pete Townshend.

Live Aid/Farm Aid—two charity rock concert events from the 1980s.

Lizard King—the persona adopted by the Doors' Jim Morrison to ignite audience reaction.

Major labels—the largest corporate record labels.

Melisma—the singing embellishment of a single syllable into several notes.

Mellotron—an early synthesizer capable of reproducing the sound of violins, cellos and flutes on tape loops activated when keys were depressed.

Mento—the indigenous folk music of Jamaica.

Merry Pranksters—the friends and followers of author Ken Kesey, who in 1965 and 1966 held a series of "acid tests," where LSD was distributed.

Mersey Beat—the name given to the snappy, upbeat music of early British Invasion bands. Named for the Mersey River in Liverpool.

MIDI—an acronym for musical instrument digital interface, a digital transfer protocol introduced in 1983.

- Minimalism—the use of short repeating musical phrases to create a hypnotic effect.
- Mini-Moog—an early portable analog electronic synthesizer developed by Dr. Robert Moog.
- Mississippi Delta—the 250-mile-long area of Mississippi stretching from Memphis south to Vicksburg that is widely believed to be the birthplace of the blues.
- Mods—a mid-1960s London youth cult that was known for snappy clothes, short hair, scooters and amphetamine consumption.
- **Monterey International Pop Festival**—one of the first large outdoor music festivals, held in Monterey, California in June 1967.
- Moondog House Rock and Roll Party, The—the name of Alan Freed's radio program on WJW in Cleveland.
- Motown Records—a record label founded in Detroit in 1959 by Berry Gordy that specialized in highly produced soul.
- **Mp3**—a digital file format that compresses sound files to approximately 1/10 normal size with little apparent loss of fidelity.
- MTV—Music Television, a TV network introduced in 1981 with programming that focuses on music.
- Music streaming—music that is available for listening in streaming (non-downloadable) format.
- Newport Folk Festival—an annual folk festival that was first held in 1959 in Newport, Rhode Island.
- Napster—a digital file-sharing website introduced in 1999 by Shawn Fanning.
- New wave—a second wave of punk that incorporated pop oriented sensibilities.
- 1968 Democratic Convention—the presidential convention held by the Democratic Party in August 1968 that was marred by clashes between anti-war protesters and police.
- Nor Va Jak Studio—the Clovis, New Mexico studio owned and operated by Norman Petty where Buddy Holly made his first hit records.
- Old school rap—the first generation of rap music, which usually had themes of fun and partying.
- Our World—the first live worldwide TV broadcast, occurring on June 25, 1967, which featured the Beatles performing "All You Need is Love."
- Overdubbing—a feature of multi-track tape records that allows the recording of additional parts independently of each other while listening to previously recorded tracks with headphones.
- Payola—the practice of DJs accepting cash (known euphemistically in the music business as the "\$50 handshake"), favors and other gifts from record companies to play their songs.
- **Philadelphia International Records (PIR)**—the Philadelphia-based label headed by producers Kenny Gamble and Leon Huff.
- **Pirate radio stations**—illegal radio stations that broadcast pop music from ships anchored off the British coast in the early 1960s before the debut of BBC's Radio One.
- PMRC—Parent's Music Resource Center, a watchdog group organized in 1985 to "educate and inform parents of this alarming new trend . . . towards lyrics that are sexually explicit."
- Pogo—a violent, body-contact style of dancing associated with punk music.
- Progressive rock radio—a radio format from the late 1960s and early 1970s characterized by the playing of an eclectic mix of music, particularly long, non-commercial album cuts, usually accompanied by low key, spaced-out DJ conversation. Sometimes called underground radio.
- Pub rock circuit—a club scene in 1970s London where little known bands were free to experiment with new music.

- **Punk**—the style emerging from New York, London and other cities in the mid-1970s characterized by an angry, nihilistic, do-it-yourself attitude.
- Race music—a catchall term to describe any records or songs by black artists, including the blues and what would later be known as rhythm and blues (R&B).
- Rap—the musical expression of hip-hop culture whose most distinguishing characteristic is the use of rhyming, melodic spoken words instead of sung lyrics.
- Rapcore—an umbrella term describing bands that combine elements of rap with hardcore, metal or punk.
- Rastafarianism—a religious movement whose followers believe they will be repatriated to their African homeland and escape Babylon (a metaphor for their oppressors in the New World).
- **Record Industry Association of America (RIAA)**—the industry trade group that certifies record sales and designates gold, platinum and diamond records.
- **Reeperbahn**—the red light district in Hamburg, Germany where the Beatles often played in the early 1960s.
- **Reggae**—the Jamaican music that evolved from the combination of indigenous folk, American R&B and traditional Afro-Caribbean music.
- Rhythm and Blues—an evolution of the blues that was more dance and commercially oriented. R&B bands often included electric instruments such as guitars, bass guitars and organs, vocalists and a horn section, often with a honking tenor saxophone soloist.
- Riddim—the intertwined patterns played by the bass and drums in reggae.
- Riot on Sunset Strip—a confrontation between youth and police on the night of November 12, 1966 that inspired Stephen Stills to write the Buffalo Springfield hit "For What It's Worth."
- Rockabilly—the first style of rock and roll, characterized by merging elements of R&B and country (the word is a contraction of the words rock and hillbilly), slap bass, hiccupping vocals and a fast, nervous beat.
- **Rock steady**—a Jamaican music that is slower and more relaxed than ska and is the immediate predecessor to reggae.
- **Scratching/back spinning**—the technique utilized by DJs of playing a record back and forth quickly to create a scratching sound.
- **Singer/songwriter**—an umbrella term describing solo performers who write and sing original songs that often tackle personal issues and emotional struggles.
- Single—the 45 rpm 7" record format introduced in 1949 by RCAVictor.
- **Ska**—an up tempo music (and predecessor to reggae) that combines an R&B influenced walking bass with accents on the offbeats from mento.
- Skiffle—an English adaptation of traditional American jug band music.
- **Slap-bass technique**—a technique for playing the electric bass guitar first conceived by Larry Graham.
- **Snakepit**, The—the Motown recording studio, located in the basement of the Detroit headquarters.
- **Soft soul**—a highly produced and polished soul from the early 1970s that emphasized lush string and horn arrangements and smooth vocal harmonies.
- **Soul music**—a more pop oriented version of R&B associated with the 1960s that contains heavy influences from gospel music.
- **Southern rock**—a rock style deeply rooted in country music and the blues that often featured bands with two or more lead guitarists.
- Stax Records—a record label founded in Memphis in 1957 as Satellite Records by Jim Stewart. The label changed its name to Stax in 1961.
- **Stop time**—the interruption of a regular beat pattern in the rhythm section.

- *Sullivan Show, The Ed*—the popular TV show running from 1948 to 1971 on which many rock stars, including Elvis Presley and the Beatles appeared.
- Sun Records—an independent label started in 1952 by Sam Phillips in Memphis.
- Sunset Strip—the stretch of Los Angeles' Sunset Boulevard that was the focal point of the city's club scene in the mid 1960s.
- **Surf**—a driving, high energy and primarily instrumental music style associated with the surfing culture of early 1960s Southern California.
- **Swing Era**—the name given to the period from 1935–1946 when big band jazz was the most popular music in America.
- **Tape-delay echo**—an effect created by feeding a sound source, such as a vocal, into the record head of a separate tape machine and back into the mix after it passes the playback head a split second later.
- **Teddy boy**—the term describing alienated British young men in the late 1950s and early 1960s, who often greased their hair and wore leather jackets.
- **Teen idols**—the clean cut, wholesome singers that the major labels promoted in the late 1950s and early 1960s to counter the success of independent label R&B and rock and roll.
- **Tin Pan Alley**—the term describing the music publishing industry in the first half of the 20th century.
- **Toasting**—spontaneous commentary to music by Jamaican DJs that creatively involved rhyming, interesting verbal sounds, the use of different dialects and nonsense syllables.
- **Top 40**—the radio format in which the 40 top selling songs are played in repetition, first developed by Todd Storz at KOWH in Omaha, Nebraska.
- Trad jazz—the British nickname for traditional New Orleans jazz.
- **Trips Festival**—a three-day music festival held at Longshoreman's Hall in San Francisco in January 1966.
- Troubadour, the—the preeminent Los Angeles nightclub for folk music in the 1960s. Underground rock radio—see progressive rock radio.
- Wall of Sound (Grateful Dead)—an innovative sound reinforcement system used by the Grateful Dead that consisted of 604 speakers and 26,400 watts of power. Also refers to a production technique used by Phil Spector.
- Wall of Sound (Phil Spector)—a production technique developed and popularized by Phil Spector that involved the use of large instrumental groups, liberal doses of reverb, and multi-track overdubbing. Also refers to a sound system used by the Grateful Dead.
- **Western swing**—a form of country music that incorporates jazz swing rhythm and instruments associated with a jazz swing band.
- Whisky a Go Go—the preeminent nightclub on Los Angeles' Sunset Strip.
- Wobblies—the nickname for the International Workers of the World labor union.
- **Woodstock Music and Arts Fair**—the music festival held in Bethel, New York in August 1969 that drew an estimated audience of 450,000.
- Work song, shout, field holler—three song forms of African origin that were widely used on slave camps in the Southern United States.
- **Wrecking Crew, the—**a loose collection of Los Angeles studio musicians often used by Phil Spector and other producers in the early 1960s.

						۵		
	¥							
				,				
	No.							

A

Abdul, Paula, 314 Abramson, Herb. 9 AC/DC, 318, 345 Aces, 260 Adkins, Adele, 341 Adler, Lou, 205 Adler, Steven, 318 Aerosmith, 232-233, 268, 335 Afanasieff, Walter, 334 Afrika Bambaataa, 266, 267 Aiello, Danny, 307 Air Supply, 216 Alabama, 13, 43, 57, 101, 102, 147, 213–215, 270 Albin, Peter, 170–172 Alexander, Dave, 281 Alexander, J. W., 88, 89 Alice Cooper, 175, 233, 241–243 Alice in Chains, 329 Allen, Lee, 41, 42 Allen, Steve, 37, 48, 62 Allison, Jerry, 50 Allman Brothers Band, 185, 213-215 Allman, Duane, 185, 214-215 Almanac Singers, 110 Alpert, Herb, 66, 71 Alternative Nation, 314, 326-332 Amboy Dukes, 162, 163, 234 Ambrose, Joey, 32 Anastasio, Trey, 329, 330 Anderson, Chris, 352 Anderson, Ian, 240 Anderson, Jon, 240 Anderson, Pink, 237 Anderson, Signe, 166, 167 Andrews, Sam, 170-172 Animals, 65, 118, 153-155, 167, 183, 186, 207, 238 Anka, Paul, 51, 59, 60

Anthony, Michael, 234

Armstrong, Dido, 336 Armstrong, Louis, 4, 15 Arnold, Billy Boy, 44 Asher, Tony, 75 Asheton, Ron, 281 Asheton, Scott, 281 Ashford, Nicholas, 91, 250 Ashford, Rosalind, 97 Ashley, Gordon, 351 Atkins, Chet, 16, 37, 342 Atkins, Cholly, 90 Atlanta Rhythm Section, 215 Autry, Gene, 22 Avalon, Frankie, 59, 60, 72 Avory, Mick, 143, 154 Axton, Charles, 101 Axton, Charles "Packy," 98 Axton, Estelle, 97, 251 Ayler, Albert, 283 Azerrad, Michael, 293, 294, 314

B

Bacharach, Burt, 65-66 Backstreet Boys, 333 Bad Brains, 294 Baez, Joan, 21, 110, 112, 113, 116, 118, 120, 122, 182 Bain, Roge, 227 Baker, Brian, 294 Baker, Ginger, 120, 184, 185 Baker, Susan, 320 Balckwell, Otis, 63 Baldry, Long John, 245 Balin, Marty, 120, 166-168 Ballard, Florence, 92, 94, 96, 97 Ballard, Hank, 19 Ballard, Red, 6 Ballroom, Grand, 111 Bangs, Lester, 225 Banks, Peter, 240

Banshees, 290 Bar-Kays, 100, 101 Barncard, Steve, 170 Barrett, Aston, 262, 263 Barrett, Carlton, 262, 263 Barrett, Richard, 20 Barrett, Syd, 237 Barry, Jeff, 64, 68 Bartholomew, Dave, 41, 42 Bartold, Norman, 92 Basie, Count, 15, 261 Bay, Victor, 5 BDP, 269 Beachcombers, 148 Beard, Annette, 97 Beastie Boys, 268, 269 Beatlemania, 66, 135, 136, 142 Beau Brummels, 174, 202 Beaulieu, Priscilla, 38 Beck, Jeff, 154, 224, 228, 329-331 Beckett, Barry, 103 Bee Gees, 253, 255 Beecher, Franny, 32 Beefeaters, 197 Bees Make Honey, 286 Belafonte, Harry, 111, 321 Bell, Jimmy, 85 Bell, Thom, 252, 253 Beller, Alex, 5 Belnick, Arnold, 92 Below, Fred, 43 Benjamin, Benny, 91 Bennett, Tony, 4 Benson, Al. 11 Benson, Carla, 253 Benson, Renaldo, 95 Benton, Yvette, 253 Berigan, Bunny, 6 Berle, Milton, 37 Berlin, Irving, 3 Berliner, Jay, 208 Bernhart, Milt, 5 Berns, Bert, 171 Berry, Bill, 315, 316 Berry, Chuck, 16–18, 40, 45–46, 56, 57, 74, 129, 136, 140, 143, 155, 184 Best, Pete, 134, 135 Betts, Dickey, 214, 215 Beyoncé, 337, 338 Biafra, Jello, 295 Bieber, Justin, 352 B.I.G, 272, 273 Big Bopper, 51 Big Brother and the Holding Company, 168, 170-172, 115, 152

Biggie Smalls, 272

Bigham, John, 336 Bihari, Jules, 9 Bihari, Sau, 9 Billy J. Kramer and the Dakotas, 152, 153 Birdsong, Cindy, 96 Bitten, Roy, 311 Black, Bill, 36, 38 Black Flag, 293, 294 Black, Jimmy Carl, 179 Black Oak Arkansas, 215 Black Sabbath, 225-227, 255, 317 Blackmore, Ritchie, 231 Blackwell, Bumps, 42 Blackwell, Chris, 262, 263 Blaine, Hal, 69, 75, 76, 198, 202 Blind Faith, 185 Blondie, 290 Blood, Sweat and Tears, 182 Bloomfield, Mike, 120 Blossoms, 69 Blow, Kurtis, 267 Blue Flames, 186 Blue Oyster Cult, 234 Blue Velvets, 212 Bluebirds, 19 Blues Incorporated, 143, 182, 183 Bluesbreakers, 183, 184, 218 Bluesology, 245 Boddicker, Michael, 305 Body Count, 271, 272 Bogart, Neil, 216, 347 Bolan, Marc, 243 Bolder, Trevor, 244 Bolognini, Ennio, 5 Bomb Squad, 269 Bon Jovi, 345 Bonfire, Mars, 225 Bongiovi, John, 317 Bonham, John, 228, 230 Bono, 310-311 Bono, Sonny, 69 Booker T. and the MGs, 98–102 Boone, Pat, 6, 58 Bourdon, Rob, 345 Bowie, David, 241, 243-245, 257 Boyce, Tommy, 71 Boyz II Men, 333, 334 Bradford, James, 44 Bradley, Owen, 342 Bragg, Billy, 344 Branca, Glenn, 315, 316 Brand, Oscar, 114, 119 Brando, Marlon, 31 Bray, Stephan, 307 Brenston, Jackie, 31, 33, 34

Bridges, Willie, 104

Campbell, Luther, 270 Bridgewater, Joe, 85 Canadian Squires, 210 Bright Eyes, 344 Canned Heat, 182 Brinsley Schwarz, 286 Broadus, Calvin, 272 Cannon, Freddy, 59 Brooks, Garth, 342 Capp, Frank, 75 Brooks, Gene, 20 Carabello, Michael, 173 Carey, Mariah, 333, 334, 338 Brooks, Glenn, 85 Broomfield, Nick, 273 Carmen Electra, 309 Brown, Dan, 352 Carroll, Hattie, 118 Cars, 291, 292 Brown, David, 173 Carson, John, 21 Brown, James, 17, 84-87, 254, 256, 257, 264, 280 Brown, Myra Gale, 48 Carter, A. P., 21 Brown, Rov. 41, 42 Carter, Immy, 265 Brown, Willie, 14, 16 Carter, Maybelle, 21 Browne, Jackson, 208, 217 Carter, Rubin "Hurricane," 122 Bruce, Jack, 182, 184, 185 Carter, Sara, 21 Carter, Shawn, 336 Bruce, Lenny, 178 Caruana, Jim, 338 Bruce, Michael, 242 Bruford, Bill, 240 Caruso, Enrico, 7 Bryon, Dennis, 255 Casady, Jack, 167-168 B52s, 292 Casey, Al, 76 Buck, Peter, 315, 316 Cash, Johnny, 47, 209 Caton, Roy, 75 Buckingham, Lindsey, 218, 219 Buddy, 65 Cecil, Malcolm, 259 Buffalo Springfield, 196, 197, 200, 201 Cedena, Dez, 294 Cedrone, Danny, 32 Buggles, 302 Chad Mitchell Trio, 197 Bulgakov, Michail, 146 Bulsara, Frederick, 232 Chalmers, Charles, 104 Bunuel, Luis, 211 Chancler, Ndugu, 305 Chandler, Bryan "Chas," 154, 155, 186, 187 Burdon, Eric, 154, 155 Burke, Solomon, 186 Chandler, Chas, 155, 187 Burnett, Chester, 17 Chantays, 73 Burns, Bob, 213, 214 Chapman, Mark David, 142, 320 Burrell, Stanley, 270 Charlatans, 139, 164, 168, 173 Burroughs, William, 225 Charles, Bobby, 44 Burroughs, William S., 116 Charles, Ray, 17, 82, 84-87, 94, 103, 321 Burrus, Terry, 334 Charlie Daniels Bank, 215 Buster, Prince, 263 Chase, Clifton "Jiggs," 268 Butler, Terry "Geezer", 226, 227 Checker, Chubby, 19, 56, 61, 62 Buttrey, Kenny, 121 Cher, 71, 174, 215 Buxton, Glen, 242 Chesney, Kenny, 342 Buzzcocks, 290 Chess, Leonard, 43–45 Byrd, Eddie, 18 Chess, Phil, 9, 43, 45 Byrds, 118, 120, 123, 152, 162, 163, 175, 196-200, 209 Chicago, 216 Byrne, David, 291 Chick Webb Orchestra, 18 Chiffons, 68 Chimes, Terry, 289 Chipmunks, 61 Cactus, 234 Chrisman, Gene, 104 Cadena, Dez, 294 Christgau, Robert, 217 Cadillacs, 19 Chuck D, 269 Chudd, Lew, 9, 41 Caillat, Ken, 218 Cale, John, 281-283 Cicle Jerks, 295 Calvert, Bernie, 153 Cipollina, John, 173

Cirimelli, Gary, 334

City, 286

Campbell, Clive, 266

Campbell, Glen, 69, 342

Clapton, Eric, 140, 141, 154, 182–186, 211, 215, 224, 260, 263, 321 Clark, Dick, 6, 49, 58, 60-61 Clark, Gene, 197, 198 Clarke, Allen, 153 Clarke, Michael, 197, 198 Clarke, Tony, 237 Clarkson, Kelly, 352 Clarkson, Lana, 70 Clash, 279, 286, 287, 289, 290 Clayton, Adam, 312 Clayton, Merry, 214 Clearwater Revival, 161, 162, 182, 209, 211-212 Clemons, Clarence, 311 Cliff, Jimmy, 260, 262 Clifford, Barry, 225 Clifford, Doug, 211, 212 Clinton, George, 241, 257-258, 291, 316 Coasters, 20, 64 Cobain, Kurt, 327, 328, 345 Cochran, Eddie, 56 Cocker, Joe, 181, 182 Cogbill, Tommy, 104 Cole, Jerry, 75, 198 Cole, Nat "King," 45, 71, 84 Coley, Doris, 64 Collins, Allen, 213, 214 Collins, Bootsy, 87, 258 Collins, Judy, 197, 200, 205, 208 Collins, Phil, 314, 321 Collins, Ray, 179 Coltrane, John, 169, 198, 283 Colvin, Doug, 284 Combs, Sean, 273 Comets, 31-33 Comfort, Joe, 5 Como, Perry, 48, 65 Constanten, Tom, 169, 170 Cook, Paul, 286, 287 Cook, Stu, 211 Cooke, Sam, 17, 71, 82, 84, 87–89, 117 Copeland, Steward, 292 Corvairs, 19 Cosby, Bill, 114 Costello, Elvis, 66, 260, 286, 291, 292 Cottier, Irving, 5 Council, Floyd, 237 Count Five, 280 Country Joe and the Fish, 161, 162, 166, 168, 173 Courson, Pamela, 178 Cox, Billy, 189 Cramer, Floyd, 37 Crazy Horse, 200

Cream, 14, 17, 184-186, 224, 225, 251, 309

Creedence Clearwater Revival, 161, 162, 182, 209, 211-212

Creed, Linda, 253, 345

Crewcuts, 20 Crimes, Tory, 289 Criss, Peter, 233 Croce, Jim, 208 Cromwell, Chad, 343 Cropper, Steve, 98-102 Crosby, Bing, 4, 7 Crosby, David, 196-201, 205 Crosby, Stills, Nash and Young, 118, 147, 153, 161, 162, 181, 182, 197, 200-201, 251 Crowe, Cameron, 165 Crows, 19 Crumb, R., 172 Crystals, 68 Cummings, Joh, 284 Cuomo, Rivers, 332 Curtis, Jim, 279 Curtis, King, 104, 186 Dacre-Barclay, Michael, 237 Dahl, Steve, 256 Dakotas, 152, 153 Dale, Dick, 72, 73 Daltrey, Roger, 148-151 Daltry, Roger, 150, 151 Damned, 290 Damone, Vic, 4 Danko, Rick, 210, 211 Dannen, Fredric, 216, 347 Darin, Bobby, 59 Dashut, Richard, 218 Dave Clark Five, 153 Dave Matthews Band, 329-331 David, Hal, 65-66 Davies, Cyril, 182 Davies, Dave, 154 Davies, Ray, 154 Davis, Bill, 18 Davis, Clive, 313 Davis, Miles, 15, 87, 189, 330, 331 Davis, Richard, 208 Day, Doris, 5, 198 DCFC, 344 de Lory, Al, 75, 76 Deacon, John, 232

Dead, Grateful, 170

Dead Milkmen, 162

Deadheads, 168, 329

Dean, Elton, 245

Dean, James, 31

Dees, Rick, 256

Dead Kennedys, 293, 295

Death Cab for Cutie, 344

Deep Purple, 180, 183, 226, 230-231

371

Def Leppard, 317 Dekker, Desmond, 260, 262, 263 Delfonics, 253 Del-Phis, 97 Delson, Brad, 345 Delta Cats, 33, 34 Del-Tones, 72, 73 Densmore, John, 173, 176, 177 Denver, John, 321, 342 Derek and the Dominoes, 185 DeShannon, Jackie, 66 Destiny's Child, 337 Detours, 148 Devo, 291, 292 Diamond, Jim, 344 Diamond, Neil, 71, 231 Diaz, Herman Jr., 111 Diddley, Bo, 17, 18, 40, 44-45, 143, 149, 154 Diggers, 164 Dijon, Rocky, 146 Dinkin, Alvin, 5 Dion and the Belmonts, 67 Distants, 96 Dixie Chicks, 342 Dixie Cups, 68 Dixon, Luther, 64 Dixon, Willie, 17, 43, 45, 143, 228, 229 DI No I.D, 337 Doherty, Denny, 199 Dolenz, Micky, 71 Domino, Fats, 6, 18, 40-42, 61, 261 Dominos, 20, 215 Donahue, DJ Tom, 165 Donegan, Lonnie, 128 Donovan, Kevin, 139, 162, 163, 266 Dorsey, Tommy, 4 Douglas, Steve, 75 Downing, K. K., 231 Dozier, Lamont, 91, 92 Dr. Dre, 271, 272, 336 Dr. Feelgood, 286 Dr. Hook and the Medicine Show, 165 Dread, Judge, 263 Drifters, 20, 63-68 Drummond, Don, 261 Dryden, Spencer, 167–168 Dukowski, Chuck, 294 Dula, Tom, 111, 112 Dunaway, Dennis, 242 Dunn, Donald "Duck," 99-102 Dupars, Joe, 87 Duran Duran, 302 Dwight, Reginald Kenneth, 245 Dylan, Bob, 21, 62, 88, 89, 93, 109, 112–123, 137, 141, 154, 155, 161–163, 169, 171, 186, 187, 196–198, 201, 203, 209-211, 310, 311, 321

E

E Street Band, 311 Eagles, 10, 217-218, 338 Earth, Wind and Fire, 259 Eastman, Linda, 141 Eddie and the Hot Rods, 286 Edelstein, Walter, 5 Edison, Harry, 5 Ehrlich, Jesse, 76 Einstürzende Neubauten, 318 El Dorados, 19 Electric Flag, 225 Elgins, 96 Elizondo, Mike, 336 Ellington, Duke, 15 Elliot, Bobby, 153 Elliot, Mama Cass, 197, 199 Elliott, Ramblin' Jack, 114, 116, 122 Ellis, Alfred "Pee Wee," 87 Emerick, Geoff, 138 Emerson, Eric, 243 Emerson, Keith, 241 Emerson, Lake and Palmer, 239, 241, 262 Eminem, 336, 337 Eno, Brian, 245, 312 Entwistle, John, 148-152, 228 Epstein, Brian, 134, 139, 143, 152 Erdely, Tom, 284 Errico, Greg, 258 Ertegun, Ahmet, 84, 85 Estes, Sleepy John, 33 Estrada, Roy, 179 Eurythmics, 302 Evans, David "the Edge," 311-312 Everly Brothers, 21, 143, 153 Evers, Medgar, 118

F

Fab Four, 118, 136, 152 Fabian, 59, 61 Fakir, Abdul, 95 Falls, Mildred, 16 Fambrough, Henry, 253 Family Dog, 164, 170 Fanning, Shawn, 348, 349 Farrow, Mia, 139 Farrow, Prudence, 139 Federici, Danny, 311 Federline, Kevin, 337 Felder, Don, 217 Feldman, Victor, 69 Fellon, Michael, 163 Fender, Leo, 73 Fergie, 340 Ferlinghetti, Lawrence, 164

Ferry, Bryan, 246 Fields, Frank, 41, 42 Fishman, Jon, 329, 330 Fitzgerald, Ella, 204, 341 Flack, Roberta, 253 Flames, 86 Flamingos, 19, 43 Flatt, Lester, 23 Flavor Flav, 269 Fleetwood, Mac, 183, 218-219 Fleetwood, Mick, 183, 218-219 Fleetwoods, 19 Fletcher, Ed "Duke Bootee," 268 Flock of Seagulls, 302 Floyd, Charles "Pretty Boy," 109 Floyd, Eddie, 99 Floyd, Harmonica Frank, 33 Flying Burrito Brothers, 210, 217 Flying Machine, 207 Fogerty, John, 212 Fogerty, Tom, 212 Fong-Torres, Ben, 165 Fontana, D. J., 38 Foo Fighters, 345, 346 Ford, Gerald, 263 Foreigner, 216 Fortina, Carl, 75 Foster, Laure, 112 Foster, Paul, 92 Four Freshmen, 74 Foxx, Jamie, 85 Francis, Connie, 59, 60, 65 Frankie Lymon and the Teenagers, 20, 304 Franklin, Aretha, 16, 17, 66, 82, 102-104, 204, 215, 313 Franklin, C. L., 103 Franklin, Carolyn, 104 Franklin, Erma, 104, 171 Frantz, Chris, 291 Fratto, Russ, 46 Freddie and the Dreamers, 152, 153 Freed, Alan, 11–12, 31, 32, 45, 46, 58, 59 Frehley, Paul "Ace," 233 Frey, Glenn, 217, 218 Friedman, Mort, 5 Fripp, Robert, 239 Frizzell, William "Lefty," 24 Froeba, Frank, 6 Fugazi, 295 Full Tilt Boogie Band, 172 Funicello, Annette, 72 Funk Brothers, 91-93, 100 Funkadelic, 257 Fugua, Harvey, 90, 95 Furay, Richie, 199 Furnier, Vincent, 241, 242

Fusari, Rob, 340

G Gabler, Milt, 18, 32 Gaines, Cassie, 214 Gaines, Steve, 214 Gaitsch, Bruce, 307 Galaxies, 19 Galuten, Albhy, 348 Gambill, Hason "Slim," 343 Gamble, Kenny, 252 Gang, James, 217 Garcia, Jerry, 132, 167-170 Garfield, Henry, 294 Garfunkel, Art, 201, 202 Garnes, Sherman, 20 Garrity, Freddie, 152 Garvey, Marcu, 261 Gary Glitter, 244 Gates, David, 306 Gaye, Anna, 95 Gaye, Marvin, 90–92, 94, 95, 97, 250 Geffen, David, 216, 217 Geldorf, Bob, 321 Generation X, 290 Genesis, 241 Gentle Giant, 241 "Georgia Tom," 16 Germanotta, Stefani, 340 Gerry and the Pacemakers, 152, 153 Gershwin, George, 3 Gershwin, Ira, 3 Getz, Dave, 170, 171 Gibb, Barry, 255 Gibb, Robin, 255 Gibbard, Ben, 344 Gibb, Maurice, 255 Gibbs, Richard, 92 Gibson, "Jockey Jack," 11 Giles, Michael, 239 Gillan, Ian, 231 Gillespie, Dizzy, 15, 16 Gilmore, Mikal, 273 Gilmour, David, 238 Ginn, Greg, 294 Ginsberg, Allen, 116, 119, 120, 164 Glass, Philip, 291 Gleason, Ralph J., 164-166 Glover, Melvin, 268 Glover, Roger, 231 Godchaux, Donna, 170 Godchaux, Keith, 170 Godrich, Nigel, 331 Goffin, Gerry, 64, 65, 70, 204

Golden Chords, 115

Goldner, George, 20

Golliwogs, 212

373

Goodman, Benny, 5, 261 Hamilton, Tom, 232 Goodman, Fred, 196 Hammer, M.C., 270 Goodman, Harry, 6 Hammerstein, Oscar II, 3 Gordon, Jim, 185 Hammond, John, 103, 116, 117, 310 Gordon, Justin, 5 Hammond, John Jr., 210 Gordon, Kim, 316 Hampton, Lionel, 17 Gordon, Mike, 329, 330 Hancock, Hunter, 11 Gordy, Berry, 64, 90, 94-97, 250, 251, 303 Handy, W. C., 13 Gore, Al, 180, 320 Hansen, Beck, 331 Gore, Tipper, 180, 320 Hardin, Thomas Louis, 12 Gorgoni, Al, 119 Hardin, Tim, 114, 182 Gozzo, Conrad, 5 Harold Melvin and the Blue Notes, 252 Graham, Bill, 164 Harrell, Kuk, 338 Graham Central Station, 259 Harris, Addie, 64 Graham, Larry, 258 Harris, Robert, 88 Grand Funk Railroad, 183 Harris, Wynonie, 17, 35 Grande, Johnny, 32 Harrison, George, 122, 129-131, 133, 134, 136-138, 140, Grandmaster Flash and the Furious Five, 265-267 141, 143, 185 Grandmaster Melle Mel, 268 Harrison, Jerry, 291 Grant, Peter, 228 Harry, Deborah, 290 Grayson, Gilliam, 112 Hart, Bobby, 71 Great Society, 164, 167, 174 Hart, Lorenz, 3 Green, Al, 253 Hart, Mickey, 164, 169, 170 Green, Jerome, 44, 45 Hatfield, Bobbie, 70 Green, Peter, 218 Havel, Vaclav, 180 Greenfield, Howard, 64, 65 Havens, Richie, 182 Greenwald, Andy, 332 Hawkins, Roger, 102 Greenwich, Ellie, 64, 67, 68 Hawkins, Ronnie, 210, 213 Greenwood, Colin, 330, 331 Hawkins, Taylor, 346 Greenwood, Jonny, 330, 331 Hawks, 120, 209 Greg, Bobby, 119 Hayes, Isaac, 83, 99, 102, 257, 260 Gregg, Bobby, 120 Hayward, Justin, 237 Gretch, Rick, 185 Haywood, Dave, 343 Griffin, Paul, 120 Headon, Topper, 289 Grim Reaper, 317 Healy, Dan, 170 Grohl, Dave, 235, 327, 328, 346 Heartbreakers, 243 Grossman, Albert, 113 Heavy Metal Kid, 225 Grundy, Bill, 287 Heider, Wally, 170 Grunt, Blind Boy, 115 Hell, Richard, 283 Guard, Dave, 112 Helm, Levon, 210, 211 Guns N' Roses, 317-318 Helms, Chet, 164, 170 Guralnick, Peter, 84, 97 Henderson, Billy, 253 Gurley, James, 171 Henderson, Fletcher, 5, 6, 15 Gurley, Jim, 170, 172 Hendrix, Jimi, 44, 45, 48, 155, 161, 162, 165, 172, 181–183, Gussak, Billy, 32 186-188, 224 Guthrie, Arlo, 182 Henley, Don, 217, 218 Guthrie, Woody, 14, 88, 109, 110, 115, 119, 344 Herman, Paul, 336 Herman's Hermits, 152, 153 Hester, Drew, 346 Н Hetfield, James, 317 Haley, Bill, 17, 31–35, 39, 129 Hewson, Paul, 311 Halford, Rob, 231 Hey, Jerry, 305 Hall, Al, 20 Hibbert, Toots, 263 Hall, Joe, 101 Hicks, Tony, 153 Hall, René, 92 Highway CQ's, 88

Hill, Faith, 342

Hall, Rick, 102

Impalas, 19

Hill, Henry, 5 Imperials, 19 Hill, Ian, 231 Ingber, Elliot, 179 Hill, Joe Louis, 34 Ingram, Barbara, 253 Hill, Raymond, 34 Ink Spots, 18 International Submaine Band, 209 "Hillbilly Shakespeare," 24 Hillman, Chris, 196, 198, 210 Iommi, Tony, 226, 227 His Comets, 31, 32 Iron Butterfly, 183, 226 Hobbstweedle, 228 Iron Maiden, 317 Hofmann, Albert, 162 Isley Brothers, 186, 259 Hogan, Carl, 18 Ives, Burl, 108 Hokum Brothers, 16 Ivy, Quinn, 103 Holdsworth, Jeff, 329 Izenhall, Aaron, 18 Holiday, Billie, 4, 103 Holland, Brian, 92, 250 J Holland, Eddie, 91, 92, 250 Jackson, 250, 304, 333 Holland, Loris, 334 Jackson 5, 83 Holland, W.S., 48 Jackson, Al Jr., 98–102 Hollings, Peatsy, 320 Jackson, Janet, 339 Holly, Buddy, 32, 34, 44, 49-51, 56, 152, 203 Jackson, Josh, 18 Holzman, Jac, 280 Jackson, Mahalia, 16 Honeydippers, 230 Jackson, Michael, 141, 204, 253, 300, 301, 303–308, 314, Hood, David, 103 321, 326, 338 Hooker, John Lee, 17 Jackson, O'Shea, 271 Hopkins, Nicky, 146 Jackson, Pervis, 253 Horn, Bob, 60 Jackson, Wayne, 101, 102 Horn, Jim, 76 Jackson, Wesley, 85 Hoskins, Barney, 174 Jaffee, Rami, 346 Hot Five, 15 Jagger, Mick, 139, 142-146, 206, 321 Hot Seven, 15 Jamerson, James, 91, 94 Hot Tuna, 168 James Brown and The Famous Flames, 86 House, Son, 14, 16, 345 James, Clifton, 44 Houston, Whitney, 313 James, Elmore, 17, 33 Howe, Steve, 240 James, Etta, 341 Howlin' Wolf, 17, 33, 43, 154 James, Fanita, 69 Hubbard, Neil, 181 Janes, Roland, 49 Hudson, Garth, 211 Jardine, Al, 73–75, 77 Hudson, Saul "Slash," 317 Jarrard, Rick, 167 Hues Corporation, 254 Jarvis, Al, 10 Huff, Leon, 252 Jay-Z, 336, 337 Human Be-In, 164 Jaz-O, 336 Human League, 302 Jefferson Airplane, 120, 123, 147, 164, 166-168, 181, 203 Hunter, Meredith, 147 Jefferson, Blind Lemon, 14 Hunter, Robert, 169, 170 Jefferson Starship, 168 Huxley, Aldous, 176 Iet Set, 197 HŸsker DŸ, 295 Jethro Tull, 241, 262 Hyland, Brian, 61 Jimi Hendrix Experience, 183, 187, 188, 224, 225 Hyman, Jeffrey, 284 Jobs, Steve, 349 Hynde, Chrissie, 292 Joel, Billy, 162, 314, 321 Johansen, David, 243 Johanson, Jai Johanny, 215 Ian and Sylvia, 202 John, Elton, 4, 216, 241, 243, 245, 254, 321 Ice Cube, 271 Johns, Glyn, 151, 217 Ice-T, 271 Johnson, Brian, 318 Iggy Pop, 281 Johnson, Jimmy, 103, 104

Johnson, Johnny, 45

Johnson, Louis, 305 Johnson, Lyndon, 110 Johnson, Maxine, 5 Johnson, Plas, 75 Johnson, Robert, 14, 16, 184 Johnston, Bob, 121 Johnston, Bruce, 75 Jolson, Al, 4 Jones, Booker T., 98–102 Jones, Brian, 143–146, 172, 174 Jones, Darryl, 147 Jones, Davy, 71, 244 Jones, Gloria, 69 Jones, John Paul, 228, 230 Jones, Kenney, 152 Jones, Mick, 289 Jones, Quincy, 84, 301, 304, 305, 321 Jones, Ralph, 16 Jones, Spike, 178 Jones, Steve, 286–288 Jones, Tom, 66 Joplin, Janis, 165, 170-172, 181 Jordan, Louis, 16-18, 261 Jordanaires, 37, 38 Joshua, Jaycen, 338 Journey, 216 Joy Division, 290 Judas Priest, 231 Julye, Kathryn, 5

K

Kantner, Paul, 166-168 Kara's Flowers, 340 Kaukonen, Jorma, 166–168 Kaye, Carol, 69, 75 Kaye, Connie, 208 Kaye, Lenny, 283 Kaye, Tony, 240 Kaylan, Howard, 180 Kazebier, Nate, 6 KC and the Sunshine Band, 254 Kear, Josh, 344 Keef Hartley Band, 182 Ke\$ha, 338 Kelley, Charles, 343 Kellum, Alphonso, 87 Kendall, Alan, 255 Kendricks, Eddie, 96 Kennedy, Robert F., 194 Kenny, Bill, 18 Kerouac, Jack, 116 Kesey, Ken, 139, 162, 164, 169 Kessel, Barney, 69, 75 Khayat, Nadir, 341 King, B. B., 11, 16, 33, 35, 184, 321 King, Ben E., 20, 64 King, Carole, 64, 65, 71, 103, 196, 203–205, 207, 216 King, Clydie, 214 King Crimson, 235, 239 King, Ed, 213, 214 King, Jean, 69 King, Martin Luther, Jr., 16, 83, 87, 101, 110, 112, 194, 251 King, Maurice, 90 King, Riley B., 10 Kingsmen, 280 Kinks, 153, 154, 183, 225, 228 Kirshner, Don, 64, 70, 71 KISS, 233 Kitwana, Bakari, 264 Kizart, Willie, 34 Klee, Harry, 5 Klein, Mannie, 5 Knechtel, Larry, 69, 75, 198 Knight, Jesse, 34 Knight, Marion "Suge," 272 Knopper, Steve, 216, 303, 337, 350 Knowles, BeyoncŽ, 339-340, 352 Kong, Leslie, 262 Kool and the Gang, 259 Kool Herc, 265, 266 Kooper, Al, 120, 121, 214 Korner, Alex, 143, 182 Kornfeld, Artie, 181 Kortchmar, Danny "Kootch," 205, 207 Kovic, Ron, 311 Kozmic Blues Band, 171, 172 Kramer, Billy J., 152 Kramer, Joey, 232 Kramer, Wayne, 280 Kreutzman, Bill, 169, 170 Krieger, Robby, 173, 176–177 Kristofferson, Kris, 172 Krupa, Gene, 6 Kwatinetz, Jeff, 352

La Bostrie, Dorothy, 43
Lacey, Jack, 6
Lady Anbtebellum, 343, 344
Lady Gag, 341–342
Lake, Greg, 239
Lambert, Kit, 149
Landau, Jon, 188, 310, 311
Landy, Bob, 115
Lane, Robin, 197
Lang, Michael, 173, 181
Langhorne, Bruce, 119
Lanois, Daniel, 312
Larkey, Charles, 205
LaRock, Scott, 269

Lynyrd Skynyrd, 213-214

Lytle, Marshall, 32

Lastie, Melvin, 104 M Lauper, Cyndi, 321 Macho, Joseph Jr, 119 Law, Don, 14, 342 MacIntosh, Peter, 263 Lawrence, Steve, 65 MacKaye, Ian, 294 Leadbelly, 14, 108, 110 Madonna, 253, 307-308 Leadon, Bernie, 217 Magic Tramps, 243 Leary, Tomothy, 138, 162, 164 Maines, Natalie, 342 Leason, Ralph J., 164-166 Mamas and the Papas, 123, 164, 175, 188, 196, 199 Leavell, Chuck, 215 Mangano, Mickey, 5 Led Zeppelin, 43, 154, 225-230, 251, 317, 349 Mann, Berry, 63-65, 70 Ledbetter, Huddie, 14, 108 Manson, Charles, 77, 194 Lee, Beverly, 64 Manson, Marilyn, 243 Lee, Peggy, 5, 64 Manuel, Richard, 211 Lee, William E., 119 Manzarek, Ray, 173, 174, 176, 177 Leeds, Milton, 73 Marcucci, Bob, 61 Lehmann, Edie, 307 Marcus, Greil, 165 Leiber, Jerry, 20, 62–65, 68, 136, 252 Margouleff, Robert, 259 Lennon, John, 129-132, 134, 136, 138, 141, 203, 245, 306, Marketts, 73 319-320, 331 Mar-Keys, 98, 99 Lennon, Julia, 134 Markoff, John, 160 Lesh, Phil, 169, 170 Marley, Bob, 260, 262-263 Lester, Richard, 136, 137 Marocco, Frank, 75 Levene, Keith, 289 Maroon, 340 Levine, Adam, 340 Mars, Bruno, 338 Levine, Larry, 70 Marsh, Dave, 328 Lewis, Huey, 314 Marshall Tucker Band, 215 Lewis, Jerry Lee, 47–49, 56, 280 Martha and the Vandellas, 91, 92, 97, 250 Lewis, Rudy, 63 Martin, Dean, 4 Lightfoot, Gordon, 208 Martin, Dewey, 199 Limelighters, 197 Martin, George, 132, 134, 136-138, 140, 141, 235 Lindo, Earl, 263 Martini, Jerry, 258 Linkin Park, 345 Marvelettes, 89, 93-94 Little Eva, 65 Mason, Nick, 238 Little Richard, 6, 16–18, 42–43, 56, 59, 100, 115, 129, 132, Matassa, Cosimo, 41 143, 186, 280 Mathers, Marshall III, 336 Livingstone, Bunny, 262, 263 Matlock, Glen, 286, 287 Lizard King, 177-178 Matthews, Sherlie, 214 L.L. Cool J., 269 Mattola, Tommy, 216 Lodge, John, 237 May, Brian, 232 Loggins, Kenny, 212 Mayall, John, 120, 183, 184 Lomax, Alan, 108 Mayfield, Curtis, 260 Lomax, John, 108 MC5, 280, 281 Lord, Jon, 231 McBride, Martina, 342 Lorenz, George "Hound Dog," 11 McCarthy, Joseph, 110 Love, Andrew, 101, 102 McCartney, Paul, 118, 130-134, 136, 138, 141, 162, 181, Love, Courtney, 327 203, 216, 255, 304–306, 321 Love, Darlene, 69 Love, Mike, 73-77, 139 McCarty, Jim, 154 McCoy, Charlie, 121 Lowe, Junior, 103 McCoy, Van, 254 Lowe, Nick, 286 McCrae, George, 254 Lustgarten, Edgar, 5 McCullough, Henry, 181 Lydon, John, 286, 287 Lymon, Frankie, 20 McDaniels, Darryl, 268 McDonald, Ian, 239 Lynn, Loretta, 321 Mcdonald, Joe, 173 Lynne, Jeff, 122, 141

McEntire, Reba, 342

McGraw, Tim, 342

McGuinn, Jim, 198 McGuinn, Jim (Roger), 196-198 McKenzie, Scott, 164, 199 McKernan, Ron "Pigpen," 169, 170 McLaren, Malcolm, 283, 286, 287, 289 McManus, DeClan Patrick, 292 McNally, Dennis, 170 McNelley, Rob. 343 McPhatter, Clyde, 20 McVie, Christine, 218, 219 McVie, John, 183, 218, 219 Meaden, Pete, 148, 149 Medley, Bill, 70 Meher Baba, 150, 151 Meisner, Randy, 217 Melanie, 182 Melcher, Terry, 195, 198 Mellencamp, John, 208 Mellor, John, 289 Melton, Barry, 173 Melvin, Harold, 252 Mendel, Nate, 346 Mendes, Sergio, 66, 71 Merchant, Jimmy, 20 Mercury, Freddie, 232 Merry Pranksters, 139, 162-164, 169 Mersey Beat, 152 Messina, Jim, 199, 212 Metallica, 317, 345 MFSB, 252, 253 MG's, 98-102 Midnighters, 19 Migliori, Jay, 69, 75 Mike, Wonder, 267 Miles, Buddy, 189 Miller, Bill, 5 Miller, Jimmy, 145-147 Miller, Tom, 283 Mills Brothers, 18 Mills, Mike, 315–317 Ministry, 319 Minor Threat, 294 Minutemen, 295 Miracles, 89, 91-93, 95 Mitchell, Chuck, 205 Mitchell, Joni, 196, 200, 203-206, 239 Mitchell, Mitch, 187, 188 Mizell, Jason, 268 Moby Grape, 167, 174 Moffett, Johnathan, 307 Mogis, Mike, 344 Mondello, Toots, 6 Monk, Thelonious, 15, 16 Monkees, 188 Monroe, Bill, 23, 36

Moody Blues, 235-237

Moog, Robert, 236

Moon, Keith, 148–152, 180, 228 Moondog House Rock and Roll party, 11, 12 Moonglows, 43, 95 Moore, Alan, 231 Moore, Jonny, 63 Moore, Pete, 93 Moore, Sam, 101, 102 Moore, Scotty, 36, 38 Moore, Thurston, 316 Morales, David, 334 Moraz, Patrick, 240 Morgan, Tommy, 76 Moroder, Georgio, 254 Morricone, Ennio, 330 Morris, Keith, 294 Morris, Nathan, 334-335 Morris, Steveland, 94 Morris, Wanya, 334-335 Morrison, George Ivan "Van," 204, 207-208, 211 Morrison, Jim, 172, 173, 175-177, 195, 294 Morrison, Sterling, 282 Morrison, Steve, 175 Morrow, Tracy, 271 Morton, George "Shadow," 243 Moss, Wayne, 121 Most, Mickie, 155 Mother McCree's Uptown Jug Champions, 169 Mothers of Invention, 175, 178-180 Mothership Connection, 257 Motörhead, 317 Mott the Hoople, 243, 246 Mottola, Tommy, 334 Mountain, 185, 234 "Mr. Rock and Roll," 11 Mštley CrŸe, 243 Mud Honey, 329 Mullen, Larry, 312 Murphy, Walter, 255 Murray, Alex, 5 Muzzillo, Ralph, 6 Myers, Richard, 283 Mysterians, 280, 281

N

Nash, Graham, 153, 161, 162, 196, 200, 201, 205
Nash, Johnny, 260
Nathan, Syd, 9, 86
Negroni, Joe, 20
Nelson, Jeff, 294
Nelson, Prince Rogers, 308–309
Nelson, Rick, 209, 217
Nelson, Ricky, 60
Nelson, Willie, 321
Nero, Paul, 5
Nesmith, Michael, 71
Nevins, Al, 64

New Christy Minstrels, 113, 197 New Journeyman, 199 New Kids on the Block, 333 New Riders of the Purple Sage, 168 New Yardbirds, 228 New York Dolls, 243, 283, 286 Newley, Anthony, 244 Newman, David "Fathead," 85 Newman, Floyd, 101 Newman, Randy, 208 Nicks, Stevie, 218, 219 Nico, 279, 282 Nietzsche, Friedrich, 175 Niggaz with Attitude (NWA), 271, 273 Nine Inch Nails, 318, 319 Nirvana, 326–329, 343, 345, 346 Nitty Gritty Dirt Band, 212 Nitzche, Jack, 69 Nitzsche, Gracia, 69 Nitzsche, Jack, 69 Nixon, Richard M., 194 Nolen, Jimmy, 87 Noone, Peter, 153 Notorious B.I.G., 272, 273 Novoselic, Krist, 327, 328 'NSync, 333 Nyro, Laura, 204, 208

0

Oakley, Berry, 215 Oberst, Conor, 344 O'Brien, Ed, 330, 331 O'Brien, Joel, 205 Ochs, Phil, 114 Odetta, 114 Odum, Bernard, 87 O'Jays, 252 Oldham, Andrew Loog, 143 Oldham, Spooner, 102-104 101ers, 286, 289 Ono, Yoko, 139, 142, 319, 320, 331 Orbison, Roy, 47, 122, 141, 321 Orioles, 19 Osbourne, Ozzy, 224, 226, 227 Osmonds, 333 Osterberg, James, 281 Otis, Jonny, 17, 44 Outler, Jimmie, 92 Owens, Shirley, 64 Owsley, 164, 170

P

Page, Jimmy, 149, 154, 224, 228 Page, Patti, 6, 8 Paice, Ian, 231

Pallenberg, Anita, 145 Palmer, Bruce, 199 Palmer, Earl, 41, 42 Pappalardi, Felix, 185 Parker, Charlie, 15, 16 Parker, Col. Tom, 37-38 Parker, Deanie, 251 Parker, James, 340 Parker, Maceo, 87, 258 Parliament, 257 Parry, Dick, 238 Parsons, Gram, 198, 209-210 Parton, Dolly, 342 Patton, Charley, 14, 16 Paul, Billy, 253 Paul Whiteman Orchestra, 4 Paxton, Tom, 114, 116 Payton, Lawrence, 95 Pearl Jam, 329 Pearlman, Lou, 333 Pearson, Gene, 63 Peckinpah, Sam, 122 Peer, Ralph, 21, 22 Penderecki, Krzysztof, 330 Penguins, 19 Pennebaker, D.A., 119, 120 Perkins, Carl, 34, 40, 47-49, 56, 132, 136 Perkins, Clayton, 47, 48 Perkins, Jay, 47, 48 Perry, Joe, 232, 268, 269 Perry, Katy, 338 Perry, Lee "Scratch," 262 Peter, Paul and Mary, 112, 113, 117 Peterson, Ray, 68 Petty, Norman, 50, 51 Petty, Tom, 122, 140, 321 P-Funk All Stars, 257 Phelge, Nanker, 144 Phillinganes, Greg, 305 Phillips, Dewey, 35, 36 Phillips, John, 164, 199 Phillips, Michelle, 199 Phillips, Sam, 9, 33–37, 40, 46–49, 102 Phish, 170, 329, 330 Pickett, Bobby "Boris," 61 Pickett, Wilson, 99, 101, 103, 215 Pinckney, St. Clair, 87 Pinder, Mike, 237 Pinetoppers, 100 Pink Floyd, 216, 237-238, 341 Pitman, Bill, 75 Pitney, Gene, 69 Pittman, Albert, 267 Plant, Robert, 228 Plotkin, Chuck, 311

Poco, 199, 212, 217

Pohlman, Ray, 75, 76 Redding, Noel, 187-188 Poindexter, Buster, 243 Redding, Otis, 17, 83, 99-101, 104 Pollock, Jackson, 283 Redman, Don, 5, 6 Pomus, Doc. 67 RedOne, 341 Porter, Cole, 3, 5 Reed, Lou, 244, 282 Porter, David, 99, 102 Reed, Waymond, 87 Reeves, Martha, 90, 97 Powell, Billy, 213, 214 Powell, Maxine, 90 Relf, Keith, 154 Prater, Dave, 101, 102 R.E.M, 314-316, 330, 343, 344 Presley, Elvis Aron, 4–6, 10, 16, 17, 23, 24, 31–33, 35–41, Renaldo, Lee, 316 46, 47, 49, 50, 59, 61–63, 67, 115, 129, 134 René, Henry, 111 Presley, Gladys and Vernon, 35, 38 Rex, T., 243, 244 Presley, Lisa Marie, 38, 306 Reves, Ron, 294 Pressler, Lyle, 294 Reynolds, Nick, 112 Pretenders, 291, 292 Reznor, Trent, 318, 319 Price, Alan, 154, 155 Rhodes, Bernard, 289 Rhythm Playboys, 50 Price, Bill, 288 Rich, Charlie, 47 Price, Lloyd, 42 Price, Vincent, 304 Richard, Renald, 85 Priddy, Jimmy, 5 Richards, Keith, 143-146, 210 Richards, Ron, 152 Prima, Louis, 17 Primes, 96 Richardson, Karl, 255 Primettes, 96 Rick and the Ravens, 176 Prince, 253, 303-309 Riddle, Nelson, 5 Prior, Richard, 114 Righteous Brothers, 65, 70 Rihanna, 338 Prisonaires, 34 Riley, Terry, 151, 291 Procol Harum, 235 "Professor Bop," 11 Rimbaud, Arthur, 176 Psychedlic Stooges, 279 Rimes, LeAnn, 342 Public Enemy, 269 Ritchie, John, 288 Public Image, 288 Ritchie, Lionel, 321 Ritz, Lyle, 75, 76 Puff Daddy, 273 Pure Prairie League, 212 Rivers, Johnny, 174 Roach, Max, 15 Putnam, John, 307 Robbins, Marty, 65 Roberts, George, 5 Robertson, Robbie, 210, 211 Quaife, Peter, 154 Robey, Don, 9 Quarry Men, 51, 134 Robinson, Claudette, 93 Queen, 232 Robinson Cynthia, 258 Queen Latifa, 269 Robinson, Ray Charles, 84-85 Quicksilver Messenger Service, 164, 168, 173 Robinson, Smokey, 93 Quiet Rio, 234 Robinson, Sylvia, 267, 268 Quill, 182 Robinson, William "Smokey," 89, 91, 93, 96, 321 Robo, 294 Rodgers, Jimmy, 21, 22 Radiohead, 329-331 Rodgers, Richard, 3 Radle, Carl, 185 Rogers, Bobby, 93 Ramones, 284-285 Rogers, Kenny, 342 Randi, Don, 69, 70 Rogers, Roy, 22 Rankin, Kenny, 119 Rojas, Michael, 343 Rasbury, Levi, 87 Rojas, Peter, 352 Ravens, 19, 176 Rolie, Gregg, 173 Reagan, Ronald, 310, 320 Rolling Stones, 17, 43, 46, 62, 142, 146, 148, 153, 154, 166, Red Hot Chili Peppers, 315–317 182, 207, 225, 239, 255, 283, 338

Rollini, Art, 6

Red, Tampa, 16

Rollins, Henry, 294 Romantics, 291, 292 Ronettes, 68 Ronson, Mick, 244 Ronstadt, Linda, 212, 217 Rose, Axel, 317, 318 Rose, Fred, 23, 25 Rosen, Hilary, 351 Ross, Diana, 20, 90, 92, 96, 97, 321 Ross, Nathan, 5 Rossington, Gary, 213, 214 Roth, David Lee, 234 Rothberg, Arlyne, 207 Rothchild, Paul, 173, 177 Rotten, Johnny, 287, 288 Rowland, Bruce, 181 Rowland, Kelly, 337 Roxon, Lillian, 197 Royal Spades, 98 Rubin, Jerry, 164 Rubin, Rick, 269 Ruffin, David, 96 Rundgren, Todd, 243 Run-D.M.C, 266, 269 Rupe, Art, 9, 42 Rush, Tom, 205 Russell, Bert, 171 Russell, Bob, 73 Russell, Curly, 15 Russell, Leon, 69, 198 Russell, Mischa, 5

S

Rydell, Boddy, 59, 61

Saddler, Joseph, 266

Sadler, Barry, 162

Sahl, Mort, 178 Sainte-Marie, Buffy, 205 Salt-n-Pepa, 269 Sam and Dave, 99, 101-102 Sambora, Richie, 317 San Francisco Mime Troupe, 164 Sandom, Doug, 148 Santana, 147, 173, 174, 181 Santana, Carlos, 173, 174 Santiago, Herman, 20 Santiago, Maria Elena, 51 Satherley, Art, 14 Savakus, Russ, 120 Schoolly D, 269 Schrader, Paul, 311 Schuckett, Ralph, 205 Schwartz, Brinsley, 292 Schwartz, Willie, 5

Scorsese, Martin, 211

Scott, Bon, 318 Scott, Hillary, 343, 345 Scott, Ken, 244 Scott, Tom, 305 Screaming Trees, 329 Scruggs, Earl, 23 Sebatian, John, 114, 182, 202 Sedaka, Neil, 64, 65 Seeger, Charles, 109 Seeger, Pete, 14, 109, 110, 112-115, 117, 119, 198 Seger, Bob, 217 Selway, Phil, 330, 331 Seville, Dave, 61 Sex Pistols, 278, 279, 286–289 Shakira, 341 Shane, Bob, 112 Shangri-Las, 68 Shankar, Ravi, 182 Shea, Dan, 334 Sheen, Bobby, 69 Sheila E., 309 Shelley, Steve, 316 Shelton, Robert, 116 Shiflett, Chris, 346 Shinoda, Mike, 345 Shirelles, 64, 65 Shirley, Jimmy, 17 Shocklee, Hank, 270 Shrieve, Michael, 173 Shuman, Mort, 67 Shure, Paul, 5 Sigma Sweethearts, 253 Simmons, Gene, 234 Simmons, Joseph, 268 Simmons, Russell, 268 Simon and Garfunkel, 103, 116, 196, 201-202 Simon, Carly, 203, 207 Simon, John, 171, 211 Simon, Paul, 201-202, 260, 321 Simon, Richard, 206 Simone, Nina, 16 Simonon, Paul, 289 Simpkins, Po, 18 Simpson, Valerie, 91, 250 Sims, Willie, 34 Sinatra, Frank, 4, 5, 45 Sinfield, Peter, 239 Siouxsie, 290 Skatalites, 261 Skinner, Leonard, 213 Skinny Puppy, 319 Slade, 244 Slatkin, Eleanor, 5 Slatkin, Felix, 5

Sledge, Percy, 103

Slick, Darby, 167

381

Slick, Grace, 164, 167, 203 Sly and the Family Stone, 181, 182, 258-259, 316 Small Faces, 152 Small, Millie, 261 Smalls, "Dr. Jive," 11 Smear, Pat, 345, 346 Smile, 232 Smith, Bessie, 14, 172 Smith, Bobby, 253 Smith, Greg, 305 Smith, Huey, 41, 42 Smith, Mamie, 14 Smith, Neal, 242 Smith, Patti, 283 Snider, Dee, 320 Snoop Doggy Dog, 271, 272 Sohl, Richard, 283 Solomon, Maynard, 113 Sommer, Bert, 182 Sonic Youth, 314-316, 343 Sons of Champlin, 174 Sopwith Camel, 174 Soul Giants, 178 Soul Sonic Force, 267 Soul Stirrers, 17, 88 Soul Survivors, 252 Soundgarden, 327, 329 Sousa, John Phillip, 7 South, Joe, 231 Souther, J. D, 217 Spann, Otis, 43, 44 Spears, Britney, 333, 334, 340 Spector, Phil, 63, 64, 67-72, 90, 91, 132, 140, 284 Spence, Skip, 166 Spenner, Alan, 181 Spice Girls, 341 Spinners, 252, 253 Springsteen, Bruce, 162, 310, 311, 321, 335, 344 Squire, Chris, 240 Stainton, Chris, 181 Stamp, Chris, 149 Stanley, Agustus Owsley, III, 164, 170 Stanley, Paul, 233 Staple Singers, 211 Stapp, Scott, 344 Starkey, Richard, 135 Starlite Wranglers, 36 Starr, Ringo, 130, 131, 135, 136, 138, 141, 180 Steals, Melvin, 253 Steals, Mervin, 253

Steel, John, 154, 155

Steinberg, Lewie, 98

Steppenwolf, 183, 225

Stevens, Cat, 206, 208

Stewart, Jim, 97, 251

Stewart, Ian, 145

Stewart, Rod, 208, 246 Stiff and Rough Trade, 286 Stiles, George "Cat Man," 11 Stills, Stephen, 71, 197, 199, 201 Sting, 292 Stipe, Michael, 315, 316 Stockman, Shawn, 334 Stoker, Gordon, 38 Stokes, Sidney, 49 Stokey, Noel Paul, 113 Stoller, Mike, 20, 62-65, 68, 136, 252 Stone Canvon Band, 212, 217 Stone, Slv, 258-259 Stooges, 244, 279, 281 Stookey, Noel Paul, 112, 116 Storz, Todd, 12 Strand, 286 String Cheese Incident, 170 Strong, Barrett, 89, 91 Strummer, Joe, 286, 289 Stubblefield, Clyde, 87 Stubbs, Levi, 95 Stylistics, 252 Sugar Hill Gang, 266 Sugarhill Gang, 266, 267 Sullivan, Ed, 37, 62, 117, 131, 135, 145, 153, 177 Sullivan, Niki, 50 Summer, Donna, 253, 254 Summers, Andy, 292 Sumner, Gordon, 292 Sutcliff, Stu, 134 Suttles, Warren, 19 Swallows, 19 Sweet, 244 Sweetwater, 182 Swift, Taylor, 342

T

Talking Heads, 290, 291, 330 Tallent, Garry W, 311 Tanner, Paul, 76 Tarantino, Quentin, 73 Tarnopol, Nat, 93 Tate, Sharon, 77, 319 Taupin, Bernie, 245 Taylor, Dick, 143 Taylor, James, 204-207 Taylor, Johnny, 255 Taylor, Mick, 146, 147, 183 Taylor, Roger, 232 T-Birds, 19 Ted Nugent and the Amboy Dukes, 234 Tedesco, Tommy, 69 Teen Idles, 294 Templeman, Ted, 234

Tempo, Nino, 69 Ten Years After, 182 Terrell, Tammi, 95 Terry, Johnny, 63 Texas Troubadours, 24 Tharpe, Sister Rosetta, 16 The Band, 120, 121, 182, 208-210 The Beach Boys, 64, 69, 71–77, 199 The Beatles, 10, 39, 43, 46, 48, 50, 51, 62, 64, 70, 71, 76, 89, 100, 118, 123, 129–132, 137–139, 141, 143, 146, 162, 195, 197, 204, 235, 239, 306, 349 The Carpenters, 66, 71 The Crickets, 50, 51 The Cure, 315, 317 The Doors, 14, 43, 123, 161, 162, 174–178 The Faces, 147 The Feelies, 315, 317 The Four Tops, 91, 92, 95, 250 The Grateful Dead, 120, 162, 164, 166, 168–170, 173, 181, 214, 329 The Hollies, 50, 51, 153 The Incredibe String Band, 182 The Kingston Trio, 111, 112 The Lovin' Spoonful, 197, 202 The Monkees, 71, 72, 244, 333 The Moondog Coronation Ball, 11 The Nitty Gitty Dirt Band, 197 The Paul Butterfield Blues Band, 119, 182, 196 The Pixies, 315, 316, 328 The Police, 260, 290-76 The Replacements, 314, 316, 343 The Robins, 19, 63 The Saddlemen, 31 The Searchers, 152, 153 The Supremes, 19, 90–92, 94, 96–97 The Surfari's, 73 The Teenagers, 20 The Temptations, 19, 91, 96, 250 The Violent Femmes, 315, 317 The Who, 44, 148, 150, 151, 182, 213, 235, 280 Thicke, Robin, 340 Thomas, B. J., 66 Thomas, Carla, 98 Thomas, Charlie, 63 Thomas, Chris, 288 Thomas, Dylan, 115 Thomas, Jasper, 45 Thomas, Millard J., 111 Thomas, Milton, 5 Thomas, Ray, 237 Thomas, Robert Milkwood, 115 Thomas, Rufus "Bear Cat," 34, 98 Thompson, Hunter S., 165 Thompson, Robert, 352 Thornton, Big Mama, 34, 38, 63, 172

Three Degrees, 252

Thunders, Johnny, 243 Till, Emmett, 116 Timberlake, Justin, 333, 339 Time, 310 Tindley, Charles, 110 Tipton, Glenn, 231 Tizol, Juan, 5 TLC, 334 Tomiie, Satoshi, 334 Tommy Dorsey Orchestra, 4 Torin, "Symphony Sid," 11 Tork, Peter, 71 Townshend, Pete, 148-151, 187 Tramps, 253 Traveling Wilburys, 123, 141 Travers, Mary, 112, 113 Tremonti, Mark, 345 Troggs, 188 Trucks, Butch, 215 Tubb, Ernest, 22, 24 Tucker, Maureen, 282 Tupac Shakur, 272 Turner, Ike, 34, 70 Turner, Joe, 17, 32 Turner, Tina, 70, 321 Turtles, 180, 202 Twain, Shania, 342, 346 Tweedy, Jeff, 344 Twisted Kites, 315 Twisted Sister, 321 2 Live Crew, 266, 269, 270 Tyler, Alvin Red, 41, 42 Tyler, Steve, 232, 268 Tympany Five, 17, 18 Tyson, Ian, 202 Tyson, Sylvia, 202

U

U2, 311–312 Ulrich, Lars, 317 Uranian Willy, 225 Urbanski, Randy, 338 Uriah Heep, 234

V

Valens, Ritchie, 51 Valenti, Dino, 173 Valentine, Hilton, 154, 155 Valentine, James, 340 Vallee, Rudy, 4 Valvano, Mike, 92 Valverde, Roberto, 294 Van Dyke, Earl, 91 Van Eaton, J. M., 49 Van Eps, George, 5, 6 Van Halen, 14, 154 Wexler, Jerry, 17, 85, 88, 98, 100–104, 251 Van Halen, 225, 234 Weymouth, Tina, 291 Van Halen, Alex, 234 Wheatly, Dennis, 226 Van Halen, Eddie, 234, 304 White, Alan, 240 White, Barry, 253 Van Ronk, Dave, 114, 116 Van Zandt, Steve, 311 White, Clifton, 92 Van Zant, Donnie, 215 White, Jack, 344 Van Zant, Ronnie, 213, 214 White, Meg, 344 Vandros, Luther, 64 White, Robert, 91 Vanilla Fudge, 183, 226, 228 White, Ronnie, 93 Vanity 6, 309 Whitfield, Norman, 91, 95, 96 Whitford, Brad, 232 Vejtables, 174 Velvet Underground, 279, 281-282 Whitley, Charles, 85 Verlaine, Tom, 283 Whitlock, Bobby, 185 Vibrators, 289 Whitter, Henry, 112 Vicious, Sid, 286, 288 Wickham, Andy, 49 Vig, Butch, 327, 328, 346 Wilco, 344 Village People, 255 Wilkerson, Don, 85 Vincent, Gene, 34 Wilkeson, Leon, 213, 214 Voidoids, 283 Will.i.am, 338 Volman, Mark, 180 Williams, Andy, 67 Williams, Audrey, 25 Williams, Billie Jean, 25 W Williams, David, 305, 307 Wailers, 260, 262-263 Williams, Eldee, 87 Wakeman, Rick, 240 Williams, Hank, 22, 24, 25, 115, 122 Williams, Michelle, 337 Walcott, Nate, 344 Walden, Phil, 215 Williamson, Billy, 32 Wales, Howard, 170 Williamson, James, 5 Williamson, Sonny Boy, 17 Walker, T-Bone, 44 Wallace, Christopher, 272 Wills, Bob, 23 Walsh, Joe, 218 Wilson, Brian, 64, 69, 73–76, 132, 138, 196 Walter, Little, 17, 43 Wilson, Carl, 73-76 Ward, Bill, 226 Wilson, Dennis, 73–76, 194 Wilson, Jackie, 93 Warhol, Andy, 147, 282, 331 Warlocks, 169 Wilson, Mary, 92, 96, 97 Warwick, Dionne, 66, 313, 321 Wilson, Murry, 73, 74 Waters, Ethel, 14 Wilson Phillips, 199 Waters, Muddy, 17, 43-45, 129, 143, 184, 211, 229 Wilson, Tom, 119, 120, 179, 201, 202, 282 Waters, Roger, 237 Wings, 141, 216, 255 Watts, Charlie, 144-146 Winter, Johnny, 182 Watts, Howard, 23 Winwood, Stevie, 185 Weaver, Jesse, 269 Wise, Chubby, 23 Wise, Fred, 73 Weavers, 110 Webber, Andrew Lloyd, 307 Wolfe, Tom, 163 Weezer, 330, 332 Wolfer, Bill, 305 Wolley, Sheb, 61 Weil, Cynthia, 65, 70, 205 Weinberg, Max, 311 Wonder, Stevie, 94, 95, 141, 250, 259, 321 Weir, Bob, 169, 170 Wood, Ron, 147 Welch, Bob, 218 Woodmansey, Mick, 244 Welker, Ed, 111 Worley, Paul, 343 Wells, Mary, 250 Worrell, Bernie, 291 Wenner, Jann, 165 Wray, Fred Lincoln "Link," 224, 280 Wrecking Crew, 69, 71, 75, 198 Wesley, Fred, 87, 258 West, Kanye, 335, 337 Wright, Edna, 69

Wright, Jimmy, 20

Westerberg, Paul, 316

American Pop, 2–3	Another Side of Bob Dylan (Bob Dylan), 118
audience segmentation and, 6	Anthem of the Sun (The Grateful Dead), 166, 169
Bacharach/David hits and, 65-66	Anti-war songs, 117, 118, 161, 162
big band Jazz and, 5	Apollo Theatre (Harlem), 51, 87, 303
Brill Building Pop and, 64–66	Appalachian region, 20–21
bubblegum pop/sing-along songs and, 72	Apple production company, 139, 140, 207
cover versions of hits and, 6	
dance crazes in, 5	Are You Experienced? (Jimi Hendrix Experience),
early pop singers and, 4	183, 187
girl groups and, 68	Art rock, 2, 195, 235
hillbilly music and, 6	additional artists in, 241
independent record labels, emergence of, 6	characteristics of, 235
Pomus/Shuman hits and, 67	classical music references and, 235, 237
post-War transitional years and, 6–7	key recordings of, 235
race music and, 6	King Crimson and, 239
Rhythm and Blues and, 6–7	Mellotron and, 235
surf culture music and, 72–77	Mini-Moog and, 236
Swing Era and, 5–6	origins of, 235–236
teen idols and, 59–61	Pink Floyd and, 237–238
Tin Pan Alley and, 3, 64	principle artists in, 235
Wall of Sound sessions, 69–70	shock tactics and, 241
Wrecking Crew and, 69	Yes and, 240–241
See also American Rock and Roll; American Rock	See also 1970s landscape
and Roll/second phase; Black popular music;	As Clean as They Wanna Be (2 Live Crew), 270
Motown Records; Rock and Roll; Stax Records;	As Nasty as They Wanna Be (2 Live Crew), 266, 270
Traditional rural music	Ash Grove (Los Angeles), 197
	Astral Weeks (Van Morrison), 204, 208
American Rock and Roll/phase one, 2	Asylum Records, 216, 217
backlash against, 12, 31, 77–74, 82	ā.
black roots of, 12–20	At Fillmore East (Allman Brothers Band), 215
Chicago Rhythm and Blues and, 43–46	Atlantic Records, 9, 20, 63, 84, 98, 102, 228
crossover artists and, 40	Audio Home Recording Act (AHRA) of 1992, 326
emergence of, 2–3, 33–35	Automobile culture, 30
explosion of, 40–51	cult heroes and, 31
generation gap and, 31	youth audiences, connectedness of, 31
grassroots independence in, 3	Avalon Ballroom (San Francisco), 164, 169
guitar technique and, 45	
jazz-rock fusion and, 15	D
Memphis sound and, 46–47	В
New Orleans sound and, 41–43	"Baba O'Riley" (the Who), 149–151
pop music industry and, 2–3	"Baby Love" (Marvelettes), 93
post-War transitional years and, 6–7, 31–35	Baby One More Time (Britney Spears), 334
regional differences and, 40–51	Back spinning technique, 266
white roots of, 20–25	Ballad form, 21
See also American Pop; American Rock and Roll;	Barn dance radio programs, 22, 50
Rock and Roll	Basement Tapes, 120–122, 211
American Rock and Roll/phase two, 49, 56	Bayou Country (Creedence Clearwater Revival),
backlash against, 57–58	209, 212
black/white audiences, intermingling of, 58	
death of Rock and Roll, changing landscapes and,	Beat writers, 108, 115–116, 164
56–57	Beatlemania, 135, 136, 142
girl groups and, 68	The Beatles, 128–131
major record labels, refined Rock and Roll and, 57	aftermath/post-Beatles lives and, 141–142
maturing audiences, tame Rock and Roll and, 57	American debut of, 135–136
payola, roll of, 58–59	American mop tops and, 71
Rock stars, turnover of, 57	Apple production company and, 139, 140
teen idols and, 59–61	audition for, 134–135

breakup of, 141 chemistry/contributions of, 132, 133, 135, 140 coming of age and, 137–138 Dylan, influence of, 118, 123, 137 early years of, 134 final work of, 140–141 impact of, 132 impending demise of, 139–140 key recordings of, 131, 135–142 management of, 132–134, 139, 140 musical influences on, 132 singles releases of, 139 See also British invasion; Post-war England Beatles for Sale (The Beatles), 139 "The Big Three Killed My Baby" (The White Stripes), 344 Big Machine Records, 338 Bikini beach party films, 72 Billboard magazine, 9, 17, 33, 36, 39, 40, 111, 128, 300, 303, 332, 333 "Billie Jean" (Wichael Jackson), 303–306 Bitter End Club (New York), 112 Black popular music, 250 Funk and, 256–260 Hip-hop and, 264–265 Philadelphia International Records and, 252–253 Rap and, 269–263 Soul, changing landscape of, 250–252 See also African American music; Blues; Soul Blackboard Jungle (film), 32 Blacklisting, 110, 178 Blackpotanto films, 260 Blonde on Blonde (Bob Dylan), 116, 120, 121, 123, 186 Blood on the Tracks (Bob Dylan), 122 "Blown' in the Wind" (Bob Dylan), 122 "Blown' in the Wind" (Bob Dylan), 122 "Blown' in the Wind" (Bob Dylan), 123, 137 Blue (oni Mitchell), 204, 206 Blues relation fields/prison camps and, 12 published sheet music and, 13 Country Blues and, 13 Country Blue	Beach Boys Pet Sounds album and, 75	Great Depression and, 14
chemistry/contributions of, 132, 133, 135, 140 coming of age and, 137–138 Dylan, influence of, 118, 123, 137 carly years of, 134 final work of, 140–141 impact of, 132 impending demise of, 139–140 key recordings of, 131, 135–142 management of, 132–134, 139, 140 musical influences on, 132 singles releases of, 139 See also British invasion; Post-war England Beatles for Sale (The Beatles), 136 The Beatles (The Beatles), 139 "The Big Three Killed My Baby" (The White Stripes), 344 Bebop, 15 Beggar's Banquet (Rolling Stones), 146 Big band music, 5, 7, 15 Big box store distribution, 348 Big Machine Records, 338 Bikini beach party films, 72 Billboard magazine, 9, 17, 33, 36, 39, 40, 111, 128, 300, 303, 332, 333 "Billie Jean" (Michael Jackson), 303–306 Bitter End Club (New York), 112 Black popular music, 250 Funk and, 256–260 Hip-hop and, 264–265 Philadelphia International Records and, 252–253 Rap and, 264–273 Reggae and, 260–263 Soft soul and, 252–253 Soul, changing landscape of, 250–252 See also African American music; Blues; Soul Blackboard Jungle (film), 32 Blackbitsing, 110, 178 Blackplotation films, 260 Blonde on Blonde (Bob Dylan), 116, 120, 121, 123, 186 Blood on the Tracks (Bob Dylan), 116, 120, 121, 123, 186 Blood on the Tracks (Bob Dylan), 116, 120, 121, 123, 186 Blood on the Tracks (Bob Dylan), 115, 179 Blue (Joni Mirchell), 204, 206 Blues or and and (Sez-253 Soul, changing landscape of, 250–252 See also African American music; Blues; Soul Blackboard Jungle (film), 32 Blackbitsing, 110, 178 Blue Jodel' (Jimmie Rodgers), 22 Bluegrass, 2, 22–23, 36 Blues, 2 AAB lytic form of, 12, 13 bortleneck guitars and, 14 Classic Blues and, 13 Country Blues and, 13 Delta bluesmen and, 14 cally recordings of, 14	Beatlemania and, 135, 136, 142	Jim Crow laws/racial oppression and, 13
coming of age and, 137–138 Dylan, influence of, 118, 123, 137 early years of, 134 final work of, 140–141 impact of, 132 impending demise of, 139–140 key recordings of, 131, 135–142 management of, 132–134, 139, 140 musical influences on, 132 singles releases of, 139 Singles releases of, 139 The Big Three Killed My Baby" (The White Stripes), 344 Beatles for Sale (The Beatles), 136 The Beatles (The Beatles), 139 The Big Three Killed My Baby" (The White Stripes), 344 Big Machine Records, 338 Big bast ore distribution, 348 Big Machine Records, 338 Bikini beach party films, 72 Billboard magazine, 9, 17, 33, 36, 39, 40, 111, 128, 300, 303, 332, 333 "Bille Jean" (Michael Jackson), 303–306 Bitter End Club (New York), 112 Black popular music, 250 Funk and, 256–260 Hip-hop and, 264–265 Philadelphia International Records and, 252–253 Rap and, 264–265 Philadelphia International Records and, 252–253 Reggae and, 260–263 Soff soul and, 252–255 Soul, changing landscape of, 250–252 See also African American music; Blues; Soul Blackboard Jungle (film), 32 Blacklisting, 110, 178 Black Joint on the Tracks (Bob Dylan), 116, 120, 121, 123, 186 Blood on the Tracks (Bob Dylan), 122 "Blowin' in the Wind" (Bob Dylan), 122 "Blowin' in the Wind" (Bob Dylan), 113, 117 Blue (Join Mitchell), 204, 206 Blonde on Blonde (Bob Dylan), 115, 117 Blue (Join Mitchell), 204, 206 Blonde on Blonde (Bob Dylan), 116, 120, 121, 123, 186 Blood on the Tracks (Bob Dylan), 122 "Blowin' in the Wind" (Bob Dylan), 113, 117 Blue (Join Mitchell), 204, 206 Blonde on Blonde (Bob Dylan), 115, 117 Blue (Join Mitchell), 204, 206 Blonde on Blonde (Bob Dylan), 115, 117 Blue (Join Mitchell), 204, 206 Blonde on Blonde (Bob Dylan), 116, 120, 121, 123, 186 Blood on the Tracks (Bob Dylan), 122 "Blowin' in the Wind" (Bob Dylan), 113, 117 Blue (Join Mitchell), 204, 206 Blonde on Blonde (Bob Dylan), 115, 117 Blue (Join Mitchell), 204, 206 Blonde on Blonde (Bob Dylan), 115, 117 Blue (Join Mitchell), 204, 206 Blonde on Blonde (Bob Dylan), 115, 117 Blue (Join Mitchell), 204, 206 Blon		Memphis Blues scene and, 34
Dylan, influence of, 118, 123, 137 carly years of, 134 final work of, 140–141 impact of, 132 impending demise of, 139–140 key recordings of, 131, 135–142 management of, 132–134, 139, 140 musical influences on, 132 singles releases of, 139 See also British invasion; Post-war England Beatles for Sale (The Beatles), 136 "The Batels (The Beatles), 136 "The Batels (The Beatles), 139 "The Big Three Killed My Baby" (The White Stripes), 344 Bebop, 15 Beggar's Banquet (Rolling Stones), 146 Big band music, 5, 7, 15 Big box store distribution, 348 Bikini beach party films, 72 Billboard magazine, 9, 17, 33, 36, 39, 40, 111, 128, 300, 303, 332, 333 "Billie Jean" (Michael Jackson), 303–306 Bitter End Club (New York), 112 Black popular music, 250 Funk and, 256–260 Hip-hop and, 264–265 Philadelphia International Records and, 252–253 Rap and, 264–273 Reegae and, 260–263 Soft soul and, 252–253 Soul, changing landscape of, 250–252 See also African American music; Blues; Soul Blackboard Jungle (film), 32 Blacklisting, 110, 178 Blazklisting, 110, 178 Blazklistin	chemistry/contributions of, 132, 133, 135, 140	
early years of, 134 final work of, 140-141 impact of, 132 impending demise of, 139-140 key recordings of, 131, 135-142 management of, 132-134, 139, 140 musical influences on, 132 singles releases of, 139 See also British invasion; Post-war England Beatles for Sale (The Beatles), 136 The Beatles (The Beatles), 136 The Beatles (The Beatles), 139 The Big Three Killed My Baby" (The White Stripes), 344 Bebop, 15 Big band music, 5, 7, 15 Big box store distribution, 348 Big Machine Records, 338 Bikini beach party films, 72 Billboard magazine, 9, 17, 33, 36, 39, 40, 111, 128, 300, 303, 332, 333 "Billie Jean" (Michael Jackson), 303–306 Bitter End Club (New York), 112 Black popular music, 250 Funk and, 256-260 Hip-hop and, 264-265 Philadelphia International Records and, 252-253 Rap and, 264-273 Reggae and, 260-263 Soft soul and, 252-253 Soul, changing landscape of, 250-252 See also African American pusic; Bob of the Meyall/Eric Clapton), 160, 182-1 Bob Diddley rhythm, 44 Bob Dylan (Bob Dylan), 115 Bob mian Rhapsody" (Queen), 232 Born In the U.S.A. (Bruce Springsteen), 310-311 Born This Way (Lady Gaga), 341 "Both Sides Now" (Join Mitchell), 206 Bottleneck guitars, 14 Bob Dylan (Bob Dylan), 113 Born This Way (Lady Gaga), 341 "Both Sides Now" (Join Mitchell), 206 Bottleneck guitars, 14 Boy bands Backstreet Boys and, 333 Bieber, Justin and, 339 Boyz II Men and, 333 New Kids on the Block and, 333 Piblic Jean" (Mischell), 206 British from, 63, 64, 66 husband/wife teams in, 64 independent producers and, 63 playlets, mini-stories/humorous lyrics and, 63 recording process, control over, 63 See also American pop to and, 75-76 Blus Yolde" (Jimmie Rodgers), 22 Bluegrass, 2, 22-23, 36 Blues, 2 "Blowin' in the Wind" (Bob Dylan), 113, 117 Blue (Join Mitchell), 204, 206 British Floxed and Folli Post-war England Rolling From Control (BBC), 129, 130 Briti	coming of age and, 137–138	plantation fields/prison camps and, 12
final work of, 140–141 impact of, 132 impending demise of, 139–140 key recordings of, 131, 135–142 management of, 132–134, 139, 140 musical influences on, 132 singles releases of, 139 See also British invasion; Post-war England Beatles for Sale (The Beatles), 136 "Bob Dylan (Bob Dylan), 115 "Bohemian Rhapsody" (Queen), 232 Born In the U.S.A. (Bruce Springsteen), 310–311 Born This Way (Lady Gaga), 341 "Bot Dylan (Bob Dylan), 115 "Bohemian Rhapsody" (Queen), 232 Born In the U.S.A. (Bruce Springsteen), 310–311 Born This Way (Lady Gaga), 341 "Bot Sides Now" (Join Mitchell), 206 Bottleneck guitars, 14 Boy bands Beggar's Banquet (Rolling Stones), 146 Big band music, 5, 7, 15 Big box store distribution, 348 Big Machine Records, 338 Bikini beach party films, 72 Billboard magazine, 9, 17, 33, 36, 39, 40, 111, 128, 300, 303, 332, 333 "Bilke [ean" (Michael Jackson), 303–306 Bitter End Club (New York), 112 Black popular music, 250 Funk and, 256–260 Hip-hop and, 264–265 Philadelphia International Records and, 252–253 Re gand, 264–273 Regage and, 260–263 Soft soul and, 252–253 Soul, changing landscape of, 250–252 See also African American music; Blues; Soul Blackboard Jungle (film), 32 Blacklisting, 110, 178 Blazkploitation films, 260 Blonde (Bob Dylan), 112, 1123, 186 Blood on the Tracks (Bob Dylan), 122 "Blowin' in the Wind" (Bob Dylan), 112, 1123, 186 Blood on the Tracks (Bob Dylan), 122 "Blowin' in the Wind" (Bob Dylan), 113, 117 Blue (Join Mitchell), 204, 206 "Blue Yode" (Jimmie Rodgers), 22 Bluegrass, 2, 22–23, 36 Blues, 2 AAB lyric form of, 12, 13 bottleneck guitars and, 14 Classic Blues and, 13 Country Blues and, 13 Colurty Blues and, 14 early recordings of, 14	Dylan, influence of, 118, 123, 137	published sheet music and, 13
impact of, 132 impending demise of, 139–140 key recordings of, 131, 135–142 management of, 132–134, 139, 140 musical influences on, 132 singles releases of, 139 singles releases of, 139 series of the Beatles of, 136 (The Beatles), 136 The Beatles (fr Sale (The Beatles), 136 The Beatles (fr Sale (The Beatles), 136 The Beatles (The Beatles), 139 The Big Three Killed My Baby" (The White Stripes), 344 Bebop, 15 Beggar's Banquet (Rolling Stones), 146 Big band music, 5, 7, 15 Big box store distribution, 348 Big Machine Records, 338 Bikini beach party films, 72 Billiboard magazine, 9, 17, 33, 36, 39, 40, 111, 128, 300, 303, 332, 333 "Billie Jean" (Michael Jackson), 303–306 Bitter End Club (New York), 112 Black popular music, 250 Funk and, 256–260 Hip-hop and, 264–265 Philadelphia International Records and, 252–253 Regae and, 260–263 Soft soul and, 252–253 Soul, changing landscape of, 250–252 See also African American music; Blues; Soul Blackboard Jungle (film), 32 Blacklisting, 110, 178 Blaxploitation films, 260 Blood on the Tracks (Bob Dylan), 122 Blown' in the Wind" (Bob Dylan), 122 Blown' in the Wind" (Bob Dylan), 122 Blown' in the Wind" (Bob Dylan), 122 Blue yould "(Immine Rodgers), 22 Bluegrass, 2, 22–23, 36 Blues, 2 AAB lyric form of, 12, 13 bottleneck guitars and, 14 Classic Blues and, 13 Country Blues and, 13 Country Blues and, 13 Classic Blues and, 14 early recordings of, 14	early years of, 134	work songs/shouts/field hollers and, 12
impending demise of, 139–140 key recordings of, 131, 135–142 management of, 132–134, 139, 140 musical influences on, 132 singles releases of, 139 See also British invasion; Post-war England Beatles for Sale (The Beatles), 136 The Beatles (The Beatles), 139 "The Big Three Killed My Baby" (The White Stripes), 344 Bebop, 15 Beggar's Banquet (Rolling Stones), 146 Big band music, 5, 7, 15 Big box store distribution, 348 Big Machine Records, 338 Bikini beach party films, 72 Billiboard magazine, 9, 17, 33, 36, 39, 40, 111, 128, 300, 303, 332, 333 "Billie Jean" (Michael Jackson), 303–306 Bitter End Club (New York), 112 Black popular music, 250 Funk and, 256–260 Hip-hop and, 264–265 Philadelphia International Records and, 252–253 Soul, changing landscape of, 250–252 See also African American music; Blues; Soul Blackboard Jungle (film), 32 Blacklisting, 110, 178 Blaxploitation films, 260 Blood on the Tracks (Bob Dylan), 112, 112, 123, 186 Blood on the Tracks (Bob Dylan), 112, 117 Blue (Joni Mitchell), 204, 206 "Blue Yordel" (Jimmie Rodgers), 22 Bluegras, 2, 22–23, 36 Blues, 2 AAB lyric form of, 12, 13 bottleneck guitars and, 14 Classic Blues and, 13 Country Blues and, 13 Classic Blues and, 13 Classic Blues and, 14 early recordings of, 14	final work of, 140–141	See also African American music; Gospel; Soul
key recordings of, 131, 135–142 management of, 132–134, 139, 140 musical influences on, 132 singles releases of, 139 See also British invasion; Post-war England Beatles for Sale (The Beatles), 136 The Beatles (The Beatles), 136 The Beatles (The Beatles), 139 "The Big Three Killed My Baby" (The White Stripes), 344 Bebop, 15 Big band music, 5, 7, 15 Big box store distribution, 348 Big Machine Records, 338 Bikini beach party films, 72 Billiboard magazine, 9, 17, 33, 36, 39, 40, 111, 128, 300, 303, 332, 333 "Billic Jean" (Michael Jackson), 303–306 Bitter End Club (New York), 112 Black popular music, 250 Funk and, 256–260 Hip-hop and, 264–265 Philadelphia International Records and, 252–253 Soul, changing landscape of, 250–252 See also African American music; Blues; Soul Blackboard Jungle (film), 32 Blacklisting, 110, 178 Blaxploitation films, 260 Blood on the Tracks (Bob Dylan), 116, 120, 121, 123, 186 Blood on the Tracks (Bob Dylan), 122 "Blowin' in the Wind" (Bob Dylan), 113, 117 Bluc (Join Mitchell), 204, 206 "Blue Yord!" (Jimmie Rodgers), 22 Bluegrass, 2, 22–23, 36 Blues, 2 AAB lyric form of, 12, 13 bottleneck guitars and, 14 Classic Blues and, 13 Country Blues and, 13 Country Blues and, 13 Delta bluesmen and, 14 early recordings of, 14		The Blues Brothers (film), 103
management of, 132–134, 139, 140 musical influences on, 132 singles releases of, 139 See also British invasion; Post-war England Beatles for Sale (The Beatles), 136 The Beatles (The Beatles), 136 The Beatles (The Beatles), 139 "The Big Three Killed My Baby" (The White Stripes), 344 Bebop, 15 Beggar's Banquet (Rolling Stones), 146 Big band music, 5, 7, 15 Big box store distribution, 348 Bikini beach party films, 72 Billboard magazine, 9, 17, 33, 36, 39, 40, 111, 128, 300, 303, 332, 333 "Billie Jean" (Michael Jackson), 303–306 Bitter End Club (New York), 112 Black popular music, 250 Funk and, 256–260 Hip-hop and, 264–265 Philadelphia International Records and, 252–253 Rap and, 264–273 Reggae and, 260–263 Soft soul and, 252–253 Soul, changing landscape of, 250–252 See also African American music; Blues; Soul Blackboard Jungle (film), 32 Blackbisting, 110, 178 Blackpopath and the Wind" (Bob Dylan), 116, 120, 121, 123, 186 Blood on the Tracks (Bob Dylan), 122 "Blowin' in the Wind" (Bob Dylan), 113, 117 Blue (Join Mitchell), 204, 206 "Blue Yodel" (Jimmie Rodgers), 22 Bluegrass, 2, 22–23, 36 Blues, 2 AAB lyric form of, 12, 13 bottleneck guitars and, 14 classic Blues and, 13 Country Blues and, 13 Columtry Blues and, 13 Delta bluesmen and, 14 early recordings of, 14	1	Bluesbreakers (John Mayall/Eric Clapton), 160, 182-184
musical influences on, 132 singles releases of, 139 See also British invasion; Post-war England Beatles for Sale (The Beatles), 136 The Beatles (The Beatles), 139 The Big Three Killed My Baby" (The White Stripes), 344 Bebop, 15 Beggar's Banquet (Rolling Stones), 146 Big band music, 5, 7, 15 Big box store distribution, 348 Big Machine Records, 338 Bikini beach party films, 72 Billiboard magazine, 9, 17, 33, 36, 39, 40, 111, 128, 300, 303, 332, 333 "Billie Jean" (Michael Jackson), 303–306 Bitter End Club (New York), 112 Black popular music, 250 Funk and, 256–260 Hip-hop and, 264–265 Philadelphia International Records and, 252–253 Rap and, 264–273 Reggae and, 260–263 Soft soul and, 253–253 Soul, changing landscape of, 250–252 See also African American music; Blues; Soul Blackboard Jungle (film), 32 Blacklisting, 110, 178 Blazklisting, 110, 178 Blue (Joni Mitchell), 204, 206 Blonde on Blonde (Bob Dylan), 116, 120, 121, 123, 186 Blood on the Tracks (Bob Dylan), 113, 117 Blue (Joni Mitchell), 204, 206 "Blue Yodel" (limmie Rodgers), 22 Bluegrass, 2, 22–23, 36 Blues, 2 AAB Pyric form of, 12, 13 bottleneck guitars, 14 Boy bands Backtsreet Boys and, 333 Bieber, Justin and, 339 Boyz II Men and, 333 'NSync and, 333, 339 Sve also Girl bands; Teen pop "Break on Through" (The Doros), 177 Breakdancing, 264, 305 "Briege Over Troubled Water" (Simon and Garfunkel) 103, 202 Brill Building Pop, 64–66 Aldon Music and, 64–65 hitis from, 63, 64, 66 husband/wife teams in, 64 independent producers and, 63 recording process, control over, 63 See also American Pop Bringing It All Back Home (Bob Dylan), 116, 118, 16 196, 198 British float tradition, 21 British invasion, 128 American mop tops and, 72 Beach Boys Per Sounds album and, 75–76 Blues-oriented groups and, 152–155 girl groups, demise of, 69 Hard Rock, second wave invasion and, 182–189 Mersey beat groups and, 152–155 girl groups, demise of, 69 Hard Rock, second wave invasion and, 182–189 Mersey beat groups and, 152–155 Top 10 hits, British arrists and, 19 Southerneck guitars, 14 Bo		Bo Diddley rhythm, 44
muscal influences on, 132 singles releases of, 139 See also British invasion; Post-war England Beatles for Sale (The Beatles), 136 The Beatles (The Beatles), 139 Born In the U.S.A. (Bruce Springsteen), 310–311 Born This Way (Lady Gaga), 341 Born In this Way Clady Gaga), 341 Born In this Way (Lady Gaga), 341 Born In this Way Clady Gaga), 341 Born In this Way Clady Gaga), 341 Born In the U.S.A. (Bruce Springsteen), 310–311 Born This Way (Lady Gaga), 341 Born In this Way Clady Gaga, 341 Born In this Way Clady Gaga), 341 Born In this Way Clady Gaga, 341 Born In thi		Bob Dylan (Bob Dylan), 115
See also British invasion; Post-war England Beatles for Sale (The Beatles), 136 The Beatles (The Beatles), 139 The Big Three Killed My Baby" (The White Stripes), 344 Bebop, 15 Beggar's Banquet (Rolling Stones), 146 Big band music, 5, 7, 15 Big box store distribution, 348 Big Machine Records, 338 Bikini beach party films, 72 Billiboard magazine, 9, 17, 33, 36, 39, 40, 111, 128, 300, 303, 332, 333 "Billie Jean" (Michael Jackson), 303–306 Bitier End Club (New York), 112 Black popular music, 250 Funk and, 256–260 Hip-hop and, 264–265 Philadelphia International Records and, 252–253 Rap and, 264–273 Reggae and, 260–263 Soft soul and, 252–253 Soul, changing landscape of, 250–252 See also African American music; Blues; Soul Blackboard Jungle (film), 32 Blackbisting, 110, 178 Blackbisting, 110, 178 Blackpiotation films, 260 Blonde on Blonde (Bob Dylan), 116, 120, 121, 123, 186 Blood on the Tracks (Bob Dylan), 122 Blood on the Tracks (Bob Dylan), 112, 123 Blue (Join Mitchell), 204, 206 "Blue Yodel" (Jimmie Rodgers), 22 Bluegrass, 2, 22–23, 36 Blues, 2 AAB lyric form of, 12, 13 bottleneck guitars, 14 Boy bands Backstreet Boys and, 333 Bieber, Justin and, 339 Boyz II Men and, 333 Nese also Girl bands; Teen pop "Breaks on Through" (The Doros), 177 Breakdancing, 264, 305 "Briege Over Troubled Water" (Simon and Garfunkel) 103, 202 Brill Building Pop, 64–66 Aldon Music and, 64–65 hits from, 63, 64, 66 husband/wife teams in, 64 independent producers and, 63 recording process, control over, 63 See also American Pop Bringing It All Back Home (Bob Dylan), 116, 118, 16 196, 198 British invasion, 128 Hilb mode and process, control over, 63 See also American Pop British flox tradition, 21 British invasion, 128 Hilb mode and process, control over, 63 See also American Pop British flox tradition, 21 British invasion, 128 Hilb mode and process, control over, 63 See also American Pop British flox tradition, 21 British invasion, 128 Hilb mode and process, control over, 63 See also American Pop Break dancing, 264, 305 Hilb mode and proces		
Born This Way (Lady Gaga), 341 "Both Sides Now" (Joni Mitchell), 206 Bottleneck guitars, 14 Boy bands Beggar's Banquet (Rolling Stones), 146 Big band music, 5, 7, 15 Big box store distribution, 348 Big Machine Records, 338 Bikini beach party films, 72 Billboard magazine, 9, 17, 33, 36, 39, 40, 111, 128, 300, 303, 332, 333 "Billie Jean" (Michael Jackson), 303–306 Bitter End Club (New York), 112 Black popular music, 250 Funk and, 256–260 Hip-hop and, 264–265 Philadelphia International Records and, 252–253 Regae and, 260–263 Soft soul and, 252–253 Soul, changing landscape of, 250–252 See also African American music; Blues; Soul Blackboard Jungle (film), 32 Blackploitation films, 260 Blonde on Blonde (Bob Dylan), 116, 120, 121, 123, 186 Blood on the Tracks (Bob Dylan), 122 "Blowin' in the Wind" (Bob Dylan), 113, 117 Blue (Joni Mitchell), 204, 206 "Blue Yodel" (Jimmie Rodgers), 22 Bluegras, 2, 22–23, 36 Blues, 2 AAB lyric form of, 12, 13 bottleneck guitars, 14 Borthis Way (Lady Gaga), 341 "Bott Sides Now" (Joni Mitchell), 206 Bottleneck guitars, 14 Bott Solds Now" (Joni Mitchell), 206 Bottleneck guitars, 14 Bot		
Bactes for Sale (I ne Beatles), 130 "The Big Three Killed My Baby" (The White Stripes), 344 Bebop, 15 Beggar's Banquet (Rolling Stones), 146 Big band music, 5, 7, 15 Big box store distribution, 348 Big Machine Records, 338 Bikini beach party films, 72 Billboard magazine, 9, 17, 33, 36, 39, 40, 111, 128, 300, 303, 332, 333 "Billie Jean" (Michael Jackson), 303–306 Bitter End Club (New York), 112 Black popular music, 250 Funk and, 256–260 Hip-hop and, 264–265 Philadelphia International Records and, 252–253 Rap and, 264–273 Reggae and, 260–263 Soft soul and, 352–253 Soul, changing landscape of, 250–252 See also African American music; Blues; Soul Blackboard Jungle (film), 32 Blackjisting, 110, 178 Blackjisting, 110, 178 Blackjisting, 110, 178 Blackjiotation films, 260 Blonde on Blonde (Bob Dylan), 116, 120, 121, 123, 186 Blood on the Tracks (Bob Dylan), 122 Blowin's in the Wind" (Bob Dylan), 116, 120, 121, 123, 186 Blood on the Tracks (Bob Dylan), 122 Blowin's in the Wind" (Bob Dylan), 113, 117 Blue (Joni Mitchell), 204, 206 "Blue Yodel" (limmie Rodgers), 22 Bluegrass, 2, 22–23, 36 Blues, 2 AAB lyric form of, 12, 13 bottleneck guitars, 14 Bob batteek guitars, 14 Boy bands Backstreet Boys and, 333 Bieber, Justin and, 339 New Kids on the Block and, 333 'NSync and, 333, 339 Set also firmds, 264-265 Bridadmard, 264-265 Bridadmard, 264-266 Aldon Music and, 64–65 hits from, 63, 64, 66 husband/wife teams in, 64 independent producers and, 63 playlets, mini-stories/humorous lyrics and, 63 playlets, mini-stories/h		
The Beaties (The Beaties), 146 Bebop, 15 Beggar's Banquet (Rolling Stones), 146 Big band music, 5, 7, 15 Big band music, 5, 7, 15 Big Machine Records, 338 Bikini beach parry films, 72 Billboard magazine, 9, 17, 33, 36, 39, 40, 111, 128, 300, 303, 332, 333 Billbie Jean" (Michael Jackson), 303–306 Bitter End Club (New York), 112 Black popular music, 250 Funk and, 256–260 Hip-hop and, 264–265 Philadelphia International Records and, 252–253 Rap and, 264–273 Reggae and, 260–263 Soft soul and, 252–253 Soul, changing landscape of, 250–252 See also African American music; Blues; Soul Blackboard Jungle (film), 32 Blackbisting, 110, 178 Blaxploitation films, 260 Blood on the Tracks (Bob Dylan), 112, 123, 186 Blood on the Tracks (Bob Dylan), 122 "Blowin' in the Wind" (Bob Dylan), 122 "Blewin' in the Wind" (Bob Dylan), 113, 117 Blue (Joni Mitchell), 204, 206 "Blue Yodel" (Jimmie Rodgers), 22 Bluegrass, 2, 22–23, 36 Blues, 2 AAB lyric form of, 12, 13 bottleneck guitars, 14 Boy bands Backstreet Boys and, 333 Bieber, Justin and, 333 New Kids on the Block and, 333 'NSync and, 333, 339 See also Girl bands; Teen pop "Break on Through" (The Doors), 177 Breakdancing, 264, 305 "Bridge Over Troubled Water" (Simon and Garfunkel) 103, 202 Brill Building Pop, 64–66 Aldon Music and, 64–65 hits from, 63, 64, 66 husband/wife teams in, 64 independent producers and, 63 recording process, control over, 63 See also American Pop Bringing It All Back Home (Bob Dylan), 116, 118, 16 196, 198 Bristol Sessions, 21 British Broadcasting Corporation (BBC), 129, 130 British flok tradition, 21 British invasion, 128 American mop tops and, 72 Beach Boyy Per Sounds album and, 75–76 Blues-oriented groups and, 152–153 Top 10 hits, British artists and, 129 See also British Rock and Roll; Post-War England Rolling Stones; The Beatles; The Who British Rock and Roll Blues scene and, 182–183	Beatles for Sale (The Beatles), 136	
Boy bands Bebop, 15 Beggar's Banquet (Rolling Stones), 146 Big Bach music, 5, 7, 15 Big box store distribution, 348 Big Machine Records, 338 Bikini beach party films, 72 Billboard magazine, 9, 17, 33, 36, 39, 40, 111, 128, 300, 303, 332, 333 "Billic Jean" (Michael Jackson), 303–306 Bitter End Club (New York), 112 Black popular music, 250 Funk and, 256–260 Hip-hop and, 264–265 Philadelphia International Records and, 252–253 Rap and, 264–273 Reggae and, 260–263 Soft soul and, 252–253 Soul, changing landscape of, 250–252 See also African American music; Blues; Soul Blackboard Jungle (film), 32 Blacklisting, 110, 178 Blaxploitation films, 260 Blonde on Blonde (Bob Dylan), 116, 120, 121, 123, 186 Blood on the Tracks (Bob Dylan), 122 "Blowin' in the Wind" (Bob Dylan), 112 "Blowin' in the Wind" (Bob Dylan), 113, 117 Blue (Joni Mitchell), 204, 206 Blues, 2 AAB lyric form of, 12, 13 bottleneck guitars and, 14 Classic Blues and, 13 Country Blues and, 13 Delta bluesmen and, 14 early recordings of, 14	The Beatles (The Beatles), 139	•
Becgar's Banquet (Rolling Stones), 146 Big band music, 5, 7, 15 Big box store distribution, 348 Big Machine Records, 338 Big Machine Relighter Leght and, 333 Big Machine Relighter, ustin and, 33 Big Machine Relighter, ustin and, 333 Big Machine Relighter, ustin and, 333 Big Machine Relighter, ustin and, 333 Big Machine Relighter All and, 339 Back It and, 333 Big Deta Extended Signal And, 333 Big Deta Extended, 333 Big Deta Extended, 333 Big Deta Extended, 333 Big Deta Extended, 333 Bie Deta Extended, 333 Bie Deta Bloes, and, 33 Betor Extended, 333 Pex tage and, 264-26 Bloe	"The Big Three Killed My Baby" (The White Stripes), 344	
Beggars Banquet (Rolling Stones), 146 Big band music, 5, 7, 15 Big box store distribution, 348 Big Machine Records, 338 Bikini beach party films, 72 Billboard magazine, 9, 17, 33, 36, 39, 40, 111, 128, 300, 303, 332, 333 "Billie Jean" (Michael Jackson), 303–306 Bitter End Club (New York), 112 Black popular music, 250 Funk and, 256–260 Hip-hop and, 264–265 Philadelphia International Records and, 252–253 Reggae and, 260–263 Soft soul and, 252–253 Soul, changing landscape of, 250–252 See also African American music; Blues; Soul Blackboard Jungle (film), 32 Blacklisting, 110, 178 Blaxploitation films, 260 Blonde on Blonde (Bob Dylan), 112, 123, 186 Blood on the Tracks (Bob Dylan), 122 "Blowin' in the Wind" (Bob Dylan), 112 "Blow (Joni Mitchell), 204, 206 Blue (Joni Mitchell), 204, 206 Blues, 2 AAB lyric form of, 12, 13 bottleneck guitars and, 14 Classic Blues and, 13 Country Blues and, 13 Delta bluesmen and, 14 early recordings of, 14	Bebop, 15	·
Big band music, 5, 7, 15 Big box store distribution, 348 Big Machine Records, 338 Bikini beach party films, 72 Billboard magazine, 9, 17, 33, 36, 39, 40, 111, 128, 300, 303, 332, 333 "Billic Jean" (Michael Jackson), 303–306 Bitter End Club (New York), 112 Black popular music, 250 Funk and, 256–260 Hip-hop and, 264–265 Philadelphia International Records and, 252–253 Rap and, 264–273 Rap and, 264–273 Rap and, 264–273 Rap and, 269–263 Soft soul and, 252–253 Soul, changing landscape of, 250–252 See also African American music; Blues; Soul Blackboard Jungle (film), 32 Blacklisting, 110, 178 Blacklisting, 110, 178 Blacklisting, 110, 178 Blowin' in the Wind' (Bob Dylan), 112 "Blowin' in the Wind' (Bob Dylan), 113, 117 Blue (Joni Mitchell), 204, 206 "Blue yodel' (Jimmie Rodgers), 22 Bluegrass, 2, 22–23, 36 Blues, 2 AAB lyric form of, 12, 13 bottleneck guitars and, 14 Classic Blues and, 13 Country Blues and, 13 Delta bluesmen and, 14 early recordings of, 14	Beggar's Banquet (Rolling Stones), 146	
Big box store distribution, 348 Big Machine Records, 338 Bikini beach party films, 72 Billboard magazine, 9, 17, 33, 36, 39, 40, 111, 128, 300, 303, 332, 333 "Billie Jean" (Michael Jackson), 303–306 Bitter End Club (New York), 112 Black popular music, 250 Funk and, 256–260 Hip-hop and, 264–265 Philadelphia International Records and, 252–253 Reggae and, 260–263 Soft soul and, 252–253 Soul, changing landscape of, 250–252 See also African American music; Blues; Soul Blackboard Jungle (film), 32 Blacklisting, 110, 178 Blackploint on Blonde (Bob Dylan), 116, 120, 121, 123, 186 Blonde on Blonde (Bob Dylan), 122 "Blowin' in the Wind" (Bob Dylan), 122 "Blowin' in the Wind" (Bob Dylan), 112 Blue (Join Mitchell), 204, 206 "Blue ycole" (Jimmie Rodgers), 22 Bluegrass, 2, 22–23, 36 Blues, 2 AAB lyric form of, 12, 13 bottleneck guitars and, 14 Classic Blues and, 13 Delta bluesmen and, 14 early recordings of, 14		
Big Machine Records, 338 Bikini beach party films, 72 Billboard magazine, 9, 17, 33, 36, 39, 40, 111, 128, 300, 303, 332, 333 "Billie Jean" (Michael Jackson), 303–306 Bitter End Club (New York), 112 Black popular music, 250 Funk and, 256–260 Hip-hop and, 264–265 Philadelphia International Records and, 252–253 Rap and, 264–273 Reggae and, 260–263 Soft soul and, 252–253 Soul, changing landscape of, 250–252 See also African American music; Blues; Soul Blackboard Jungle (film), 32 Blacklisting, 110, 178 Blaxploitation films, 260 Blonde on Blonde (Bob Dylan), 112 Bloud on the Tracks (Bob Dylan), 122 Bloud on the Tracks (Bob Dylan), 122 Bloud on the Tracks (Bob Dylan), 117 Blue (Joni Mitchell), 204, 206 "Bluey ass, 2, 22–23, 36 Blues, 2 AAB lyric form of, 12, 13 bottleneck guitars and, 14 Classic Blues and, 13 Country Blues and, 13 Delta bluesmen and, 14 early recordings of, 14		
Bikini beach party films, 72 Billboard magazine, 9, 17, 33, 36, 39, 40, 111, 128, 300, 303, 332, 333 "Billie Jean" (Michael Jackson), 303–306 Bitter End Club (New York), 112 Black popular music, 250 Funk and, 256–260 Hip-hop and, 264–265 Philadelphia International Records and, 252–253 Rap and, 260–263 Soft soul and, 252–253 Soul, changing landscape of, 250–252 See also African American music; Blues; Soul Blackboard Jungle (film), 32 Blacklisting, 110, 178 Blaxploitation films, 260 Blonde on Blonde (Bob Dylan), 116, 120, 121, 123, 186 Blood on the Tracks (Bob Dylan), 1122 "Blowin' in the Wind" (Bob Dylan), 113, 117 Blue (Joni Mitchell), 204, 206 "Blue Yodel" (Jimmie Rodgers), 22 Bluegrass, 2, 22–23, 36 Blues, 2 AAB lyric form of, 12, 13 bottleneck guitars and, 14 Classic Blues and, 13 Country Blues and, 13 Delta bluesmen and, 14 early recordings of, 14		
Billboard magazine, 9, 17, 33, 36, 39, 40, 111, 128, 300, 303, 332, 333 "Billie Jean" (Michael Jackson), 303–306 Bitter End Club (New York), 112 Black popular music, 250 Funk and, 256–260 Hip-hop and, 264–265 Philadelphia International Records and, 252–253 Reggae and, 260–263 Soft soul and, 252–253 Soul, changing landscape of, 250–252 See also African American music; Blues; Soul Blackboard Jungle (film), 32 Blacklisting, 110, 178 Blaxploitation films, 260 Blonde on Blonde (Bob Dylan), 116, 120, 121, 123, 186 Blood on the Tracks (Bob Dylan), 122 "Blowin' in the Wind" (Bob Dylan), 122 "Blowin' in the Wind" (Bob Dylan), 113, 117 Blue (Joni Mitchell), 204, 206 "Blue Yodel" (Jimmie Rodgers), 22 Bluegrass, 2, 22–23, 36 Blues, 2 AAB lyric form of, 12, 13 bottleneck guitars and, 14 Classic Blues and, 13 Delta bluesmen and, 14 early recordings of, 14 "Break on Through" (The Doors), 177 Breakdancing, 264, 305 "Break on Through" (The Doors), 177 Breakdancing, 264, 305 "Break on Through" (The Doors), 177 Breakdancing, 264, 305 "Bridge Over Troubled Water" (Simon and Garfunkel) 103, 202 Brill Building Pop, 64–66 Aldon Music and, 64–65 hits from, 63, 64, 66 husband/wife teams in, 64 independent producers and, 63 playlets, mini-stories/humorous lyrics and, 63 recording process, control over, 63 See also American Pop Brisistol Sessions, 21 British Broadcasting Corporation (BBC), 129, 130 British flok tradition, 21 British invasion, 128 American mop tops and, 72 Beach Boys Pet Sounds album and, 75–76 Blues-oriented groups and, 153–155 girl groups, demise of, 69 Hard Rock, second wave invasion and, 182–189 Mersey beat groups and, 152–153 Top 10 hits, British artists and, 129 See also British Rock and Roll Blues scene and, 182–183		
"Billie Jean" (Michael Jackson), 303–306 Bitter End Club (New York), 112 Black popular music, 250 Funk and, 256–260 Hip-hop and, 264–265 Philadelphia International Records and, 252–253 Rap and, 264–273 Reggae and, 260–263 Soft soul and, 252–253 Soul, changing landscape of, 250–252 See also African American music; Blues; Soul Blackboard Jungle (film), 32 Blacklisting, 110, 178 Blackpliation films, 260 Blonde on Blonde (Bob Dylan), 116, 120, 121, 123, 186 Blood on the Tracks (Bob Dylan), 122 "Blowin' in the Wind" (Bob Dylan), 113, 117 Blue (Join Mitchell), 204, 206 "Blue Yodel" (Jimmie Rodgers), 22 Bluegrass, 2, 22–23, 36 Blues, 2 AAB lyric form of, 12, 13 bottleneck guitars and, 14 Classic Blues and, 13 Country Blues and, 13 Delta bluesmen and, 14 early recordings of, 14 British Rock and Roll British Rock and Roll Blues scene and, 182–183 British Rock and Roll Blues scene and, 182–183		
"Billie Jean" (Michael Jackson), 303–306 Bitter End Club (New York), 112 Black popular music, 250 Funk and, 256–260 Hip-hop and, 264–265 Philadelphia International Records and, 252–253 Rap and, 264–273 Reggae and, 260–263 Soft soul and, 252–253 Soul, changing landscape of, 250–252 See also African American music; Blues; Soul Blackboard Jungle (film), 32 Blacklisting, 110, 178 Blaxploitation films, 260 Blonde on Blonde (Bob Dylan), 116, 120, 121, 123, 186 Blood on the Tracks (Bob Dylan), 122 "Blowin' in the Wind" (Bob Dylan), 112, 123 Bloe (Joni Mitchell), 204, 206 "Blue Yodel" (Jimmie Rodgers), 22 Bluegrass, 2, 22–23, 36 Blues, 2 AAB lyric form of, 12, 13 bottleneck guitars and, 14 Classic Blues and, 13 Country Blues and, 13 Delta bluesmen and, 14 early recordings of, 14 "Bridge Over Troubled Water" (Simon and Garfunkel) 103, 202 Brill Building Pop, 64–66 Aldon Music and, 64–65 hits from, 63, 64, 66 husband/wife teams in, 64 independent producers and, 63 playlets, mini-stories/humorous lyrics and, 63 recording process, control over, 63 See also African American Pop Bringing It All Back Home (Bob Dylan), 116, 118, 16 196, 198 Bristol Sessions, 21 British Broadcasting Corporation (BBC), 129, 130 British folk tradition, 21 British invasion, 128 American mop tops and, 72 Beach Boys Pet Sounds album and, 75–76 Blues-oriented groups and, 153–155 girl groups, demise of, 69 Hard Rock, second wave invasion and, 182–189 Mersey beat groups and, 152–153 Top 10 hits, British artists and, 129 See also British Rock and Roll Blues scene and, 182–183 Whe Belte Steve Troubled Water" (Simon and Garfunkel) 103, 202 Brill Building Pop, 64–66 Aldon Music and, 64 husband/wife teams in, 64 independent producers and, 63 playlets, mini-stories/humorous lyrics and, 63 playlet, 64 independent producers and, 63 playlets, mini-stories himore, 63 See also African American Pop Bringing It All Back Home		
Bitter End Club (New York), 112 Black popular music, 250 Funk and, 256–260 Hip-hop and, 264–265 Philadelphia International Records and, 252–253 Rap and, 260–263 Soft soul and, 252–253 Soul, changing landscape of, 250–252 See also African American music; Blues; Soul Blackboard Jungle (film), 32 Blacklisting, 110, 178 Blaxploitation films, 260 Blonde on Blonde (Bob Dylan), 116, 120, 121, 123, 186 Blood on the Tracks (Bob Dylan), 122 "Blowin' in the Wind" (Bob Dylan), 112 "Blue (Joni Mitchell), 204, 206 "Blue Yodel" (Jimmie Rodgers), 22 Bluegrass, 2, 22–23, 36 Blues, 2 AAB lyric form of, 12, 13 bottleneck guitars and, 14 Classic Blues and, 13 Country Blues and, 13 Delta bluesmen and, 14 early recordings of, 14 Bilue (Joni Mitchell), 204, 206 Bluesseen and, 14 early recordings of, 14		
Black popular music, 250 Funk and, 256–260 Hip-hop and, 264–265 Philadelphia International Records and, 252–253 Rap and, 264–273 Reggae and, 260–263 Soft soul and, 252–253 Soul, changing landscape of, 250–252 See also African American music; Blues; Soul Blackboard Jungle (film), 32 Blacklisting, 110, 178 Blaxploitation films, 260 Blonde on Blonde (Bob Dylan), 116, 120, 121, 123, 186 Blood on the Tracks (Bob Dylan), 122 "Blowin' in the Wind" (Bob Dylan), 113, 117 Blue (Joni Mitchell), 204, 206 "Blue Yodel" (Jimmie Rodgers), 22 Bluegrass, 2, 22–23, 36 Blues, 2 AAB lyric form of, 12, 13 bottleneck guitars and, 14 Classic Blues and, 13 Country Blues and, 13 Country Blues and, 13 Delta bluesmen and, 14 early recordings of, 14 British lining Pop, 64–66 Aldon Music and, 64–65 hits from, 63, 64, 66 husband/wife teams in, 64 independent producers and, 63 recording process, control over, 63 See also American Pop Bringing It All Back Home (Bob Dylan), 116, 118, 16 196, 198 Bristol Sessions, 21 British Broadcasting Corporation (BBC), 129, 130 British linvasion, 128 American mop tops and, 72 Blues-oriented groups and, 153—155 girl groups, demise of, 69 Hard Rock, second wave invasion and, 182–189 Mersey beat groups and, 152–153 Top 10 hits, British artists and, 129 See also British Rock and Roll Blues scene and, 182–183 Blues scene and, 182–183		
Funk and, 256–260 Hip-hop and, 264–265 Philadelphia International Records and, 252–253 Rap and, 264–273 Reggae and, 260–263 Soft soul and, 252–253 Soul, changing landscape of, 250–252 See also African American music; Blues; Soul Blackboard Jungle (film), 32 Blacklisting, 110, 178 Blaxploitation films, 260 Blonde on Blonde (Bob Dylan), 116, 120, 121, 123, 186 Blood on the Tracks (Bob Dylan), 122 "Blowin' in the Wind" (Bob Dylan), 113, 117 Blue (Joni Mitchell), 204, 206 "Blue Yodel" (Jimmie Rodgers), 22 Bluegrass, 2, 22–23, 36 Blues, 2 AAB lyric form of, 12, 13 bottleneck guitars and, 14 Classic Blues and, 13 Country Blues and, 13 Delta bluesmen and, 14 early recordings of, 14 Aldon Music and, 64–65 hits from, 63, 64, 66 husband/wife teams in, 64 independent producers and, 63 playlets, mini-stories/humorous lyrics and, 63 recording process, control over, 63 See also American Pop Bringing It All Back Home (Bob Dylan), 116, 118, 16 196, 198 Bristol Sessions, 21 British Broadcasting Corporation (BBC), 129, 130 British folk tradition, 21 British invasion, 128 American mop tops and, 72 Blues-oriented groups and, 153–155 girl groups, demise of, 69 Hard Rock, second wave invasion and, 182–189 Mersey beat groups and, 152–153 Top 10 hits, British artists and, 129 See also British Rock and Roll; Post-War England Rolling Stones; The Beatles; The Who British Rock and Roll Blues scene and, 182–183		
Hip-hop and, 264–265 Philadelphia International Records and, 252–253 Rap and, 264–273 Reggae and, 260–263 Soft soul and, 252–253 Soul, changing landscape of, 250–252 See also African American music; Blues; Soul Blackboard Jungle (film), 32 Blacklisting, 110, 178 Blaxploitation films, 260 Blonde on Blonde (Bob Dylan), 116, 120, 121, 123, 186 Blood on the Tracks (Bob Dylan), 122 "Blowin' in the Wind'' (Bob Dylan), 113, 117 Blue (Joni Mitchell), 204, 206 "Blue Yodel'' (Jimmie Rodgers), 22 Bluegrass, 2, 22–23, 36 Blues, 2 AAB lyric form of, 12, 13 bottleneck guitars and, 14 Classic Blues and, 13 Country Blues and, 13 Delta bluesmen and, 14 early recordings of, 14 hits from, 63, 64, 66 husband/wife teams in, 64 independent producers and, 63 playlets, mini-stories/humorous lyrics and, 63 recording process, control over, 63 See also American Pop Bringing It All Back Home (Bob Dylan), 116, 118, 16 196, 198 Bristol Sessions, 21 British Broadcasting Corporation (BBC), 129, 130 British folk tradition, 21 British invasion, 128 American mop tops and, 72 Blues-oriented groups and, 153–155 girl groups, demise of, 69 Hard Rock, second wave invasion and, 182–189 Mersey beat groups and, 152–153 Top 10 hits, British artists and, 129 See also British Rock and Roll; Post-War England Rolling Stones; The Beatles; The Who British Rock and Roll Blues scene and, 182–183		
Philadelphia International Records and, 252–253 Rap and, 264–273 Reggae and, 260–263 Soft soul and, 252–253 Soul, changing landscape of, 250–252 See also African American music; Blues; Soul Blackboard Jungle (film), 32 Blacklisting, 110, 178 Blaxploitation films, 260 Blonde on Blonde (Bob Dylan), 116, 120, 121, 123, 186 Blood on the Tracks (Bob Dylan), 122 "Blowin' in the Wind" (Bob Dylan), 113, 117 Blue (Joni Mitchell), 204, 206 "Blue Yodel" (Jimmie Rodgers), 22 Bluegrass, 2, 22–23, 36 Blues, 2 AAB lyric form of, 12, 13 bottleneck guitars and, 14 Classic Blues and, 13 Country Blues and, 13 Delta bluesmen and, 14 early recordings of, 14 husband/wife teams in, 64 independent producers and, 63 recording process, control over, 63 See also American Pop Bringing It All Back Home (Bob Dylan), 116, 118, 16 196, 198 Bristol Sessions, 21 British Broadcasting Corporation (BBC), 129, 130 British folk tradition, 21 British invasion, 128 American mop tops and, 72 Beach Boys Pet Sounds album and, 75–76 Blues-oriented groups and, 153–155 girl groups, demise of, 69 Hard Rock, second wave invasion and, 182–189 Mersey beat groups and, 152–153 Top 10 hits, British artists and, 129 See also British Rock and Roll Blues scene and, 182–183 Husband/wife teams in, 64 independent producers and, 63 playlets, mini-stories/humorous lyrics and, 63 recording process, control over, 63 See also American Pop Bringing It All Back Home (Bob Dylan), 116, 118, 16 196, 198 Bristol Sessions, 21 British Broadcasting Corporation (BBC), 129, 130 British Rock and, 72 Beach Boys Pet Sounds album and, 75–76 Blues-oriented groups and, 152–153 Top 10 hits, British artists and, 129 See also British Rock and Roll		
Rap and, 264–273 Reggae and, 260–263 Soft soul and, 252–253 Soul, changing landscape of, 250–252 See also African American music; Blues; Soul Blackboard Jungle (film), 32 Blacklisting, 110, 178 Blaxploitation films, 260 Blonde on Blonde (Bob Dylan), 116, 120, 121, 123, 186 Blood on the Tracks (Bob Dylan), 122 "Blowin' in the Wind" (Bob Dylan), 113, 117 Blue (Joni Mitchell), 204, 206 "Blue Yodel" (Jimmie Rodgers), 22 Bluegrass, 2, 22–23, 36 Blues, 2 AAB lyric form of, 12, 13 bottleneck guitars and, 14 Classic Blues and, 13 Country Blues and, 13 Delta bluesmen and, 14 early recordings of, 14 independent producers and, 63 playlets, mini-stories/humorous lyrics and, 63 recording process, control over, 63 See also American Pop Bringing It All Back Home (Bob Dylan), 116, 118, 16 196, 198 Bristol Sessions, 21 British Broadcasting Corporation (BBC), 129, 130 British folk tradition, 21 British invasion, 128 American mop tops and, 72 Beach Boys Pet Sounds album and, 75–76 Blues-oriented groups and, 153–155 girl groups, demise of, 69 Hard Rock, second wave invasion and, 182–189 Mersey beat groups and, 152–153 Top 10 hits, British artists and, 129 See also British Rock and Roll; Post-War England Rolling Stones; The Beatles; The Who British Rock and Roll Blues scene and, 182–183		
Reggae and, 260–263 Soft soul and, 252–253 Soul, changing landscape of, 250–252 See also African American music; Blues; Soul Blackboard Jungle (film), 32 Blacklisting, 110, 178 Blaxploitation films, 260 Blonde on Blonde (Bob Dylan), 116, 120, 121, 123, 186 Blood on the Tracks (Bob Dylan), 122 "Blowin' in the Wind" (Bob Dylan), 113, 117 Blue (Joni Mitchell), 204, 206 "Blue Yodel" (Jimmie Rodgers), 22 Bluegrass, 2, 22–23, 36 Blues, 2 AAB lyric form of, 12, 13 bottleneck guitars and, 14 Classic Blues and, 13 Country Blues and, 13 Delta bluesmen and, 14 early recordings of, 14 playlets, mini-stories/humorous lyrics and, 63 recording process, control over, 63 See also American Pop Bringing It All Back Home (Bob Dylan), 116, 118, 16 196, 198 Bristol Sessions, 21 British Broadcasting Corporation (BBC), 129, 130 British folk tradition, 21 British invasion, 128 American mop tops and, 72 Beach Boys Pet Sounds album and, 75–76 Blues-oriented groups and, 153–155 girl groups, demise of, 69 Hard Rock, second wave invasion and, 182–189 Mersey beat groups and, 152–153 Top 10 hits, British artists and, 129 See also British Rock and Roll; Post-War England Rolling Stones; The Beatles; The Who British Rock and Roll Blues scene and, 182–183		
Soft soul and, 252–253 Soul, changing landscape of, 250–252 See also African American music; Blues; Soul Blackboard Jungle (film), 32 Blacklisting, 110, 178 Blaxploitation films, 260 Blonde on Blonde (Bob Dylan), 116, 120, 121, 123, 186 Blood on the Tracks (Bob Dylan), 122 "Blowin' in the Wind" (Bob Dylan), 113, 117 Blue (Joni Mitchell), 204, 206 "Blue Yodel" (Jimmie Rodgers), 22 Bluegrass, 2, 22–23, 36 Blues, 2 AAB lyric form of, 12, 13 bottleneck guitars and, 14 Classic Blues and, 13 Country Blues and, 13 Delta bluesmen and, 14 early recordings of, 14 recording process, control over, 63 See also American Pop Bringing It All Back Home (Bob Dylan), 116, 118, 16 196, 198 Bristol Sessions, 21 British Broadcasting Corporation (BBC), 129, 130 British folk tradition, 21 British invasion, 128 American mop tops and, 72 Blues-oriented groups and, 153–155 girl groups, demise of, 69 Hard Rock, second wave invasion and, 182–189 Mersey beat groups and, 152–153 Top 10 hits, British artists and, 129 See also British Rock and Roll Blues scene and, 182–183 British Rock and Roll Blues scene and, 182–183 British Broadcasting Corporation (BBC), 129, 130 British folk tradition, 21 British invasion, 128 American mop tops and, 72 Blues-oriented groups and, 153–155 girl groups, demise of, 69 Hard Rock, second wave invasion and, 182–189 Mersey beat groups and, 152–153 Top 10 hits, British artists and, 129 See also British Rock and Roll Blues scene and, 182–183		
Soul, changing landscape of, 250–252 See also African American music; Blues; Soul Blackboard Jungle (film), 32 Blacklisting, 110, 178 Blaxploitation films, 260 Blonde on Blonde (Bob Dylan), 116, 120, 121, 123, 186 Blood on the Tracks (Bob Dylan), 122 Blue (Joni Mitchell), 204, 206 Blue Yodel" (Jimmie Rodgers), 22 Bluegrass, 2, 22–23, 36 Blues, 2 AAB lyric form of, 12, 13 bottleneck guitars and, 14 Classic Blues and, 13 Country Blues and, 13 Country Blues and, 13 Delta bluesmen and, 14 early recordings of, 14 See also American Pop Bringing It All Back Home (Bob Dylan), 116, 118, 16 196, 198 Bristol Sessions, 21 British Broadcasting Corporation (BBC), 129, 130 British folk tradition, 21 British invasion, 128 American mop tops and, 72 Beach Boys Pet Sounds album and, 75–76 Blues-oriented groups and, 153–155 girl groups, demise of, 69 Hard Rock, second wave invasion and, 182–189 Mersey beat groups and, 152–153 Top 10 hits, British artists and, 129 See also British Rock and Roll; Post-War England Rolling Stones; The Beatles; The Who British Rock and Roll Blues scene and, 182–183		
See also African American music; Blues; Soul Blackboard Jungle (film), 32 Blacklisting, 110, 178 Blaxploitation films, 260 Blonde on Blonde (Bob Dylan), 116, 120, 121, 123, 186 Blood on the Tracks (Bob Dylan), 122 "Blowin' in the Wind" (Bob Dylan), 113, 117 Blue (Joni Mitchell), 204, 206 "Blue Yodel" (Jimmie Rodgers), 22 Bluegrass, 2, 22–23, 36 Blues, 2 AAB lyric form of, 12, 13 bottleneck guitars and, 14 Classic Blues and, 13 Country Blues and, 13 Delta bluesmen and, 14 early recordings of, 14 British Broadcasting Corporation (BBC), 129, 130 British folk tradition, 21 British invasion, 128 American mop tops and, 72 Beach Boys Pet Sounds album and, 75–76 Blues-oriented groups and, 153–155 girl groups, demise of, 69 Hard Rock, second wave invasion and, 182–189 Mersey beat groups and, 152–153 Top 10 hits, British artists and, 129 See also British Rock and Roll; Post–War England Rolling Stones; The Beatles; The Who British Rock and Roll Blues scene and, 182–183		
Blackboard Jungle (film), 32 Blacklisting, 110, 178 Blaxploitation films, 260 Blonde on Blonde (Bob Dylan), 116, 120, 121, 123, 186 Blood on the Tracks (Bob Dylan), 122 "Blowin' in the Wind" (Bob Dylan), 113, 117 Blue (Joni Mitchell), 204, 206 "Blue Yodel" (Jimmie Rodgers), 22 Bluegrass, 2, 22–23, 36 Blues, 2 AAB lyric form of, 12, 13 bottleneck guitars and, 14 Classic Blues and, 13 Country Blues and, 13 Delta bluesmen and, 14 early recordings of, 14 Elsaklisting, 110, 178 British Sessions, 21 British Broadcasting Corporation (BBC), 129, 130 British folk tradition, 21 British invasion, 128 American mop tops and, 72 Beach Boys Pet Sounds album and, 75–76 Blues-oriented groups and, 153–155 girl groups, demise of, 69 Hard Rock, second wave invasion and, 182–189 Mersey beat groups and, 152–153 Top 10 hits, British artists and, 129 See also British Rock and Roll; Post-War England Rolling Stones; The Beatles; The Who British Rock and Roll Blues scene and, 182–183		
Blacklisting, 110, 178 Blaxploitation films, 260 Blonde on Blonde (Bob Dylan), 116, 120, 121, 123, 186 Blood on the Tracks (Bob Dylan), 122 "Blowin' in the Wind" (Bob Dylan), 113, 117 Blue (Joni Mitchell), 204, 206 "Blue Yodel" (Jimmie Rodgers), 22 Bluegrass, 2, 22–23, 36 Blues, 2 AAB lyric form of, 12, 13 bottleneck guitars and, 14 Classic Blues and, 13 Country Blues and, 13 Delta bluesmen and, 14 early recordings of, 14 British Broadcasting Corporation (BBC), 129, 130 British Broadcasting Corporation (BBC), 129, 140 British Broadcasting Corporation (BBC), 129 British Broadcasting Corporation (BBC), 129 British Roll 12		
Blaxploitation films, 260 Blonde on Blonde (Bob Dylan), 116, 120, 121, 123, 186 Blood on the Tracks (Bob Dylan), 122 "Blowin' in the Wind" (Bob Dylan), 113, 117 Blue (Joni Mitchell), 204, 206 "Blue Yodel" (Jimmie Rodgers), 22 Bluegrass, 2, 22–23, 36 Blues, 2 AAB lyric form of, 12, 13 bottleneck guitars and, 14 Classic Blues and, 13 Country Blues and, 13 Delta bluesmen and, 14 early recordings of, 14 British Broadcasting Corporation (BBC), 129, 130 British Broadcasting Corporation (BEC), 129, 130 British Broadcasting Corporation (BEC), 129, 130 British Broadcasting Corporation (BEC), 129, 140 British Broadcasting Corporation (BEC), 129, 140 British Broadcasting Corporation (BEC), 129, 140 British Broadcasting Corporation (BEC), 129 British Industry (Botton (Botton (Botton (Botton (BC)), 129 British Industry (Botton (Botton (Botton (Botton (Bot		
Blonde on Blonde (Bob Dylan), 116, 120, 121, 123, 186 Blood on the Tracks (Bob Dylan), 122 "Blowin' in the Wind" (Bob Dylan), 113, 117 Blue (Joni Mitchell), 204, 206 "Blue Yodel" (Jimmie Rodgers), 22 Bluegrass, 2, 22–23, 36 Blues, 2 AAB lyric form of, 12, 13 bottleneck guitars and, 14 Classic Blues and, 13 Country Blues and, 13 Delta bluesmen and, 14 early recordings of, 14 British folk tradition, 21 British invasion, 128 American mop tops and, 75–76 Blues-oriented groups and, 153–155 girl groups, demise of, 69 Hard Rock, second wave invasion and, 182–189 Mersey beat groups and, 152–153 Top 10 hits, British artists and, 129 See also British Rock and Roll; Post–War England Rolling Stones; The Beatles; The Who British Rock and Roll Blues scene and, 182–183		
Blood on the Tracks (Bob Dylan), 122 "Blowin' in the Wind" (Bob Dylan), 113, 117 Blue (Joni Mitchell), 204, 206 "Blue Yodel" (Jimmie Rodgers), 22 Bluegrass, 2, 22–23, 36 Blues, 2 AAB lyric form of, 12, 13 bottleneck guitars and, 14 Classic Blues and, 13 Country Blues and, 13 Delta bluesmen and, 14 early recordings of, 14 British invasion, 128 American mop tops and, 72 Beach Boys Pet Sounds album and, 75–76 Blues-oriented groups and, 153–155 girl groups, demise of, 69 Hard Rock, second wave invasion and, 182–189 Mersey beat groups and, 152–153 Top 10 hits, British artists and, 129 See also British Rock and Roll; Post–War England Rolling Stones; The Beatles; The Who British Rock and Roll Blues scene and, 182–183	•	
"Blowin' in the Wind" (Bob Dylan), 113, 117 Blue (Joni Mitchell), 204, 206 "Blue Yodel" (Jimmie Rodgers), 22 Bluegrass, 2, 22–23, 36 Blues, 2 AAB lyric form of, 12, 13 bottleneck guitars and, 14 Classic Blues and, 13 Country Blues and, 13 Delta bluesmen and, 14 early recordings of, 14 American mop tops and, 72 Beach Boys Pet Sounds album and, 75–76 Blues-oriented groups and, 153–155 girl groups, demise of, 69 Hard Rock, second wave invasion and, 182–189 Mersey beat groups and, 152–153 Top 10 hits, British artists and, 129 See also British Rock and Roll; Post–War England Rolling Stones; The Beatles; The Who British Rock and Roll Blues scene and, 182–183		British folk tradition, 21
Blue (Joni Mitchell), 204, 206 "Blue Yodel" (Jimmie Rodgers), 22 Bluegrass, 2, 22–23, 36 Blues, 2 AAB lyric form of, 12, 13 bottleneck guitars and, 14 Classic Blues and, 13 Country Blues and, 13 Delta bluesmen and, 14 early recordings of, 14 Blues criented groups and, 153–155 girl groups, demise of, 69 Hard Rock, second wave invasion and, 182–189 Mersey beat groups and, 152–153 Top 10 hits, British artists and, 129 See also British Rock and Roll; Post–War England Rolling Stones; The Beatles; The Who British Rock and Roll Blues scene and, 182–183	·	British invasion, 128
"Blue Yodel" (Jimmie Rodgers), 22 Bluegrass, 2, 22–23, 36 Blues, 2 AAB lyric form of, 12, 13 bottleneck guitars and, 14 Classic Blues and, 13 Country Blues and, 13 Delta bluesmen and, 14 early recordings of, 14 Blues oriented groups and, 153–155 girl groups, demise of, 69 Hard Rock, second wave invasion and, 182–189 Mersey beat groups and, 152–153 Top 10 hits, British artists and, 129 See also British Rock and Roll; Post–War England Rolling Stones; The Beatles; The Who British Rock and Roll Blues scene and, 182–183	"Blowin' in the Wind" (Bob Dylan), 113, 117	
Bluegrass, 2, 22–23, 36 Blues, 2 AAB lyric form of, 12, 13 bottleneck guitars and, 14 Classic Blues and, 13 Country Blues and, 13 Delta bluesmen and, 14 early recordings of, 14 girl groups, demise of, 69 Hard Rock, second wave invasion and, 182–189 Mersey beat groups and, 152–153 Top 10 hits, British artists and, 129 See also British Rock and Roll; Post–War England Rolling Stones; The Beatles; The Who	Blue (Joni Mitchell), 204, 206	
Blues, 2 AAB lyric form of, 12, 13 bottleneck guitars and, 14 Classic Blues and, 13 Country Blues and, 13 Delta bluesmen and, 14 early recordings of, 14 Hard Rock, second wave invasion and, 182–189 Mersey beat groups and, 152–153 Top 10 hits, British artists and, 129 See also British Rock and Roll; Post–War England Rolling Stones; The Beatles; The Who	"Blue Yodel" (Jimmie Rodgers), 22	
Blues, 2 AAB lyric form of, 12, 13 bottleneck guitars and, 14 Classic Blues and, 13 Country Blues and, 13 Delta bluesmen and, 14 early recordings of, 14 Hard Rock, second wave invasion and, 182–189 Mersey beat groups and, 152–153 Top 10 hits, British artists and, 129 See also British Rock and Roll; Post–War England Rolling Stones; The Beatles; The Who British Rock and Roll Blues scene and, 182–183	Bluegrass, 2, 22–23, 36	
AAB lyric form of, 12, 13 bottleneck guitars and, 14 Classic Blues and, 13 Country Blues and, 13 Delta bluesmen and, 14 early recordings of, 14 Mersey beat groups and, 152–153 Top 10 hits, British artists and, 129 See also British Rock and Roll; Post–War England Rolling Stones; The Beatles; The Who British Rock and Roll Blues scene and, 182–183	-	
bottleneck guitars and, 14 Classic Blues and, 13 Country Blues and, 13 Delta bluesmen and, 14 early recordings of, 14 Top 10 hits, British artists and, 129 See also British Rock and Roll; Post-War England Rolling Stones; The Beatles; The Who British Rock and Roll Blues scene and, 182–183		
Classic Blues and, 13 Country Blues and, 13 Delta bluesmen and, 14 early recordings of, 14 See also British Rock and Roll; Post-War England Rolling Stones; The Beatles; The Who British Rock and Roll Blues scene and, 182–183		
Country Blues and, 13 Delta bluesmen and, 14 early recordings of, 14 Rolling Stones; The Beatles; The Who British Rock and Roll Blues scene and, 182–183	_	
Delta bluesmen and, 14 early recordings of, 14 British Rock and Roll Blues scene and, 182–183		
early recordings of, 14 Blues scene and, 182–183	·	
11 10 1 (400 400		
	first singers of, 13	Hard Rock, emergence of, 182–189

"Cold Sweat" (James Brown), 87

The College Dropout (Kanye West), 337

British Rock and Roll (Continued) Columbia Records, 8, 103, 116, 171, 197 mods and, 148-150 Columbia/CBS, 216 pirate radio stations and, 130 Come On Over (Shania Twain), 342 popular music culture and, 129 Communism, 31, 57, 108, 110 Radio One and, 130 Compact discs (CDs), 301, 347-349 skiffle and, 128-129 Computer-based music, 180 Teddy boys and, 40, 134 Concerto for Group and Orchestra (Deep Purple), 231 Top 10 hits, British artists and, 129 Consumerism culture, 30-31 trad Jazz and, 128 Contemporary Rock. See 2000s/New Millennium Rock See also American Rock and Roll; American Rock Copyright law, 348-349 and Roll/second phase; British invasion; Post-War Corporate rock, 215, 236 England; The Beatles The Eagles and, 216-218 Broadside, 114-115 Fleetwood Mac and, 218-219 Broadway musicals, 3, 4, 148 key recordings of, 216 "Brown Sugar" (Rolling Stones), 147 mergers/megahits and, 215-216 Brown v. Board of Education of Topeka (1954), 83 principle artists in, 216 Bubblegum pop, 72 See also 1970s landscape Burnin' (Bob Marley and the Wailers), 260, 262, 263 "Could It Be I'm Falling in Love" (Spinners), 253 "Burning Down the House" (Talking Heads), 291 Counterculture. See Drug culture; Sixties counterculture Burru drumming, 261 Country, 2 "Bus Stop" (The Hollies), 153 Bristol Sessions and, 21 early country recordings and, 21-22 major record labels and, 8 Nashville/Grand Ole Opry and, 22 Calypso, 108, 111-112 radio, popularization of country and, 22 Calypso (Harry Belafonte), 111 record sales trends and, 9-10 "Candle in the Wind 1997" (Elton John), 245, 246 Rockabilly sound and, 32-35 Capitol Records, 9, 74, 135 yodeling in, 22 Capitol/EMI, 216 See also Cowboy songs; Folk; 2000s/New Millennium Rock: Traditional rural music Casablanca Records, 216, 256, 300, 347 Country Blues, 13 Cashbox magazine, 40, 59 Country rock, 122, 123, 195, 208 Cassette tapes, 300 additional artists in, 212 Cavern Club (Liverpool), 134, 152 CBGB club (New York), 283, 316 The Band and, 210–211 characteristics of, 209 Censorship, 180 Creedence Clearwater Revival and, 211-212 "Chain of Fools" (Aretha Franklin), 103 Dylan, influence of, 208-209 Cheap Thrills (Big Brother and The Holding key recordings of, 209 Company), 171 Parsons, Gram and, 209–210 Chess Records, 9, 17, 89 principle artists in, 209 characteristic sound of, 44 See also 1970s landscape; 2000s/New Millennium Chicago Rhythm and Blues and, 43-46 Rock key recordings of, 43-45, 144 Country Western, 6, 9 Chicago Rhythm and Blues, 43–46 Cover versions, 6 Chitlin' circuit, 86, 88, 303 Cowboy songs, 22–23 "Choo Choo Ch' Boogie" (Louis Jordan), 18 Crawdaddy Club (London), 143, 154 "The Circle Game" (Joni Mitchell), 206 Creem magazine, 230 Civil Right Movement, 83, 112, 118, 161 Crews/posses, 266 Civil Rights Act of 1964, 83 "Cross Road Blues" (Robert Johnson), 14 Classic Blues, 13 Crossover artists, 17, 40 Classic Rock era, 56 Close to the Edge (King Crimson), 240 D "Cloud Nine" (Temptations), 96

Daily Variety magazine, 71

Damaged (Black Flag), 294

Dance crazes	Doggystyle (Snoop Doggy Dog), 272
Bebop, danceability of, 15	"Don't Eat Yellow Snow" (Mothers of Invention), 180
breakdancing and, 264, 305	"Don't Make Me Over" (Dionne Warwick), 66
Doo-wop, danceability of, 19–20	The Doors (The Doors), 175
Let's Dance radio program and, 5	Doo-wop, 18
Nashville barn dance programs, 22	amateur teen vocal groups and, 18
post-disco dance dominance and, 303–309	Atlantic Records, success of, 20
Rhythm and Blues and, 17	bass line in, 19
Swing era and, 5	bird groups/car groups and, 19
teen idols, early 1960s and, 61	a cappella group vocal style of, 18
Winter Dance Party tour and, 51	choreographed performances and, 19
See also Disco; Punk; Reggae	danceability of, 19–20
"Dancing in the Dark" (Bruce Springsteen), 310	Jazz/barbershop harmonies in, 18
The Dark Side of the Moon (Pink Floyd), 235–238	male Gospel quartets and, 17
"Dark Star" (The Grateful Dead), 169	melismatic singing and, 18
DAT (Digital Audio Tape) recording technology, 302	principle artists in, 18–19
The David Letterman Show, 315	record sales potential, maximization of, 19–20
Daydream (Mariah Carey), 334	tenor line in, 18
Daydream Nation (Sonic Youth), 314, 316	See also African American music
Days of Future Passed (Moody Blues), 236	The Dorsey Brothers Stage Show, 37
Deadheads, 168	Double Fantasy (John Lennon/Yoko Ono), 320
Decca Records, 9, 32, 50, 110, 129, 143, 149	The Downward Spiral (Nine Inch Nails), 320
Def Jam, 336	Draft-dodgers, 161–162
Déjà Vu (Crosby, Stills, Nash and Young), 196, 200, 201	Drug culture
Delta bluesmen, 14, 33	acid rock scene and, 163-174
Democratic Convention (1968), 161	acid tests and, 163
Desire (Bob Dylan), 122	electric ballrooms and, 164
Diamond records, 10, 229, 333	Haight-Ashbury district and, 163
	Hippie culture and, 163–164
Digital Audio Workstations (DAW), 351–352	human be-in and, 164–165
Digital technology	psychedelic rock scene and, 174–181
Digital Audio Tape recording technology and, 302 digital samplers and, 301	recreational drug use and, 162–163
early computer-based music and, 180	Sixties Rock songs and, 162, 163
file sharing and, 10, 348–349	Summer of Love and, 164–165
future music industry and, 350–352	Trips Festival and, 164
MIDI protocol and, 301–302	See also Sixties counterculture
Mp3 file format and, 348, 350	Dual Showman amplifiers, 73
music streaming and, 350	Duke/Peacock Records, 9
See also Electronic music; Technological innovation	Dylan, Bob, 115
Dinkytown folkies, 115	anti-war songs by, 117, 118
Disc jockeys (DJs), 10–11	Basement Tapes of, 120–122
Disco, 253–255	beat writers and, 115–116
audience, role of, 254	Beatles, meeting with, 118, 136–137
backlash against, 255–256	biblical rock music and, 122
characteristics of, 254	Country rock conre and 122 123 208 209
dance-oriented pop and, 253	Country rock genre and, 122, 123, 208–209 Dinkytown folkies and, 115
key recordings of, 254	double album release and, 120
origins of, 254	electric material of, 119
principle artists in, 253–255	Folk rock genre, foundations of, 119–120, 123, 196
radio airplay and, 254–255	Greenwich Village life of, 116
synthesizers/drum machines in, 253, 254	Hammond's Folly and, 116
See also 1970s landscape	introspective songs of, 118
Disraeli Gears (Cream), 183, 184	key recordings by, 116–120, 123
Dixieland Jazz, 128	later career of, 122–123

Farm Aid concert, 321

Dylan, Bob (Continued)	Fear of Music (Talking Heads), 291, 292
legacy of, 123	Federal Bureau of Investigation (FBI), 110
Newport Folk Festival appearances and, 117,	Federal label, 86
119–120, 196	"Feel Like I'm Fixin'To Die Rag" (Country Joe and the
recreational drugs, experimentation with, 162	Fish), 166
Rock, foray into, 119–120	Festival, 200
singer/songwriters, influence on, 203–204	Field hollers, 12
talking blues style of, 116	Fifties folk revival, 111–115
topical protest songs by, 118	File sharing, 10, 348–349, 351
Traveling Wilburys and, 123	Fillmore Ballroom (San Francisco), 164, 169, 173, 184
See also Folk	Fillmore East Ballroom (New York), 189, 215
	Film
E	bikini beach party films, 72
Eagles/Their Greatest Hits 1971-1975 (The Eagles),	recording stars, vehicles for, 38, 39
216, 218	Folk, 57, 108
Ed Sullivan Show, 62	acoustic instruments in, 21
The Beatles and, 135	anti-war songs, 117, 118
The Doors and, 177	ballad form and, 21
Dylan, Bob, refusal to appear, 117	basket house venues and, 114
Presley, Elvis and, 38	blacklisting/witch hunts and, 109-110
Rolling Stones and, 145	British folk tradition and, 21
"Eight Days a Week" (The Beatles), 136	Calypso fad and, 111–112
Eighties Alternative, 314	colonial America and, 21
AC/DC and, 318	Dinkytown folkies and, 115
Alternative rock and, 314–317	fifties folk revival, 111–112
Bon Jovi and, 317	folk music preservation efforts and, 108
Guns N' Roses and, 317–318	Greenwich Village scene and, 113–114
Industrial and, 318–319	hillbilly music and, 21
Metal and, 317–318	hootenannies and, 109-110
Metallica and, 317	left-leaning political material and, 115
New Wave of British Heavy Metal and, 317	left-wing folksong conspiracy and, 108
See also Alternative Nation; nine1980s landscape	newsletters and, 115
"Eleanor Rigby" (The Beatles), 103	1950s revival of, 111–115
Electric ballrooms, 164	political/social activism and, 109–115
Electric Lady Studios, 189	principle artists in, 107–113
Electric Ladyland (Jimi Hendrix Experience), 188	radio shows of, 108
Electric recording process, 7–8	traditional rural music and, 20–21
Electric Warrior (T. Rex), 244	workers' rights activism and, 108, 109
Electronic music. See Digital technology	See also Acid Rock; Dylan, Bob
Electronica, 245	Folk rock, 2, 118, 123, 175, 195
Elektra Records, 176	additional artists in, 202
EMI Records, 129, 134, 135, 154, 237	Buffalo Springfield and, 200
"The End" (Jim Morrison), 176	The Byrds and, 197–199
	characteristics of, 197
"Eruption" (Van Halen), 225, 234	Crosby, Stills, Nash & Young and, 200–201
Exploding Plastic Inevitable, 282	Dylan, influence of, 196–197 key recordings of, 196–197
	Laurel Canyon, role of, 196–197
F	Mamas and the Papas and, 199
Fabulous 224, 130	principle artists in, 195
Falsetto, 96	Simon and Garfunkel and, 201–202
"Fame" (David Bowie), 245	The Troubadour and, 197
Fame Studios, 102–103	See also 1970s landscape
Fantasy Records, 212	Folklore Center, 114

"For the Love of Money" (O'Jays), 252

"For What It's Worth" (Buffalo Springfield), 197, 200	Soul music and, 17
45 rpm records, 8, 34, 139	See also African American music; Soul
Freak Out! (Mothers of Invention), 175, 179	Graceland, 39
"Free Bird" (Lynyrd Skynyrd), 213	Graffiti art, 264
The Freewheelin' Bob Dylan (Bob Dylan), 116, 117	Grand Ole Opry, 22, 36
"Fresh Air" (Quicksilver Messenger Service), 173	Great Depression, 7
	Greenwich Village scene, 113–114, 186, 188, 199
Fret board tapping, 234 Funk, 256	See also Dylan, Bob; Folk
additional artists in, 259–260	Grunge, 226, 328–329
characteristics of, 257	characteristics of, 328–329
Clinton, George and, 257–258	key recordings of, 329
key recordings of, 257	principle artists in, 329
lyrical themes in, 257	Sub Pop indie label and, 328
principle artists in, 256, 259	See also Alternative Nation
slap-bass technique and, 259	
Sly and the Family Stone and, 258–259	H
tight rhythmic patterns and, 256	Haight-Ashbury district, 163
See also Black popular music; nine1970s landscape	Hammond organs, 17, 183
	Hammond's Folly, 116–118
G	
	A Hard Day's Night (film), 136
Gangsta rap, 270–272	A Hard Day's Night (The Beatles), 135–136
Garage bands, 280	Hard Rock, 2, 182–183
Gaslight Club (New York), 117	Blues riffs/power chords and, 183 British Blues scene and, 182–183
Generation gap, 31	characteristics of, 183
"Get Off My Cloud" (Rolling Stones), 144	emergence of, 183
"Get Up, Get Into It, Get Involved" (James Brown), 87	Heavy Metal, forerunner of, 183–184
"Get Up (I Feel Like Being a) Sex Machine (James	key recordings of, 183–189
Brown), 256	principle artists in, 183–189
"Get Up, Stand Up" (Bob Marley), 262, 263	Hardcore, 293
The Gilded Palace of Sin (Flying Burrito Brothers), 210	additional artists in, 294-295
Girl bands, 65, 334	Black Flag and, 294
Carey, Mariah and, 333–335	characteristics of, 293
Spears, Britney and, 333, 334	key recordings of, 293
TLC and, 334 See also Boy bands; Teen pop	Minor Threat and, 294
Glam rock, 243–244	principle artists in, 293–295
Bowie, David and, 244–245	See also Punk
characteristics of, 243	Harlem. See African American music; Apollo Theatre
John, Elton and, 245	(Harlem)
key recordings of, 243	Heavy Metal, 183–184, 224
principle artists of, 243–244	additional artists in, 236
Stewart, Rod and, 246	Aerosmith and, 232–233
See also 1970s landscape; Shock rock	aggressive/rebellious attitudes and, 224, 226 Black Sabbath and, 226–227
"Gloria" (Van Morrison), 207	blues ethos and, 224
Gold records, 9–10, 39, 103, 195, 229, 232	characteristics of, 224, 225
Gold Star Studios (Los Angeles), 69, 70, 75	classical music references and, 225
Goodbye Cream (Cream), 185	Deep Purple and, 231
"Goodnight Irene" (Leadbelly), 108	distortion/power chords and, 224–225
Gospel, 2, 16–17	earliest bands in, 226–230
Blues-influenced melodies/rhythms and, 16	fret board tapping and, 234
commercialization of, 16	industrial roots of, 224–226
Hammond organs and, 17	Judas Priest and, 231
melismatic singing and, 17	key early recordings of, 225
Rhythm and Blues music and, 16	KISS and, 233

Heavy Metal (Continued)	"I Shot the Sheriff" (Bob Marley and the Wailers), 262, 263
later bands in, 230–233	"I Shot the Sheriff" (Eric Clapton), 185, 260, 262, 263
Led Zeppelin and, 227–230	"I Want to Hold Your Hand" (The Beatles), 135
lyrical themes of, 225	Ice House (Los Angeles), 197
principle artists in, 225	Icky Thump (White Stripes), 345
Queen and, 232	"If I Had a Hammer" (Pete Seeger), 110, 112, 113
shock tactics and, 241	"If You Don't Know Me By Now" (Harold Melvin and
swagger/machismo posturing and, 225 Van Halen and, 234	the Blue Notes), 252
See also Eighties Alternative; 1970s landscape; 2000s/	"I'm Waiting for the Man" (Velvet Underground), 282
New Millennium Rock	Imagine (John Lennon), 142
Help! (Beatles), 10, 137	Imperial Records, 9
"Here Comes the Night" (Van Morrison), 207	In the Court of the Crimson King (King Crimson),
High Time (MC5), 280	235, 239
Highway 61 Revisited (Bob Dylan), 123, 196	"In the Midnight Hour" (Wilson Pickett), 99
Hillbilly music, 2, 6, 21, 23	In-A-Gadda-Da-Vida (Iron Butterfly), 183
See also Country; Rockabilly sound	Independent record labels, 6–9
Hip-hop, 264–265	backroom operations of, 9
See also 2000s/New Millennium Rock	emerging industry trends and, 9
Hippie culture, 163–164, 173	market share, expansion of, 9, 40
"Hold On, I'm Comin" (Sam and Dave), 99	post-War American music and, 32–33
Holland/Dozier/Holland (HDH) releases, 91–92,	R&B/Country music and, 8 risk taking tactics of, 9
95–96, 143	See also Recording industry
Holly, Buddy, 49	Industrial, 318
death of, 56	characteristics of, 319
early influences on, 49–50	key recordings of, 319
legacy of, 51	Nine Inch Nails and, 318–319
marriage of, 56	principle artists in, 318
Nor Va Jak Studio and, 51	See also Eighties Alternative
recordings of, 50, 51	International Federation of the Phonographic Industry, 332
See also American Rock and Roll	International Workers of the World (IWW), 108
Hollywood movie industry, 3, 174	"Iron Man" (Black Sabbath), 227
"Honky Tonk Woman" (Rolling Stones), 146	Island Records, 262
Honky-tonk, 24	It Takes a Nation to Hold Us Back (Public Enemy), 269
Hootenannies, 109–110, 197	"It's Too Late" (Carole King), 204, 205
Hot Buttered Soul (Isaac Hayes), 260	iTunes Music Store, 349–350
Hot Mainstream Rock Tracks chart, 345	IWW Songs: Songs of the Workers to Fan the Flames of
Hot Rats (Mothers of Invention), 180	Discontent, 108
Hot 100s chart, 9–10, 128	
Hotel California (The Eagles), 218	J
"House of the Rising Sun" (The Animals), 154, 155 House Un-American Activities Committee, 110	Jazz, 2, 15
	big band jazz and, 5, 15
Human Be-In, 164–165	cool jazz/free jazz and, 15
Human Clay (Creed), 345 Hurricane Katrina, 41	first recording of, 7, 14
	improvisation and, 15
Hybrid Theory (Linkin Park), 345	modern jazz/bebop and, 15
	negative connotations of, 5
T. Control of the Con	post-bebop era, new stylistic approaches and, 15
I Am Sasha Fierce (Beyoncé), 337	riff-based boogie style and, 15
"I Can See for Miles" (The Who), 150	rock-jazz fusion and, 15
"I Can't Get No Satisfaction" (Rolling Stones), 144	soloist art form and, 15
"I Got a Woman" (Ray Charles), 82–85	Swing era and, 15 trad jazz and, 128
"I Never Loved a Man" (Aretha Franklin), 103	See also African American music
1 1.0.01 Loved a triality (Interna I talikility, 100	Cot was illiferent illiferenti fittate

Jazz from Hell (Mothers of Invention), 180 music streaming and, 350 Jefferson Airplane Takes Off (Jefferson Airplane), 167 Napster/file sharing and, 348-349 Nashville/Grand Ole Opry and, 22 Jim Crow laws, 13 1980s/1990s, hubris/living large and, 346-348 J&M Recording Studio, 41, 42 piracy and, 348-350 Jobete Music publishing, 89 post-War American music and, 32, 33 John Wesley Harding (Bob Dylan), 122 producers and, 9 The Joshua Tree (U2), 312 radio play, national charts and, 9 Jug band music, 128 refined Rock and Roll and, 57 Jump bands, 17 sales potential, maximization of, 9 singles sales, discontinuation of, 347-348 K small brick/mortar distributors, demise of, 348 talent scouts and, 9 Kags Music publishing, 89 See also Recording industry Kent State University massacre (1970), 162, 201 Marijuana, 162 King Records, 9, 86 The Marshall Mathers LP (Eminem), 336 Master tapes, 8 Matrix Club (San Francisco), 166 L.A. Woman (the Doors), 178 MCA, 216 Lady Sings the Blues (film), 97 McLemore Avenue (Booker T. and the MGs), 100 The Last Waltz (film), 211 Melismatic singing, 17, 18, 84 Laurel Canyon, 196, 205 Mellotron, 235 Led Zeppelin IV/Zoso (Led Zeppelin), 225, 228, 229 Melody Maker magazine, 230 Left-wing folksong conspiracy, 108 Memphis Recording Service, 33 "Lemon Tree" (Peter, Paul and Mary), 112 Memphis Rock and Roll, 46-48 Let It Be (The Beatles), 140 Mento, 261 "Light My Fire" (The Doors), 176 Mercer Art Center (New York), 243 Like a Rolling Stone (Bob Dylan), 116, 119 Mercury Records, 8, 9 The Little Red Songbook, 108 Merry Pranksters, 162, 169 Live Aid concert, 321 Mersey beat groups, 152-153 Live at Leeds (the Who), 149, 151 "The Message" (Grandmaster Flash and the Furious Five), Live at the Apollo (James Brown), 82, 86 266-268, 270 London Fog club (Los Angeles), 174, 176 Metal. See Eighties Alternative; Heavy Metal; 2000s/ Los Angeles. See Psychedelic Rock; Sixties counterculture New Millennium Rock Louisiana Hayride, 36 Metallica (Metallica), 317 Love and Theft (Bob Dylan), 123 MGM Records, 9 "Love to Love You Baby" (Donna Summer), 254 MGM-Verve Records, 179 LP album format, 8 MIDI (Musical Instrument Digital Interface) protocol, 301-302 LSD, 160, 162, 165, 169, 186 "Midnght Special" (Leadbelly), 108 Millennium (Backstreet Boys), 333 M Milton Berle Show, 37 Mafioso Rap, 336 Minimalism, 86 Magical Mystery Tour (The Beatles), 139 Mini-Moog, 236 Major record labels, 8-9 Minton's Playhouse, 15 artist & repertoire staff and, 9 Mississippi Delta, 13, 33, 147 big box store distribution and, 348 Modern Records, 9 consolidated ownership and, 347 Mods, 148-150 distribution networks and, 8 "Monday, Monday" (Mamas and the Papas), 199 future of, 350-352 "Money" (Pink Floyd), 238 headquarters of, 9 iTunes Music Store and, 349-350 Monterey International Pop Festival, 150, 165, 169, 172, market share, losses in, 40 177, 180, 181, 188

The Moondog Coronaton Ball, 11

Mp3 file format and, 348, 350-351

Moondog House Rock and Roll Party (radio), 11	principle artists in, 291 Talking Heads and, 291
Mothership Connection (George Clinton), 257	See also Punk
Motown Records, 83	New Wave of British Heavy Metal (NWOBHM), 317
assembly line production, quality control and, 89 characteristic sound of, 91	Newport Folk Festival, 108, 112–113, 117–120, 196
falsetto, use of, 96	Nielsen Soundscan, 332
Holland/Dozier/Holland releases and, 91–97	
Jackson 5 and, 303–304	A Night at the Opera (Queen), 232
key recordings of, 91	"The Night They Drove Old Dixie Down" (Joan Baez), 112
origins of, 89	1970s landscape, 194
overdubbing technique and, 91	American society, changes in, 194–195
principle artists of, 93–97	Art rock and, 235–241
Snakepit recording studio and, 91	Corporate rock and, 215–219 Country rock and, 208–212
sound of young America and, 90–91	Disco and, 253–255
See also African American music; American Pop; Soul	Folk rock and, 196–202
Mp3 file format, 348, 349	Funk and, 256–260
"Mr. Tambourine Man" (Byrds), 196–198	Glam rock and, 243–246
MTV (Music Television), 227, 302-303	Heavy Metal and, 224–234
MTV Unplugged in New York, 328	Rap and, 264–273
"The Mud Shark" (Frank Zappa), 229	Reggae and, 260–263
Murmur (R.E.M.), 315	Rock, fragmentation of, 195, 241
Muscle Shoals Rhythm Section (MSRS), 103	Shock rock and, 241-246
Fame Studios and, 102–103	singer/songwriters and, 203-208
members of, 102	Soft soul and, 250-253
principle artists of, 102–104	Southern rock and, 213–215
Rolling Stones releases and, 147	See also Punk
See also Soul	1980s landscape, 300, 320–321
Music from Big Pink (The Band), 209, 211	additional artists in, 312–313
Music streaming, 350	basics, return to, 310–314
Music videos, 136, 302, 303	cassette tapes, market for, 300
My Aim is True (Elvis Costello), 292	charity events, Live Aid/Farm Aid concerts and, 321
My Generation (The Who), 149, 150	compact discs and, 301
, , , , , , , , , , , , , , , , , , , ,	consumer technologies, changes in, 300–301
N	Digital Audio Tape recording technology and, 302
	digital samplers and, 301 home taping trend and, 301
Napster, 10, 348–349	Houston, Whitney and, 313–314
Nashville barn dance programs, 22	Jackson, Michael/King of Pop and, 303–306
Nashville Skyline (Bob Dylan), 122	Madonna/Material Girl and, 307–308
National Barn Dance program, 22	MIDI protocol and, 301–302
"Need You Now" (Lady Antebellum), 343	MTV phenomenon and, 302–303
Never Mind the Bollocks, Here's the Sex Pistols (The Sex	music industry, hubris/living large and, 346–348
Pistols), 288	music videos and, 302-303
Neverland Ranch, 306	Parents Music Resource Center and, 320-321
Nevermind (Nirvana), 326–327	political conservatism and, 320–321
New Millennium. See 2000s/New Millennium Rock	post-disco dance dominance and, 303-309
New Orleans sound, 41	post-punk styles, emergence of, 300
characteristics of, 42	Prince/The Artist Formerly Known As and,
key recordings of, 41, 42	308–309
recording artists of, 41–43	Springsteen, Bruce/The Boss and, 310–311
stop time and, 43	technological innovation and, 300–301
trad Jazz and, 128–129	U2 and, 311–312
New Wave, 291	See also Eighties Alternative
Cars and, 292	1990s landscape, 326
characteristics of, 292 key recordings of, 292	Alternative Nation, triumph of, 326–332 Boy bands and, 333
key recordings of, 292	Doy Danus and, 333

Girl bands/performers and, 334–335	Post-War America, 30
music industry, hubris/living large and, 346-348	authority, questioning of, 31
Nielsen Soundscan data and, 332	automobile culture and, 30, 31
pop music and, 332–335	early Rock and Roll bands and, 32-35
teen pop and, 333–335	independent record labels and, 8, 32–33
Nor Va Jak Studio, 50	isolation/loneliness and, 31
	major record labels and, 32, 33
0	middle class, dramatic expansion of, 30
Odelay (Beck), 330, 332	R&B/Country music and, 8
OK Computer (Radiohead), 330	Rhythm and Blues, white performers of, 31–32 Rock and Roll, birth of, 33–35
Old school rap, 267	Rock and Roll, explosion of, 40–51
Oldies, 195	Rockabilly sound and, 34–35
"On Broadway" (The Drifters), 63	suburbanization trend and, 30, 31
"One Sweet Day" (Mariah Carey/Boyz II Men), 334	technological/economic developments in, 30
"Oops! I Did It Again" (Britney Spears), 333	teenagers, consumer entity of, 30–31
Open mic nights, 197	transitional musical styles, 6-7
Ostinato, 177	See also Holly, Buddy; Post-War England; Presley, Elvis;
Our World program, 139	Sun Studio Records
Overdubbing technique, 91, 180	Post-War England, 128
o veradoonig teeninque, >1, 100	pirate radio stations and, 130
D	popular music culture and, 129
P	skiffle and, 128–129
Palomar Ballroom (Los Angeles), 5	trad Jazz and, 128
Pandora's Box (Los Angeles), 197	See also British invasion; British Rock and Roll; The Beatles
"Papa Don't Preach" (Madonna), 307, 308	Power chord, 183
"Papa's Got a Brand New Bag Part 1" (James Brown), 86	Presley, Elvis, 32, 35
Paranoid (Black Sabbath), 225, 227	army service of, 38, 56
"Paranoid Android" (Radiohead), 331	audience-performer interaction and, 39
Parents Music Resource Center (PMRC), 180, 271, 320–321	conservative re-packaging of, 38
Parlophone Records, 135	decline of, 39
Payola, 58–59	discovery of, 35–37
Pearl (Janis Joplin), 172	film vehicles for, 38, 39
"Pedro's Dowry" (Frank Zappa), 180	Graceland and, 39
"Penny Lane" (The Beatles), 138	legacy of, 39
People's Songs, 114	marriage of, 39
The Perfect Stranger (Mothers of Invention), 180	RCA Records contract with, 37, 46
Pet Sounds (The Beach Boys), 74–76	recordings of, 37–40
Philadelphia International Records (PIR), 252–253	suggestive sexuality of, 38, 39
"Piece of My Heart" (Big Brother and The Holding	television appearances by, 38
Company), 171, 172	See also Post-War America "Protty Boy Floyd" (Woody Cythylo) 100
Pinkerton (Wheezer), 330, 332	"Pretty Boy Floyd" (Woody Guthrie), 109
Piracy, 349–350	Progressive rock movement, 240 Progressive rock radio, 165
Pirate radio stations, 130	
Platinum records, 10, 39, 195, 231, 232, 257, 268, 271, 305,	Psychedelic Rock, 2, 77, 132 backlash against, censorship and, 180
308, 312, 313, 330, 333	characteristics of, 174
"Please Mr. Postman" (Marvelettes), 89	diverse music scene of, 174
"Please, Please" (James Brown), 86	key recordings of, 174, 177–180
Pogo, 279	outdoor music festivals and, 146, 180–182
"Poker Face" (Lady Gaga), 340	principle artists in, 176–180
Polo Grounds be-in (San Francisco), 164	"Purple Haze" (Jimi Hendrix Experience), 187
Pop music. See American Pop; Black popular music; 2000s/	Riot on Sunset Strip and, 174
New Millennium Rock	splicing/overdubbing techniques and, 180
Posse. See Crew/posse	Sunset Strip and, 174-175, 197

Psychedelic Rock (Continued)	targeted audiences and, 11
thespian ecosystem and, 175	television, radio's demise and, 10
Whisky a Go Go nightclub and, 174, 176, 177	Top 40 format and, 12
See also Acid Rock; Folk rock movement; Hard Rock;	transistor radios and, 11
Sixties counterculture	The Wayfaring Stranger program, 108
Psychoactive drugs. See Drug culture	youth audiences, programming selections and, 11, 130
Pub rock circuit, 285–286	Radio One, 130
Pulp Fiction (film), 73	Railway tavern (London), 149
Punch phrasing technique, 266	Raising Hell (Run-D.M.C.), 266, 268–269
Punk, 236, 278	The Ramones (The Ramones), 284–285
additional artists in, 291	Rap, 86, 264
CGBG club and, 283	back spinning technique and, 266
characteristics of, 279	beginnings of, 266–268
The Clash and, 289–290	characteristics of, 266, 272
culture of, 279	court obscenity rulings and, 270
garage bands and, 280	crews/posses and, 266
Hardcore and, 293–295	East Coast (What Coast rively) and 272, 273
key recordings of, 279	East Coast/West Coast rivalry and, 272–273
London scene and, 285–290	Gangsta rap and, 270–272 Hip-hop and, 264–265
New Wave, punk aftermath and, 290–293 New York scene and, 283–285	key recordings of, 266, 272
pogo and, 279	Mafioso Rap, 336
principle artists in, 279	old school rap and, 267
protopunk, earliest punk bands and, 280–281	principle artists in, 267–269, 272
pub rock circuit and, 285–286	punch phrasing and, 266
Ramones and, 284–285	rage/violence themes and, 270, 271
rebellious attitude and, 278–279	scratching technique and, 266
Sex Pistols and, 278–279, 286–289	toasting and, 265
Velvet Underground and, 281–282	West Coast rap and, 270–272
	See also Black popular music; 1970s landscape; 2000s/
0	New Millennium Rock
Q	Rastafarianism, 261
Quadrophenia (The Who), 152	Rastaman Vibration (Wailers), 263
	RCAVictor Records, 8, 33, 37, 46, 216
R	Ready, Steady, Go show, 149
Race music, 6, 14	Reasonable Doubt (Jay-Z), 336
Radio broadcasting, 10	Reconstruction, 13
automobile culture and, 31	Recording industry, 5
country music, popularization of, 22	acoustical process and, 7
disc jockeys on, 9–11	album format and, 8
disco music and, 254–255	big band music and, 7
folk radio shows, 108	chart listings and, 10
Grand Ole Opry and, 22	cover versions of hits and, 5
Let's Dance program, 5	crossover artists and, 40
local disc jockeys and, 10	Diamond records and, 10
major record labels, alliances with, 8-9	electrical process and, 7, 8
modern mass marketing and, 30–31	45 rpm records and, 8
Moondog House Rock and Roll Party program, 11	Gold records and, 10
Nashville barn dance programs and, 22, 48	Great Depression, effects of, 7, 14
payola and, 58–59	Hot 100s/Top 100 and, 9–10
pirate radio stations and, 130	independent labels, emergence of, 6–9
progressive rock radio and, 165	LPs, introduction of, 8
renegade disc jockeys and, 9, 11	major record labels/1950s, 8–9
rock, fragmentation of, 195	master tapes/magnetic tape technology and, 8
segregated broadcasts and, 11	1980s/1990s, hubris/living large and, 346–348

"San Francisco (Be Sure to Wear Flowers in Your Hair)"

(Mamas and the Papas), 164-165

Distinguis as a said and 10	D A F 11 D 1 227
Platinum records and, 10	Roc-A-Fella Records, 337
record sales trends and, 9–10, 195	Rock and Roll, 2–3
rock, fragmentation of, 195	backlash against, 12, 31, 57-58, 82
sales potential, maximization of, 9, 19–20	black roots of, 12–20
sales tracking technology and, 332	emergence of, 2–3, 33–35
singles and, 6, 10, 12	generation gap and, 31
Swing Era and, 5	grassroots independence in, 3
trade group for, 10	musical ancestors of, 2
See also Major record labels	post-War transitional years and, 6–7
Recording Industry Association of America (RIAA), 10, 39, 300, 321, 332, 346, 349	styles in, 2 white roots of, 20–25
Red Scare. See Communism	youthful audience for, 3, 9, 30-31, 56-57
Reeperbahn section (Hamburg), 134	See also American Pop; American Rock and Roll;
Reggae, 260–261	American Rock and Roll/second phase; British
additional artists in, 264	Rock and Roll; 1970s landscape; 1980s landscape
burru drumming and, 261	1990s landscape; Post-War America; Sixties
characteristics of, 260	counterculture; 2000s/New Millennium Rock
Island Records and, 262	Rock and Roll Hall of Fame, 93
key recordings of, 260	The Rock and Roll Show (radio), 12
Marley, Bob/Wailers and, 262–263	Rock Around the Clock (film), 32
mento and, 261–262	
musical roots of, 261–262	Rock steady, 262
principle artists of, 261	Rock theatre, 241–243
Rastafarian culture and, 261	See also Glam rock; Shock rock
riddim and, 261	Rockabilly sound, 32–35
rock steady and, 262	characteristics of, 34
ska and, 262	key recordings of, 34
See also Black popular music; 1970s landscape	Memphis sound and, 46–48
	See also American Rock and Roll; Post-War America
"Respect" (Aretha Franklin), 83, 103	"Rocket 88" (Jackie Brenston), 34
Revolver (The Beatles), 137–138	Rolling Stone magazine, 123, 230
Rhythm and blues (R&B), 2, 6–7	Rolling Stones, 142
amplification and, 17	Altamont Speedway Free Festival and, 147
boogie-woogie bass lines and, 17	anti-Beatles image of, 142
Chicago sound and, 43–46	break-through success of, 143-144
crossover artists and, 17, 40	creative triumph of, 146–147
down-and-dirty bar bands and, 17	early years of, 143
honking tenor sax solos and, 17	key recordings of, 142–147
independent record labels and, 8	later years of, 147
instrumentation in, 17, 32	Rock and Roll bad boy image and, 144-146
Jazz/Blues roots of, 17	sexually suggestive onstage antics and, 145
jump bands and, 17	See also British invasion
major record labels and, 8	Rolling Thunder Revue, 122
principle artists in, 17–18	Romantic soul. See Soft soul
record sales trends and, 9	"Rope" (Foo Fighters), 346
Rockabilly sound and, 32–35	Rubber Soul (The Beatles), 137
segregated radio broadcasts and, 11	Rumours (Fleetwood Mac), 216, 218–219
white audiences for, 11, 40	Rural music. See Traditional rural music
white performers of, 31–32	Rufai music. See traditional rufai music
See also African American music; Black popular music;	
Funk; Soul	S
Riddim, 261	Safe at Home (International Submarine Band), 209
Riot on Sunset Strip, 174	Sam Goody, 348
"Rise Above" (Black Flag), 294	San Francisco. See Acid Rock; Sixties counterculture
The Rise and Fall of Ziggy Stardust and the Spiders from	"San Francisco (Be Sure to Wear Flowers in Your Hair)"

Mars (David Bowie), 243, 244

Saturday Night Fever soundtrack (Bee Gees/Tramps), See also Hard Rock; Monterey International Pop Festival; 1970s landscape; Woodstock Music and 254, 255 Arts Fair Saturday Night Live, 299 Ska, 261 "Say It Loud, I'm Black and I'm Proud" (James Brown), Skiffle, 128-129 87 Slap-bass technique, 259 Scratching technique, 266 "Smells Like Teen Spirit" (Nirvana), 328 Screaming for Vengeance (Judas Priest), 231 The Snakepit, 91 Second Helping (Lynyrd Skynyrd), 213 The Soft Parade (The Doors), 177 Self Portrait (Bob Dylan), 122 Soft rock, 195, 226 Sgt. Pepper's Lonely Hearts Club Band (The Beatles), Soft soul, 252-253 138-139, 235 characteristics of, 252 Shaft (Isaac Hayes), 257 key recordings of, 252 "Sheena Is a Punk Rocker" (Ramones), 285 principle artists in, 252, 253 Shock rock, 241 See also Black popular music; Soul Alice Cooper, gruesome rock theatre and, 241-243 Songs in the Key of Life (Stevie Wonder), 259 arena concerts and, 240 Sony records, 216 theatrics/stagecraft and, 241 See also Glam rock; 1970s landscape Soul, 2, 57, 82 anticipation/hope, sense of, 84 "Shop Around" (Miracles), 89 archetypal song form in, 84-85 Shouts, 12, 86 avant-garde/rhythm-oriented approach in, 87 Sing Out!, 115 changing landscape in, 250-252 Singer/songwriters, 195, 203 Civil Rights Movement and, 83, 84, 87 additional important artists and, 208 crossover appeal of, 87 characteristics of, 204 crying out/vocal exclamations in, 86 Dylan, influence of, 203-204 early soul artists and, 84-89 female performers and, 203 essence/characteristics of, 83-84 key recordings of, 204 first Soul recording and, 82 King, Carole and, 204–205 Gospel foundation of, 16–17 me-first decade and, 203 key recordings of, 82, 87, 88 Mitchell, Joni and, 205-206 melismatic singing and, 84 Morrison, Van and, 207-208 minimalism technique and, 86 principle artists in, 203 origins of, 82-84 Simon, Carly and, 206 rap, emergence of, 86 Taylor, James and, 206, 207 regional nature of, 83 See also 1970s landscape Soft soul and, 252-253 Singles, 6, 10, 12, 348 See also American Pop; American Rock and Roll/ Sixties counterculture, 160-161 second phase; Black popular music; Motown acid rock scene and, 163-174 Records; Muscle Shoals Rhythm Section (MSRS); anti-establishment sentiment and, 161, 166 Stax Records; 2000s/New Millennium Rock anti-war songs and, 161, 162 "Soul Man" (Sam and Dave), 102 counterculture media and, 165 "Soulsville, U.S.A." motto, 99-100 Haight-Ashbury district and, 163 "The Sound of Silence" (Simon and Garfunkel), 196, 202 hippie culture and, 164-165 Soundscan Era, 332, 342 human be-in and, 164-165 Southern rock, 213 media of, 164 additional artists in, 215 outdoor music festival and, 147, 180-182 Allman Brothers Band and, 214–215 progressive rock radio and, 165 characteristics of, 213 psychedelic rock scene and, 174–181 country music/blues roots of, 213 radical theater groups and, 164 key recordings of, 213 recreational drugs, use of, 162-163 sexual revolution, contraceptive use and, 161 Lynyrd Skynyrd and, 213-214 principle artists in, 213 Summer of Love and, 164-165 See also 1970s landscape Vietnam War, opposition to, 161–162 Specialty Records, 9 youth culture, emergence of, 160-161

St. Martin's School of Art (London), 278	"Sweet Home Alabama" (Lynyrd Skynyrd), 214
Stadium rock anthems, 232	Sweetheart of the Rodeo (Byrds), 198, 209
"Stan" (Eminem), 336	Swing era, 5–6, 17
Stax Records, 83, 97–100	dance crazes in, 5
characteristic sound of, 99	jazz in, 15
founding of, 97	original material/arrangements and, 5
in-house songwriters for, 99	record sales trends and, 7–8
key recordings of, 99	riff-based boogie style and, 15
live/spontaneous production in, 99–100	vocalists in, 5
principle artists of, 100–102	Western swing and, 23
"Soulsville, U.S.A." motto for, 99–100	"Sympathy for the Devil" (Rolling Stones), 146
See also American Pop; Motown Records; Soul	Synthesizers, 253, 254, 301
Steppenwolf (Steppenwolf), 183	
Sticky Fingers (Rolling Stones), 147	T
Stop time, 43	-
Straight Outta Compton (NWA), 271, 272	"Take It Easy" (The Eagles), 217
Straight Records, 242	Tamla Records, 89
Strange Days (The Doors), 177	Tape-delay echo technique, 34
"Strawberry Fields Forever" (The Beatles), 138	Tapestry (Carole King), 204-206, 216
Students for a Democratic Society (SDS), 161	Technological innovation, 300
Studio 54 (New York), 256	cassette tapes and, 300
Studio Z (Cucamonga), 178	compact discs and, 301
Sub Pop indie label, 328	consumer technologies, changes in, 300–301
Suburbanization trend, 30, 31	Digital Audio Tape recording technology and, 302
Summer of Love, 164–165	Digital Audio Workstations and, 351–352
Sun Studio Records, 9	digital samplers and, 301
Rock and Roll, emergence of, 33–35	file sharing and, 348–349
Rockabilly recordings and, 32–35, 46–49	future music industry and, 350–352 home taping trend and, 301
Southern black/Southern country white talent and,	iTunes Music Store and, 349–350
33–35	MIDI protocol and, 301–302
tape-delay echo technique and, 34	Mini-Moog and, 236
See also Post-War America; Presley, Elvis	Mp3 file format and, 348, 349
Sunset Sound (Los Angeles), 75	music streaming and, 350
Sunset Strip, 174–175, 197, 199, 200	Napster and, 348–349
"Sunshine of Your Love" (Cream), 184, 185	Soundscan data collection and, 332, 342
"Superstition" (Stevie Wonder), 94	synthesizers and, 253, 254, 301
Surf Ballroom (Iowa), 51	Walkman cassette players and, 300
Surf culture music, 72	See also Digital technology; 1980s landscape; 2000s/
bands of, 73–75	New Millennium Rock
Beach Boys formula and, 74	Teddy boys, 40, 134
bikini beach party films and, 72	Teen idols, 59, 333
characteristics of, 72	American Bandstand and, 58, 60-61
distortions in, 73	dance crazes and, 61
Dual Showman amplifier, use of, 73	Ed Sullivan Show and, 62
evolution of, 75–76	key recordings by, 60
key recordings of, 72–77	major record labels, artist development and, 59-60
Pet Sounds album and, 74–76	novelty tunes and, 61
psychedelic era and, 77	typical song format of, 59–60
reverb effect and, 73	See also American Rock and Roll/second phase;
	Teen pop; Youth audiences
See also American Pop; American Rock and Roll/ phase two	Teen pop, 333
Surrealistic Pillow (Jefferson Airplane), 166, 167	Boy bands and, 333
Sweet Baby James (James Taylor), 204, 207	Girl bands/performers and, 333–335
5 meet Daby James Games ray101/, 204, 207	See also 1990s landscape; Teen idols; Youth audiences

Television American mop tops and, 71 early Rock and Roll bands and, 32 modern mass marketing and, 30-31 MTV phenomenon and, 302-303 Our World program, 139 radio, demise of, 10 youth isolation/loneliness and, 31 See also American Bandstand; Ed Sullivan Show; Radio broadcasting Ten (Pearl Jam), 329 "Thank You (Falletin Me Be Mice Elf Agin)" (Sly and the Family Stone), 257, 258 "That'll Be the Day" (Buddy Holly), 50 Theater music, 3 "Then Came You" (The Spinners), 252, 253 "Third Stone From the Sun" (Jimi Hendrix Experience), Thriller (Michael Jackson), 303-306 The Times They Are a Changin' (Bob Dylan), 116, 118 Tin Pan Alley, 3, 62 Tipitina's Foundation, 41 Toasting, 265 "Tom Dooley" (The Kingston Trio), 111 Tommy (The Who), 149-151, 235 "Tomorrow Never Knows" (The Beatles), 138 Top 10 hits, 32, 64, 96, 129, 144 Top 40 hits, 12, 64, 65, 71, 85, 88, 96, 147, 165 Top 100 Pop Chart, 9-10, 99, 111 Tower Records, 348 Toys in the Attic (Aerosmith), 232 Trad Jazz, 128, 148 Traditional rural music, 20 barn dance programs and, 22 Bristol Sessions and, 21 British folk tradition and, 21 early country recordings and, 21-22 hillbilly music and, 21, 23 Nashville/Grand Ole Opry and, 22 See also Country; Cowboy songs; Folk Traveling Wilburys, 122–123 Trips Festival, 164 The Troubadour (Los Angeles), 197, 199, 245 "Turn! Turn! Turn!" (Byrds), 198 21 (Adele), 341 2000s/New Millennium Rock, 335 Adele and, 341 Beyoncé and, 337 Bright Eyes and, 344 Brooks, Garth and, 342 contemporary Hard Rock/Metal and, 345-346 Country music and, 342–343 Creed and, 345 Death Cab for Cutie and, 344

Digital Audio Workstations and, 351–352 Dixie Chicks and, 342 Eminem and, 335-337 Foo Fighters and, 345–346 future music industry and, 350-352 Indie/Alternative and, 343-345 iTunes Music Store and, 349-350 Jay-Z and, 336-337 Lady Antebellum and, 343 Lady Gaga and, 340-341 Linkin Park and, 345 Mp3 file format and, 348 music streaming and, 350 Napster/file sharing and, 348-349 Pop/Rock and, 338-341 Rap/Soul/Hip-hop and, 335–338 Swift, Taylor and, 343 Timberlake, Justin and, 339 Twain, Shania and, 342 West, Kanye and, 337 The White Stripes and, 344 Wilco and, 343-344

Uncle Meat (Mothers of Invention), 179 Under the Table and Dreaming (Dave Matthews Band), 330, 331 Unicorn (Los Angeles), 197 United Artists, 89 United Artists/MGM, 216 Urban contemporary rock, 195

The Velvet Underground and Nico (The Velvet Underground), 282 Victor Records, 21 Vietnam War, 160-162 Vocal chant technique, 33 Vogue Magazine, 143 Voting Rights Act of 1965, 83

W

"Walk This Way" (Aerosmith), 232–233, 268 "Walk This Way" (Run-D.M.C.), 268 Wall of Sound sessions, 69–70 Wall of Sound system innovation (The Grateful Dead), 170 Warner Brothers label, 207, 242, 315 Warner Communications, 216 "The Weight" (The Band), 211 "We Shall Overcome" (Pete Seeger), 110 Western Studio (Los Angeles), 75 Western swing, 23 vocal chant technique and, 33

See also Swing era What's Going On (Marvin Gaye), 95 "When a Man Loves a Woman" (Percy Sledge), 103 "Where Did Our Love Go" (The Supremes), 92 "Where Have All the Flowers Gone" (Pete Seeger), 110 "Whip It" (Devo), 292 Whisky a Go Go nightclub (Los Angeles), 174, 176, 177, 197, 200 The White Album (The Beatles), 139, 140 "White Rabbit" (Jefferson Airplane), 167 "White Room" (Cream), 184 "A Whiter Shade of Pale" (Procol Harum), 235 Whitney Houston (Whitney Houston), 313-314 The Who, 148 creative triumph of, 152 early years of, 148 key recordings of, 149-150 masculine attitude of, 149 Maximum R&B motto of, 149 mods and, 148-150 Monterey Pop Festival and, 150 stage violence of, 149-150 tragic ending and, 152 See also Country; Cowboy songs; Folk "Who Are the Brain Police?" (Mothers of Invention), 179 Who Are You (The Who), 152 (The Who Sings) My Generation (The Who), 149 "Whole Lotta Love" (Led Zeppelin), 225, 228, 229 Who's Next (The Who), 149, 151 "Why Do Fools Fall in Love" (Frankie Lymon), 20 Wide Open Spaces (Dixie Chicks), 342 "Wild Thing" (Jimi Hendrix Experience), 188 "Will You Love Me Tomorrow" (Carole King), 64 Windsor Jazz and Blues Festival, 184 Wind-Up Records, 345 Winterland Ballroom (San Francisco), 211 Wobblies, 108 "Won't Get Fooled Again" (The Who), 149, 151

"Woodstock" (Joni Mitchell), 206
Woodstock Music and Arts Fair, 169, 177, 180–181, 188, 200, 206
Woodstock Nation, 195
Work songs, 12, 21
Workingman's Dead (The Grateful Dead), 170
"Wouldn't It Be Nice" (The Beach Boys), 75
Wrecking Crew, 69, 71, 75

Yellow Submarine (The Beatles), 140

"Yesterday" (The Beatles), 137, 144 Yodeling, 22 "You Can't Always Get What You Want" (Rolling Stones), "You Make Me Feel Like a Natural Woman" (Aretha Franklin), 103 "You Send Me" (Sam Cooke), 87, 88 "You're So Vain" (Carly Simon), 206 Youth audiences, 3, 9, 11 authority, questioning of, 31 automobile culture, connectedness and, 31 black/white audiences, intermingling of, 59 bubblegum pop/sing-along songs and, 72 consumer entity of, 30-31 generation gap and, 31 isolation/loneliness of, 31 juvenile delinquency and, 31 maturation of, second phase Rock and Roll and, 57 sexual permissiveness and, 31 See also Sixties counterculture; Teen idols; Teen pop "You've Got to Hide Your Love Away" (The Beatles), 137 "You've Lost That Lovin' Feeling" (The Righteous Brothers), 70

Z

"Ziggy Stardust" (David Bowie), 244